MONUMENTA AEGYPTIACA X

Série IMAGO no. 2

Tomb Painting and Identity in Ancient Thebes, 1419-1372 BCE

BY

Melinda K. HARTWIG

FONDATION ÉGYPTOLOGIQUE REINE ÉLISABETH

BREPOLS

D/2004/0095/74
ISBN 2-503-51315-8

Printed in the E.U. on acid-free paper

TABLE OF CONTENTS

ACKNOWLEDGMENTS

The subject of this book has been incubating for many years in a number of different forms. From its gestation during my year in Egypt as a Thomas J. Watson fellow studying artist's "hands" in Theban tomb painting to its birth as my Ph.D. dissertation which focused on the communicative and commemorative aspects of mid-eighteenth dynasty tomb painting. As often happens when revising one's dissertation for publication, I decided to expand my focus. What resulted was an examination of the role of iconography in a ritual context which, I argue, created an existential reality within the tomb chapel that negotiated the deceased's self-presentation and regeneration across space and time, and in so doing, encoded larger ideological and religious movements that permeated the society. Given the long gestation period of this book, I want to thank a number of people who encouraged and aided me along the way. Names omitted here in no way erase my heartfelt thanks and appreciation for their support and contributions.

Initially, Bernard Bothmer at the Institute of Fine Arts, New York University encouraged me to expand my preliminary ideas about Theban tomb painting. He taught me the intricacies of connoisseurship, and his infectious enthusiasm, relentlessly high standards, and exhaustive knowledge of Egyptian art taught me much. My dissertation advisor, David O'Connor, who joined the faculty of the IFA in 1995, gave unstintingly of his time and enormous expertise during the writing of my dissertation and this book, continually leading me down avenues that created a richer product. I am also eternally grateful to my official dissertation readers, Ogden Goelet from the Middle East Studies Department at NYU, Donald Hansen at the Institute of Fine Arts, NYU, and Betsy Bryan from the Department of Near Eastern Studies at Johns Hopkins University. Their suggestions provided a preliminary guideline for the revised version presented here. Gay Robins in the Art History Department at Emory University kindly agreed to review my revised manuscript, and her insights enriched the book in a number of key areas. While writing the manuscript, I benefitted greatly from discussions and email exchanges with a number of colleagues, including Ray Johnson, Director of the Epigraphic Survey of The University of Chicago; Dimitri Laboury at the Université de Liège; Nigel Strudwick and John Taylor from The British Museum; Stephen J. Harvey at the Oriental Institute, The University of Chicago; Christian Loeben, Richard-Lepsius-Institute, Humboldt-Universität, Berlin; Jean and Helen Jacquet in Luxor; and Naguib Kanawati and Boyo Okinga at Macquarie University. Many thanks to Nozomu Kawai and Sakuji Yoshimura from Waseda University, who kindly provided me with all the publications by the Architectural Research Mission for the Study of Ancient Egyptian Architecture on the installations at the palace of Amenhotep III at Malkata. Roland Tefnin at the Université Libre de Bruxelles, Belgium, and Dimitri Laboury suggested my manuscript for publication in the Monumenta Aegyptiaca series, and I am deeply indebted to them both as well as Jean Bingen, Université Libre, Bruxelles. While I have benefitted enormously from conversations with these colleagues, the responsibility for the ideas put forth in this book is my own.

My fieldwork in the Theban necropolis was carried out under the auspices of the American Research Center in Egypt as a USIA pre-doctoral fellow in 1996-1997, as a post-doctoral ARCE research affiliate in 2000 funded by both the Alumni Association of the Institute of Fine Arts, New York University, and the Faculty Development Grant, University of Memphis, and as a post-doctoral fellow in the Fall of 2003 funded by the United States Bureau of Educational and Cultural Affairs. During these field seasons, I thank my Egyptian colleagues for expediting and kindly assisting my research in the field, particularly the current Secretary General of the Supreme Council of Antiquities, Dr. Zahi Hawass, and the past secretaries, Prof. Dr. Ali Hassan and Prof. Dr. G.A. Gaballa. I also thank the current General Director of Antiquities in Upper Egypt and Luxor, Dr. Holeil Ghaly and former directors, Sabry Abdel Aziz and Dr. Mohammed el-Soghir; the current General Director of Antiquities on the West Bank, Dr. Ali Asfar, and past directors Mohamed el-Bially and Dr. Mohammed Nasr; and my inspectors on the west bank, Mohammed Said and Yasser Youssef Ahmed.

In Egypt, I owe an eternal debt to Ray Johnson, and Mark Easton, the former Director of the American Research Center in Egypt in Cairo. Both facilitated my research in Egypt and opened their respective "homes" to me during my field seasons in Egypt. During the final stages of editing the manuscript for publication, the library of the German

Institute provided the perfect environment, and a very special thank you goes to Günter Dreyer, Director of the Deutsches Archäologisches Institut Kairo, and the librarian of the DAI, Isolde Lehnert. As is the case with every American doing research in Egypt, I am indebted to the staff of ARCE in Cairo for their help at every turn during my many field seasons, and in particular, I would like to single out the Assistant Director, Mrs. Amira Khattab, and Mr. Amir Abdel Hamid. At Chicago House, photographer Yarco Kobylecky, finance manager, Safinaz Ouri, and the fomer administrator Ahmed Harfoosh helped me enormously while I was doing fieldwork in Luxor.

In Europe, I offer thanks to Luc Limme of the Musées Royaux d'Art et d'Histoire in Brussels; Martina Minas-Nerpel at the Universität Trier, Germany; Jaromir Malek at the Griffith Institute, Oxford, U.K.; and Friederike Kampp-Seyfried fomerly at the Ägyptologisches Institut at the Universität Heidelberg and now at the Ägyptisches Museum, Leipzig, Germany, all of whom generously opened their collections and archives to me. Marianne Eaton-Krauss, Berlin-Brandenburgische Akademie der Wissenschaften, graciously provided critical bibliography on artisan organization. And a special thank you to Eberhard Dziobek whose expertise and moral support were always freely offered and appreciated, as was his hospitality during my stay with him and his wife Almut in Heidelberg during September 1998. At Brepols Publishers NV, Chris VandenBorre, Publishing Manager, was the epitome of patience, both for answering all my queries and continually extending my deadline.

In the U.S., I am grateful to Dorothea Arnold, Dieter Arnold, Marsha Hill, and Adela Oppenheim of the Egyptian Department at The Metropolitan Museum of Art for kindly giving me access to the Burton and Brack photo archives, as well as to Catharine Roehrig for answering my questions about nurses and unassigned Theban tombs. Special thanks goes to Emily Teeter at the Oriental Institute Museum, Peter Brand at the University of Memphis, and Yvonne Markowitz from the Museum of Fine Arts, Boston, all of whom quickly and unfailingly provided pertinent bibliography. I thank the curators of the Egyptian, Classical and Middle Eastern Department at the Brooklyn Museum of Art, especially Richard Fazzini who always provided that crucial reference, and Edna R. Russmann who kindly allowed me to examine Malkata painting fragments at the BMA before their publication. Diane Bergman, formerly of the Wilbour Library of Egyptology and now Assistant Librarian at the Ashmolean Library in Oxford provided invaluable research support during my visits. I am indebted to my draftsperson, Tamara Bower, who took my initial sketched line drawings and photos of the unpublished tomb walls and, with her abundant talent, inked the final line drawings for this book. In Atlanta, I want to thank especially Jamie Allen, Justin King, David Ritter, and Susanne Wilhelm who had the herculean effort of editing, imaging, and indexing this manuscript. And thanks to Julia Hilliard whose generous donation of a notebook computer made the final editing of the manuscript in Egypt possible. Also deserving special mention are Paul Brown and Laura Smith from the Department of University Relations and Creative Services at Georgia State University who formatted the book for publication. The research, writing, and drawings that went into this book were facilitated, in part, through a 2002-2003 Research Initiation Grant from GSU. To my colleagues at GSU as well as my wonderful students, I express my gratitude for your help and understanding while I wrestled with this manuscript.

The burden of writing a book is always borne by those closest to the author. In this regard, I would like to express deep appreciation to my friends and my family. Jack Josephson and Magda Saleh have been with me every step of the way, and continually humble me with their kindness. Without Jack, this book in its present form would never have made it to press, and I remain eternally grateful to him for his friendship, advice, and support. To all those mentioned or inadvertently omitted for the sake of space, once again, my heartfelt thanks.

Atlanta, December 2003
Melinda K. Hartwig

LIST OF ABBREVIATIONS

AAAE	W. Stevenson Smith. *The Art and Architecture of Ancient Egypt*, 3d rev. ed. by W.K. Simpson. New Haven and London, 1998.
ÄA	Ägyptologische Abhandlungen. Wiesbaden.
ÄAT	Ägypten und Altes Testament. Wiesbaden.
ADAIK	Abhandlungen des Deutschen Archäologischen Instituts Kairo. Glückstadt, Hamburg, New York.
ÄF	Ägyptologische Forschungen. Glückstadt, Hamburg, New York.
AJSL	*The American Journal of Semitic Languages and Literature*. Chicago.
AOAT	Alter Orient und Altes Testament. Kevalaer and Neukirchen-Vluyn.
AOS	American Oriental Series. New Haven.
ASAE	*Annales du Service des Antiquités de l'Égypte*. Cairo.
ASE	Archaeological Survey of Egypt. London.
AV	Archäologische Veröffentlichungen. Deutsches Archäologisches Institut Abteilung Kairo. Vol. 1-3, Berlin; vol. 4ff, Mainz.
BABA	Beiträge zur ägyptischen Bauforschung und Altertumskunde. Cairo.
BARCE	*Bulletin of the American Research Center in Egypt*. Cairo.
BASOR	*Bulletin of the American Schools of Oriental Research*. New Haven, Cambridge, MA., Philadelphia.
BdÉ	Bibliothèque d'Étude. Cairo.
BES	*Bulletin of the Egyptological Seminar*. New York.
BiAeg	Bibliotheca Aegyptiaca. Brussels.
BIE	*Bulletin de l'Institut d'Égypte*. Alexandria, Egypt.
BIFAO	*Bulletin de l'Institut Français d'Archéologie Orientale*. Cairo.
BiOr	*Bibliotheca Orientalis*. Leiden.
BMMA	*Bulletin of the Metropolitan Museum of Art*. New York.
Boreas	Acta Universitatis Upsaliensis: Uppsala Studies in Ancient Mediterranean and Near Eastern Civilizations. Uppsala.

BSÉG	*Bulletin, Société d'Égyptologie Genève*. Geneva.
BSFÉ	*Bulletin de la Société Française d'Égyptologie*. Paris.
CAJ	*Cambridge Archaeological Journal*. Cambridge, U.K.
CANE	J.M. Sasson, ed. *Civilizations of the Ancient Near East*. New York, 1995.
CdÉ	*Chronique d'Égypte*. Brussels.
CDME	Raymond O. Faulkner. *A Concise Dictionary of Middle Egyptian*. Oxford, 1962.
CNS	Centre of Non-Western Studies. Leiden.
DIE	*Discussions in Egyptology*. Oxford.
DIFAO	Documents de fouilles de l'Institut français d'Archéologie Orientale. Cairo.
EG(3)	Alan H. Gardiner. *Ancient Egyptian Grammar*, 3d ed. Oxford, 1957.
EEF	Egypt Exploration Fund. London.
EU	Egyptologische Uitgaven. Leiden.
FIFAO	Fouilles de l'Institut Française d'Archéologie Orientale du Caire. Cairo.
GM	*Göttinger Miszellen*. Göttingen.
HÄB	Hildesheimer Ägyptologische Beiträge. Hildesheim.
JARCE	*Journal of the American Research Center in Egypt*. Cambridge, MA., Boston, Princeton, New York, Evanston, IL.
JEA	*The Journal of Egyptian Archaeology*. London.
JEOL	*Jaarbericht van het Vooraziatisch-Egyptisch Gezelschap Ex Oriente Lux*. Leiden
JESHO	*Journal of the Economic and Social History of the Orient*. Leiden.
JNES	*Journal of Near Eastern Studies*. Chicago.
JSSEA	*The Journal of the Society for the Study of Egyptian Antiquities*. Toronto.
LÄ	*Lexikon der Ägyptologie*. Wiesbaden.
LÄS	Leipziger Ägyptologische Studien. Glückstadt, Hamburg, New York.
MÄS	Münchner Ägyptologische Studien. Munich.
Mem. Miss.	*Mémoires publiés par les membres de la Mission Archéologie Français au Caire*. Paris.

MDAIK	*Mitteilungen des Deutschen Archäologischen Instituts Abteilung Kairo.* Before 1944: *Mitteilungen des Deutschen Instituts für Ägyptische Altertumskunde in Kairo.* Berlin, Wiesbaden, Mainz.
MIFAO	Mémoires publiés par les membres de l'Institut Français d'Archéologie Orientale du Caire. Cairo.
MMJ	*The Metropolitan Museum of Art Journal.* New York.
MMS	*Metropolitan Museum Studies.* New York.
NARCE	*Newsletter of the American Research Center in Egypt.* Princeton and New York.
OBO	Orbis Biblicus et Orientalis. Fribourg and Göttingen.
OEAE	Donald Redford, editor-in-chief. *The Oxford Encyclopedia of Ancient Egypt.* Oxford and New York, 2001.
OIC	Oriental Institute Communications. University of Chicago, Chicago.
OIP	Oriental Institute Publications. University of Chicago, Chicago.
OLA	Orientalia Lovaniensia Analecta. Leuven.
OLZ	*Orientalistische Literaturzeitung.* Leipzig.
OMROL	*Oudheidkundige medelelingen uit het Rijksmuseum van Oudheden te Leiden.* Leiden.
Or. Ant.	*Oriens Antiquus.* Rome.
PÄ	Probleme der Ägyptologie. Leiden.
PKG	Propyläen Kunstgeschichte. Berlin.
PM I,1(2)	Bertha Porter and Rosalind Moss. *Topographical Bibliography of Ancient Egyptian Hieroglyphic Texts, Reliefs, and Paintings. I. The Theban Necropolis. Part 1. Private Tombs.* 2d ed. Oxford, 1960.
PN	Hermann Ranke.*Die ägyptischen Personennamen,* 3 vols. Glückstadt-Hamburg-New York, 1977.
PMMA	Publications of the Metropolitan Museum of Art, Egyptian Expedition. New York.
PTT	Private Tombs at Thebes. Oxford.
RdÉ	*Revue d'Égyptologie.* Cairo and Paris.
Rec. Trav.	*Recueil de travaux rélatifs à la philologie et à l'archéologie égyptiennes et assyriennes.* Paris.
SAGA	Studien zur Archäologie und Geschichte Altägyptens. Heidelberg.

SAK	*Studien zur altägyptischen Kultur*. Hamburg.
SAOC	Studies in Ancient Oriental Civilization. The Oriental Institute of the University of Chicago. Chicago.
SAS	Schriften aus der Ägyptischen Sammlung. Munich.
SBAW	Sitzungsberichte der Bayerischen Akademie der Wissenschaften, Philos.- philol. u. hist. Klasse. Munich.
SDAIK	Sonderschrift. Deutsches Archäologisches Institut Abteilung Kairo. Mainz.
TTS	Theban Tomb Series. London.
URAÄ	Urkunden zum Rechtsleben im Alten Ägypten. Tübingen.
Urk. I	Kurt Sethe. *Urkunden des Alten Reiches*, 4 vols. Leipzig, 1933.
Urk. IV	Kurt Sethe. *Urkunden der 18. Dynastie*, 4 vols. (fasc. 1-16). 2d ed. Berlin and Graz, 1961. Wolfgang Helck. *Urkunden der 18. Dynastie* (fasc. 17-22). Berlin, 1955-1961.
VA	*Varia Aegyptiaca*. San Antonio.
Wb.	Adolf Erman and H. Grapow. *Wörterbuch der Aegyptischen Sprache*, I-VI, 4th ed. (Berlin, 1982); *Belegstellen* I-VI (Berlin, 1982).
WO	*Die Welt des Orients*. Wuppertal and Göttingen.
YES	Yale Egyptological Studies. New Haven.
ZÄS	*Zeitschrift für Ägyptische Sprache und Altertumskunde*. Leipzig and Berlin.
ZDMG	*Zeitschrift der Deutschen Morgenländischen Gesellschaft*. Leipzig.

INTRODUCTION

Almost 3500 years ago, the ancient Egyptian scribe Any instructed his son on the importance of the tomb:[1]

> Furnish your station in the valley,
> The grave that shall conceal your corpse;
> Set it before you as your concern,
> A thing that matters in your eyes.
> Emulate the great departed,
> Who are at rest within their tombs.
> No blame accrues to him who does it.

This concern for the body's final resting place was more than just a practical consideration for the ancient Egyptians; they charged their tombs with a number of vital functions. In private eighteenth dynasty Theban rock-cut tombs, the burial chamber protected the body of the dead and, in conjunction with the above-ground chapel, acted as a vehicle for his and her regeneration and eternal well-being in the hereafter. The chapel also provided a space in which the identity of the tomb owner(s) was projected into the next world and commemorated among the living who visited the tomb and met with the dead. In addition, the tomb was also a part of a vast complex of monuments in ancient Egypt dedicated to sacred permanence that linked society and visually reinforced its cultural identity.

The painted decoration that adorned the walls within the chapel addressed all of these functions, but to date, there have been few studies that comprehensively examined these various levels of meaning in eighteenth dynasty Theban tomb painting, and even fewer that compared those meanings among a number of painted chapels. In broad terms, the majority of treatments on eighteenth dynasty Theban tomb painting rely heavily on what is represented rather than what is signified for the eternal benefit of the tomb owner.[2]

Previous studies, most notably those by Max Wegner[3] and Arpag Mekhitarian,[4] have focused on the general stylistic development of painting, including its technical procedures and cultural aspects.[5] Other scholars such as

[1] Miriam Lichtheim, *Ancient Egyptian Literature, Volume II: The New Kingdom* (Berkeley-Los Angeles-London, 1976), 138.

[2] A good example of this tendency is found in the recent study by Sigrid Hodel-Hoenes, *Life and Death in Ancient Egypt: Scenes from Private Tombs in New Kingdom Thebes*, translated from the German by D. Warburton (Ithaca and London, 2000), who tends to interpret painted scenes too literally. Nigel Strudwick, in his review of the book in *JARCE* 38 (2001), 142-144, states: "Understanding an 18ᵗʰ dynasty tomb is much harder and open to variable interpretation, but it is sad to see the rather old-fashioned view brought out again of the tomb being a recreation of this world for the next. The prevailing view of the 18ᵗʰ Dynasty tomb at the present is that it has two main functions, namely the projection of the personality of the owner into the next world while commemorating him in this, and as a 'machine' for his regeneration and the creation of new life."

[3] Max Wegner, "Die Stilentwickelung der thebanischen Beamtengräber," *MDAIK* 4 (1933), 38-164.

[4] Arpag Mekhitarian, *Egyptian Painting* (Geneva, 1954).

[5] Guilo Farina, *La pittura egiziana* (Milano, 1929); Luise Klebs, *Die Reliefs und Malereien des neuen Reiches (XVIII. - XX. Dynastie, ca. 1580-1100 v. Chr.)*, Teil I: *Szenen aus dem Leben des Volkes* (Heidelberg, 1934); Marcelle Baud, *Les dessins ébauchés de la nécropole thébaine (au temps du Nouvel Empire)*, MIFAO 63 (Cairo, 1935); Nina de Garis Davies, *Ancient Egyptian Paintings*, 3 vols. (Chicago, 1936); George Steindorff and Walther Wolf, *Die thebanische Gräberwelt*, LÄS 4 (Glückstadt-Hamburg-New York, 1936); André Lhote and Hassia, *Les chefs-d'oeuvre de la peinture égyptienne* (Paris, 1954); Nina de Garis Davies, *Egyptian Paintings* (London, 1954); idem, and Alan H. Gardiner, *La peinture égyptienne ancienne* (Paris, 1954); Walther Wolf, *Die Kunst Ägyptens: Gestalt und Geschichte* (Stuttgart, 1957), 278-284; Hans Wolfgang Müller, *Alt-Ägyptische Malerei* (Berlin, 1959); Cyril Aldred, *New Kingdom Art in Ancient Egypt During the Eighteenth Dynasty 1570-1320 B.C.*, 2d ed. (London, 1961); Jacques Vandier, *Manuel d'archéologie égyptienne*, tome IV-V: *Bas-reliefs et peintures, Scènes de la vie quotidienne* (Paris, 1964-1969); Robert Boulanger and Hatice Nesrin, *Egyptian Painting and the Ancient Near East*, translated from the French by Anthony Rhodes (London, 1965); Jan Assmann, "Flachbildkunst des Neuen Reiches," in *Die Alte Ägypten*, edited by C. Vandersleyen, Propyläen Kunstgeschichte 15 (Berlin, 1975), 304-325; idem, "Die Gestalt der Zeit in der ägyptischen Kunst," in *5000 Jahre Ägypten: Genese und Permanenz Pharaonischer Kunst*, edited by J. Assmann and G. Burkard (Nussloch, 1983), 11-32; T.G.H James, *Egyptian Painting and Drawing in the British Museum* (Cambridge, Mass., 1985); Gay Robins, *Egyptian Painting and Relief*, Shire Egyptology (Aylesbury, 1986); Robert S. Bianchi, "Ancient Egyptian Reliefs, Statuary, and Monumental Paintings," *CANE* IV, 2533-2554; T.G.H James, "Egypt, ancient, X: Painting and Drawing," in *The Dictionary of Art*, vol. 9, edited by J. Turner (New York, 1996), 897-906; Gay Robins, *The Art of Ancient Egypt* (Cambridge, Mass. 1997), 138-142, 162-163; Friederike Kampp-Seyfried, "Overcoming Death - The Private Tombs of Thebes," in *Egypt: The World of the Pharaohs*, edited by R. Schulz and M. Seidel (Cologne, 1998), 249-263; W. Stevenson Smith, *The Art and Architecture of Ancient Egypt*, 3d rev. ed. by W.K. Simpson (New Haven and London, 1998); and Melinda K. Hartwig, "Painting," *OEAE* III (2001), 1-13. Maya Müller, "Malerei," *LÄ* III (1980), 1168-1173, avoided the evolution of style and concentrated instead on cataloguing the monuments in which painting occurred.

Arielle Kozloff,[6] Abdel Ghaffar Shedid[7] as well as Mekhitarian,[8] have analyzed painting style in eighteenth dynasty tombs in terms of how the paintings expressed the 'signature' of a particular artist or workshop. Still other treatments examine stylistic details such as figural proportions, ornament, and dress to date tombs to a particular king's reign.[9]

Recent examinations have turned to iconography and its function within the tomb chapel. Scholars such as Lise Manniche[10] and Dimitri Laboury[11] have looked at the iconography of eighteenth dynasty Theban tomb painting and its underlying symbolism as a creative mechanism for the deceased's eternal survival and rebirth.[12] Other scholars, such as Roland Tefnin[13] and Jan Assmann,[14] have addressed Theban tomb iconography as a complex semiological system that served the existential world of the tomb owner in the hereafter. In these and other studies, the communicative aspects of Theban tomb painting are rarely explored[15] and only tangentially,[16] often anchored in terms of the tomb owner's status and how it impacted the viewer.[17]

While valuable treatments, these studies examine only a few aspects of the total meaning available in tomb chapel decoration. With the exception of Max Wegner, stylistic surveys often summarize general trends in eighteenth dynasty tomb painting and use a select number of painted tombs, specific motifs, or techniques to make their points. The use of stylistic details as dating criteria is not always foolproof.[18] While semiological systems highlight fundamental

[6] Arielle Kozloff, "Paintings from the So-called Tomb of Nebamun in the British Museum," *NARCE* 95 (Fall 1975-Winter 1976), 8; idem, "A Study of the Painters of the Tomb of Menna, No. 69," in *Acts, First International Congress of Egyptology*, edited by W.F. Reineke, Schriften zur Geschichte und Kultur des Alten Orients 14 (Berlin, 1979), 395-402; idem, "Theban Tomb Paintings from the Reign of Amenhotep III: Problems in Iconography and Chronology," in *The Art of Amenhotep III: Art Historical Analysis*, edited by L.M. Berman (Cleveland, 1990), 55-64; idem, "Tomb Decoration: Paintings and Relief Sculpture," in *Egypt's Dazzling Sun: Amenhotep III and His World*, edited by A. Kozloff and B. Bryan (Cleveland, 1992), 261-283.

[7] Christine Beinlich-Seeber and Abdel Ghaffar Shedid, *Das Grab des Userhat (TT 56)*, AV 50 (Mainz, 1987), 139-141; Abdel Ghaffar Shedid, *Stil der Grabmalereien in der Zeit Amenophis' II. untersucht an den Thebanischen Gräbern Nr. 104 und Nr. 80*, AV 66 (Mainz, 1988), 89-90.

[8] Arpag Mekhitarian, "Personnalité de peintres thébains," *CdÉ* 31, no. 62 (1956), 238-248; idem, "Un peintre thébain de la XVIIIe dynastie," *MDAIK* 15 (1957), 186-192.

[9] Nadine Cherpion, "Quelques jalons pour une histoire de le peinture thébaine," *BSFÉ* 110 (Octobre, 1987), 27-47; Beinlich-Seeber and Shedid, *Userhat*, 142-145; Shedid, *Stil der Grabmalereien*, 90-95; Eberhard Dziobek, Thomas Schneyer, and Norbert Semmelbauer, *Eine ikonographische Datierungsmethode für thebanische Wandmalereien der 18. Dynastie*, SAGA 3 (Heidelberg, 1992); Betsy M. Bryan, *The Reign of Thutmose IV* (Baltimore and London, 1991), 300-303; Gay Robins, *Proportion and Style in Ancient Egyptian Art* (Austin, 1994), 87-118.

[10] Lise Manniche, *City of the Dead: Thebes in Egypt* (Chicago, 1987), esp. 31; idem, "Reflections on the Banquet Scene," in *La peinture égyptienne ancienne: Un monde de signes à préserver, Actes de Colloque international de Bruxelles, avril 1994*, edited by R. Tefnin, Monumenta Aegyptiaca 7 (Brussels, 1997), 29-35.

[11] Dimitri Laboury, "Une relecture de la tombe de Nakht (TT 52, Cheikh 'Abd el-Gourna)," in *La peinture égyptienne ancienne: Un monde de signes à préserver, Actes de Colloque international de Bruxelles, avril 1994*, edited by R. Tefnin, Monumenta Aegyptiaca 7 (Brussels, 1997), 49-81.

[12] See also studies of specific scenes in Theban tomb painting, such as: Eric Miller and R.B. Parkinson, "Reflections on a gilded eye in 'Fowling in the Marshes' (British Museum, EA 37977)," in *Colour and Painting in Ancient Egypt*, edited by W.V. Davies (London, 2001), 49-52.

[13] Roland Tefnin, "Éléments pour une sémiologie de l'image égyptienne," *CdÉ* 66 (1991), 60-88; idem, "Réflexions liminaires sur la peinture égyptienne, sa nature, son histoire, son déchiffrement et son avenir," in *La peinture égyptienne ancienne: Un monde de signes à préserver, Actes de Colloque international de Bruxelles, avril 1994*, edited by R. Tefnin, Monumenta Aegyptiaca 7 (Brussels, 1997), 3-9; idem, "Reflexiones sobre la imagen Egipcia antigua: La medida y el juego," *Arte y sociedad del Egipto antiguo*, edited by M.Á. Molinero Polo and D. Sola Antequera (Madrid, 2000), 15-36. I am indebted to Roland Tefnin for kindly sharing this last article with me.

[14] Jan Assmann, "Hierotaxis: Textkonstitution und Bildkomposition in der ägyptischen Kunst und Literatur," in *Form und Mass: Beiträge zur Literatur, Sprache, und Kunst des alten Ägypten, Festschrift für Gerhard Fecht*, edited by J. Osing and G. Dreyer, ÄAT 12 (Wiesbaden, 1987), 18-42.

[15] But see: Melinda K. Hartwig, "Style and Visual Rhetoric in Theban Tomb Painting," in *Egyptology at the Dawn of the Twenty-First Century: Proceedings of the Eighth International Congress of Egyptologists, Cairo 2000*, vol. 2, edited by Z. Hawass and L.P. Brock (Cairo, 2002), 298-307.

[16] Dietrich Wildung, "Écrire sans écriture: Réflexions sur l'image dans l'art égyptien," in *La peinture égyptienne ancienne: Un monde de signes à préserver, Actes de Colloque international de Bruxelles, avril 1994*, edited by R. Tefnin, Monumenta Aegyptiaca 7 (Brussels, 1997), 11-16.

[17] For example, Betsy M. Bryan, "Private Statuary," in *Egypt's Dazzling Sun: Amenhotep III and His World*, edited by A. Kozloff and B. Bryan (Cleveland, 1992), 237, says: "...the magnificence of the tomb chapels and their furnishings was surely message enough to the population at large that these were the 'movers and shakers' of the day."

[18] One particular example is the square offering table. Siegfried Schott, *Das schöne Fest vom Wüstentale: Festbräuche einer Totenstadt* (Mainz, 1952), 71, mentioned that the square offering table did not occur in Theban tomb decoration after the reign of Thutmose IV, which has been used by Lise Manniche, *The Wall Decoration of Three Theban Tombs (TT 77, 175, 249)*, CNI Publications 4 (Copenhagen, 1988), 46, fig. 64, to support her date for the tomb of Neferrenpet (TT 249) although the cartouches on the tomb lintel clearly date it to the reign of Amenhotep III (see Appendix I). Also, the presence of eyelid lines, once used to date figures to the reign of Amenhotep III (Betsy M. Bryan, *The Reign of Thutmose IV* (Baltimore and London, 1991), 301) are found in figures dating to the reign of Thutmose IV (see Plate 1,2).

organization principles in tomb scenes, scholars approach these scenes as self-contained systems rather than addressing the decoration's communicative aspects.[19]

Any study on eighteenth dynasty Theban tomb painting must take into account the function of the chapel and how the style, content, and symbolism of the painted decoration served the tomb owner and the society of which he was a part. The decoding of iconography is essential to understanding the underlying meaning and cultural dynamics of imagery. Theban tomb painting and its iconography bear the imprint of the social, religious, economic, and artistic realities present at the time of the painting's creation. Perceived by a wide range of chapel viewers, this imagery had the power to impact the visitor who left testimonies about their appreciation of the imagery and prayers for the benefit of those interred in the tomb's subterranean chambers. Likewise, Theban tomb texts are often directed towards these potential viewers, and some inscriptions are didactic in nature. Through the nexus of text and image and their magical and commemorative properties, Theban tomb iconography provides a window into what the ancient Egyptians valued in this world and secured their eternal life in the next. The iconography also reveals the ideological truths and religious ideas that permeated the age in which the tomb owner lived. In this way, Theban tombs documented and represented "the whole of culture, *Diesseits* and *Jenseits*, professional life and the funerary cult, (and) individual and social existence..."[20]

To this end, this book examines the style and iconography of flat painting as present in every extant private Theban tomb chapel dating to the reigns of the pharaohs Thutmose IV (1419-1410 BCE) and Amenhotep III (1410-1372 BCE).[21] For the purposes here, the words "chapel" and "tomb" will be used interchangeably to indicate the decorated above-ground structure. These tombs contain some of the finest paintings ever created in ancient Egypt, and they belonged to officials who lived during an age of relative peace, enormous prosperity, and religious change. These officials were part of a large bureaucratic system in the eighteenth dynasty composed of civil, regional, palace, military, and religious administrative branches.[22] In general terms, an official was affiliated with a particular administrative area and this was reflected in his characteristic title.[23] Many of these tomb owners were from prominent families who had served earlier pharaohs; others were members of a rising middle class of artisans, grain scribes, and temple provisioners. Still others were men who, after years of military service, had been pensioned off with less-demanding positions. And others had hardly seen battle from their place behind a bureaucrat's desk. The temple elite were also well represented in the necropolis, particularly those who served the god Amun-Re in his temple at Karnak, the king of the gods during the New Kingdom and the chief god of Thebes. Yet, in this time of prosperity, religious change was gaining momentum, and this is reflected in the iconography that decorated focal walls of the private tomb chapels.

The following chapters will explore the nature of personality and society as it was manifested in eighteenth dynasty Theban tomb painting. Chapter 1 will survey the aspects of personal and social identity in ancient Egypt as well as the technical aspects of painting, including structural and decorative templates, workshop organization, and patronage.

[19] See in particular the statement by Tefnin, *CdÉ* 66 (1991), 69.

[20] Jan Assmann, "Der literarische Aspekt des ägyptischen Grabes und Seine Funktion im Rahmen des 'monumentalen Diskurses,'" in *Ancient Egyptian Literature: History and Forms*, edited by A. Loprieno (Leiden-New York-Köln, 1996), 98.

[21] On the selection criteria of the tombs, please see Appendix I. Dates taken from Donald Redford, editor-in-chief, *The Oxford Encyclopedia of Egypt* (Oxford and New York, 2001).

[22] These divisions are followed largely in the literature on the social history of the eighteenth dynasty and reflect an administrative reality in ancient Egypt. A few of the basic works on the administrative branches of ancient Egypt as well as the main titles of officials during the reigns of Thutmose IV and Amenhotep III are: Gustave Lefebvre, *Histoire des grands-prêtres d'Amon de Karnak jusqu'à la XXIe dynastie* (Paris, 1929); Wolfgang Helck, *Der Einfluss der Militärführer in der 18. ägyptischen Dynastie*, UGAÄ 14 (Leipzig, 1939); Hermann Kees, *Das Priestertum im ägyptischen Staat vom Neuen Reich bis zur Spätzeit; Indices und Nachträge*, PÄ I (Leiden and Köln, 1953-1958); Wolfgang Helck, *Zur Verwaltung des Mittleren und Neuen Reichs*, PÄ 3 (Leiden, 1958); Alan Schulmann, *Military Rank, Title and Organization in the Egyptian New Kingdom*, MÄS 6 (Berlin, 1964); Charles F. Aling, "A Prosopographical Study of the Reigns of Thutmosis IV and Amenhotep III," (Ph.D. Dissertation, University of Minnesota, 1976); Bryan, *Thutmose IV*, 242-331; Pierre-Marie Chevereau, *Prosopographie des cadres militaires égyptiens du Nouvel Empire* (Paris, 1994); Andrea Gnirs, *Militär und Gesellschaft: Ein Beitrag zur Sozialgeschichte des Neuen Reiches*, SAGA 17 (Heidelberg, 1996); William J. Murnane, "The Organization of Government under Amenhotep III," in *Amenhotep III: Perspectives on His Reign*, edited by D. O'Connor and E. Cline (Ann Arbor, 1998), 173-222; Selke Susan Eichler, *Die Verwaltung des "Hauses des Amun" in der 18. Dynastie*, SAK Beihefte 7 (Hamburg, 2000). An excellent schematic diagram is found in: David O'Connor, "New Kingdom and Third Intermediate Period, 1552-664 B.C.," *Ancient Egypt: A Social History* (Cambridge, 1983), 208, fig. 3.4.

[23] Although an official could acquire a number of titles over his lifetime, he usually had a title most characteristic of his office based on its frequency in his tomb, his other monuments and texts, as well as its placement within his titulary, sometimes corresponding to the last title before the name.

Chapter 2 will examine the magical and commemorative properties of the image, how this imagery was organized and functioned on behalf of the deceased, as well as how it may have been "received" or understood by visitors to the tomb. This introductory survey will lead to the analysis of specific iconic configurations and how they preserved and presented personal and professional identity in the painted tomb chapel and manifested the various cultural and religious forces that shaped Egypt in the mid-eighteenth dynasty. It is important to note that with any study of iconography, a range of meaning is available to the researcher. This study has endeavored to follow a method that allows for the exploration of the available meanings inherent in a given form, action, or motif with the goal of arriving at a predominant symbolic association. By 'reading' these iconic configurations on various levels, from their aesthetic qualities to their representational and symbolic properties, this study aims to understand, as best as possible, the original contextual and conceptual matrix of private Theban tomb painting and how it acted as a creative medium of power, display, and cultural identity on behalf of the tomb owner and the world of which he was a part.

CHAPTER 1

THE PRIVATE TOMB: A MONUMENT TO IDENTITY

1.1 The Function of the Private Theban Tomb

1.1.1 Identity, Death, and Resurrection

The Greek writer Diodorus Siculus (60-56 BCE) recorded ancient Egyptian beliefs about death, the tomb, and its place in the mortuary cult when he wrote:[1]

> For the inhabitants of Egypt consider the period of this life no account whatever, but place the greatest value on the time after death *when they will be remembered* for their virtue and while they give the name of lodgings to the dwellings of the living thus intimating that we dwell in them a brief time, they call the tombs of the dead *eternal homes* since the dead spend endless hours in Hades; consequently they give less thought to the furnishings of their houses but in the manner of their burials they do not forgo any excess of zeal.

This "zeal" led the ancient Egyptians to create an effective physical setting within the tomb for the commemoration and eternal life of the owner. Often referred to as the "house of eternity" (*ḥwt n nḥḥ* or *pr ḏt*)[2], the private tomb complex protected the body of the deceased, acted as a ritual complex to ensure his or her transfiguration and eternal well-being, and served as a monument to project the identity of the owner into the next world and to commemorate the dead in this world. More will be said about the commemorative function of the tomb below, but for now the discussion will center on the aspects that defined the individual that were preserved and transfigured within the tomb.

The ancient Egyptians believed human beings were composed of both physical and non-physical elements. Known as *kheperu* (*ḫprw*) or "manifestations," the most important components were the body (living: *ḥt* or *ḥʿw*; corpse: *ḥ3wt*), the heart (*íb* or *ḥ3ty*), the *ka*, the *ba*, the shadow (*šwt*), and the name (*rn*).[3] The heart and the physical body were critical for the eternal life of the deceased. The heart held the moral, intellectual, and emotional qualities of the individual.[4] The mummified body, protected within its coffin and concealed within its subterranean burial chamber, preserved the deceased's individual physical appearance and provided a home for the *ka* and the *ba*. The *ka* was the deceased's non-physical "double" or vital force that was created along with its owner at birth.[5] Food and drink were essential to the life of the *ka*, which could leave the mummified body and inhabit the statues, reliefs, and paintings of the tomb owner to partake of the sustenance offered before them. The *ba* (movement and effectiveness) took the form of a

[1] C.H. Oldfather, *Diodorus of Sicily* I, Loeb Classical Library nr. 279 (Cambridge, Mass., 1968), 1,51. Translation and italics from Herman te Velde, "Commemoration in Ancient Egypt," *Visible Religion* 1: *Commemorative Figures, Papers Presented to Dr. Th. P. van Baaren on the Occasion of his Seventieth Birthday, May 13, 1982* (Leiden, 1982), 139.

[2] Erik Hornung, *Idea into image: Essays on Ancient Egyptian Thought*, translated by E. Bredeck (New York, 1992), 175-184; John H. Taylor, *Death and the Afterlife in Ancient Egypt* (London, 2001), 31. Note also the concept of spacial eternity and temporal eternity in another term used for the tomb, *3ḥt nt nḥḥ* (David Warburton, Review of *Death and the Afterlife in Ancient Egypt* by John H. Taylor (London, 2001), in *DIE* 52 (2002), 119).

[3] Alan B. Lloyd, "Psychology and Society in the Ancient Egyptian Cult of the Dead," *Religion and Philosophy in Ancient Egypt*, YES 3 (New Haven, 1989), 117-120; Lanny D. Bell, "Appendix: Ancient Egyptian Personhood (Anthropology/Psychology): the nature of humankind, individuality, and self-identity," *Akten der Ägyptologischen Tempeltagungen* 3, edited by H. Beinlich, et al., ÄAT 33 (Wiesbaden, 2002), 38-42; Taylor, *Death and the Afterlife*, 15-23.

[4] Hellmut Brunner, "Herz," *LÄ* II (1977), 1158-1168; Jan Assmann, "Zur Geschichte des Herzens im alten Ägypten," in *Die Erfindung des Inneren Menschen*: *Studien zur religiösen Anthropologie*, edited by T. Sundermeier and J. Assmann (Gütersloh, 1993), 96-100; idem, *The Mind of Egypt: History and Meaning in the Time of the Pharaohs*, translated by A. Jenkins (New York, 2002), 161.

[5] Monographs: Liselotte Greven, *Der Ka in Theologie und Königskult der Ägypter des Alten Reiches*, ÄF 17 (Glückstadt-Hamburg-New York, 1954); Ursula Schweitzer, *Das Wesen des Ka im Diesseits und Jenseits der alten Ägypter*, ÄF 19 (Glückstadt-Hamburg-New York, 1956). Translation of *ka* as "double" in: Herman te Velde, "Some Remarks on the Concept of 'Person' in the Ancient Egyptian Culture," *Concepts of Person in Religion and Thought*, edited by H.G. Kippenberg, et al. (Berlin and New York, 1990), 95-98, with relevant bibliography. The *ka* as the vital force of a person, see: Hornung, *Idea into image*, 175.

human-headed bird at the death of the deceased and could leave the tomb.[6] The shadow (*šwt*) was a mysterious physical entity that also came into being after death in different shapes and sizes, and was closely associated with the body and the individuality of the owner.[7]

The name (*rn*) was an important component of the personality of the deceased.[8] A name was given to an individual at birth, and that name identified the person in life and commemorated the individual in death. The Vizier Useramun (Theban Tomb 131, hereby abbreviated TT) wrote about the importance of remembering and speaking his name when he wrote in his tomb chapel:[9]

> I erected for myself a magnificent tomb
> in my city of eternity.
> I equipped most lavishly the site of my rock tomb
> in the desert of eternity.
> May my name endure on it
> in the mouths of the living,
> while the memory of me is good among men
> after the years that are to come.
> A trifle only of life in this world,
> [but] eternity is in the realm of the dead.
> Praised by god is the noble
> who acts for himself with a view to the future
> and seeks with his heart to find salvation for himself,
> the burial of his corpse, and the revival of his name,
> and who is mindful of eternity.

The name was essential to the deceased's identity. The name was inscribed and painted everywhere within the tomb, near his or her sculpted or painted images and on burial goods.[10] One need only look at the practice of destroying a person's name and image, otherwise known as *damnatio memoriae*, to see how closely they were linked to an individual's identity in the minds of the ancient Egyptians.[11] The name was also included in the deceased's titulary, genealogy, and (auto)biography.

At least in the New Kingdom, the tomb itself may have been regarded as an aspect of the person. Inscribed on the southern wall of the tomb of Amenemhet (TT 82), an offering was written to the tomb owner's name and title, his *ka*, his stela, "this tomb which is in the necropolis," his fate, his lifetime, his birth-goddess, the goddess of his upbringing, and his creator god.[12] On the northern wall, an offering was made to the name and title of the tomb owner, his *ka*, his stela, [to this grave in the necropolis, his *ba*], his *akh*, his body, his shadow, to all his forms of appearance.

[6] Stephen Quirke, *Ancient Egyptian Religion* (London, 1992), 106; Taylor, *Death and the Afterlife*, 18-20; James P. Allen, "Ba," *OEAE* I (2001), 161-162; Naguib Kanawati, *The Tomb and Beyond: Burial Customs of the Egyptian Officials* (London, 2002), 23-24.

[7] James P. Allen, "Shadow," *OEAE* III (2001), 277-278. See also: George Beate, *Zu den altägyptischen Vorstellungen vom Schatten als Seele* (Bonn, 1970).

[8] Pascal Vernus, "Name," *LÄ* IV (1982), 322-326; Denise Doxey, "Names," *OEAE* II (2001), 490; Janet H. Johnson, "What's in a Name?" *Lingua Aegyptia 9* (2001), 143-152.

[9] Eberhard Dziobek, *Denkmäler des Vezirs User-Amun*, SAGA 18 (Heidelberg, 1998), 78-80, taf. 4; quoted from Assmann, *The Mind of Egypt*, 66-67.

[10] Ann Macy Roth, "The Social Aspects of Death," in *Mummies & Magic: The Funerary Arts of Ancient Egypt*, edited by S. D'Auria, P. Lacovara, and C. H. Roehrig (Boston, 1988), 55. Images of the tomb owner's family, colleagues, friends, and ancestors were also similarly identified, see: Martin Fitzenreiter, "Totenverehrung und sozial Repräsentation im Thebanischer Beamtengrab der 18. Dynasie," *SAK* 22 (1995), 95-130; Karl-J. Seyfried, "Generationeneinbindung," in *Thebanische Beamtennekropolen: Neue Perspektiven archäologischer Forschung, Internationales Symposion Heidelberg 9.- 13.6.1993*, edited by J. Assmann, E. Dziobek, H. Guksch, and F. Kampp, SAGA 12 (Heidelberg, 1995), 223-224, 230.

[11] For explanation of *damnatio memoriae* in private tomb contexts, see: Alan Schulman, "Some Remarks on the Alleged 'Fall' of Senmut," *JARCE* 8 (1969-1970), 29-48; Patricia A. Bochi, "Death by Drama: The Ritual of *Damnatio Memoriae* in Ancient Egypt," *GM* 171 (1999), 73-86. For specific examples, see: Friederike Kampp, *Die thebanische Nekropole: Zum Wandel des Grabgedankens von der XVIII. bis zur XX. Dynastie*, 2 vols., Theben XIII (Mainz, 1996).

[12] Norman de Garis Davies and Alan H. Gardiner, *The Tomb of Amenemhet (no. 82)*, TTS 1 (London, 1915), 99-100, pls. 19, 20, 22, 23.

As discussed by Herman te Velde, these elements were likely selected from an available series of concepts that defined personhood in ancient Egypt. He notes:[13]

> Apart from the first element in the two enneads consisting of the title and name of the person, all elements except the unmistakeable (*sic*) 'this tomb that is in the necropolis' in which the inscription itself is placed, are provided with a possessive pronoun of the third person: To the person belongs that which one essentially is.

The importance of the tomb for the identity of an elite Egyptian was also underscored by a later text that defines the fourfold *ka* of private individuals as plenty, a long life, a beautiful funeral after a happy old age, and worthy descendants.[14] As often related in Egyptian Wisdom Texts, a member of the elite was not complete unless he secured a tomb.[15]

The deceased's attainment of the afterlife depended on the survival of these physical and non-physical elements within the preserved, mummified body and the protective, magical structure of the tomb. To this end, the tomb was equipped with funerary texts known as *sakhu*, literally translated as "that which makes [a person] an *akh*." *Sakhu*-texts were inscribed on the walls of the chapel, the coffin, papyri, stelae, mummy wrappings, and/or amulets. These texts were provided to replicate magically the rituals they described. These texts also supplied the needed information for the deceased to pass into the next world and help him or her make the successful transition into an *akh*, or "transfigured being" that represented the total person in a state of beatitude.[16] The *akh* was different from the other aspects of human existence because the status of an *akh* could only be attained after death, once the deceased received the proper rituals and offerings and knew the correct spells to guarantee successful passage through various tests and obstacles encountered. Furthermore, the *akh* and its immortality was dependent on receiving offerings, rituals, and spells in a liminal area such as the tomb.[17]

If successful, the dead ultimately entered a new state of existence that linked them with cyclical eternity (*nhh*) and permanent eternity (*dt*). Cyclical eternity (*nhh*) was manifest in the daily cycle of the sun god Re and the changes of the seasons.[18] Permanent, static eternity (*dt*) was associated with the god Osiris, and the realm of the tomb in which the dead were provisioned by the mortuary cult and the creative power of text and image.[19] At least during the New Kingdom, the sun god was identified with Osiris as he traversed through the underworld which allowed him to be rejuvenated and reborn.[20] The dead hoped to be identified with the immortal characteristics and repeated rejuvenations symbolized by these gods so that they could enjoy endless rebirth.

1.1.2 Magic and Commemoration in the Mortuary Cult

The survival of the dead depended on the tomb and the efficacy of the mortuary cult that provided the deceased with offerings, funerary rituals, and the spoken pronouncement of his or her name. As stated in the instructions of the Insinger Papyrus:[21] "The grace of the god for the man of god is his burial and his resting place. The renewal of life before the dying is leaving his name on earth [behind] him."

[13] te Velde, *Concepts of Person*, 97, also 88.

[14] Dimitri Meeks, "Génies, Anges, Démons en Égypte," in *Génies, Anges and Démons,* Sources Orientales 8 (Paris, 1971), 40; cited in te Velde, *Concepts of Person*, 88, 97.

[15] Lichtheim, *Ancient Egyptian Literature* II, 138.

[16] Gertie Englund, *Akh - Une notion religieuse dans l'Égypte pharaonique,* Boreas 11 (Uppsala, 1978), 205-211; Robert J. Demarée, *The 3ḫ ikr n r'-stelae: On Ancestor Worship in Ancient Egypt,* EU 3 (Leiden, 1983), 190-195, 276-278; Taylor, *Death and the Afterlife*, 31-32, 193.

[17] Lloyd, *Religion and Philosophy in Ancient Egypt*, 122; Alan H. Gardiner, *The attitude of the ancient Egyptians to death and the dead* (Cambridge, 1935), 10-15, 25-28.

[18] Janice Kamrin, *The Cosmos of Khnumhotep II at Beni Hasan* (London and New York, 1999), 4.

[19] Assmann, *The Mind of Egypt*, 18-19 with n. 17, 73; Taylor, *Death and the Afterlife*, 31. Assmann's version of *dt* time as the suspension of time and not a linear concept of time is accepted here. See also: Jan Assmann, *Zeit und Ewigkeit im alten Ägypten* (Heidelberg, 1975).

[20] Erik Hornung, *Conceptions of God in Ancient Egypt: The One and the Many,* translated by J. Baines (Ithaca, 1982), 155-156.

[21] Miriam Lichtheim, *Ancient Egyptian Literature, Volume III: The Late Period* (Berkeley-Los Angeles-London, 1980), 186-187, the sixth instruction 2,1 (11)-(12); Richard Jasnow, "Insinger Papyrus," *OEAE* II (2001), 167-169.

A key component of this exchange depended on the interaction between the living and the dead within the tomb chapel. Eighteenth dynasty tomb texts mention the opening of chapel doors for ceremonies and celebrations, which suggests chapels were accessible on specific occasions while the cult of the deceased functioned.[22] Family members, priests, and even random visitors performed cultic activities, left offerings, or spoke prayers for the tomb owner. Ideally, the son was the chief cult officiant for his parents, perhaps motivated by the fact that inheritance was contingent on his performance of these activities.[23] On a mythic level, the son's cultic actions on behalf of his father emulated Horus' actions on behalf of Osiris, in essence strengthening the deceased's identification with the god of resurrection.[24] Besides the son, priests from the local temple or special mortuary priests (*hmw-k3*) could be entrusted with the funeral, the burial, and the long-term continuation of the deceased's mortuary cult. To guarantee the continuation of the deceased's mortuary observances, an endowment of cultivated land was often made by the tomb owner, the proceeds of which served as offerings for the deceased, and acted as payment for the officiants of his cult. Presumably, the duties and endowment were passed from generation to generation to guarantee the provisioning of the deceased.[25]

The *ka* or creative life force of the dead needed constant nourishment in the form of food offerings presented by relatives or priests within the context of formal rituals within the tomb. However, the Egyptians were well aware that the long-term celebration of one's cult could fall into abeyance with the death of relatives or *ka*-servants,[26] so other avenues were devised to ensure the deceased's provisioning within the tomb through the magical power of word and image. The offering formula was a key component of the deceased's sustenance and was inscribed on the stela and false door in the chapel as well as statues, coffins, and other tomb images and furnishings. According to the principles of Egyptian magical practice, the offering formula and ritual texts in the tomb possessed the power to bring what was written into existence in order to ensure the perpetual delivery of goods.[27] A typical eighteenth dynasty offering formula reads:[28]

> ...an offering which the king gives to Amun-re, Horakhty, Osiris, Lord of Eternity, and Anubis who
> is preeminent in the divine booth that they may grant invocation (*prt-ḫrw*) offerings of bread, beer,
> oxen and fowl, and all good, pleasant and pure things, plants, wine and milk, which are issued in the
> presence of the Lord of Eternity....for the *ka* of the royal scribe....called Djehutnefer.

The offering itself was called a *prt-ḫrw* or "the going forth at the voice," which underscored the role recitation played in securing sustenance for the dead. In essence, the offering formula functioned on a symbolic level whereby the king made offerings to the gods who, in turn, would provision the dead.[29]

Outside of family members and priests, the eighteenth dynasty tomb owner intended that his tomb chapel be viewed by an entire range of visitors who were requested to read aloud the inscriptions, because "a man lives when his name is called."[30] One can assume that once the family or priestly practitioners passed away, the tomb chapel was accessible to a range of visitors. Although the tomb was built on sacred land and policed, numerous texts and archaeo-

[22] As for example in the tomb of Menna (TT 69): Schott, *Das schöne Fest*, nr. 61. See also Hellmut Brunner, "Tür und Tor," *LÄ* VI (1986), 778-787. On the sealing of tomb doors, see: Dieter Arnold, "Grabbau, A.," *LÄ* II (1977), 850-851. See n. 86 above.

[23] Schafik Allam, "Inheritance," *OEAE* II (2001), 160.

[24] Wolfgang Helck, "Sohn," *LÄ* V (1984), 1054; Taylor, *Death and the Afterlife*, 191.

[25] Serge Sauneron, *The Priests of Ancient Egypt,* translated from the French by D. Lorton (Ithaca, 2000), 108-109; Denise M. Doxey, "Priesthood," *OEAE* III (2001), 68-73, esp. 71; John Baines and Peter Lacovara, "Burial and the Dead in ancient Egyptian Society," *Journal of Social Archaeology* 2.1 (2002), 10-11; Kanawati, *The Tomb and Beyond*, 13; Taylor, *Death and the Afterlife*, 175-176. See examples of mortuary endowments in: *Urk.* IV, 1618-1619; Norman de Garis Davies, *The tombs of two officials of Thutmosis IV (nos. 75 and 90),* TTS 3 (London, 1923), pl. XXVI.

[26] See for example P. Chester Beatty IV in: Lichtheim, *Ancient Egyptian Literature* II, 177: "Their portals and mansions have crumbled, their *ka*-servants are [gone]; their tombstones are covered with soil, their graves are forgotten."

[27] Robert K. Ritner, "Magic in the Afterlife," *OEAE* II (2001), 333-336.

[28] *Urk.* IV, 1610: Stela of Djehutnefer (TT 104).

[29] Stephen E. Thompson, "Cults: An Overview," *OEAE* I (2001), 326-332, esp. 330; Ronald J. Leprohon, "Offerings: Offering Formulas and Lists," *OEAE* II (2001), 569-572.

[30] Eberhard Otto, *Die biographische Inschriften der ägyptischen Spätzeit,* PÄ 2 (Leiden, 1954), 62 with n. 1. See also the eighteenth dynasty tomb stela of the "Overseer of Sculptors" Djehut, who mentions that: "...I did that which people love so that they might cause that my estate of eternity endure and that my name flourish in the mouths of the people..." (*Urk.* IV, 131, 7-8; see also *Urk.* IV, 430-431).

logical finds in and around the tomb suggest that visitors could come into the chapel.[31] Thus, the deceased inscribed his name along with his life history in the hope that it would be read, repeated, and remembered by the living.[32] Remembrance was vital for the time after death, because the dead who were venerated and commemorated were retained in the community of ordered being (*ntt*: lit. "that which is"). Those who were not commemorated were cast off into the land of non-being (*iwtt*) and relegated to an existence as ghosts.[33] As such, tomb texts depended on a real-world circle of readers who were entreated not only to provide the dead with sustenance via an offering or prayer but also to help them be remembered through recitation of the name.

At this juncture, a word or two needs to be said about literacy among the elite in ancient Egypt. As will be discussed below, the majority of visitors attested in Theban tombs were literate members of the Egyptian elite, from family members and priests, to other tomb owners and students who left graffiti attesting to their visits. However, semi-literate[34] or illiterate visitors can be assumed based on archaeological remains, addresses to those that "hear" in the Appeal to the Living, copy grids and festival visitations by artisans, female family members, and children. It is estimated that 5% of the total Egyptian population had some degree of literacy.[35] Of these, most were male but some women had scribal talents, *albeit* in lower numbers than men.[36] Although the written language of everyday life was hieratic, hieroglyphs were probably understood by many literate members of the elite given the intimate connection between writing and art as well as the semiotic and cognitive properties of hieroglyphs. In the hieroglyphic language, written signifiers (signs) are images and images have a built-in property of the script.[37] Composed of prototypical repetitive images, Egyptian hieroglyphs consist of many signs that served as both signifier and signified.[38] Recent work by Orly Goldwasser has shown that the choice of the pictorial signifier (termed "signified elect") emanated from the ideology of the elite and their choices of prototypical members of a category.[39] Hieroglyphic script was part of this self-reinforcing system in which prototypical images both encoded and revealed ancient Egyptian cognitive procedures and elite world view. Goldwasser's work is further reinforced by modern cognitive research that shows that prototype categories (genus) are basic to the perception and the organization of knowledge and communication.[40] Transferred to ancient Egypt, this would suggest that most literate members of the elite could understand monumental hieroglyphs at different levels of facility. Basic word groups such as hieroglyphic names of gods, kings, and private people, titles, as well as simple

[31] Stephan J. Seidlmayer, "Necropolis," *OEAE* II (2001), 510-511. See discussion of groups of visitors below, pp. 10-15.

[32] Jan Assmann, "Schrift, Tod und Identität: Das Grab als Vorschule der Literatur im alten Ägypten," *Schrift und Gedächtnis: Beiträge zur Archäologie der literarischen Kommunikation*, edited by A. and J. Assmann and C. Hardmeier (Munich, 1983), 67.

[33] te Velde, *Visible Religion* 1 (1982), 140-142; illustrated in the story of Khonsu-em-hab and the spirit in: Gustave Lefebvre, *Romans et contes égyptiens de l'époque pharaonique* (Paris, 1949), 168-177; Jürgen von Beckerath, "Zur Geschichte von Chonsuemhab und dem Geist," *ZÄS* 119 (1992), 90-107.

[34] On semi-literacy: Peter der Manuelian, "Semi-literacy in Egypt," in *Gold of Praise: Studies on Ancient Egypt in Honor of Edward F. Wente*, edited by E. Teeter and J.A. Larson, SAOC 58 (Chicago, 1999), 285-298.

[35] Edward F. Wente, "The Scribes of Ancient Egypt," *CANE* IV (1995), 2214; Leonard H. Lesko, "Literacy," *OEAE* II (2001), 298. A literacy rate of 5% is accepted here, although note models by John Baines and C.J. Eyre, "Four Notes on Literacy," *GM* 61 (1983), 65-96, and John Baines, "Literacy and Ancient Egyptian Society," *Man* 18 (1983), 572-599, that arrive at a total of 1% literacy rate. Given the plethora of ostraca, Letters to the Dead, correspondence, and graffiti (often in out of the way places) a larger estimate of 5% appears reasonable.

[36] On female literacy: Baines and Eyre, *GM* 61 (1983), 81-85; Gay Robins, *Women in Ancient Egypt* (London, 1993), 111-114; L. Lesko, *OEAE* II (2001), 297-298. See also the visual evidence discussed in: Betsy M. Bryan, "Evidence for Female Literacy from Theban Tombs of the New Kingdom," *BES* 6 (1984), 17-32.

[37] Orly Goldwasser, *From Icon to Metaphor: Studies in the Semiotics of the Hieroglyphs*, OBO 142 (Fribourg and Göttingen, 1995), 29.

[38] Ibid., 40. See also: Kurt Sethe, *Das hieroglyphische Schriftsystem*, LÄS 3 (Glückstadt-Hamburg-New York, 1935), 12; Pascal Vernus, "L'écriture hiéroglyphique: une écriture duplice?," *Cahiers Confrontation* 16 (Automne, 1986), 59-66; Leo Depuydt, "On the nature of the hieroglyphic script," *ZÄS* 121 (1994), 1-36.

[39] Goldwasser, *Icon*, 31-34; idem, "The Determinative System as a Mirror of World Organization, *GM* 170 (1999), 49-68; idem, "Scripts: Hieroglyphs," *OEAE* III (New York, 2001), 202. And recently: idem, *Prophets, Lovers and Giraffes: wor(l)d classification in ancient Egypt*, Göttinger Orientforschungen IV, Reihe: Ägypten 38,3 (Wiesbaden, 2002).

[40] George Lakoff, *Women, Fire, and Dangerous Things: What Categories Reveal about the Mind* (Chicago & London, 1987), 46; and see also discussion by Paul J. Frandsen, "On Categorization and Metaphorical Structuring: Some Remarks on Egyptian Art and Language," *CAJ* 7 (1997), 80-81. Perceptually, most types of objects are initially understood by viewers in simple combinations of visual components; see: I. Biederman, "On the Semantics of a Glance at a Scene," *Perceptual Organization*, edited by M. Kubovy and J. Pomerantz (Hillsdale, N.J., 1981), 213-253.

formulas such as the *htp-di-nsw* were probably understood by a number of viewers of varying literacy.[41] The accompanying scenes would have made the reading of the adjacent text easier as well.

Returning to the eighteenth dynasty private tomb chapel, viewers can be reconstructed from a number of texts that were placed or written in the tomb. These people were frequently addressed in the 'Appeal to the Living,' a type of offering formula that was inscribed on stela, statues, and walls in the tomb chapel.[42] The Appeal in the eighteenth dynasty included the standard funerary prayer, the *htp-di-nsw* or "an offering which the king gives" to a particular deity for the ultimate benefit of the deceased; it was often attached to a monumental biographical text about the tomb owner. After relating his life history and praising himself, the tomb owner would ask the reader to pour water, proffer a gift, or recite the offering formula along with his name. To goad the reader into action, the author appealed to the reader's self-interest, wish for a long life, and would sometimes resort to threats if he did not obey.[43] A number of these texts employ the *sdmty.fy* grammatical form in terms of the future (hoped-for) actions of the visitor. An example of a popular Appeal occurs on a stela from the tomb of Menkheperresonb (TT 79). This text calls to future visitors and asks them to remember the deceased's name and say an offering prayer for him:[44]

> O living ones on earth,
> [people] living in future times,
> [*wa'b*-priests, lector-priests of Osiris Khenamenthes]
> all those skilled in divine words:
> As they enter my tomb, worship in it,
> read my stela, recall my name,
> [your god] will favor you,
> you will bequeath your office to [your children in old age],
> a son will abide in his father's seat in the favor of every town-god,
> Re will live for you in heaven and Osiris in Ro[stau] inasmuch as you will say,
> An offering-that-the-king-gives...

Still other Appeals use the "Breath of Mouth" formula by asking for a simple prayer from the visitor because "a breath of the mouth is useful for the Blessed Dead (*s'h*)."[45] In terms of the intended audience of the Appeal, both visitors and passers-by were invoked by the tomb owner:[46]

> O living ones on earth [people] living in future times,
> [*wa'b*-priests, lector-priests of Osiris],
> all those skilled in divine words
> who enter into my tomb (or) who pass in front of it, recite (*šdi*) after my stela, remember (*sh3*) my name...

[41] Goldwasser, *Icon*, 33: "It seems that categoric definitions and differentiations play a most important cognitive role within the script system, as well as in the maintaining of control by the leading groups over the conceptual system of the reader and, to a certain extent, also that of the non-literate beholder, as at least parts of the script were probably comprehensible even to the uninitiated." This viewpoint is shared also by Leonard H. Lesko, "Some Comments on Ancient Egyptian Literacy and Literati," *Studies in Egyptology Presented to Miriam Lichtheim*, vol II, edited by S.I. Groll (Jerusalem, 1990), 658.

[42] Instances of the 'Appeal to the Living' are quite numerous, so only a few general studies pertinent to eighteenth dynasty tombs will be cited here. Alfred Hermann, *Die Stelen der thebanischen Felsgräber der 18. Dynastie*, ÄF 11 (Glückstadt-Hamburg-New York, 1940), 145-152, presented one of the first studies of texts occurring on eighteenth dynasty tomb stela; Christa Müller, "Anruf an Lebende," *LÄ* I (1975), 293-299, traces the 'Appeal to the Living' on tomb walls, stele, and statues; and Jean Sainte Fare Garnot, *L'appel aux vivants* (Cairo, 1938), with a number of examples from the New Kingdom. Miriam Lichtheim, *Maat in Egyptian Autobiographies and Related Studies*, OBO 120 (Freiburg and Göttingen, 1992), 155-190, studies the evolution of the grammatical forms present in the 'Appeal'; and most recently, Leprohon, *OEAE* II (2001), 570-571. On the difference between the 'Appeal to the Living' and the 'Address to the Visitor,' see Elmar Edel, "Untersuchungen zur Phraseologie der ägyptischen Inschriften des Alten Reiches," *MDAIK* 13 (1944), 2-3.

[43] Ursula Verhoeven, "The Mortuary Cult," in *Egypt: The World of the Pharaohs*, edited by R. Schulz and M. Seidel (Cologne, 1998), 485-486.

[44] *Urk.* IV, 1197; translation in Lichtheim, *Maat*, 174-175, no. 27. This appeal is part of "der grosse Stelentext" enumerated in *Urk.* IV, 1515-1539, which is found on six other stela dating from the reigns of Thutmose III to Ay.

[45] Hermann, *Stelen*, 150, from the stela of Duaerneheh, TT 125; and *Urk.* IV, 1535: "The breath of the mouth (which is) effective for a dignitary is not something of which to become weary..." See also the variant in Leprohon, *OEAE* II (2001), 571.

[46] Louvre C 55: Paul Pierret, *Recueil d'inscriptions inédites du Musée Égyptien du Louvre*, vol. II (Paris, 1878), 90-93; Karl Piehl, *Inscriptions hiéroglyphiques recueillies en Europe et en Égypte*, vol. I (Leipzig, 1886), 12-13. See also the Appeal on the stela in TT 88 (Barbara Cumming, *Egyptian Historical Records of the Later Eighteenth Dynasty*, fasc. II (Warminster, 1984), 204; *Urk.* IV, 1536-1537.

The Appeal is addressed primarily to mortuary or temple priests, although the phrase "people living in future times" denotes a larger, more generic audience.[47] While the majority of Appeals were directed to the literate reader, some texts are phrased in terms of "hearing," which suggests the text was intended to be received by the semi-literate or illiterate viewer who would hear the stela as it was read to them.[48]

The primary responsibility for the celebration of the mortuary cult fell to the relatives of the deceased. Scenes and captions depict these family members attending the various ceremonies and ritual festivities that were expected to occur regularly in the tomb chapel. One such scene occurs in the tomb of Senneferi (TT 99), where the deceased is portrayed receiving gifts accompanied by this caption:[49]

> Seeing the gifts which are being brought (*innt*) by his wife, his children, his brothers and his craftsmen
> on the day of the New Year Festival (*wpt-rnpt*), *Nehebkaw*-festival, on the day of the First of the Year
> (*tpy rnpt*), the heliacal rising of Sirius (*prt Spdt*)...

All of these celebrations are New Year's Festivals and related to rebirth.[50] The New Year Festival of *wpt-rnpt* opened the civil year and symbolized the time of rejuvenation. The *Nehebkaw*-festival on the 1st day of the 5th month was another New Year's day festival that celebrated the rebirth of Osiris, and the king as the living Horus. The Sothic rising, *prt Spdt*, signified the rebirth of Sothis after an absence of 70 days. *Prt Spdt* was originally linked to the beginning of the New Year (*tpy rnpt*) and later was equated with the rebirth of the land. Of these festivals, the New Year Festival (*wpt-rnpt*) and the *Nehebkaw*-festival had virtually the same rituals to mark the occasions. During these festivals in the Theban necropolis, tombs were lit, and the festivities were celebrated by banqueting in the tomb chamber and by the bringing of offerings and bouquets by family members and friends. Religious festivals were important times during which the deceased's mortuary rites were renewed. During these occasions as well as others, offerings were reverted (at least theoretically) to the dead from the god's temples so the dead could receive nourishment.[51]

Of these festivals, the Valley Festival (in German, *Talfest)* was the most important visitor celebration in the Theban necropolis.[52] The Valley Festival was originally a Hathoric celebration in Thebes that became linked to the cult of Amun-Re, the local Theban deity and the national god of the New Kingdom. The Valley Festival lasted two days, with the feast occurring on the new moon during the second month of *šmw*, which was the tenth month of the year. During the Valley Festival, the barks of Amun, his consort Mut, and their son Khonsu were carried across the Nile from Karnak to tour the royal funerary temples on the West Bank of Thebes and stopped at the mortuary temple of the reigning king. The king usually led the procession to honor his dead royal ancestors, followed by members of his family and the Amun

[47] Another example on the Northampton Stela from the tomb of Djehut, TT 11 (*PM* I,1(2), 23, (12), *Urk*. IV, 430) uses a slightly different phraseology: "May my name be good with the people who shall come in years following that they may give me adoration..."

[48] Richard B. Parkinson, *Voices from Ancient Egypt: An Anthology of Middle Kingdom Writings* (London, 1991), 136-137. "Hearing" in the Appeal of Intef, Louvre C 26, *Urk*. IV, 965ff, in Lichtheim, *Maat*, 173-174.

[49] *Urk*. IV, 538, 11-12, inscription found on Pillar A in his tomb, *PM* I,1(2), 205-206 A (a). The excavators of TT 99, Nigel and Helen Strudwick, will publish a monograph on this tomb shortly.

[50] Anthony J. Spalinger, "Festivals," *OEAE* I (2001), 521-522; Anthony John Spalinger, *The Private Feast Lists of Ancient Egypt*, ÄA 57 (Wiesbaden, 1996), 56, 58 with n. 1, 68; Jan Assmann, "Das ägyptische Prozessionsfest," in *Das Fest und das Heilige: Religiöse Kontrapunkte zur Alltagswelt*, edited by J. Assmann and Th. Sundermeier, Studien zum Verstehen fremder Religionen 1 (Gütersloh, 1991), 105-122. See also: Hartwig Altenmüller, "Feste," *LÄ* II (1977), 174-176.

[51] Siegfried Schott, "The Feasts of Thebes," in *Work in Western Thebes 1931-1933*, edited by H. Nelson and U. Hölscher, OIC 18 (Chicago, 1934), 79; Taylor, *Death and the Afterlife*, 177-178.

[52] On the Theban Valley Festival: Schott, *Work in Western Thebes 1931-1933*, 73-74; idem, *Das schöne Fest* (Mainz, 1952); Arne Eggebrecht, "Brandopfer," *LÄ* I (1975), 848-850; C. Traunecker, F. Le Saout, and O. Masson, *La chapelle d'Achôris à Karnak, II: Texte*, Recherche sur les grandes civilisations: Synthèse 5 (Paris, 1981), 134-137; Erhart Graefe, "Talfest," *LÄ* VI (1986), 187-189; Martha Bell, "Regional Variation in Polychrome Pottery of the 19th Dynasty," in *Cahiers de la céramique égyptienne*, vol. I, edited by P. Ballet (Cairo, 1987), 56-57; Jean-Claude Golvin and Jean-Claude Goyon, *Les bâtisseurs de Karnak* (Paris, 1987), 49-51; Jan Assmann, "Der schöne Tag, Sinnlichkeit und Vergänglichkeit im altägyptischen Fest," in *Das Fest*, edited by W. Haug and R. Warning, Poetik und Hermeneutik 14 (Munich, 1989), 3-28; idem, *Das Fest und das Heilige*, 111; Saphinaz-Amal Naguib, "The Beautiful Feast of the Valley," in *Understanding and History in Arts and Sciences*, edited by R. Skarsten, et al., Acta Humaniora Universitatis Bergensis I (Oslo, 1991), 21-32; Janusz Karkowski, "Notes on the Beautiful Feast of the Valley as represented in Hatshepsut's Temple at Deir el-Bahri," in *50 Years of Polish Excavations in Egypt and the Near East: Acts of the Symposium at the Warsaw University 1986* (Warsaw, 1992), 155-166; Manniche, *City of the Dead*, 45-46; Lanny Bell, "The New Kingdom 'Divine' Temple: The Example of Luxor," in *Temples of Ancient Egypt*, edited by B. Shafer (London and New York, 1997), 136-137; Hodel-Hoenes, *Life and Death in Ancient Egypt*, 14-15; Spalinger, *OEAE* I (2001), 521-522; Seidlmayer, *OEAE* II (2001), 510.

priesthood. In private tombs, inscriptions reveal that family members came to venerate their dead ancestors during this festival.

When the mortuary temple visits were completed, the procession moved to the Hathor sanctuary at Deir el-Bahri, where Amun joined with the goddess to renew the fertility of the land. The bark spent the night floating on a "lake of gold" surrounded by four basins filled with milk, around which were placed burning torches. In the morning, the torches were extinguished in the milk, signifying the return of the dead to Hathor, and the barks of Amun set out again, this time to return to their home at Karnak.

According to Silvia Wiebach's reading of the symbolism of the Valley Festival, the living and the dead were brought into association with the god Amun-Re and the cult of the deceased kings, thereby mingling the private, royal, and divine spheres, and linking the earthly and spiritual realms.[53] During the festival, the westward journey of the bark of Amun-Re symbolized the sun's journey into the netherworld. The living (who accompanied the boat as the sun god's crew) and the dead (who praised the god's journey as illuminator of the underworld) were integrated with Amun-Re and the solar cycle through the intermediary element of the *ba* of the sun god. Likewise, the dead and living kings were incorporated with Amun-Re as the god toured their funerary temples and rested in the mortuary temple of the reigning king. Thus, both the living and the dead were brought into contact with the course of the sun god Amun-Re, dissolving the boundaries between the temporal, earthly, and divine realms.

During the Valley Festival, living or deceased family members, friends, and colleagues visited Theban tomb chapels and celebrated their dead ancestors and their shared professional, social, and cultural ties.[54] During this festival as well as others, the forecourt and the chapel received visitors.[55] Literate and non-literate alike assembled in the chapel where they probably collectively read and viewed the painted decoration and texts.[56] Offerings to the sun god were burnt; animals were butchered; food offerings were made; bouquets were presented; and an all-night vigil was held with banqueting, music, and drinking. The goal of this vigil was to blur the limits between this world and the next so the living could communicate with the dead. This distinction was reflected in the people portrayed and captioned in these festival banqueting scenes who were a combination of both living and dead relatives, friends, and colleagues who would continue to exist with him or her in the afterlife.[57] Banqueting scenes also may have portrayed the tomb owner celebrating this festival during his life in the forecourt and within the confines of his tomb chapel.[58]

Archaeological remains of funerary or festival banquets in or near the tomb chapel help identify those who visited the tomb.[59] For example, at the foot of the southern and northern rock walls in the forecourt of the tomb of Tjenuny (TT 74) were remnants of plant material, fibers (probably from mats), and blackened food vessels.[60] Interspersed with this excavated material were a number of ostraca written by the same hand, probably belonging to the brother of the tomb owner, A'a-amun, who was a scribe and author of two ostraca.[61] Another ostracon gives the names of 14

[53] Silvia Wiebach, "Die Begegnung von Lebenden und Verstorbenen im Rahmen des thebanischen Talfestes," *SAK* 13 (1986), 263-291.

[54] See, for example, the Valley Festival participants depicted in the tomb chapel of the "scribe of recruits" Haremhab (TT 78), who consisted of the tomb owner; the king's daughter Amenemopet, sitting on Haremhab's knee; his mother, "the *nbt-pr* Isis, justified and honored"; his wife, "the *nbt-pr*, Atuia"; and a group of unnamed seated troop captains (Artur and Annelies Brack, *Das Grab des Haremhab: Theben Nr. 78*, AV 35 (Mainz, 1980), 28-30, taf. 32).

[55] Hermann, *Stelen*, 13-14, 100; Brack, *Haremhab*, 19. On the transverse hall's use within the context of necropolis festivals, see: Assmann, *5000 Jahre Ägypten*, 28-29; Martin Fitzenreiter, "Zum Ahnenkult in Ägypten," *GM* 143 (1994), 66.

[56] Cf. "hearing": Parkinson, *Voices from Ancient Egypt*, 136-137; Appeal of Intef, Louvre C 26, *Urk.* IV, 965ff; Lichtheim, *Maat*, 173-174.

[57] Schott, *Das schöne Fest*, 7; Graefe, *LÄ* VI (1986), 187; Jesus Lopez, "Gastmahl," *LÄ* II (1977), 383-386. Also note that depictions of the Valley Festival banquet may also have 'doubled' for the meal taken by family and friends at the burial of the deceased: Gay Robins, "Dress, Undress, and the Representation of Fertility and Potency in New Kingdom Egyptian Art," *Sexuality in Ancient Art*, edited by N. Kampen (Cambridge, 1996), 31.

[58] Hermann, *Stelen*, 100; Hodel-Hoenes, *Life and Death in Ancient Egypt*, 15. On the establishment of the private mortuary cult during the life of the deceased, see: Andrey Bolshakov, "The Moment of the Establishment of the Tomb-Cult in Ancient Egypt," *Altorientalische Forschungen* 19 (1991), 204-218.

[59] For a listing of funerary banquet remains, see: Ursula Verhoeven, "Totenmahl," *LÄ* VI, 677-678, n. 2.

[60] Artur and Annelies Brack, *Das Grab des Tjanuni: Theban Nr. 74*, AV 19 (Mainz, 1977), 60.

[61] Artur and Annelies Brack, "Hieratische Ostraka vom Grab des Tjanuni, Theben Nr. 74, Funde von der Schweizerischen Grabung 1975," in *Acts, First International Conference of Egyptology*, edited by W.F. Reineke, Schriften zur Geschichte und Kultur des Alten Orients 14 (Berlin, 1979), 121-124; Brack, *Tjanuni*, 73-75, 81, Fund 5/4-5/5; see also ostracon with Tjanuny and Mutiry's name in a cartouche, Fund 5/6, Abb. 29, 75-77.

servants who, perhaps, wanted to be honored near the sepulchre of their deceased lord. Texts on these ostraca all contain the name and titles of Tjenuny and his wife; this suggests that all those named sought to commemorate the deceased and left evidence of their sojourn to the tomb.[62]

Visits to eighteenth dynasty Theban tomb chapels are also recorded in hieratic inscriptions known as *Besucherinschriften* or visitor inscriptions.[63] Ancient visitor inscriptions offer the largest body of material with which to reconstruct the visitors who viewed Theban tomb chapels, their responses to the monument, and the dates of their visits. More will be said about the response of these visitors concerning the decoration of the tomb chapel in Chapter 2.4. For our purposes here, we will examine six hieratic graffiti copied by Robert Hay in the tomb of Nakht, "the Gardener of Divine Offerings of Amun" (TT 161), to illustrate the types of visitors who could enter a given chapel (in this instance TT 161) and the nature of their stay.[64] The first graffito, made by a gardener named Siamon and his son or pupil,[65] Nen-nesut, indicates a visit, motivated perhaps by the former's being the grandchild of the tomb owner, Nakht.[66] Another graffito documents the visit of an unnamed "scribe...of the divine offerings (?) of Amun," who, finding the chapel was "more beautiful than any temple (?) of any town," may have come to get ideas for his own tomb.[67]

A few graffiti were inscribed in TT 161 during the Theban Valley Festival. One inscription gives verses of ceremonies to be recited during the festival, and another records a visit during its feasts by "Amennakht, pupil (or son) of Wer..."[68] Perhaps the latter was an inscription written during a student "field trip" to the necropolis, a practice which is supported by graffiti left at the Step Pyramid of Djoser that detail the visits of staff members of several scribal schools.[69]

Returning to Nakht's tomb, visitors left three graffiti after the persecution of the god Amun in the Theban necropolis. One specifies the need to purify cult objects supposedly after a period of neglect,[70] and another refers to the beauty of the tomb after "...the battleground(?) (of) Amun."[71] The most important visitor inscription in terms of dating

[62] Ibid., 60, assigned these finds exclusively to the workers on the tomb. The Bracks found an ostracon with relief decoration (Fund 5/8) in a dump spot near the remnants of matting and plant material, which led them to assign these remains to the workers rather than the family. The ostracon, however, is by an untrained hand, which suggests it could have been the product of a child, as the Bracks also noted, and not an artist.

[63] In Theban tomb chapels, visitor inscriptions can range in date from those written by ancient Egyptians to graffiti written by Romans, Copts, and various European and Egyptian visitors. For purposes here, only general surveys on ancient Egyptian visitor inscriptions from the Pharaonic period (not including the Roman period) will be cited. Wolfgang Helck, "Die Bedeutung der ägyptischen Besucherinschriften," *ZDMG* 102 (1952), 39-46; Jean Yoyotte, *Les pèlerinages dans l'Egypte ancienne*, Sources orientales 3 (Paris, 1960), 49-53; Dietrich Wildung, "Besucherinschriften," *LÄ* I (1975), 766-767; Maya Müller, "Die ägyptische Kunst aus kunsthistorischer Sicht," *Studien zur ägyptischen Kunstgeschichte*, edited by M. Eaton-Krauss and E. Graefe, HÄB 29 (Hildesheim, 1990), 46-50; Alexander J. Peden, *The Graffiti of Pharaonic Egypt: Scope and Roles of Informal Writings (ca. 3100-332 BC)*, PÄ 17 (Leiden, 2001).

[64] Published and studied in: Stephen Quirke, "The Hieratic texts in the Tomb of Nakht the Gardener, at Thebes (No. 161) as Copied by Robert Hay," *JEA* 72 (1986), 79-90.

[65] *s3.f* meaning "his son"; or "his pupil," see: Morris L. Bierbrier, "Terms of Relationship at Deir el-Medina," *JEA* 66 (1980), 101-102. Teachers could also be fathers or grandfathers of their pupils who were family relatives: Andrea McDowell, "Teachers and Students at Deir el-Medina," in *Deir el-Medina in the Third Millennium A.D.: A Tribute to Jac. J. Janssen*, edited by R.J. Demarée and A. Egberts, EU 14 (London, 2000), 230.

[66] Quirke, *JEA* 72 (1986), 79-80, Graffito 1. Siamon records his filiation in the graffito as "son of...Huy..." One of Nakht's sons was named Huy-nefer who was a "Gardener of divine offerings of Amun" (Sheila Whale, *The Family in the Eighteenth Dynasty of Egypt*, The Australian Centre for Egyptology Studies 1 (Sydney, 1989), 229-231). Siamon bore the title "Offering Bearer of Amun" which would strongly suggest that he was the son of Huy-nefer and continued his father's office. Quirke also considers that Siamon was a minor temple official capable of writing the graffito himself.

[67] Ibid., 88-90, Graffito 6. For example, Manniche, *Lost Tombs*, 85-86, discusses how the individual figures as well as the general layout of their scenes in the tombs of Wensu at Thebes (TT A4) and Paheri at El-Kab (both of which belonged to grain scribes serving under Thutmose III) were extremely similar and may have been copies of one another.

[68] Quirke, *JEA* 72 (1986), 80-81, Graffito 2; Ibid., 81-82, Graffito 3, respectively.

[69] Cecil M. Firth and J.E. Quibell, *Excavations at Saqqara: The Step Pyramid*, vol. 1 (Cairo, 1935), 78 text A; 80 text F; as cited in Quirke, *JEA* 72 (1986), 80, n. 5; see also Peden, *Graffiti*, 62-63.

[70] Quirke, *JEA* 72 (1986), 82-85, Graffito 4.

[71] Ibid., 87, Graffito 5c, which reads: "(1) On this day (2) one was... (3) the battleground(?) (4) Amun.........(5) He comes to...finding (?) (6) (it?) beautiful." A similar graffito is found in the tomb of Pairy, TT 139. This graffito is a complaint by a man named Pawah, who, as a follower of Amun, longed to see the God while that deity was being persecuted during the reign of Ankhkheperure Neferneferuaten (Jan Assmann, "Ocular Desire in a Time of Darkness: Urban Festivals and Divine Visibility in Ancient Egypt," in *Torat ha-Adam*, edited by A.R.E. Agus and J. Assmann, Yearbook of Religious Anthropology 1 (Berlin, 1994), 13-29; date and identification of king discussed by James P. Allen, "Nefertiti and Smenkh-ka-re," *GM* 141 (1994), 9, n. 22). See discussion in Chapter 4, p. 126.

is Graffito 5, which gives one of the hightest dates known for King Horemhab: "Year 12, month 2 of summer, day 16 of King Djeserkheperure-setepenra..." This graffito was probably penned by "the scribe Amenmose" who wrote his name close to the date. The date of Graffito 5 is within the context of the Valley Festival, when the scribe, Amenmose, visited the tomb to participate in the celebrations with the deceased tomb owner.[72] In sum, these six inscriptions record the use of the tomb chapel by a relative, a prospective tomb owner, priests, various Valley Festival celebrants, and possibly a student, sometime after the deceased's burial in the reign of Amenhotep III at least until year 12 of Horemhab.[73]

Letters to the Dead also document visits to the tomb and reflect the commemorative – and often practical – attitude of the living towards the dead.[74] Letters to the Dead were written on bowls, jug stands, ostraca, or papyri and were often deposited at the tomb so the deceased person could read them. Inscriptions in Letters to the Dead point to the power that the living assigned to the dead. These letters often ask the deceased to stop exerting malevolent influences or to help in the legal proceedings against a fellow spirit who is creating problems for the author of the letter. As Batiscombe Gunn so clearly put it: "After all, the dead are the best people to deal with the dead, especially since they can identify the enemy when we cannot."[75]

Letters to the Dead are labeled with the names of the addressee and addressor, and as such, they chronicle visits by relatives of the deceased to tombs in the Theban necropolis. The visits between the living and their dead relatives could be quite frequent, as suggested by John Paul Frandsen's translation of O. Louvre 698.[76] This letter painted on limestone was written to the coffin of the writer's dead wife, Ikhtay, and was deposited in her tomb in front of her sarcophagus.[77] On the recto, lines 7 and 8, it reads:

> I have appealed to you directly, all the time that you might respond...blessed to me are my mother and father, my brother and my sister. They have returned (to me when I have called), (while) you have been away from me (*since you do not answer my callings*).[78]

This passage provides evidence of attempted, repeated communication between the writer and his wife, probably occurring within the tomb chapel itself. Frequent visits between the living and the dead are mentioned in later texts,

[72] Ibid., 85-87, Graffito 5a.

[73] Over a period of time, known individuals who also owned tombs in the necropolis wrote a number of the graffiti in Theban tombs. Beside a subscene of musicians in the tomb of Kenamun (TT 93), "the vizier, Paser, hereditary and local prince, beloved god's father, supreme judge and mayor of the city," documented his visit. Paser was the owner of TT 106 and served under Seti I and Ramesses II (Norman de Garis Davies, *The tomb of Ken-Amun at Thebes* I, PMMA 5 (New York, 1930), 22, pl. 68). A graffito of Amenemhet, the owner of TT 82, recorded his visit to the Middle Kingdom tomb of Antefoker and his mother Senet TT 60 (Norman de Garis Davies, *The tomb of Antefoker vizier of Sesostris I and of his wife, Senet (no. 60)*, TTS 2 (London, 1920), 29, no. 33, pl. 37, 37a). Thirty-six graffiti in all were recorded in TT 60, dating primarily to the reign of Thutmose I. Of those, one (no. 29) refers to the correct date of the tomb chapel as belonging to the time of Sesostris I, and two others, confusing the name of the wife of Antefoker, Satsasobek with the name of Sobekneferu, believe they are in the presence of the sepulchre of that queen (nos. 2 and 3). For a recent compilation of New Kingdom Theban tomb graffiti, see Peden, *Graffiti*, 68ff.

[74] Many of the published accounts of "Letters to the Dead" are from the Old and Middle Kingdoms, although a few publications translate a number of later letters with a tomb provenance: Alan H. Gardiner and Kurt Sethe, *Egyptian letters to the dead, mainly from the Old and Middle Kingdoms* (London, 1928), 8-9, 26-27 on the Leiden Papyrus 371 (tp. Dynasty 19) and the Oxford Bowl (Dynasty 17 or early Dynasty 18); both were probably deposited in the tomb, although the former appears to have been tied to the back of a wooden statuette and then deposited (Gaston Maspero, *Études égyptiennes*, vol. 1 (Paris, 1886), 4); see also the Louvre Ostraca 698 (Dynasty 21) in: Paul John Frandsen, "The Letter to Ikhtay's Coffin: O. Louvre Inv. no. 698," in *Village Voices: Proceedings of the Symposium 'Texts from Deir el-Medina and their Interpretation' Leiden, May 31 - June 1, 1991*, edited by R.J. Demarée and A. Egberts, CNS 13 (Leiden, 1992), 31-49; Jaroslav Černý and Alan H. Gardiner, *Hieratic Ostraca*, vol. I (Oxford, 1957), pl. 80; Reinhard Grieshammer, "Briefe an Tote, A.," *LÄ* 1 (1975), 864-870; Demarée, *The 3ḫ iḳr n r'-stelae*, 213-218; Edward F. Wente, *Letters from Ancient Egypt*, edited by E.S. Meltzer, Society of Biblical Literature Writings from the Ancient World 1 (Atlanta, 1990), 216-219; Robert K. Ritner, *The Mechanics of Ancient Egyptian Magical Practice*, SAOC 54 (Chicago, 1993), 180-183; Michael O'Donoghue, "The 'Letters to the Dead' and Ancient Egyptian Religion," *BACE* 10 (1999), 87-104; Martin Bommas, "Zur Datierung einiger Briefe an die Toten," GM 173 (1999), 53-60; Edward F. Wente, "Correspondence," *OEAE* I (2001), 313-314; Hisham El-Leithy, "Letters to the Dead in Ancient and Modern Egypt," in *Egyptology at the Dawn of the Twenty-First Century: Proceedings of the Eighth International Congress of Egyptologists, Cairo 2000*, vol. 1, edited by Z. Hawass and L.P. Brock (Cairo, 2003), 304-313.

[75] Battiscombe Gunn, review of *Egyptian Letters to the Dead, mainly from the Old and Middle Kingdoms* by Alan H. Gardiner and Kurt Sethe, *JEA* 16 (1930), 147.

[76] Frandsen, *Village Voices*, 31-49.

[77] Jaroslav Černý, *A Community of Workmen at Thebes in the Ramesside Period*, BdÉ 50 (Cairo, 1973), 369: "We are certainly not far from the truth if we surmise that the ostracon was deposited in Akhtay's tomb in front of the coffin."

[78] Frandsen, *Village Voices*, 37, recto 7 and 8; italics mine.

which characterize the tombs as "the noble (mail)-box of Osiris" or "deposit box" for petitions to those existing in the next world.[79]

Artists and prospective tomb owners also visited Theban tomb chapels, and copied scenes or, sometimes, entire decorative programs. Direct evidence is furnished by copy grids or tombs with similar scenes where one tomb clearly served as the prototype for the other. Copy grids, or grids placed over various motifs to aid in their copying, are found, for example, in the tomb chapel of Kenamun (TT 93), where a vignette of an ibex and a hound has been squared-off in red for copying purposes.[80] Other images were reproduced from one tomb to another. A motif of a woman nursing a child from the Late Period tomb of Mentuemhat was copied directly from the New Kingdom tomb of Menna (TT 69).[81] A scene of musicians in the tomb of Amenhotep-si-se (TT 75) also served as a model for a chapel vignette in the tomb of his steward, Djeserkarasoneb (TT 38).[82]

1.2 The Structural and Decorative Features of the Private Theban Tomb

1.2.1 Architectural and Decorative Templates

During the reigns of Thutmose IV and Amenhotep III, painted rock-cut Theban tombs were fairly standard in type yet revealed sophisticated concepts of the afterlife.[83] Cut into the Theban cliffs or desert valley floor, these tombs were composed of three levels: the upper level of the chapel superstructure that included a facade wall; a middle level composed of a walled forecourt leading to a rock-cut chapel; and a lower level made up of the subterranean burial complex (Figure 1).[84] Often the forecourt was sunk into the ground in order to gain the necessary height for the facade, and it was accessed by ramp or stairway. Ideally, the forecourt was rectangular and opened to the east with the chapel facade facing west, creating a symbolic passage from the land of the living to the land of the dead in the "beautiful West" (Figure 2). The facade was often crowned by a torus molding with a cavetto cornice and several rows of frieze cones set into the superstructure, each stamped with the name and titles of the deceased, his wife, and, sometimes, prayers and other dedications.[85] Sometimes a niche was cut above the entrance to the chapel and housed a stelophoros statue. The chapel was entered from the forecourt through an entrance that was often closed by means of a wooden door that was easily opened for chapel ceremonies, celebrations, and other visits.[86]

The chapel proper could have a number of components, but characteristically the ground plan was organized as an inverted "T" (Figure 3). In its basic conception, the T-shaped plan was composed of a broad transverse hall bisected by a long inner hall leading back to an offering place. This basic plan could be modified by extensions and/or "supporting

[79] Ritner, *Ancient Egyptian Magical Practice*, 181.

[80] Charles K. Wilkinson and Marsha Hill, *Egyptian Wall Paintings: The Metropolitan Museum of Art's Collection of Facsimiles* (New York, 1983), 28, no. 23; other examples in Ernest Mackay, "Proportional squares on tomb walls in the Theban necropolis," *JEA* 4 (1917), 74-75, 83, n. 1.

[81] Smith, *AAAE*, 242.

[82] *PM* I,1(2), 70, (6); and compare Nina de Garis Davies, *Scenes from some Theban Tombs (Nos. 38, 66, 162, with excerpts from 81),* PTT IV (Oxford, 1963), 6-7, pl. VI, with Davies, *Two officials*, pl. V-XVIII.

[83] The most comprehensive publication on the development and the significance of the architectural components of Theban rock-cut tombs is Kampp, *Nekropole* I-II; and recently, idem, "The Theban necropolis: an overview of topography and tomb development from the Middle Kingdom to the Ramesside period," in *The Theban Necropolis: Past, Present and Future*, edited by N. Strudwick and J.H. Taylor (London, 2003), 2-10.

[84] Kampp-Seyfried, *Egypt: The World of the Pharaohs*, 250.

[85] Manniche, *Lost Tombs*, 3-12; idem, "Funerary Cones," *OEAE* I (2001), 566-567.

[86] Entreaties in the "Appeal to the Living," the presence of visitor graffiti, inscriptions, or archaeological remains in the tomb chapel suggest that doors were easily opened for many types of visitors. For example, eighteenth dynasty tomb texts mention the opening of chapel doors for ceremonies and celebrations (Schott, *Das schöne Fest*, nr. 61). Painted images of eighteenth dynasty tomb chapels show they were closed by a wooden door with a frame and cornice above and placed on a platform or threshold (Nina de Garis Davies, "Some representations of tombs from the Theban necropolis," *JEA* 24 (1938), 25-40). See also representations of tombs depicted in the *Book of Going Forth by Day*; for bibliography see: Svenja Gülden, Irmtraut Munro, Christina Regner, and Oliver Sütsch, *Bibliographie zum altägyptischen Totenbuch*, Studien zum altägyptischen Totenbuch 1 (Wiesbaden, 1998). A few doors remain *in situ,* such as the simple one-winged wooden door from an eleventh dynasty rock-cut tomb (Brunner, *LÄ* VI (1986), 778-787; photo in Herbert E. Winlock, "The Museum's Excavations at Thebes," *BMMA* 18, pt. II, *The Egyptian Expedition 1922-23* (October, 1923), 15, fig. 5). Archaeological remains of door frames and mud brick porches fronting Theban tomb chapels have been discussed recently by Kampp, *Nekropole* I, 72-74.

elements" such as rock-cut pillars or columns.[87] Another popular chapel type was composed of a simple rectangular room with a niche or offering place on the wall opposite the doorway. Later in the reign of Amenhotep III, private tombs became temple-like structures with chapels the size of large halls decorated with rock-cut columns or pillars. In this type of plan, the courtyard became more important as a cult site.

The lower level burial complex was composed of one or more vertical shafts and/or sloping passages that were cut into the floor of the chapel or forecourt, each leading to single or multiple burial chambers below.[88] The burial chamber held the coffin with the mummy, and other funerary objects. Once the body and funerary goods were deposited in the burial chamber, the doorway was blocked by a wall of mud brick, stones, or more elaborate constructions,[89] and, if accessed by a vertical shaft, the shaft was filled in with stone or sand. The burial chamber could be used or reused for new burials over a period of several generations before it was abandoned.[90] Often, the burial chamber was not decorated, although there are exceptions.[91]

Conceptually, the architectural levels of the tomb related to the tomb owner's eternal life (Figure 5).[92] The upper level or superstructure related to the solar cult and the worship of the sun. The middle level was the place in which the tomb owner's cult was celebrated and remained accessible to the living. The lower level was closed after the funeral ceremonies, and related to the Osirian realm and the burial of the body. The decoration of the private tomb complex conformed to this tripartite division with solar themes in the upper level, scenes focusing on the life, cult, and afterlife of the tomb owner in the chapel or middle level, and images of the hereafter in the burial chamber (if decorated).

Within the tomb chapel proper, a number of scene types became associated with certain walls based on the meaning and use of the different rooms and their orientation.[93] In the eighteenth dynasty, T-shaped Theban tomb chapels were oriented ideally east to west, and wall scenes were arranged along this axis as a metaphorical reflection of the transition from life (east) into death (west). In a very general sense, scenes in the outer, "eastern" transverse hall of T-shaped Theban tomb chapels were concerned with the earthly life of the deceased, and those in the "western" interior hall of the chapel addressed his or her transition into and life in the hereafter.[94] Since the transverse hall was the room nearest to the external world, the decoration reflects its use as a type of receiving room for people during necropolis festivals and visits.[95]

At the structural and visual intersection point between the transverse hall and the inner passage were the western back walls of the chapel, which lay to either side of the entrance into the inner hall, opposite the outer doorway to the

[87] For the variants to these basic ground plans and forecourts, see: Kampp, *Nekropole* I, 11-40, esp. fig. 1, 78-81, 110-117.

[88] Ibid., 83-94. On sloping passages, see: Jan Assmann, "Das Grab mit gewundenem Abstieg: Zum Typenwandel des Privat-Felsgrabes im Neuen Reich," *MDAIK* 40 (1984), 277-290; Karl-Joachim Seyfried, "Bemerkungen zur Erweiterung der unterirdischen Anlagen einiger Gräber des Neuen Reiches in Theben -Versuch einer Deutung," *ASAE* 71 (1987), 229-249.

[89] For example, the three burial chambers of TT 74 were closed with sandstone slabs, one of which measured 100 x 85 x 15 cm.; Brack, *Tjanuni*, 15.

[90] On the reuse of the tomb by different occupants, see: Daniel Polz, "Bemerkungen zur Grabbenutzung in der thebanischen Nekropole," *MDAIK* 46 (1990), 301-336.

[91] A few examples of decorated eighteenth dynasty burial chambers exist in TT 96 and TT 201: Rolf Gundlach, et al., *Sennefer: Die Grabkammer des Bürgermeisters von Theben*, 2d ed. (Mainz, 1991), 23ff; and Susan and Donald Redford, *Tomb of Re'a (TT 201)*, The Akhenaton Temple Project 4 (Toronto, 1994), 14-29, pl. XXVII-XXXI.

[92] Kampp-Seyfried, *Egypt: The World of the Pharaohs*, 249-251.

[93] Brack, *Haremhab*, 18-19; Manniche, *Lost Tombs*, 31-42; Fitzenreiter, *SAK* 22 (1995), 102-129. For a thorough examination of the decoration program of early eighteenth dynasty Theban tombs, see Barbara Engelmann-von Carnap, "Soziale Stellung und Grabanlage: zur Struktur des Friedhofs der ersten Hälfte der 18. Dynastie in Scheich Abd el-Qurna und Chocha," in *Thebanische Beamtennekropolen: Neue Perspektiven archäologischer Forschung, Internationales Symposion Heidelberg 9.-13.6.1993*, edited by J. Assmann, E. Dziobek, H. Guksch, F. Kampp, SAGA 12 (Heidelberg, 1995), 107-128; idem, *Die Struktur des Thebanischen Beamtenfriedhofs in der ersten Hälfte der 18. Dynastie: Analyse von Position, Grundrissgestaltung und Bildprogramm der Gräber*, ADAIK 15 (Berlin, 1999).

[94] Jan Assmann, "Priorität und Interesse: Das Problem der Ramessidischen Beamtengräber," in *Problems and Priorities in Egyptian Archaeology*, edited by J. Assmann, G. Burkard, and V. Davies (London and New York, 1987), 36. See also: Jan Assmann, "Geheimnis, Gedächtnis und Göttesnähe: zum Strukturwandel der Grabsemantik und der Diesseits-Jenseitsbeziehungen im Neuen Reich," in *Thebanische Beamtennekropolen: Neue Perspektiven archäologischer Forschung, Internationales Symposion Heidelberg 9.-13.6.1993*, edited by J. Assmann, E. Dziobek, H. Guksch, F. Kampp, SAGA 12 (Heidelberg, 1995), 281-293.

[95] Hermann, *Stelen*, 13-14, 100, discussed the use of the transverse hall as a type of reception or visitor room and compared it structurally to the reception hall in the houses of the New Kingdom. See also Assmann, *Genese und Permanenz*, 28.

forecourt in the T-shaped tomb (Figure 4). Lying opposite the main exit from the tomb chapel, the back walls frequently received the best light and were the first to be seen by viewers entering the tomb chapel.[96] Aesthetically, the images on the back walls often included innovative or accomplished renderings with sophisticated coloring.[97] Beginning with Max Wegner,[98] scholars noted that the images on the western back walls of the transverse hall were a sensitive indicator of the deceased's status, identity, relationships, and social environment. Known as the *"Blickpunktsbild"*[99] or the "focal point representation," this term was adopted in scholarship to express the significance of the images.[100] In simple rectangular tombs, one of the long walls, either the southern or northern, conformed in content and meaning to the *Blickpunktsbild* in T-shaped tomb chapels.[101]

A number of ancient Egyptian chapel texts in Theban tombs point to the importance of the scenes on the western back walls of the transverse hall (or the long walls in rectangular chapels) for the self-presentation of the owner and the efficacy of the deceased's eternal cult. A few Appeals to the Living refer the reader to the content of the back wall images.[102] Visitor graffiti on the *Blickpunktsbild* mention the beauty of the depictions or make reference to the importance of the scenes.[103] Also, autobiographical texts appear on these walls in which the tomb owner is represented as the actor, yet orients his autobiographical speech not to those represented in the scene but to the viewer outside who is beholding the image.[104]

[96] Schott, *Das schöne Fest*, 88; Assmann, *Problems and Priorities*, 36; Hodel-Hoenes, *Life and Death in Ancient Egypt*, 14.

[97] Consider the left back wall in TT 92, PM (8), which has an elaborately colored scene of gifts completed entirely by the master artist (Betsy M. Bryan, "Painting techniques and artisan organization in the Tomb of Suemniwet, Theban Tomb 92," in *Colour and Painting in Ancient Egypt*, edited by W.V. Davies (London, 2001), 68), or the sophisticated compositions on the back wall of Haremhab, TT 78, PM (4), such as troops vanishing behind the door to the supply depot of Thutmose IV (Figure 24) (Brack, *Haremhab*, 35). The abbreviation, PM (#), refers to the numbers assigned to particular tomb walls by Bertha Porter and Rosalind Moss, *Topographical Bibliography of Ancient Egyptian Hieroglyphic Texts, Reliefs and Paintings, I: The Theban Necropolis, Part 1: Private Tombs*, 2d ed. (Oxford, 1960). Bryan, *Colour and Painting*, 67, pls. 21.2, 22.1-2, 22.4, 23.1-2, has found evidence of sophisticated pictorial compositions on the north back wall of the entrance hall as well as adept techniques of color layering in which huntite white was used as an undercoat to make reds and yellows more vibrant (see also: Blythe McCarthy, "Technical analysis of reds and yellows in the Tomb of Suemniwet, Theban Tomb 92," in *Colour and Painting in Ancient Egypt*, edited by W.V. Davies (London, 2001), 17-21 with table 1). In this tomb, huntite appears to have been used as a preservative for orpiment and realgar red so they would not fade in the ambient light. In the front hall of Suemniwet, figural proportions were also more consistent and exhibited a greater degree of competence than in the other rooms of the chapel (Bryan, *Colour and Painting*, 64). See also the discussion of the placing of amusing and lively scenes on walls in order to elicit an offering or a prayer from visitors in: Roth, *Mummies & Magic*, 54-55; idem, "Social Change in the Fourth Dynasty: The Spacial Organization of Pyramids, Tombs, and Cemeteries," *JARCE* 30 (1993), 33-55, esp. 50. These attention-gathering figures act in much the same way as Wolfgang Kemp's *Apellfiguren* (Wolfgang Kemp, ed., *Der Betrachter ist im Bild: Kunstwissenschaft und Rezeptionsästhetik* (Cologne, 1985); see also Kaufmann, *Dictionary of Art*, vol. 26, 63).

[98] Wegner, *MDAIK* 4 (1933), 95.

[99] Dieter Arnold, *Wandrelief und Raumfunktion in ägyptischen Tempeln des Neuen Reiches*, MÄS 2 (Berlin, 1962), 128. Arnold discussed the *Blickpunktsbild* within temple contexts, and how it identified to the viewer the deity of the sanctuary, who donated the building, and the high favour with which the donator stood with the god.

[100] Various interpretations on the meaning and function of the *Blickpunktsbild* are presented by Fitzenreiter, *SAK* 22 (1995), 95-130, esp. 105, n. 36, who addresses its function as the "icon of social representation" within the realm of the hereafter; and Engelmann-von Carnap, *Thebanische Beamtennekropolen*, 127; idem, *Struktur des thebanischen Beamtenfriedhofs*, 379, 411-417, who argues (along with Fitzenreiter) that the status of the deceased dictated the contents of the *Blickpunktsbild*. While both of these scholars present compelling arguments, they do not examine the full meaning of the *Blickpunktsbild* which must be analyzed, both in terms of the tomb's purpose as a regenerative machine and as a living, commemorative monument.

[101] The long walls in rectangular Theban tombs dating between 1410-1372 BCE that conform to the *Blickpunktsbild* are: TT 161, PM (3)-(2) (Kampp Typ IIb); TT 165, PM (3)(4)(5) (Kampp Typ I); TT 175, PM (4) (Kampp Typ I); TT 258, PM (1)-(2) (Kampp Typ IIb). Note that in Hartwig, *Egyptology at the Dawn of the Twenty-First Century*, vol. 2, edited by Z. Hawass and L.P. Brock (Cairo, 2002), 299, fig. 1, the publisher printed the wrong drawing: on the lower tomb plan, both walls should be shaded with the word "or" between them to indicate only one wall conformed to the *Blickpunktsbild*. See Figure 4.

[102] *Urk.* IV, 939, 6-15 (TT 84); *Urk.* IV 1032, 3-6, probably from TT 131, *PM* I,1(2), 247; Eberhard Dziobek, *Die Gräber des Vezirs User-Amun Theben Nr. 61 und 131*, AV 84 (Mainz, 1994), 61; TT 57, *Urk.* IV, 1845: "He says to the people who shall pass by his tomb chapel...who shall look at my walls, and who shall read out my sayings ...," PM (6) outer lintel of western wall.

[103] TT 63, PM (9): Günter Burkhard, "Die Besucherinschriften," in Eberhard Dziobek and Mahmud Abdel Raziq, *Das Grab des Sobekhotep Theben Nr. 63*, AV 71 (Mainz, 1990), 88-91; TT 93, PM (16): Davies, *Kenamun* I, 22, pl. 68; TT 139, PM (5): Peden, *Graffiti*, 70, n. 52, for complete bibliography; TT 161, PM (3): Quirke, *JEA* 72 (1986), 79.

[104] Also known as biography 'à part' (Heike Guksch, *Königsdienst: Zur Selbstdarstellung der Beamten in der 18. Dynastie*, SAGA 11 (Heidelberg, 1994), 15, 25). A few examples: TT 39, PM (12): *Urk.* IV, 525-526; TT 85, PM (17): *Urk.* IV, 890-897; TT 75, PM (6): *Urk.* IV, 1208-1209; TT 76, PM (5): *Urk.* IV, 1577; TT 90, PM (4): *Urk.* IV, 1618-1620; TT 101, PM (4): *Urk.* IV, 1474-1475.

The tomb owner was the focus of the decorative program, which included gods and goddesses to whom the funerary procession led or from whom the deceased sought favor. In the most general sense, Theban chapel entrance walls were decorated on the east with images of the deceased going out of the tomb (towards the rising sun) and on the west going into the chapel (towards the setting sun, or the god of the underworld, Osiris).[105] In T-shaped chapels, ideally, the small walls of the transverse hall contained a painted stela on the right wall and a false door on the left wall. The stela, with its autobiographical text, was fundamental to the self-representation of the tomb owner for posterity. The false door often had the burial shaft cut in the floor before it, and that underscores its function as the contact and transition point between the world of the living and the world of the dead.[106]

In the eighteenth dynasty before the Amarna period, the decoration on the back walls of the transverse hall, and the "western" long walls on either side of the doorway into the inner passage or niche, was variable and contained focal representations of the tomb owner honoring the reigning monarch seated in a kiosk with adjacent scenes associated with aspects of the deceased's career,[107] or images of offering and banqueting,[108] or pictures of hunting or fishing and fowling,[109] among many other types of scenes. In T-shaped tombs, the eastern front walls of the transverse hall, on either side of the doorway to the forecourt, often contained images of the deceased and family participating in the cults of local or Theban gods, scenes of craftsmen at work, or images of agricultural activities.[110] If pillars appeared in the transverse hall, they could be decorated with images of the deceased participating in the festivals of the local gods, offering rituals, as well as going in and out of the tomb.[111]

In the western interior passage – the place of transit to the next world – the long walls were concerned with the deceased's way into and life in the hereafter. Here, on the left were portrayed scenes of burial or the "Judgement of the Dead" (ideally, the southern long wall) and, on the right, vignettes such as the "Opening of the Mouth" (ideally, the northern long wall) were portrayed.[112] A recess at the end of the longitudinal inner passage (ideally, the wall farthest west) held a representation of the tomb owner and his wife, usually in the form of a statue, statue group, or on a stelae before which offerings were left.[113] Eighteenth dynasty Theban tombs that were aligned north-south instead of the usual east-west corrected for their less-than-ideal orientation and changed the placement of the tomb program accordingly.[114] In simple rectangular chapels, one long wall was decorated with images concerned with the deceased's way into the

[105] Kampp-Seyfried, *Egypt: The World of the Pharaohs*, 252-253. This east-west orientation reflected the perceptions of the ancient Egyptians and not true compass readings. East was marked by the rising sun, and West was tracked by the setting sun. Günter Vittmann, "Orientierung," *LÄ* IV (1982), 607-609, esp. 608.

[106] Hermann, *Stelen*, 18-31; Kampp, *Nekropole* I, 51-55.

[107] See: Ali Radwan, *Die Darstellungen des regierenden Königs und seiner Familienangehörigen in den Privatgräbern der 18. Dynastie*, MÄS 21 (Berlin, 1969), Abb. 1; and Brack, *Tjanuni*, 21-22.

[108] Engelmann von Carnap, *Thebanischen Beamtenfriedhofs*, 410-417.

[109] Fitzenreiter, *SAK* 22 (1995), 112; Barbara Engelmann-von Carnap, "Zur zeitlichen Einordnung der Dekoration thebanischer Privatgräber der 18. Dynastie anhand des Fisch- und Vogelfang-Bildes," in *Stationen: Beiträge zur Kulturgeschichte Ägyptens: Rainer Stadelmann gewidmet*, edited by H. Guksch and D. Polz (Mainz, 1998), 247-262. While Engelmann-von Carnap finds a consistency in the placing of hunting scenes in the transverse hall during the reign of Thutmose IV, in the reign of Amenhotep III, these scenes move to the right wall of the inner hall.

[110] Schott, *Das schöne Fest*; 87; Rosemarie Drenkhahn, *Die Handwerker und ihre Tätigkeiten im alten Ägypten*, ÄA 31 (Wiesbaden, 1976), 164-165, liste 4.3; Manniche, *Lost Tombs*, 37, 39-40.

[111] Andrea Gnirs, "Das Pfeilerdekorationsprogramm im Grab des Meri, Theben Nr. 95: Ein Beitrag zu den Totenkultpraktiken der 18. Dynastie," in *Thebanische Beamtennekropolen: Neue Perspektiven archäologischer Forschung, Internationales Symposion Heidelberg 9.- 13.6.1993*, edited by J. Assmann, E. Dziobek, H. Guksch, F. Kampp, SAGA 12 (Heidelberg, 1995), 237 with table 5.

[112] Assmann, *Problems and Priorities*, 36. See *PM* I,1(2), TT 69, PM (10) & (11), 138; and TT 78, PM (11) & (12), 155.

[113] Fitzenreiter, *SAK* 22 (1995), 105, 107; Kampp-Seyfried, *Egypt: World of the Pharaohs*, 252.

[114] Such is the case with the tomb of Userhet (TT 56), where the tomb is situated N-S instead of the ideal E-W direction. The burial scene that usually appears on the left wall of the inner passage is put instead on the opposite wall to the right, which corresponds to the west. 'Daily life' scenes that usually occur in the transverse hall are also mixed with funerary scenes throughout the tomb. The conclusion is that the artisans corrected for the N-S orientation with a carefully devised decorative scene program; discussion in Beinlich-Seeber and Shedid, *Das Grab des Userhat*, 31-37.

hereafter, while the other related to the content of the *Blickpunktsbild* in T-shaped tomb chapels.[115] The cult place was marked by a false door and/or stela on the small, western wall. Images on either side of the doorway to the forecourt were concerned with the deceased's participation in the cults of the local gods, as well as offering processions.

The presence of standard image types discussed here assumes the existence of copybooks that were utilized by both the patron and the artist alike. Although none are preserved today, ancient copybooks, such as the "Instruction for the Painting/Writing of the Wall and the Painting of the Body" that once resided in the temple library of Edfu are attested.[116] Rather than being catalogues of specific scenes or texts, copybooks were probably summaries of basic types of scenes, outlines of picture programs, and information on the canon, color symbolism, and other important references.[117] The training of scribes and painters in ancient Egypt was based largely on repetition, so they had to be conversant with a number of standard texts and scenes that could be altered and executed on demand, either by memory or aided by some type of general visual reference.

1.2.2 Construction, Materials, and Techniques

A number of procedures were used to construct Theban rock-cut tombs. Usually, a passage was hewn into the rock that conformed to the height and length of the structure.[118] A red line was drawn down the middle of the ceiling, and that line served as the tomb axis. Measurements taken from this line determined the width of the rooms. A series of secondary cuts were made, and these secondary cuts extended the original passage outwards at right angles in order to form the transverse or front hall. If pillars were needed, the front portion of the hall would be cut in its entirety, the pillars would be marked, and the spaces between and around them would be cut away. Subsequent chambers required additional cutting.[119] Additional architectural marks in red ochre were used on the ceiling, floors, and vertical edges to level surfaces and/or to straighten walls and delimit pillars, doors, and shrine niches.[120] Other ocher lines may have corresponded to work progress marks.

Once the tomb was hewn out of the rock, the chapel walls, ceilings, and pillars would be decorated in either painting or relief. Since this study concerns flat painting on tomb walls, the procedure described here is for painting alone.[121] Much of the painting in the Theban necropolis occurs on walls of poor-quality stone. To create a suitable surface for painting, irregular patches of wall surface were filled with hacked straw and mud. Where the rock was of particularly bad quality, the gaps were stabilized with a combination of limestone chips in a light gypsum mortar base that was

[115] Fitzenreiter, *SAK* 22 (1995), 99-102, divides the distribution of decoration in early eighteenth dynasty rectangular tombs into the burial icon on the left or southern wall, and the banqueting icon (illustrating the connection between the living and the dead) on the right or north wall of the chapel. While this may be true early in the dynasty, by the reigns of Thutmose IV and Amenhotep III, the division is not as clear cut, and scenes depicting contact between the living and the dead occur *either* on the southern or the northern wall.

[116] Emile Chassinat and Le Marquis de Rochemonteix, *Le temple d'Edfou* III, *Mem. Miss.*, 20 (1928), 351; Maya Müller, "Musterbuch," *LÄ* IV (1982), 244-246.

[117] Beinlich-Seeber and Shedid, *Userhat*, 123-124.

[118] The best general description of private tomb construction remains that by Ernest Mackay, "The cutting and preparation of tomb-chapels in the Theban necropolis," *JEA* 7 (1920), 154-168. See also Hodel-Hoenes, *Life and Death in Ancient Egypt*, 16-17.

[119] See, for example, the preliminary passage and partially hewn outer passage with columns in TT 229 (*PM* I,1(2), 326; and Mackay, *JEA* 7 (1920), fig. 1).

[120] These marks conform to the Egyptian *Elle*, see: Dziobek and Raziq, *Sobekhotep*, 19-23. See recent discussion of these marks in Heike Guksch, *Die Gräber des Nacht-Min und des Men-cheper-Ra-seneb, Theben Nr. 87 und 79*, AV 34 (Mainz, 1995), 31-38, 131-134.

[121] See discussions on the procedure of decorating Theban tombs in James, *Egyptian Painting*, 10-18; idem, *Dictionary of Art*, vol. 9, 898; idem, "Painting Techniques on Stone and Wood," in *Conservation of Ancient Egyptian Materials*, edited by S.C. Watkins and C.E. Brown (London, 1988), 55-59; Lorna Lee and Stephen Quirke, "Painting materials," in *Ancient Egyptian Materials and Technology*, edited by P.T. Nicholson and I. Shaw (Cambridge, 2000), 117-118; Hartwig, *OEAE* III (2001), 1-2.

covered by a layer of chopped straw and mud. Larger gaps were spanned with mud bricks and limestone chips. Holes in the rock were often patched with limestone chips in a matrix of straw and mud.[122]

A rough gypsum plaster was applied next, and it was smoothed and then followed by a fine layer of white or yellow gypsum plaster, which served as the ground for painting.[123] The rough gypsum layer was applied by hand and often bore the palm and finger marks of the ancient workmen.[124] On a few figures in this study, the rough and fine plaster was carved to show the patterning on the king's crown or locks of the deceased's hair.[125] Sometimes, the rough plaster was omitted, and a chalk-like whitewash was painted directly on the mud and straw foundation.[126] When the rock was of good quality, a simple layer of fine, white gypsum plaster was applied and used as a base for the paintings. The use of a gypsum plaster wash ensured the color was applied evenly and that it would not be fully absorbed into the wall matrix.[127]

The basic Egyptian palette was composed of white ($h\underline{d}$), black (km), red ($d\check{s}r$), green ($w3\underline{d}$), blue ($\underline{h}sbd$), and yellow, which were used alone or mixed to form additional colors such as brown, grey, orange, and pink.[128] These colors were derived largely from naturally occurring substances.[129] Black was carbon from charcoal or deposited soot. White came from calcium carbonate (whiting) or calcium sulphate (gypsum). Huntite white was first employed during the Old Kingdom[130] and became more common in the New Kingdom when it was used as a contrast to whitewash or as a base to bring out the luminosity of the overlaid pigments. Ochres ranging from yellow to red to dark brown originated from naturally occurring iron oxides. Beginning in the Middle Kingdom, yellow was also obtained from orpiment, which appeared as bright yellow. A lighter yellow was derived from jarosite. Realgar red was used in the New Kingdom and appeared as a bright orange-red. The principal blue pigment was Egyptian blue, composed by heating together silica, copper alloy filings, or a copper ore (malachite, lime, alkali) and mixing in varying amounts to produce a range from light blue to dark blue to turquoise. Green was made of green frit (a wollastonite-rich or glass-rich form), and basic copper chloride. Varnish (tree resin, lipids) was added or applied to color and could appear as a translucent yellow coating that

[122] MacKay, *JEA* 7 (1920), 159; Alfred Lucas, *Ancient Egyptian Materials and Industries*, 4th rev. ed. by J.R. Harris (London, 1962), 75-76. Many other variations were used by ancient workmen in order to stabilize rock surfaces in the tomb chapel so it could receive painted decoration. For an excellent summation of working methods in a Theban tomb dating to the reign of Thutmose IV, see: Dziobek and Raziq, *Sobekhotep*, 19-30. Some tomb walls could have up to four or five layers of limestone chip and mud plaster mixture, measuring anywhere from 13 cm. (TT 91) to almost 15-20 cm. (TT 77) in depth.

[123] Lucas, *Materials*, 76-77, 353-354; Brack, *Tjanuni*, 15, pl. 57e; Robert Fuchs, "Stuck," *LÄ* VI (1986), 87-92; Lee and Quirke, *Materials and Technology*, 117-118.

[124] For example, TT 91, PM (3) & (2); TT 77, PM (2).

[125] TT 64, PM (5) plaster worked in relief on the crown of Thutmose IV; TT 69, PM (2) hair of deceased worked in relief; TT 74, PM (1) the wig of the deceased is molded out of gypsum plaster on the entry wall, south (Brack, *Tjanuni*, taf. 19a). See also, MacKay, *JEA* 7 (1920), 167.

[126] Such as TT 181: Norman de Garis Davies, *The tomb of two sculptors at Thebes*, PMMA, Robb de Peyster Tytus Memorial Series 4 (New York, 1925), 18.

[127] McCarthy, *Colour and Painting*, 19, detected a process by which the water was drawn quickly into the porous gypsum substrate, allowing the binder to thicken with the paint on the surface. The coagulation of binder and paint created an effective barrier against absorption into the porous wall.

[128] Emma Brunner-Traut, "Farben," *LÄ* II (1977), 117-119; John Baines, "Color Terminology and Color Classification: Ancient Egyptian Color Terminology and Polychromy," *American Anthropologist* 87 (1985), 287; Lee and Quirke, *Materials and Technology*, 104-117; Stephen Quirke, "Colour vocabularies in Ancient Egyptian," in *Colour and Painting in Ancient Egypt*, edited by W.V. Davies (London, 2001), 186-192; Gay Robins, "Color Symbolism," *OEAE* I (2001), 291-294, who states that there is no specific color term for yellow, and it may have been included under the term *dšr*. For a list of color terms see: Rainer Hannig and Petra Vomberg, *Wortschatz der Pharaonen in Sachgruppen, Kulturhandbuch Ägyptens, Hannig-Lexica 2,* Kulturgeschichte der Antiken Welt 72 (Mainz, 1999), 186-187, 277-278.

[129] As summarized in Lucas, *Materials*, 338-351; Claude Traunecker, "Farbe," *LÄ* II (1977), 115-117; Waltraud Guglielmi, "Holzkohle," *LÄ* II (1977), 1271-1272; Rainer Hannig and Robert Fuchs, "Ocker," *LÄ* IV (1982), 550-551; Robins, *Art of Ancient Egypt*, 27; Lee and Quirke, *Materials and Technology*, 104-117.

[130] Ann Heywood, "The use of huntite as a white pigment in ancient Egypt," *Colour and Painting in Ancient Egypt*, edited by W.V. Davies (London, 2001), 7-8.

darkened over time.[131] There is some evidence that beeswax was used to coat paintings or as a pigment binder in the New Kingdom.[132]

To make these minerals and compounds suitable for application, the workers first ground them into a powder. Natural gum, derived from animal glue or indigenous trees such as the acacia, was combined with these colored particles.[133] The pigment was then applied with a brush to a dry wall in a technique known as tempera. Brushes from all periods were made from a commonly found Egyptian rush (*Juncus maritimus*), palm ribs, or wood, and these were cut, folded in half, bruised into bristles, and bound together at the fold with a string.[134] The thickness of the brush determined the thickness of the line.

For artificial light, Egyptian artists used a shallow clay vessel with a flat bottom and splayed rim called a *khebes* lamp.[135] The *khebes* lamp was filled with animal or vegetable fat in which a number of linen wicks were placed. Once lit, the lamp produced a minimum amount of smoke, which may or may not have been aided by a little salt added to the oil.[136]

Pigments composed of natural or artificial materials of different particle size were painted in solid blocks, glazes, or semi-transparent layers above various colored bases (Plate 1,1).[137] Color could be layered to give richness and luminescence to the paint matrix. Pigment could also be placed side-by-side to create gradations of color and could be dabbed on to indicate texture. The Egyptian word "variegated" (*s3b*) described the use of color to indicate textures such as fur, feathers, and scales, and the addition of the word *nḫt* ("strong") to the name of a color referred to the brightness of the hue.[138] The deliberate use of shading and shadowing was sporadic.[139] Color could be manipulated in order to differentiate forms and create overlapping figures and objects through alternating tones.

The organization of work in the private Theban tomb chapels can be reconstructed based on the visual remains of work processes on the walls,[140] as well as painted scenes depicting tomb construction.[141] In wall compositions, scenes and figures were often constructed with the help of a system of guide lines.[142] First, a string dipped in red paint marked the boundaries of the wall and register lines. Artisans stretched the string across the wall and snapped it at intervals.

[131] Lucas, *Materials*, 2-4, 307, 337, 352-353, 356-361; Brack, *Tjanuni*, 16; Wolfgang Helck, "Harze," *LÄ* II (1977), 1022-1023; Margaret Serpico, "Resins, amber and bitumen," in *Ancient Egyptian Materials and Technology*, edited by P.T. Nicholson and I. Shaw (Cambridge, 2000), 459-460.

[132] Ernest Mackay, "On the use of beeswax and resin as varnishes in Theban tombs," *Ancient Egypt* 5 (1920), 35-38; Robert Fuchs, "Wachs," *LÄ* VI (1986), 1088-1094; Shedid, *Stil der Grabmalereien*, 23; Margaret Serpico and Raymond White, "Oil, fat and wax," in *Ancient Egyptian Materials and Technology*, edited by P.T. Nicholson and I. Shaw (Cambridge, 2001), 411.

[133] Lucas, *Materials*, 351; Richard Newman and Margaret Serpico, "Adhesives and binders," in *Ancient Egyptian Materials and Technology*, edited by P.T. Nicholson and I. Shaw (Cambridge, 2000), 475-494; Richard Newman and Susana M. Halpine, "The binding media of ancient Egyptian painting," *Colour and Painting in Ancient Egypt*, edited by W.V. Davies (London, 2001), 22-32.

[134] Lucas, *Materials*, 365; Rosemarie Drenkhahn, "Pinsel," *LÄ* IV (1982), 1053-1054; Mary Anne Murray, "Fruits, vegetables, pulses and condiments," in *Ancient Egyptian Materials and Technology*, edited by P.T. Nicholson and I. Shaw (Cambridge, 2000), 619-620.

[135] Jaroslav Černý, *The Valley of the Kings*, BdÉ 61 (Cairo, 1973), 43-54; Hodel-Hoenes, *Life and Death in Ancient Egypt*, 18.

[136] See description by Alan B. Lloyd, *Herodotus, Book II, Commentary 1-98* (Leiden, 1976), 282. On wicks: Gillian Vogelsang-Eastwood, "Textiles," in *Ancient Egyptian Materials and Technology*, edited by P.T. Nicholson and I. Shaw (Cambridge, 2000), 291. On lamp fuel: Serpico and White, *Ancient Egyptian Materials and Technology*, 392, 402, 422.

[137] McCarthy, *Colour and Painting*, 17.

[138] Brunner-Traut, *LÄ* II, 119-120; Baines, *American Anthropologist* 87 (1985), 283-284; Quirke, *Colour and Painting*, 188, mentions the term *s3b* may have originally referred to a combination of black, white, and red/brown.

[139] Nina Davies, *Ancient Egyptian Paintings* II, pl. LXX, LXXXVII, XCI; III, 135, 169, 177; Baines, *American Anthropologist* 87 (1985), 287.

[140] A number of studies survey the work processes and artistic techniques in New Kingdom Theban tombs. For a general survey, see Baud, *Les dessins*, 229-233; for studies of specific tombs, see Kozloff, *Acts, First International Congress of Egyptology*, 395-402; Maya Müller, "Zum Werkverfahren an thebanischen Grabwänden des Neuen Reiches," *SAK* 13 (1986), 149-164; Shedid, *Stil der Grabmalereien*, 89-93, 97-101; Beinlich-Seeber and Shedid, *Userhat*; Abdel Ghaffar Shedid and Matthias Seidel. *The Tomb of Nakht*, translated from the German by M. Eaton-Krauss (Mainz, 1996); Bryan, *Colour and Painting*, 63-71; Cathleen A. Keller, "A family affair: the decoration of Theban Tomb 359," in *Colour and Painting in Ancient Egypt*, edited by W.V. Davies (London, 2001), 73-93.

[141] See examples in TT 154: Norman de Garis Davies, *Five Theban Tombs*, ASE 21 (London, 1913), pl. XXXIX; and TT 368: Baud, *Les dessins*, 223-224, fig. 10.

[142] Gay Robins, *Proportion and Style in Ancient Egyptian Art* (Austin, 1994), 23-30; idem, "Grid Systems," *OEAE* II (2001), 68-71; idem, "The use of the squared grid as a technical aid for artists in Eighteenth Dynasty painted Theban Tombs," in *Colour and Painting in Ancient Egypt*, edited by W.V. Davies (London, 2001), 60-62.

Within this, a system of lines was drawn to aid the artist in building figures, texts, and scenes. After the sketch was drawn and corrected and the hieroglyphs were sketched in, a background wash of white, cream, pale blue-grey, or yellow was applied around the figures and objects. Next, individual colors were painted in blocks of pigment; forms received a final outline with the interior details being delineated with a fine brush. When required, a final background wash was also applied. Procedural exceptions do exist, as in the example in the tomb of Tjanuny (TT 74), in which many of the completed figures were never outlined.[143] Some painted chapels in this study have several images of the deceased and wife carved in relief. In this case, the corrected sketch was chiseled into raised relief and then painted.[144]

Forms and scenes were sketched and painted by outline-draughtsmen (in ancient Egyptian, *sš-ḳd*), aided by painters (*sš*) who laid on blocks of color and assistants who prepared the pigments. The *ḥry sš-ḳd* ("overseer (or chief) of the outline-draughtsmen") supervised the entire procedure, correcting the workers as they went along. The *ḥry sš-ḳd* may have completed specific motifs and hieroglyphs without the help of guidelines and may have added final outlines to figures. Procedurally, the outline-draughtsmen, the assistants who prepared the wall and pigment, and overseers combined their talents to decorate a tomb. Artists operated according to fixed rules within a cooperative workshop system in which apprentices were taught and checked by those with more experience.[145] Tomb artists worked as a team that brought the varying abilities of individual artists into harmony through overlapping work processes and the master craftsman's supervision. This process ensured and produced a stylistic uniformity across the chapel wall.

1.3 Painting Workshops and Private Patronage

The right to receive "a goodly burial in the west" depended, in theory, on the king as well as the status and the means of the deceased.[146] In Thebes, the area of land on which the tomb was built was granted by the king to an official, as revealed in texts that mention that the deceased was "interred into land given of the king, into the tomb of the west."[147] Royal authority in the Theban necropolis was organized by the administration and led by the "overseer of Western Thebes," who could also be the chief of the necropolis police.[148] Elite officials were given plots of land for the building of their tombs, which, as suggested by tomb placement and professional distribution in the Theban necropolis, related in part to their administrative group or rank in the hierarchy.[149] For unknown reasons, women were rarely afforded tomb chapels in the Theban necropolis, and were interred in the tomb of their husband or a male relative around whom the decoration was configured.[150] For members of the lower classes, a shallow pit dug into the sand served as their final resting place. In essence, the sumptuousness of the tomb reflected a combination of an official's personal means or

[143] Brack, *Tjanuni*, 94.

[144] In TT 253, images of the deceased and wife were carved in relief on PM (4) & (7) into the back wall of the transverse hall on either side of the entrance to the inner passage (Nigel Strudwick with Helen Strudwick, *The Tombs of Amenhotep, Khnummose, and Amenmose at Thebes (Nos. 294, 253, and 254)* (Oxford, 1996), 42, scene 3.1.a; 44, scene 7.1.a).

[145] Bryan, *Colour and Painting*, 68-69. These apprentices also may have been offspring of the outline-draughtsmen, given the fact that occupations were passed from father to son; see Christopher J. Eyre, "Work and the Organisation of Work in the New Kingdom," *Labor in the Ancient Near East*, edited by M.A. Powell, AOS 68 (New Haven, 1987), 173-174.

[146] Eyre, *Labor*, 197-198; Hodel-Hoenes, *Life and Death in Ancient Egypt*, 2-4; Seidlmayer, *OEAE* II (2001), 509-511; Kanawati, *The Tomb and Beyond*, 6-8.

[147] Djehut (TT 110) and Antef (TT 164): Davies and Gardiner, *Amenemhet*, 56.

[148] Seidlmayer, *OEAE* II (2001), 510. "Overseer of the lands [on] the west of Thebes" *(imy-r ḫ3swt [ḥr] imntt w3st)* = Norman de Garis Davies and M.F.L. Macadam, ed., *A Corpus of Inscribed Egyptian Funerary Cones* I (Oxford, 1957), nos. 22, 398; "Overseer of western Thebes" *(imy-r imntt w3st)*: TT 200 = Peter Der Manuelian, *Studies in the Reign of Amenophis II*, HÄB 26 (Hildesheim, 1987), 119.

[149] On tomb placement as a reflection of social status, see: Wolfgang Helck, "Soziale Stellung und Grablage: Bemerkungen zur thebanischen Nekropole," *JESHO* 5 (1962), 225-243; Engelmann-von Carnap, *Thebanische Beamtennekropolen*, 107-128; idem, *Struktur des Thebanischen Beamtenfriedhofs*, 403-417. However, these works must be used with caution: Status as reflected in the private tomb responded to many factors, of which placement, size, and orientation were only a part; see critique in: Friederike Kampp-Seyfried, "Thebes, New Kingdom private tombs," in *Encyclopedia of the Archaeology of Ancient Egypt*, edited by K. Bard (London and New York, 1999), 810; Melinda K. Hartwig, "Institutional Patronage and Social Commemoration in Private Theban Tomb Painting during the reigns of Thutmose IV (1419-1410 BC) and Amenhotep III (1410-1382 BC)," (Ph.D. Dissertation, Institute of Fine Arts - New York University, 2000), 93-97.

[150] Discussion in Robins, *Women in Ancient Egypt*, 164-166. For the rare exception, see the tomb of Senet (TT 60), *PM* I,1(2), 121-123; Kampp, *Nekropole* I, 275. See also Georges Posener, "Le Vizir Antefoqer," in *Pyramid Studies and Other Essays Presented to I.E.S. Edwards*, edited by J. Baines, T.G.H. James, A. Leahy, and A.F. Shore, Occasional Publications 7 (London, 1988), 75-76.

access to skilled craftsmen, probably by virtue of his affiliation within a particular branch of the administration (see discussion below).

The considerable amount of wealth and resources that went into the building and decoration of an elite tomb secured a number of people, from specialists who would excavate and decorate the tomb to workshops that would produce funerary goods. Since this study concerns tomb painting in Thebes, the following discussion will center only on the painters (*sš*, *sš-ḳd*, *ḥry sš-ḳd*) who were charged with the decoration of pre-Amarna eighteenth dynasty tombs and the patronage system that commissioned them.

While the numbers of private Theban tombs are significant, information about the painters who constructed, designed, and decorated them is scarce.[151] We can, however, draw a number of conclusions about the location and nature of this pre-Amarna workforce from Theban data, including archaeological remains of workmen's villages, artists' autobiographies, administrative documents, and the art itself.[152] In eighteenth dynasty Thebes, there is no clear written evidence of free craftsmen working in an open market.[153] Instead, artists, including painters, belonged to workshops connected to state or temple institutions, which provided their craftsmen with materials, produce, goods, and services.[154] Documentary sources identify a number of *sš*, *sš-ḳd*, and *ḥry sš-ḳd* who worked in the Theban area who were associated with the projects of the Temple of Amun at Karnak,[155] or who were affiliated with the state, such as the workmen's village at Deir el-Medina (*st- m3ʿt* or *p3-ẖr* or *st-ʿ3(t)*)[156] or who were in general royal service for "the Lord of Two Lands" (*nb-t3wy*).[157]

Of these, the configuration of the village of Deir el-Medina during the eighteenth dynasty remains most problematic. Documentation on the village during the first half of the eighteenth dynasty sheds little light on the commissioning of the workmen, how they lived, or whether an equivalency can be sought among the workmen of the *st-m3ʿt*, *p3-ẖr*, or *st-ʿ3(t)*.[158] Based on the present state of documentation and later Ramesside archives, it seems logical to assume that Deir el-Medina workmen were not exclusively responsible for the painting of private Theban chapels, given the demands of constructing and decorating the royal tomb. Therefore, it seems probable that Deir el-Medina

[151] Although a few artists "signed" their works, painters of Theban tomb chapels remain largely anonymous (Marianne Eaton-Krauss, "Artists and Artisans," *OEAE* I (2001), 138). A few examples of New Kingdom artists signing their works exist, but they are predominately from the early eighteenth dynasty or the Ramesside period. For a few examples, see: Edith W. Ware, "Egyptian artists' signatures," *AJSL* 43 (1926-1927), examples I, V, XXV, XXVII; and Wilhelm Spiegelberg, "Eine Künstlerinschrift des Neuen Reiches," *Rec. Trav.* 24 (1902), 185-187.

[152] The literature is quite extensive on the artists in the New Kingdom, so only a few important works will be cited here. For general documentary and pictorial evidence, see: Drenkhahn, *Handwerker*, 69-71; idem, "Handwerker," *LÄ* II (1977), 950; idem, "Werkstatt," *LÄ* VI (1986), 1224-1225; idem, "Artisans and Artists in Pharaonic Egypt," translated from the German by J. Baines, *CANE* I (1995), 332-343; Frank Steinmann, "Untersuchungen zu den in der handwerklich-künstlerischen Produktion beschäftigten Personen und Berufsgruppen des Neuen Reichs I-V," *ZÄS* 107 (1980), 137-157; *ZÄS* 109 (1982), 66-72, 149-156; *ZÄS* 111 (1984), 30-40; *ZÄS* 118 (1991), 149-161; Dominique Valbelle, "Craftsmen," in *The Egyptians*, edited by Sergio Donadoni and translated from the Italian by B. Bianchi (Chicago, 1997), 31-59.

[153] On the lack of free craftsmen working for a free market, see: Jac J. Janssen, "Prolegomena to the Study of Egypt's Economic History during the New Kingdom," *SAK* 3 (1975), 159; Drenkhahn, *LÄ* II (1977), 949-950; Eyre, *Labour*, 200.

[154] After Steinmann, *ZÄS* 109 (1982), 154-156.

[155] With titles such as "Overseer of craftsmen in the temple of Amun": *Urk.* IV, 525, 14-15. Or generally: "Outline-draughtsman of Amun": *Urk.* IV, 128,16; Davies, *Two officials*, pl. VI.

[156] Henry R. Hall, *Hieroglyphic Texts from Egyptian Stelae, &c., in the British Museum*, vol. 7 (London, 1925), 11, pls. 32-33; Jeanne Vandier d'Abbadie, *Deux tombes de Deir el-Médineh : I, La chapelle de Khâ*, MIFAO 73 (Cairo, 1939), 1-18. See also Jeanette Anne Taylor, *An Index of Non-Royal Egyptian Titles, Epithets & Phrases of the 18th Dynasty* (London, 2001), nos. 2185- 2186. Although Deir el-Medina painters had titles with the extension "of Amun" (*n Imn*), it appears to have held no administrative reality (Eyre, *Labor*, 194).

[157] Stephen Quirke, *Owners of Funerary Papyri in the British Museum*, BM Occassional Paper 92 (London, 1993), no. 124 F; Steinmann, *ZÄS* 109 (1982), 152, on the extension "*nb t3wy*" as an epithet for general royal (state) service.

[158] Černý, *A Community of Workmen*, 72-74; and Charles Bonnet and Dominique Valbelle, "Le village de Deir el-Médineh: Reprise d l'étude archéologique," *BIFAO* 75 (1975), 429-446, accept the equivalence between *st- m3ʿt* and *st-ʿ3(t)* in the first half of the eighteenth dynasty; however, Raphael Ventura, *Living in a City of the Dead: A Selection of Topographical and Administrative Terms in the Documents of the Theban Necropolis*, OBO 69 (Freiburg and Göttingen, 1986), 53-54, states this cannot be accepted based on the present lack of documentation. On the eighteenth dynasty village, see: Mournir Megally, "A propos de l'organisation administrative des ouvriers à la XVIIIe dynastie," *Studia Aegyptiaca: Recueil d'études dédiées à Vilmos Wessetzky à l'occasion de son 65e anniversaire*, vol. I (Budapest, 1974), 297-311.

craftsmen may have *occasionally* decorated private tombs, but this practice may have been more the exception than the rule.[159]

A number of painters connected to Amun temple works are represented in eighteenth dynasty Theban tomb chapels such as "the painter of Amun, *Wsr-ḥ3t*" from the chapel of Amenhotep-si-se (TT 75) and the "painter of Amun, *P3-s3-nsw*, called *P3-rn-nfr*" from the chapel of Nebamun and Ipuky (TT 181).[160] From eighteenth dynasty titles, we know Amun temple artists were also associated with work on the Luxor Temple[161] and the royal funerary temples on the West Bank.[162] Other texts refer to Karnak workshop locations "on the south side of Karnak."[163] Onomastic data also exists for outline-draftsmen and painters attached to the temple treasury at Karnak.[164] In this regard, a series of workshops have been excavated near the Treasury of Thutmose I; cakes of pigment and remains of paint in vessels were found. Information on workshops at Karnak is supplemented further by private Theban tomb decoration that shows the manufacturing and painting of a number of items in temple ateliers.[165]

Texts also reveal that artists were employed for general royal commissions under the authority of the state in the eighteenth dynasty. Artists and supervisors connected with the state held titles such as "Chief of outline-draftsmen of the Lord of Two Lands" (*ḥry sšw-ḳdw n nb t3wy*).[166] Of these, we can presume that, during the reign of Amenhotep III, a number of the best craftsmen were based in his palace at Malqata as recipients of royal patronage and providers for specific state needs.[167] Workshops also appear to have been attached to particular temples or sites on the West Bank, as attested in artists' titles that juxtapose epithets like *n nb t3wy* "of the Lord of Two Lands" with sites such as *Herihermeru*, which has not yet been localized.[168]

Unfortunately, we have few archaeological remains of permanent or semi-permanent workmen's communities on the West Bank outside of Deir el-Medina. Workshop and domestic installations have been located near the mortuary temple of Thutmose IV[169] and behind the mortuary temple of Amenhotep III at Kom el-Hetan.[170] Remains of craftsmen's homes have been found in the "village area" between the great court of the audience pavilion adjacent to the west end of the North Palace of Amenhotep III at Malqata; and another large workman's village existed to the south of the palace precinct along the hills of the Birket Habu.[171] Domestic installations from the time of Amenhotep III were also preserved

[159] The principal evidence for Deir el-Medina workmen involved with painting eighteenth dynasty private Theban tombs is based on stylistic criteria (Kozloff, *The Art of Amenhotep III*, 59-60; but note, idem, *Egypt's Dazzling Sun*, 264), and the organization of labor (Kozloff, *Acts, First International Congress of Egyptology*, 395-402), both of which have been questioned based on the lack of inscriptional evidence (Eyre, *Labor*, 197; Morris Bierbrier, *The Tomb-Builders of the Pharaohs* (London, 1982), 18; Taylor, *Death and the Afterlife*, 173). Recently, a study of the technique and palette found in the back rooms of the tomb chapel of Suemniwet (TT 92) was compared to painting on furniture or funerary implements at Deir el-Medina (Bryan, *Colour and Painting*, 70). Yet, given the debate that still rages, the question of Deir el-Medina artists' working in Theban tombs remains a problematic one.

[160] Norman de Garis Davies, *Two officials*, pl. IV; Davies, *Two sculptors*, pl. XI, XII, XIV. See also TT 82: *Urk.* IV, 1056.

[161] *Urk.* IV, 1889, 19; 1948, 6 and 11. All date to the reign of Amenhotep III.

[162] *Urk.* IV, 1613, 4 ("Overseer of works of the temple of Thutmose IV, given life"); Steinmann, *ZÄS* 109 (1982), 151, n. 31 ("Great craftsman of the temple of Amenhotep III on the West of Thebes").

[163] On the Lateran Obelisk; see translation in: Bryan, *Thutmose IV*, 176-179. The text reads: ". . .after his Majesty found this obelisk, it having completed 35 years lying on its side in the hands of artisans on the southern side of Karnak."

[164] Wolfgang Helck, *Materialien zur Wirtscaftsgeschichte des Neuen Reiches*, vol. I (Wiesbaden, 1961), 44-47; Jean Jacquet, *Karnak-Nord V: Le trésor de Thoutmosis Ier*, FIFAO 30/1-2 (Cairo, 1983), par. 3.2.17. Material dates from Thutmose I to Ramesses II.

[165] See examples in Drenkhahn, *CANE* I (1995), 332-343.

[166] Steinmann, *ZÄS* 109 (1982), 152, n. 41, title on a relief fragment in Leipzig 5069, tp. Haremhab. I thank Friederike Kampp-Seyfried for the dating of this object. For similar titles: "Overseer of all the works of the king in the Southern City," (*Urk.* IV, 1948, tp. Haremhab); and "Overseer of craftsmen of the Lord of Two Lands" (*Urk* IV, 1470).

[167] Eyre, *Labor*, 194.

[168] As attested in the tomb of Nebamun and Ipuky (TT 181); Davies, *Two sculptors*, pl. 5. See discussion in: Helck, *Materialien* I, 76; Polz, *MDAIK* 46 (1990), 320; Wb Zettl. 2065. The *Herihermeru* may correspond to a village near the *Imn-hri-hr-mrw*.

[169] Valbelle, *The Egyptians*, 42-43.

[170] Alexandre Varille and Clément Robichon, "Nouvelles fouilles de temples funéraires thébains (1934-1935)," *RdÉ* 2 (1936), 180; Clément Robichon and Alexandre Varille, *Le temple du scribe royal Amenhotep, fils de Hapou*, FIFAO 11 (Cairo, 1936), 34, 46.

[171] Smith, *AAAE*, 162; Birgit Schlick-Nolte, "Glass," *OEAE* II (2001), 31; W. Raymond Johnson, "Monuments and Monumental Art under Amenhotep III: Evolution and Meaning," in *Amenhotep III: Perspectives on His Reign*, edited by D. O'Connor and E. Cline (Ann Arbor, 1998), 76 with n. 80.

under the filling in the lowest part of the mortuary temple of Ramesses III at Medinet Habu.[172] Yet, if there was a workmen's village charged with the manufacturing of elite Theban tombs during the eighteenth dynasty, one would expect more substantial remains, given the excellent state of preservation of the Ramesside constructions associated with Deir el-Medina. Instead, we have no textual or archaeological record of a permanent artist's community that constructed and decorated private eighteenth dynasty Theban tombs.

Several statistical and demographic studies have argued unconvincingly for a separate, permanent group of craftsmen on the West Bank who were charged with the manufacturing of elite Theban tombs during the New Kingdom. John Romer pointed to rates of royal and private tomb production and indicated that they increased and decreased exactly at the same time, which led him to suggest that there were two separate workforces – one at Deir el-Medina and another in the Theban necropolis – that responded to the same set of labor demands.[173] However, this "equivalence of effort" does not offer proof that the private workforce was a permanent entity situated on the West Bank, directed by the same authority that oversaw the Deir el-Medina workmen. Nigel Strudwick also referenced the large number of private tombs to argue for a permanent group of 200 workmen and their families living on the West Bank (distinct from Deir el-Medina), although there is little physical or documentary evidence to support this claim, a point that was also noted by the author.[174]

Instead, ancient documents indicate that the composition of workforces in Thebes West may have been rather fluid and semi-permanent. A number of ostraca found in connection with the private tombs of Senenmut and the mortuary temples of Hatshepsut and Thutmose III shed light on a temporary group of workmen who were brought together for various works around Deir el-Bahri.[175] This workforce was drawn from employees attached to the service of the pharaoh, the vizier, various nobles, as well as individuals sent from the southern cities of Esna, El-Kab, El-Matanah, and Asfun, and from Neferusi in Middle Egypt.[176] Furthermore, several ostraca from the tomb of Senenmut (TT 353) mention the arrival of laborers from Hermopolis (Khnum), Nubia, and other places to work on the vizier's tomb,[177] as well as a special work detachment of 10 outline-draughtsmen who came from the city of Thebes to work on Hatshepsut's temple.[178] Another ostraca from the same tomb lists monthly contributions from a number of sources such as the Overseer of the Treasurers, Hatshepsut ("the house of the King's wife"), the pharaoh Thutmose III, and Senenmut himself.[179] These Senenmut ostraca are important because they indicate that artists in his tombs were employed for relatively concentrated periods of time and were derived from different places and different institutions or people. These ostraca also strongly suggest that Senenmut used royal workmen employed at Deir el-Bahri for the building and decorating of his tombs, and this is further substantiated by the similarity between the work control in the tombs of Senenmut and the mortuary temples at Deir el-Bahri.[180]

While we may view the borrowing of artists by high officials overseeing royal projects as an abuse of power, the ancient Egyptians may not have, as it seems to have been relatively common during the eighteenth dynasty. The most prominent examples, of course, come from officials who held the title "Overseer of Works," such as Senenmut, cited

[172] Uvo Hölscher, *The Excavation of Medinet Habu* I, OIP 21 (Chicago, 1934), 68-74; II, OIP 41, 26; folio, pls.12, 14-15.

[173] John Romer, "Who Made the Private Tombs of Thebes?" in *Essays in Egyptology in honor of Hans Goedicke*, edited by B. Bryan and D. Lorton (San Antonio, 1994), 211-232.

[174] Nigel Strudwick, "The population of Thebes in the New Kingdom: Some preliminary thoughts," in *Thebanische Beamtennekropolen Neue Perspektiven archäologischer Forschung, Internationales Symposion Heidelberg 9.- 13.6.1993*, edited by J. Assmann, E. Dziobek, H. Guksch, F. Kampp, SAGA 12 (Heidelberg, 1995), 101.

[175] William C. Hayes, *Ostraka and name stones from the tomb of Sen-Mut (no. 71) at Thebes*, PMMA 15 (New York, 1942); idem, "A Selection of Tuthmoside Ostraca from Dēr el-Bahri," *JEA* 46 (1960), 29-52; Valbelle, *The Egyptians*, 42.

[176] Hayes, *Ostraka and name stones*, 23, no. 83, from TT 71, which lists 56 workmen, of which 21 came from the estate of Senenmut, seven from the Vizier, 23 from the town of Neferusi in Middle Egypt near Beni Hasan (Dieter Kessler, "Neferusi," *LÄ* IV (1982), 383-385) and five from the scribe Hori.

[177] Hayes, *JEA* 46 (1960), no. 13, 39-41.

[178] Eyre, *Labor*, 185. Ostraca no. 12 (Hayes, *JEA* 46 (1960), 39, pl. XI) "the crews (*ist*) of Djeseru (Deir el-Bahri) doing the like in the Town (=of Thebes)."

[179] Hayes, *JEA* 46 (1960), 41-42, no. 14, pl. XI.

[180] Mounir Megally, "Un intéressant ostracon de la XIIIe dynastie de Thèbes," *Bulletin du centenaire, Supplément au BIFAO* 81 (1981), 293-312; Eyre, *Labor*, 185.

above. A block from the mortuary temple of Amenhotep, son of Hapu, states that his tomb was erected on his behalf by the state, with stonemasons, painters, and craftsmen appointed by the pharaoh. These are workers whom we know were already under his control in his capacity as "Overseer of Works."[181] Based on the text on this block, the tomb appears to have passed to the owner as a benefit of his official position and royal favor.

In fact, a number of New Kingdom officials describe how they were "favored" or "rewarded" by the king for their years of service and were given funerary equipment, statues, and the burial.[182] One such official, the "Scribe of Recruits" Tjanuny (TT 74), who lived during the reigns of Amenhotep II and Thutmose IV, wrote on his autobiographical stela:

> ...(the king) he made for me a beautiful tomb (*krst*) as one praised [of the king]....In the favor of the
> Good God, I have received a rock tomb (*ḥrt*) in the West.[183]

Another official, a "Chief Steward of Amun" named Roau, wrote on the door jamb of his tomb that it was "given as a favor of the king's bounty" by Thutmose III "on the occasion of the founding of Djeser-akhet" (the Hathor chapel built by the king at Deir el-Bahri).[184] Another example is provided by a letter written by a scribe who was supervising construction on a Memphite tomb that belonged to a general named May. In it, the scribe refers to 'payment' which came from private sources to pay for the workmen, such as the general himself and a chantress of Thoth. The letter was addressed to the royal administration, which suggests the project was, in some fashion, under its authority. This leads to a number of suppositions: 1, the tomb was a royal gift; 2, the general was part of the royal entourage; and/or 3, the craftsmen constructing May's tomb were employees of the state.[185]

For officials of the 'middle class,'[186] their tombs, artisans, and funerary equipment may have been acquired much in the same way that their high-ranking colleagues acquired them – by the authority of their office and their own resources. Yet, for the middle class, we can assume the construction and decoration of a private tomb was a costly affair, especially in cases where the pharaoh is not specifically cited as the donor of the tomb, its furnishings, or its endowment. Since there are no recorded transactions that set prices for the construction or decoration of tombs, the most extensive evidence for the private purchase of art is found in receipts from the Ramesside workmen's village at Deir el-Medina. It is a well-known fact in the Ramesside Period that state-employed craftsmen and painters at Deir el-Medina supplemented their income by manufacturing grave goods and coffins to offset their wages.[187] This archive reveals that the "average" cost of painting a coffin or funerary equipment was 5-20 *deben* of copper, which, using materials provided by the state, was at least equal to a workman's monthly salary (in grain rations) during the middle of the nineteenth dynasty.[188] The value of grain in the barter economy of ancient Egypt led Wolfgang Helck to suggest that many officials

[181] *Urk.* IV, 1836; *PM* II(2), 455; Helck, *Materialien* III,150; Benedict G. Davies, *Egyptian Historical Records of the Later Eighteenth Dynasty*, vol. V (Warminster, 1994), 24.

[182] For example, *Urk.* IV, 537-538, 912-913, 1010, 1422; Norman de Garis Davies, *The Tomb of Rekh-mi-re at Thebes*, 2 vols., PMMA 11 (New York, 1943; reprint 1973), 13, pl. CXIIIB.

[183] Brack, *Tjanuni*, 46-47, text 40.

[184] Helck, *Materialien* III, 150. Text found on MMA 26.2.55, published in William C. Hayes, *The Scepter of Egypt, Part II: The Hyksos Period and the New Kingdom (1675-1080 B.C.)*, rev. ed. (New York, 1990), 129, fig. 67. Hayes further suggests that Roau used the royal workmen at Deir el-Bahri to construct and decorate his tomb, a fact that is supported by the high quality of the carving on the jamb.

[185] Paule Posener-Kriéger, "Construire une tombe à l'ouest de *mn-nfr* (P. Caire 52002)," *RdÉ* 33 (1981), 47-58.

[186] The middle class in Egypt was composed of temple provisioners, traders, craftsmen, etc., who, in the New Kingdom, began to emerge as a group in their own right; see: Wolfgang Helck, "Die soziale Schichtung des ägyptischen Volkes im 3. und 2. Jahrtausend v. Chr," *JESHO* 2 (1959), 1-36; Pascal Vernus, "Quelques exemples du type du 'parvenu' dans l'Égypte ancienne," *BSFÉ* 59 (1970), 35ff; Toby A.H. Wilkinson, "Social Stratification," *OEAE* III (2001), 302-303.

[187] In ancient Egypt, these goods were not sold but were traded for merchandise that was valued in terms of commodities such as copper, silver, oil, or grain. For example, a Ramesside ostraca from Deir el-Medina mentions that a man whose name began with the prefix Neb (*Nb...*) gave one pair of sandals, one *kbs*-basket, one *mnḏm*-basket, and a *nkr*-sieve (among other things) to the painter Burequenef for the painting of the tomb owner's pyramid (O. DeM 215: Jaroslav Černý, *Catalogue des ostraca hiératiques non littéraires de Deir el Médineh*, vol. III, DIFAO 5 (Cairo, 1973), 7, pl. 10). On private trade among Deir el-Medina craftsmen in the Ramesside period, see: Jac J. Janssen, "Kha'emtōre, a Well-to-do workman," *OMROL* 58 (1977), 231-232; Evgeni S. Bogoslovsky, "Hundred Egyptian Draughtsmen," *ZÄS* 107 (1980), 115-116.

[188] Eyre, *Labor*, 202; see also Jac J. Janssen, *Commodity Prices from the Ramessid Period* (Leiden, 1975), 207-248, for prices of tomb equipment; Bogoslovsky, *ZÄS* 107 (1980), 113-116. See also: Kathlyn Cooney, "The Economics of Art: An Analysis of Price and Wages from the Ramesside Period," (Ph.D. dissertation, The Johns Hopkins University, 2002). On the economics of a fine burial, see: Barry J. Kemp, *Ancient Egypt: Anatomy of a Civilization* (London and New York, 1989), 240-241.

may have embezzled small amounts to pay for their tombs.[189] Helck cites as his proof the lavish decoration and prominent placement of tombs in the Theban necropolis that belonged to low-ranking officials attached to the grain administration and the working of gold. Helck argued that these officials siphoned off raw materials under their responsibility and used them as "bribes" to pay for their tombs as well as the workmen and goods to outfit them. To substantiate his argument, he pointed to the controversy regarding deficiencies in corn measures at Deir el-Medina in the Ramesside period as proof that small amounts could be withheld. These trial proceedings and theft investigations in the late New Kingdom show a robber could steal enough material wealth by tapping temple grain, robbing tombs, and pilfering temple equipment and exchange it for personal effects, food, animals, and even services.[190] During the Ramesside period, some officials even took craftsmen off the main work detail at Deir el-Medina and used them instead for private projects such as the building and equipping of their tombs. Even at that time, this practice was considered an abuse of office.[191] While it is tempting to accept these later Ramesside tendencies as manifestations of an earlier tradition of abuse, the greater social stability of the early New Kingdom would strongly suggest that the embezzlement of goods to pay for private tombs was more the exception than the rule.

For people of lower social rank, there may have been institutions responsible for the distribution of abandoned tombs. B.M. Ostracon 5624 mentions a Deir el-Medina workman named Haí who received the abandoned tomb of Amenmose from the '3 n pr n niwt, Thutmose, in year 7 of Horemhab.[192] Haí legitimized his 'personal right' to the tomb in year 21 of Horemhab by having it confirmed by the oracle of the deified Amenhotep I at Deir el-Medina. He began work on the tomb shortly thereafter. It is interesting to note that in the workmen's village the allocation of forsaken tombs was done by an official linked to the royal state bureaucracy and not by one linked to the administration of Deir el-Medina.[193] Other hieratic documents show that, at least by year 21 of Ramesses III, an institution was in place in Thebes that oversaw the distribution of deserted tombs to other occupants.[194] Elsewhere in Egypt, the reuse of older tombs is attested since the late Old Kingdom.[195] Therefore, we can assume that those of lower social rank in the pre-Amarna period had access to abandoned Theban tombs.[196]

In terms of manufacturing, tombs belonging to artists in the Theban necropolis may have been completed by the owners themselves, perhaps helped by family and other associates. It is well-attested in the Ramesside period that Deir el-Medina craftsmen constructed and decorated their own tombs.[197] Furthermore, the tombs of craftsmen in the Theban necropolis show similar individualistic qualities as those painted by the artists at Deir el-Medina, and this suggests self-manufacture.[198]

[189] Wolfgang Helck, "Wer konnte sich ein Begräbnis in Theben-West leisten?" *GM* 135 (1993), 39-40.

[190] Papyrus Geneva (D 191): Edward F. Wente, *Late Ramesside Letters*, SAOC 33 (Chicago, 1967), 71-74, nr. 37. An excellent discussion with bibliography on the bartering of stolen goods for items and services is in Kemp, *Anatomy*, 238-260.

[191] Jaroslav Černy, "Papyrus Salt 124 (Brit. Mus. 10055)," *JEA* 15 (1929), 243-258. In the Salt Papyrus, a foreman for the royal tomb, Paneb, misused his office by embezzling equipment and craftsmen intended for the royal tomb.

[192] Aylward M. Blackman, "Oracles in ancient Egypt," *JEA* 12 (1926), 176-177; Schafik Allam, *Hieratische Ostraka und Papyri aus der Ramessidenzeit*, URAÄ 1 (Tübingen, 1973), 43-45.

[193] Helck, *Materialien*, III, 151-152; Daniel Polz, "Excavation and Recording of a Theban Tomb: Some Remarks on Recording Methods," in *Problems and Priorities in Egyptian Archaeology*, edited by J. Assmann, G. Burkhard, and W.V. Davies (London and New York, 1987), 123-124; idem, *MDAIK* 46 (1990), 335-336.

[194] Polz, *MDAIK* 46 (1990), 335-336; also O. Florenz 2621 (Allam, *Hieratische Ostraka*, 148-149) and P. Berlin 10496 (Ibid., 277-280).

[195] Old Kingdom: Kanawati, *The Tomb and Beyond*, 18. A hieratic inscription on a bowl found in a burial shaft of Tomb 30b in the Qubbet el-Hawa (Hans Goedicke, "The High Price of Burial," *JARCE* 25 (1988), 195-199) refers to a sizable payment made by Sebekhotep to another tomb owner so he could bury his father in it.

[196] In the New Kingdom: TT 22, TT 77, TT 84, discussed in: Polz, *MDAIK* 46 (1990), 301-315.

[197] Blackman, *JEA* 12 (1926), 176, translating the recto, 1 of B.M. Ostracon 5624: "Thereafter, I was standing building and the [work]man Ḫ'-m-nw was at work in his tomb." On other examples from Deir el-Medina, see Bernard Bruyère, *Tombes thébaines de Deir el-Médineh à décoration monochrome* (Cairo, 1952), 18; Helck, *Materialien* III, 150-151; Christopher J. Eyre, "A Draughtsman's Letter from Thebes," *SAK* 11 (1984), 195-207; idem, "Royal painters: Deir el-Medina in Dynasty XIX," in *Fragments of a Shattered Visage: The Proceedings of the International Symposium on Ramesses the Great*, edited by E. Bleiberg and R. Freed, Monographs of the Institute of Egyptian Art and Archaeology 1 (Memphis, 1991), 63-66; idem, *Colour and Painting in Ancient Egypt*, 73-93; Bierbrier, *Tomb Builders of the Pharaohs*, 55-64; Eyre, *Labor*, 197; Taylor, *Death and the Afterlife*, 172.

[198] Baud, *Les dessins*, 253-257; Eyre, *Labor*, 191.

In terms of timing, there is evidence that private tombs were decorated at the height of an official's career, probably before his death.[199] In the tomb of Amenemhet (TT 82), two stelae (one of which was dated to year 28 of Thutmose III) were painted over the existing chapel decoration, indicating that some of Amenemhet's chapel had been completed well before his death in the reign of Amenhotep II.[200] Other documents suggest the actual painting of a New Kingdom Theban tomb chapel may have taken place fairly quickly. A hieratic ostraca records that one small Ramesside T-shaped tomb took three months and 19 days to paint.[201] A longer, intermittent work schedule can also be assumed for larger tombs. In the Senenmut ostraca from TT 71, work began with the quarrying of the tomb in year 7 of Hatshepsut, 4 *Prt* 2, while another ostracon indicates work was continuing in year 11, some five years later.[202]

It is generally accepted that the prospective tomb owner would regularly examine the work on his tomb, given its importance for his afterlife and his self-presentation for posterity. On this score, a few chapel scenes depict the deceased and his wife overseeing the construction and decoration of their tomb.[203] Several Theban tomb chapels also contain captioned images of the tomb owners examining their burial goods.[204] In the event of the untimely death of the tomb owner (or lack of resources), family members or other people may have oversaw the building of his sepulcher.[205] However, the large number of unfinished tombs in the necropolis also argues for the cessation of all work upon the owner's death.

As part of supervising the building of their tombs, Theban owners or their delegates would have selected from basic types of images, and these images would have been individualized by a group of painters who placed them in the tomb chapel according to the patron's requirements.[206] This would have been done within prescribed limits set by the available repertoire of scenes and the "fixing" of these images on certain walls of the chapel according to the meaning and use of the different rooms and the orientation of the tomb (see above 1.2.1). The responsibility for the acceptable rendering of the painting rested largely with the artist. Since the tomb was a monument charged with a number of vital functions in regard to the perpetuation of the deceased, too much license taken by the artist would not have been easily

[199] Kanawati, *The Tomb and Beyond*, 9-10; Baines and Lacovara, *Journal of Social Archaeology* 2 (2002), 10-11. See also *Urk.* I, 221-223; Text of Anu of Assiut in: Detlef Franke, *Das Heiligtum des Heqaib auf Elephantine, Geschichte eines Provinzheiligtums im Mittleren Reich*, SAGA 9 (1994), 22 with n. 72.

[200] Davies and Gardiner, *Amenemhet*, 8, 70-72, pl. XXV, XXVI. An inscription belonging to Amenemhet at Gebel es-Silsileh indicates he lived into the reign of Amenhotep II. See also the work process in the tomb of Haremhab, TT 78 (Brack, *Haremhab*, 83-84). "Double tombs" also point to an extended work schedule in which both tombs were completed at different times, sometimes with the earlier tomb being vacated towards the end of the official's career in favor of another, larger tomb (Peter Dorman, "Two Tombs and One Owner," in *Thebanische Beamtennekropolen: Neue Perspektiven archäologischer Forschung, Internationales Symposion Heidelberg 9.- 13.6.1993*, edited by J. Assmann, E. Dziobek, H. Guksch, and F. Kampp, SAGA 12 (Heidelberg, 1995), 144-145). One prominent example is that of the tombs of Djehuty-nefer (TT 104 and TT 80), which show that the earlier tomb was abandoned in favor of a later, larger tomb. Other double tombs such as those belonging to Senenmut (TT 71 and TT 353) and Useramun (TT 61 and 131) may have been private mortuary complexes with one tomb acting as a chapel and the other as a burial place.

[201] Amin A.M.A. Amer, "A Unique Theban Tomb Inscription under Ramesses VIII," *GM* 49 (1981), 9-12.

[202] Peter F. Dorman, *The Monuments of Senenmut: Problems in Historical Methodology* (London, 1988), 95-97.

[203] Davies, *Five Theban Tombs*, 43, pl. XXXIX. The caption to the scene reads: "Providing a tomb (*ḥꜣt*) in the necropolis for the Butler.... Tati." Another scene of tomb construction appears in TT 368, which belongs to an "Overseer of Sculptors of Amun in the Southern City"; see Baud, *Les dessins*, 223-224, fig. 110. Scenes of the owner visiting his tomb in a carrying chair are known in the Old Kingdom and show his personal involvement with the construction of his chapel and the payment of his workmen. These scenes were often placed on the northern wall of the mastaba, within direct sight of visitors; see: Ann Macy Roth, "The Practical Economics of Tomb-Building in the Old Kingdom: A Visit to the Necropolis in a Carrying Chair," in *For His Ka: Essays Offered in Memory of Klaus Baer*, edited by R. Ritner, SAOC 55 (Chicago, 1994), 227-238.

[204] *Urk.* IV, 912, 12 - 913, 15, found in TT 85 of Amenemhab, PM (20); see also a similar inscription, although largely reconstructed by Sethe, in TT 99 of Senneferi, *Urk.* IV, 537-538, which appears on PM (7) and (8) with images of the deceased inspecting his funeral outfit and statues.

[205] For example, whoever undertook the actual burial stood to inherit the property of the deceased party; see: Jac J. Janssen and P.W. Pestman, "Burial and Inheritance in the Community of the Necropolis Workmen at Thebes (Pap. Bulaq X and O. Petrie 16)," *JESHO* 11 (1968), 137-170. See also the tomb of Amenemhet (TT 82), which was built by "his son, the director of constructions on this tomb, the scribe Amenemhet, justified" (Davies and Gardiner, *Amenemhet*, 36-37, pl. VIII).

[206] For excellent but brief discussions of patronage and work procedures in ancient Egyptian mastabas and tombs, see: William Kelly Simpson, *The Offering Chapel of Sekhem-Ankh-Ptah in the Museum of Fine Arts* (Boston, 1976), 2-3; Brack, *Haremhab*, 18-19; Beinlich-Seeber and Shedid, *Userhat*, 123.

tolerated by the patron or his delegate.[207] Steady supervision may not have been required on the part of the patron because, "in principle, the commissioning of the artist for a desired work implied approval of his individual approach and confidence in his ability to realize the program of the commission in his own respected and admired way."[208]

The suggestion that smaller tombs were generically mass-produced without a tomb owner in mind and later assigned to minor officials does not bear up under scrutiny. In the 1930's, Marcelle Baud listed a number of New Kingdom private tombs whose decoration she thought bore no resemblance to the career of the tomb owner or whose texts contained gaps.[209] Since many tombs in the Theban necropolis lie in various states of completion, unfinished scenes or texts cannot be taken as proof that sections of the wall were left deliberately free of decoration in order to receive names, titles, or scenes at another time.[210] As for the tomb scenes that Baud felt did not reflect the nature of the deceased's career, TT 43, which belonged to Neferrenpet, contained banqueting scenes and two scenes of the deceased before the king seated in a kiosk. Far from being an anomaly, Neferrenpet's titles indicate that he was intimately connected with the king and therefore would have portrayed him in his chapel.[211] The horses depicted in a sketched scene of animal registration in the tomb of a "troop commander" named Nebamun (TT 145) are commonly found in the tombs of military officials, particularly in scenes of tribute or produce processions.[212] A scene of Amenhotep-si-se (TT 75) displaying royal gifts intended for the Temple of Amun reflected his duties as "Second Prophet of Amun."[213] Similarly, Ptahemhet (TT 77) depicted the presentation of royal gifts for the mortuary temple of Thutmose IV in his capacity as "Overseer of Works."[214] And Maspero's suggestion that the tomb of Nakht (TT 52) was produced in advance is inaccurate: The blank or partially completed texts, unfinished scenes, and quickly prepared walls, are usually found in Theban tombs and reflected the unfinished state of the chapel which was conceived with a particular tomb owner in mind. For these reasons, the agricultural scenes in the tomb of Nakht represented the cycle of the seasons and alluded to the tomb owner's position as an "Hour Observer" in the Temple of Amun.[215] Therefore, Theban tomb chapels were not anonymously mass-produced in advance for later occupancy.

Of the 210 or so numbered decorated tomb chapels dating to the eighteenth dynasty (1569-1315 BCE) that are preserved today, we can assume that there were almost double that number in antiquity, roughly 420 tombs, half of which have been lost or destroyed.[216] Roughly 50 painted tombs remain that were decorated during the reigns of Thutmose IV and Amenhotep III, and double that amount must have existed in antiquity.[217] Given the 47 year period that encompasses the reigns of Thutmose IV and Amenhotep III, that would mean an average of two to three tombs were painted a year,

[207] See various discussions on decorum in Egyptian art: John Baines, *Fecundity Figures: Egyptian Personification and the Iconology of a Genre* (Warminster, 1985), 277-305; idem, "Restricted Knowledge, Hierarchy, and Decorum: Modern Perceptions and Ancient Institutions," *JARCE* 27 (1990), 17-21.

[208] Meyer Schapiro, "On the Relation of Patron and Artist: Comments on a Proposed Model for the Scientist," in *Theory and Philosophy of Art: Style, Artist and Society* (New York, 1994), 230.

[209] Baud, *Les dessins*, 245-249.

[210] For example: TT 255 shows a named couple who were completely finished on the upper register; and on the lower register, a couple who were never finished nor named (PM (3)-(4)). The white areas in the lower scene were simply never completed (George Foucart, *Tombes thébaines: nécropole de Dirâʿ Abû'n Nága*, in colaboration with Marelle Baud and Étienne Drioton, MIFAO 57 (Cairo, 1928), 6). Of the remaining tombs in Baud's study, TT 84 belonged to an "Overseer of the Gate" and contained scenes of tribute on PM (5) & (9), which are to be expected, given the nature of Iamunedjeh's office. Baud mentioned the style of the scenes was too calm in TT 84 (Baud, *Dessins*, 248), but this may be attributed to the style of the group of artisans who decorated the tomb. TT 138 of Nedjemger was painted in the Ramesside period when career scenes were much less common, and the decorative program was concerned almost exclusively with the hereafter (Assmann, *Problems and Priorities*, 31-42).

[211] Wolfgang Helck, "Das thebanische Grab 43," *MDAIK* 17 (1961), 99-110; complete bibliography in Der Manuelian, *Amenophis II*, 23.

[212] Compare depictions in TT 40, TT 74, TT 78, TT 90, TT 91, TT 99, TT 239; and discussion in Wolfgang Helck, "Ein verlorenes Grab in Theben-West: TT 145 des Offiziers Neb-Amun unter Thutmosis III," *Antike Welt* 27.2 (1996), 73-85.

[213] Kees, *Priestertum*, 15; Bryan, *Thutmose IV*, 269.

[214] Manniche, *Three Theban Tombs*, 10, 22-25.

[215] See the discussion of cyclical and cosmological associations of the images in the tomb of Nakht in: Laboury, *La peinture égyptienne ancienne*, 49-81; and Melinda K. Hartwig, "The Tomb of Nakht," in *Valley of the Kings: The Tombs and Funerary Temples of Thebes West*, edited by K.R. Weeks (Vercelli, Italy, 2001), 390-397; and see above 3.2.8 and 3.2.9.

[216] Method used in: Strudwick, *Thebanische Beamtennekropolen*, 99. Total number of tombs based on: Kampp, *Nekropole* I, 144-146. Dates taken from *The Oxford Encyclopedia of Egypt* (2001).

[217] See Appendix I for dating of tombs.

outside of relief decorated tombs in the Theban necropolis and the workmen's sepulchers in Deir el-Medina. Each tomb would have required, on average, five to ten painters and assistants to prepare the wall, mix the pigments, and paint the scenes and texts.[218] Of course, there are exceptions, such as small chapels crafted by one or two painters, medium-sized chapels done by three or more painters, and larger tombs decorated by many artists.[219] Taking into account a fairly concentrated work period, we can assume, on average, a group of painters would have taken four to six months to decorate a tomb, which would have necessitated at least temporary housing on the West Bank.

1.4 Patrons and Workshops in Thebes during the reigns of Thutmose IV and Amenhotep III (1419-1372 BCE)

Of the 30 painted chapels that comprise the core of this study, eight were decorated in the reign of Thutmose IV, 14 were painted during the transitional period at the end of the reign of Thutmose IV and the beginning of Amenhotep III, and eight were completed solely in the reign of Amenhotep III (Table 1). The short nine-year reign of Thutmose IV meant that many chapels begun during that king's reign were not completely decorated until the beginning of Amenhotep III's rule. As discussed above, during the reigns of Thutmose IV (1419-1410 BCE) and Amenhotep III (1410-1372 BCE), roughly two to three private tomb chapels were completed a year. Again, this figure reflects an average completion rate that, in reality, may have been more sporadic, with a number of tombs nearing completion at the same time, punctuated by a lull in activities at others.

If each year saw the decoration of two to three private tomb chapels lasting on average four to six months, then from where did this workforce come and where were they housed? As mentioned above, there is no archaeological evidence for a permanent artisan community on the West Bank (outside of Deir el-Medina). The best answer to the question lies in the analysis of the painting of the chapels themselves.

In earlier studies, Arpag Mekhitarian[220] and Arielle Kozloff[221] distinguished the styles of several Theban painting workshops in the private tombs dating from Amenhotep II to Amenhotep III. Mekhitarian classified painters in terms of their use of color, form, and technique. Kozloff adapted the Morellian method[222] to Theban tomb painting in order to identify the style of individual artists and their groups. She examined individual forms, their linear and proportional characteristics (draftsmanship), costume, the organization of pictorial composition and space, subject matter, and palette.

Mekhitarian found one style of painting in the tombs of Sennefer (TT 96), Menna (TT 69), Nakht (TT 52), and Pairy (TT 139) and assigned it to a school of painters who operated during the reigns of Amenhotep II and Thutmose IV.[223] Kozloff identified two master craftsmen and their groups who worked either in a "Plain" or "Impressionistic" style, or an "Ornate" or "Formalistic" style. The "Plain/Impressionistic" style was "very free and sketchy and very subtly colored, almost monochromatic"; exploited figural repetition, patterning, overlapping and movement; showed a lack of detail; and employed a palette of earth tones with few blues and greens, which, when used, appeared muted.[224] To this group of painters, she assigned tomb numbers TT 38, TT 75, TT 77, TT 78, TT 79, TT 82, TT 89, TT 90, TT 91, TT

[218] For stylistic evidence, see for example: Mekhitarian, *CdÉ* 31, no. 62 (1956), 238-248; Kozloff, *Acts, First International Congress of Egyptology*, 399-401.

[219] For tomb chapels completed by a few painters, see: Nina de Garis Davies, *Scenes from some Theban Tombs (Nos. 38, 66, 162, with excerpts from 81)*, PTT IV (Oxford, 1963), 1; Shedid, *Stil der Grabmalereien*, 89-91; Shedid and Seidel, *Nakht*, 30; for tombs completed by a number of artists, see: Bryan, *Colour and Painting*, 70.

[220] Mekhitarian, *CdÉ* 31, no. 62 (1956), 238-248; idem, *MDAIK* 15 (1957), 186-192.

[221] Kozloff, *NARCE* 95 (Fall 1975-Winter 1976), 8; idem, *Acts, First International Congress of Egyptology*, 395-402; idem, "Study of Two Styles of Theban Paintings from the Amarna Period," in *L'Égyptologie en 1979: Axes prioritaires de recherches* 2, Colloques Internationaux du Centre National de la Recherche Scientifique 595 (Paris, 1982), 263; idem, *Art of Amenhotep III*, 55-64; idem, *Egypt's Dazzling Sun*, 261-283; Arielle Kozloff and el Sayed Ali Higazy, "The Painted Scenes in the Tomb of Paser, Theban Tomb No. 367," in *Abstracts of Papers, Fourth International Congress of Egyptology* (Munich, 1985), 115-116.

[222] On the Morellian method, see: D.C. Kurtz, "Beazley and the Connoisseurship of Greek Vases," *Greek Vases in The J. Paul Getty Museum* 2, Occasional Papers on Antiquities 3 (Malibu, 1985), 244-250. Broadly speaking, the Morellian method (as applied to Greek vase painting) analyzes the details, the graphic aspects of the decoration, such as major and minor lines, and how they are rendered by the artist.

[223] Mekhitarian, *CdÉ* 31, no. 62 (1956), 238-239.

[224] Kozloff, *L'Égyptologie en 1979*, 263; idem, *Art of Amenhotep III*, 57-59; idem, *Egypt's Dazzling Sun*, 267.

100, TT 116, TT 172, TT 201, and TT 367.[225] On the other hand, Kozloff noted another group of tombs (TT 43, TT 52, TT 69, TT 108, TT 139, TT 161, TT 175, TT 181, TT 226, TT 249, BM 37976-86, and Musée Calvet no. A 51) that were painted in a "Ornate/Formalistic" style.[226] This style was brilliantly colored and meticulously detailed; experimented with luxurious compositions, ornaments, group relationships, and movement; and used a palette of rich colors that emphasized blues and greens.[227]

Unfortunately, Kozloff's results are stylistically inconsistent in a few instances. Tombs TT 38 and TT 75 are placed into her "Plain/Impressionistic style," but instead they have more stylistic affinities with tombs belonging to her "Ornate/Formalistic" style. For example, the tomb of Djeserkarasoneb (TT 38) has a scene of musicians that is based on a similar motif in his employer's tomb, Amenhotep-si-se (TT 75),[228] and both chapels are stylistically similar to Nakht (TT 52) and TT 175, which are in her "Ornate/Formalistic" camp, and will be discussed below. These inconsistencies appear to be the result of Kozloff's preference for color palette above all other criteria, which, alone, is not a reliable single component in the overall assessment of style.

In short, Mekhitarian and Kolzoff's recognition of two groups of painters in the private Theban necropolis offers a point of departure. While only a selection of tombs were examined by these scholars, the study of a complete series of painted chapels dating from a single period might offer more revealing data. When all the painted private Theban tombs from the reigns of Thutmose IV and Amenhotep III are analyzed by comparing form, line, composition, proportion, subject matter, and palette, a complete progression takes form, along with a refinement of Kolzoff and Mekhitarian's initial stylistic divisions.[229] In painted chapels dating from 1419-1372 BCE, one style of painting can be traced in the following tomb chapels: TT 120,[230] TT 75 (Plate 1,2), TT 38 (Plate 2,1), TT 108 (Plate 2,2), TT 52,[231] TT 175 (Plate 3,1), TT 253 (Plate 3,2), TT 165 (Plate 3,3), TT 139 (Plate 4,1), TT 69 (Plate 4,2), TT 161 (Plate 5,1), TT 181 (Plate 5,2), TT 139 (Plate 6,1), TT 249 (Plate 6,2), and TT 151 (Plate 6,3). Stylistically, in each of these chapels, compositions are fairly static and are arranged around the large, seated figure of the deceased and wife. Minor figures are arranged in small, lively vignettes that are rendered gracefully.[232] Forms are evenly spaced horizontally across the wall, and these forms are grouped in twos and threes by gesture and glance. Figural proportions are symmetrically rendered, and shapes are drawn with fine, relatively precise outlines with many interior details. Faces show dish-shaped profiles, curving or arched eyebrows, and obliquely-set almond-shaped eyes with pupils that touch the lower lid.[233] Colors are saturated and comprise the usual ochres with frequent additions of blue and green. Varnish is used liberally on the figures. The overall effect is formal, fine, graceful, and ornate, with a linear quality that recalls the sharp lines of relief carving.

On the other hand, another style can be traced in the following painted tomb chapels: TT 78 (Plate 7,1), TT 116 (Plate 7,2), TT 64 (Plate 8,1), TT 63 (Plate 8,2), TT 66 (Plate 9,1), TT 77 (Plate 9,2), TT 74 (Plate 14,1), TT 239 (Plate 10,1), TT 89 (Plate 10,2), TT 91 (Plate 11,1), TT 76 (Plate 12,1), TT 201 (Plate 12,2), TT 118 (Plate 13,1), TT 258 (Plate 13,2), TT 90 (Plate 15,2), and TT 226 (Plate 16,1).[234] Forms in these chapels are generally painted with strong,

[225] Kozloff and Higazy, *Abstracts, Fourth Congress of Egyptology*, 115-116; Kozloff, *Art of Amenhotep III*, 57-59.

[226] Kozloff and Higazy, *Abstracts, Fourth Congress of Egyptology*, 115-116; and Kozloff, *Art of Amenhotep III*, 60-64, attributing tombs TT 52, 69, TT 108, TT 226, BM nos. 37976-86, and Musée Calvet no. A 51 to one master artist; tombs TT 43, TT 175, TT 253, TT 161, and TT 181 to his followers; and in another study, (Kozloff, *Egypt's Dazzling Sun*, 280) she places tombs TT 139, TT 249, minor figures in TT 52 and TT 69 as well as the box of Perpawty in the oeuvre of another painter who followed the master.

[227] Kozloff, *L'Égyptologie en 1979*, 263.

[228] *PM* I, 1(2), 70; Davies, *Two officials*, 7, n. 15; Davies, *Some Theban Tombs*, 6-7.

[229] For the selection of tombs and their dating, see the Appendix I.

[230] See photos in: Lyla Pinch Brock, "Polishing a Jewel in the Gebel: The Tomb of Anen (TT 120) Conservation Project," *BARCE* 183 (Fall-Winter 2002-2003), 1, 5-7; and facsimile painting in: Robins, *Art of Ancient Egypt*, fig. 155.

[231] Shedid and Seidel, *Nakht*, 48-49.

[232] See for example: Davies, *Some Theban Tombs*, pl. II; Shedid and Seidel, *Nakht*, 39, 52, 66.

[233] These figural and facial details are criteria that date to both Thutmose IV and Amenhotep III; for more, see: Cherpion, *BSFÉ* 110 (Octobre, 1987), 36-37; Bryan, *Thutmose IV*, 300-301; Kozloff, *The Art of Amenhotep III*, 60-61.

[234] Bernard V. Bothmer, et al., *The Luxor Museum of Ancient Egyptian Art: Catalogue* (Cairo, 1979), no. 101, 79, fig. 59, pl. VII; Kozloff, *Egypt's Dazzling Sun*, 297, pl. 28.

thick outlines.[235] At other times, figural outlines are quite sketchy. Faces and bodies of the individual figures are rendered with few details, and figural proportions tend to be exaggerated. Color is used to differentiate overlapping figures and to indicate ethnicity. The palette is earth-toned with an emphasis on ochre reds and yellows. Pattern is stressed by the texture of animal fur, the variation of postures, and the movement of figures. Compositions tend to be quite complex, with imaginative architectural depictions, changes in direction, and dense figural overlapping that frequently accentuates the vertical axis by stacking forms one above the other. The effect is strong, powerful, and spontaneous, allowing a more "Impressionistic" conception of form.

When the characteristic titles (the title most characteristic of the tomb owner's office) of tomb owners are compared to the two styles of painting, a compelling correlation occurs among the private tombs that were decorated during the reigns of Thutmose IV and Amenhotep III: Officials whose chapels were painted in the first style of painting belonged to individuals employed in the religious administration (priests, temple provisioners, grain or field scribes of Amun and temple artisans), and those whose chapels were executed in the second style of painting belonged to officials of the civil, military, palace, or regional administrations who together comprised the "state class" (Table 1).[236]

The lack of archaeological and inscriptional evidence on a workforce charged exclusively with the decoration of private eighteenth dynasty tombs suggests that these two groups of painters must have been part of well-documented artists' workshops or communities that belonged to existing institutional bodies in Thebes. During the reigns of Thutmose IV and Amenhotep III, these institutional bodies were the Amun precinct at Karnak, the workmen's village at Deir el-Medina, and, from 1402 BCE or so,[237] the palace of Amenhotep III at Malqata. As stated above, the indistinct nature of the Deir el-Medina community in the eighteenth dynasty and the demands of constructing and decorating the royal tomb may have excluded these painters from undertaking private commissions in the Theban necropolis. Instead, it seems likely that a special group of artists attached to the Karnak temple, the Malqata complex, or other royal structures may have been detached from their workshops as a cohesive workforce to decorate private tomb chapels. Given that, at any one time, two to three private chapels were being decorated in the Theban necropolis for an average of four to six months, a sustained work schedule may have necessitated several groups of painters to meet the demand.[238] According to this hypothesis, once the work was completed, the painters would return to their workshops to continue with their institution's ongoing projects. As discussed above, a complete absence of documentation regarding a permanent workforce residing on the West Bank (outside of Deir el-Medina) argues for such a practice. To bear out this hypothesis, motifs in private Theban chapels must be compared to those found in the Palace of Amenhotep III at Malqata and the Temple of Amun at Karnak to see if a stylistic similarity exists between them.

Blue ware, dado and floor paintings offer an adequate picture of the painting created by the palace workshops at Malqata.[239] A vase decorated in blue pigment, probably from Malqata and now in the Brooklyn Museum of Art

[235] In one chapel (TT 74), the final outline was applied to some figures and not to others; see Brack, *Tjanuni*, 94.

[236] The term "state class" coined by Fitzenreiter, *SAK* 22 (1995), 120, n. 84.

[237] On the dating of the Palace of Amenhotep III at Malqata, see: Smith, *AAAE*, 161, from jar labels dated to yr. 8 of Amenhotep III; and also William C. Hayes, "Inscriptions from the Palace of Amenhotep III," *JNES* 10 (1951), 36-37, 88, 179-180. However, the king may not have occupied the palace himself until his year 20 (Betsy M. Bryan, "Amenhotpe III," *OEAE* I (2001), 72). David O'Connor, "Malqata," *LÄ* III (1980), 1174, argues against the early occupation of the site, but notes that it is unknown exactly when construction began on the structures at Malqata.

[238] Betsy M. Bryan, "A work in progress: the unfinished tomb of Suemniwet," *Egyptian Archaeology* 6 (1995), 14-16; and idem, *Colour and Painting*, 70, has already discussed the insufficient numbers of trained artists to decorate elite Theban tombs during the mid-eighteenth dynasty. She hints that crews may have come from several local sources.

[239] On the painting in the palace of Amenhotep III at Malqata: Robb de Peyster Tytus, *A Preliminary Report on the Re-excavation of the Palace of Amenhetep III* (1903/R San Antonio, 1994), 16-21; Waseda University, *Research in Egypt: 1966-1991*, (Tokyo, 1991), 10, 15-16; Smith, *AAAE*, 161-169, figs. 282-283, 285, 286-288, 290. A number of these fragments are currently in the Brooklyn Museum of Art, and will be published by Edna R. Russmann. On the excavations at Malqata: Herbert E. Winlock, "The Work of the Egyptian Expedition," *BMMA* 7 (October, 1912), 184-190; H.G. Evelyn White, "The Egyptian Expedition, 1914-15: excavations at Thebes," *BMMA* 10 (December, 1915), 253-256; Ambrose Lansing, "Excavations at the palace of Amenhotep III at Thebes," *BMMA* (supp.) 13 (March, 1918), 8-14; H.E. Winlock, "Excavations at Thebes 1919-20: The Egyptian expedition 1918-1920," *BMMA* 15, pt. 2 (December, 1920), 12-14.

(BMA 59.2), illustrates the theme of leaping bull calves (Plate 15,1).[240] This same motif appears on a painted side panel of a bench in the southwest suite of the same palace, now in the Metropolitan Museum of Art (MMA 11.215.453) (B&W Plate 1).[241] In the tomb chapel of a military official named Nebamun (TT 90), a leaping bull calf appears center right in a branding scene on the northwest transverse wall (Plate 15,2). These images display the same thick lines and quick brush strokes that indicate mottling or emphasize movement.

Another motif from the site of Malqata is a pair of hands raised in praise, which were found by the Waseda University excavations at Kom al-Samak (Plate 11,2).[242] The strong, broad outline that defines these hands is a hallmark of the style in the state class tombs, particularly in TT 91 (Plate 11,1), TT 239 (Plate 10,1) and the tomb chapels of Haremhab (TT 78) (Plate 7,1) and TT 116 (Plate 7,2), respectively.

In his excavation of the palace of Amenhotep III, Robb de Peyster Tytus described a painting of a king seated on a throne that decorated the southern wall of the entrance leading from the columned hall into the royal throne room.[243] Given the symmetry of ancient Egyptian art, this painting was probably mirrored by another image of the enthroned king on the opposite wall. Together, the paired images of the ruler seated on the throne framed the doorway through which the ruler could be seen seated on his throne dais (Plate 16,2).[244] In private Theban tombs, the image of the king enthroned in a kiosk was painted on one or both back walls flanking the doorway leading into the inner hall of the chapel, but this is usually in those tombs belonging to officials of the "state class" or those promoted by the pharaoh.[245] Furthermore, Tytus, describing a painting depicting the feet of dancing Nubians in antechamber D, said they "show such freedom of treatment and drawing as to suggest a comparison with the painting of female slaves dancing before their masters found in a Theban tomb" (Figure 6).[246] The Theban tomb to which Tytus refers belongs to Haremhab (TT 78) and preserves a comparable image of dancing Nubian girls (Plate 14,2).[247]

These few examples illustrate a stylistic similarity between the paintings from the Palace of Amenhotep III at Malqata and those found in the Theban tomb chapels of officials in service of the state during the reign of that king. This correlation suggests that painters affiliated with palace workshops were assigned or secured by state officials to decorate their tombs. Furthermore, the tomb chapels that clearly bear the imprint of the Malqata style of painting are those that belong to officials who served in the military, civil, palace, or regional administrations. Images found in these tombs

[240] Richard Fazzini, *Images for Eternity: Egyptian Art from Berkeley and Brooklyn* (Brooklyn, 1975), 78, cat. 58; Arielle Kozloff, "Molded and Carved Vessels and Figurines," in *Egypt's Dazzling Sun: Amenhotep III and His World*, edited by A. Kozloff, B. Bryan, and L. Berman (Cleveland, 1992), 396. Special thanks to Richard Fazzini, chairman and curator of the department of Egyptian, Classical, and Ancient Middle Eastern Art at the Brooklyn Museum of Art for making this photo available to me. See other examples of painted blue ware in: André Wiese with Silvia Winterhalter and Andreas Bodbeck, *Antikenmuseum Basel und Sammlung Ludwig: Die Ägyptische Abteilung* (Mainz, 2001), 124, no. 84.

[241] Hayes, *Scepter* II, 246-247, fig. 149; Smith, *AAAE*, 163-164, fig. 283.

[242] Waseda University, *Studies on the Palace of Malqata 1985-1988: Investigations at the Palace of Malqata 1985-1988*, Waseda University, Architectural Research Mission for the Study of Ancient Egyptian Architecture (Tokyo, 1993), pl. 3b. Special thanks to Prof. Dr. Sakuji Yoshimura and Nozomu Kawai for making this photo and the following books available to me. For other works on the painting at Kom el-Samak, see: Sakuji Yoshimura, ed., *Painted Plaster from Kom el-Samak at Malqata-South* [1], The Egyptian Cultural Center of Waseda University Occasional Papers Number 1 (Tokyo, 1995); Sakuji Yoshimura and Yumiko N. Nagasaki, *Painted Plaster from Kom el-Samak at Malqata-South* [II], The Egyptian Cultural Center of Waseda University Occasional Papers Number 2 (Tokyo, 1999).

[243] Tytus, *Palace of Amenhetep III*, 20-21, mistakenly describes the room as a "great banqueting (?) hall (H)" which Smith, *AAAE*, 166, correctly labels as a long columned hall with a throne room.

[244] As reconstructed by: Alexander Badawy, *A History of Egyptian Architecture: The Empire (the New Kingdom)* (Berkeley and Los Angeles, 1968), pl. III.

[245] For example, the king enthroned in the kiosk appears in the following chapels belonging to military, civil, palace, or regional administration employees: TT 63, PM (5) & (10); TT 64, PM (5) & (8); TT 66, PM (4)?[destroyed] & (6); TT 74, PM (6) & (11); TT 76, PM (5); TT 77, PM (4) & (7); TT 78, PM (4) & (8); TT 89, PM (15); TT 90, PM (4) & (9); TT 91, PM (3) & (5); TT 116, PM (2); TT 118, PM (1)? [destroyed]; TT 201, PM (7) & (9) in: Redford, *Re'a (TT 201)*, 11, 130; TT 239, PM (3)? [destroyed] & (6)? [destroyed]; Gardiner MSS Notebook no. 72, p. 125 verso.

[246] Tytus, *Palace of Amenhetep III*, 16. In another quote, Tytus mentions the decoration as "so free from restraint as to appear almost caricature, and it seems most probable that even at this time there was a strong leaning toward naturalism in art, which was only kept in check by the traditionary(*sic*) precepts of religious conservatism" (Ibid., 21).

[247] Haremhab was a prominent palace official during the reigns of Amenhotep II, Thutmose IV, and Amenhotep III. Discussion of Haremhab's career in: Bryan, *Thutmose IV*, 282. Biographical tomb text in: Brack, *Haremhab*, 50-53, text 35, and 83-84.

include foreigners and captive prisoners,[248] as well as marsh scenes with calves and bulls,[249] which also decorated the palace complex.[250] Stylistically, these tombs show a "freer" conception of form that is characteristic of painting in profane contexts, where painters were less concerned with the precise articulation of form content.[251] To reference the correlation between the style of painting in the Malqata palace complex with tomb paintings belonging to officials of the state class who served Amenhotep III, this style of painting will be called the "Court Style" (Table I).

On the other hand, the style of decoration that adorned the Temple of Amun at Karnak is found in the noble's tombs on the West Bank. Although temple decoration was commonly executed in relief, when provisional flat painting did occur in temple contexts, it was minutely detailed and often provided the outline and interior elements that were followed by relief sculptors.[252] For example, the careful and precise outline and interior linear details of a seated male banqueter on the top register of the southeastern back wall in the tomb of Nebseny (TT 108) (Plate 17,2) are duplicated in the relief-cut face of Thutmose IV from his alabaster bark shrine in the Karnak precinct (Plate 17,1). Those same characteristics are also found in painted figures that decorate the tombs of Nakht (TT 52) and Amenhotep-si-se (TT 75) (Plate 17,3).[253] All three tombs belong to priests, two of whom were employed by the Temple of Amun at Karnak; the other was the High Priest of Onuris. Figures in the tomb of the "overseer of the fields of Amun" Menna (TT 69) (Plate 18,1) and Nakht[254] also show similar outlines, interior details, and proportions to those found on the wall of the Peristyle Court of Thutmose IV in the Karnak precinct, such as this figure of Amunet (Plate 18,2).

In fact, the temple statues, furniture, edifices, and treasures that adorn the painted reliefs on the west wall of the Peristyle Court at Karnak (Plate 18,3) are represented on the painted walls of the tomb chapel of Amenhotep-si-se (TT 75), who served as Second Prophet of Amun and the overseer of works at Karnak under the pharaoh who commissioned this court (Figure 19).[255] Occurring in both contexts are: pectorals, a statues of the king bearing a standard (called "[Amun-re] who hears prayers" in TT 75), a statue of the ruler as a sphinx presenting ointment jars, and the depiction of the porch and door to the IVth pylon that was dedicated by Thutmose IV.[256] The standard-bearing statue, in particular, relates to an actual statue in the Cairo Museum (JE 43611), which probably once rested along one of the alleys in the gateway of the eastern temple at Karnak.[257]

The stylistic similarity between contemporary reliefs at the Temple of Amun at Karnak and those found in the Theban chapels of officials who served the god indicates painters from temple workshops were utilized to decorate private tombs. In addition, the tomb chapels that clearly bear the imprint of the Karnak style are those that belonged to temple priests, provisioners, artists, and grain scribes of Amun during the reigns of Thutmose IV and Amenhotep III.

[248] Foreigners and captives appear in TT 63, PM (5) (name rings) & (9); TT 64, PM (5) (frieze) & (8) (under throne); TT 74, PM (5)-(6); TT 77, PM (4) (name rings); TT 78, PM (8) (name rings); TT 89 (15); TT 90, PM (9); TT 91, PM (3) & (5); TT 201, PM (3)?; TT 239, PM (3).

[249] Marsh scenes with bulls and calves: TT 76, PM (2); TT 90 PM (8); TT 201, PM (3).

[250] For a partial list of types of scenes that occur in the palace of Malqata, see: Manniche, *Lost Tombs*, 26, table VI.

[251] Assmann, *Die Alte Ägypten*, 306; Smith, *AAAE*, 166.

[252] A few examples of flat painting in temple contexts are: J. L. de Cenival and Gerhard Haeny, "Rapport préliminaire sur la troisième campagne de fouilles à Ouadi es-Sebouâ Novembre-Décembre 1961," *BIFAO* 62 (1964), 224-226; Jean Lauffray, *Karnak d'Égypte – Domaine du divin* (Paris, 1979), fig. 150, 182; Christian E. Loeben, "Thebanische Tempelmalerei – Spuren religiöser Ikonographie," in *La peinture égyptienne ancienne: Un monde de signes à préserver, Actes de Colloque international de Bruxelles, avril 1994*, Monument Aegyptiaca 7, edited by R. Tefnin (Brussels, 1997), 111-120. For Abydos, see: John Baines, "Techniques of Decoration in the Hall of Barques in the Temple of Sethos I at Abydos," *JEA* 75 (1989), 13-30; idem, "Colour use and the distribution of relief and painting in the Temple of Sety I at Abydos," in *Colour and Painting in Ancient Egypt*, edited by W.V. Davies (London, 2001), 147-149.

[253] Compare also TT 52: Shedid and Seidel, *Nakht*, 43, 46, 81; TT 75: Davies, *Two officials*, pl. V (middle row of banqueters).

[254] Shedid and Seidel, *Nakht*, 45.

[255] For publication of the Peristyle Court of Thutmose IV, see: Bernadette Letellier, "La cour à péristyle de Thoutmosis IV à Karnak," *BSFÉ* 84 (1979), 40, fig. 2; see also idem, "La cour à péristyle de Thoutmosis IV à Karnak (et la "cour des Fêtes" de Thoutmosis II)," in *Hommages à la mémoire de Serge Sauneron*, vol. I, BdÉ 81 (Cairo, 1979), 51-71. On Amenhotep-si-se's function as overseer of works at Karnak, see: *Urk.* IV, 1213; Bryan, *Thutmose IV*, 269.

[256] Davies, *Two officials*, 14, first identified this portal as the doorway to the IVth pylon; see also Bryan, *Thutmose IV*, 170-171.

[257] This standard-bearing statue is discussed in: Catherine Chadefaud, *Les statues porte-enseignes de l'Egypte ancienne (1580-1085 av. J.C.): Signification et insertion dans le culte du Ka royal* (Paris, 1982), 4; Marianne Eaton-Krauss, "Concerning Standard-bearing Statues," *SAK* 4 (1976), 71-73; Betsy M. Bryan, "Portrait Sculpture of Thutmose IV," *JARCE* 24 (1987), 12-20; idem, *Thutmose IV*, 175, figs. 25-26.

Images found in these tombs show the same minutely painted details that appear in temple paintings and drawings that, ultimately, would have either stood alone or served as the outlines followed by relief carvers.[258] To reference the correlation between the style of decoration found at Karnak with the tomb paintings belonging to officials of the religious administration, this style will be called the "Temple Style" (Table 1).

These are just a few of the many stylistic examples that suggest artists attached to workshops of the Karnak temple or the palace at Malqata may have been used to paint private Theban tombs. In this regard, military, civil, palace, or regional officials from the reign of Amenhotep III appear to have favored or were assigned painters attached to palace workshops, and officials attached in some fashion to the religious administration preferred or received painters from the Amun temple workshops. This correlation between profession and style suggests that tomb owners may have acquired artists attached to the workshops most closely associated with their institutions. Whether these artists were assigned or 'hired' by the tomb owner is unknown, given the lack of texts that refer to the payment of workmen. Reference to the payment of craftsmen is rare outside of Deir el-Medina and is often couched in terms of the contentment of the craftsmen or the rights of the workmen to share in the income associated with the tomb owner's mortuary cult.[259] Nevertheless, the internal consistency within the Court and Temple styles of painting lends support to the existence of two different but relatively stable workforces of artists who were brought together to decorate the private tombs. The slight variations that appear in each of these two different group styles may have been the result of the addition of new artists to the group or a detachment of artists who branched off to paint other tomb chapels; both practices have been highlighted above in the Senenmut ostraca.

1.5 Summary

The private eighteenth dynasty Theban tomb functioned on a number of different levels. The burial chamber protected the deceased's body and, along with the above-ground decorated memorial chapel, acted as a machine to ensure the tomb owner's eternal prosperity and transfiguration. The tomb chapel also provided a place where the identity of the deceased was projected into the afterlife and existed in this world through contact with the living. Attainment of the afterlife depended on the survival of the deceased's physical and non-physical elements within the mummified body and the creative environment of the tomb as well as the ritual actions of the living. Family members, priests, and even random visitors performed cult activities, left offerings, and recited prayers for the benefit of the deceased, many of whom left graffiti or remnants of their stay. Many tomb visitors were literate elite members of society, although visits by semi- or non-literate women, children, and artisans can be assumed. Remembrance was a key component of interchange between the living and the dead because, as summed up in an autobiographical text, "a man lives when his name is called." Ritual actions and gifts were also reinforced by the magical power of word and image in the tomb chapel that had the ability to make manifest what was represented.

Theban tombs were conceived as three-level structures: 1, the lower level with the subterranean burial chamber protected the body and was associated with the realm of Osiris; 2, the middle level, composed of the decorated chapel, corresponded to the self-presentation of the tomb owner and his transition into the next life and was accessible to the living; and 3, the upper level with the recessed facade and stelophorous statue related to the worship of the sun. Within the middle or chapel level of the T-shaped tomb, the decoration was ideally organized to reference the metaphorical passage from the land of the living in the east to the realm of the dead in the west. Generally, the front transverse hall held images concerned with the earthly life of the tomb owner, and the western inner hall (or shrine) had scenes concerned with the deceased's transition into and life in the hereafter. At the structural and visual intersection point between these two general types of themes stood the *Blickpunktsbild* or "focal point representation." The *Blickpunktsbild* was found on the back walls to either side of the entrance into the inner hall or shrine, opposite the external doorway of the chapel. The focal point representations were a sensitive indicator about the identity, life, and larger social world of the deceased, as well as how the tomb owner desired to be remembered to the living, and how he wanted to be maintained in the hereafter. In rectangular chapels, the long walls (either the southern or northern) showed material consistent with the *Blickpunktsbild*.

[258] For an excellent discussion of temple painting, see: Baines, *JEA* 75 (1989), 15, n. 5; idem, *Colour and Painting*, 145-157, esp. 149.

[259] *Urk.* IV, 132-133, 1055; Davies and Gardiner, *Amenemhet*, 36-37, pl. VIII; Eyre, *Labor*, 197-198.

In the New Kingdom, prior to the Amarna period, artists were connected to 'state' or temple workshops and the village of Deir el-Medina. The demands of constructing and decorating the royal tomb argues against artists connected to Deir el-Medina decorating private Theban tombs. The lack of documentation of free craftsmen working in an open market during the eighteenth dynasty and the absence of material remains of a permanent workmen's settlement on the West Bank (outside of Deir el-Medina) imply a situation by which painters, permanently affiliated with state or temple workshops, may have been delivered to decorate private tombs and may have returned to their workshops once work was completed. Stylistic affinities between the decoration produced by these workshops and Theban tomb painting support such a hypothesis.

While a few patrons mention how they were 'favored' by the king with their burial and furnishings, in reality, the acquisition of a decorated tomb appears to have depended on a combination of royal favor as well as the professional affiliation and means of the official. Tombs were prepared specially for their owners, who determined their layout and supervised the work, usually at the height of their career. In the event of an untimely death (or lack of resources), the tomb was left incomplete or family members finished the building and decoration of the tomb. As part of overseeing the building of the tomb, Theban owners or their delegates would have selected from a number of basic scenes composed of images and the texts. The owner/delegate, working in conjunction with a group of artists, would have individualized the scenes and arranged them thematically into a program. This would have been done within prescribed limits set by decorum, the available repertoire of scenes, and the relative standardization of these scenes on certain walls of the tomb chapel according to the meaning and use of the different rooms and their orientation.

Unfortunately, ancient contracts about specific agreements between patrons and the painters regarding the decoration of private tombs and specific work procedures are almost nonexistent. The few texts that remain only refer to the payment of tomb painters, compensating them in terms of goods or, perhaps, rights to part of the tomb owner's mortuary income. Stylistic analysis of chapel painting indicates that artists were trained and worked according to a cooperative workshop system that created a stylistic uniformity on the walls of the tomb.

During the reigns of Thutmose IV and Amenhotep III, several group styles of painting appear in private Theban tombs. The first style, which occurs in 14 tomb chapels, was found to be associated with tomb owners whose characteristic titles connect them to the god's temples, and the estate of Amun-Re (religious administration); the second style, which appears in 15 (possibly 16) tomb chapels, was linked to tomb owners whose characteristic titles place them in the state class (palace, civil, regional, or military administrations). To confirm or at least suggest a workshop location for each style, the style of painting found in the tomb chapels of religious officials was discovered to have characteristics similar to decoration in the Karnak precinct. In the tombs decorated during the reign of Amenhotep III, the style of painting observed in the chapels of the state class had traits similar to paintings found in the king's palace at Malqata. To reflect the correspondence between the painting style and the deceased's professional affiliation, the first style was designated the Temple Style, and the second style was called the Court Style. Whether officials chose or were assigned painters attached to these workshops is something that cannot be known at this stage, because of the absence of contracts between patron and artist or any other type of documentary corroboration. However, officials appear to have made use of painters associated with institutional workshops most closely connected with their administrative institutions.

Within the protective, magical, and commemorative environment of the private Theban tomb, the various manifestations of the deceased dwelled and, with the aid of the creative power of image and text as well as the ritual actions of the living, prospered. A key component in the proper functioning of the tomb lied in the imagery of the tomb, which linked the living to the dead and provided for the tomb owner in his next life. In the following chapters, this painted imagery will be explored in terms of its magical properties, commemorative function, and reception, with the goal of understanding how the Theban tomb chapel preserved and disseminated the identity of the deceased and the society of which he was a part.

CHAPTER 2
THE FUNCTIONING IMAGE

2.1 Introduction

As discussed in the previous chapter, private tombs were charged with a number of vital functions, namely, to protect the body of the deceased, to provide a ritual complex for the tomb owner's regeneration and eternal well-being, and to project his or her personality simultaneously into the next world while commemorating the tomb owner to the living who would visit the tomb chapel. In the eighteenth dynasty, tomb architecture, text, and image were organized to address these basic functions, which can be understood in broad terms as both magical and commemorative. Magically, the tomb was a vehicle for the owner's rebirth, the projection of his identity, and the eternal effectiveness of the deceased's cult; commemoratively, the tomb offered a place in which the living could celebrate the tomb owner and perpetuate his memory. This chapter will examine the nature of private tomb imagery, the potential levels of meaning inherent in it and its reception.

2.2 The Magical Image

As noted by Robert Ritner, Egyptian *ḥk3* was the primary force through which the universal creator generated and maintained the ordered cosmos.[1] Through incantations, charged substances, and ritual, this energy was available and manipulated by the ancient Egyptians for their benefit. This included the continued preservation of the universe, particularly within the context of religious rites. The god Heka, whose name most likely means "He who dedicates or initiates the *ka*,"[2] filled the Creator god's projections (*ka*-spirits) with magical life. According to the *ka*-theology and its resulting imagistic principle, deities may be seen as reflections of the creator, reliefs and statues as enlivened images of the deity, royal statues as animated figures of the king, and private statues, tomb reliefs, and paintings as vitalized images of the dead.[3] The empowered *ka*-spirits in Heka's mouth that "knit the firmament together" underscore the strong connection between word and magic in ancient Egypt, whether the word is spoken or written.[4]

Andrey Bolshakov has written on the images in Old Kingdom private tombs, which he maintains were provided to create a "double-world" for the *ka* of the deceased, thereby reproducing essential aspects of the deceased's earthly life for perpetuity.[5] According to Bolshakov, the mechanism guaranteeing the creative power of the image in the private chapel rested in the unbreakable link between the principle of the "twin" (*ka*) and the imagistic objectification of conscious perception:[6]

> The Egyptians were amazed by the fact that depiction can evoke in consciousness an image of the represented. These images were objectified, turned from a part of the psyche into a part of the medium, and identified with the external *ka*. As a result, these representations (at first statues, but also murals) became the main cult objects in tombs and temples. This is further supported by the words *n k3 n* NN ("for the *ka* of NN"), which were almost obligatory in the adjacent offering formulas.

[1] Ritner, *Ancient Egyptian Magical Practice*, 247-249; idem, "Magic: An Overview," *OEAE* II (2001), 321-326, with bibliography.

[2] Herman te Velde, "The God Heka in Egyptian Theology," *JEOL* 21 (1970), 179-180; etymology confirmed in CT spell 261; see: Ritner, *Ancient Egyptian Magical Practice*, 25.

[3] Ritner, *OEAE* II (2001), 333.

[4] CT 648, in Ritner, *Ancient Egyptian Magical Practice*, 17; idem, *OEAE* II (2001), 321-322.

[5] Andrey O. Bolshakov, *Man and his Double in Egyptian Ideology of the Old Kingdom*, ÄAT 37 (Wiesbaden, 1997), 210-213, 264-266. Bolshakov examined daily-life scenes, seeing in them an objectified representation of things and people that the tomb owner desired during his lifetime and wanted to maintain in the next world.

[6] Andrey O. Bolshakov, "Ka," *OEAE* II (2001), 215.

The *ka,* born with an individual, was revealed by representations and lived as long as the images endured. Bolshakov maintains that all living things and inorganic objects had doubles of their own which were manifest in tomb images, creating a permeable link between the tomb and the Doubleworld, which existed in another dimension.[7] Furthermore, the Doubleworld could function even before the tomb owner's death, provided the tomb had been properly equipped.[8]

Both Ritner and Bolshakov underscore the importance of the *ka* principal and its resulting imagistic dimension. Through the manipulable link between a given object and its depiction, two- and three-dimensional images of people, places, things, and texts in the tomb acted as a sophisticated series of magical reinforcements to aid and provide for the tomb owner in his afterlife.[9] Specific examples include an Old Kingdom lintel from Saqqara belonging to *i3r.tí,* which is carved with a text that mentions that the adjacent image of the *k3*-servant was the "door" or medium that could "go forth" out of his representation to serve the tomb owner as a funerary priest.[10] Another inscription from the wall of a private tomb chapel states: "May my *ba* alight on my images (*'hmw*) in the monument I have made."[11] Even artists reference the inherent creative principal of their products such as the relief sculptor, Irtisen, who noted on his stela:[12]

Every *hk3,* I had command of it. In that I was not surpassed.
I was indeed an artist who excelled in artistic ability.

Thus, two- and three-dimensional figures of the dead in the tomb chapel ensured the continuation of those represented in the next world and provided a form the dead could inhabit to receive offerings left for them by the living. Additional images of offerings, estates, and crop production were included in the tomb as creative mediums to assure the well-being of the deceased in the next life.

Ritual was an important aspect of the magical activation of the image.[13] Images were consecrated and made to "live" by means of the "Opening of the Mouth" ritual, which was performed on all kinds of representations – from statuary, to painting and relief, the mummy, divine barks and even temples.[14] Rubrics that follow passages of the *Book of Going Forth by Day* (also known as the *Book of the Dead*) that accompanied the dead, usually on papyrus, give directions about how the chapters were to be used, along with instructions for creating images and objects. These rubrics indicate that images as well as the written word could be activated by ritual in order to function effectively. Once consecrated, the image was transformed into a living force, effectively creating a channel between this world and the next. This type of image magic was performed by the living for the benefit of the dead, but a few also explain how the imagery could be used by the dead in the next world. The rubric from the end of Chapter 148 indicates how the deceased

[7] Bolshakov, *Man and His Double*, 262-265, 279-280; idem, *OEAE* II (2001), 216; idem, "Ka-Chapel, *OEAE* II (2001), 218.

[8] Bolshakov, *Altorientalische Forschungen* 19 (1991), 204-218.

[9] See discussion in: Cyril Aldred, "Bild ("Lebendigkeit" eines Bildes)," *LÄ* I (1975), 794-795; Robins, *Art of Ancient Egypt*, 12; Hans Bonnet, *Reallexikon der ägyptischen Religionsgeschichte*, 3d ed. (Berlin, 2000), 118-120; Ritner, *OEAE* II (2001), 333; Taylor, *Death and the Afterlife*, 95-98, 186; Hodel-Hoenes, *Life and Death in Ancient Egypt*, 22. See also: Peter Eschweiler, *Bildzauber im alten Ägypten*, OBO 137 (Freiburg and Göttingen, 1991).

[10] Bolshakov, *Man and his Double*, 139-140. I thank Dr. John Taylor for this citation.

[11] Jan Assmann, *The Search for God in Ancient Egypt*, translated from the German by D. Lorton (Ithaca and London, 2001), 43, citing *Urk.* IV, 1526. Likewise, painted and sculpted images in temples were intended to be inhabited by gods, as suggested in the following inscriptions from the temple of Hathor at Dendera: "she (Isis) rests (*shn*) herself in her engraved form (*bs*) on the wall" (Sylvie Cauville, *Dendara IV: Traduction*, OLA 101 (Leuven, 2001), 209,3 = pp. 314-315; Ibid., 73, 7,= pp. 188-199, about Horsamtous: "he bases himself in his forms engraved on the walls"; also 58, 12 = pp. 94-95; 107, 1 = pp. 166-167; 172,8 = pp. 262-263; 175, 1 = pp. 264-265. For more examples, see Assmann, *Search for God*, 40-43; Siegfried Morenz, *Egyptian Religion*, translated from the German by A.E. Keep (London, 1973), 151-152.

[12] te Velde, *JEOL* 21 (1970), 185. See translations of the Stela of Irtisen in: Alexander Badawy, "The Stela of Irtysen," *CdÉ* 36, no. 72 (1961), 271-276; and Winfried Barta, *Das Selbstzeugnis eines altägyptischen Künstlers (Stele Louvre C 14)*, MÄS 22 (Berlin, 1970), esp. 90.

[13] Morenz, *Egyptian Religion*, 155-156; Jan Assmann, "Die Macht der Bilder: Rahmenbedingungen ikonischen Handelns im alten Ägypten," in *Genres in Visual Representations*, *Visible Religion* 7 (Leiden, 1990), 8-9; Ritner, *Ancient Egyptian Magical Practice*, 247-249; Ritner, *OEAE* II (2001), 322-324.

[14] See discussion of the objects to be animated in the Opening of the Mouth ceremony: Eberhard Otto, *Das ägyptische Mundöffnungsritual*, 2 vols., ÄA 3 (Wiesbaden, 1960), 27, 30-32; Morenz, *Egyptian Religion*, 155-156; Jean-Claude Goyon, *Rituels funéraires de l'ancienne Égypte* (Paris, 1972), 85-91; Aldred, *LÄ* I (1975), 794-795 with bibliography; Stephen Quirke and Werner Forman, *Hieroglyphs and the Afterlife in Ancient Egypt* (Norman, Oklahoma, 1996), 21; Eugene Cruz-Uribe, "Opening the Mouth as Temple Ritual," in *Gold of Praise: Studies on Ancient Egypt in Honor of Edward F. Wente*, edited by E. Teeter and J.A. Larson, SAOC 58 (Chicago, 1999), 69-73; Ann Macy Roth, "Opening of the Mouth," *OEAE* II (2001), 605-609; David Lorton, "The Theology of Cult Statues in Ancient Egypt," in *Born in Heaven, Made on Earth: The Making of the Cult Image in the Ancient Near East*, edited by M.B. Dick (Winona Lake, Indiana, 1999), 199.

could be provisioned eternally in the next world through the recitation of the following spell over the required image:[15]

> [Words] to be spoken by a man, when Re manifests himself over these gods depicted in paint on a writing-board. There shall be given to them offerings and provisions before them, consisting of bread, beer, meat, poultry, and incense. The invocation-offering for his spirit shall be made to them in the presence of Re; it means that this soul will have provision in God's domain...

And, in the rubric to Chapter 130, by simply speaking an incantation over a drawing of a spiritual likeness "his soul will live forever and he will not die again."[16] In terms of practitioners, some sculptors and draftsmen at Deir el-Medina had minor priestly titles indicating that the ritualist and the artist could be one and the same person.[17]

Within the tomb, the owner's cult depended on the living to perform the requisite ceremonies, but in case the participants ceased to execute the rites on behalf of the owner, the text itself had the power to bring what was written into reality. As discussed in Chapter 1, the offering formula that accompanied representations of food, drink, and other items could be activated to supply the deceased with a limitless number of goods within the creative environment of the tomb. To protect the body of the deceased, hieroglyphs were sometimes assembled into tomb curses and inscribed around tomb doors and on walls.[18] The ancient Egyptians also believed that hieroglyphs could be empowered, and ritually mutilated the hieroglyphs to protect the deceased from their dangerous or adverse effects.[19]

In ancient Egypt, the sacred was made manifest in the image. The common term for hieroglyphs, *mdw-nṯr* "god's words,""divine words," expressed the ancient Egyptian belief that the sacred was implicit in words.[20] By fixing god's words on monuments, the ancient Egyptians made tangible what was sacred and invisible, and in so doing, they created an unbroken communication with the divine.[21] In the same way that words were sacred, so were images. An inscription in the fourth dynasty tomb of Atet at Meidum refers to not only the enduring quality of the images but also their sacred character by stating: "He made his gods (*nṯrw*) in [a type of] drawing that cannot be erased."[22] Here the word *nṯrw* describes both the texts and images in the chapel, as well as their inherent sacred power that was expressed in durable, externalized form. In this way, text and image belonged to the realm of the gods, a realm to which the tomb was linked and the owner sought to join to gain eternal life.[23]

Symbolism played an important role in the magical environment of the private tomb complex. In ancient Egypt, symbols represented and communicated many of the prevalent ideas, beliefs, and attitudes about the nature of life and reality that circulated in society. Pictorial symbolism was also inextricably linked with magic and the "transformation of state" or the changing of existent reality into something more desirable.[24] Typically, symbolism is defined as "the use

[15] Raymond O. Faulkner, *The Egyptian Book of the Dead*, with introduction and commentaries by C. Andrews, O. Goelet Jr., edited by E. Von Dassow (San Francisco, 1994), pl. 35; see also rubric to Chapter 125, pl. 32.

[16] Ibid., Chapter 130, 118, rubric: "To be said over a Bark of Re drawn in ochre on a clean place. When you have placed a likeness of this spirit in front of it, you shall draw a Night-bark on its right side and a Day-bark on its left side. There shall be offered to them in their presence bread and beer and all good things on the birthday of Osiris. If this is done for him, his soul will live forever and he will not die again." See also Ibid., Chapter 165, 126.

[17] Leonard H. Lesko, ed., *Pharaoh's Workers* (Ithaca, 1994), 90; Geraldine Pinch, *Magic in Ancient Egypt* (London, 1994), 55, fig. 26; idem, "Red things: the symbolism of colour in magic," in *Colour and Painting in Ancient Egypt*, edited by W.V. Davies (London, 2001), 182.

[18] For a few examples, see: Ritner, *OEAE* II (2001), 335; Stefan Wimmer, "Hieroglyphs - Writing and Literature," *Egypt: The World of the Pharaohs*, edited by R. Schulz and M. Seidel (Cologne, 1998), 347, from tomb of Meni, Dynasty VI; and see also: Günter Vittmann, "Verfluchung," *LÄ* VI (1986), 977-981, with bibliography.

[19] Pierre Lacau, "Suppressions et modifications de signes dans les textes funéraire," *ZÄS* 51 (1914), 63-64; Orly Goldwasser, *OEAE* III (2001), 202.

[20] On the sacred and magical character of hieroglyphs, see: Herman te Velde, "Egyptian Hieroglyphs as Signs, Symbols and Gods," *Visible Religion* 4-5 (1985-1986), 63-72; Goelet in Faulkner, *The Egyptian Book of the Dead*, 147; Goldwasser, *OEAE* III (2001), 198-204.

[21] Jan Assmann, "Semiosis and Interpretation in Ancient Egyptian Ritual," in *Interpretation in Religion*, edited by S. Bidermann and B.-A. Scharfstein, Philosophy and Religion: A Comparative Yearbook 2 (Leiden-New York-Köln, 1992), 87-89.

[22] W.M.F Petrie, *Medum* (London, 1892), pl. 24.

[23] Assmann, *The Mind of Egypt*, 57; Quirke, *Hieroglyphs and the Afterlife*, 26; Richard H. Wilkinson, *Symbol & Magic in Egyptian Art* (London and New York, 1994), 150.

[24] Anthony Wallace, *Religion: An Anthropological View* (New York, 1966), 107; R. Wilkinson, *Symbol & Magic*, 7. For the importance of symbolism in pictorial analysis, see: Willem F. Lash, "Iconography and iconology," *The Dictionary of Art*, vol. 15, edited J. Turner (New York, 1996), 94.

of symbols to represent ideas" that "represent something other than what they actually depict."[25] Symbolism could be both primary or direct and secondary or indirect. Symbolism is direct when "the form of an object suggests concepts, ideas or identities with which the object is directly related" and indirect when "the form of an object suggests another, different, form which has its own symbolic significance."[26]

The multi-layered nature of Egyptian symbolism is seen in the visual symbol of a crocodile.[27] In its direct or primary association, the hieroglyphic sign for crocodile could mean, simply, "crocodile" (*msh*). But indirectly, the image of the crocodile could also serve as the determinative for words meaning "to be greedy" (*skn, hnt*) or "to be angry, aggressive, attack" (*3d*), concepts that are associated with the crocodile and its behavior, then transferred to the human realm. Further, the daily movements of the Nile crocodile, which would emerge out of the water at sunrise to the east and at sunset would turn to the west and dive back into the water, became associated secondarily with the concept of solar regeneration.

Another aspect of the magical image in the tomb chapel was the self-presentation of the dead and the projection of their identity into the next world.[28] Identified by name, surrounded by family and friends, and depicted executing his official duties, the tomb owner's individual, familial, social, and professional identity was carried over the threshold of death into the afterlife. Images such as the deceased overseeing work on his estate or supervising works of art commissioned by the king depicted, in part, aspects of the deceased's official status that would be transferred into the next world. These scenes also had a secondary meaning that related to the deceased's eternal provisioning (see below Chapter 3).

Within an intricate system of magical reinforcement, the deceased was depicted in his "official form" (*Amtsgestalt*). By wearing distinct clothing, wigs, and insignia, the tomb owner's office, class, and role were visually accentuated.[29] In eighteenth dynasty tomb chapels, officials tended to idealize beauty and portray their professional identities while suppressing their natural hair, skin color, or even clothing. In this way, Egyptian officials were portrayed as they wished to live in the hereafter: leading their daily lives as people of worth, refinement, and beauty. Pictorially, this was expressed by the refined form of the official wrapped in light, white clothing, standing out against the representations of lower-order individuals, who were portrayed with real-world abnormalities such as stubbly beards, sagging bellies, and distorted physiognomies. Within this configuration, the deceased was always represented in the prime of life. His two- and three-dimensional figure, rendered as a composite of individual parts in their most characteristic aspect, was magically 'correct' and served as the actor or subject in scenes that had the power to exist in the afterlife.[30]

2.3 The Commemorative Image

Whereas the magical dimension of imagery in private Theban tombs could assure and supplement the afterlife of the deceased, text and image was also organized commemoratively to memorialize the dead and appeal to visitors to perform cult activities with the goal of securing the tomb owner's eternal well-being. To live as an immortal, the

[25] Definition in *The Oxford Dictionary and Thesaurus, American Edition* (New York, 1996), 1549. See also definition in Wolfhart Westendorf, "Symbol, Symbolik," *LÄ* VI (1986), 122.

[26] R. Wilkinson, *Symbol & Magic*, 16-17.

[27] Westendorf, *LÄ* VI (1986), 122-128; Jan Assmann, "Ancient Egypt and the Materiality of the Sign (=Nr. 68)," in *Materialities of Communication*, edited by H.U. Gumbrecht and K.L. Pfeiffer, translated from the German by W. Whobrey (Stanford, 1994), 15-31, esp. 29-30; Emma Brunner-Traut, "Krokodil," *LÄ* III (1980), 791-801, with pertinent bibliography.

[28] Assmann, *Visible Religion* 7 (1990), 7-8; Assmann, *The Mind of Ancient Egypt*, 158-159.

[29] Jan Assmann, "Ikonographie der Schönheit im alten Ägypten," in *Schöne Frauen - schöne Männer, literarische Schönheitsbeschreibungen*, edited by Th. Stemmler (Mannheim, 1988), 13-32; idem, "Ikonologie der Identität: Vier Stilkategorien der ägyptischen Bildniskunst," in *Das Bildnis in der Kunst des Orients*, edited by M. Kraatz, J. Meyer zur Capellen, D. Seckel (Stuttgart, 1990), 24-26. See also: Kent R. Weeks, "Art, Word, and the Egyptian World View," in *Egyptology and the Social Sciences: Five Studies*, edited by K.R. Weeks (Cairo, 1979), 69-71; and William Kelly Simpson, "Egyptian Sculpture and Two-dimensional Representation as Propaganda," *JEA* 68 (1982), 268. For definition of status symbols in ancient Egypt, see Rosemarie Drenkhahn, "Statussymbol," *LÄ* V (1984), 1270-1271; Rachael Dann, "Clothing and the Construction of Identity: Examples from the Old and New Kingdoms," *Current Research in Egyptology* 2000, edited by A. McDonald and C. Riggs, BAR International Series 909 (Oxford, 2000), 41-44.

[30] Roth, *Mummies & Magic*, 55; Hodel-Hoenes, *Life and Death in Ancient Egypt*, 22; Bolshakov, *OEAE* II, 215; Ritner, *OEAE* II (2001), 333.

transcended dead or *akhu* were dependent on receiving offerings, rituals, and spells in a liminal area such as the tomb chapel where contact with the living could easily be made.[31] In the chapel, text and two- and three-dimensional images were combined as a vehicle for the self-presentation of the individual, and showed the sum of his life and accomplishments to the living.[32] Elite Theban tomb chapels were meant to be viewed by an entire range of living visitors who were requested to read the tomb owner's inscriptions aloud, leave an offering, or say a prayer. A critical component was the reciting of the deceased's name which was carrier of his or her identity in the chapel. The significance of the name can be observed in phrases such as: "...The life of those who are yonder consists in this, that their names are pronounced" or "A man lives when his name is called."[33] Visitors and reciters could include performers of the deceased's cult such as family members and priests; professional colleagues; other tomb owners who came for ideas for their own tombs; artists in search of models; tutors and pupils of scribal schools; and random passers-by.

Images in the tomb chapel were crafted and oriented to commemorate the tomb owner to the living, often within the confines of necropolis celebrations. During these times, the forecourt and the chapel acted as "receiving rooms" for visitors. Images and texts were engineered to present the deceased in the most favorable light. In broad terms, the front rooms showed the deceased conducting his duties of office, banqueting with his family, or enjoying leisurely pastimes, and the inner rooms were dedicated to his life in the beyond. As part of his self-presentation, the tomb owner sought to impress these living visitors, and he directed them to particular parts of the chapel in the hopes of pressing them into ritual service on his and his family's behalf.

The address in the "Appeal to the Living" was directed towards these visitors. As discussed in Chapter 1, the Appeal was a telling of the deceased's life history that ended with a request for an offering of some type. To incite the viewer to perform such actions, the text uses various mechanisms to appeal to the reader and point him or her in the direction of the images painted or engraved on the wall. In the Late Period tomb of Iby (TT 36), the Appeal describes the chapel decoration and details, and it instructs the visitors to find the names and images of the people, animals, and plants portrayed in his tomb.[34] Iby's Appeal asks the viewer to "hear" the quarreling of the workers, the playing of the music, and the wailing of the mourners that are depicted on the walls. This Appeal effectively engaged the spectator in the visual and "aural" dimensions of the decoration. The Appeal ends by asking the visitor to copy the representations, leave a message, and produce funerary offerings. The goal of this exercise was explicit: to gain the necessary offerings to secure Iby continual life in the hereafter.

Other Appeals directed visitors to specific chapel walls to "see" what the tomb owner had accomplished in life.[35] In TT 84, Iamunedjeh specifically asks spectators to view what he had done for the pharaoh. This was recorded in text and image on the back walls of the transverse hall, PM (5) & (9). These focal walls depict the tomb owner leading tribute delegations before images of Thutmose III. The text reads:[36]

> [O every living one] who shall enter into my tomb *in order to see* what I have done on earth beneficial
> for the Great God, may you praise [Amun]...may you hate death and think about [life], may you love
> the king of your time (=the reigning king), may your nose be refreshed in [life when you say: an
> offering which the king gives... for the *ka* of....Iamunedjeh, justified.]

The message of the text and image in the tomb was organized to prove Iamunedjeh's worthiness to the visitors and focus their attention on pertinent images so that the deceased could receive funerary offerings and prayers or simply have his name remembered.

[31] Lloyd, *Religion and Philosophy in Ancient Egypt*, 122; Gardiner, *The attitude of the ancient Egyptians to death and the dead*, 10-15, 25-28. Other liminal areas included temples, shrines, and homes.

[32] Defined as 'self-thematization' (*Selbstthematisierung*), see: Assmann, *Genese und Permanenz*, 29; idem, "Sepulkrale Selbstthematerisierung im alten Ägypten," *Selbstthematisierung und Selbstzeugnis: Bekenntnis und Geständnis*, edited by A. Hahn and V. Kapp (Frankfurt, 1987), 211-213.

[33] Eberhard Otto, *Die biographische Inschriften der ägyptischen Spätzeit*, PÄ 2 (Leiden, 1954), 59-69, esp. 62, n. 1; te Velde, *Visible Religion* 1 (1982), 143. From the tomb stela of the "Overseer of Sculptors" Djehut, he mentions that: "...I did that which people love so that they might cause that my estate of eternity endure and that my name flourish in the mouths of people...," *Urk.* IV, 131, 7-8; see also *Urk.* IV, 430.

[34] Klaus P. Kuhlmann, "Eine Beschreibung der Grabdekoration mit der Aufforderung zu kopieren und zum Hinterlassen von Besucherinschriften aus saitischer Zeit," *MDAIK* 29 (1973), 205-213; idem, and Wolfgang Schenkel, *Das Grab des Ibi, Obergutsverwalters der Gottesgemahlin des Amun (Thebanisches Grab Nr. 36), vol. I: Text*, AV 15 (Mainz, 1983), 71-73.

[35] See 1.2.1, n. 102.

[36] *Urk.* IV, 939, 6-15, from the tomb of Iamunedjeh (TT 84), tp. TIII, PM (4). Italics mine.

Eighteenth dynasty Theban tomb biographies were also intentionally organized to impress their readers and were often part of painted or sculpted scenes that commemorated aspects of the deceased's life.[37] Here, texts do not address anyone within the composition but are "turned outwards" to the observer of the scene or the reader of the text. An example of a well-integrated scene with an externalized biography occurs in the chapel of Nebamun (TT 90), which depicts the deceased receiving a standard of office that relates to his promotion (Figure 29):[38]

> Regnal year 6. The command of a gift in the presence of the Majesty, l.p.h., on this day to the *ḥȝty-ʿ* and Commander of the Fleet of Upper and Lower Egypt. The command in saying: My Majesty commanded (l.p.h.) acceptance of a good old age in royal favor in order to effect the settlement of the affairs of the Standard Bearer, Neb[amun], of the king's ship 'Beloved of [Amun].'
>
> He had reached an old age following Pharaoh, (l.p.h.), in integrity of his heart,[39] being more perfect today than yesterday doing that which had been enjoined upon him. He was not accused and there did not exist one who (could) find fault which one (could) accuse him (as) one who acts falsely.
>
> Then my Majesty (l.p.h.) commanded that he be promoted (*sʿr{.n}.f*)[40] as Chief of Police in the west of the city in the locality of *Ṯmbw* and in the locality of *ʿȝ-bȝw* until he reaches the blessed state, together with providing his household, his cattle, his arable lands, his servants and all his property on water and on land without allowing any interference (*ḏȝ tȝ*)[41] therein by any agent of the king – the Standard Bearer (of the ship) 'Beloved of Amun' and old man of the army, Nebamun, justified.

In this scene, the text identifies Nebamun, indicates the time and nature of the royal command, launches into the biography of the tomb owner, and ends with a short description of the event depicted on the wall. All of this was intended to commemorate his identity in the next world and to the living. This text from the tomb of Nebamun is also known as a biography 'à part.' The biography 'à part' often occurs in connection with scenes decorating the back walls of the transverse hall on either side of the doorway into the inner hall or niche of the chapel in eighteenth dynasty T-shaped tombs.[42]

Prestige also played a role in the commemorative self-presentation of the tomb owner within the tomb chapel. Swathed in the trappings of his "official status," the tomb owner presented himself as someone worthy of cultic actions. The tomb owner's costume, dress, and insignia emphasized his prestige to the viewer.[43] In fact, recent analysis of fold marks on ancient garments indicated that immaculately pressed clothing conveyed the high wealth and status.[44] On a societal level, the impressiveness of tomb chapels and their furnishings conveyed the status of the deceased to the larger population, and thus could act as objects of competition or marks of division between groups.[45] Literate visitors often left their impressions about the tomb or its owner in graffiti that addressed the importance of the deceased as "one praised like yourself." However, illiterate viewers were likely influenced by the accouterments of the tomb owner's prestige as well.[46]

Besides presenting the deceased's worthy life and status, another goal of the commemorative image within the tomb chapel was to immortalize the deceased's identity within a social framework. Jan Assmann has written extensively on the "monumental discourse" of the tomb as a medium in which the state made itself visible as a mechanism of social

[37] Guksch, *Königsdienst*, 9-25, 101-104.

[38] Davies, *Two officials*, pl. XXVI; *Urk.* IV, 1618-1619.

[39] Cumming, *Egyptian Historical Records* III, 307.

[40] Guksch, *Königsdienst*, 160, n. 276.

[41] Faulkner, *CDME*, 318.

[42] See 1.2.1, n. 104. The tomb biography in TT 90 also illustrates the practice of exempting private estates from taxation to ensure a guaranteed income for a loyal official (Eyre, *Labor*, 206).

[43] Drenkhahn, *LÄ* V (1984), 1270-1271; Assmann, *Schöne Frauen, schöne Männer*, 13-32; Klaus Heinrich Meyer, "Kunst," *LÄ* III (1980), 877.

[44] Vogelsang-Eastwood, *Ancient Egyptian Materials and Technology*, 286.

[45] On the status of the tomb: Bryan, *Egypt's Dazzling Sun*, 237. On intra elite competition: John Baines, "On the Status and Purposes of Ancient Egyptian Art," *CAJ* 4 (1994), 75.

[46] Parkinson, *Voices from Ancient Egypt*, 59c, 59d. On the impact of art on the illiterate: Betsy M. Bryan, "The Disjunction of Text and Image in Egyptian Art," *Studies in Honor of William Kelly Simpson*, edited by P. Der Manuelian (Boston, 1996), 161-168.

order and an institution charged with rendering immortality.[47] According to Assmann, monumental discourse in the tomb was composed of durable materials, hieroglyphs, canonical forms, and cultic actions, all of which secured the continuation of the deceased's identity and his social world and preserved him in the cultural memory. Assmann states that the tomb was designed to be visited by the living who, by performing cult activities and leaving offerings, helped the deceased be remembered and remain part of society. As Assmann explains, the tomb belonged to the same world inhabited by pyramids, temples, obelisks, statues, stela, etc. Thus, the tomb connected the deceased to these media of sacred permanence and cultural remembrance. In this way, the tomb was a structure that preserved the deceased's identity and, by its connection with other tombs and monuments, linked society and visually reinforced its collective identity.

Assmann maintains that monumental discourse served to perpetuate individuality and was indebted to state license. Since craftsmanship in ancient Egypt was a monopoly accessible to the individual only through his service to the state, the tomb was naturally a place in which collective identity was preserved and the community was self-thematized. If we take the discussion in Chapter 1 as a point of departure, the acquisition of the tomb and the artists with which to decorate it was dependant on the official's service within the administrative hierarchy, and probably his means as well. In this way, the tomb owner's self-presentation was intimately linked with his professional standing, and this was memorialized within the tomb. Thus, the tomb presented a social framework that reinforced institutional ties and collective identity and perpetuated a type of social memory after death.[48]

2.4 The Reception of the Image

Through his eternal commemoration, the deceased sought to be retained in the community of the living. Crucial in this process was the ability to engage the visitors to the tomb by impressing them with the deceased's status, appealing to their sense of duty, and/or impacting their aesthetic tastes. But how did these ancient visitors process or 'receive' the images?[49]

More often than not, the ancient Egyptian viewer responded to the aesthetic value of the imagery. Maya Müller analyzed a number of visitor graffiti (*Besucherinschriften*), many of which occur in eighteenth dynasty Theban tomb chapels.[50] Most *Besucherinschriften* were cast in stock phrases, which say: "...there came (*íwt pw ir.n/íít-ín*) the scribe NN in order to see the (name of the monument). I found it very beautiful (*nfr*) therein."[51]

While it is clear that these inscriptions show the viewer's appreciation of the aesthetic components of the chapel decoration, the inscriptions' underlying meaning has been debated by scholars. Wolfgang Helck took these inscriptions to be products of ancient tourists who took an interest in their past.[52] Dietrich Wildung believed the use of a stock formula written over a wide number of sites meant they were primarily religious inscriptions rather than a tourist's spon-

[47] On the characteristics of 'Monumental Discourse': Assmann, *Selbstthematisierung und Selbstzeugnis*, 208-213; idem, *Das kulturelle Gedächtnis: Schrift, Erinnerung und politische Indentität in frühen Hochkulturen* (Munich, 1992), 170-171. On the social role of the tomb: Jan Assmann, "Vergeltung und Erinnerung," in *Studien zu Sprache und Religion Ägyptens: Zu Ehren von Wolfhart Westendorf* (Göttingen, 1984), 691-692; idem, "Schrift, Tod und Identität: Das Grab als Vorschule der Literatur," in *Stein und Zeit: Mensch und Gesellschaft im Alten Ägypten* (Munich, 1991), 172; idem, Assmann, *Ancient Egyptian Literature*, 103-104.

[48] Assmann, *Das kulturelle Gedächtnis*, 170; idem, *The Mind of Ancient Egypt*, 70.

[49] This approach conforms to the tenets of Reception Theory, which is defined as "a concern with the reaction or response to a work of art or literature....[and] often involves an interest in the effect (*Wirkung*) of a work and consequently with the history of this effect (*Wirkungsgeschichte*)" (Thomas Dacosta Kaufmann, "Reception theory," *The Dictionary of Art*, vol. 26, edited by J. Turner (New York, 1996), 61). The confrontation between the beholder and the work of art can be anchored in a specific historical context, or that confrontation can literally stretch the space between beholder and object across time so that the perception of a work of art becomes an ongoing historical process, as in, for example: W. Iser, *The Act of Reading: A Theory of Aesthetic Response* (Baltimore and London, 1978); and H.R. Jauss, *Toward an Aesthetic of Reception*, translated by Timothy Bahti (Minneapolis, 1982). See discussion in: Robert C. Holub, *Reception theory: a critical introduction* (London and New York, 1984), 57-139.

[50] Müller, *Studien zur ägyptischen Kunstgeschichte*, 39-56.

[51] Helck, *ZDMG* 102 (1952), 39-46, esp. 40; Yoyotte, *Les pèlerinages*, 49-53, 57-60; Dietrich Wildung, *Die Rolle ägyptischer Könige im Bewusstsein ihrer Nachwelt*, Teil I: *Posthume Quellen über die Könige der ersten vier Dynastien*, MÄS 17 (Munich, 1969), 65-73; idem, *LÄ* I (1975), 766-767; Mounir Megally, "Two Visitors' Graffiti from Abûsîr," *CdÉ* 56, no. 112 (1981), 218-240; Quirke, *JEA* 72 (1986), 88.

[52] Helck, *ZDMG* 102 (1952), 43-45.

taneous responses about the decoration.[53] Stephen Quirke agreed with Wildung's assessment, citing the occurrence of this formula in prayer inscriptions.[54] However, in a separate article, Mounir Megally[55] found that eighteenth dynasty visitor inscriptions often included phrases drawn from literary texts, which suggests visitor graffiti were not purely religious in focus. Alexander Peden suggests a discretely written graffito was the means by which the name and function of the author could be preserved for eternity.[56] Given the wide range of interpretations, perhaps the best way to understand these inscriptions is summed up by Quirke, who says: "Perhaps it is anachronistic to demand too rigorous a separation of the religious from the secular, since the texts indicate that, for the Egyptians, piety was not incompatible with pleasure."[57] This sentiment is certainly in evidence in a visitor inscription in TT 504, in which, after a long *ḥtp-dí-nsw* formula addressed to various state and local gods and deified kings, the writer Nebwa explained the reason for his visit:[58]

> The *wab*-priest and scribe in the temple of Thutmose I, Nebwa, came to see this place, and to enjoy
> himself in it (*sḏȝy-ḥr.f ím.s*)

Therefore, it is at this nexus of piety, beauty, and pleasure that we can understand the ancient Egyptian's appreciation of the image in tomb chapels.

Müller's work has also shown that the ancient Egyptians had an aesthetic sense and associated their art works with quality and beauty.[59] Where the Greeks defined aesthetics in art in terms of *mimesis* (imitation or representation),[60] the ancient Egyptians defined the aesthetic value of a work of art in terms of *nfr* (beautiful, perfect).[61] Müller collected a number of ancient monumental and literary inscriptions, and she established that the word *nfr* had a certain aesthetic connotation in the New Kingdom. In her study, she found that 1, works of art were identified by the ancient Egyptians in terms of quality or beauty (i.e. aesthetics, truth, creativity, and symbolic form); and 2, ancient Egyptian texts dealing with art works used expressions that coincided with the corresponding European concepts of art and could be recognized as such.[62]

But how did tomb visitors comment on the tomb owner's self-presentation in the chapel? How did they understand the underlying meaning of the image? Most ancient viewers couched their experience of the monument and/or its decoration in aesthetic terms, finding it "more beautiful than any temple of any town,"[63] "pleasant in his heart,"[64] or "as though heaven were within it."[65] A number of eighteenth and nineteenth dynasty visitor graffiti commented on the age of the monument or its impressiveness.[66] In one *Besucherinschriften*, Paser, the vizier of Ramesses II, stated that he visited the eleventh dynasty tomb chapel of Khety, a high official of Mentuhotep II, to revere the monument of "his

[53] Wildung, *Die Rolle ägyptischer Könige*, 70.

[54] Quirke, *JEA* 72 (1986), 88.

[55] Megally, *CdÉ* 56, no. 112 (1981), 240.

[56] Peden, *Graffiti*, 293-294.

[57] Quirke, *JEA* 72 (1986), 88.

[58] Marek Marciniak, "Une texte inédit de Deir el-Bahri," *Bulletin du centenaire, supplément au BIFAO* 81 (1981), 283-291; Peden, *Grafitti*, 73-74, 58, n. 1.

[59] Müller, *Studien zur ägyptischen Kunstgeschichte*, 39-56.

[60] Kendall L. Walton, "Aesthetics, I. Introduction," *The Dictionary of Art*, vol. 1, edited by J. Turner (New York, 1996), 171-174; Martha C. Nussbaum, "Aesthetics, II,1: Classical," *The Dictionary of Art*, vol. 1, edited by J. Turner (New York, 1996), 174-176.

[61] *Wb.* II, 253,1 - 256,15 gives meanings for *nfr* in a general sense (good quality of a thing, well-worked, beautiful, perfect); following a substantive like in *nfr m33* "beautiful to look at"; used as an impersonal such as *nfr* "it is good." In the Amarna Period, it has been suggsted that *nfr* related to a system of aesthetics in which *nfrw* was the quality of *Maat* (Roland G. Bonnel, "The ethics of el-Amarna," in *Studies in Egyptology Presented to Miriam Lichtheim*, edited by S. Israelit-Groll (Jerusalem, 1990), 71-97). For its Coptic associations, see: Werner Vycichl, *Dictionnaire étymologique de la langue copte* (Leuven, 1983), 150-151.

[62] Müller, *Studien zur ägyptischen Kunstgeschichte*, 54-55; Baines, *CAJ* 4 (1994), 67-94. For a contrasting view: Eaton-Krauss, *OEAE* I (2001), 137.

[63] Quirke, *JEA* 72 (1986), 88-89, graffito 6. Variant in: Burkhard, in Dziobek and Raziq, *Sobekhotep*, 88-90.

[64] Davies, *Antefoker,* 29, no. 33, pl. 37, 37a.; no. 34, pl. 37, 37a.

[65] Peden, *Graffiti*, 60 (top), 62, n. 16, n. 19, 65; Burkhard, in Dziobek and Raziq, *Sobekhotep*, 88-90; Davies, *Antefoker,* 35, no. 2-3.

[66] Peden, *Graffiti*, 60 (bottom), 61-63, 66 (top), 68-74, 104 with n. 275, 105.

ancestor."[67] Paser also visited the tomb chapel of Kenamun (TT 93), in which he admired a scene of female musicians, placing the remark "very beautiful" next to it.[68]

Amenemhet, the owner of TT 82 and the Steward of the Vizier User (tp. Thutmose III), visited the tomb of Antefoker and his mother Senet (TT 60), and he left an inscription that mentioned he found the chapel like "...[a monument(?)] which exists for eternity."[69] His graffito goes on to reveal that Amenemhet believed TT 60 was the tomb of the Vizier Antefoker alone. Later, Amenemhet patterned a number of his scenes after those in TT 60.[70] This conscious patterning may have been done to associate Amenemhet with the Vizierial office in perpetuity, which suggests an understanding of the underlying commemorative meaning of the scenes. Interestingly enough, this practice was followed by other eighteenth dynasty tomb owners who copied existing chapel scenes from the tombs of their employers or predecessors.[71]

Because the ancient Egyptians did not write about their experience of the image in philosophical terms that we can understand, we are left to cull the writings of classical authors for insight. Plato and his followers were convinced that the ancient Egyptians had a system of representation using images and symbols that expressed the idea of things and the mysteries of knowledge and wisdom.[72] Plato talked about this visual symbolism in terms of "image types" (*schemata*) and how they preserved the fundamental principles and values of ancient Egyptian society.[73] Plato noted that these "image types" were placed on temple walls and allowed the Egyptians to educate their young citizens about the forms of virtue. Although Plato's statements were largely informed by his own ideas on education, they may have reflected his understanding of the general symbolic character of Egyptian temple art in the Late Period. For example, sometime between the sixth and the fourth centuries BCE in Egypt, there was a systematic codification of cultic knowledge that was inscribed in vignettes on temple walls, as for example in the Hibis Temple of Darius I in the Kharga Oasis.[74] This process, according to Heike Sternberg-el Hotabi, appears to have begun in the Saite Period.[75] Seen thus, Plato's statement points to the importance of "image types" in temple decoration as being an integral part of cultural knowledge, providing a meta-text of right forms and instruction in the service of religious cult.[76]

Through the mixing of Platonism and mysticism, the Neoplatonists offered their understanding of the underlying meanings of Egyptian imagery. Plotinus, the Neoplatonic philosopher who was born in Assiut in 204 or 205 A.D. and lived until 270 A.D., wrote:[77]

> ...when they want to signify things with wisdom, the wise of Egypt do not avail themselves by letters of writing which follow the order of the words and of propositions, and imitate sound and speech, but

[67] Kenneth A. Kitchen, *Pharaoh Triumphant: The Life and Times of Ramesses II, King of Egypt* (Cairo, 1997), 148.

[68] Davies, *Ken-Amun*, 21-22 and pl. 68.

[69] Davies, *Antefoker*, 27-29, no. 33, pl. 37, 37a. Translation from Parkinson, *Voices from Ancient Egypt*, 148, 59d.

[70] Davies and Gardiner, *Amenemhet*, 6–7; Davies, *Antefoker*, 10, 22.

[71] For example, TT 38 belonging to the steward of the second prophet of Amun, Djeserkarasoneb, and TT 75 belonging to Djeserkarasoneb's employer, Amenhotep-si-se: *PM* I,1(2), 70; Davies, *Two officials*, 7, n. 5; Nina Davies, *Some Theban Tombs*, 7. Tomb of Paheri and TT A4, both belonging to grain scribes: Manniche, *Lost Tombs*, 62-87; regarding the connection between El-Kab and Thebes, see the statue published in Bernard V. Bothmer, et al., *The Luxor Museum of Ancient Egyptian Art, Catalogue* (Cairo, 1979), 71, no. 91.

[72] Plato, *Laws*, translated by Benjamin Jowett (Amherst, New York, 2000), 656c-657a.

[73] See the excellent discussion in Dimitry Laboury, "Fonction et signification de l'image égyptienne," *Bulletin de la Classe des Beaux-Arts* 7 (1998), 131-148. See also Whitney Davis, "Plato on Egyptian Art," *JEA* 65 (1979), 121-127, who translates *schemata* as proportional rules that transfer three-dimensional form into two-dimensional form, which does not take into account Plato's interest in the fundamental values of ancient Egypt and their transposition from the artistic to the educational plane.

[74] Heike Sternberg el-Hotabi, "Die 'Götterliste' des Sanktuars im Hibis-Temple von El-Chargeh: Überlegungen zur Tradierung und Kodifizierung religiösen und kulttopographischen Gedankengutes," in *Aspekte spätägyptischer Kultur, Festschrift für Erich Winter zum 65. Geburtstag*, edited by M. Minas und J. Zeidler, Aegyptiaca Treverensia 7 (1994), 239-254.

[75] Ibid., 246.

[76] Assmann, *The Mind of Egypt*, 343-344, 419.

[77] E. de Keyser, *La signification de l'art dans les Enneades de Plotin* (Louvain, 1955), 60-62. Italics mine. I am grateful to Dimitry Laboury for bringing this citation to my attention. See also: Erik Iversen, "The Hieroglyphic Tradition," in *The Legacy of Egypt*, 2d ed., edited by J.R. Harris (Oxford, 1971), 175; Margaret R. Miles, *Plotinus on body and beauty: Society, philosophy, and religion in third-century Rome* (Oxford and Malden, Mass., 1999), 149.

on the contrary, *they express all the characteristics of a thing in the drawing of images and in the engraving in their temples, an image of each distinct thing, so that every image constitutes a sum of knowledge and of wisdom, a subject of thought seized in a single time, without proceeding from discursive reflection or deliberation.* It is only then that the intellectual content is extracted from this concentrated image, unraveled and translated in words, and that the reason for which each thing is like it is and not otherwise is discovered.

According to Plotinus, the imagery developed by the ancient Egyptians was perceived as a receptacle of thought that expressed "all characteristics of a thing" so every image was a kind of knowledge and wisdom. These images did not just represent the obvious but were also endowed with symbolic qualities (*sophia*) through which the viewer could gain insight spontaneously into the fundamental essence of things. As representations, they revealed, "the ideal world of the soul."[78]

The Platonic and Neoplatonic ideas that hieroglyphic images were allegorical symbols mirrored concepts found in Late Egyptian texts and the myths of Egyptians themselves. In the Memphite Theology, the totality of creation was summed up in "all things and all hieroglyphs" that were created by Ptah.[79] In this work, written signs originated at the same time as the things they stood for, and together they encompassed the totality of creation.[80] These concepts are reflected by later Neoplatonic philosophers such as Iamblichus (second century A.D.), who wrote about the Egyptian magico-religious theology in his *Mysteries of the Egyptians*:[81]

For they [the Egyptians], endeavoring to represent the productive principle of the universe and the creative function of the gods, exhibit certain images as symbols of mystic, occult and invisible conceptions, in a similar manner as Nature (the productive principal) in her peculiar way, makes a likeness of invisible principles through symbols of visible forms.

Later, Horapollo, a fifth century A.D. author, expounded on the inherent symbolism of Egyptian hieroglyphs in the *Hieroglyphika*, which is consistently recognized as the only true treatise preserved from Classical antiquity that deals with hieroglyphs.[82] In it, Horapollo wrote that Egyptian hieroglyphic images could be understood both in simple terms and as allegorical symbols that related to the mysteries of the universe. Furthermore, these symbolic interpretations of hieroglyphic images appear to have had their antecedents in Late Egyptian texts.[83] For example, the demotic *Myth of the Solar Eye* contains passages that refer to the symbolic meanings of hieroglyphic signs such as "if one wants to write the word 'honey', one draws a picture of Nut with a reed in her hand"[84] or "if one wants to write the word 'year', one draws the picture of a vulture because it causes the months to be."[85]

Important to the understanding of these classical authors is the indissoluble connection between art and writing in ancient Egypt. The Egyptians had no strict distinction between hieroglyphic writing and pictorial art. Hieroglyphic

[78] Erik Iversen, *The Myth of Egypt and its Hieroglyphs in European Tradition* (Copenhagen, 1961), 45-46.

[79] Memphite Theology, 58 = Miriam Lichtheim, *Ancient Egyptian Literature, Volume I: The Old and Middle Kingdoms* (Berkeley-Los Angeles-London, 1973), 54-55. On the dating of the Memphite Theology and relevant bibliography, see Hartwig Altenmüller, "Denkmal memphitischer Theologie," *LÄ* I (1975), 1066-1069; Lichtheim, *Ancient Egyptian Literature* I, 51; Rolf Krauss, "Wie jung ist die memphitische Philosophie auf dem Shabaqo-Stein?" in *Gold of Praise: Studies on Ancient Egypt in Honor of Edward F. Wente*, edited by E. Teeter and J. Larson, SAOC 58 (1999), 239-246; Vincent Arieh Tobin, "Myths: Creation Myths," *OEAE* II (2001), 469-472.

[80] See complete discussion in: Assmann, *The Mind of Ancient Egypt*, 352-354.

[81] Iamblichus, *Theurgia or The Egyptian Mysteries,* translated from the Greek by A. Wilder (London, 1911), VII, 1. See also discussion of Iamblichus in Ritner, *Ancient Egyptian Magical Practice*, 246-247 with n. 1132.

[82] Iversen, *The Myth of Egypt*, 47-48; Gerald E. Kadish, "Wisdom Tradition," *OEAE* III (2001), 509. For a more cautious appraisal: Alan B. Lloyd, "Ancient Historians," *OEAE* I (2001), 87. For the most recent translation, see: Heinz Josef Thissen, ed., *Des Niloten Horapollon Hieroglyphenbuch I: Text und Übersetzung*, Archiv für Papyrusforschung und verwandte Gebiete, Beiheft 6/1 (Munich and Leipzig, 2001); idem, *Des Niloten Horapollon Hieroglyphenbuch II: Kommentar*, Archiv für Papyrusforschung und verwandte Gebiete, Beiheft 6/2 (Munich and Leipzig, 2003).

[83] Stanley M. Burnstein, "Images of Egypt in Greek Historiography," in *Ancient Egyptian Literature: History and Forms*, edited by A. Loprieno, PÄ 10 (Leiden-New York-Köln, 1996), 604 with n. 64; Assmann, *The Mind of Ancient Egypt*, 418-419.

[84] Sonnenauge VII, 10 = Antonio Loprieno, "Der demotische 'Mythos vom Sonnenauge," in *Weisheitstexte, Mythen und Epen, Mythen und Epen III*, Texte aus der Umwelt des Alten Testaments, III/5 (Gütersloh, 1995), 1054, with note VII,10c, who explains the phrase as an interpretation of a possible writing of the word *ibyt* "honey" in an enigmatic hieroglyphic inscription of the Late Period.

[85] Sonnenauge IX, 10 = Loprieno, *Mythen und Epen* III, 1057.

pictograms are miniature pictures that obey all the rules of Egyptian pictorial art.[86] Classical authors were aware, as are contemporary scholars, of the symbiotic relationship between word and image, represented and signified in ancient Egypt.[87] As "all the characteristics of a thing," hieroglyphs and hieroglyphic pictorial images corresponded to the 'mind' of ancient Egypt.[88] Echoed in these ancient and contemporary writings is the appreciation of the image as a conceptual tool of Egyptian thought and as a medium of symbolic exchange. Thus, a glimpse is gained of the language of images in which the ancient Egyptians themselves revealed the function and the signification of their iconography in a coherent system of communication.

Visitor inscriptions in tomb chapels and the perceptions of classical authors provide a valuable resource that chronicles the ancient viewer's appreciation of monumental art. Traditional scholarship has tended to see artistic discourse as internal and hidden and addressed largely to the world of the gods or highly informed observers.[89] While this communicative link is clearly in evidence in ancient Egypt, a number of recent articles have argued that the language of images was available to all, even to the illiterate, particularly within the context of the tomb chapel.[90] While we can assume that many of these chapel visitors were literate members of the ruling elite, we can also speculate that many visitors were also semi- or non-literate, particularly female members of the tomb owner's family and children. We can presume that within the context of the tomb chapel, the process of viewing for the illiterate may have been a collective experience, organized around the various necropolis festivals or family visiting situations. The connection between text and image suggests that literate visitors apprehended the full meaning of the composition directly. On the other hand, semi- or non-literate viewers may have understood the composition, provided the text adjacent to the scene was read aloud to him or her.[91] Reinforcing this hypothesis are a number of Appeals to the Living, which describe the (hoped-for) actions of tomb visitors in terms of "hearing" the text.[92]

Besides the literal viewing of text and image, we can assume that symbolism played a role in the viewer's understanding of the monument and the image. Symbolism has been described as the primary form of ancient Egyptian thought.[93] As stated above, symbols represented and communicated many of the prevalent ideas, beliefs, and attitudes held by the ancient Egyptians, and these were circulated throughout society and written down. To this end, artists, architects, and designers used symbols in the decoration, design, and building of temples, tombs, and everyday objects as they were sanctioned by the elite who created and commissioned them. Symbols facilitated the representation of subjects that did not lend themselves easily to *mimesis*, including abstract concepts, light, sexuality, etc.[94] Symbolism

[86] Henry G. Fischer, *L'écriture et l'art de l'Égypte ancienne: Quatre leçons sur la paléographie et l'épigraphie pharaoniques* (Paris, 1986); Assmann, *Form und Mass*, 18-42; Roland Tefnin, "Discours et iconicité dans l'art égyptien," *GM* 79 (1984), 55-72; Pascal Vernus, "Des relations entre textes et représentations dans l'Egypte pharaonique," in *Écritures* II, edited by A.-M. Christin (Paris, 1985), 45-66; Goldwasser, *OEAE* III (2001), 202.

[87] Laboury, *Bulletin de la Classe des Beaux-Arts* 7 (1998), 135; Tefnin, *CdÉ* 66 (1991), 60-88; Erik Homung, *L'esprit du temps des Pharaons* (Paris, 1996), 26.

[88] See discussion above, 1.1.2, pp. 9-10, on how the selection of superordinates in the hieroglyphic determinative system reflected the "collective mind" of the ancient Egyptians.

[89] John Baines, "Communication and display: the integration of early Egyptian art and writing," *Antiquity* 63 (1989), 471-482, esp. 479; idem, "Restricted Knowledge, Hierarchy, and Decorum: Modern Perceptions and Ancient Institutions," *JARCE* 27 (1990), 1-23; idem, *CAJ* 4 (1994), 70-72, 88; John Baines and Norman Joffee, "Order, Legitimacy, and Wealth in Ancient Egypt and Mesopotamia," in *Archaic States*, edited by G. Feinman and J. Marcus (Sante Fe, 1998), 236-238, 241-242. However, see recent discussion in Baines and Lacovara, *Journal of Social Archaeology* 2.1 (2002), 11-12, that adds a temporal dimension to the discourse.

[90] Wildung, *La peinture égyptienne ancienne*, 14-15; Hartwig, *Egyptology at the Dawn of the Twenty-First Century*, 298-307. See also Roth, *Mummies & Magic*, 53-55. On the language of status and official form, see: Jan Assmann, *Schöne Frauen, schöne Männer*, 13-32; idem, *Das Bildnis in der Kunst des Orients*, 24-26; Bryan, *Studies in Honor of William Kelly Simpson*, 161-168.

[91] For an example of this theory, see: Michael Camille, "Seeing and Reading: Some Visual Implications of Medieval Literacy and Illiteracy," *Art History* 8 (March, 1985), 32.

[92] Parkinson, *Voices from Ancient Egypt*, 137; Lichtheim, *Maat*, 174.

[93] Siegfried Schott, "Symbol und Zauber als Grundform altägyptischen Denkens," *Studium Generale* 5 (1953), 278-288, esp. 287; Richard H. Wilkinson, "Symbols," *OEAE* III (2001), 330.

[94] Jean Wirth, "Symbols," *The Dictionary of Art*, vol. 30, edited by J. Turner (New York, 1996), 167. See also discussions on the use of symbolism and decorum in Baines, *Fecundity Figures*, 277-305; idem, "Egypt, ancient, IV, I (iii): Ideology and conventions of representation: Decorum," *The Dictionary of Art*, vol. 9, edited by J. Turner (New York, 1996), 796-798.

could conceal and reveal. It revealed by representing aspects of ancient Egyptian culture, and it concealed by limiting the audience who could access the underlying message, and thus was a vehicle for the expression of elite power.[95]

The ancient viewer's understanding of symbolism was based, in part, on recognizable objects, rituals, and concepts that permeated Egyptian civilization and continually shaped it. To the modern eye, the dictates of decorum and a vast bridge of time often veil the underlying significance of the image. The ancient Egyptian viewer, however, would have understood the images, *albeit* in varying degrees, based on their literacy, status, and level of cultural knowledge. The process of decoding the meaning of these images was much easier because, to them, the visible world was likely seen as a symbol in its entirety.[96]

In Egyptian art, symbols could hold a number of meanings that varied according to monument or type of object, often within the same time period.[97] Interpreting what these symbols meant for the ancient Egyptians has been a topic of scholarly debate based on the fluidity of Egyptian religion that allowed for an open exchange of ideas that were sometimes contradictory.[98] However, by studying an object and its symbolic referent, a consistent interpretation can often be made by taking into account the object/referent's specific context and time. Still, it is important to be mindful of the other symbolic associations connected to the setting or object, and to avoid any unfounded speculation, especially in cases where the ancient Egyptians may have intended none. Generally speaking, once a single, predominant symbolic association had been established by the ancient Egyptians between an object and its referent, other aspects tended to reinforce this meaning and provide deeper levels of signification.

In terms of the semiotic and social aspects of symbolism, Assmann has written about the tomb chapel as a 'sign' (*sema*) of a personality belonging to an individual who, as the subject of the identity to be preserved, acted as the sender; the community who viewed the tomb functioned as the receiver. In this way, collective identity was preserved.[99] Through the viewing of the tomb architecture and wall decoration and the reading or hearing of its monumental inscriptions, the tomb preserved the identity of the deceased as well as influences present in society at the time of its construction.[100] According to Assmann, the tomb inscribed its owner into a network of social memory: a network of verbal intercourse, mutual regard, and reciprocal action that in the eyes of the Egyptians constituted the essence of human society.[101]

In support of the social and educational aspects of tomb decoration, critical theories of semiology and visual interpretation assert that a work of art is a system of culturally and historically determined signs, and it is through the viewer-- the interpreter, that those signs acquire meaning. An artwork is a system of communication where the conventional signs of a culture are articulated and disseminated through society.[102] In this regard, a painting exists as a system of signs, a type of discourse, that is bathed in the same circulation of signs that permeated the rest of society. By tracing a painting back to its original context of production, one will find that factors that made up the sphere of culture, such as military, intellectual, and religious practices, political structures, and structures of class, gender, and economics, were integrated into the painting. If, in the case of ancient Egyptian tomb chapels, a wide range of viewers came in contact with a painting, the signs manifested in it were disseminated to a larger audience, who acted as interpreters. The

[95] R. Wilkinson, *OEAE* III (2001), 330; Assmann, *The Mind of Egypt*, 31-32.

[96] Manfred Lurker, *An Illustrated Dictionary of The Gods and Symbols of Ancient Egypt* (London, 1995), 7-12; Patrick Schmoll, "Organisation des représentations, symbolisme et écriture dans la peinture égyptienne," *La linguistique* 17 (1981), 77-89; Westendorf, *LÄ* VI (1986), 122-128, with bibliography, 330; Assmann, *Interpretation in Religion*, 88-89.

[97] R. Wilkinson, *Symbol & Magic in Egyptian Art*, 11-13; idem, *OEAE* III (2001), 329-330, 334.

[98] Westendorf, *LÄ* VI (1986), 122 with n. 4.

[99] Jan Assmann, *Stein und Zeit: Mensch und Gesellschaft im Alten Ägypten* (Munich, 1991), 169-171. See also Assmann, *Visible Religion* 7 (1990), 7-8; idem, "Preservation and Presentation of Self in Ancient Egyptian Portraiture," *Studies in Honor of William Kelley Simpson*, vol. 1, edited by P. Der Manuelian (Boston, 1996), 61; idem, *Selbsthematisierung*, 208-232; idem, *Ancient Egyptian Literature: History and Forms*, 97-104.

[100] Assmann, *Stein und Zeit*, 172; idem, *Ancient Egyptian Literature: History and Forms*, 103-104.

[101] Assmann, *The Mind of Ancient Egypt*, 70.

[102] Keith Moxey, "Semiotics and the Social History of Arts: Toward a History of Visual Representation," in *Acts of the 27th International Congress of the History of Art*, vol. V (Strasbourg, 1992), 216; idem, *The Practice of Theory: Poststructuralism, Cultural Politics and Art History* (Ithaca and London, 1994), 31; Norman Bryson, "Semiology and Visual Interpretation," in *Visual Theory: Painting and Interpretation*, edited by N. Bryson, et al. (New York, 1991), 71.

process of experiencing the artwork lies in the recognition of the sign, and in this process of recognition, culture is both learned and transmitted.[103]

The tomb provided a distinctive environment in which visitors could assemble to view the chapel scenes, commemorate the deceased, and reinforce their collective identity. Many of the groups who visited Theban tomb chapels are known from their graffiti as well as from archaeological data. A number of these visitors were linked to the tomb owner based on kinship, official position, priestly duty, and aesthetic appreciation, and certainly all were connected by a shared knowledge of ancient Egyptian culture, *albeit* experienced it in different ways.

Many of these visitors were elite officials, literate, and therefore, could respond to the decorative program. Those of limited literacy probably relied on a combination of factors, based partially on their direct apprehension of the images and partly on the assistance of others who could read or decipher the texts and related forms. The semi-literate may have also responded directly to common and easily recognizable signs, cartouches, titularies, and formulas such as the *ḥtp-dí-nsw* formula. The viewer's literacy and level of cultural knowledge informed their understanding of the levels of meaning inherent in the decoration.[104] Given the spectrum of human experience and the complexity of pictorial meaning in ancient Egypt, the iconography and symbolism of the chapel imagery provided each viewer with a means to experience, at some level, the deceased's identity, prestige, and 'virtue' as well as the larger Egyptian cultural context and world view.

2.5 The so-called Daily Life Scenes

So-called scenes of daily life in the tomb are defined as depictions of "an ideal everyday life passed on earth and desired in the hereafter."[105] Traditional scholarship has viewed daily life scenes as 1, capable of being transformed magically into a living reality; and/or 2, commemorative of the deceased's environment in life.[106] For example, H.A. Groenewegen-Frankfort[107] discussed how both of these functions were joined in New Kingdom Theban tomb chapels where "the new confrontation of king and servant in the latter's tomb insisted on man's individual status and at the same time lastingly linked him with his divine ruler."[108]

Many scholars make a distinction between scenes with sacred or secular subjects. While daily life scenes are viewed as representations of the tomb owner's everyday life, ritual scenes have been treated as insurance that the rites would be carried out properly to ensure the eternal well-being of the deceased in the next world. Unfortunately, these categories reflect a modern bias that may not have been shared by the ancient Egyptians.[109]

[103] Bryson, *Visual Theory*, 65: "…the difference between the term 'perception' and the term 'recognition' is that the latter is social. It takes one person to experience a sensation, it takes (at least) two to recognize a sign. When people look at a representational painting and recognize what they see, their recognition does not unfold in the solitary recesses of the sensorium but through their activation of codes of recognition that are learnt by interaction with others, in the acquisition of human culture." According to Bryson, what is disseminated can be the original meaning or subsequent interpretations, because signs are able to travel away (via the viewer/interpreter, etc.) from the context of its making in both space and time without ceasing to be signs.

[104] The conditions needed for understanding an act of communication to take place are termed "communication intentions" which are inherent in the image and can be recognized by the viewer who shares a common background or knowledge with the author of the image (H.P. Grice, "Utterer's Meaning and Intentions," *Philosophical Review* LXXVIII (1969), 147-177; elaborated and modified by P.F. Strawson, "Intention and Convention in Speech Acts," *Logico-Linguistic Papers* (London, 1971), 155-158, 168); adapted for visual images by David Novitz, *Pictures and their use in communication* (The Hague, 1977), 149-154. See the commendable synopsis on visual communication in: Whitney Davis, "Communication Theory," *The Dictionary of Art*, vol. 7, edited by J. Turner (New York, 1996), 659-662, with complete bibliography. In visual communication theory, a message must have a context which is understood by the receiver; a code or logical system of forms comprehended by the sender and receiver; and a contact or "physical channel and psychological connection" between both parties.

[105] Cyril Aldred, "Grabdekoration," *LÄ* II (1977), 856.

[106] For summations of the dialogue on daily life scenes, see: Whitney Davis, *The Canonical Tradition in Ancient Egyptian Art* (Cambridge, 1985), 199-201, with bibliography; Kanawati, *The Tomb and Beyond*, 116.

[107] H.A. Groenewegen-Frankfort, *Arrest and Movement: An Essay on Space and Time in the representational Art of the ancient Near East* (London, 1951), 78-81.

[108] Ibid., 79.

[109] Weeks, *Egyptology and the Social Sciences*, 59-60.

Recently, scholars have opened a dialogue about daily life scenes, moving away from interpreting such scenes based solely on what they represent, and towards an examination of the potential levels of meaning inherent in them.[110] Designations such as "daily life scenes" and "ritual scenes" have been abandoned in favor of an approach that addresses the multivalent meaning of the Egyptian image. The key to such an approach lies in the analysis of the symbolism of tomb scenes. Recent studies have examined symbolism in specific eighteenth dynasty tomb scenes in order to understand their underlying significance. A few scholars have linked symbolic analysis with the meaning of the tomb but differ in terms of how the image functioned. Roland Tefnin and Dimitri Laboury argue that, while the underlying meaning of the representation acted as a point of contact between this world and the next, it played out in an enclosed circuit for the spectator who existed within the composition.[111] Others have approached tomb decoration as a dialogue between the dead and the living to commemorate the identity of the dead and preserve social ties,[112] or as a link to preserve the continuity between past and present.[113] These studies suggest the best approach lies in analyzing the content and symbolism of tomb scenes in terms of the tomb's overall function, both as a creative vehicle for the deceased's regeneration and as a commemorative monument.

Another topic of consideration concerns the categories of daily life scenes and why they were consistently standardized. For example, if agricultural scenes could magically ensure a perpetual supply of grain, the staple of the Egyptian diet, then why didn't every patron select agricultural scenes for his chapel? And why are certain foods represented on offering tables and not others that were known to have been highly prized in ancient Egypt? Kent Weeks has argued that the depiction of certain types of images reflected the way in which the ancient Egyptians codified and organized their world.[114] According to Weeks, artistic representations were a basic statement of "significant attributes" that were essential to identify and illustrate a particular category which had meaning to the ancient Egyptians. Representations of particular types of food could stand for the category of "food" in the afterlife. Selected depictions of agricultural pursuits could have symbolized the entire cycle that ensured an abundant harvest in the next world. Specific attributes could also be organized to signify the earthly place of the tomb owner so he could fully play that role in the afterlife. In terms of the meaning of particular career scenes, Weeks focuses on the tomb owner's role vis-à-vis the king, stating that "to test this hypothesis, we need to determine whether there exists a correlation between relief scenes in a tomb and the titles held by the tomb owners in a given cemetery at a given time."[115]

Thus, in order to understand the purpose and meaning of so-called daily life scenes in the tomb, we must look at them in terms of a holistic framework. First, the designation of scenes as "daily life" or "ritual" reflects a modern bias in categorizing scenes as secular or sacred which was not shared by the ancient Egyptians. Second, specific categories of images and scenes were chosen to illustrate concepts, much in the same way as selected superordinates in the hieroglyphic determinative system reflected the cognitive procedures of the ancient Egyptians as well as their world view.[116] Specific selections of scenes may have symbolically rendered a number of concepts or ideas that were easily understood by the initiated observer and that may elude us today. Third, the content of chapel scenes and their symbolism must be examined in terms of the tomb's overall function, both as a vehicle for the deceased's regeneration and as a commemorative monument. Using this outline, the various meanings of Egyptian tomb scenes can be analyzed.

[110] Most notably by Kamrin, *Khnumhotep II*, 41-51, who also offers a complete bibliography of recent investigations on the meaning of the so-called scenes of "daily life." See also the recent article by Lise Manniche, "The so-called scenes of daily life in the private tombs of the Eighteenth Dynasty: an overview," in *The Theban Necropolis: Past, Present and Future*, edited by N. Strudwick and J. H. Taylor (London, 2003), 42-45.

[111] Roland Tefnin, "Discours et iconicité dans l'art égyptien," *Annales d'Histoire de l'Art et d'Archéologie* 5 (1983), 11-12; idem, *CdÉ* 66 (1991), 60; Laboury, *Bulletin de la Classe des Beaux-Arts* 7 (1998), 141, 146-147.

[112] Assmann, *Selbstthematisierung und Selbstzeugnis*, 208-213, and discussion above in 2.3, pp. 42-43.

[113] Claudio Barocas, "La décoration des chapelles funéraires égyptiennes," in *La mort, les morts dans les sociétés anciennes*, edited by G. Gnoli and J.-P. Vernant (Cambridge, 1982), 429-440.

[114] Weeks, *Egyptology and the Social Sciences*, 61-62, 65-69.

[115] Ibid., 72.

[116] Orly Goldwasser, "The Narmer Palette and the 'Triumph of Metaphor,'" *Lingua Aegyptia* 2 (1992), 67-85. See also Eugene Cruz-Uribe, "Scripts: An Overview," *OEAE* III (2001), 192-198.

2.6 *Blickpunktsbild*

As discussed in Chapter 1, ancient texts reveal the importance of the scenes that occurred on the "western" back walls of the transverse hall in T-shaped tombs or one of the long walls in rectangular chapels for the self-presentation of the owner.[117] These walls were aesthetically and symbolically significant for the tomb owner. Symbolically, the back walls of T-shaped chapels generally occurred at the intersection between representations concerned with the life of the tomb owner in the transverse hall and images of his transition into or life in the hereafter in the interior hall of the chapel or shrine.[118] Aesthetically, these walls were the first to be seen by those entering the tomb, and they received adequate light lying opposite the entry from the forecourt into the chapel.[119] The western back walls as well as the long walls in rectangular tombs frequently contained innovative or accomplished renderings.

Contemporary scholarship has adopted the term *Blickpunktsbild* or focal point representation to describe the importance of these images, which offer the clearest and most significant information about the deceased's social environment, in what role the tomb owner desired to be remembered to the living, and by what means he or she wanted to be sustained in the next world. Furthermore, ancient documentary evidence points to the importance of these walls for the self-presentation and preservation of the deceased. For these reasons, we can assume that the deceased or his delegate chose the most significant scenes for the focal walls, for it was here that the tomb owner presented images of himself and his family for future generations, images that would also provide for them in the hereafter. In rectangular chapels, either the southern or the northern long walls conformed in content and meaning to the *Blickpunktsbild* in T-shaped tombs.

As key images in the chapel, the *Blickpunktsbilder* functioned in concert with the various functions and meanings of the tomb. As stated above, the tomb had two primary functions: It served to project the identity of the dead into the next world and commemorate them to the living; and the tomb acted as a machine for the tomb owner's regeneration and rebirth, as well as the regeneration and rebirth of those who were interred and depicted along with him. Commemoratively, the focal point representations presented the personality of the tomb owner and his world to the living. Sequential vignettes, innovative or amusing motifs, sophisticated renderings, and the details of status were all combined on the focal walls to engage the beholder in the process of viewing.[120] Ancient visitor graffiti attest to the focal wall's effect on the observer and suggest that the tomb owner may have placed the images specifically on this wall to impress the living viewers. Magically, the imagery on the focal walls would be projected into the next world to preserve the deceased's identity as well as provide for his regeneration and the creation of new life. In this way, the *Blickpunktsbilder* worked in concert with the functions and meaning of the tomb.

2.7 **The Functioning Image in Eighteenth Dynasty Private Theban Tomb Chapels**

This brings us full circle and back to the nature of the functioning image in the private tomb chapel. Images not only represented reality but also had the power to become animated. Through the power of magic and symbolism, a bridge was created between what was represented and what was signified, between the mundane and the sacred, between the here and the hereafter, the living and the dead. Within the environment of the tomb chapel, a representational world was created to protect, provision, and provide for the deceased's rebirth in the eternal time of the hereafter. Ritual played an important role in the activation of the image, which was dependent on the living to perform cult for the deceased but also could, in their absence, be brought into being by the deceased and the inherent creative power of the image itself. Through the intersection of magic and symbolism, the magical force by which the Creator god sustained the ordered

[117] See discussion on the *Blickpunktsbild* above, 1.2.1, pp. 16-17.

[118] Fitzenreiter, *SAK* 22 (1995), 105; on the organization of the semantic axis of the tomb, Assmann, *Problems and Priorities*, 37.

[119] Assmann, *Genese und Permanenz*, 29.

[120] Examples of sophisticated color treatment: Bryan, *Colour and Painting*, 67-68, pls. 21.2, 22.1-2, 22.4, 23.1-2, and McCarthy, *Colour and Painting*, 17-21 with Table 1. Examples of innovative and amusing motifs, usually at eye-level: Brack, *Haremhab*, 35; Shedid and Seidel, *Nakht*, 29-30, fig. 14, pp. 52, 66-67. In the front hall, figural proportions were also more consistent and exhibited a greater degree of competence than in the other rooms of the chapel (Bryan, *Colour and Painting*, 64).

cosmos was manipulated by the ancient Egyptians and made manifest through images that represented, preserved, and communicated their ideas, beliefs, and attitudes. Once activated, these images could provide for the deceased's rebirth and eternal well-being, as well as project his personality into the next world and commemorate him in this world.

Commemoratively, the image acted as the visual means by which the tomb owner presented himself and his accomplishments to the world. It was part of a net of social and cultural remembrance, known as monumental discourse, that visually linked society, reinforced political affiliation and collective identity, and perpetuated social memory after death. The commemorative image was also intentionally organized externally towards the viewer and reader of the scene to impress them, and motivate them to leave an offering or say a prayer for the well-being of the deceased.

In private Theban tombs of the eighteenth dynasty, the *Blickpunktsbild* or "focal point representation" was an important vehicle for the tomb owner. The external significance of these focal images related to the commemorative, "living" nature of the tomb chapel in which the identity and message of the deceased and his world was preserved and presented to the living. These focal images also held an internal, magical significance that would be carried over the threshold into the next world to provide for the deceased. Tomb texts, visitor graffiti, and sophisticated renderings indicate the importance of the focal scenes to the cult of the deceased. Therefore, we can assume that the *Blickpunktsbild* offered critical information about the deceased's life and social environment and how he or she wanted to be sustained in the next world.

Visitor graffiti reflected both the piety and the pleasure of the writers, who responded to the chapel's aesthetic qualities, antiquity, or the status of the tomb owner, often leaving prayers for the deceased and even prayers for themselves. Classical authors (informed by Late Egyptian texts, myths, and temple symbolism) discussed the symbiotic relationship between word and image, that revealed a type of pictorial language in which the ancient Egyptians themselves presented their world to the viewer through the function and the signification of their iconography. The iconography and symbolism of the image provided the informed viewer with a type of window into the identity and status of the deceased as well as societal influences and the larger Egyptian world view.

Taking a broader interpretation of so-called daily life scenes, images in tomb chapels are best viewed as depictions of a particular category of actions or objects that stood for specific ideas, concepts, or beliefs held by the ancient Egyptians. Certain types of scenes not only reflected aspects of the deceased's earthly life and daily needs, but also made use of a subset of symbols that related to ancient Egyptian religious concepts and belief systems about this world and the next. In these terms, tomb scenes functioned as a point of contact between the dead and the living and generated an existential reality for the dead in their afterlife.

Thus, in order to understand the functioning image in the private eighteenth dynasty tomb chapel, one must decipher the iconography and symbolism of the image on a number of fronts: magically, to gain insight into how it functioned for the afterlife for the deceased; and commemoratively, to distinguish how it presented the deceased's identity, status, and worthiness to the living on one hand, and how it revealed societal influences on the other. The ancient Egyptian image in the private tomb, then, can be seen to function on multiple levels: It represented and signified, revealed and encoded, provided and instructed for the eternal benefit of the deceased and living visitors.

CHAPTER 3

ICONOGRAPHY, THE HERE, AND THE HEREAFTER

3.1 The Intersection of Iconography, Symbolism, Magic, and Commemoration

3.1.1 Method

The preceding discussion focused on how the ancient Egyptian image operated on various levels within the tomb. Through representation, signification, encoding, and reception, the images in the chapel magically provided for the tomb owner and presented the deceased's identity, status, and worthiness, as well as the societal influences that shaped his world, to the living and were transferred to the next world. Particularly potent were the *Blickpunktsbilder* that occurred on the "western" back walls or focal walls of the transverse hall in T-shaped tomb chapels to either side of the passage into the inner hall or shrine, opposite the outer doorway. In simple rectangular tombs, the southern wall or northern wall conformed in content and meaning to the imagery found on the focal walls in T-shaped tombs. These images gave a sense of the identity, life, and social environment of the deceased, what he wanted to be remembered by, and by what means he wanted to be sustained in the next world.

Chapter One's brief review of the decorative program in Theban tomb chapels found that standard scenes were modified for each tomb owner and were arranged thematically within the chapel. These standardized scenes were composed of a number of images that were joined to form themes or motifs such as 'fishing and fowling,' 'banqueting,' and 'royal kiosk.' While the details of no two scenes were alike, partly because of the dictates of the tomb owners (or their delegate), the themes themselves remained fairly regular. These scenes not only reflected aspects of the deceased's life but also symbolically encoded ancient Egyptian ideas, concepts, and beliefs about this world and the next. These standardized scenes can also be understood as icons.[1] Understood thus, the properties of these images and their accompanying texts make them ideally suited for iconographical analysis.

As developed by the art historian Erwin Panofsky, the analysis of iconography is based on three levels of interpretation: pre-iconographical analysis of primary subject matter; iconographical analysis of themes or concepts that are expressed by objects or events; and iconographical interpretations of the intrinsic meaning or content of the work.[2] All three levels of interpretation must be followed in order: Correct identification of form leads to correct iconographical analysis of themes or concepts, and this, in turn, leads to correct iconographical interpretation.

Integral to the iconographical analysis is the role of symbols that indicate a general idea.[3] In iconography, objects served as vehicles for symbolic meaning that could be overt and primary or disguised and secondary. While symbols can hold a number of contradictory meanings that vary according to the monument or type of object, the key to deciphering symbolic meaning lies in ancient Egyptian religion, literature, myth, and social history, etc. Through this

[1] The use and meanings of iconic depictions in the tomb have been examined most admirably in recent articles by Fitzenreiter, *GM* 143 (1994), 51-72; idem, *SAK* 22 (1995), 95-130, who focuses on the meaning of the icons for the deceased's provisioning and social status in the hereafter. In a later article (Martin Fitzenreiter, "Grabdekoration und die Interpretation funerärer Rituale im Alten Reich," in *Social Aspects of Funerary Culture in the Egyptian Old and Middle Kingdoms*, edited by H. Willems, OLA 103 (Leuven, 2001), 67-140), Fitzenreiter approaches icons (particularly the *M33*-icon) in terms of their continual communication of the tomb owner with the *Diesseits* and the deceased's eternal provisioning.

[2] On iconography and iconology, see: Erwin Panofsky, *Studies in Iconology* (New York, 1939/*R* 1972), 3-31; idem, "Iconography and Iconology: An Introduction to the Study of Renaissance Art," in *Meaning in the Visual Arts* (Garden City, N.Y., 1955/*R* London, 1970), 26-54. For an overview, see: Lash, *Dictionary of Art*, vol. 15, 89-98.

[3] Definition in *The Oxford Dictionary and Thesaurus, American Edition* (New York, 1996), 1549; Westendorf, *LÄ* VI (1986), 122; R. Wilkinson, *Symbol & Magic*, 16-17.

method, a consistent, single, and predominant symbolic association between object and concept arises, and other aspects tend to reinforce this meaning and provide deeper levels of understanding.[4] The theory of iconography holds that art is influenced by its historical context, becoming a type of document of a civilization and its different historical or societal conditions. Thus, while in concept, iconography assumes a number of interpretations for a particular image, in practice, a consistent meaning is reinforced by a number of similar symbolic associations.

In this study, standardized scenes as they occurred on the focal wall(s) of 30 private Theban tomb chapels dating to 1419-1372 BCE will be treated as icons composed of images and their texts that were combined into thematic groups and were made specific to the patron. For the sake of clarity, the icons will be discussed according to their configurations on the focal walls, beginning with the icons directly adjacent to the entrance to the chapel's inner hall or shrine, followed by the icons that are thematically linked with them. Three configurations of icons appear on the focal walls in this study: the Royal Kiosk Icon and its adjacent icons; the Offering Table Icon and the icons characteristically connected to it; and the Worshiping Osiris Icon and the icons usually associated with it (Table 2). For the sake of clarity, each icon and its pertinent details will be examined in order to gain insight into how the imagery in the icon functioned magically, commemoratively, and symbolically on behalf of the deceased and the world of which he was a part. While intentionality on the part of the patron is impossible to gauge in the absence of specific contracts or agreements, the nature of iconographical analysis assumes that imagery and its symbolic associations derive directly from the cultural background. This approach leads away from looking at chapel scenes as simple depictions of ritual or everyday life and leads towards an understanding of the chapel scenes as highly significant and symbolic vehicles that functioned on behalf of the deceased, his world, and reflected the societal and religious forces that shaped Egypt.

3.2 Icons

3.2.1 Royal Kiosk Icon

The image of the king seated in a kiosk was first introduced in tomb repertoires early in the eighteenth dynasty. Composed of a number of divine and royal symbols, the image of the ruler enthroned in a kiosk emphasized the divine and terrestrial nature of kingship. The first comprehensive study about this motif was done by Ali Radwan, who examined the various types of royal representations and their underlying meanings in eighteenth dynasty tombs.[5] Klaus Kuhlmann and Martin Metzger, who both examined the iconography and symbolism of the royal throne and its context, added significantly to Radwan's work.[6] While these works are exhaustive in their treatment of the actions, participants, and structural members of the royal kiosk scene, they do not address additional pertinent details such as the king's dress, insignia, or crowns, as well as some of the other symbolism inherent in the motif that was, arguably, outside the scope of their studies.

On the focal walls that preserve the Royal Kiosk Icon in this study (Figures 11-14, 19, 21-25, 28- 32, 34-35, 43; B&W Plates 3 and 4),[7] the majority contain some or all of the following components: The monarch is represented seated on a throne on a dais under a canopied baldachin, often accompanied by a member of the royal family, a deity, or the royal-*ka*; while before the king, the tomb owner honors him, fans him, or offers him gifts. Textual captions identify

[4] R. Wilkinson, *OEAE* III (2001), 334.

[5] Radwan, *Königs*.

[6] Klaus Kuhlmann, *Der Thron im alten Ägypten: Untersuchungen zu Semantik, Ikonographie und Symbolik eines Herrschaftszeichens*, ADAIK 10 (Glückstadt, 1977); Martin Metzger, *Königsthron und Gottesthron*, 2 vols, AOAT 15/1-2 (Kevelaer and Neukirchen-Vluyn, 1985), 5-123. See also: Norman de Garis Davies, "The place of audience in the palace," *ZÄS* 60 (1925), 50-56.

[7] The focal walls that preserve the royal kiosk scene in some form are: TT 63, PM (5) & (10); TT 64, PM (5) & (8); TT 66, PM (6); TT 74, PM (6) & (11); TT 75, PM (3); TT 76, PM (5); TT 77, PM (4) & (7); TT 78, PM (4) & (8); TT 89, PM (15); TT 90, PM (4) & (9); TT 91, PM (3) & (5); TT 116, PM (2); TT 120, PM (3) and northwest back wall (Lyla Pinch Brock, "ARCE's Egyptian Antiquities Project: The Anen Protection Project-Guarding A Jewel in the Gebel," a paper presented at the American Research Center in Egypt, Cairo, Egypt, September 17, 2003); TT 226, PM (4). Focal walls that do not preserve the royal kiosk scene, but are suggested here, are: TT 66, PM (4); TT 75, PM (6) (Davies, *Two officials*, 8); TT 118, PM (1); TT 201, PM (7) & (9) (Redford, *Re'a (TT 201)*, 11, 13); TT 239, PM (3) & (6) (Gardiner Notebooks No. 72, p. 125 verso).

the king and many of the individuals depicted. The icon is placed to either side of the entrance to the chapel shrine or inner hall (Table 2) and is associated with tomb owners who served in the military, palace, regional or civil administrations or were promoted by the king (Table 1).[8]

The kiosk represented the structure in which the king sat that was originally set up in his palace audience hall, as referenced in "The Story of Sinuhe":[9]

Ten men came and ten men went to usher me into the palace. My forehead touched the ground between the sphinxes, and the royal children stood in the gateway to meet me. The courtiers who usher through the forecourt set me on the way to the audience-hall. I found his majesty on the great throne in a kiosk of gold.

The statement "kiosk of gold" is a metaphor that not only refers to the warm golden color of materials used to construct the kiosk and the throne (gold, woven matting, wood) but also relates to its meaning as the seat of the king as the earthly manifestation of the sun god.[10] The background color of the Royal Kiosk Icon reinforces this strong solar symbolism through the use of a warm yellow or red, which were both strong solar colors.[11]

The kiosk motif includes a number of components, first and foremost of which was the throne itself. Three types of thrones are depicted on the focal walls in this study: 1, the block throne; 2, the lion throne chair; and 3, the lion throne armchair. The block throne has been described by Kuhlmann as the *ḥwt*-block throne because of its form, which resembled the enclosure hieroglyph used in the word "temple" (*ḥwt*) and "enclosure of the god" (*ḥwt-nṯr*). He explains that the *ḥwt*-block-throne was symbolic of a sacred space, relating to the divine nature of its occupant, who was the representative of the gods.[12]

In the Royal Kiosk Icon, the block-throne could be either a simple throne with feather decoration[13] or a throne with feather decoration and the *sm3-t3wy* motif placed in the small square at the lower corner.[14] The *sm3-t3wy* was composed of the sedge-plant flower of Upper Egypt tied with the papyrus of Lower Egypt to the lung and windpipe sign meaning "unity." Together, this motif indicated the political entity of the Two Lands.[15] Seated on the block-throne, the king is portrayed as the living Horus who ruled over the dominion of Egypt.[16] Also depicted in the Royal Kiosk Icon is

[8] For example, Amenhotep-si-se (TT 75) and Anen (TT 120), who both held the title "Second Prophet of Amun," and yet had very strong connections to the king, having been promoted by the ruler to that position (*Urk.* IV, 1208-1209; Sauneron, *Priests*, 45-47), presumably through family connections (Kees, *Priestertum*, 16; Wolfgang Helck, "Anen," *LÄ* I (1975), 270; Murnane, *Amenhotep III: Perspectives*, 210). Corroborative evidence is furnished by a statue of Anen which does not mention the god Amun nor contains an offering formula or an invocation to a deity. Instead, the text focuses on Anen's favor with the king as the sole source of sustenance for the statue (Betsy M. Bryan, "Statue of Anen, Second Prophet of Amen," in *Egypt's Dazzling Sun: Amenhotep III and His World*, edited by A. Kozloff and B. Bryan (Cleveland, 1992), 249-250).

[9] Lichtheim, *Ancient Egyptian Literature I*, 231= Sinuhe, (248)-(254).

[10] On the kiosk, see: Wolfgang Helck, "Kiosk A," *LÄ* III (1980), 441-442; and its components: Dieter Arnold, *The encyclopedia of ancient Egyptian architecture*, translated from the German by S.H. Gardiner and H. Strudwick, edited by N. and H. Strudwick (Princeton, 2003), 44. For an example of a golden throne, see: JE 62028 in: Francesco Tiradritti (ed.), *Egyptian Treasures from the Egyptian Museum in Cairo* (New York, 1999), 218-219; and in texts: *Urk.* IV, 349, 9-14. On the protocol in the palace, see: Sherine El Menshawy, "The Protocol of the Ancient Egyptian Royal Palace," in *Egyptology at the Dawn of the Twenty-First Century: Proceedings of the Eighth International Congress of Egyptologists, Cairo 2000*, vol. 2, edited by Z. Hawass and L.P. Brock (Cairo, 2003), 400-406.

[11] Yellow kiosk background: TT 63, PM (5) & (10); TT 64, PM (5) & (8); TT 74, PM (6) & (11); TT 75, PM (3); TT 76, PM (5); TT 77, PM (4) & (7); TT 78, PM (4) & (8); TT 90, PM (9); TT 91, PM (3) & (5); TT 120, PM (3); TT 226, PM (4). Red background: TT 89, PM (15). On color symbolism, see: Robins, *OEAE* I (2001), 291-294; Pinch, *Colour and Painting*, 184.

[12] Kuhlmann, *Thron*, 82-83, 89. Metzger, *Königsthron und Gottesthron*, 115, refers to this type of "würfelförmigen Thron" as originating from the Benben stone and Upper Egypt, but Kuhlmann argues this is not supported by the evidence; see: Klaus Kuhlmann, "Königsthron und Gottesthron," review of *Königsthron und Gottesthron* by Martin Metzger, *AOAT* 15/1-2 (Kevelaer and Neukirchen-Vluyn, 1985), *BiOr* 44 (1987), 348-352, 366.

[13] TT 91, PM (5); TT 116, PM (2). Double *ḥwt*-block throne with feather decoration: TT 76, PM (5).

[14] TT 64, PM (5); TT 75, PM (3). Double *ḥwt*-block throne with *sm3-t3wy*: TT 89, PM (15).

[15] Heinrich Schäfer, "Die 'Vereinigung der beiden Länder': Ursprung, Gehalt und Form eines ägyptischen Sinnbildes im Wandel der Geschichte," *MDAIK* 12 (1943), 73-95; Baines, *Fecundity Figures*, 245-250; Mahmoud I. Hussein, "Notes on: Some Hieroglyphic Signs (continued)," *DIE* 51 (2001), 33-45; Metzger, *Königsthron und Gottesthron*, 119. For an alternate reading of these plants and their symbolism as plants of the Red Land and Black Land, see: Alessandra Nibbi, "The So-called Plant of Upper Egypt," *DIE* 19 (1991), 53-68; idem, "A Postscript to 'The So-Called Plant of Upper Egypt,'" *DIE* 20 (1991), 35-38; idem, "The Two Lands: the Black and Red," *DIE* 22 (1992), 9-23; idem, "A Note on *t3-šm'w*," *DIE* 23 (1992), 39-44; and idem, "Some Notes on the Two Lands of Ancient Egypt and the 'Heraldic' Plants," *DIE* 37 (1997), 23-49.

[16] Kulhmann, *Thron*, 83. Symbolism evoking Re-Horakhty, who is "variagated of plumage": Geoffrey Graham, "Insignias," *OEAE* II (2001), 163.

the lion throne chair and armchair, which signified earthly and profane kingship.[17] The lion was intimately associated with Egyptian kingship as a guardian figure that held strong solar associations.[18] In form, the lion throne was composed of two stylized lions supporting the seat bed. Symbolically, the form of the lion throne can be equated with the leonine forms of Shu and Tefnut, who, in the vignette to Spell 17 of the *Book of Going Forth by Day,* guard the horizon in which the sun, their father Atum, rose and set. Seated thus, the king would have appeared as the sun god, rising from and sitting on the throne in an action that evoked the sun's daily cycle.[19]

The throne arm was sometimes decorated with the image of the king as a sphinx trampling his enemies, symbolizing the power and dominion of the ruler over Egypt's foreign enemies.[20] In this form, the ruler was also linked with the sun god who was associated with the sphinx.[21] The arm on the lion throne armchair in the tomb of Anen (TT 120) depicts the king as a sphinx trampling prostrate northern and southern enemies (Figure 35). He wears a *nemes* headress, which was associated with the sun god, surmounted with a sun disk and two *uraei*, which was seen as the fiery Eye of Re.[22] Above him hovers an ostrich feather sunshade with its attendant solar associations. The sunshade was also a sign of the divine presence of the king in the form of a sphinx.[23] Behind the royal sphinx rises Wadjet in the form of a winged cobra, who was also associated with the Eye of Re and represented the emblematic deity of Lower Egypt. This meaning is reinforced by the papyrus plants around which she wraps her body.[24] The solar symbolism inherent in the composition is also emphasized by the throne arm of the king's principal wife, Tiy, which is decorated with a row of *uraei* wearing sun disks with a protective bird wing above. Thus, the visual symbolism in the throne arms accentuate the territorial power and solar qualities of kingship embodied in the ruler.

Between the legs of the lion throne chair and armchair, the *sm3-t3wy* motif often appeared, emphasizing the dominion of Egypt that was under the control of the king. A couple of different variants of this motif occur on the focal walls of this study: the basic image of the plants of Upper and Lower Egypt tied around the hieroglyphic sign for 'union' or tied around a northern and a southern enemy joined to the 'union' sign.[25] In TT 120, beneath the lion throne armchair of queen Tiy, a cat is depicted with its paw draped over a pintail duck and a monkey leaping above them. Although these

[17] TT 64, PM (8); TT 77, PM (4); TT 78, PM (4) & (8); TT 120, PM (3); TT 226, PM (4). Often, the head and mane of the lion were preserved on these thrones where the seat bed and legs met the arm rail. On the throne: Kuhlmann, *Thron*, 61, 63-64, 85, 89; Klaus P. Kuhlmann, "Thron," *LÄ* VI (1986), 526. This throne was also used by the gods (Metzger, *Königsthron und Gottesthron*, 115), as illustrated in the Book of Gates, where Osiris sits in the Hall of Judgement on a lion chair (Kuhlmann, *BiOr* 44 (1987), 366, with n. 164).

[18] Ursula Rössler-Köhler, "Löwe, L.-Köpfe, L.-Statuen," *LÄ* III (1980), 1079-1090; Metzger, *Königsthron und Gottesthron*, 115, 118-119. On the iconography of the lion: Jaromir Malek, *The Cat in Ancient Egypt* (London, 1993), 77-78, 87-88; Patrick F. Houlihan, *The Animal World of the Pharaohs* (London,1996), 90-95; Dagmar Kleinsgütl, *Feliden in Altägypten*, Beiträge zur Ägyptologie 14 (Wien, 1997), 47.

[19] Graham, *OEAE* II (2001), 165 with fig. 4. See also Constant de Wit, *Le rôle et le sense du lion dans l'Égypte ancienne* (Leiden, 1951), 158ff; idem, "Un curieux symbole de résurrection dans l'ancienne Égypte: le double lion," *Revue Belge de Philologie et d'Histoire*, Bruxelles 29 (1951), 318-319.

[20] Kuhlmann, *Thron*, 87-88.

[21] André Dessenne, *Le sphinx: Étude iconographique* (Paris, 1957), 98-115; Ian Shaw and Paul Nicholson, *British Museum Dictionary of Ancient Egypt* (London, 1995), 276-278; Rainer Stadelmann, "Sphinx," *OEAE* III (2001), 307.

[22] Sandra A. Collier, "The Crowns of Pharaoh: Their Development and Significance in Ancient Egyptian Kingship" (Ph.D. Dissertation, University of California-Los Angeles, 1996), 75-78, 93; Manfred Lurker, *An Illustrated Dictionary of The Gods and Symbols of Ancient Egypt*, translated from the German by B. Cumming (London, 1980), 125.

[23] Lanny Bell, "Aspects of the Cult of Deified Tutankhamun," in *Mélanges Gamal Eddin Mokhtar* volume I, edited by P. Posener-Kriéger, BdÉ 97 (Cairo, 1985), 31-59, esp. 33-34 with bibliography.

[24] Hans-Werner Fischer-Elfert, "Uto," *LÄ* VI (1986), 906-911; Bonnet, *Reallexikon*, 582-583; Lurker, *Gods and Symbols*, 127.

[25] Emblematic plants tied around the "union"-sign: TT 77, PM (4); TT 78, PM (4) & (8); TT 120, PM (3); TT 226, PM (4). Emblematic plants tied around enemies: TT 64, PM (8).

animals had erotic, Hathoric overtones,[26] the cat had an additional meaning that related to the solar sphere based on its associations in the *Book of Going Forth by Day* Spell 17a.[27]

Under the king's sandaled feet in the Royal Kiosk Icon is a foot rest, which could be decorated with prostrate and bound northern and southern enemies, representing the visual rendering of the ancient Egyptian phrase "every foreign land is under your sandals."[28] The simple act of the monarch crushing bound enemies of Egypt under his feet led to the symbolic result in which the king, as a passive actor, ritually destroyed the enemies of Egypt.[29] The foot rest could also be decorated with *rekhyet*-birds *(rḫyt)* (anthropoid lapwing birds), which symbolized the subservient Egyptian population.[30] In the tomb of Haremhab (TT 78), five *rḫyt*-birds are represented with their arms raised in a gesture of praise (Figure 24). The five *rḫyt*-birds are fronted by the hieroglyphs *nṯr nfr pn* "this good god." Taken together, the elements of this motif form a rebus that means "common people praise this good god."[31] The image of the *rḫyt* or Egyptian masses under the feet of the king indicates they are under his control.

In the Royal Kiosk Icon, the foot rest often sat on a mat that signified kingship in ancient Egypt.[32] The reed mat sign forming the uniliteral sign *p* appears in words for "base" or "seat."[33] In Ptolemaic texts, the reed mat sign was also utilized in the word for the royal throne.[34] In African cultures, the mat was the oldest seat emplacement of rulers, and raised them above their subjects. The concept of this visual hierarchy is expressed in Egyptian texts as the raising of "the great ones who are on their mats."[35]

The throne podium in the Royal Kiosk Icon was decorated with a frieze of northern and southern enemies or hieroglyphic epithets. The frieze of foreign enemies varied from anthropomorphic bound enemy name rings conforming to the Nine Bows[36] to kneeling or standing bound northerners and southerners of alternating skin color and/or dress,[37]

[26] Phillipe Derchain, "La perruque et le cristal," *SAK* 2 (1975), 62 and n. 26; Luc Delvaux and Eugène Warmenbol, *Les divins chats d'Égypte: un air subtil, un dangereux parfum* (Leuven, 1991), 57-58. Identification of pintail duck in TT 120: Patrick F. Houlihan, *The Birds of Ancient Egypt*, Natural History of Egypt 1 (London, 1986), fig. 103.

[27] Matthieu Heerma van Voss, *De oudste versie van dodenboek 17a* (Leiden, 1963), 81; cited in Herman te Velde, "The Cat as Sacred Animal of the Goddess Mut," *Studies in Egyptian Religion: Dedicated to Professor Jan Zandee*, edited by M. Heerma Van Voss, D.J. Hoens, G. Mussies, D. van der Plas, and H. te Velde, Studies in the History of Religions 43 (Leiden, 1982), 133; Houlihan, *The Animal World of the Pharaohs*, 86-87.

[28] TT 64, PM (8); TT 120, PM (3). Text from a footstool found in the tomb of Tutankhamun: Kamal El Mallakh and Arnold C. Brackman, *The Gold of Tutankhamen* (New York, 1978), pls. 82 and 121-123. See also Alabaster Stele of Seti I: Constantin E. Sander-Hansen, *Historische Inschriften der 19. Dynastie* I, BiAeg 4 (Brussels, 1933), 2 and 14: "all flat lands and all hill lands are united under his feet" (*t3w nbw ḫ3swt nbt dmḏ ḫr ṯbwty.fy*); Kuhlmann, *Thron*, 89.

[29] Ritner, *Ancient Egyptian Magical Practice*, 131-134.

[30] TT 78, PM (4). Alan H. Gardiner, *Ancient Egyptian Onomastica*, Text I (Oxford, 1947), *98-*105; Jacques J. Clère, "Fragments d'une nouvelle représentation égyptienne du monde," *MDAIK* 16 (1958), 43-44; Denise M. Doxey, *Egyptian Non-royal Epithets in the Middle Kingdom: A Social and Historical Analysis* (Leiden, 1998), 193-196; Metzger, *Königsthron und Gottesthron*, 93, 97-98, 118. The frequent appearance of *rekhyet*-birds on throne, dais, and statue bases, Window of Appearances (Ritner, *Ancient Egyptian Magical Practice*, 127) as well as columns, pillars, and walls in god's temples (Bell, *Temples*, 135, 164-165), belies the narrow definition of the *rḫyt* as "westerners" or "Libyans" presented by Nibbi, a definition which is not followed here (Alessandra Nibbi, *Lapwings and Libyans in Ancient Egypt* (Oxford, 1986); idem, "*Rḥy.t* Again," *DIE* 46 (2000), 39-48, with additional bibliography).

[31] Brack, *Haremhab*, 31, taf. 86, which shows five *rekhyt*-birds, and on p. 32, texte 13e, the number is restored as six. See similar frieze of six *rekhyt*-birds in the same posture but on *nb*-signs under the royal throne at Deir el-Bahri, accompanied by two symmetrical lines of text that read: "Praise of (=by) all the common people, that they may live" (Édouard Naville, *The temple of Deir el Bahri*, vol. IV, EEF 16 (London, 1902), pl. 85).

[32] TT 63, PM (5) & (10); TT 64, PM (5) & (8); TT 75, PM (3); TT 76, PM (5); TT 77, PM (4); TT 78, PM (4) & (8); TT 89, PM (15); TT 91, PM (5); TT 116, PM (2); TT 120, PM (3); TT 226, PM (4).

[33] Gardiner, *EG*(3), sign-list Q3.

[34] Kuhlmann, *Thron*, 70.

[35] Kuhlmann, *Thron*, 90; Selim Hassan, *Hymnes religieux du Moyen Empire* (Cairo, 1928), 40.

[36] TT 63, PM (5) reconstructed as the Nine Bows (Dziobek and Raziq, *Sobekhotep*, 37-38); TT 74, PM (6) as the Nine Bows (Brack, *Tjanuni*, 37-38); TT 77, PM (4), name rings are blank. On the symbolism of name rings: Schott, *Studium Generale* 5 (1953), 280.

[37] TT 63, PM (10), enemies tied with Egyptian emblematic plants; TT 64, PM (5); TT 120, PM (3); TT 226, PM (4) has a double podium with kneeling enemies on the lower podium and a blank upper podium crowned with a *uraeus* above a cavetto cornice.

to anthropoid *rekhyet*-birds on *nb*-signs with their arms raised before the word for "praise."[38] Seated above the enemies of Egypt, the pharaoh would have eternally crushed them in this and the next world, thereby maintaining cosmic order.[39] In one tomb, that of Anen (TT 120), eight named foreigners are bound with the emblematic plants of the Two Lands and represent Egypt's hegemony over its imperial and exchange networks (Figure 35).[40] Seated above these nations, the king would symbolically reinforce his political authority and royal power.

In the Royal Kiosk Icon, the podium was often embellished with hieroglyphic signs that spelled a variant of "all life, all stability, and all dominion" (*'nḫ-ḏd-w3s-nb*).[41] These signs recall words spoken by the gods to rulers, such as those recorded in the mortuary temple of Hatshepsut at Deir el-Bahri, in which Amun-re says to Hatshepsut: "I give you all life, all stability, all dominion, all health and all joy, which is within me (lit. by me)."[42] Thus the signs *'nḫ-ḏd-w3s-nb* inscribed on the kiosk podium may be understood in terms of the divine qualities bestowed on the king by the gods on which he based his rule.[43]

A number of Royal Kiosk icons preserve stairs or ramps leading up to the podium.[44] Hans Brunner made the argument that these stairs were to be associated with the hieroglyphic platform used as a phonogram for the word *M3'* and its variant *Maat* (*M3't*).[45] In support of this, he noted the similarity between the form of the steps and the representation of the primeval mound used in the hieroglyphic writing of *M3't*.[46] Phrases such as "May you be high on the *M3't*-dais,"[47] and "O you who stand high on his *M3't*,"[48] associate the platform phonogram relating to *Maat* with the throne and its symbolism.[49] Based on these observations, the throne dais with its stairs or ramp can be read as a symbol of the "truth" or "justice" on which the king, like the Creator god, established the universal order of the world. In one

[38] Brock, "ARCE's Egyptian Antiquities Project: The Anen Protection Project," ARCE paper, Sept. 17, 2003. On the northwest wall of TT 120, the kiosk podium is decorated with a frieze of *rekhyet*-birds resting on *nb*-signs with their arms raised before the word *dw3* "praise." The far left section of the podium is now missing and may have had the signs *nṯr nfr pn* (compare footrest on TT 78, PM (4), Figure 24) which formed the rubric "all common people praise this good god."

[39] Kuhlmann, *LÄ* VI, 523; idem, *Thron*, 32; Metzger, *Königsthron und Gottesthron*, 91-93, 119; Ritner, *Ancient Egyptian Magical Practice*, 115-116, 160, 186-187. The sides of the dais steps are sometimes painted with images of foreigners and adoring subjects (Radwan, *Königs*, taf. XIX; Figure 32), which underscores the king's domination over the masses and Egypt's enemies. See similar examples of bound enemies in: The Epigraphic Survey, *Medinet Habu*, vol. 2 (1932), pl. 101; Émile Chassinat, *Le temple d'Edfou* III, *Mem. Miss.* 20 (Paris, 1928), 349/3.

[40] Norman de Garis Davies, "The Graphic Work of the Expedition," *BMMA*, part II (November, 1928-1929), figs. 1-2, representing from right to left: *Sangar* (Babylonia), *Kush*, *Naharina* (Mittani), *Arame*, *Keftiu* (Crete), bowmen of Nubia, *Tehenu*, and the nomads of Asia. See discussion in Eric H. Cline, "Amenhotep III, the Aegean, and Anatolia," in *Amenhotep III: Perspectives on His Reign*, edited by D. O'Connor and E. Cline (Ann Arbor, 1998), 239-240.

[41] TT 64, PM (8); TT 75, PM (3); TT 76, PM (5); TT 78, PM (8); TT 89, PM (15); TT 91, PM (5). Variants "all life and dominion" (*'nḫ w3s nb*): TT 78, PM (4); TT 77, PM (7) not indicated in Manniche, *Three Theban Tombs*, 20-22, who mentions only "the scene on the north wall is very damaged and only fragments of the throne (different from that on the south wall) can be distinguished."

[42] *di.n.(i) in.t 'nḫ ḏd w3s nb snb nbt 3wt-ib nb ḫr.i*. Naville, *Deir el-Bahri* I, 24; *Urk.* IV, 298, 4. See also *Urk.* IV, 229, 14-17.

[43] See discussion in: Kuhlmann, *LÄ* VI, 526; idem, *Thron*, 95.

[44] Stairs: TT 63, PM (5) & (10); TT 75, PM (3); TT 76, PM (5); TT 78, PM (8); TT 91, PM (5); TT 120, PM (3) (Davies, *BMMA*, part II (November, 1928-1929), 35. In the form of a ramp: TT 78, PM (4); TT 226, PM (4), as reconstructed by Norman de Garis Davies, *The tombs of Menkheperrasonb, Amenmose, and another (nos. 86, 112, 42, 226)*, TTS 5 (London, 1933), pl. XLI-XLII.

[45] Hellmut Brunner, "Gerechtigkeit als Fundament des Thrones," *Vetus Testamentum* 8 (1958), 426-428.

[46] Kuhlmann, *Thron*, 93-95, argues for the linguistic and symbolic connection between the throne platform used and the representation of the primeval mound. In this way, *Maat* as "the right order, truth, justice" was written with the sign of the primeval mound on which the Creator god established the order of the world. Kuhlmann traces the concept of "justice as the foundation of the throne" in the Old Testament back to ancient Egypt, stating that the throne dais made manifest the concept of *Maat*. On the platform hieroglyph as the phonogram for *M3't*: Gardiner, *EG*(3) sign-list Aa11; see also James P. Allen, *Middle Egyptian: An Introduction to the Language and Culture of Hieroglyphs* (Cambridge, 2000), Aa11.

[47] *'h'.k hr ḫtíw m3't*: The Epigraphic Survey, *Medinet Habu*, vol. 4, taf. 205, Z. 10; Richard Lepsius, *Denkmäler aus Aegypten und Aethiopien, Text* III, compiled by E. Naville and L. Borchardt with K. Sethe (Geneva, 1975), taf. 162.

[48] *i3 k33 hr m3't.f* : Adriaan de Buck, *The Egyptian Coffin Texts*, VI, 139j.

[49] On *Maat*, see Jan Assmann, *Ma'at: Gerechtigkeit und Unsterblichkeit im alten Ägypten* (Munich, 1990); Emily Teeter, *The Presentation of Maat: Ritual and Legitimacy in Ancient Egypt*, SAOC 57 (Chicago, 1997); idem, "Maat," *OEAE* II (2001), 319-321; Wolfgang Helck, "Maat," *LÄ* III (1980), 1110-1119.

instance, the tomb owner stands on the sloping platform that supports the king and is thus brought into association with *Maat* (Figure 24). This visual treatment is supported by assertions in eighteenth dynasty private tomb biographies, which equate an official's service to the king as service to *Maat*.[50]

In the Royal Kiosk Icon, stairs and ramps could be decorated with supplicant northerners and southerners, or they could be guarded by couchant Horus-sphinxes wearing the double crown.[51] Raised high on the throne platform, the importance of the king over his subjects and foreigners was reinforced. The Horus-sphinxes related to the king's role as the living Horus, whose dominion extended over the Two Lands and Egypt's foreign enemies (Figure 43).[52]

The structure of the baldachin is composed of a number of different elements in the Royal Kiosk Icon. Colorful columns with capitals of various types hold up an architrave with a cavetto cornice. This cornice is surmounted by a number of different elements, including a frieze of *uraei,* birds, or animals with sun disks. The architrave was decorated with block borders, a feathered frieze or cavetto cornice, a hanging grape frieze, and, in one case, a winged sun disk.[53] Columns were purely functional and served to support the architrave and canopy above. Columns were depicted in the Royal Kiosk Icon as plant stalks or were decorated with colorful bands to indicate woven matting.[54] Sometimes, streamers were drawn fluttering from the sides of the columns or capitals. Lotiform or papyriform capitals were topped by a simple abacus or abaci of falcon heads that related to kingship and the role of the king as the living Horus.[55] Above the capitals, a feathered frieze on the architrave further reinforced the falcon imagery and its relationship with the king. The winged sun disk was associated with kingship and protection.[56] Grapes and vines had associations with Osiris, in his role as the "Lord of Wine" within the funerary realm (PT 820a).[57] With this symbolism in mind, the presence of the hanging grape frieze may relate to the deceased king seated in his kiosk in the hereafter. In the world of the living, these grapes also may have signified the wine offering through which the king would receive life, luck, stability, health, and happiness in order to maintain the order of the world.[58]

The top of the baldachin was surmounted by a frieze of *uraei* with solar disks or crowns; a frieze of *uraei* alternating with lions, both wearing solar disks; or a frieze of falcons with sun disks.[59] The symbolism of the *uraeus* or cobra related to kingship and the eye of Re in the form of a fire-spitting serpent who protected the king from his enemies.[60] The relationship between the lion and kingship has been discussed above, and the presence of a frieze of

[50] On *Maat* in eighteenth dynasty tomb biographies, see: Guksch, *Königsdienst*, 103-104.

[51] Supplicant northerners and/or southerners: TT 91, PM (5); TT 226, PM (4); Horus-sphinxes: TT 226, PM (4).

[52] See symbolism of sphinx above, p. 56, n. 21; meaning of Horus-sphinx in Davies, *Menkheperrasonb*, 38.

[53] Architrave block border with feathered frieze: TT 76, PM (5); TT 78, PM (4) & (8); TT 91, PM (5); TT 226, PM (4) uppermost architrave of four. Architrave with cavetto cornice: TT 63, PM (5); TT 64, PM (5) & (8); TT 74, PM (6); TT 77, PM (4); TT 89, PM (15) unfinished; TT 91, PM (3); TT 116, PM (2); TT 226, PM (4) on two lower architraves. Hanging grape frieze: TT 64, PM (5) & (8); TT 76, PM (5); TT 77, PM (4); TT 78, PM (4) & (8); TT 89, PM (15); TT 91, PM (3) with lotus flowers; TT 91, PM (5); TT 116, PM (2); TT 226, PM (4). Winged sun disk: TT 63, PM (5) (Dziobek and Raziq, *Sobekhotep*, 37, pls. 33-34, reconstructed a winged sun disk on PM (10) based on its occurrence on PM (5), which is not accepted here because there were not enough remains on the wall to substantiate this assumption).

[54] Helck, *LÄ* III (1980), 441-442. Compare the columns of the king's kiosk in: Davies, *Ken-amun*, pl XI.

[55] Simple abacus: TT 64, PM (5); TT 89, PM (15); TT 91, PM (3) & (5); TT 116, PM (2); TT 226, PM (4) simple abacus for three capitals; one capital supplemented by ducks. Falcon head abacus: TT 76, PM (5); TT 78, PM (4) & (8) (Brack, *Haremhab*, 30-31, 36, pl. 46c). On falcon/Horus imagery: S.A.B. Mercer, *Horus, Royal God of Egypt* (Grafton, 1942); Bonnet, *Reallexikon*, 307-314; Houlihan, *Birds of Ancient Egypt*, 48; Edmund S. Meltzer, "Horus," *OEAE* II (2001), 119-122.

[56] Kuhlmann, *Thron*, 91; Dietrich Wildung, "Flügelsonne," *LÄ* II (1977), 277-279.

[57] Christine Meyer, "Wein," *LÄ* VI (1986), 1175-1176; idem, "Weintrauben," *LÄ* VI (1986), 1190-1191; Mu-Chou Poo, "Weinopfer," *LÄ* VI (1986), 1188; idem, "Wine," *OEAE* III (2001), 503. See also depictions of Osiris seated under a baldachin with a grape frieze in TT 181: Davies, *Two sculptors*, pl. 15, 19; Erik Hornung, *Das Totenbuch der Ägypter* (Zürich and Munich, 1979), 362, Abb. 87.

[58] Mu-Chou Poo, *Wine and Wine Offering in the Religion of Ancient Egypt* (London and New York, 1995), 169.

[59] Frieze of *uraei* with solar disks: TT 64, PM (5); TT 74, PM (6) & (11); TT 75, PM (3); TT 76, PM (5); TT 77, PM (4); TT 89, PM (15); TT 90, PM (4); TT 91, PM (3) & (5); TT 226, PM (4) on three canopies, uppermost *uraei* with *šwty*-crown; TT 78, PM (4), alternately wearing the red crown and the white crown; TT 78, PM (8) frieze of *uraei* and lions with solar disks (Brack, *Haremhab*, taf. 46b); frieze of falcons with sun disks: TT 66, PM (6).

[60] Karl Martin, "Uräus," *LÄ* VI (1986), 864-868; Kuhlmann, *LÄ* VI (1986), 527.

falcons with sun disks corresponded to divine kingship in the person of Horus, who was syncretized with Re as Re-Horakhty.[61]

An animal protome in the form of a head of a bull or lion was sometimes found at the front of the canopy.[62] Both animals were intimately associated with kingship. In TT 78, the lion's head, although now partly destroyed, was recorded by Champollion as having a crown of two feathers, with a solar disk and *uraeus*, which would have visually reinforced the lion's solar symbolism (Figure 24).[63] The bull's association with kingship begins in the Early Dynastic Period on slate palettes on which the ruler is depicted as a bull eviscerating his enemies. In the New Kingdom, the bull's association with kingship continued in epithets describing the king as "mighty bull" or "strong bull of Horus." The use of bull heads as protective symbols occurred in amulets and bucrania, suggesting its use as an apotropaic device in the kiosk.[64]

Above the royal kiosk is found the sky-sign (*pt*),[65] meaning "sky" or "heaven" which is decorated with stars. Taken in context with the king enthroned below, this motif recalls representations in the New Kingdom and Late Period in which the king is shown holding up the sky-hieroglyph, symbolically supporting the heavens and cosmic order.[66] Below the sky sign in the Royal Kiosk Icon soars Nekhbet, the Griffon vulture, with her wings outstretched protectively, holding the '*nḫ* sign ("life") or the *šn* sign ("eternity") in her claws. Twice, she is accompanied by inscriptions that mention she is bestowing "life, stability, dominion, and health like Re" on the king.[67] As the tutelary deity of Upper Egypt, Nekhbet appears as a symbol of kingship, protecting the ruler.[68]

The king appears in the Royal Kiosk Icon wearing specific clothing and holding insignia that conveyed his sacred and political office. In terms of dress, the king often wore the "royal jacket" decorated with paillettes or embroidery that was tied in a criss-cross pattern over the chest or over a long bag tunic.[69] In addition, the king wore a solid kilt or a skirt embellished with a *rishi* pattern.[70] Above the kilt, the ruler often appeared with an apron that had a folded front and/or falcon tail centerpiece with *uraei* crowned by sun disks. The king's dress was often completed with a sash, pendant cords with papyrus umbels, a bull's tail, and sandals.[71] Where the king's image was preserved in its entirety in the Royal Kiosk Icon, he was bejeweled with a broad collar, armbands, bracelets, and, sometimes, a pectoral.

[61] Meltzer, *OEAE* II (2001), 119-122.

[62] Bull's head protome: TT 76, PM (5); TT 91, PM (3). Lion's head protome: TT 78, PM (4).

[63] Jean-François Champollion, *Notices descriptives,* vol. I, Collection des classiques égyptologiques (Genève, 1973-1974), 488; Brack, *Haremhab*, 30-31, Abb.12b. On lion's solar aspects: Rössler-Köhler, *LÄ* III (1980), 1079-1090; Houlihan, *Animal World of the Pharaohs*, 94-95.

[64] For example, the Bull Palette, Louvre E 11255: Guillemette Andreu, Marie-Hélène Rutschowscaya, and Christiane Ziegler, *Ancient Egypt at the Louvre* (Paris, 1997), 42; and Narmer Palette, CG 14716: Mohamed Saleh and Hourig Sourouzian, *The Egyptian Museum Cairo: Official Catalogue* (Mainz, 1987), no. 8; Lurker, *Gods and Symbols*, 36-37; Bonnet, *Reallexikon*, 751; Kuhlmann, *LÄ* VI (1986), 527.

[65] Gardiner, *EG*(3), Sign-list N 1.

[66] Erik Hornung, "Himmelsvorstellungen," *LÄ* II (1980), 1215-1218; Richard H. Wilkinson, *Reading Egyptian Art* (London and New York, 1992), 127.

[67] TT 78, PM (4) holding '*nḫ* sign bearing text "Nekhbet, mistress of the sky, may she give life, stability, dominion and health like Re" (Brack, *Haremhab*, 32, text 13d); TT 78, PM (8) with text "May she give life like Re" (Brack, *Haremhab*, 37, text 16c); TT 116, PM (2) inside of kiosk holding *šn*-sign above the king.

[68] Emma Brunner-Traut, "Geier," *LÄ* II (1977), 514; Matthieu Heerma van Voss, "Nechbet," *LÄ* IV (1982), 366-367; Metzger, *Königsthron und Gottesthron*, 119; R. Wilkinson, *Reading Egyptian Art*, 193.

[69] TT 64, PM (5) & (8) (not shown on drawing); TT 78, PM (4) with falcon head; TT 89, PM (15); TT 91, PM (3) & (5) (not shown on drawings); TT 116, PM (2); TT 120, PM (3); TT 226, PM (4). "Royal jacket" in Gillian M. Vogelsang-Eastwood, *Tutankhamun's Wardrobe: Garments from the Tomb of Tutankhamun* (Rotterdam, 1999), 62-64, 94.

[70] Rishi decoration on kilt: TT 63, PM (10); TT 75, PM (3); solid-colored kilt: TT 77, PM (4) & (7) (king not shown on Figure 23); TT 91, PM (5); TT 226, PM (4); with fringed sash: TT 120, PM (3); with fringed kilt: TT 64, PM (4).

[71] Apron with folded front: TT 75, PM (3); TT 78, PM (4) & (8); TT 91, PM (5). Feathered centerpiece with *uraei*: TT 120, PM (3); TT 226, PM (4) *uraei* with sun disks. Simple striped centerpiece: TT 116, PM (2); striped centerpiece with *uraei*: TT 75, PM (3); TT 78, PM (4). Feathered centerpiece: TT 76, PM (5); TT 77, PM (4); TT 89, PM (15). Cord with papyrus umbels: TT 76, PM (5); TT 120, PM (3). Bull's tail: TT 64, PM (5) & (8); TT 75, PM (3); TT 76, PM (5); TT 78, PM (4) & (8); TT 89, PM (15); TT 116, PM (2); TT 120, PM (3); TT 226, PM (4). Sash: TT 63, PM (5); TT 64, PM (5); TT 77, PM (4); TT 89, PM (15); TT 91, PM (5). Where the feet are preserved, all the kings wear white sandals.

Additional elements included the *shebyu*-collar or the *wah*-collar.[72] This type of ornamentation was largely solar in its association and reflected the king's assimilation with the sun god in the eternal, unchanging time of the afterlife. W. Raymond Johnson discussed this solar ornamentation regarding the image of Amenhotep III in his fourth decade of reign:[73]

> Amenhotep's complex costumes with their long pleated skirts, overgarments, and multiple sashes are festooned with solar and funerary symbols....pendant cords tipped with sedge-plant blossoms and papyrus umbels, gold-disc *shebyu* necklaces, associated armbands and bracelets, broad floral *wah*-collars, falcon-tail sporrans (aprons), and sporran cobras crowned with sun discs all make their appearance.....In private tombs starting from the time of Amenhotep III's grandfather Amenhotep II, the king was often depicted on the tomb walls enshrined and wearing the very same costumes and solar iconography. The king in these tomb scenes is shown in eternal time after his eventual death and is identified in the accompanying inscriptions as the sun god Re. All Egyptian kings attained this sort of deification after their mortal deaths, "flying up to the sun disc" in the form of a falcon and uniting with the sun, becoming one with their divine father. The kings in these scenes are often wearing the *shebyu*-collar of gold-disc beads, which, when presented to a private person by the king as a reward, represented an elevation in that person's status. Around the neck of the king they reflect the change in the deceased king's state-of-being in the eternal time of the afterlife, the result of his assimilation and identification with his father the sun.

In terms of insignia, the symbolism of the royal crown evoked important aspects of kingship in ancient Egypt. In the Royal Kiosk Icon, the Blue Crown (*ḫprš*) was by far the most common crown worn by the pharaoh, and it identified the wearer as the inheritor of the royal *ka*.[74] This crown, by definition, was blue, although in several instances on the focal walls in this study, the blue appears to have degraded to black.[75] An alternate explanation may be that the color black was used instead of blue.[76] In several Royal Kiosk icons, the king wears the *šwty*-crown, composed of cow and ram horns surmounted by a sun disk and a pair of curved ostrich feathers. The crown was placed over a wig tied with a fillet (*ssd*) bearing a *uraeus*.[77] The combination of *šwty*-crown and *ssd*-fillet associated the wearer with Horus, as indicated by an eighteenth or nineteenth dynasty stela from Abydos, which states: "I have purified the head of Horus when he has received his *ssd*; O, I have fastened for him his *šwty*."[78] The term *ssd*, meaning "luminous," is found in ancient Egyptian funerary literature relating to the radiant appearance of the gods and the deceased.[79] The putting on of

[72] Broad collar, armbands, and bracelets: TT 63, PM (5), only bracelets preserved; TT 64, PM (5) bracelets not preserved & PM (8), broad collar and armbands not preserved; TT 75, PM (3), only armbands preserved; TT 76, PM (5); TT 77, PM (4) bracelets not preserved; TT 78, PM (4); TT 89, PM (15); TT 91, PM (3) armbands and bracelets not preserved & PM (5); TT 116, PM (2); TT 120, PM (3), broad collar not preserved; TT 226; PM (4). *Shebyu*- collar: TT 91, PM (5); TT 116, PM (2); TT 226, PM (4). *Wah*-collar: TT 226, PM (4). Pectoral: TT 78, PM (4); TT 91, PM (5) falcon pectoral (compare Carol Andrews, *Ancient Egyptian Jewellery* (London, 1996), 134, fig. 117); TT 116, PM (2).

[73] W. Raymond Johnson, "The Revolutionary Role of the Sun in the Reliefs and Statuary of Amenhotep III," *The Oriental Institute News and Notes*, no. 15 (Fall 1996), 2.

[74] Blue crown: TT 64, PM (5); TT 77, PM (4); TT 89, PM (15); TT 91, PM (3) & (5); TT 116, PM (2); TT 226, PM (4). Katja Goebs, "Crowns," *OEAE* I (2001), 324. Collier, "The Crowns of Pharaoh," 118-128. Collier stresses the connection of the *khepresh*-crown to the Kamutef Theology and the king's identification with Amun, through whom the king was regenerated and became heir to the throne. This identification is not entirely convincing. Examples of Nefertiti wearing the *khepresh* and Ramesses II sporting the blue crown in connection with the three creator gods (Amun, Re, Ptah) at Abu Simbel suggest that this crown may have been a more generalized symbol of the ruler's legitimacy to the throne.

[75] TT 64, PM (5); TT 116, PM (2). See discussion in: Lorna Green, "Colour transformations of ancient Egyptian pigments," in *Colour and Painting in Ancient Egypt*, edited by W.V. Davies (London, 2001), 44-45; and Lucas, *Materials*, 344.

[76] Blue and black were often interchangeable in the minds of the ancient Egyptians: R. Wilkinson, *Symbol & Magic*, 111; Lise Manniche, "The Body Colours of Gods and Men in Inlaid Jewellery and Related Objects from the Tomb of Tutankhamun," *Acta Orientalia* 43 (1982), 6.

[77] TT 75, PM (3); TT 76, PM (5). Terminology and symbolism of *šwty*-crown and the *ssd*-fillet in: Collier, "The Crowns of Pharaoh," 53-68.

[78] *w'b.n.[i] tp Hrw ššp.n.f ssd.f i smn.[i] n.f šwty.f.* Georges Daressy, "Remarques et notes," *RT* 11 (1889), 90-91.

[79] As, for example, in the Pyramid Texts and the *Book of Going Forth by Day*: "The falcon is spiritualized, his *ssd* is powerful, his rays are bright"; Édouard Naville, *Das ägyptischen Todtenbuch der XVIII. bis XX. Dynastie* (Berlin, 1886; reprint Austria, 1971), Ch. 78, l. 29; Goebs, *OEAE* I (2001), 324.

the fillet also corresponded to the reaffirmation of royal power during the Sed Festival and the Festival of the New Year.[80] It is significant that the ssd-fillet is worn by the king in the Royal Kiosk Icon when one of the adjacent icons relate to gift-giving within the context of the New Year's Festival (Figure 21).[81] In this context, the fillet worn by the king not only associated him with the living Horus but also may have represented the actual headband the ruler wore during the celebration of the New Year's Festival.

The nms-headdress and 3tf-crown also make their appearance in the royal kiosk. The 3tf-crown consists of a central element similar in form to the White Crown with two ostrich feathers to either side. To this could be added three sun disks, two uraei crowned by solar disks, and horizontal ram's horns with cow's horns on which all the components rested.[82] Symbolically, the 3tf-crown was the crown of kingship over the unified two lands and was closely associated with Osiris and Herishef (the united gods Re and Osiris). As discussed above, the nms-headdress was associated with the god Re and expressed the royal Son of Re name.[83] With its solar and Osirian elements, the nms-headdress and the 3tf-crown in TT 78 symbolized the uniting of Re and Osiris, rulers of the sky and the underworld.[84] Worn together by the king, these crowns may have related to his combined roles as the Son of Re and (Son of) Osiris in this world and assimilated with these gods in the hereafter.

In the Royal Kiosk Icon, the king and/or his fan-bearers hold a number of different elements that relate to the nature of his office. The hk3-scepter or Crook, and the Flail were the most common insignias of kingship. The hieroglyphic values of the forms of the Crook and Flail were "rule" (hk3) and "protect" (hwi), respectively.[85] Both implements were associated with Osiris, who likely inherited them from the god Andjety. Another common element held by the king was the ankh, the hieroglyphic sign for "life," which, as a symbol of an imperishable animating force, related to eternal existence.[86] In the Royal Kiosk Icon, the ruler could also wield the piriform mace, a royal weapon that signified the might of the king. The weapon had secondary solar associations as the hieroglyph for "bright" (hd).[87] Various staffs are held by the ruler, from the simple to the more ornate; one has two thorn-like outgrowths at the bottom.[88] In the Royal Kiosk Icon, both the staff and the club relate to the king's might and position as a ruler.

Other implements carried by royal fan-bearers relate to the office of the king in the Royal Kiosk Icon. The hts-scepter appears in a number of icons and is distinguished by its short handle and rounded, leafy form that resembled the lettuce plant.[89] Used for consecrating offerings, the hts-scepter emphasized the king's role as chief officiant before the gods. The piece of cloth held by fan-bearers is either a 'Steinkern' or a handkerchief with which to wipe off the royal sweat, and it may have held a secondary symbolic association because of its visual resemblance to the shoulder knot

[80] Jean-François Pecoil and Mahmoud Maher-Taha, "Quelques aspects du bandeau-seched," BSÉG 8 (1983), 79. On the Gift Icon, see above 3.2.4.

[81] Jean-Claude Goyon, Confirmation du pouvoir royal au nouvel an: Brooklyn Museum Papyrus 47.218.50, BdÉ 52 (Cairo, 1972), 20.

[82] TT 78, PM (4). See correct photograph of this crown in: Brack, Haremhab, taf. 86. In Figure 24, the king's crown is incorrectly drawn by Boussac (see also: Urbain Bouriant, "Tombeau de Harmhabi," Mém. Miss. V, 3 (1894), pl. III), which Collier, "The Crowns of Pharaoh," 204 (nms #13), mistakenly accepted to assert an early presence of the hmhm-crown.

[83] Goebs, OEAE I (2001), 323, 325.

[84] Collier, "Crowns of Pharaoh," 47-51, 146-147; Katja Goebs, "Untersuchungen zu Funktion und Symbolgehalt des nms," ZÄS 122 (1995), 180; idem, OEAE I (2001), 324. Goeb's study of the textual attestations of the word nms and its role in royal iconography found that the crown related to aspects of the 'heir to Osiris,' the 'helper and reviver of his father,' 'Horus, appearing in the form of a falcon,' and its aspect as a 'solar or sky divinity.' The Egyptian verb nms corresponds in meaning to 'illuminate, lighten.'

[85] Crook: TT 64, PM (8) (Champollion, Not. descr. I, 570), not shown on drawing; TT 76, PM (5); TT 77, PM (4) also held by [fan-bearer]; TT 78, PM (4) held by fan-bearers; TT 89, PM (15); TT 116, PM (2); TT 226, PM (4). Flail: TT 64, PM (8); TT 77, PM (4); TT 78, PM (4); TT 90, PM (9); TT 120, PM (3); TT 226, PM (4) and with fan-bearers. Discussion of both in: Percy E. Newberry, "The shepherd's crook and the so-called 'flail' or 'scourge' of Osiris," JEA 15 (1929), 84-94; Henry G. Fischer, "Geissel," LÄ II (1977), 516-517; Peter Kaplony, "Zepter," LÄ VI (1986), 1376-1389; Graham, OEAE II (2001), 165.

[86] Ankh: TT 63, PM (4); TT 64, PM (8); TT 76, PM (5); TT 78, PM (4); TT 89, PM (15); TT 116, PM (2); TT 120, PM (3); TT 226, PM (4). Lurker, Gods and Symbols, 27; Shaw and Nicholson, Dictionary of Ancient Egypt, 34.

[87] Gardiner, EG(3), Sign-list T 3. Found in: TT 78, PM (4); TT 91, PM (5); TT 226, PM (4). Symbolism in: Graham, OEAE II (2001), 165.

[88] Staffs found in: TT 77, PM (7), not on Manniche's drawing; TT 91, PM (3) & (5); with two thorn-like outgrowths: TT 78, PM (4) (Figure 24); TT 64, PM (5). Henry G. Fischer, "Notes on Sticks and Staves in Ancient Egypt," MMJ 13 (1978), 17-18, with figure 24, found the forked staff in a twelfth dynasty hieroglyph for "sovereign." See also the staff held in the hieroglyph in Gardiner, EG(3), A 23.

[89] TT 76, PM (5); TT 78, PM (4); TT 90, PM (9); TT 91, PM (5); TT 226, PM (4). Kaplony, LÄ VI (1986), 1374, with n. 8.

hieroglyph *s t t*, which Westendorf interprets as the "loop of rebirth."[90] In one tomb, the fan-bearers hold a battle axe with the blade turned towards them (Figure 30). Turned thus with the blade facing away from the dominant subject, the battle axe reinforced the king's dominance because it was he who would wield the axe in order to protect Egypt's domain.[91]

The preserved titles of the king in the Royal Kiosk Icon establish his identity and stress aspects of kingship as well as the ruler's divinity in this world and the next.[92] This is illustrated by the following text associated with the Royal Kiosk Icon in the tomb of Amenmose (TT 89) (Figure 28):[93]

(1)The Perfect God, Lord of the Two Lands, Lord of Rituals, Lord of Appearances, who takes possession of the beautiful White Crown, (2) King of Upper and Lower Egypt, *Neb-Maat-Re*, (3) Son of Re, Amenhotep, ruler of Thebes, (4) given life like Re, (5) beloved of Amun-re.

The titles of the king reflect his many roles by emphasizing the ruler's divinity, his dominion over Egypt, his theoretical responsibility for the daily temple rituals to the gods, his solar aspects, his filial connection to the Creator God Re, his special relationship to Thebes, and his dominion over Egypt. As "Lord of Rituals," the king performed rites for the gods in the temples to guarantee their continued functioning and prevent them from abandoning humankind.[94] The king, as conqueror of Egypt's enemies, tamed disorder and maintained *Maat* in the realm. As the representative of the gods on earth, the king was the terrestrial embodiment of Horus, the son of Re in life and Osiris in death. Furthermore, the cartouches in which his nomen and prenomen were written visually symbolized "that which Re, the sun god, encircles."[95]

In one instance in the Royal Kiosk Icon, a large standing composite bouquet of papyrus stalks, poppy petals, and lotus blossoms is placed at the king's feet (Figure 35). The symbolism of the bouquet will be discussed at length below in situations in which the tomb owner offers it to the king. However, a few points can be addressed here. Bouquets in ancient Egypt were primarily composed of lotus and papyrus, which were highly symbolic plants in the ancient Egyptian world view. Papyrus signified the protective marsh thicket of Chemmis, where Horus was born and raised.[96] Thus, papyrus was associated with Horus, who was the protector of the king and the embodiment of divine kingship.

[90] TT 76, PM (5); TT 78, PM (4); TT 90, PM (9); TT 91, PM (5); TT 226, PM (4). As a *Steinkern*: Wilhelm Spiegelberg, "Der 'Steinkern' in der hand von Statuen," *Rec. Trav.* 28 (1906), 174-176; as a handkerchief: Henry G. Fischer, "An Elusive Shape within the Fisted Hands of Egyptian Statues," *MMJ* 10 (1975), 148-155. As shoulder knot: Wolfhart Westendorf, "Bemerkungen zur 'Kammer der Wiedergeburt' im Tutanchamungrab," *ZÄS* 94 (1967), 148, n. 56. See also Wolfgang Helck, "Taschentuch," *LÄ* VI (1986), 238, with bibliography; and Melinda K. Hartwig, "Fist holding a cylindrical object," in *The Collector's Eye: Masterpieces of Egyptian Art from The Thalassic Collection, Ltd.*, edited by P. Lacovara, B. Trope, and S. D'Auria (Atlanta, 2001), 68.

[91] TT 90, PM (9). On the turned bow, see: Richard H. Wilkinson, "The Turned Bow in Egyptian Iconography," *VA* 4 (1988), 181-187; idem, "The Representation of the Bow in the Art of Ancient Egypt and the Near East," *JANES* 20 (1991), 83-99. On axes: Ian Shaw, *Egyptian Warfare and Weapons*, Shire Egyptology 16 (Princes Risborough, 1991), 34-37; James K. Hoffmeier, "Military: Materiel," *OEAE* II (2001), 407.

[92] Preserved portions of royal titularies in Royal Kiosk Icon: TT 63, PM (5) (Dziobek and Raziq, *Sobekhotep*, 37, text 5a); TT 64, PM (5) & (8) (nomen and prenomen were recorded by Champollion, *Not. descr.* I, 570; Lepsius, *Denkmäler*, text III, 260), not shown in drawing; TT 75, PM (3); TT 76, PM (5), TT 77, PM (4) (Manniche, *Three Theban Tombs*, 22); TT 78, PM (4) & (8) (Brack, *Haremhab*, 31, text 13a; 32, Abb. 14, 13a; 37, Abb. 19a, text 16a); TT 89, PM (15); TT 90, PM (9); TT 91, PM (3) & (5); TT 116, PM (2) reading: *[ntr nfr] s3 R' Dhwty-ms h'i h'w {over} Imn-htp hk3 w3st 'nh dt mi R' r' nb snb nb...*" [The Perfect God], Son of Re, Thutmose, shining of appearances {over} Amenhotep, ruler of Thebes, living eternally like Re, every day, all health..."; TT 120, PM (3); TT 226, PM (4) (Davies, *Menkheperrasonb*, 38). On the various roles of the king: David O'Connor and David P. Silverman, ed., *Ancient Egyptian Kingship*, PÄ 9 (Leiden, 1995); Marie-Ange Bonhême, "Royal Roles," translated from the French by E. Schwaiger, *OEAE* III (2001), 161-163; Ulrich H. Luft, "Religion," *OEAE* III (2001), 143-144. On the dual (sacred/profane) nature of kingship: Georges Posener, *De la divinité du Pharaon*, Cahiers de la Société Asiatique 15 (Paris, 1960).

[93] Reading: (1) *ntr nfr nb t3wy nb ir(t)-ht nb h'w itt nfrt hdt* (2) *nsw-bity Nb-M3't-R'* (3) *s3 R' Imn-htp hk3 W3st* (4) *di 'nh mi R'* (5) *mry Imn-R'*. Titulary of TT 89: Radwan, *Königs*, pl. XXI; Lila Pinch Brock and Roberta Lawrie Shaw, "The Royal Ontario Museum Epigraphic Project-Theban Tomb 89 Preliminary Report," *JARCE* 34 (1997), 176-177.

[94] *íri-ht* in: Penelope Wilson, *A Ptolemaic Lexikon*, OLA 78 (Leuven, 1997), 88.

[95] For the meaning of the titulary, see: Stephen Quirke, *Who Were the Pharaohs? A history of their names with a list of cartouches* (New York, 1990), 9-19; Ronald J. Leprohon, "Titulary," *OEAE* III (2001), 409-411; Peter Kaplony, "Königstitulatur," *LÄ* III (1980), 642-659. Symbolism of cartouche: Schott, *Studium Generale* 5 (1953), 281.

[96] On the symbolism of papyrus, see: Lurker, *Gods and Symbols*, 94; Johanna Dittmar, *Blumen und Blumensträusse als Opfergabe im alten Ägypten*, MÄS 43 (Munich-Berlin, 1986), 133-143; Sylvia Schoske, Barbara Kreissl, and Renate Germer, *"Anch" Blumen für das Leben: Pflanzen im alten Ägypten*, SAS 6 (Munich, 1992), 56-58; Shaw and Nicholson, *Dictionary of Ancient Egypt*, 197; Doha M. Mostafa, "L'usage culturel du bouquet et sa signification symbolique," in *Hommages à Jean Leclant*, vol. 4, edited by C. Berger, G. Clerc, and N. Grimal, BdÉ 106/4 (1994), 244. While Dittmar, *Blumen*, 133-143, uses largely Greco-Roman examples in discussing the symbolism of the papyrus plant, she references a number of spells from the Coffin Texts (Ibid., 140-141) that agree with the symbolism found in later Ptolemaic texts.

Epithets associated with papyrus evoke the concept of continual life and creation in phrases such as "the papyrus of life," a concept reinforced by the papyrus stalk hieroglyph *w3ḏ*, meaning "growth." Papyrus also appeared as a structural member in temple architecture as columns, evoking the idea of the world rising out of the primeval waters of Nun. As the heraldic plant of Lower Egypt, the papyrus was connected to kingship and aided the king in conquering foreign lands and fending off enemies.[97] The ancient Egyptians also saw papyrus as a protective symbol, often taking the form of a scepter held in the hands of mother goddesses like Hathor.

　　The lotus flower or water lily was equated with the concept of rebirth and regeneration by the ancient Egyptians.[98] The action of the blue lotus flower – blooming at sunrise, closing in the evening, sinking into the water, only to rise and open again the next morning – was connected by the ancient Egyptians to the daily cycle and regeneration of the sun. The white lotus is a night blooming flower and also signified rebirth.[99] In Chapter 15 of the *Book of Going Forth by Day*, the sun god Re appears as a golden youth who was born from a lotus, and in Chapter 81, the deceased asks to be transformed into a lotus, in a statement that expresses his or her desire for rebirth.[100] Later in the New Kingdom, the lotus became the symbol of creation rising out of the primeval waters.[101]

　　In the New Kingdom, the most frequent word for bouquet was the same as the word for "life," ankh (*'nḫ*).[102] In the Royal Kiosk Icon in the tomb of Anen (TT 120), the *ankh*-bouquet is tilted towards the king's nose in a way that visually recalls the gods holding the sign for life to the nose of a ruler, and this would provide the ruler with eternal rejuvenation (Figure 35). By sniffing the divine scent of the bouquet, the king would partake of the protection and eternal life promised by the flowers. More will be said about the presentation of the bouquet offering and its relevance to the tomb owner below.

　　In the Royal Kiosk Icon, a number of divine or royal individuals accompanied the king. Hathor makes an appearance, either seated on a *ḥwt*-block throne covered with feather-decoration or standing before the king, offering him gifts.[103] In all cases, her titles refer to her funerary aspect as "Hathor, Mistress of Thebes." On another level, Hathor wraps the king in a maternal embrace, symbolizing her role as the mother of Horus, the god whom the king embodied on earth.[104] The protective and life-giving symbolism of Hathor is also reinforced by the gifts she presents to the king: the *ankh* of life and the *menit* (Figures 31 and 32). The *menit*, a beaded necklace with a counterbalance in the back, was sacred to Hathor and was imbued with the goddess's healing power. The rattle of the *menit* and the *sistrum*, the other instrument sacred to Hathor, were protective objects used to pacify the gods and banish evil. Egyptian texts tell of the

[97] Dittmar, *Blumen*, 138-139, with references; Mostafa, *Hommages à Jean Leclant*, 245.

[98] Emma Brunner-Traut, "Lotos," *LÄ* III (1980), 1091-1095; Dittmar, *Blumen*, 132-133; Stephan Weidner, *Lotos im Alten Ägypten* (Freiburg, 1985); Renate Germer, "Flowers," translated from the German by J. Harvey, *OEAE* I (2001), 541-542.

[99] Renate Germer, "Flora," translated from the German by J. Harvey, *OEAE* I (2001), 536; W. Benson Harer, Jr., M.D., "Lotus," *OEAE* II (2001), 305.

[100] Chapter 15: Jan Assmann, *Ägyptische Hymnen und Gebete*, 2d rev. ed. (Göttingen, 1999), 131, 43. Chapter 81A: Raymond O. Faulkner, *The Ancient Egyptian Book of the Dead*, rev. ed. (London, 1985), 79. See also: Lurker, *Gods and Symbols*, 78; Hermann Schlögl, "Gott auf der Blume," *LÄ* II (1977), 786.

[101] Adolf Erman, "Gebete eines ungerecht Verfolgten und andere Ostraka aus den Königsgräbern," *ZÄS* 38 (1900), 23-25; Hermann Schlögl, *Der Sonnengott auf der Blüte: Eine ägyptische Kosmogonie des Neuen Reiches*, AH 5 (Genève, 1977), 33-34.

[102] On the etymology of the term *'nḫ* and its definition as "bouquet," see Dittmar, *Blumen*, 132, 148. Its meaning is discussed by L. Bell, *Temples*, 137, n. 43, 183.

[103] Hathor: TT 76, PM (5), and TT 89, PM (15), where she is seated on a *ḥwt*-block throne, but her fingers on the king's shoulder are not indicated; TT 91, PM (3) & (5), standing, offering a *menit* and an *ankh*.

[104] In Egyptian religion, Hathor's role as mother of Horus (based on the metaphorical reading of *ḥwt* as "womb") gradually expanded to encompass that of mother and wife of Re, as Re superceded Horus in kingship mythology. Hathor was believed to be impregnated by and gave birth to the sun god each day. Bonnet, *Reallexikon*, 279-280; François Daumas, "Hathor," *LÄ* II (1977), 1024-1033; Deborah Vischak, "Hathor," *OEAE* II (2001), 84-85. On her symbolism in kiosk representations: Radwan, *Königs*, 106.

revivifying power of the *menit*, which was delivered by placing one's hands on it.[105] Its name also relates to the word for nurse, *mn 't*.[106]

The goddess Maat also appears in the Royal Kiosk Icon, where she stands behind the king and wraps a protective arm around his shoulders.[107] The presence of Maat, as the daughter of the sun god Re, reinforces the solar symbolism present in the icon. Her appearance also alludes to the ruler's primary duty: to maintain *M3 't* or "truth, order, and cosmic balance" by correct and just rule and by his service to the gods, through which the order of the cosmos would be maintained.

Wives and mothers also accompany the king in the Royal Kiosk Icon. In TT 226, the king's mother Mutemwia stands next to her son, embracing him and wearing the vulture crown (Figure 43). In the tomb of Anen (TT 120), Tiy, the primary wife of Amenhotep III, is seated next to her husband (Figure 35). Although the crown does not appear in Davies' drawing, Tiy wears the vulture crown with the heads of Nekhbet and Wadjet attached, surmounted by two feathers set on a platform.[108] The vulture crown associated Tiy with the goddess Mut, the consort of Amun-Re, and emphasized the queen's maternal role. Other elements on her crown add an additional layer of symbolism: The platform relates to the marsh of Chemmis, the two feathers signify the two horizons or two solar eyes, and the two ladies symbolize Upper and Lower Egypt. Together, these components of Tiy's crown relate to protection, renewal, and unity.[109] Tiy also holds a flail and *ankh*-sign bouquet composed of lotus flowers, perhaps as a visual reinforcement for the word "bouquet" (*'nḫ*).[110] Thus, the iconography of wives and mothers added a protective, maternal dimension to the royal ideology inherent in the Royal Kiosk Icon.

In a number of Royal Kiosk icons, the royal *ka* stands behind the king and is identified by the open arms of the *ka*-sign that rests on his head, enclosing the ruler's Horus or *ka*-name. The royal *ka* is also depicted holding a *Maat* feather, an *ankh*-sign, and a *mdw-špsy* staff surmounted by a human head.[111] As explained by Lanny Bell, the king's *ka* was a fragment of the collective royal *ka* of all kings past and present.[112] The royal *ka* was the immortal nature of divine kingship that inhabited and animated the body of the king until his death, when it would pass to the new king. The royal *ka* was also the earthly form of the collective *ka* of the Creator God. The function of the royal *ka* was to establish the ruler's link to his ancestral royal clan and thus establish his legitimacy on the throne. The royal *ka* reaffirmed the king's divine origins and earthly right to rule. His *ka*, by holding the *Maat*-feather, indicates that the king's rule is governed and maintained by *Maat*. The *mdw-špsy* staff, also referred to as *'nḫ*, was regarded as the manifestation of the royal *ka*. Therefore, the iconography of the royal *ka*-figure related the king's connection to his royal clan of ancestors, thereby reaffirming his legitimacy to the throne and his earthly right to rule as part of the collective *ka* of the Creator God.

[105] *Menit* and sistrum in: Bonnet, *Reallexikon*, 450-451, with bibliography; Lurker, *Gods and Symbols*, 79; Christiane Ziegler, "Music," in *Egypt's Golden Age: The Art of Living in the New Kingdom 1558-1085 B.C.*, edited by E. Brovarski, S.K. Doll, and R.E. Freed (Boston, 1982), 256; Robins, *Women in Ancient Egypt*, 145-146, 164; L. Bell, *Temples*, 183-184.

[106] Ruth Schumann-Antelme and Stéphane Rossini, *Sacred Sexuality in Ancient Egypt*, translated from the French by J. Graham (Vermont, 2001), 44. On nurses, see: Catharine Roehrig, "The Eighteenth Dynasty titles royal nurse (*mn 't nswt*), royal tutor (*mn ' nswt*), and foster brother/sister of the Lord of the Two Lands (*sn/snt mn ' n nb t3wy*)," (Ph.D. dissertation, University of California-Berkeley,1990); Erika Feucht, "Childhood," *OEAE* I (2001), 261-262.

[107] Maat: TT 78, PM (4), the fingers of the goddess are not shown on Boussacs' drawing, and she may appear on PM (8). Brack, *Haremhab*, 31 with n. 130, 36, is undecided on the identity of the figures in TT 78, but Radwan, *Königs*, 7, n. 21, identified at least one of them as the goddess Maat based on similar example in the tomb of Ramose (Norman de Garis Davies, *The tomb of the vizier Ramose*, Mond Excavations at Thebes I (London, 1941), pl. XXIX). On the relationship between Maat and kingship, see: Teeter, *OEAE* II (2001), 319.

[108] See discussion in: Norman de Garis Davies, "The Graphic Work of the Expedition," *BMMA*, part II (November, 1928-1929), 38.

[109] Lana Troy, *Patterns of Queenship in Ancient Egyptian Myth and History,* Boreas 14 (Uppsala, 1986), 115-131; Goebs, *OEAE* I (2001), 325.

[110] Interestingly enough, Tiy holds similar implements such as the *ankh* and a slightly different flail than her husband's – a reflection, perhaps, of her central role during her husband's rule. On Tiy, see: Marianne Eaton-Krauss, "Tiye," *OEAE* III (2001), 411.

[111] TT 63, PM (5) with top of pole and the *ankh*-sign destroyed; TT 63, PM (10) royal *ka* reconstructed by Dziobek and Raziq, *Sobekhotep*, taf. 33, presumably on analogy with PM (5); TT 64, PM (5), top of staff destroyed; TT 64, PM (8) with the *ankh*-sign, top of pole destroyed; TT 75, PM (3) with feather and *ankh*-sign. On the iconography of the royal *ka*-figure, see: L. Bell, *Temples*, 142-145, 183-184.

[112] Lanny Bell, "Luxor Temple and the Cult of the Royal *Ka*," *JNES* 44 (1985), 251-294; idem, *Temples*, 127-184; David Moyer, "Symposium: Temples, Tombs, and the Egyptian Universe," *KMT: A Modern Journal of Ancient Egypt* (Summer, 1994), 64, 78-79.

A few other figures are present in the Royal Kiosk Icon, including fan-bearers, anthropoid fan-bearing *ankh*-signs, sunshades, and the king's bodyguard.[113] The fan-bearers are depicted holding fans aloft towards the king. Anthropomorphic *ankh*-signs fanning the king recall temple reliefs in which the *ankh*-sign was passed from the gods to the king to give him the breath of life. By fanning the king within the permanent time of the hereafter, the anthropomorphic *ankh*-sign would continually give the king eternal life. The ostrich feather sunshade, on the other hand, is found in the Royal Kiosk Icon behind the king, alone or held by an anthropomorphic *ankh*. The sunshade was meant to protect the king from the heat of the sun, but through its secondary associations, the sunshade was symbolic of the divine presence inhabiting the ruler.[114]

The king's bodyguard often appears in the register below the kiosk.[115] The fact that the bodyguards were represented beneath the king, slightly to the front, and are oriented in the same direction as the ruler suggests that they are to be understood as belonging to him. In TT 91, the royal bodyguard is composed of Nubian soldiers, as characterized by their hairstyles, dress and stereotypical physiognomy, who kneel and adore the king, accompanied by the caption "giving praise to the Lord of the Two Lands by the escort of his Majesty" (Figure 32).[116] The king's bodyguard are frequently depicted with weapons (battle axes, throw sticks) and colorful animal hide shields. The troops could also be accompanied by lions, which, as mentioned above, were guardian figures with solar associations associated with Egyptian kingship.

In terms of the ethnicity of the bodyguard, foreigners settled early on in Egypt and found employment as mercenaries and royal protectors.[117] As soldiers, these men were charged with the protection of the Two Lands, which revealed the rather ambiguous relationship Egypt had with foreigners. While they are often referenced as the embodiment of evil, foreigners also appear in literature and texts as "good" and part of the Egyptian cultural framework.[118] Within the context of the Royal Kiosk Icon, these soldiers represent the guard that protected the king in life but in death may have acted as an apotropaic motif to protect him in the hereafter.

To summarize the previous discussion of the iconography in the Royal Kiosk Icon, the king seated in a kiosk was composed of a number of divine and royal symbols that emphasized the nature of kingship in ancient Egypt in this world and the next. The figural and structural components of the Royal Kiosk Icon conveyed information about kingship as incarnated by the ruler who was the earthly embodiment of Horus; the son of Re in life and assimilated with Re and Osiris in death; the upholder of *Maat* and the repeller of chaos; the legitimate heir of the royal *ka*; the delegate of the gods on earth charged with the running of the state; and a terrestrial symbol of power who held sway over the dominion of Egypt. Apotropaic imagery in the royal kiosk protected the king and supported cosmic order. In essence, the Royal Kiosk Icon depicted the king as a commemorative symbol of rulership in this world. At the same time, in linear and cyclical eternity, the king was ritually projected into the permanent time of the afterlife (*ḏt*) and joined with the repeated rejuvenations (*nḥḥ*) of his father, the sun god Re.

[113] Figures of fan-bearers: TT 76, PM (5); TT 77, PM (4) & (7); TT 78, PM (4); TT 90, PM (9); TT 91, PM (3) & (5) (in PM (5) note the top layer of plaster has fallen away revealing the original preliminary drawing underneath, see Figure 32); TT 226, PM (4). Anthropomorphic fan-bearers: TT 64, PM (8); TT 89, PM (15). On symbolic meaning: R. Wilkinson, *Symbol & Magic*, 160. The tomb owner as fan-bearer will be dealt with below under the tomb owner offering to the king (TT 64, PM (5); TT 116, PM (2)).

[114] TT 91, PM (3) & (5); TT 116, PM (2). L. Bell, *Mélanges Gamal Eddin Mokhtar,* 31-59, esp. 33-34 with bibliography; Lurker, *Gods and Symbols,* 51, 110; Bonnet, *Reallexikon,* 178.

[115] Bodyguard in TT 78, PM (8) introduced by trumpeter; TT 90, PM (4) & (9) with chariot (Davies, *Two officials,* 34); TT 91, PM (3) & (5) with lions; TT 201, PM (7) with horses (B&W Plate 2,2).

[116] *Urk. IV,* 1599; Cumming, *Egyptian Historical Records* III, 293.

[117] Rosemarie Drenkhahn, "Leibwache," *LÄ* III (1980), 993-994; Shaw, *Egyptian Warfare,* 27-28. On the ethnicity of the royal bodyguard, see: Rosemarie Drenkhahn, "Darstellungen von Negern in Ägypten," Dissertation zur Erlangung der Doktorwürde der Philosophischen Fakultät der Universität Hamburg, 1967, 100-103; and Radwan, *Königs,* 57, 60. See also: Edda Bresciani, "Foreigners," in *The Egyptians,* edited by S. Donadoni and translated from the Italian by B. Bianchi (Chicago, 1997), 224-225.

[118] On characterizations of Nubians and their place in the cultural framework of Egypt, see: Antonio Loprieno, *Topos und Mimesis: Zum Ausländer in der ägyptischen Litteratur,* ÄA 48 (Wiesbaden, 1988); David O'Connor, "Egypt's View of 'Others'," in *'Never Had the Like Occurred': Egypt's View of its Past,* edited by J. Tait, Encounters with Ancient Egypt (London, 2003), 155-186.

The final component in the Royal Kiosk Icon concerns the tomb owner's offering of various gifts to the king. These offerings operate on a number of different levels and are particularly significant to the overall meaning of the icon. The first type of gift, a bouquet or an offering stand with lotus flowers and papyrus, is given by the tomb owner to the king enthroned in a kiosk.[119] The presentation of a bouquet that contained papyrus and lotus may have been the usual tribute given to the king by an official when he was received during a royal audience,[120] but it is also a highly symbolic act that indicated the transfer of the magical force inherent in the plants.[121] Bouquets were presented by the gods to the king, from the king to the gods, from the ruler to officials, by officials to a deity or the king, or between private individuals.[122] However, the bouquet's meaning varied according to the hierarchical status of the presenter and the receiver. The caption that accompanied a number of these motifs reveals the underlying symbolism inherent in the offering act:[123]

> Coming in peace [carrying a life-bouquet of Amun, lord of the Thrones of the Two Lands in][124] Karnak. May he praise you (i.e. reward) you, may he love you, may he cause that you endure. [May he give] you life, stability and [dominion], bravery and strength against all lands. [Fear of you] is in the hearts of the southern lands [as] your noble [father Amun decreed, lord of the Thrones of the Two Lands, all foreign lands being] under your sandals. May you live like Re! (Said) by the Prince and Count, Seal-bearer of the King of Lower Egypt [the Second Prophet of Amun, Amenhotep-si-se, justified].

As the text indicates, the bouquet carried the name of the god or the temple from which it came. The bouquet mediated the god's good wishes and power to guarantee the ruler triumph, dominion over his enemies, and the promise of eternal rule. The ancient Egyptians believed that the gods themselves were present in the bouquets through the divine scent of the flowers.[125] As stated above, symbolically, the ancient Egyptian word for bouquet, *ankh* (*'nḫ*), had the same consonantal value as the ancient Egyptian word for "life." Composed of plants and flowers that symbolized eternal life, protection, and divine kingship, the action of presenting a bouquet to the king visually recalled the god's holding the *ankh*-sign to the nose of the king, which provided him with strength and rebirth. However, in this case, both the mechanism and hierarchical relationship are different: A subservient being (the tomb owner) offers the king "life" in the form of a bouquet. This would lead us to believe that secondary symbolism is present in the offering of the bouquet.

In Egyptian religion, the king was the intercessor and link between god and man, and, as such, the king was responsible for humanity.[126] As the representative of humanity to the gods, the king presented offerings to various deities to ensure the well-being of the land and the order of the cosmos. In essence, the ruler's offering action was based on a reciprocal "I give in order that you give" relationship (*do-ut-des*), a concept reflected in statements from ancient Egyptian

[119] TT 64, PM (5) & (8); TT 74, PM (6); TT 75, PM (3); TT 77, PM (7); TT 78, PM (4); TT 90, PM (9); TT 91, PM (3) & (5); TT 116, PM (2) with woman offering a bouquet to the king. On TT 63, PM (5), Dziobek and Raziq, *Sobekhotep*, 37, taf. 43, offer a reconstruction of a bouquet offering scene, although they qualify this by saying: "So ist es auch nicht einfach zu entscheiden, was Sobekhotep dem König darbot."

[120] Cyril Aldred, "The Foreign Gifts Offered to Pharaoh," *JEA* 56 (1970), 76. Also the interpretation accepted by Sherine El-Menshawy, "Pictorial Evidence Depicting the Interaction between the King and his People in Ancient Egypt," in *Current Research in Egyptology 2000*, edited by A. McDonald and C. Riggs, BAR International Series 909 (Oxford, 2000), 85.

[121] Bonnet, *Reallexikon*,120-121; Mostafa, *Hommages à Jean Leclant*, 245; Dittmar, *Blumen*, 125.

[122] Examples in: Dittmar, *Blumen*, 125-132. On later occurrences, see: Philippe Derchain, "La visite de Vespasien au Sérapéum d'Alexandrie," *CdÉ* 28, no. 56 (1953), 261-279.

[123] *Urk*. IV, 1210-1211; Davies, *Two officials*, 13, pl. XI.

[124] This reconstruction by Sethe from the tomb of the "Second Prophet of Amun" Amenhotep-si-se (TT 75) was based on a similar text in TT 86 on PM (8) belonging to Menkheperresoneb, "High Priest of Amun" (*Urk*. IV, 928, 16-17; *PM* I,1(2), 177-178). Note that Sethe's reconstruction of *iit m [htp r bw ḥr nsw ḥr 'nḫ n Imn nb nswt t3wy m] Ipt-swt* is too long to fit the column in TT 75; and Davies' reconstruction, *iit m [htp ḥr 'nḫ n Imn m] Ipt-swt*, is too short for the space (Davies, *Two officials*, 13, pl. XI).

[125] Bonnet, *Reallexikon*, 120-121; Dittmar, *Blumen*, 73, 127; Lurker, *Gods and Symbols*, 52.

[126] The sources that discuss the king's religious role as an intermediary between god and man are too numerous to detail. For purposes here, a few key sources will be mentioned: Morenz, *Egyptian Religion*, 40-41; Hornung, *Conceptions of God*, 201-204; Herman te Velde, "Mittler," *LÄ* IV (1982), 161-163; Ulrich H. Luft, "Religion," *OEAE* III (2001), 143-144, with bibliography.

didactic literature that say, "work for god, he will work for you also, with offerings that make the altar flourish."[127] In this reciprocal arrangement, the king made offerings to the gods, who responded by bestowing gifts on the king. The gifts exchanged were concerned with the preservation of life and the maintenance of order. However, the king acted in an intercessory capacity where a private offering is concerned. This is reflected in the *htp-dí-nsw* offering formula in which the king (*nsw*), gives (*dí*) offerings (*htp*, lit.: "satisfaction, contentment") to the god(s) on the behalf of an elite individual for his or her sustenance or well-being, reflecting the symbolic role of the king as chief officiant to the gods as well as his function as the source of all goods in ancient Egypt.[128] Used in private tombs, this offering formula relates, in theory, to the reversion of offerings, in which offerings given by the king to the gods in the temple went out into the necropolis to provide for the eternal well-being and prosperous afterlife of the dead. In essence, in the *htp-dí-nsw* formula and the reciprocal relationships that underlie it, the king appears as the provider of goods for the dead.

Eighteenth dynasty *htp-di-nsw* formulas contained requests for "all kinds of sweet-smelling flowers and all plants" given by the king to the god(s) on behalf of and for the benefit of the deceased.[129] In one eighteenth dynasty Theban tomb, the *htp-dí-nsw* offering formula is inscribed as a caption accompanying the action of the deceased presenting the life-bouquet to the pharaoh who was seated in his kiosk.[130] Other depictions place the king at the center or top of the composition in an intermediary position, adoring or offering to a deity, directly followed by the tomb owner or stelae patron who bears floral and other offerings.[131] These examples show the bouquet (i.e. "sweet smelling flowers") was a medium of exchange in a *htp-dí-nsw* arrangement through the intermediary of the king. Transferred to the Royal Kiosk Icon, the action of the deceased proffering a life-bouquet of papyrus (protection) and lotus (rebirth) to the king can be seen as a visual *htp-dí-nsw* offering in which the offering of life to the king would ultimately provide for the eternal life and protection of the deceased. The life-bouquet is also offered to the king in his potential or deceased deified state, assimilated with the gods in the eternal time of the hereafter, and thus the ruler is directly able to provide for the continual well-being of the tomb owner.[132]

Offering-bringers who appear on the lowermost register or registers leading to the royal kiosk present products symbolic of the Red Land and the Black Land to the pharaoh.[133] Only one tomb in this study preserves the original caption which addresses the offering to the king in terms of the phrase "for your *ka*, receiving all beautiful and pure plants" and identifies the bearers as brothers of Haremhab (Figure 24).[134] In the action of offering goods to the king,[135] the offering-bearers reinforce the life-bouquet gift to the ruler above. When offering friezes were not captioned as part

[127] Quote, "Teachings of Merikare," 129-130, in Lichtheim, *Ancient Egyptian Literature* I, 106. See also: Hartwig Altenmüller, "Opfer," *LÄ* IV (1982), 581; Hornung, *Conceptions of God*, 203-204, 213-215.

[128] See discussion in: Gertie Englund, "Offerings: An Overview," *OEAE* II (2001), 565-569; Leprohon, *OEAE* II (2001), 569-570; Hornung, *Conceptions of God*, 203-204, 213-215.

[129] Davies, *Ramose*, pls. 19, 21; idem, *Menkheperrasonb*, pl. 29; Cairo CG 34050 & CG 34099 in Dittmar, *Blumen*, 116-117.

[130] Radwan, *Königs*, 4 (TT 110). Another tomb, TT 73, (Ibid., 11) has the *htp-dí-nsw* formula above the tomb owner offering a pectoral to the king.

[131] W.M. Flinders Petrie, *History of Egypt,* vol. 2 (1897), 172-173, fig. 110; Auguste Mariette, *Catalogue général des monuments d'Abydos découverts pendant les fouilles de cette ville* I (Paris, 1880), no. 1061, with king's name in cartouche; Pierre Lacau, *Stèles du Nouvel Empire* (Cairo, 1909-1957), I, 10-11 (CG 34005), 44-45 (CG 34023), II, pl. V, XIV; H.M. Stewart, *Egyptian Stelae, Reliefs and Paintings from the Petrie Collection, Part One: The New Kingdom* (Warminster, 1976), pl. 41,1; Radwan, *Königs*, 42-43, taf. V (TT 85); idem, "Thutmosis III. als and idem, "Ramesses II as mediator," *Fragments of a Shattered Visage: The Proceedings of the International Symposium on Ramesses the Great*, edited by E. Bleiberg and R. Freed, Monographs of the Institute of Egyptian Art and Archaeology 1 (Memphis, 1991), 221-222, n. 7; idem, "Thutmosis III. als Gott," *Stationen: Beiträge yur Kulturgeschichte Ägyptens Rainer Stadelmann Gewidmet*, edited by H. Guksch and D. Polz (Mainz, 1999), 333-336.

[132] The idea of the image of the king offering to the gods on behalf of the deceased was first mentioned by Petrie, *History of Egypt*, 257, in reference to a stela; and was later expanded by Radwan, *Königs*, 10, n. 39, 39-40, 41-42, 106, to encompass the king's intermediary role on behalf of the eternal well-being of the deceased in the private tomb. On the role played by the king on behalf of the dead in the afterlife, see: Morenz, *Egyptian Religion*, 194; Dimitri Meeks and Christine Favard-Meeks, *Daily Life of the Egyptian Gods*, translated from the French by G.M. Goshgarian (Ithaca and London, 1997), 141; Maya Müller, "Afterlife," translated from the German by R.E. Shillenn and J. McGary, *OEAE* I (2001), 32-36.

[133] Bottom register: TT 77, PM (7); TT 78, PM (4); TT 90, PM (4); or registers directly adjacent to Royal Kiosk: TT 64, PM (8).

[134] TT 78, PM (4): Brack, *Haremhab*, 33, text 15, Abb. 17. Reading: *n k3.k ššp rnpwt nbt nfrt w'bt i[n]......snt(sic).f mrí.f hrí mg3 n hm.f Imn-m-h3t snt(sic).f mrí.f Imn-htp* "For your *Ka*, receiving all beautiful and pure plants by....his brother who he loves, the Chief of *Mg3*-soldiers of his Majesty, Amenemhat. His brother, who he loves, Amenhotep."

[135] Radwan, *Königs*, 6, n. 17, offers an intriguing suggestion about the common appearance of offering-bearers bringing gifts to the king. He posited that offering scenes conducted before the pharaoh's image in official's tombs acted as additional cult offerings to the royal funerary temple.

of the Royal Kiosk scene, we can assume that they could be read as reinforcements regarding the offering action of the deceased.[136] Offering formulas often reference products of the Red Land and the Black Land as reflections of the Egyptian cosmos in phrases that ask for "that which heaven gives, the earth creates and the Nile brings."[137] These products not only derive from the land under the control of the king but also reflect the symbolic role of the ruler who was the theoretical source of all goods in Egypt.

In the Royal Kiosk Icon, the tomb owner sometimes offers a gift that was representative of the objects produced in royal workshops which were given to the king during special celebrations.[138] In the tombs of Tjenuna (TT 76) (Figure 21) and TT 226 (Figure 43), the gift could take the form of a pectoral, which, to the ancient Egyptians, symbolized life and protection.[139] In TT 226, additional gifts are presented on a stand by the deceased in the form of royal accouterments such as bracelets, an armlet inscribed with the king's name, a beaded fillet with pendants, and possibly a crook (only the handle remains). Captions that accompany these scenes mention that the pectorals were offered by officials to the king as signs of loyalty and affection and to commemorate specific events.[140] In the tomb of Ptahemhet (TT 77), the tomb owner presents gifts symbolizing "good and pure things" commissioned by the king for his mortuary temple and "his father [Amun-re]" (Figure 22).[141] In the tomb of Sobekhotep, the tomb owner offers several necklaces and a golden stave that represent part of the foreign 'tribute' brought to the king (Figure 12).[142]

Golden ornamental vessels and other objects were offered by the deceased to the king in the Royal Kiosk Icon.[143] In the tomb of Tjanuny (TT 74), a caption above the deceased presenting a golden Syrio-Palestinian vessel describes it as part of the *inw* (official gifts) presented to the pharaoh (B&W Plate 4):[144]

> Presenting official gifts (*inw*) of Retenu, the taxes (*ḫrpwt*) of the northern foreign lands: electrum, lapis lazuli, turquoise and all precious stones of god's land, by the chiefs of all foreign lands when they come to the Good God in order to request the breath (of life) for their noses *(r dbḥ ṯ3w r fnd.sn)*. By the true royal scribe, whom he loves, the General, the Scribe of Recruits, Tjanuny.

Edward Bleiberg has defined *inw* as diplomatic gifts of commodities exchanged between the sovereign and subject nations that strengthened social and cultural ties.[145] The valuable items listed in the text represent the goods that were received by the king as part of the ceremonial display of foreign peoples.

[136] See captioned offering friezes in tombs outside of this study that reference the offering action of the deceased before the pharaoh: TT 72, PM (5), *Urk.* IV, 1458; TT 85, PM (9), *Urk.* IV, 922-925, and Philippe Virey, "Le tombeau d'Amenemheb," *Mem. Miss.* V,2 (1891), 236; TT 101, PM (5), Radwan, *Königs*, 6-7; TT 367, PM (5), *Urk.* IV, 1455-1456.

[137] Leprohon, *OEAE* II (2001), 570.

[138] TT 76, PM (5); TT 77, PM (7); TT 226, PM (4).

[139] Erika Feucht, "Pektorale," *LÄ* IV (1982), 923. The word "pectoral" *wd3* (Andrews, *Ancient Egyptian Jewellery*, 127) was also the same word for "prosperous" and serves as the root for *wd3w* "amulets." Pectorals offered by deceased: TT 76, PM (5); TT 226, PM (4).

[140] TT 76: *Urk.* IV, 1577, 10-18, reading: "Bringing....of fine gold being very many...his majesty hears your counsel......The 'Great One of the House' was appointed to 'Overseer of the Treasury'..........he [entrusted] him with his seal..........I....them under the authority..." (1) *st3[////] nt d'mw wrw* (3-6) [////] (7) *sdm ḥm.f ndwt-r. tn[////]dhn.tw* (8) *'3 n pr r imy-r ḥtmw [////////] [di].f sw m ḥtm.f [//////].i* (10) *///.sn r ḥt [...]*. TT 226: *Urk.* IV, 1877-1878, Davies, *Egyptian Historical Records* V, 41.

[141] *Urk.* IV, 1599. See titles also in a frieze cone belonging to Ptahemhet: Heike Guksch, "Ergänzungen zu den 'Ergänzungen zu Davies-Macadam, Cone Nr. 475,'" *GM* 47 (1981), 25; Manniche, *Three Theban Tombs*, 23. The text in the tomb of Ptahemhet (TT 77) places the inspection of gifts "in the great forecourt of the funerary temple of Thutmose IV in the [Temple of Amun]" whose construction and outfitting the tomb owner oversaw on behalf of the king. See also temple gifts arrayed above the excised figure of Ptahemhet.

[142] TT 63, PM (10) shows an openwork pectoral decorated with a striding sphinx and the remains of a golden stave which he may have held (compare Davies, *Menkheperrasonb*, pls. XLII); and a necklace with disk-shaped golden beads.

[143] Offering Syrio-Palestinian-type golden vase with small blue frog in center: TT 63, PM (10); TT 74, PM (11); for type, see: Heinrich Schäfer, *Die altägyptischen Prunkgefässe mit aufgesetzten Randverzierungen: ein Beitrag zur Geschichte der Goldschmiedekunst*, UGAÄ 4 (Leipzig, 1903), 3-44, esp. 41, Abb. 112. Syrio-Palestinian ornamental golden vases resting on stands before the king in the Royal Kiosk Icon: TT 78, PM (8) (Figure 26); TT 116, PM (2) with several vases on stands. Below offering stand carried by tomb owner: TT 91, PM (3); above offering stand carried by owner: TT 77, PM (7).

[144] TT 74, PM (11): Brack, *Tjanuni*, 40, text 29; Edward Bleiberg, *The Official Gift in Ancient Egypt* (Norman, Oklahoma and London, 1996), 104, no. 25. *Inw* is translated as "official gifts" in: Ibid., 117. A more neutral denotation of *inw* as "supplies" is found in Mario Liverani, *International relations in the ancient Near East, 1600-1100 BC* (New York, 2001), 179.

[145] Bleiberg, *The Official Gift*, 115-125; idem, "The Economy of Ancient Egypt," *CANE* III, 1380-1381.

According to Mario Liverani, the request for the "breath of life" by foreign chiefs functioned on an integrated political, theological, and economic level.[146] Politically, the monarch gave "life" to these vassal chiefs by allowing them to continue to rule. In this sense, the request for the "breath of life" expressed the foreign prince or envoy's wish for a treaty with Egypt.[147] Theologically, the king could grant the subject ruler eternal life if he shared an Egyptian world view. And, economically, the king allowed "life" to flourish through the distribution and redistribution of foreign goods, which resulted in the economic health of the state for which the monarch was responsible. Because of the king's aggressive foreign policy, trade goods, tribute, and raw materials flowed through Egypt, thereby increasing the country's prosperity.[148] The request does not differentiate between independent or subject rulers, but it stresses instead the all-powerful nature of the Egyptian king. All these levels were contained in the concept of the "breath of life," which the king granted to foreign nations.

These interrelated concepts of "life" are encapsulated in the golden ornamental vase offered by the tomb owner as an example of the official gifts presented to the pharaoh in the Royal Kiosk Icon. The vessel related to the high status of the official who was a participant in the *inw* ceremony, but it also symbolized the redistributive system in which the "life" dispensed by the king to his Egyptian and foreign subjects was ensured through the ruler's role as collector and distributor of foreign goods. By presenting the vessel, the tomb owner is depicted as a participant in the redistributive system and the life inherent in it.

In the tomb of Nebamun (TT 90), the deceased presents two registers of bound Mitanni captives to the pharaoh interspersed with official gifts and their bearers (Figure 30). Rather than existing as a separate scene, it is connected with the Royal Kiosk Icon through the action of the deceased who stands before the pharaoh offering a bouquet with one hand and bound prisoners with the other. The adjacent text spoken by the tomb owner, Nebamun, says: "For your *ka*....consisting of great plunder (*ḥ3k*)[149] [from your] very valiant armies and the children of the Mitanni *(Naharin)*."[150] The tomb owner conducts the bound prisoners and plunder in what was probably a formal ceremony around yr. 6 of Thutmose IV that showed Egypt's dominance over the Mitanni and rebellious Egyptian vassals.[151] On a cosmological level, the presence of bound prisoners before the king created a sympathetic reality in which the ruler and the state were eternally victorious over the Mitanni who, as foreigners, were considered by the ancient Egyptians to be the embodiment of earthly chaotic forces.[152] In royal *Maat* theology, the king's defeat of foreign enemies was linked to the sun god's defeat of chaos.[153] In the iconography of the Royal Kiosk Icon, the king appears as the son of Re and the upholder of *Maat* and is thus presented eternally defeating chaotic forces and maintaining order. In the eternal time of the afterlife, Nebamun's offering of defeated foreigners would also aid the king in his quest to subdue Egypt's enemies eternally.

In several Royal Kiosk icons, the deceased is portrayed in the act of fanning the king or praising him. By raising his arms in a gesture of praise, the deceased is shown honoring a higher power.[154] Most of the tomb owners who were

[146] Liverani, *International relations*, 98, 160-165, with bibliography. For the phrase "breath of life" in the tombs in this study, see: TT 74, PM (6): *Urk*. IV, 1007; TT 91, PM (5): *Urk*. IV, 159-158.

[147] David Lorton, *The Juridical Terminology of International Relations in Egyptian Texts through Dyn. XVIII* (Baltimore and London, 1974), 142-143, 146.

[148] Andrea M. Gnirs, "Ancient Egypt," in *War and Society in the Ancient and Medieval Worlds: Asia, the Mediterranean, Europe, and Mesoamerica*, edited by K. Raaflaub and N. Rosenstein, Center for Hellenic Studies Colloquia 3 (Cambridge, Mass., 1999), 84-85; Stuart Tyson Smith, "Imperialism," *OEAE* II (2001), 155-156.

[149] On *ḥ3k*: David Lorton, "Terminology Related to the Laws of Warfare in Dyn. XVIII," *JARCE* 11 (1974), 53-68, esp. 67.

[150] TT 90, PM (9); Davies, *Two officials*, pl. XXVIII; *Urk*. IV, 1620. This text and image in the tomb of Nebamun has been interpreted by Betsy Bryan as a tour taken by Thutmose IV in Syria to quash a rebellion in a vassal city, perhaps Sidon, Qatna, or Tunip; see: Bryan, *Thutmose IV*, 336-340.

[151] Betsy M. Bryan, "The 18th Dynasty before the Amarna Period (*c.* 1550-1352 BC)," in *The Oxford History of Ancient Egypt*, edited by I. Shaw (Oxford, 2000), 257-258.

[152] See similar bound prisoner imagery discussed in Ritner, *Ancient Egyptian Magical Practice*, 113-136.

[153] Jan Assmann, *Ma'at: Gerechtigkeit und Unsterblichkeit im alten Ägypten* (Munich, 1990), 51-54, 200-272; Smith, *OEAE* II (2001), 153.

[154] TT 90, PM (4). Gesture: R. Wilkinson, *Symbol & Magic*, 194-195; Emma Brunner-Traut, "Gesten," *LÄ* II (1977), 577-578, gesture 1c; Brigitte Dominicus, *Gesten und Gebärden in Darstellungen des Alten und Mittleren Reichs*, SAGA 10 (Heidelberg, 1994), 34-35.

depicted fanning the pharaoh held the titles of "Fan-Bearer on the Right of the King," and it is in these positions that they are commemorated on the back walls of their tombs.[155] The act of fanning the king indicated the tomb owner's place as a trusted official and reinforced magically his protection of the king as well as his gift of "life."[156] Unfortunately, in a few Royal Kiosk icons, the action and insignia of the tomb owner before the pharaoh cannot be reconstructed based on the poor state of preservation of the wall, although the presence of the tomb owner is indicated by the accompanying texts and their orientation.[157]

 In the Royal Kiosk Icon, tomb owners are shown as high-status individuals. Officials wear a combination of dress that included different wigs, bag tunics, aprons, and kilts, some of which had scalloped edges and fringed sashes.[158] Generally speaking, the more elaborate the dress, the higher the status of the individual. Insignia such as standards, scribal palettes, royal implements, and jewelry were also devices used to display the tomb owner's office and status.[159] In the Royal Kiosk Icon, several officials are depicted wearing the "Gold of Honor," an ensemble of one or more *shebyu* necklaces, a broad collar, a pair of double armlets, two bracelets, earrings, and signet rings that were awarded by the king to his most exceptional officials.[160] According to later Theban festival calendars, award ceremonies occurred once or twice a year and represented a special appearance of the king.[161] Through the reward ceremony, the flow of gold and gifts from the king was institutionalized and found its way into private hands. The Gold of Honor also signified an elevation of status when presented to a favored official by the king.[162]

 In a few instances, the tomb owner is also accompanied by family members in the Royal Kiosk Icon, and they may reinforce and elaborate on the deceased's personal status vis-à-vis the king. In TT 76, Tjenuny is depicted along with a male family member, offering a pectoral (Figure 21).[163] In TT 64, Hekarneheh is shown offering a papyrus to Thutmose IV behind the excised figure of his father, Hekareshu, who fans the king (Figure 13).[164] In TT 116, an unnamed woman

[155] TT 64, PM (5); TT 77, PM (7) (Manniche, *Three Theban Tombs*, 23), and perhaps TT 77, PM (4) based on the remains of a fan(?) held in the upraised arm of the excised figure of the deceased; TT 116, PM (2). On Fan-Bearer title: Irena Pomorska, *Les flabellifères à la droite du roi en Égypte ancienne*, Académie polonaise des sciences, Comité des études orientales (Warsaw, 1987), 32-35; and Bettina Schmitz, "Wedelträger," *LÄ* VI (1986), 1161-1163. On the assignment of Hekareshu as Fan-Bearer, see: *Urk.* IV, 1574; Ptahemhet as Fan-Bearer, see: Manniche, *Three Theban Tombs*, 9-11. It is unknown who owned TT 116 due to the extensive damage within the tomb. However, it is clear from the preserved texts that he was a *ḥȝty-ʿ* and a military official who was "[not absent from the Lord] of the Two Lands in the southern desert" (*Urk.* IV, 1602; WB-Zettel "Thebanische Gräber 952"). As for other examples of the "Fan-Bearer to the Right of the King" who is represented holding a fan, see: Davies, *Kenamun*, pl. IX (Pehsukher who owned TT 88); TT 85, Virey, *Mém. Miss.*, V,2 (1894), 237, fig. 3. As "King's Son of Kush" and "Fan-Bearer to the Right of the King," Merymose is shown on many of his monuments with a fan in his hand (see list of monuments in: Pomorska, *Les flabellifères*, 114-119); and Huy is shown fanning the king seated in his kiosk (Nina de Garis Davies and Alan H. Gardiner, *The Tomb of Huy, viceroy of Nubia in the reign of Tutʿankhamūn (no. 40)*, TTS IV (London, 1926), pls. XIX, XXII; C. Wilkinson, *Egyptian Wall Paintings*, 134-135, no. 30.4.21).

[156] This same fan is also used in the writing of the word *ḥwi*, meaning "to protect" (*Wb.* III, 244). On the fan and its relationship to life, see n. 113.

[157] TT 66, PM (6), no titles preserved; TT 63, see n. 119 on reconstruction.

[158] Assmann, *Schöne Frauen - schöne Männer*, 13-32. See discussion of different types of dress and their relation to the elite in: Gillian Vogelsang-Eastwood, *Pharaonic Egyptian Clothing*, Studies in Textile and Costume History 2 (Leiden-New York-Cologne, 1993); Lyn Green, "Clothing and Personal Adornment," *OEAE* I (2001), 274-279.

[159] Drenkhahn, *LÄ* V (1984), 1270-1271.

[160] TT 64, PM (5) Hekarneheh; TT 74, PM (11); TT 90, PM (4) & (9); TT 226, PM (4). On the Gold of Honor, see: Heinrich Schäfer, "Die Simonsche Holzfigur eines Königs der Amarnazeit," *ZÄS* 70 (1934), 10-13; Hildegard von Deines, "Das Gold der Tapferkeit, eine militärische Auszeichnung oder eine Belohnung?," *ZÄS* 79 (1954), 83-86; Erika Feucht, "Gold, Verleihung des," *LÄ* II (1977), 731-733. For a faience imitation of the *shebyu*-collar, see: Marianne Eaton-Krauss, "Disc beads," in *Egypt's Golden Age: The Art of Living in the New Kingdom 1558-1085 B.C.*, edited by E. Brovarski, S. K. Doll, R. E. Freed (Boston, 1982), 238-239, no. 316; Andrews, *Ancient Egyptian Jewellery*, 181-184.

[161] Kemp, *Anatomy*, 212-213, 259.

[162] W. Raymond Johnson, "The Deified Amenhotep III as the Living Re-Horakhty: Stylistic and Iconographic Considerations," in *Atti del VI Congresso Internazionale di Egittologia*, vol. 2 (Turin, 1993), 231-236; idem, "The *Nfrw*-collar Reconsidered," in *Gold of Praise: Studies on Ancient Egypt in Honor of Edward F. Wente*, edited by E. Teeter and J.A. Larson, SAOC 58 (Chicago, 1999), 232.

[163] This individual is not mentioned in any of the previous literature on TT 76 (*PM* I,1(2), 149-150; Torgny Säve-Söderbergh, *Four Eighteenth Dynasty Tombs*, PTT I (Oxford, 1957), 51). His identity as a family member is reconstructed here based on evidence in contemporary tombs in which the deceased is represented offering gifts to the king seated in a kiosk, accompanied by his three brothers (i.e., TT 72: Radwan, *Königs*, 6); or by his father (TT 64, see n. 164).

[164] Identified in the text, which reads: "The Prince and Count, God's Father, beloved of the God, firm of favor in the palace, (l.p.h.), Fan-Bearer on the Right [of] the King, who educated the divine person.......[the prophet of the] Great of Magic, Hekareshu. Bringing all (kinds of) good and pure plants...... [Hekarneheh]" (*Urk.* IV, 1574).

is represented offering lotus flowers behind the destroyed figure of the tomb owner (Figure 34). This woman may have been the tomb owner's wife and possibly a nurse to the king.[165] In TT 116, the woman holds a *menit*, which, as mentioned above, was an attribute of Hathor, the divine mother of Re and each reigning Horus-king, and bestowed life and protection when offered.[166] By offering the *menit* in the Royal Kiosk Icon, the woman not only offers a gift of life to the ruler, but the symbolism of the gift may indirectly relate to her position as nurse of the king.

The presence of the Royal Kiosk Icon on the focal walls of painted private Theban tomb chapels dating from the reigns of Thutmose IV and Amenhotep III suggests that the tomb owner saw his role in this world and in the next as one intimately associated with the king. As the monarch provided for the tomb owner in life, so too would the ruler ensure the official's mortuary provisioning and well-being in the next world. The mechanism to secure this arrangement is embedded in the iconography of gift-giving on the focal walls. Gifts offered by the tomb owner to the king symbolically spanned two temporal dimensions in the tomb chapel. The gift may have represented an actual gift given by the tomb owner during a formal audience with the king during his life, and, at the same time, it signified a continual gift offered to the ruler in the eternal time of the afterlife (*dt*). On a commemorative level, the gift conferred status on the deceased, who is shown in a personal relationship to the king. The tomb owner is also identified to visitors in the captions as an individual by his name, and as part of collective, institutional order through his titles.[167] By commemorating and preserving his institutional identity, the tomb owner would continue to function in his professional role in the king's reconstituted kingdom in the next world.[168]

Of the offerings given by the tomb owner to the king, many symbolically relate to life: *ankh*-bouquets imbued with divine essence; pectorals symbolizing life and protection; and foreign vessels as tokens to secure the ruler's "breath of life" with its political, economic, and religious benefits. According to Gertie Englund, all types of funerary offering gifts were called the "Eye of Horus" and participated in the preservation of life and regeneration.[169] Based on the Eye of Horus and its regeneration of Osiris in (i.e. *PT* 192), it also served as the mythic prototype for the dead whose vitality would be restored through the life inherent in the mortuary offerings.[170] By presenting these life-bearing objects to the ruler in the Royal Kiosk Icon, the tomb owner is depicted entering a *do-ut-des* offering situation with the king, in essence, creating a visual rendering of the *htp-di-nsw* formula. As discussed above, the offering formula or the *htp-di-nsw* was used in private tombs to provide the deceased with offerings, and evoked the role of the king as chief officiant to the gods and the source of all goods in ancient Egypt. In the funerary realm, the *htp-di-nsw* also reflected the peculiarities of the reversion of offerings in which gifts given by the ruler to the deities in the temple 'reverted' back to provide for the dead. In the same way as the dead were provisioned by the offering formula, the presentation of life-bearing gifts in the Royal Kiosk Icon can be seen as a visual *htp-di-nsw* in which the gifts of life given to the ruler were part of a cycle of offerings evoking the king's symbolic role in the funerary realm to present gifts to the gods on the behalf of an elite individual for his or her sustenance or well-being in the next world. In the eternal time of the hereafter, the king in the Royal Kiosk Icon

[165] Radwan, *Königs*, 9, posed the question whether the woman in TT 116 was also a nurse to the king and appeared before the pharaoh because of her special connection to the palace. The theme of the wife offering to the king, alone or with her husband, appears in several officials' tombs dating to the reign of Amenhotep II, and in each case, the women represented are nurses of the king. Examples of women who are nurses offering to kings in kiosks: see TT 85, Amenemhab, *PM* I,1(2), PM (9), 171, with Amenemhab's wife offering a bouquet of Amun to Amenhotep II; and TT 88, Pehsukher, *PM* I,1(2), PM (4), 180, with Pehsukher and his wife offering a bouquet to Amenhotep II.

[166] Vischak, *OEAE* II (2001), 84-85, and see p. 65 with n. 105.

[167] Dittmar, *Blumen*, 127, discusses how the bouquet offering communicated a high official's loyalty. Hodel-Hoenes, *Life and Death in Ancient Egypt*, 4, mistakenly argues that while images of the king show a "cordial personal relationship," they do not have any religious significance.

[168] Meeks, *Daily Life of the Egyptian Gods*, 149, relates how the dead probably suspected that they would serve the monarch in death as in life, to ensure the smooth functioning of his empire as it was reconstituted in the next world.

[169] Gertie Englund, "Gifts to the Gods - a necessity for the preservation of cosmos and life: Theory and praxis," *Gifts to the Gods: Proceedings of the Uppsala Symposium 1985*, edited by T. Linders and G. Nordquist, Boreas 15 (Uppsala, 1987), 57-61; Paul J. Frandsen, "Trade and Cult," in *The Religion of the Ancient Egyptians: Cognitive Structures and Popular Expressions*, edited by G. Englund, Boreas 20 (Uppsala, 1989 (sic); 1991), 98-99. The concept of the "Eye of Horus" is presented here, but note that *Maat* could denote another offering concept that reflected the Egyptian world view (Troy, *Patterns of Queenship*, 41-43). According to Gertie Englund (Englund, *OEAE* II (2001), 564), all types of offering gifts were called the Eye of Horus, a designation that "...indicates that they are considered participants in the preservation of life...also characterizes the offerings as divine substance and even allows for discussions about the transsubstantiation of the materia of the offerings."

[170] In the funerary sphere, *PT* 188b-192 relates how the Eye of Horus was given to his dead father Osiris, who ate it and was resurrected as the ruler of the Netherworld. See discussion in: Englund, *Gifts to the Gods*, 57.

also appears as potentially assimilated with the gods. Thus, the gifts of life can be seen on another level as offerings to the king as a god who would guarantee the deceased's eternal sustenance and favor in the afterworld.

3.2.2 'Tribute' Icon

'Tribute' or the presentation of official gifts[171] by foreign delegations is one of the more topical depictions that appear in the tombs of officials during the reigns of Thutmose IV and Amenhotep III. Termed here as the 'Tribute' Icon, nine focal walls in this study display this icon, all in various states of preservation (Figures 12, 25, 28, 31, 32, 44, 45; B&W Plate 2,2).[172] Officials who held titles that linked them to the recording 'tribute' and diplomatic interactions portrayed this icon on their focal walls.[173] In its complete form, the Tribute Icon is composed of Egyptian or Nubian soldiers framing the composition with Asiatic and Nubian tribute-bearers in the middle registers carrying official gifts to the king. Sometimes, a large figure of the tomb owner was depicted facing the procession, directing operations. The action of the deceased presenting a gift to the king in the Royal Kiosk Icon signified the tribute arrayed on the adjacent registers in the Tribute Icon. In this way, the gift proffered by the tomb owner provided a thematic and symbolic link between the Tribute and Royal Kiosk icons.[174]

In several tombs, a textual caption identifies the goods as *inw* presented to the ruler in return for his "breath of life."[175] *Inw* has been defined as a diplomatic gift that was offered as an expression of relationship and social obligation. Exchanged between a ruling country and its vassal principalities, *inw* illustrated the king's superiority over other men and foreign states.[176] Furthermore, the collection of *inw* appears to have been a yearly event, conducted by the king and attended by nobles, envoys, and chiefs of foreign countries who brought their gifts before the ruler.[177] As discussed above, the phrase "breath of life" related to the life given by the king who sanctioned foreign rule, economic health, and, if the subject nations shared the Egyptian world view, their well-being in the hereafter through the role of the king.[178]

[171] On the nature of official gifts (*inw*) in the textual record, see: Bleiberg, *The Official Gift*, 115-125; and also Renate Müller-Wollermann, "Bemerkungen zu den sogenannten Tributen," *GM* 66 (1984), 83-84, who sees *inw* as "free gifts irregularly delivered and repaid by a counter gift."

[172] TT 63, PM (9); TT 78, PM (8); TT 89, PM (15); TT 91, PM (3) Nubian tribute & PM (5) Mitanni tribute; TT 118, PM (1), Asiatics; TT 201, PM (7)(?) (Redford, *Re'a (TT 201)*, 11 with n. 26; compare with Brack, *Haremhab*, taf. 47b, 51c); TT 239, PM (3), Asiatics & PM (6) with military escort and ships. In TT 74, PM (11) tribute is telescoped into the Royal Kiosk Icon and referenced either by text or by a representative image; see discussion pp. 69-70. Davies, *BMMA*, part II (1928-1929), 40, suggests a tribute scene originally existed on TT 120, PM (3) which is not accepted here because of the complete destruction of the wall and the small amount of adjacent space allotted. Davies' suggestion was accepted by Lila Pinch Brock, "Jewels in the Gebel: A Preliminary Report on the Tomb of Anen," *JARCE* 36 (1999), 79, n. 47, who found florets on the adjacent small northeastern wall which she identified as Minoan-style vases belonging to a Minoan tribute scene. However, it appears they belong to a Syrian-type vase (vase type in Wachsmann, *Aegeans*, 64-65); see also (Figure 21) (second register, first vessel, upper sub-register) and (Figure 44) (top register kneeling Syrians) which may be part of a tribute, registration, or gift scene that was on the small wall, and not part of the focal wall.

[173] As the "Overseer of the Treasury," Sobekhotep (TT 63) would have recorded the proceeds as part of the king's wealth (Betsy Bryan, "The Tombowner and His Family," in Eberhard Dziobek and Mahmud Abdel Raziq, *Das Grab des Sobekhotep Theben Nr. 63*, AV 71 (Mainz, 1990), 81). Tjanuny (TT 74) (Brack, *Tjanuni*, 40, text 29, 84-87); Haremhab (TT 78) (Brack, *Haremhab*, 18, 80-82); and Amenmose (TT 89) (Helck, *Verwaltung*, 107; Hayes, *JNES* 10 (1951), 100 with n. 208) were both royal scribes who would have recorded tribute and diplomatic interactions (see also: Wente, *CANE* IV (1995), 2217). The owner of TT 91 may have accompanied foreign delegations to Egypt with their revenues as a "Troop Commander for the Good God" (Bryan, *Thutmose IV*, 288-289). Amenmose (TT 118) was a [*ṯ3w ḫw ḥr*] *wnmy nsw* or "Fan-Bearer on the Right of the King" from a text on the door lintel (personal photo), and the ceiling which gives the name of the deceased (*PM*, I,1(2), 233-234). Re (TT 201) was a "First Royal Herald" who was directly involved in diplomatic exchanges for the pharaoh between foreign nations and Egypt (Bryan, *Thutmose IV*, 263). Penhet (TT 239) as the "Overseer of all Northern Countries" was responsible for "administering the *b3kw* of the northern foreign lands" and may have held the title "Troop Commander" (*ḥry-pḏt*) based on the titles of previous holders of "Overseer of all Northern Countries" (Gardiner Notebook no. 27, 125 verso, text 5; Murnane, *Amenhotep III: Perspectives*, 180, n. 22). On *b3kw*, Edward Bleiberg, "The Redistributive Economy in New Kingdom Egypt: an Examination of *b3kw(t)*," *JARCE* 25 (1988), 157-168; and Anthony Spalinger, "From Local to Global: The Extension of an Egyptian Bureaucratic Term to the Empire," *SAK* 23 (1996), 353-376.

[174] The vase can be understood as a symbol of all the tribute presented to the king; in cases where the tribute scene is not depicted, the vase stands for the entire tribute scene (Radwan, *Königs*, 17; Brack, *Tjanuni*, 39-40, with n. 205).

[175] TT 91, *Urk.* IV, 1597-1598; TT 74, PM (11): Brack, *Tjanuni*, 40, text 29.

[176] Bleiberg, *The Official Gift*, 114-125.

[177] Papyrus Koller, 4:7-5:3, in: Wolfgang Helck, "A. Papyri, hieratische: Papyrus Koller," *LÄ* IV (1982), 717 with bibliography; Ricardo A. Caminos, *Late Egyptian Miscellanies*, Brown Egyptological Studies 1 (London, 1954), 437-446; Bleiberg, *The Official Gift*, 106.

[178] TT 91, PM (5): *Urk.* IV, 1597-1598; TT 74: *Urk.* IV, 1007 (part of Royal Kiosk Icon). See discussion above on *inw*, pp. 69-70.

Egypt's superiority over its foreign neighbors is illustrated in Tribute Icon texts that describe the inhabitants of Kush (Nubia) and Naharin (Mitanni) as subject peoples at the mercy of the pharaoh. In the case of Kush, its denizens were often denoted by the term "vile."[179] These texts may function on several levels and can be seen in the light of royal skirmishes against the Nubians and Mitanni.[180] However, at the same time, they may have existed as generalized depictions of foreign tribute.[181] Although cordial relations were cemented through diplomatic marriage or treaties between Egypt and other countries, foreigners were seen as the embodiment of the forces of chaos outside of the ordered world of *Maat* (*M3't*), symbolized by the Two Lands.[182] Thus, the depiction of processions of foreigners humbly presenting their gifts before the king enthroned in a kiosk evoked not only the ruler's political and economic authority but also his cosmological power as the son of Re and the upholder of *Maat* over evil as symbolized by the foreigners.

Foreigners in the Tribute Icon are depicted in the classic topos of the "other," with distinctive skin coloring, racial physiognomy, and ethnic dress outside of the norms of conventional depictions of Egyptians.[183] Syrians were usually depicted as having yellow-colored skin and sporting beards and long hair tied with a fillet or with shaved heads. Syrians wore the 'Syrian' tunic, which was an elaborate tapestry-woven tunic with broad, colored bands on the front and back edges of the garment.[184] Often this tunic was worn with a hip wrap that circled the body or with a cloak, embellished with various designs. Sometimes only a long 'Syrian' skirt was worn. Nubians, on the other hand, were represented with a dark skin tone, short curly hair, and large gold hoop earrings. Nubians were often shown wearing cloth or leather loin cloths, animal-skin skirts, or Egyptian-type kilts, and they sometimes carried indigenous musical instruments.[185] Foreign hybrids also appear, composed of characteristics associated with several different ethnicities that were distilled by Egyptian artists into one figure.[186]

Gifts arrayed before the king in the Tribute Icon reference the ethnic groups depicted and the wealth of goods brought to the king. Primarily, metal vessels of different types, glass ingots, raw goods, weaponry, chariots, and/or animals such as horses and bears are associated with the Syrians.[187] Nubians bring various products from their lands, including raw materials, live animals, pelts, and gold ingots.[188] It is important to note that a number of these 'Syrian' vessels are hybrid copies, composed of a mixture of elements belonging to several or more objects, or vase types appro-

[179] TT 78, PM (8): "the vile ruler of vile Kush" (*wr ḥs(y) n K3š ḥsy*), *Urk.* IV, 1592, 14; Brack, *Haremhab*, 39, text 19, Abb. 21.

[180] Thutmose IV Mitanni skirmish: Bryan, *Thutmose IV*, 337-399; however see more cautious assessment in Bryan, *The Oxford History of Ancient Egypt*, 258; Kenneth A. Kitchen, "The World Abroad: Amenhotep III and Mesopotamia," in *Amenhotep III: Perspectives on His Reign*, edited by E. Cline and D. O'Connor (Ann Arbor, 1998), 252. Thutmose IV in Nubia in yr. 7/8: Bryan, *Thutmose IV*, 333-336, which she suggests was motivated by Nubians and not a war against Nubia. David O'Connor, "The World Abroad: Amenhotep III and Nubia," in *Amenhotep III: Perspectives on His Reign*, edited by E. Cline and D. O'Connor (Ann Arbor, 1998), 264-265, who interprets Amenhotep III's "first campaign of victory" in year 5 as a major military initiative.

[181] Tribute scenes as emblematic statements: G.A. Gaballa, *Narrative in Egyptian Art* (Mainz, 1976), 65.

[182] Andrew Gordon, "Foreigners," *OEAE* I (2001), 544; Stuart Tyson Smith, "Race," *OEAE* III (2001), 114-115; Wolfgang Helck, "Fremde in Ägypten," *LÄ* II (1977), 306-307; Mu-Chou Poo, "Encountering the Strangers: a Comparative Study of Cultural Consciousness in Ancient Egypt, Mesopotamia, and China," *Proceedings of the Seventh International Congress of Egyptologists*, edited by C.J. Eyre, OLA 82 (Leuven, 1998), 886-887; Assmann, *The Mind of Egypt*, 151-153, 247.

[183] For a recent examination, see: Thomas Gilroy, "Outlandish Outlanders: Foreigners and Caricature in Egyptian Art," *GM* 191 (2002), 35-52.

[184] Vogelsang-Eastwood, *Tutankhamun's wardrobe*, 80-86. See also: J.B. Pritchard, "Syrians as Pictured in the Paintings of the Theban Tombs," *BASOR* 122 (April, 1951), 36-41.

[185] Drenkhahn, "Darstellungen von Negern in Ägypten," 52-68, 82-86; Jean Vercoutter, "The Iconography of the Black in Ancient Egypt: From the Beginnings to the Twenty-fifth Dynasty," in *The Image of the Black in Western Art*, I: *From the Pharaohs to the Fall of the Roman Empire*, edited by L. Bugner (New York, 1976), 33-88; idem, "L'image du noir en Égypte ancienne," *BSFÉ* 135 (Mars, 1996), 30-38; Vogelsang-Eastwood, *Pharaonic Egyptian Clothing*, 20-21.

[186] Shelley Wachsmann, *Aegeans in the Theban Tombs*, OLA 20 (Leuven, 1987), 4-11. See example of a Aegean/Syrian mixture in TT 89, discussed in Lyla Pinch Brock, "Art, Industry and the Aegeans in the Tomb of Amenmose," *Ägypten und Levante* X (2000), 136-137.

[187] Syrians: TT 63, PM (9), two lower registers; TT 78, PM (8), middle register; TT 89, PM (15), top register with standing Syrians and kneeling Aegeans with blue glass ingots (Brock, *Ägypten und Levante* X (2000), 133-134); TT 91, PM (5); TT 118, PM (1) with bears; TT 239, PM (3). In the Royal Kiosk Icon, Mitanni prisoners and plunder are presented in TT 90, PM (9) on three registers, and Syrian tribute in TT 74, PM (11), see discussion above, p. 70.

[188] Nubians: TT 63, PM (9), two top registers; TT 78, PM (8), two bottom registers; TT 89, PM (15), middle register (Brock, *Ägypten und Levante* X (2000), 133 suggests the middle register represents Puntites, but does not substantiate that identification); Nina and Norman de Garis Davies, "The Tomb of Amenmosĕ (No. 89) at Thebes," *JEA* 26 (1940), 134, simply characterize them as "negroes"; and TT 91, PM (3).

priated from another culture by Egyptian artists who were, perhaps, motivated by the desire to create a design considered 'foreign.'[189] Sometimes, horses appear as part of the procession, led by Egyptian soldiers or Syrians.[190] In the ancient Near East and north Africa, horses were symbols of status and were prestige gifts in the exchange of tribute. Besides holding high status as gifts, the presence of horses in the Tribute Icon also referred directly to the titles of the official in whose tomb they appear.[191]

In the tomb of Penhet (TT 239), a number of soldiers march in procession (Figure 45). Although the adjacent images are destroyed, the soldiers can be identified, based on similar parallels, as part of tribute processions conducted before the pharaoh. The tomb owner, Penhet, is portrayed standing before a military escort holding batons with three transport ships below. Given the tomb owner's occupation and contemporary parallels for this scene, the entire wall may once have contained an image of Penhet arriving from Syria, bringing tribute gifts to the king.[192]

The actual Tribute ceremony is described in a model student's letter dating to the Ramesside Period:[193]

Take care! Think about the day when the Tribute is sent, and you are brought into the presence (of the king) under the Window (of Appearances),[194] the Nobles to either side in front of his Majesty, the Princes and Envoys of every foreign land standing, looking at the Tribute....Tall *Trk*-people in their (leather?) garments, with fans of gold, high (feathered?) hair-styles, and their jewelry of ivory and numerous Nubians of all kinds.

This letter evoked the ancient Egyptian spectacle of a large-scale state ceremony populated by humble foreigners in their exotic dress bringing valuable goods under the watchful gazes of nobles, foreign rulers, and ambassadors.[195] Music and dance were part of the ceremony, as illustrated in vignettes found in the Tribute Icon.[196] As the receiver of the gifts, the pharaoh sat at the center of this highly organized event, as a symbol of the power that could command foreign people and their luxury goods. In essence, the performative, visual, symbolic, and architectonic aspects of the tribute ceremony were organized for the benefit of an internal Egyptian audience,[197] who, in witnessing the actual ceremony, probably understood the underlying ideology associated with the formal display of foreign goods and people, *albeit* in varying degrees. On the most esoteric level, we can assume that the literate elite apprehended the meaning of the tribute ceremony and recognized in it strains of Egypt's imperialistic and royal ideology. Yet, some of these aspects could also be transmitted and disseminated to the lower orders through the impressiveness of the ceremonial display. In the tribute performance, the king was presented to the audience as the legitimizing royal authority in Egypt and abroad.[198] In the Tribute Icon, these meanings were translated and transmitted into two dimensions and placed on the tomb's focal walls to be projected into the next world and to impact this world through the viewers who could understand its import.

[189] Wachsmann, *Aegeans*, 4-6, 11-12, 63-64. TT 63, PM (9) including an Aegean bull statuette in the round (Ibid., 60-61); TT 89, PM (15) & TT 91, PM (5) including bull-headed rhyta (Ibid., 56-57); TT 78, PM (8) with hybrid vessels (Walter Wreszinski, *Atlas zur altägyptischen Kulturgeschichte* I (Slatkine Reprints, Genève-Paris, 1988), 245); TT 89, PM (15) including lion-headed rhyta (Wachsmann, *Aegeans*, 58-59).

[190] TT 63, PM (9); TT 78, PM (8); TT 90, PM (9); TT 91, PM (5).

[191] As in the "Overseer of horses" title: Haremhab (TT 78) (Brack, *Haremhab*, 92); TT 91, PM (5), (*Urk.* IV, 1599). For more on the "overseer of horses" title, see: Charles F. Aling, "The title 'Overseer of Horses' in the Egyptian Eighteenth Dynasty," *Near East Archaeological Society Bulletin* 38 (1993), 53-60. Horses and a chariot are included in the tomb of Sobekhotep, TT 63, PM (9) (Dziobek and Raziq, *Sobekhotep*, 35-37, British Museum EA 37987) as a symbol of the tribute brought by the Syrians that he would record as "Overseer of the treasury." In the tomb of Nebamun (TT 90), the horses on the top register, and the chariot referenced under the king's kiosk (see: Davies, *Two officials*, 34) and may also have been included to illustrate Nebamun's long military career in the royal service.

[192] Compare: Raymond O. Faulkner and Norman de Garis Davies, "A Syrian Trading Venture to Egypt," *JEA* 33 (1947), pl. VIII with Syrian ships; Davies, *Some Theban Tombs*, 14, pl. XV; Nina Davies and Gardiner, *Huy (No. 40)*, 14-20, pl. X, with ships and Nubian tribute. Amenmose (TT 42), the "Overseer of all Northern Countries," had a conventional Syrian tribute scene on his wall (Davies, *Menkheperrasonb*, 28-30, pls. XXXIII-XXXV).

[193] Papyrus Koller in: Smith, *OEAE* III (2001), 115; Caminos, *Late Egyptian Miscellanies*, 437-446.

[194] This Late Egyptian passage mentions the king at the Window of Appearances receiving tribute, which, before the Amarna period, would also have taken place before the king enthroned in a royal kiosk; Redford, *Re'a (TT 201)*, 13 with n. 32; Radwan, *Königs*, 16-17, 69-71.

[195] In the Tribute Icon in TT 78, a number of these nobles are named, ranging from the "Steward of the King" to the "Steward of the Room of the Palace": Brack, *Haremhab*, 38-39, text 17-18, Abb. 21, 17, 18a-b, taf. 48b.

[196] TT 78, PM (8), Nubian drummers and dancers in ethnic dress (Brack, *Haremhab*, taf. 12, 47b, 51a, 51c); Nubian drummers (?) in TT 201, PM (7), Redford, *Re'a (TT 201)*, pl. XXIII.

[197] For a discussion of this audience, see: El-Menshawy, *Current Research in Egyptology 2000*, 87.

[198] Liverani, *International relations*, 25; Stuart Tyson Smith, "Ancient Egyptian Imperialism: Ideological Vision or Economic Exploitation?: Reply to Critics of *Askut in Nubia*," *CAJ* 7 (1997), 302; Stuart Tyson Smith, "State and Empire in the Middle and New Kingdoms," in *Anthropology and Egyptology: A Developing Dialogue*, edited by J. Lustig (Sheffield, 1997), 83-85.

'Visual hooks,' such as dancing or drumming Nubians rendered in innovative postures and distinctive dress, unusual animals such as bears, and sophisticated transport such as Syrian chariots or ships, appear in the Tribute Icon to gain the viewer's attention. Often occurring on the middle to lower registers of the wall, roughly at eye-level, these visual hooks would have been immediately visible to visitors to engage their attention.[199]

The tomb owner bearing a foreign gift in the Royal Kiosk Icon acted as a thematic and symbolic link. In a few cases, the deceased is shown twice: once before the king presenting a gift, and again turned in the opposite direction in the Tribute Icon, striding towards the procession with an arm raised in a gesture of address, actively conducting the ceremony (Figures 12, 25-26, 32).[200] The gift and the foreign tribute symbolized the goods obtained through Egypt's imperial and exchange networks that reinforced the position of the king as the manifestation of royal power and political authority and the enforcer of *Maat*. The gift can also be seen as a symbol of the redistributive system. Reading the Royal Kiosk and Tribute icons from right to left, *inw* passed from the donor nation through the tomb owner, who presented an object relating to *inw*, hence "life," to the king. The benefit of *inw* also flowed outwards from the king, who granted 'life' eternally to the official, and to subject nations through the existing political, redistributive, and theological networks. By emphasizing his relationship with the king within the context of the *inw* ceremony, the tomb owner stressed his status and professional role in this life, preserved his identity in the next, and benefitted from the reciprocal arrangement, in which the king, as the symbolic source of all goods in Egypt, would magically provide for the eternal life of the deceased.

3.2.3 Registration Icon

The Registration Icon contains images concerned with the inspection, recruiting, registration, and provisioning of troops and workers. The Registration Icon occurs on as many as five focal walls, belonging to tomb owners who were "scribes of recruits" (*šs nfrw*) or who were involved in the military bureaucracy (Figures 23, 24, 42; B&W Plate 3 and 4).[201] The images in this icon illustrate the military and civil responsibilities associated with these officials. On a more symbolic level, their actions took place on a larger stage and related to New Kingdom wealth, imperialism, and royal ideology. The Registration Icon is connected to the Royal Kiosk Icon through the actions of the deceased, who is often depicted twice, back to back (Figures 23-24, B&W Plates 3 and 4). First, he is represented presenting a gift to the king in the Royal Kiosk Icon; and then in the Registration Icon, he conducts various activities relating to his office. In the tomb of Haremhab, three smaller unlabeled figures are depicted, presumably of the tomb owner, each on its own register, issuing orders that are taken down by the scribes at his feet (Figure 24).[202] In the case of TT 74, two figures of Tjanuny, one sitting and the other standing, record troops on PM (5) (B&W Plate 3), while on the opposite wall, PM (10) (B&W Plate 4), a larger figure of the deceased writes the tallies, aided by four scribes positioned at the beginning of each register. Two separate captions are associated with Tjanuni's actions on these focal walls:

> PM (5):[203] "Registering the troops [before his majesty], registering the military recruits *(ḏ3mw nfrw)*, and causing every man to know his duties in the entire army by the true scribe of the king, whom he loves, the scribe of the army, Tjanuni, justified."

[199] Nubian dancers and drummers, TT 78, PM (8), and TT 201, PM (7) (see n. 196); bears, TT 118, PM (1); Syrian chariots, TT 63, PM (9); transport ships, TT 239, PM (6). On placing visually interesting scenes of the walls to engage visitors in Egyptian tombs, see: Roth, *Mummies & Magic*, 54-55; idem, *JARCE* 30 (1993), 33-55, esp. 50. See also literature on *Apellfiguren* (Kemp, ed., *Der Betrachter ist im Bild*; and Kaufmann, *The Dictionary of Art*, vol. 26, 63).

[200] TT 63, PM (9), Sobekhotep holding *ḥk3*-scepter, the flail, and the ostrich plume fan – all symbols of kingship (see p. 62). Remains of striding feet of deceased: TT 78, PM (8); TT 91, PM (5). On the gesture of address: Dominicus, *Gesten*, 77-80.

[201] Scribe of Recruits: Tjanuny, TT 74, PM (5) & (10); and Haremhab, TT 78, PM (4). Military administration: Ptahemhet, TT 77, PM (7); Re, TT 201, PM (9). The translation of *nfrw* as "recruits" is followed here; see discussion in: Murnane, *Amenhotep III: Perspectives*, 197. On the duties of the scribe of recruits, see: A. Varille, *Inscriptions concernant l'architecte Amenhotep, fils de Hapou*, BdÉ 44 (Cairo,1968), 36-41. On the scribal profession in the reign of Thutmose IV: Bryan, *Thutmose IV*, 299, 354; and during Amenhotep III: Murnane, *Amenhotep III: Perspectives*, 197-198. Ptahemhat (TT 77) began his career as a *ḥrd n k3p* in the royal military academy (Manniche, *Three Theban Tombs*, 10, n. 7); on the *ḥrd n k3p*, see: Gnirs, *War and Society*, 86; and Erika Feucht, "The *ḥrdw n k3p* Reconsidered," in *Pharaonic Egypt: The Bible and Christianity*, edited by S. Israelit-Groll (Jerusalem, 1985), 38-47. Re (TT 201) the "First Royal Herald" was responsible for deliveries and logistics for the army (Redford, *Re'a (TT 201)*, 32; Säve-Söderbergh, *Four Eighteenth Dynasty Tombs*, 13).

[202] Brack, *Haremhab*, 34.

[203] Brack, *Tjanuni*, 40-41, text 30; text caption to a scene of a military parade being brought before Tjanuny on PM (5); see also Brack, *Haremhab*, 34.

PM (10):[204] "Registering the land to its end before his majesty, doing what is seen with every eye, namely: soldiers, *wab*-priests, workers of the king, all craftsmen of the land in its entirety, [all oxen, fowl and all small livestock], by the army scribe, [who is loved] by his lord, Tjanuny, justified. He says: We have completed it."

As suggested by these passages, troop registration, the issuing of military duties, and the recording of Egypt's manpower and economic resources were part of the duties associated with the scribe of recruits, all conducted under the watchful eye of the pharaoh.

In the tomb of Ptahemhat (TT 77), the military police are arranged on two registers behind two larger figures who are facing each other (Figure 23). These larger figures have been excised but still conform to their outlines. The comportment of the two figures suggests a reporting scene was once here, composed of a figure on the left with an arm raised in a gesture of address and a figure on the right standing before him, reporting. The text above them has been completely destroyed and preserves only the phrase, "by the Fan-Bearer of the Lord of Two Lands, Ptahemhet."[205] Although it is hard to discern the exact nature of the scene, one could venture a guess that it once depicted the deceased receiving the report upon his inspection of the soldiers.[206] In Figure 42, the upper register displays the remains of a procession of soldiers with shields, spears, fans, standards, and axes that perhaps originally belonged to a complete registration scene that is now destroyed.[207]

In the tombs of Haremhab, (Figure 24), and Tjanuni, (B&W Plate 3), the masses step forward to be registered, provisioned, and trained. These actions depict the practice of mass conscription in Egypt, by which men were obtained for both military operations and civil projects for the crown.[208] These projects required manual labor. Evasion and desertion were punished severely, with the guilty and their families assigned to state labor. This was akin to complete annihilation, leaving no immediate relations to till the land on which the family lived. Foreign prisoners were also utilized. According to Egyptian practice, the foreign prisoners could gain their freedom by serving in the military. On the top two registers of TT 78 to the far right, the carrying out of forced labor is evoked by the mass of troops whose arms appear to have been tied behind their backs.[209]

The training of troops is illustrated in the tomb of Tjanuny where groups of five, seven, eight, or ten soldiers are divided into divisions and marched with the aid of stick-wielding officers (B&W Plate 3). Others line up to take the oath of allegiance to the state by kissing a ribbon that hangs down from a standard adorned with the names of Thutmose IV.[210] In these motifs appear the realities of Egyptian military training which was based on a combination of drill motivated by physical punishment that was conducted by officers in special military camps under the authority of specific commanders. The often painful process of military training is discussed in the Papyrus Anastasi III:[211]

Come, I will describe to you the lot of the infantryman, the much exerted one: he is brought as a child of *nbi* and confined to a barrack. A painful blow is dealt to his body, a savage blow to his eye and a splitting blow to his brow. His head is split open with a wound. He is laid down and beaten like a piece of papyrus. He is lambasted with beatings...

[204] Brack, *Tjanuni*, 43-44, text 34.

[205] *Urk.* IV, 1599.

[206] Left figure with hand raised in a gesture of address: Dominicus, *Gesten*, 77-80. Compare similar reporting scenes in TT 88, Wreszinski, *Atlas* I, tafs. 279-280; TT 56, Beinlich-Seeber and Shedid, *Userhat*, 67-68, taf. 5; TT 78, PM (4) (Figure 24).

[207] Compare TT 74 and TT 78 (B&W Plate 3; Figure 24). The Redford's reconstruction of a tribute scene in TT 201, PM (9) does not appear justified, given that the parallels cited to support this reconstruction belong instead to registration, training, offering, and promotion scenes (Redford, *Re'a (TT 201)*, 13, n. 32).

[208] Andrea M. Gnirs, "Military: An Overview," *OEAE* II (2001), 404; Antonio Loprieno, "Slaves," in *The Egyptians*, edited by S. Donadoni and translated from the Italian by B. Bianchi (Chicago, 1997), 197.

[209] Bouriant, *Mém. Miss.* V,2 (1894), 421; Brack, *Haremhab*, 20.

[210] Brack, *Tjanuni*, 42, text 32, Abb. 11, right standard: "Thutmose IV, lord of strength"; left standard: "Thutmose IV, festival of his victory."

[211] Quote from Shaw, *Egyptian Warfare*, 29, dating to the nineteenth dynasty.

In the tombs of Tjanuny and Haremhab, troops of Egyptian and Nubian origin are arrayed before the deceased, illustrating the nationalities drafted into the army.[212] Dress serves to distinguish Egyptian soldiers from foreign conscripts: The former wear the military skirt, and the latter sport ethnic dress.[213] For example, in the tomb of Tjanuny, a contingent of Nubian mercenaries is depicted on the second register at the far left, wearing leather net loincloths with feline tails (B&W Plate 3). Syrians or foreign princes also appear in the Registration Icon and perhaps are included here as emissaries who presented troops for conscription.[214] The Syrians appear seated on cushions that indicated their high status, being fed in the supply depot (Figure 24).

The economic largess of the land is also depicted in the Registration Icon. On the right focal wall in the tomb of Haremhab, the supply depot is depicted along with the wealth of Egypt's land (Figure 24). These supplies are piled high into baskets, and symbolize wages given to Egypt's soldiers. A caption to a similar image of military provisioning from the tomb of Pehsukher (TT 88) summarizes the nature of the scene:[215]

> Bringing the high-ranking among the military and the ordinary soldiers to Pharaoh, l.p.h., in order to provision them with bread, ox flesh, wine, *š'yt*-cakes, vegetables and all (kinds of) good things for satisfying the heart...

On the left focal wall in the tomb of Tjanuny, the deceased is shown in the process of recording key resources, signifying the entire manpower in ancient Egypt (B&W Plate 4). From top to bottom, the registers are filled with files of *wab*-priests, soldiers, oxen, and then horses, all representing categories of service, food, and transportation in Egypt.

The variation of postures, insignia (standards, weapons, sunshades, etc.), and movement, as well as the depiction of overlapping, directional changes, and innovative vignettes in the Registration Icon can be seen as a device to draw viewers into the composition. For example, in the tomb of Haremhab TT 78, the middle register contains a depiction of the troops passing through the door to the supply depot, which is adorned with cartouches of *Menkheperure* (Thutmose IV) (Figure 24).[216] As the troops near the depot, they bend down in submission before an official with a stick who is represented larger than the troops and wears different dress. The troops then disappear behind the doorway that leads into the court, with the first soldier depicted only in part, which is a rare portrayal in Egyptian art.[217] The entire vignette also occurs roughly at eye-level on the wall, and thus indicates its importance in engaging the viewer.[218] One can presume that a wide array of actions, specialized depictions, and insignia that occur in the Registration Icon may have been used to gain the viewer's attention, and impress upon them the importance of the deceased and the power of Egypt.

The depiction of the deceased conducting duties which were associated with Egypt's military centralization and sophisticated bureaucracy provided a thematic and symbolic link with the Royal Kiosk Icon. The tomb owner's supervision of Egypt's wealth, not only served the king but his theoretical role as the source of all goods, the same source from which the deceased would be provided in his eternal life. The tomb owner's maintenance of Egypt's manpower provided the grist for the pharaoh's imperialistic vision and ideological role through royal building projects that would legitimize him to the gods and the population. Many of the troops being inspected and registered may have been charged with the control of Egypt's imperial, trade, and diplomatic interests abroad. Others may have performed civil tasks, from corvée labor in the quarries to the transportation of goods and the supply of raw materials for building projects. Still

[212] Nubians in TT 74: Brack, *Tjanuni*, 41, 43; TT 78: Brack, *Haremhab*, 33, 36-37; clothing described in Vogelsang-Eastwood, *Pharaonic Egyptian Clothing*, 26-31. Syrians in TT 78: Brack, *Haremhab*, 37. By the reign of Amenhotep III, soldiers from Syria, Libya, Sherden, Shekelesh, and Hittite were drafted into the Egyptian army, see: Shaw, *Egyptian Warfare*, 30.

[213] Gnirs, *War and Society*, 87.

[214] As suggested by Brack, *Haremhab*, 36.

[215] *Urk.* IV, 1459-1460; Cumming, *Historical Records* II, 154. See similar rations listed from the Middle Kingdom and the twentieth dynasty in: Gnirs, *OEAE* II (2001), 404-405.

[216] See photographs in: Brack, *Haremhab*, 35, taf. 42, 45b.

[217] Examples of partial figures are discussed by Heinrich Schäfer, *Principles of Egyptian Art*, translated from the German by J. Baines (Oxford, 1974), 136-137.

[218] The motif of the troops passing through the supply depot door occurs about 1.25 to 1.55 meters from the tomb floor, or 4'10" to 5'1". The height of ancient Egyptian males has been estimated from 1.65 to 1.75 meters or 5'4" to 5'7" (Gay Robins, "Natural and Canonical Proportions in Ancient Egyptians," *GM* 61 (1983), 19; idem, "The Stature and Physical Proportions of the brothers Nakhtankh and Khnumnakht (Manchester Museum, nos. 21470-1)," *ZÄS* 112 (1985), 44-48) which, assuming the floor has risen from antiquity that would put the vignette roughly at eye-level. The height of females would have been proportionally smaller.

others may have been charged with policing Egypt's domestic borders. All of these activities were associated with the assertion of royal power and ideology at home and abroad. In the Registration Icon, the tomb owner is identified by his service to the state and the pharaoh, dutifully assembling the lists on which the Egyptian bureaucracy ran, in this world and the next. In this official capacity, the deceased would continue to exist in the pharaoh's reassembled kingdom in the next world and would be provided for by the ruler, as in life.

3.2.4 Gift Icon

The Gift Icon is distinguished by the presentation of two types of gifts to the pharaoh: gifts given during the New Year ceremony and gifts commissioned by the king for the Temple of Amun-Re at Karnak. The Gift Icon is thematically and symbolically linked to the Royal Kiosk Icon through the image of the tomb owner offering a gift that is representative of the objects displayed in the registers behind him and/or by the caption that explains the nature of the gifts and the owner's responsibility for them. In each instance, the tomb owner's titles relate to the supervision of works.[219]

The tomb of Tjenuna (TT 76) displays gifts associated with the start of the civil New Year (*wpt-rnpt*), during which officials presented to the king various items produced annually in the royal workshops (Figure 21).[220] These images clearly marked an important event in the career of the tomb owner and relayed his high status as one who was in the presence of the king during the festival. In ancient Egypt, the New Year's Festival was interpreted mythologically as the birthday of Re(-Horakhty); thus, solar symbolism played a prominent role, where light connoted life and the animation of the world.[221] In the royal realm, the New Year's celebration was connected to the rebirth and protection of the king.[222] Golden objects displaying solar iconography expressed the festival's cosmological and royal meaning as well as the power of the king under whose patronage these gifts were manufactured. A reciprocal exchange network is evoked by the New Year's gifts: while many of these items were intended for the ruler, others would have been given to officials as marks of royal favor (i.e. Gold of Honor, etc.).[223]

Gifts that contain strong solar and religious associations, such as necklaces with solar-crowned lions or *uraei*, collars with falcon-headed terminals, and falcon-winged pectorals, sphinx statues, and mirrors, express the cosmological symbolism of the New Year's ceremony.[224] Most of the gifts are colored yellow for gold, a solar material, or speckled with red pigment to indicate granite, which was a solar stone.[225] Other objects, such as the mace, sickle, and foreign vases, relate to royal power. One particular grouping of objects may relate to the deification of the king. Occurring in the tomb of Tjenuna (TT 76), Thutmose IV's favorite and "true foster child of the king, beloved of him" (*sḏty nsw m 3' mry.f*), the

[219] Amenhotep-si-se (TT 75) held the title "Second Prophet of Amun," which was responsible for the output of the temple workshops (Davies, *Two officials*, 4-18; Sauneron, *Priests*, 58). Tjenuna (TT 76) was the: "(6) Chief Steward of the King, (7) Chief/////, Overseer of Works (8) in////" (*imy-r pr wr nswt imy-r/////imy-r k3t m /////*; from an unpublished inscription on the right entry door jamb; see also pillar B(a) (Champollion, *Not descr.* I, 829 [to p. 480, l. 22]). Ptahemhat (TT 77) held the title "Overseer of Works of the Funerary Temple of [Thutmose IV in] the temple of Amun (or 'front area' of Amun)" (*imy-r k3t hwt [Mn-prw-R' m] pr/š/mr Imn*) from a funerary cone discussed in: Heike Guksch, "Ergänzungen zu Davies-Macadam, Cone Nr. 475," *GM* 44 (1981), 21-22; idem, *GM* 47 (1981), 23-27; idem, "Die Grabkegelaufschrift DAVIES-MACADAM Nr. 475 - und ein Ende!" *GM* 158 (1997), 9-10. See also: Manniche, *Three Theban Tombs*, 23. The anonymous owner of TT 226 whose main function was as Overseer of Nurses, also held the title "Overseer of all works of the King" (*Urk.* IV, 1877-1878; Davies, *Egyptian Historical Records* V, 41).

[220] Säve-Söderbergh, *Four Eighteenth Dynasty Tombs*, 51, identifies these gifts as New Year's Gifts, based on the frequency of this motif in tombs of "Chief Stewards" such as Tjenuna (Ibid., 2 with n. 1, 38) and their similarity to objects captioned as "New Year's Gifts" in TT 93 and TT 96 (Radwan, *Königs*, 12-13; Davies, *Ken-Amun*, pls. XI-XXIV; Gundlach, et al., *Sennefer*, 40, Abb. 25). On their manufacture in royal workshops rather than temple or personal workshops, see: Davies, *Ken-Amun*, 24. Note, however, that Cyril Aldred, "The 'New Year' Gifts to the Pharaoh," *JEA* 55 (1969), 78-79, suggests the gifts in Tjenuna (TT 76) are not New Year's Gifts but tribute to celebrate the king's coronation on the throne. His argument hinges on the translation of the word *ḫ'i* as "coronation" which often captions these scenes, a usage found to be incorrect by Donald Redford, *History and Chronology of the Eighteenth Dynasty of Egypt: Seven Studies*, Near and Middle East Studies 3 (Toronto, 1976), 3-27, 121-127, who notes the term *ḫ'i* was used to designate any formal appearance of the king.

[221] Altenmüller, *LÄ* II (1977), 174; François Daumas, "Neujahr," *LÄ* IV (1982), 471.

[222] Torgny Säve-Söderbergh, "Några egyptiska nyårsföreställningar," *Religion och Bibel*, Nathan Söderblom-Sällskapets Årsbok, Lund, C.W.K. Gleerup 9 (1950), 1-19; J.F. Borghouts, *Nieuwjaar in het Oude Egypte* (Leiden, 1986), 1-36.

[223] Discussion in Davies, *Ken-Amun*, 24-25.

[224] Wreszinski, *Atlas* I, 46a-b. On the symbolism of mirrors: Claire Derriks, "Mirrors," *OEAE* II (2001), 421. See discussion of the solar symbolism of these objects above in 3.2.1.

[225] For more on the symbolism of materials, see: Brunner-Traut, *LÄ* II (1977), 117-128. On granite as a solar stone, see: Betsy M. Bryan, "Royal and Divine Statuary," in *Egypt's Dazzling Sun: Amenhotep III and His World*, edited by A. Kozloff and B. Bryan (Cleveland, 1992), 142. See also: Sydney Aufrère, *L'univers minéral dans la pensée égyptienne*, 2 vols., BdÉ 105/1-2 (Cairo, 1991).

motif becomes all the more significant.[226] On the top register, a small yellow statue of "the perfect god *Mn-ḫprw-rʿ*" is depicted censing a larger black statue of himself.[227] While this unnamed statue has been assigned by a few scholars to Amenhotep II, one would suppose the adjacent statue of his queen "the Great Royal Wife, Tiaʿa" would not be identified by a title she did not hold during the reign of her husband.[228] Furthermore, the iconographical similarities among the censing statue and the black statue in the tomb of Tjenuna (Figure 21) and another named statue in the tomb of Amenhotep-si-se (TT 75) (Figure 19) suggest that these statues represent Thutmose IV.[229]

Some royal images have black skin, signifying the king's transformation and rebirth.[230] Golden statues, colored yellow, related to gold, the flesh of the gods, the sun, and luminosity.[231] When one examines this statue group according to its color and material symbolism, it is possible that they illustrate Thutmose IV's identification with the sun and his participation in his own rejuvenation. Comparable iconography from later reigns exists, particularly on private stelae that depict Ramesses II censing a larger statue of himself, in a motif that relates to the king's deification.[232] While there is no evidence that Thutmose IV deified himself during his reign, he certainly laid the foundation for his son, Amenhotep III, and his self-deification.[233] Perhaps it is best to view this intriguing vignette of Thutmose IV in the Gift Icon as a visual symbol relating to his potential deification and identification with solar gods in the eternal realm of the afterlife.[234]

Another group of gifts includes those found in the tomb of Amenhotep-si-se (TT 75) (Figure 19). These were manufactured under the supervision of the tomb owner and were dedicated by the king to the Temple of Amun-Re at Karnak. The inscription from this tomb mentions the owner's supervisory role in the fabrication of gifts for the king. The sovereign commissioned the gifts from Egyptian workshops specifically for Amun's temple:[235]

> Supervising monuments and placing (them) in the presence in order to view [each of] the works as was commanded, that which his Majesty desired doing (what) satisfies the heart of the lord [of the gods, Amun, Lord of the Thrones of the Two Lands], and seeking to do what is good [for his temple], and adorning his temple[236] with electrum. (They) are more numerous than (one) could record (lit. establish them in writing), all (kinds of) vessels without (lit. its) end, *menits*, sistra, statues [Amun]-re, king of the gods. Then the Second Prophet of [Amun, Amen]hotep went forth, praised and loved in the presence of his Majesty.

[226] Quote: *Urk.* IV, 1578, 12. See discussion of the personal relationship between Tjenuna and Thutmose IV in: Bryan, *Thutmose IV*, 353.

[227] Säve-Söderbergh, *Four Eighteenth Dynasty Tombs*, 50-51, pl. LXXII. This scene was traced by Hay and his assistant (B.M. Add. MSS. 29852, 167-171, 176-193; 29853, 193, 195), and fit into the registers on the wall by Nina de Garis Davies.

[228] On titles of Tiaʿa: Bryan, *Thutmose IV*, 93-119; idem, "Antecedants to Amenhotep III," in *Amenhotep III: Perspectives on His Reign*, edited by D. O'Connor and E. Cline (Ann Arbor, 1998), 44-45.

[229] Aldred, *JEA* 55 (1969), 79, n. 2, believed this statue belonged to Amenhotep II, as does Eaton-Krauss, *SAK* 4 (1976), 70, n. 11, who also suggested the statue held a standard. Bryan, *JARCE* 24 (1987), 18-19, n. 33, fig. 27, argues it was not a standard-bearing statue because the pole does not touch the ground but instead was a statue with its near hand raised in a gesture of address with the far hand holding the shaft, identical to the statue "*Menkheperure*, beloved of Amun" in the tomb of Amenhotep-si-se (TT 75). On the discussion of the "Great Royal Wife" title of Tiaʿa, see: Bryan, *Thutmose IV*, 108.

[230] Robins, *OEAE* I (2001), 292-293.

[231] Winfried Barta, "Materialmagie und -symbolik," *LÄ* III (1980), 1235; Brunner-Traut, *LÄ* II, 125; R. Wilkinson, *Symbol & Magic*, 108-116; Sydney Aufrère, "Les couleurs sacrées dans l'Egypte ancienne: vibration d'une lumière minérale," *Techne* 9-10 (1999), 26-29.

[232] Stela of Rahotep in the Aeg. Seminar of Munich, in: Labib Habachi, *Features of the Deification of Ramesses II*, ADAIK 5 (1969), 33-34, ill. 21, pl. XIIIb; other examples in: Wildung, *Die Rolle ägyptischer Könige*, 113, n. 12-14; Hans D. Schneider, *Life and Death under the Pharaohs: Egyptian Art from the National Museum of Antiquities in Leiden, The Netherlands* (Leiden, 2002), 38-39, no. 40. On royal deification: Ali Radwan, "Einige Aspekte der Vergöttlichung des ägyptischen Königs," in *Ägypten- Dauer und Wandel*, SDAIK 18 (Mainz, 1985), 58-59, esp. n. 26, with bibliography.

[233] See discussion pp. 127-128.

[234] For discussion of Thutmose IV's solarization and self-presentation, see: Bryan, *Thutmose IV*, 351-352; idem, *The Oxford History of Ancient Egypt*, edited by I. Shaw (Oxford, 2000), 255-256; and Johnson, *Gold of Praise*, 232, who says: "Thutmose IV, who would probably have gone through the rites of deification-while-alive himself had he lived long enough, is the first king depicted wearing the *shebyu*-collar and arm bands in a non-funerary monument, on a relief from Giza where he is shown worshiping the Great Sphinx/Horemakhet. The intention here was to show his identification with that god."

[235] Reading: *ḥrp mnw rdít m-bȝḥ r m33 [tnw] kȝwt mí wddt mrt.n ḥm.f m irt shtp íb nb [ntrw imn nb nswt tȝwy] hhy ȝḫt [hwt-ntr.f] shkr pr.f m dʿmw iw(.sn) ʿȝ r smnt st m sš krht nbt n dr-ʿ(wy).s mnit sššt [////] twt [/////] [Imn]-rʿ nsw ntrw íst prr snw n [Imn, Imn]-htp hsw mrw m-bȝḥ ḥm.f* (*Urk.* IV, 1211-1212; Davies, *Two officials*, pl. XII). See also: Redford, *History and Chronology*, 123.

[236] Patricia Spencer, *The Egyptian Temple: A Lexicographical Study* (London, 1984), 18-20, the word *pr* can describe the main temple building or temenos.

The gifts depicted in the tomb of Amenhotep-si-se represent actual, context-specific objects that directly relate to those illustrated in relief on the walls of Thutmose IV's Peristyle Court at Karnak (Plate 18,3). This wall and the western wall of the Peristyle Court depict libation vases with ram's head covers, fans, pectorals, harps, sphinxes with ointment jars, and statues of the king in various poses. One such image is a two-dimensional rendering of an actual statue of Thutmose IV holding a ram's head standard, now in the Cairo Museum (JE 43611). Based on its caption "[Amun] who hears prayers" in TT 75, this statue probably once rested along one of the alleys in the gateway of the Eastern Temple at Karnak, where common people assembled to pray to Amun.[237] Another image shared by both the tomb of Amenhotep-si-se (TT 75) and the Karnak temple is that of the porch and doorway to Pylon IV named "Amun powerful of respect." This doorway was one of the four monumental entries to the court embellished by Thutmose IV.[238] During Thutmose IV's reign, the porch and doorway to Pylon IV was an entrance area that lead from the Peristyle Court to temple proper. It is likely the various rituals and 'festivals' that took place in the court were witnessed by the public who were admitted during celebrations to the temple's entrance area.[239] In the tomb of Amenhotep-si-se, the context-specific world of the Karnak Temple is evoked through the depiction of objects, statues, and architectural structures that also decorated the walls of Peristyle Court and the entrance to the Eastern Temple. In TT 75, these objects were gifts donated by the king to the god Amun, and they represented items manufactured under the supervision of the tomb owner.

In the Gift Icon, the objects and structural members depicted relate to the ruler's symbolic role, his rebirth and protection, and the preservation and maintenance of life and order. The gifts refer to the status of the king, who, as the head of state, provided the raw materials, tools, and remuneration that made the creation of these objects possible.[240] Some of these gifts, such as the Gold of Honor, would find their way into the private sphere as rewards for private individuals (see the Award of Distinction Icon 3.2.5 below). On another level, these gifts embodied the pharaoh's role as the principal supplier and benefactor of all goods in Egypt, through whom eternal provisioning would be secured in the next world. Formal performance and issues of reception are evoked by representations of context-specific objects, public entryways, and festival displays whose symbolism legitimated the role and activities of the king to an informed Egyptian audience. The Gift Icon is linked thematically and symbolically to the Royal Kiosk Icon by the action of the deceased, who offers an emblem of his successful service to the king in the form of an object symbolizing "life." This emblematic gift and the objects it represented were part of the cycle of offering that would ultimately secure the eternal well-being of the deceased. In the tomb, the deceased, by virtue of his proximity to the pharaoh, also commemorated his prestige to the living and transferred it to the next world, where he would eternally fulfill his duties to the king.

3.2.5 Award of Distinction Icon

The Award of Distinction Icon includes images associated with the tomb owner's receiving an award or being appointed to a specific office. On three focal walls, the deceased is shown receiving an award such as the *shebyu*-collar, followed by a homecoming ceremony (Figures 11, 19, 22).[241] Two focal walls depict the tomb owner's promotion which

[237] Bryan, *JARCE* 24 (1987), 16-20; and idem, *Thutmose IV*, 175, who suggests this placement based on the similarity between the statue's name and the designation of the gateway of the Eastern Temple at Karnak. Note the translation of the statue as "[Amun] who hears prayers" is accepted here as originally suggested by Davies, *Two officials*, 13. See also: Chadefaud, *Les statues porte-enseignes*, 4(c).

[238] Peristyle Court and its reliefs were reconstructed by Bernadette Letellier, "La cour à peristyle de Thoutmosis IV à Karnak," in *Hommages à la Mémoire de Serge Sauneron*, vol. I, BdÉ 81 (Cairo, 1979), 51-71, pls. 10-12; idem, "La cour à peristyle de Thoutmosis IV à Karnak," *BSFÉ* 84 (1979), 33-49, note images particularly on wall B (p. 40, fig. 2). On the porch and doorway to Pylon IV in TT 75, see: Davies, *Two officials*, 14; and, Bryan, *Thutmose IV*, 170-171.

[239] Paul Barguet, *Le Temple d'Amon-Rê à Karnak* (Cairo, 1962), 307-310, suggested the function of Thutmose IV's Peristyle Court was as a "festival court" where the various divine celebrations and jubilee ceremonies and rituals took place and were open to the public.

[240] On conditions of service and remuneration in state and temple workshops, see: Drenkhahn, *CANE* I (1995), 334-335.

[241] TT 63, PM (4); TT 75, PM (3); TT 77, PM (4). Dziobek argues convincingly that the text mentioning the deceased "coming in [peace to the palace]" and "receiving at the treasury house" points to an award ceremony conducted in the treasury, based on parallels with the tomb of Huy (TT 40) and Amenhotep-si-se (TT 75) (Dziobek and Raziq, *Sobekhotep*, 39-40). Manniche, *Three Theban Tombs*, 24, does not identify the scene; however, several indicators suggest an award scene is to be reconstructed here because of the presence of temple gifts, and a stooping man fastening a necklace (?) on another figure bending towards him; compare Figure 19 with Figure 22.

is followed by a parade or procession (Figures 20 and 29).[242] Two more walls may have also had the Award of Distinction Icon but only portions remain (Figures 15-16).[243] As with the previous icons, the Award of Distinction Icon is linked thematically and symbolically to the Royal Kiosk Icon through the action of the deceased, who is depicted twice in sequential vignettes: first in the Royal Kiosk Icon before the pharaoh,[244] and then receiving the award and/or accolades in a procession. In a few instances, the deceased is shown a third time, leaving the ceremony and returning home.

In reward motifs, texts reference the nature of the ceremony by stating that the tomb owner is "receiving the favor (i.e. reward) of the Lord of the Two Lands in gold."[245] In the icon, the deceased stands facing the pharaoh, before an official who bends over slightly to fasten a gold collar around the tomb owner's neck. The collar was probably the *shebyu*-collar, as suggested by other tombs in which the deceased was awarded.[246] As stated above, when received by a private person from the king, the *shebyu*-collar represented an elevation in the status of the official.[247] It has also been suggested that the award represented the state-sanctioned flow of precious materials into the private sector, which maintained supply.[248] A variant occurs in the tomb of Ptahemhet (TT 77), in which a kilted official bends towards an excised figure whose outline is still legible (Figure 22). The configuration of the original motif and the extensive textual caption (now destroyed) suggests the tomb owner was receiving a collar or an ointment cone.[249] In reward motifs, captions situate the award ceremony in the treasury (Figure 11) or during the inspection of the temple gifts (Figures 19, 22).[250] By fixing the ceremony within these contexts, the award not only represented an elevation of the official's status but also rewarded him for the successful discharging of his office. Context is also referenced in the titles of tomb owners, which connected them to the manufacture or documentation of temple utensils or objects in the treasury.[251]

In the next vignette, the tomb owner, this time oriented away from the pharaoh, is depicted "coming home from the mark of distinction by the king" carrying a papyrus fan or holding a staff.[252] In several cases, a procession of men carrying bunches of foliage accompanies the tomb owner. As suggested by Davies, these plants are a sign of jubilation.[253] This meaning is reinforced by a caption to a similar procession found in the tomb of Kenamun (TT 93) in which men carry festive branches:[254]

> Our master comes(?). He has received(?) favor;
> I rejoice as one in a happy mood,
> seeing that he is provided for daily to the end of eternity.

[242] TT 75, PM (6); TT 90, PM (4).

[243] TT 66, PM (4) & (6).

[244] Action of the deceased depicted in the Royal Kiosk Icon: TT 75, offering a bouquet on PM (3) and receiving appointment before the pharaoh on PM (6); TT 77, PM (4), holding a fan (?); TT 90, PM (4), praising the pharaoh; TT 63, PM (5), deceased is reconstructed offering a bouquet to the pharaoh, see n. 119.

[245] *Urk.* IV, 1212,4; Davies, *Two officials*, 13, pl. XII.

[246] For pre-Amarna tombs in which an award scene is depicted, see: TT 75, PM (3) (Figure 19); TT 57, PM (15): Wreszinski, *Atlas* I, 203, top register and 205; and *Urk.* IV, 1841-1842; TT 192, PM (6): Radwan, *Königs,* 24-25; *Urk.* IV, 1865-1867; The Epigraphic Survey, *The Tomb of Kheruef, Theban Tomb 192,* OIP 102 (Chicago, 1980), 45, pls. 24, 30.

[247] On the meaning of the *shebyu*-collar: Alan Schulman, *Ceremonial Execution and Public Rewards, Some Historical Scenes on New Kingdom Private Stelae,* OBO 75 (Freiburg and Göttingen, 1988), 192-193; Johnson, *Amenhotep III: Perspectives,* 86; Eaton-Krauss, *Egypt's Golden Age,* 238-239, no. 316; and Brand, *JARCE 39* (2002), in press.

[248] Kemp, *Anatomy,* 259.

[249] Manniche, *Three Theban Tombs,* 24, reconstructs two figures with their backs turned towards the king when, in fact, the excised figure faces the king and a stooped official has his back turned towards the ruler.

[250] TT 75, PM (3): *Urk.* IV, 1211; TT 63: Dziobek and Raziq, *Sobekhotep,* 39-40. Although no text on TT 77, PM (4) describes the gifts, it is probable that they are the "good and clean things" of the king's mortuary temple mentioned on the adjacent wall, PM (7): Manniche, *Three Theban Tombs,* 24-25; *Urk.* IV, 1599, Guksch, *GM* 47 (1981), 25.

[251] See n. 173 and 219.

[252] TT 63, PM (4); TT 75, PM (3). On this vignette, see: Dziobek and Raziq, *Sobekhotep,* 38 with n. 58-60.

[253] Davies, *Rekh-mi-re* I, 17.

[254] Davies, *Ken-Amun,* 40, pl. XXXIX; Nina Davies, *Some Theban Tombs,* 12, n. 1.

These sequential vignettes of reward and homecoming emphasize the exceptional honor being conferred on the tomb owner. In the Theban festival program, the award ceremony may have occurred only once or twice a year in Thebes, during which time the rare appearance of the king argued for the extraordinary merit of those who were being rewarded.[255] The very importance of the event was underscored by its relatively frequent occurrence in the "public portion" of Theban tombs where the official was depicted in text and/or image alone with a *shebyu*-collar or as part of an awards ceremony before the king.[256] The award ceremony was likely a highly charged event in which the status of the tomb owner was elevated and his dependence on the king for this honor was reinforced.

In appointment motifs, the tomb owner's autobiography accompanies the images that show the conferral of his office. On the left focal wall in the tomb of Nebamun (TT 90), the biographical text states that on yr. 6 of Thutmose IV, Nebamun was appointed to the "Chief of Police in the west of Thebes" after "he had reached an old age in the following of the pharaoh (l.p.h.) in the integrity of his heart," and was to remain in office "until he reaches the blessed state" (Figure 29).[257] On the right focal wall in the tomb of Amenhotep-si-se (TT 75), the biography records aspects of the tomb owner's initiation to "Second Prophet of Amun" (Figure 20). The text mentions that the king caused Amenhotep-si-se to "look to the heavens" so that he could know "the mystery therein," the 'mystery' being the divine presence which was made manifest in the statue of the god. Through the twin faculties of reason (*rḫ*) and mystical knowledge (*bsỉ*), Amenhotep-si-se discovered "the way of satisfying the gods and of raising *Maat* for her lord," which, in relational terms, describes the acquisition of the faculties needed by a high priest to manipulate the forces of the divine presence and preserve the equilibrium of the cosmos.[258] In both of these cases, the autobiography is addressed to the viewer and to no one in the scene.[259]

In Figure 20, Amenhotep-si-se marches away from the pharaoh in a temple procession conducted in his honor. The procession is arranged on multiple registers. In the scene, Amenhotep-si-se, holding a long staff and wearing a tall ointment cone on his shaven head, is met by female family members who are all identified textually as "musicians of Amun" and hold insignia relating to their office (sistrums, *menits*).[260] The celebration is situated in the Amun Temple precinct as relayed by the pylon to the far right. This pylon marked the southern entrance into the Festival Court.[261] The goal and environment of the procession is referenced not only by the pylon but also by the statues which, in a highly unusual configuration, are oriented outwards towards the oncoming procession.[262]

[255] Kemp, *Anatomy*, 213. See also *Urk.* IV, 1842; and *Urk.* IV, 1867, which place the ceremony within the context of Amenhotep III's Sed Festival in yr. 30/31.

[256] Schulman, *Ceremonial Execution*, 192-193. See examples in Radwan, *Königs*, 23-27, all scenes on back wall of the transverse hall or the court. See also: Rosemarie Drenkhahn, "Auszeichnung," *LÄ* I (1975), 581-582; and Feucht, *LÄ* II (1977), 731-733.

[257] See the translation of text in 2.3, p. 42.

[258] Text: *Urk.* IV, 1208-1209. Jean-Marie Kruchten, *Les annales des prêtres de Karnak (XXI-XXIIImes dynasties) et autres textes contemporains relatifs à l'initiation des prêtres d'Amon*, OLA 32 (Leuven, 1989), 195-196, 289. For other texts belonging to high temple officials in the Temple of Amun that imply divine communication and selection, see: Malte Römer, *Gottes- und Priesterherrschaft in Ägypten am Ende des Neuen Reiches*, ÄAT 21 (Wiesbaden, 1994), 98-99.

[259] See 1.2.1, n. 104.

[260] *Urk.* IV, 1210; Davies, *Two officials*, 9, pl. XIV. The *sistrum* and *menit* were sacred to Hathor but were also used in many gods' cults during the New Kingdom to pacify the deities, banish evil, and serve as festive instruments; see: Bonnet, *Reallexikon*, 450; Robins, *Women in Ancient Egypt*, 145-146, 164; Ziegler in *Egypt's Golden Age*, 256. Reliefs of the Opet festival at Karnak depict groups of women shaking sistrums alongside the sacred bark of Amun (Hans Hickmann, *45 siècles de musique dans l'Égypte ancienne* (Paris, 1956), pls. 24-25).

[261] Reconstructed and discussed by Luc Gabolde, "La 'Cour de Fêtes' de Thoutmosis II à Karnak," *Karnak* IX (Paris, 1993), 15. The pylon is no longer standing today.

[262] Christian E. Loeben, "Beobachtungen zu Kontext und Funktion königlicher Statuen im Amun-Tempel von Karnak," Ph.D. dissertation, Humboldt-Universität zu Berlin (Berlin, 1999), 239-241. I am extremely grateful to Dr. Loeben for making portions of his dissertation available to me prior to its publication. The usual orientation for statues in temple representations is facing inwards, see: Nina de Garis Davies, "Two Pictures of Temples," *JEA* 41 (1955), 80-82; Wolfgang Helck, "Tempeldarstellungen," *LÄ* VI (1986), 377-379.

The men in procession above and behind the women carry papyrus stems or long, prickly heads of lettuce, items that refer to the celebration. The symbolism of these plants relate to the nature of Amenhotep-si-se's appointment. Lettuce (*Lactuca sativa* L.) was sacred to the god of fertility, Min, as well as to the god Amun, due to the plant's high yield and milky juice that resembled semen.[263] Priests are often depicted in statuary holding this type of lettuce in their hands.[264] As discussed above, papyrus symbolized the sun's rising from the abyss. It was also the symbol of the marsh that protected Horus as a child.[265] According to a recent study, the initiation of the prophets of Amun found its expression in the Myth of Horus with its components of the "introduction," "emergence," "illumination and transmutation," and "presentation."[266] As the beloved son of his father Re, Horus was, in the eyes of the Egyptians, the common archetype of the high priests who were the king's substitutes in the temple. The papyrus staff may have expressed this solar and mythic symbolism, a suggestion which is supported by an existing papyrus staff inscribed for an official named May, who was attached to the Temple of Re.[267] In the scene, Amenhotep-si-se's wife, Roy, also wields a papyrus staff, which also reinforces the initiation symbolism and, through its secondary association, relates also to the goddess Hathor, the mother of Horus.[268]

The Award of Distinction Icon makes use of visual narrative or sequential images that are particularly potent communicative devices because, by definition, they require the viewer to follow the cycle and retrieve the meaning of the scene. For example, in the tomb of Nebamun (Figure 29), Nebamun is depicted praising the king in the Royal Kiosk Icon, and in the adjacent Award of Distinction Icon, he stands oriented towards the pharaoh with his hand raised in greeting to the royal scribe and the king's delegate Iuny,[269] who confers on Nebamun the warrant of his new office and the 'Gazelle and Ostrich-plume'-standard of the armed police of Western Thebes.[270] Behind Nebamun stretch three registers of troops identified by their ceremonial standards and weapons. The troops march in a formal parade and salute Nebamun's appointment.[271] At the head of the second register appears the "Chief of Police in Thebes, Turi," who is "kissing the earth," and the "Deputy of Police, Mana," who is holding the same standard as that presented to Nebamun.[272] Specific people, titles, actions, and dates are relayed in the text, and they serve to identify Nebamun to viewers and impress upon them his exemplary service for the king, which resulted in the conferral of a new office. Sequential images

[263] Ludwig Keimer, "Die Pflanze des Gottes Min," *ZÄS* 59 (1924), 140-143; Renate Germer, "Die Bedeutung des Lattichs als Pflanze des Min," *SAK* 8 (1980), 85-87; idem, "Lattich," *LÄ* III (1980), 938-939; Klaus Kuhlmann, "Bemerkungen zum Lattichfeld und den Wedelsinsignien des Min," *WO* 14 (1983), 196-206; Michel Defossez, "Les laitues de Min," *SAK* 12 (1985), 1-4; M. Nabil el Hadadi, "Notes on Egyptian Weeds of Antiquity: 1, Min's Lettuce and the Nagada Plant," in *The Followers of Horus: Studies dedicated to Michael Allen Hoffman 1944-1990*, edited by R. Friedman and B. Adams, Egyptian Studies Association Publication No. 2, Oxbow Monograph 20 (Oxford, 1992), 323-326; Renate Germer, "Vegetables," translated from the German by J. Harvey and M. Goldstein, *OEAE* III (2001), 477.

[264] Georges Legrain, *Statues et statuettes de rois et de particuliers*, vol. II, Catalogue général des antiquités égyptiennes du musée du Caire nos. 42001-42250 (Cairo, 1906-), nr. 42170, 42172, 42174, 42177, 42179; Bonnet, *Reallexikon*, 120, 261, Abb. 64.

[265] Graham, *OEAE* I, 166; and see n. 96 on papyrus.

[266] Kruchten, *Les annales des prêtres de Karnak*, 269-270.

[267] Alnwick Castle Collections Nr. 1440, measuring 88.9 cm long x 3.8 cm in diameter, and engraved. S. Birch, *Catalogue of Egyptian Antiquities at Alnwick Castle* (London, 1880), 187. Text translated in Ali Hassan, *Stöcke und Stäbe im Pharaonischen Ägypten bis zum Ende des Neuen Reiches*, MÄS 33 (Munich and Berlin, 1976), 155-156. Titles of May in: Serge Sauneron, "Le chef de travaux Mây," *BIFAO* 53 (1953), 57-63; Labib Habachi, "Grands Personnages en mission ou de passage à Assouan: I, Mey, attaché au Temple de Rê," *CdÉ* 29, no. 58 (1954), 210-215.

[268] Bonnet, *Reallexikon*, 582-583; Hassan, *Stöcke und Stäbe*, 197-199; Graham, *OEAE* II (2001), 166.

[269] Iuny holds a short-handled fan that signifies he was the king's delegate on palace business. The fan is used in the title _t3y ḫw_ (Gardiner, *EG*(3), Sign-list S 37), or "Fan-Bearer," which, according to Helck, was honorific and bestowed by the king on his high officials for personal reasons, particularly those officials who were employed in the palace (Helck, *Verwaltung*, 282-284). Besides the title of "Royal Scribe," Iuny also held the position of scribe of the treasury (*sš pr-ḥd*) and is attested on a stela in the reign of Amenhotep III having led quarrying work for the state. On Iuny, see: Helck, *Verwaltung*, 403-404, 511, 545.

[270] Raymond O. Faulkner, "Egyptian Military Standards," *JEA* 27 (1941), 15-16, pl. VI, fig. 22.

[271] Davies, *Two officials*, 35-37. Bow and formal emblematic gesture with strings facing the bowmen, indicating their subordinate status: R. Wilkinson, *Symbol & Magic*, 200-201. Exceptions are the first two bowmen in the row and the sixth and seventh who hold their bowstrings outward. Perhaps this alteration was done for variation or to reinforce the formal emblematic gesture because the bow is useless when turned like this. A throw stick is the hieroglyphic determinative for *Md3wy*. Gestures and postures: Dominicus, *Gesten*, 21-25, 33-35.

[272] Davies, *Two officials*, pl. XXVII; *Urk.* IV, 1620, 3-4; Faulkner, *JEA* 27 (1941), 15-16.

and narratives direct the viewers' attention and guide them to retrieve pertinent information about the deceased's status, while involving them in an interactive relationship with the artwork.[273]

A special appointment scene is associated with the "Installation of the Vizier" text (Figure 16). Although completely destroyed, the figure of the Vizier Hepu (TT 66) once stood before the king as recorded in the preserved text and comparative scenes illustrating the Vizier's installation to office.[274] The "Installation of the Vizier" text records an address made by the king to his newly appointed Vizier. In this address, he lays down the principles that should govern the Vizier's conduct in office. The public at large and their dealings with the Vizier are also referenced frequently in this text. Although the final paragraph concerning the inspection of plough lands is missing from the installation text in the tomb of Hepu, this subject matter is illustrated in several vignettes at the far left of the wall. These vignettes depict the registration and presentation of land revenues.[275]

The left focal wall of TT 66 is poorly preserved, and its remnants suggest several alternate reconstructions (Figure 15). A procession of men bearing branches is depicted on this wall. The men step ahead of another group of five closely overlapping figures who probably accompanied the now-destroyed image of the deceased. On one hand, the festive bunches of foliage suggest this is a celebratory scene that accompanied the tomb owner's homecoming "from the mark of distinction by the king."[276] However, several of the men holding foliage are identified by cursive hieroglyphs as "his brother" (sn.f) and bear titles such as "God's Father" or "Third Lector Priest of [Amun?]."[277] Although it was characteristic to depict members of the tomb owner's family in homecoming scenes after his appointment to office,[278] the appearance of a lector priest here suggests another configuration, one in which the men are accompanying a statue of the deceased.[279] In comparison with the tomb of Kenamun (TT 93), lector priests are portrayed accompanying the deceased's statue on its way to a number of Theban temples and to his tomb. The text reads:[280]

> Accompanying the statues of the superintendent of the calves of Amun, Kenamun, to the temple of Amun in Karnak and to the temples of all the gods of Upper and Lower Egypt. In peace, in peace to his tomb of the necropolis in accordance with favors of the king which are accorded to a humble servant. All his kindred, together with the household shout before them. Now his Majesty ordered to have men accompany these statues to the temple, (now that) they (the statues) had been provided with loaves and meat-offerings in the course of every day.

Thus, the scene in the tomb of Hepu may illustrate another type of award by the king. The award may have been in the form of a statue of the tomb owner carried in procession to the temple and to his tomb. With these two alternatives in mind, a more definite reconstruction of this scene cannot be made because of the damage inflicted on the wall.

[273] Peter J. Holliday, *Narrative and event in ancient art* (Cambridge and New York, 1993), 4-8. However, Holliday argues against a "single and definite meaning" in narrative. He stresses the on-going process of perception between the work of art and its audience which stretches the space between the beholder and the object across time so that the experience of that artwork becomes a continual historical process. Holliday's post-structuralist "on-going process of negotiation" is noted, but not followed here.

[274] The beginning of the text reads: "The Court was admitted to the [audience hall of the pharaoh] and it was ordered that the newly [appointed] Vizier [Hepu] should be ushered in. Thus said His Majesty to him: [Look] to the office of Vizier, be vigilant concerning [all that] is done in it, for it is the mainstay of the entire land...". For the remains of the complete text, see: Kurt Sethe, *Die Einsetzung des Veziers unter der 18. Dynastie: Inschrift im Grabe des Rech-mi-re' zu Schech Abd el Gurna*, UGAÄ 5, Heft 2 (Leipzig, 1909), 62-63; Nina Davies, *Some Theban Tombs*, 10, pl. 10. Translations and reconstructions in: Raymond O. Faulkner, "The Installation of the Vizier," *JEA* 41 (1955), 18-29; Davies, *Rekh-mi-re* I, 84-88, II, pls. CXVI-CXVII. For comparative scenes: TT 100, PM (5): Davies, *Rekh-mi-re* II, pls. XIII-XV; TT 131, PM (12), Dziobek, *User-Amun*, 65, 77ff. On Hepu's career and position as Vizier of the South, see: Bryan, *Thutmose IV*, 243-244.

[275] Compare images of Rekhmire inspecting produce: Davies, *Rekh-mi-re* I, 41-42; II, pls. XLIV-XLVI; and inspecting revenues of the land: Ibid., 33, pls. XXXIII-XXXV.

[276] Compare Dziobek, *User-Amun*, 76-77, taf. 72, of a procession of men with lettuce stalks; and Davies, *Rekh-mi-re* I, 17, of companions going out in front of the Vizier with a "festal bunch of green foliage."

[277] The first man in procession not holding foliage is termed *sn.f it-n tr* "his brother, the god's father"; and the second is identified as *sn.f hry-hbt 3-nw n [Imn?]* "His brother, the third Lector Priest of [Amun?]" (for similar titles: Wolfgang Helck, *Zur Verwaltung des Mittleren und Neuen Reichs: Register* (Leiden, 1975), 21, 26). Not recorded by Nina Davies, *Some Theban Tombs*, 11-12. The cursive hieroglyphs do not appear to stem from a later reuse of the tomb, but exist as markers for the scribe to render them into monumental hieroglyphs.

[278] For similar homecoming scenes attended by family or colleagues, see: Davies, *Two officials*, pl. XIV; Nina Davies and Gardiner, *Huy*, 11, pl. VI.

[279] As originally suggested by Nina Davies, *Some Theban Tombs*, 12, n. 1.

[280] *Urk.* IV, 1398; Cumming, *Historical Records* II, 105-106; Davies, *Ken-Amun*, pl. XXXIX.

While two distinct cycles comprise the Award of Distinction Icon, the basic meaning of reward or appointment motifs is essentially the same. Clearly, the tomb owner's status is being elevated through his connection to the ruler who bestows on him gifts and public office in text and image. Furthermore, the deceased's award or appointment is at the behest of the king whose presence in the icon reminds all those who read it of the administrative power of the pharaoh and his importance to the deceased's livelihood in this world and the next. Told in a series of sequential vignettes or pure narrative, the 'stories' about the tomb owner are relayed to the audience using a particularly potent communicative device that required the viewer to connect the actions in order to understand the meaning.

In the Award of Distinction Icon, the official's initiative and exceptional qualities as a loyal servant of the king are being honored. In the case of Amenhotep-si-se (TT 75) and Hepu (TT 66), these officials act as representatives of *Maat* and serve the needs of the king, the gods, and, indirectly, the people by "raising *Maat* for her lord" and by doing "*Maat* for all men."[281] Here, the principle of *Maat* is heralded through the tomb owner's good deeds, which successfully serve the king through maintenance of the welfare of the land, the cosmos, and, indirectly, mankind.[282] In the case of Nebamun (TT 90), as "Chief of Police" he would have commanded troops in the policing of the desert necropolis and the borders of Thebes West. In Egyptian religion, the western desert was known as a chaotic region, being the domain of Seth and the entrance to the underworld.[283] Charged with maintaining the security of Egypt's borders, Nebamun is thus presented as one who would repel chaos by subduing the chaotic forces inherent in the desert with the help of the troops he oversaw, thereby maintaining the ordered world of *Maat* for the crown.

To summarize the previous discussion, the 'Tribute,' Registration, Gift, and Award of Distinction icons are all linked thematically and symbolically to the Royal Kiosk Icon. Depicted actively discharging the duties of his office before the watchful eye of the pharaoh, the deceased is presented as a high-status individual who undertakes various tasks for the ruler and a loyal servant of the king. Visual hooks, sequential vignettes, narrative, and context-specific objects were used to engage viewers and impress upon them the importance and the duties of the deceased. Scenes of ceremonial display were translated into two dimensions on chapel walls and disseminated to visitors who may have recognized in these scenes the nature of royal ideology, or at the very least, kingly authority and the tomb owner's contribution to it. On the chapel's focal walls, the identity of the tomb owner was defined by his service to the king who would secure the deceased's maintenance in the hereafter. This identity would have been projected into the permanent time of the afterlife, where the tomb owner would continue to serve the ruler in his reassembled kingdom. Symbolically, through the successful discharging of his office, the deceased aided the central roles of the king, who, as the maintainer of *Maat* and the theoretical source of all goods in Egyptian thought and practice, would provide for the eternal needs of the tomb owner in the next life.

3.2.6 Offering Table Icon

The motif of the deceased seated before an offering table is one of the oldest images in Egyptian art. The *Speisetischszene,* or food table scene, originated in the cylinder seals and elite niche stones of the Early Dynastic Period and was later expanded to include images of family members, offering figures, banqueting, and funerary rituals such as the "Opening of the Mouth."[284] The Offering Table Icon occurs on 18 focal walls, where it is placed on the surfaces immediately adjacent to the entrance to the chapel shrine or inner hall (Figures 7-10, 17-18, 27, 33, 37-39, 41, 47-50; B&W Plates 2,1; 5-7). The icon is composed of an image of the deceased and wife (sometimes with children) or mother

[281] Amenhotep-si-se: *Urk.* IV, 1208,10; Hepu reconstructed from the "Installation of the Vizier" text in Rekhmire (TT 100): *Urk.* IV, 1092,8. See Faulkner, *JEA* 41 (1955), 23, (18)-(19).

[282] See discussion of *Maat* in eighteenth dynasty Theban tomb autobiographies in: Guksch, *Königsdienst*, 103-104; Lichtheim, *Maat*, 54-57.

[283] Karl W. Butzer, "Wüste," *LÄ* VI (1986), 1293. See also the discussion on the symbolic meaning of the desert in: Kamrin, *Khnumhotep II*, 88-89.

[284] On the development of the offering table scene, see: Karl Martin, "Speisetischszene," *LÄ* V (1984), 1128-1133; Peter Kaplony, "Toter am Opfertisch," *LÄ* VI (1986), 711-726; Jacques Vandier, *Manuel d'archéologie égyptienne*, tome IV: *Bas-reliefs et peintures, Scènes de la vie quotidienne* (Paris, 1964), 81-102. On its early development, see: Peter Kaplony, *Die Inschriften der ägyptischen Frühzeit*, vols. I-III, ÄA 8 (Wiesbaden, 1963), tafs. 98 (nr. 409-411), 100 (nr. 434), 101 (nr. 446-447), 103 (nr. 466-467, 469), 105-106 (nr. 497-498, 500-522), 138-140, 147; Jacques Vandier, *Manuel d'archéologie égyptienne*, tome 1,2: *Les époques de formation* (Paris, 1952), 733ff.

seated before a table of offerings (or an offering stand) receiving gifts from family members, friends, and anonymous participants.[285] Textual captions identify actions, gifts, and individuals and may include offering lists and prayers.

Three general types of inscriptions accompany the Offering Table Icon. The first type of text appears over the images of the tomb owner and wife seated before an offering table and refers to the origin of the offerings:[286]

Sitting [in] a booth[287] in order to enjoy (himself)

in his funerary chapel (of) justification;

receiving....bread which comes forth [from the offering table of Amun][288]....*snw*-cakes[289]...

The second caption type, which only occurs once, is a simple *htp-di-nsw* offering prayer that secures the deceased's provisioning in the hereafter.[290] The third type of text associated with the Offering Table Icon relates to the offering action conducted by a family member on behalf of the deceased and wife and will be discussed further below. All texts give the deceased's name and characteristic title(s), which, in all but two cases, reveal duties associated with service to the God's temples and temple holdings (Table 1).[291]

As the first type of inscription implies, the offerings were reverted (at least theoretically) from the altar of Amun and went out into the necropolis to provision the cults of private individuals. With such a provenance, offerings redistributed from the god's altars carried some divine imprint for the benefit of the recipient, who would be incorporated into the divine realm by means of these offerings.[292]

The divine life-force contained in reverted temple offerings for the dead parallels the ideology of offering in ancient Egypt. As stated above, offerings related to the Eye of Horus and were characterized as divine material.[293] In the realm of the dead, the mythic prototype of the Eye of Horus related to regeneration of Osiris, whose vitality was restored by means of the life inherent in the offerings. Translated to the funerary realm, "the dead were momentarily in an inert state, according to the Egyptian way of thinking, and to bring them out of that state and back to life they were given 'all good and pure things on which the god lives,' which was the appropriate offering for those who entered the divine world."[294]

[285] The focal walls that preserve the Offering Table Icon in some form are: TT 38, PM (4) & (6); TT 52, PM (3) & (6); TT 69, PM (4) & (7); TT 89, PM (8); TT 108, PM (5); TT 139, PM (5) & (6) = same focal wall; TT 151, PM (4); TT 161, PM (3); TT 165, PM (5); TT 175, PM (4); TT 181, PM (8); TT 249, PM (4); TT 253, PM (4) & (7); TT 258, PM (1).

[286] TT 38, PM (4): Nina Davies, *Some Theban Tombs*, 5, pl. IV. Variants in TT 38, PM (6): *Urk.* IV, 1638; TT 52, PM (6)II: *Urk.* IV, 1606; TT 139, PM (6): "all that goes up upon the altar of Amun in Karnak, pure, pure, bread, beer, cattle, fowl" (Vincent Scheil, "Le tombeau de Pârj," *Mém. Miss.* V, 2 (1894), 585); TT 139, PM (5): Ibid., 588; TT 151, PM (4)II; TT 253, PM (4) (Strudwick, *The Tombs of Amenhotep, Khnummose, and Amenmose*, 42-43, text 4). And relating to the context of the meal in TT 108, PM (5): "Sitting in a booth in order to enjoy (oneself) [in his funerary chapel (of) justification, by the High Priest of Onuris] Neb-s[ny],....his wife, the Lady of the [House]... Sen-[seneb]."

[287] In several depictions of the Offering Table Icon, the deceased and wife are depicted enclosed in a 'booth' or kiosk: TT 52, PM (6)II; TT 165, PM (5)II.

[288] Reconstructed on the basis of similar examples in: *Urk.* IV, 1416; TT 161, PM (2): Lise Manniche, "The Tomb of Nakht, the Gardener, at Thebes (No. 161), as Copied by Robert Hay," *JEA* 72 (1986), 59, no. 13; Schott, *Das schöne Fest*, 121-123, nos. 112, 113, 115, 116.

[289] *Snw*-cakes were temple breads that were reverted from the deity's altar to priests. At least in the Middle Kingdom, *snw*-cakes were associated with the prolonging of life. See: L. Bell, *Temples*, 183-184. Middle Kingdom texts accompanying Hathoric rites with *snw*-cakes are depicted in the tomb of Ukhhotep, nr. B 2: Aylward M. Blackman, *The rock tombs of Meir*, vol. II, ASE 23 (London, 1915), 24, pl. XV, XXV,2.

[290] TT 253, PM (7), over seated figures of deceased and wife: Strudwick, *The Tombs of Amenhotep, Khnummose, and Amenmose*, 44, text 5.

[291] Tomb owners with focal walls that preserve the Offering Table Icon and who are priests in the god's temples: Nakht (TT 52) (Eichler, *Die Verwaltung des "Hauses des Amun,"* 299, no. 385), Nebseny (TT 108), Pairy (TT 139) (Ibid., 270, no. 203); stewards of priests: Djeserkarasoneb (TT 38); or were supervisors of temple fields and holdings: Menna (TT 69) (Ibid., 278, no. 254; see also n. 579); Haty (TT 151) (Bryan, *Thutmose IV*, 272); or were grain scribes: Khnummose (TT 253) (Ibid., 310, no. 462; and Strudwick, *The Tombs of Amenhotep, Khnummose, and Amenmose*, 23-24); or were in charge of temple provisioning: Nakht (TT 161) (Ibid., 200, no. 384), owner of TT 175 (unguent maker) (Manniche, *Three Theban Tombs*, 31; and see n. 499 on the association between the temple and the unguent industry); Neferrenpet (TT 249) (see n. 574); or were temple artisans: Nehemaway (TT 165) (see n. 474), Nebamun and Ipuky (TT 181) (see n. 575). The exceptions are: Amenmose (TT 89), who as Steward of the "Southern City," was involved in the administration of the estate of Amun, the chief cult in Thebes (on Amenmose's titles: *Urk.* IV, 1024; Davies, *JEA* 26 (1940), 131; Helck, *Verwaltung*, 107; on the duties of the title, see: Murnane, *Amenhotep III: Perspectives*, 193-194, 206-207; Helck, *Verwaltung*, 99, 418-429, 522-531); and Menkheper (TT 258), a palace scribe for the house of the royal children. Both exceptions made use of the Offering Table Icon.

[292] See: L. Bell, *Temples*, 302, n. 185; Jan Assmann, "Totenkult, Totenglauben," *LÄ* VI (1986), 663.

[293] See discussion pp. 72-73.

[294] Englund, *OEAE* II (2001), 565. See also: Assmann, *Religion and Philosophy in Ancient Egypt*, 145-146, on the sharing of divine nourishment that made the deceased a member of the community of the gods.

The transfer of the properties of the offerings is indicated by the tomb owner's gesture in the Offering Table Icon, with his hand outstretched towards the food and beverage offerings on the table to receive their sustenance.[295] Egyptian texts and the pictorial record reveal that spontaneous eternal life and resurrection were connected to food. The word for food, *k3w*, has as its root the word *k3*, meaning the "vital force."[296] The Pyramid Texts talk of the bread and drink of eternal life.[297] Following the act of creation in the Dramatic Ramesseum Papyrus, the word created *k3w* (the vital force which is contained in food) and *ḥmswt* (the female aspect of the same concept) which made "all nourishment and all offerings."[298] Two-dimensional renderings of offering tables composed of *ka*-arms on a standard that enclosed bread and other offerings illustrate the ancient Egyptian belief that the *ka* sustained life, and nourishment maintained the *ka*.[299] These texts and images indicate that the partaking of food and drink gave corporeal and spiritual energy to the dead who thus participated in the magical power that was the essence of life. In other words, food and drink were seen by the ancient Egyptians as the renewal of life and the basis of eternal life.

In private Theban burials after the reign of Hatshepsut, the *Book of Going Forth by Day* was the primary guarantor of new life, and it offered instructions and incantations to provision and protect the dead in the afterlife.[300] The culmination of the passage of the dead into the next world was summarized in Chapter 125, where the dead were judged as to whether they were worthy of receiving eternal life. At the Judgement, the dead person denied his or her wrongdoings in a 'negative confession' before 42 deities and, once found innocent, was declared 'true of voice' (*m3'-ḫrw*). The deceased was then ushered into the presence of Osiris, and his or her heart was weighed against the feather of truth on the scales of justice. If vindicated, the individual was allowed to partake of the funerary meal, thus signaling his or her integration into the realm of the blessed where food and drink would ensure eternal survival. As one blessed, the dead person could leave the tomb at will, could be transformed into various gods, and could feast in the fields of offerings in paradise.[301]

Thus, in the Offering Table Icon, the deceased and wife are represented in their potential, transcended state as the blessed dead, who are joined with the gods in the hereafter, partaking of food and receiving offerings that would result in their eternal survival.[302] They are seated before a table heaped with food that represented their post-vindication funerary meal and the divine substances that would guarantee their eternal life and regeneration. If the actual cultic rituals and food offerings lapsed, the creative power of the image acted to secure the dead's eternal sustenance and rebirth.[303] The tomb owner, accompanied by his name and title(s), was commemorated (in all but two cases)[304] as a member of the god's temples or dependencies, an identity that would be projected into the eternal time of the afterlife, where the deceased would continue to serve the gods. Depicted in the state of the blessed dead, the deceased and wife are also shown as worthy of cultic actions from the living. The images of the tomb owner and wife seated at a table heaped with

[295] Martin, *LÄ* V (1984), 1128; Verhoeven, *LÄ* VI (1986), 679, n. 7. Tomb owners are rarely shown eating; instead, the deceased by stretching his hand over the food signifies the action of partaking of food and drink.

[296] Alan H. Gardiner, "Some personifications," *Proceedings of the Society of Biblical Archaeology* 38 (1916), 89. The translation of the concept of the *ka* as "vital force" is discussed in Hornung, *Idea into image*, 175.

[297] *PT* 1177b: Kurt Sethe, *Die altägyptischen Pyramidentexte nach den Papierabdrücken und Photographien des Berliner Museums* (Leipzig, 1908-1922), 157; idem, *Übersetzung und Kommentar zu den altägyptischen Pyramidentexten*, vol. 5 (Hamburg, 1962), 70; Raymond O. Faulkner, *The Ancient Egyptian Pyramid Texts* (Oxford, 1969), 190.

[298] Kurt Sethe, *Dramatische Texte in altägyptischen Mysterienspielen*, UGAÄ 10 (Leipzig, 1928), 61-64, 66-68; W. Brede Kristensen, *Life Out of Death: Studies in the Religions of Egypt and Ancient Greece*, translated from the Dutch by H.J. Franken and G.R.H. Wright (Louvain, 1992), 41.

[299] TT 181, PM (8)I. See similar examples of *ka*-offering tables in: Davies, *Two sculptors*, pl. XXIX; Henri Frankfort, *Kingship and the Gods: A Study of Ancient Near Eastern Religion as the Integration of Society and Nature* (Chicago and London, 1948/R 1978), fig. 21; Lorton, *Born in Heaven, Made on Earth*, 180-181, fig. 6.

[300] Quirke and Forman, *Hieroglyphs and the Afterlife*, 119-120; Erik Hornung, *The Ancient Egyptian Books of the Afterlife*, translated from the German by D. Lorton (Ithaca and London, 1999), 11-22; Quirke, *Egyptian Religion*, 160-163; Taylor, *Death and the Afterlife*, 196-198.

[301] See discussion in Müller, *OEAE* I (2001), 34-35; Meeks, *Daily Life of the Egyptian Gods*, 142-147; Demarée, *The 3ḫ íkr n r'-stelae*, 238-247; and Morenz, *Egyptian Religion*, 212, who states the deceased "is preserved in his own particular form; he enters into God or is with God."

[302] Martin, *LÄ* V (1984), 1128. See also: Fitzenreiter, *Social Aspects of Funerary Culture*, 79.

[303] See discussion of the magical and functional use of offering table elements and how they symbolize different actions of the offering ritual in: Regina Hölzl, *Ägyptische Opfertafeln und Kultbecken: Eine Form- und Funktionsanalyse für das Alte, Mittlere und Neue Reich*, HÄB 45 (Hildesheim, 2002), 133-135.

[304] See n. 291.

food may also have chronicled celebrations held in the chapel during their lives, particularly within the context of necropolis festivals.[305]

In the Offering Table Icon, a number of objects, people, and actions reinforce the concept of the tomb owner's potential, transcended state and relate to his or her provisioning and rebirth in the next life. Beginning with the image of the offering table, a number of tables contain 'prt- form bread loaves, which are tall, thin loaves with flat sides and pointed tops.[306] As discussed by Miroslav Bárta,[307] bread loaves baked in 'prt molds were interspersed with and gradually replaced by reed leaves in the late Old Kingdom. Bárta argues that the equivalence between bread loaves baked in 'prt molds and reed leaves was based on their similar form as well as their common symbolic link in ancient Egyptian beliefs of the afterlife. While bread was essential for the existence of the deceased in the hereafter, and reed leaves symbolized the "Field of Reeds" where the deceased would obtain food in the next world.[308] Thus, the offering table with bread baked in 'prt molds may have drawn on two levels of symbolism: 1, as bread, the loaves would provide the deceased with eternal life; and 2, their symbolic link to the "Field of Reeds" related to the place of sustenance that the deceased would inhabit in his or her transcended state.

Other tables in the Offering Table Icon are heaped with offerings, including different kinds of bread, vegetables, fruit, choice cuts of meat, fowl, and, sometimes, fish. A few chapels depict offering stands or holders upon which rest a vase, a lotus bouquet, a vessel containing unguent, or a basket filled with fruit.[309] Lotus flower bouquets with coiled stems are also placed above offerings and vessels in the Offering Table Icon. The lotus in the Egyptian world view related to rebirth and regeneration, which, when added among the offerings, may have symbolized the eternal rejuvenation of these food items for the benefit of the deceased in the hereafter.

In one chapel, a head of lettuce (*Lactuca sativa* L.) is placed above a bouquet holder which, based on its symbolism, related to fertility.[310] In several instances, onions are displayed on top of the offering table; these symbolized illumination, resurrection, and cosmic order.[311] Below the table, vessels filled with water, beer, or wine are depicted draped with garlands of lotus flowers, signifying their continual renewal.[312]

As a key agent and partner in the tomb owner's eternal life and rebirth, the wife appears in the Offering Table Icon always seated behind (or beside) her husband in a secondary position. In ancient Egypt, the wife was dependent on her husband for her burial, which was received as a privilege of his professional office, yet she was still an active recipient in his funerary cult.[313] In the Offering Table Icon, the deceased and wife are either seated on separate lion-legged, high-backed chairs or seated together on a low-back couch or bed with feline legs.[314] "Classic" chairs were found

[305] After Hermann, *Stelen*, 100; Hodel-Hoenes, *Life and Death in Ancient Egypt*, 15.

[306] 'prt bread loaves in: TT 38, PM (6)II; and TT 69, PM (7)II with a table top in the form of a *htp*-sign which imitates the ancient mat with a bread loaf offering (Andrey O. Bolshakov, "Offerings: Offering Tables," *OEAE* II (2001), 574); TT 181, PM (8)II, offering table with *k3* arms signifying the food (*k3w*) of life (*k3*). On the 'prt bread loaf, see: Miroslav Bárta, "Archaeology and Iconography: *bd3* and 'prt bread moulds and *Speisetischszene* development in the Old Kingdom," *SAK* 22 (1995), 21-35, particularly stage 3, fig. 4 (no. 3), which closely resembles the bread on the two offering tables mentioned above.

[307] Bárta, *SAK* (1995), 31-34.

[308] On the depiction of reed leaves as the "Field of Reeds," see: Nadine Cherpion, *Mastabas et hypogées d'Ancien Empire: Le problème de la datation* (Brussels, 1989), 43; Charles E. Worsham, "A Reinterpretation of the So-called Bread Loaves in Egyptian Offering Scenes," *JARCE* 16 (1979), 10.

[309] TT 38, PM (6)I; TT 52, PM (6)II; TT 139, PM (6)I; TT 249, PM (4)I with unguent (Manniche, *Three Theban Tombs*, 51); TT 249, PM (4)II with fruit? See example of a vase stand in Geoffrey Killen, *Egyptian Woodworking and Furniture*, Shire Egyptology 21 (Princes Risborough, 1994), 48, fig. 57.

[310] See n. 263.

[311] TT 52, PM (3); TT 69, PM (7)II; TT 108, PM (5); TT 249, PM (4)I? The onion as an instrument of solar resurrection and cosmic order is discussed by Catherine Graindorge, "L'oignon, la magie et les dieux," *Encyclopédie religieuse de l'Univers végétal, Coyances phytoreligieuses de l'Égypte ancienne*, vol. I, edited by S. Aufrère, Orientalia Monspeliensia 10 (Montpellier, 1999), 328-329, 330-331.

[312] Sometimes, vessels filled with wine, unguent, or organic material hover on a register above the central offering table, again strewn with lotus flower bouquets (TT 69, PM (7)I). The rebirth symbolism of vessels decorated with lotus garlands from Deir el-Medina is discussed by M. Bell, *Cahiers de la ceramique égyptienne* I, 49-76, esp. 56.

[313] Robins, *Women in Ancient Egypt*, 163-165, 173; and see also discussion above 1.3, p. 22. However, the wife's role in the tomb chapel appears to change during the reign of Thutmose III, where she begins to take a more active role in ritual scenes, see: Whale, *Family*, 241-242, 271-275.

[314] Separate chairs: TT 38, PM (4); TT 69, PM (4) & (7); TT 108, PM (5)II; TT 139, PM (6); TT 161, PM (3); TT 165, PM (5); TT 175, PM (4); TT 181, PM (8); TT 249, PM (4); TT 253, PM (7). A variant appears in TT 69, PM (7)I, which shows a papyrus umbel projecting out from the seat bed; the umbel is associated with stools beginning in the Second Dynasty (Zaky Y. Saad, *Ceiling Stelae in Second Dynasty Tombs* (Cairo, 1957), fig. 9). Couch: TT 38, PM (6); TT 52, PM (3) & (6); TT 108, PM (5)I; TT 151, PM (4).

in ancient Egyptian homes of the wealthy middle class, and thus are associated with affluence and status.[315] The symbolism of the couch may have related to the marriage bed of procreation. Two-dimensional representations of elongated chairs, couches, and beds are often rendered identically and display objects with erotic significance such as mirrors, unguent jars, and sandals beneath the seat, with additional images of monkeys and/or hairdressing above.[316] In the Offering Table Icon, the sexual symbolism of the couch/bed is emphasized by the presence of a cat beneath the seat (Figure 9), which, as argued by Herman te Velde, was related to female sexuality through the cat's association with the goddess Mut.[317] Furthermore, the action of the cat eating a Tilapia fish, with its connotation of fertility and rebirth,[318] also enhances the theme of sexuality and regeneration. If the association between the couch and the bed is correct, then the deceased and wife are rendered in the Offering Table Icon seated on an integral component that would aid their sexual union. Since rebirth was considered by the ancient Egyptians as the reenactment of birth,[319] the necessarily accouterments are depicted in the creative environment of the tomb chapel to ensure the tomb owners' rebirth in the next world.

Objects depicted underneath the chair were significant to the overall meaning of the composition. The presence of kohl pots and mirrors related to beauty in ancient Egypt.[320] Men and women used kohl to beautify and protect the eyes.[321] Kohl was also a required component for the dead's judgement and rebirth. After purifying themselves and dressing in white, the dead made up their eyes and anointed themselves with myrrh before being led to the Hall of Judgement. If judged worthy, they would then enter into the realm of Osiris.[322] Likewise, the mirror in ancient Egypt was associated with regeneration, as relayed by its distinctive yellow orb that symbolized the sun. The mirror was also connected to Hathor. The handle was often decorated with a figure of the goddess or iconography that was specific to her (i.e. feminine statuettes or papyrus stalks).[323] Both the mirror and the kohl pot related to sexuality, and thus represent the necessary preliminaries for the union of the husband and the wife, which would result in their rebirth in the hereafter.

In the tomb of Khnummose (TT 253) on the left focal wall, four dogs are represented, one underneath the tomb owner's chair and three beneath the wife's (Figure 48). Since the Predynastic Period, domesticated dogs were associated with hunting and men, and in New Kingdom representations are often found placed under the chairs of males.[324] Placed thus, the dog symbolized male potency much in the same way as the cat seated under a female's chair signified fertility.[325]

[315] Peter Der Manuelian, "Classic Chair," *Egypt's Golden Age*, 66-67, no. 37; Killen, *Egyptian Woodworking and Furniture*, 47-48. High-backed chairs with lion legs resting on truncated cones are the most frequently represented chairs in the New Kingdom in painting, relief, and sculpture.

[316] Compare the couches in the Offering Table Icon with the image of Mereruka and his wife seated on a bed (Lise Manniche, *Sexual Life in Ancient Egypt* (London and New York, 1987), 39, fig. 27); Sobeknakht from el-Kab (Madeleine Gauthier-Laurent, "Les scènes de coiffure féminine dans l'ancienne Égypte," *Mélanges Maspero*, vol. 1, fasc. 2, MIFAO 66 (Cairo, 1935-1938), fig. 5-6); and Säve-Söderbergh, *Four Theban Tombs*, 39-40, pls. XXXVII, XXXVIII. For discussion of the erotic associations of beds, see: David O'Connor, "Sexuality, Statuary and the Afterlife; Scenes in the tomb-chapel of Pepyankh (Heny the Black), An Interpretive Essay," in *Studies in Honor of William Kelly Simpson*, vol. 2, edited by P. Der Manuelian (Boston, 1996), 629-630. Derchain, *SAK* 2 (1975), 68, has argued that the elongation of the chair seat in some two-dimensional representations resembles a bed more than a couch. Actual beds have short lion-shaped legs which are set on truncated cones, see: J.E. Quibell, *Tomb of Yuaa and Thuiu*, Cat. gén. nos. 51001-51191 (Cairo, 1908), 50, nos. 51108-51109; Geoffrey Killen, *Ancient Egyptian Furniture, Vol. I: 4000-1300 BC* (Warminster, 1980), 30-31, fig. 14, 31-32, pl. 39. On erotic elements see: Manniche, *Sexual Life*, 40-44.

[317] TT 52, PM (3). The other couch/beds do not have items beneath them. On the connection between the cat and the goddess Mut: te Velde, *Studies in Egyptian Religion*, 127-137. See also: Eugène Warmenbol and Florence Doyen, "Le chat et la maîtresse: les visages multiples d'Hathor," *Les divins chats d'Égypte: un air subtil, un dangereux parfum*, edited by L. Delvaux and E. Warmenbol (Leuven, 1991), 59-60.

[318] On the symbolism of the Tilapia fish, see: Christiane Desroches-Noblecourt, "Poissons, tabous et transformations du mort," *Kêmi* 13 (1954), 33-42; Ingrid Gamer-Wallert, *Fische und Fischkulte im alten Ägypten*, ÄA 21 (Wiesbaden, 1970), 124-131.

[319] Gay Robins, "Ancient Egyptian Sexuality," *DIE* 11 (1988), 61-64; Lise Manniche, "Sexuality," *OEAE* III (2001), 276.

[320] Kohl pots and mirrors: TT 69, PM (4)II; TT 161, PM (3)I; TT 249, PM (4)I (under child's seat).

[321] Ed Brovarksi, "Kohl and Kohl Containers," *Egypt's Golden Age*, 216-217; Lise Manniche, *Sacred Luxuries: Fragrance, Aromatherapy, and Cosmetics in Ancient Egypt* (Ithaca, 1999), 135-137.

[322] Manniche, *Sacred Luxuries*, 137, quoting the rubric to Chapter 125 of the *Book of Going Forth by Day*.

[323] On the forms and symbolism of mirrors, see: Arielle Kozloff, "Mirror, Mirror," *Bulletin of the Cleveland Museum of Art* 71 (1984), 271-276; Christa Müller, "Speigel," *LÄ* V (1984), 1147-1150; Christine Lilyquist, *Ancient Egyptian Mirrors from the Earliest Times through the Middle Kingdom*, MAS 27 (Munich and Berlin, 1979); idem, "Mirrors," *Egypt's Golden Age*, 184; Derriks, *OEAE* II (2001), 419-422.

[324] John Baines, "Symbolic Roles of Canine Figures on Early Monuments," *Archéo-Nil* 3 (Mai, 1993), 57-74; Henry G. Fischer, "Hunde, A.," *LÄ* II (1980), 77-81; te Velde, *Studies in Egyptian Religion*, 131; Malek, *The Cat in Ancient Egypt*, 51, 54, 59. See also: Douglas J. Brewer, Terence Clark, and Adrian Phillips, *Dogs in Antiquity* (Warminster, England, 2001).

[325] Malek, *The Cat in Ancient Egypt*, 59.

Besides acting as household pets, the depiction of canines under the chair of Khnummose's wife may relate to the eternal sexual union of the deceased and wife, particularly when viewed in light of an eleventh dynasty text which describes an official as "a dog who sleeps in the tent, a hound of the bed, whom his mistress loves."[326] The dog also has religious connotations through its association with the god Anubis, who was associated with the Hall of Judgement where he supervised the weighing of the heart.[327]

Particularly interesting is the leather scribal bag and palette that appear under the chair of Menna's wife, Henettawy (Figure 17). As discussed by Betsy Bryan, scribal palettes under women's chairs were associated with them and commemorated their literacy and the ability to write.[328] The scribal kit, as well as the literacy and status it conveyed, may have impressed the viewer of the image, but the ability and means to read and write also would have been transferred with Henettawy into the next world. The kit also may have reflected a particular social convention that existed among the elite women during the New Kingdom, a fact borne out by scribal titles and letters, ostraca, and funerary literature either written by or belonging to women.[329]

The accessories worn by the deceased and wife are particularly evocative of their transcended state and rebirth in the hereafter. Both are often depicted wearing *wah*-collars composed of fresh flowers that are schematically drawn to show only the blue and white lotus petals.[330] Extensively examined by Martha Bell, the floral *wah*-collar is first mentioned in the Pyramid Texts, where it is put around the head and neck.[331] The *wah*-collar symbolized rebirth and regeneration in the hereafter, as conveyed by an inscription on a portable chest from the tomb of Tutankhamun: "May you take the *wah*-collar of justification which was at the neck of *Wenennefer* (that is Osiris) (so that) your limbs may become young and your heart may become strong (again) when you are examined/assessed by the Ennead."[332] The *Book of Going Forth by Day* refers to the *wah*-collar as the "crown of justification," a symbol of the vindication of Osiris and, by extension, a symbol of the dead after their successful judgement before Osiris.[333] Floral *wah*-collars were worn during burial ceremonies and necropolis celebrations such as the Valley Festival, where they were distributed to all participants, both the living and the dead (on their statues), and worn on their heads or around their necks.[334] Thus, the floral *wah*-collars worn by the deceased and wife in the Offering Table Icon directly relate to their funerary provisioning, vindicated state, and rebirth as the blessed dead in the hereafter.

[326] CG 20506, cited in Fischer, *LÄ* II (1980), 78.

[327] Fischer, *LÄ* II (1980), 78-81; Lurker, *Gods and Symbols*, 28; Patrick F. Houlihan, "Canines," *OEAE* I (2001), 231. The Greeks identified the dog as the sacred animal of Anubis, and scholars continue to argue whether the jackal or the dog served as the prototype for the god, although it is likely that the ancient Egyptians didn't necessarily distinguish between the two. Pascal Vernus, *The Gods of Ancient Egypt*, translated from the French by J. M. Todd (London and New York, 1998), 34, suggests Anubis was a crossbred dog and jackal.

[328] Bryan, *BES* 6 (1984), 21, 24-25.

[329] L. Lesko, *OEAE* II (2001), 297; Patrizia Piacentini, "Scribes," *OEAE* III (2001), 191. In addition, ancient Egyptian miniature painters' palettes are inscribed for women, which offers evidence of female literacy as well as skill in the arts (Hayes, *Scepter* II, 296, fig. 183; I.E.S. Edwards, *Treasures of Tutankhamun* (London, 1972), no. 19). For a more cautious assessment of female literacy, see Robins, *Women in Ancient Egypt*, 111-114. See also discussion of literacy in ancient Egypt above, 1.1.2, pp. 9-10.

[330] TT 38, PM (6)I; TT 69, PM (4) & PM (7)I (not indicated on drawing); TT 139, PM (6)II; TT 151, PM (4); TT 161, PM (3)II; TT 165, PM (5)-not indicated on drawing; TT 175, PM (4); TT 249, PM (4); TT 253, PM (7). On its depiction in art, see: Germer, *OEAE* I (2001), 542.

[331] M. Bell, *Cahiers de la céramique égyptienne* I, 56-57. *PT* 1213 d-e: Sethe, *Übersetzung Pyramidentexten* 5, 114; *Wb.* I, 257,13.

[332] Edwards, *Treasures of Tutankhamun,* 108, pl. 7, cat. no. 7; M. Bell, *Cahiers de la céramique égyptienne* I, 57; idem, "Lotiform collar terminal," in *Mummies and Magic: The Funerary Arts of Ancient Egypt,* edited by S. D'Auria, et al. (Boston, 1988), 134; idem, "Floral Collars, *W3h ny m3'-hrw* in the Eighteenth Dynasty," in *Abstracts of Papers, Fifth International Congress of Egyptology,* edited by A. Cherif (Cairo, 1988), 20. In the New Kingdom, the floral *w3h* collar could also be referred to as a "collar of justification" *(m3h n(y) m3'-hrw).*

[333] Richard Lepsius, *Das Todtenbuch der Ägypter nach dem hieroglyphischen Papyrus in Turin* (Leipzig, 1842), Kapitel 19; Bonnet, *Reallexikon,* 121; Dieter Jankuhn, "Kranz der Rechtfertigung," *LÄ* III (1980), 764; Germer, *OEAE* I (2001), 543.

[334] M. Bell, *Cahiers de la céramique égyptienne* I, 57; L. Bell, *Temples,* 137, 183; Arielle Kozloff, "Jewelry," in *Egypt's Dazzling Sun: Amenhotep III and His World,* edited by A. Kozloff, B. Bryan, and L. Berman (Cleveland, 1992), 435. See also the remains of six *wah*-collars that were buried in a pit outside of the tomb of Tutankhamun along with banqueting remains and embalming materials: H.E. Winlock, *Materials Used at the Embalming of King Tut'Ankh-Amun,* The Metropolitan Museum of Art Papers 10 (New York, 1941), 17-18, pl. 6; F.N. Hepper, *Pharaoh's Flowers: The Botanical Treasures of Tutankhamun* (London, 1990), 10.

The deceased and wife are also depicted wearing the broad collar, known as the *weskhet* (*wsḫt*).[335] The broad collar could be composed of cylindrical beads of various sizes strung vertically, or with individual elements that were strung for an openwork effect. The *weskhet* collar had an amuletic, protective function based on its appearance next to other types of amuletic jewelry on Middle Kingdom coffin friezes.[336]

Another element worn by the deceased and wife in the Offering Table Icon is the unguent cone, which symbolized the scented fat or wax that was rubbed into the hair. Scented unguent (*bít*) was made of ox tallow or beeswax infused with myrrh, which emitted a pleasing odor and a soothing oil to combat dryness.[337] As argued by Nadine Cherpion, the unguent cone was a concrete image chosen by the ancient Egyptians to render abstract notions about its material qualities and funerary symbolism.[338] Regarding the latter, she reviewed the slight evidence originally put forth by Bernard Bruyère who believed the cone was a graphic expression of a metaphysical state.[339] Cherpion asserted instead that the unguent cone expressed a *desire* for eternity on behalf of the wearer rather than a permanent state. She based her argument on the appearance of the unguent cone in imagery relating to the hereafter and in scenes of banqueting attended by the living and the dead.

The unguent cone is also linked to a verbal pun in which the word for odor (*stí*) was written with the same letters as the word "to engender."[340] Odor was believed to be erotic, as relayed by Egyptian love poetry in which a lovesick man cries, "I feel like a man in incense land who is immersed in scent,"[341] and another says, "...she brings you an abundance of scent, intoxicating those present."[342] Thus on another level, the accessory of the scented unguent cone on the heads of the deceased and wife related to their transcended state as well as the promise of their sexual union, which would result in their rebirth in the hereafter.

Items appearing in the Offering Table Icon also directly relate to the deceased's status. In several instances, the deceased wears the "Gold of Honor."[343] As mentioned above, the Gold of Honor indicated a significant elevation in status for the deceased who, by depicting himself wearing these objects, conveyed his importance to visitors and transferred it into the hereafter. The deceased also holds various insignia such as the *'b3*-scepter, which, through its hieroglyphic association, signified authority but also was used to consecrate offerings.[344] The tomb owner is also depicted holding a

[335] Simple broad collars: TT 38, PM (4) & (6)II?; TT 52, PM (6); TT 69, PM (7)II (wife, husband below); TT 108, PM (5)II; TT 151, PM (4)I (on wife); TT 181, PM (8); TT 258, PM (1). Openwork broad collar: TT 38, PM (6)I; TT 161, PM (3)I. On the *weskhet* (*wsḫt*), see: Andrews, *Ancient Egyptian Jewellery*, 119-123; and recently: Edward Brovarski, "Old Kingdom Beaded Collars," in *Ancient Egypt, the Aegean, and the Near East: Studies in Honour of Martha Rhoads Bell*, vol. I, edited by J. Phillips, et al. (San Antonio, 1997), 137-162. On later symbolic uses of the collar: Richard Beaud, "L'offrande du collier-*ousekh*," in *Studies in Egyptology Presented to Miriam Lichtheim*, vol. I, edited by S. Israelit-Groll (Jerusalem, 1990), 46-62.

[336] Marianne Eaton-Krauss, "Broad-collar necklace," in *Egypt's Golden Age: The Art of Living in the New Kingdom 1558-1085 B.C.*, edited by E. Brovarski, S. K. Doll, and R. E. Freed (Boston, 1982), 234, no. 307. See also: M. Gustave Jéquier, *Les frises d'objects des sarcophages du moyen empire*, MIFAO 47 (Cairo, 1921), 62-64, types 1 and 2.

[337] Rita Freed, "Cosmetic Arts," *Egypt's Golden Age*, 199, with notes 12-13; Christa Müller, "Salbkegel," *LÄ* V (1984), 366-367; Manniche, *Sacred Luxuries*, 85; Lyn Green, "Toiletries and Cosmetics," *OEAE* III (2001), 414. On its representation in art, see: Élisabeth Maraite, "Le cône de parfum dans l'ancienne Égypte," in *Amosiadès: Mélanges offerts au Professeur Claude Vandersleyen par ses anciens étudiants*, edited by C. Obsomer and A. L. Oosthoek (Louvain-la-Neuve, 1992), 213-219.

[338] Nadine Cherpion, "Le <<cône d'onguent>>, gage de survie," *BIFAO* 94 (1994), 83-88.

[339] Bernard Bruyère, *Rapport sur les fouilles de Deir el Médineh (1924-1925)*, FIFAO 3 (Cairo, 1926), 69-72, 137.

[340] Manniche, *La peinture égyptienne ancienne*, 34; idem, *Sacred Luxuries*, 96.

[341] Ostracon CM 25218: Georges Posener, *Catalogue des ostraca hiératiques littéraires de Deir el-Médineh*, vol. II, Documents de Fouilles 18 (Cairo, 1972), 43-44, pls. 75-79a.

[342] See quote p. 101.

[343] TT 69, PM (4) & (7); TT 139, PM (6). See: Schäfer, *ZÄS* 70 (1934), 10; von Deines, *ZÄS* 79 (1954), 83-86; Feucht, *LÄ* II (1977), 731-733; Andrews, *Ancient Egyptian Jewellery*, 181-184. On the symbolism of the Gold of Honor, see: Eaton-Krauss in *Egypt's Golden Age*, 238-239, no. 316; Johnson, *Gold of Praise*, 232. See discussion, p. 71.

[344] TT 69, PM (7); TT 108, PM (5)I (compare similar scepter in: Hodel-Hoenes, *Life and Death in Ancient Egypt*, fig. 83). *'b3*-scepter: *EG*(3), Signlist S 42; Kaplony, *LÄ* VI (1986), 1374, with n. 3.

New Kingdom forked stave.[345] However, in the Offering Table Icon, the majority of the tomb owners held handkerchiefs which were not only a masculine attribute but also were related to the deceased's status and rebirth.[346]

In the Offering Table Icon, the wife of Menna, Henettawy holds the sistrum (Figure 18). The sistrum was sacred to Hathor and was used by temple musicians who were frequently culled from the ranks of noble women in the eighteenth dynasty.[347] The sistrum was used in many of the god's cults during the New Kingdom; its protective rattle was believed to pacify the gods and banish evil. Representations of singers shaking their sistrums and *menit*-necklaces appear in scenes relating to the Sed, Opet, and Valley festivals where the sound was meant to bestow life, stability, and health in the name of the deity of the temple.[348] Through its association with Hathor, the sistrum was also associated with fertility and regeneration.[349] In TT 69, Henettawy carries the title "Musician of Amun" (*šm'yt nt Imn*),[350] and thus by holding the sistrum, her status is related to the living but it signifies her protection and rebirth in the next.

In a number of Offering Table icons, the wife is shown with her hand on her husband's shoulder while her other hand grasps his arm. In another posture, the wife holds a lotus in her free hand. The former, in particular, indicates a loving relationship between the husband and wife, whereas the latter is a more formal pose.[351] On the top register of PM (4) in the tomb of Menna (TT 69), the wife completely enfolds her husband in her embrace, and this is a particularly intimate embrace (Figure 17).[352] In a few instances, the wife is seated below her husband on a low chair and grasps his wrist with one hand and puts her other hand on his knee in a loving gesture.[353] In a number of Offering Table icons, the wife is also accompanied by her children, who stand behind her or sit under (or beside) her chair or her husband's chair.[354]

The presence of the wife and other family members in the Offering Table Icon illustrates the central credo that the married state was the ideal state in ancient Egypt. The importance of marriage and children is relayed in the Instruction of Any, in which the father tells his son:[355]

> Take a wife while you're young.
>
> That she make a son for you;
>
> She should bear for you while you're youthful

Marriage and procreation were integral to Egyptian society. Marriage created a stable social order, and children provided the continuation of the family line and were ultimately responsible for the performance of their parents' funerary cult. As mentioned above, the wife was commemorated and provisioned in her husband's tomb both by the living and through the creative power of text and image. Richly dressed, she may have enhanced the status of her spouse to the living who visited the chapel. Her clothing accentuated her sensuality and fertility through the outline and transparency of the

[345] TT 175, PM (4). Manniche, *Three Theban Tombs*, 34-36, indicates a bulbous tip that is actually forked (compare staff held by figure of deceased on the door jamb in B&W Plate 6). Forked stave: Hassan, *Stöcke und Stäbe*, 38, n. 7, 130, 190, 193, pl. VIII, calls this the *'wnt*-stave, whose name actually refers to the type of wood used to manufacture it (Fischer, *MMJ* 13 (1978), 28-29). Fischer suggests its Old Kingdom name may have been the *m3ty*-staff based on a similar example in a sixth dynasty text (*Urk*. I, 216), but the New Kingdom name of this staff is not known (Fischer, *LÄ* VI (1986), 54). The tomb owner in TT 165, PM (5) holds a stave with the bottom missing.

[346] TT 38, PM (4) & (6)I; TT 108, PM (5)II; TT 151, PM (4); TT 165, PM (5)I; TT 175, PM (4)II. See discussion on the handkerchief in: Fischer, *MMJ* 10 (1975), 148-155; Helck, *LÄ* VI (1986), 238; Hartwig, *The Collector's Eye*, 68; Westendorf, *ZÄS* 94 (1967), 148, n. 56.

[347] TT 69, PM (7)I. On the symbolism of the sistrum, see: Bonnet, *Reallexikon*, 450; Ziegler in *Egypt's Golden Age*, 256; Manniche, *Sexual Life*, 45; Robins, *Women in Ancient Egypt*, 145-146, 164. See also p. 83, n. 260.

[348] Silvana E. Fantecchi and Andrea P. Zingarelli, "Singers and Musicians in New Kingdom Egypt," *GM* 186 (2002), 34 with notes 67-69. See also: Emily Teeter, "Female Musicians in Ancient Egypt," in *Rediscovering the Muses: Women's Musical Traditions*, edited by K. Marshall (Boston, 1993), 68-91.

[349] Westendorf, *ZÄS* 94 (1967), 145-146; Schumann-Antelme and Rossini, *Sacred Sexuality*, 44.

[350] *Urk*. IV, 1609.

[351] These positions relate to Positions V and VI in Whale, *Family*, 241, 275, pl. 7.

[352] Whale, *Family*, pl. 6, Position II; see also Nadine Cherpion, "Sentiment conjugal et figuration à l'Ancien Empire," in *Kunst des Alten Reiches*, SDAIK 28 (Mainz, 1995), 33-47.

[353] TT 139, PM (6)II; TT 165, PM (5)II. Whale, *Family*, 244, notes that this depiction, while common during the reigns of Thutmose IV and Amenhotep III, does not reflect the status of women during this period. In each of these tombs, the wife is depicted smaller than her husband seated on a low chair; in other scenes, she is portrayed equal to him in stature.

[354] Children are depicted in: TT 161, PM (3)II; TT 165, PM (5)I; TT 249, PM (4)I; TT 253, PM (7).

[355] Lichtheim, *Ancient Egyptian Literature* II, 136 (3,1-2).

garments that highlighted her breasts and hips, features that related to her child-bearing abilities.[356] The procreative capabilities of the married couple were also emphasized in the depiction of their children, who appear seated beside them.

Since sexuality, birth, and rebirth were so closely intertwined in ancient Egyptian thought, the appearance of the wife in the tomb, which was the setting for rebirth, promised the sexual union through which the husband would be reborn.[357] On a cosmological level, the female principle was fundamental, and it ensured, through interaction with the male, the continuation of the universe. For example, every evening the sun impregnated Nut and was reborn through her the next morning. Likewise, the dead sought to be reborn like the sun and spend eternity with the source of life and youth.[358] Thus, the wife appeared as the generative female principal of the universe, and within the tomb, provided for the deceased's rebirth.

In several cases, the parents or mother of the tomb owner are represented in the Offering Table Icon. In these instances, it is clear that the tomb owner sought to present his family line through the depiction of his parents.[359] In the case of Menkheper (TT 258), the owner may have been too young to marry, and his mother assumed the position ordinarily taken by the wife in the tomb.[360]

Flowers played an integral role in the Offering Table Icon and carry an important symbolism that related to the regeneration of the deceased. Lotus buds and flowers are held and sniffed by the deceased and his wife. In one instance (Figure 41), a bouquet composed of lotus is placed beneath the seat of Nebamun's mother. Based on the flower's relationship to rebirth and continual life, whoever inhaled the scent of the lotus received life-giving strength.[361]

An important mechanism for the deceased's regeneration was presentation of the life-bouquet. As stated above, the word for bouquet in the New Kingdom had the same consonantal value as the word for "life," ankh ('nḫ).[362] Reinforcing this link are actual depictions of bouquets fashioned in the shape of the hieroglyphic sign for "life."[363] In the Offering Table Icon, the presentation of the bouquet is often accompanied with a variant of the text: "For your ka, a life-bouquet of the God NN, may he praise you, may he give you life!"[364] The gods most often evoked in the offering of the bouquet are Amun-Re "when he comes from *Ipt-Swt*," or Hathor. This suggests that the bouquet was composed of flowers reverted from offerings that were presented to the gods and purchased from priests within the context of necropolis celebrations, particularly the Valley Festival.[365] During the Valley Festival, bouquets were stacked around the Hathor

[356] Gay Robins, "Women," *OEAE* III (2001), 513; idem, *Sexuality in Ancient Art*, 36-37.

[357] Christiane Desroches-Noblecourt, "Concubines du mort et mères de famille au Moyen Empire: A propos d'une supplique pour une naissance," *BIFAO* 53 (1953), 15-33; Westendorf, *ZÄS* 94 (1967), 139-150; Gay Robins, "Problems in interpreting Egyptian art," *DIE* 17 (1990), 47; idem, *Women in Ancient Egypt*, 187-188; Manniche, *Sexual Life*, 39; Ann Macy Roth, "The Absent Spouse: Patterns and Taboos in Egyptian Tomb Decoration," *JARCE* 36 (1999), 42.

[358] Odgen Goelet in Faulkner, *The Egyptian Book of the Dead*, 149-150; Robins, *Sexuality in Ancient Art*, 27-28.

[359] Parents: TT 151, PM (4)I; possibly TT 253, PM (7) (couple to the right) (Strudwick, *The Tombs of Amenhotep, Khnummose, and Amenmose*, 24); mother and son: TT 181, PM (8)I, but wife is shown elsewhere. See also: Whale, *Family*, 261-264; Roth, *JARCE* 36 (1999), 42.

[360] TT 258, PM (1), deceased shown with no wife or children. Menkheper was a ḥrd n k3p and a sš n pr msw nsw who probably, as a child, had his education at court (see: Feucht, *Pharaonic Egypt*, 44); and later served the palace administration as a royal scribe for the children of the pharaoh. Despite his age or marital status, his association with the pharaoh and his court (as well as a member of the k3p) probably aided him in securing a tomb in the Theban necropolis.

[361] Emma Brunner-Traut, "Blume," *LÄ* I (1975), 836; idem, *LÄ* III (1980), 1094; Dittmar, *Blumen*, 132-133. See also: Weidner, *Lotos im Alten Ägypten*.

[362] On the etymology of the term 'nḫ and its definition as "bouquet," see: Dittmar, *Blumen*, 132, 148. Its meaning is discussed by L. Bell, *Temples*, 137, 183, n. 43. See also discussion, pp. 67-68.

[363] Schott, *Das schöne Fest*, 49; Dittmar, *Blumen*, 35, 39. Examples of ankh-shaped bouquets in this study: TT 108, PM (5)II (Figure 33); TT 161, PM (6): Manniche, *JEA* 72 (1986), 78, fig. 13. These ankh-shaped bouquets appear in private tombs beginning with the reign of Thutmose IV.

[364] TT 38, PM (4)I: Nina Davies, *Some Theban Tombs*, 5, pl. III. TT 38, PM (6)II: Vincent Scheil, "Le tombeau de Rat'eserkasenb," *Mém. Miss.* V, 2 (1894), 576, pl. II; Charles M. Kuentz, "Les textes du tombeau no. 38 à Thèbes (Cheikh Abd-el-Gourna)," *BIFAO* 21 (1923), 130, no. (27); Nina Davies, *Some Theban Tombs*, 7, pl. VI; TT 89, PM (8): *Urk.* IV, 1022-1023 (305) E 1-2; TT 139, PM (5): Scheil, *Mém. Miss.* V, 2 (1894), 588; TT 161, PM (3)I: Manniche, *JEA* 72 (1986), 59, no. 14, fig. 2; TT 181, PM (8)II: Davies, *Two sculptors*, 36-37, pl. XVIII[2]; TT 253, PM (4): Strudwick, *The Tombs of Amenhotep, Khnummose, and Amenmose*, 42-43, text 4.

[365] Texts referring to the god Amun: TT 38, PM (4)I (see n. 364 for citations); TT 38, PM (6)II, "[Amun] in *Djeser-Djeseru*"(Deir el-Bahri); TT 89 (*Urk.* IV, 1023, "Coming with a bouquet of Amun when he comes from Karnak (*Ipt-swt*)"); TT 161, PM (3)I (Manniche, *JEA* 72 (1986), 59, no. 14); TT 181, PM (8)II, "I have brought you a bunch of flowers which have appeared before [Amun]" (Davies, *Two sculptors*, 37); TT 253, PM (4), "A coming in [peace] bearing the bouquet of [Amun]." Texts referring to Hathor: "Hathor chieftainess of [Thebes]," TT 139, PM (5). TT 52, PM (3) refers to "a bouquet after having done that which is praised by her son, Amenemopet, justified" presumably within the context of the Valley Festival (Shedid and Seidel, *Nakht*, 17; Laboury, *La peinture égyptienne ancienne,* 64). See discussion of the 'bouquet of Amun' by Schott, *Das schöne Fest*, 50-51; Strudwick, *La peinture égyptienne ancienne*, 47. On the purchase of the god's bouquets: Bonnet, *Reallexikon*, 121; Wilhelm Spiegelberg and

sanctuary at Deir el-Bahri (*Djeser-Djeseru*) to receive the life-force of Amun-Re and then were purchased for distribution to the outlying Theban tomb chapels.[366] The presentation of the *ankh*-bouquet was the culmination of the Valley Festival. Papyrus and lotus were the most popular flowers for *ankh*-bouquets, and additional flora, such as corn flowers, red poppies, jasmine, mandrake, and persea fruit, could be added. Viewed through the intersection of text, image, and symbolism, the bouquet conveyed the deity's strength and blessing for eternal life to the dead. This was reinforced by the symbolism of the plants that made up the bouquet, namely the lotus of rebirth and the papyrus of protection and resurrection.[367] By the act of smelling the flowers and plants, the recipient would take in the divine essence that was contained in the bouquet. This action is indicated by a text in the tomb of Djeserkarasoneb (TT 38), which is spoken by the son who is presenting a bouquet of papyrus and lotus buds to his parents (Figure 7):[368]

> His son, scribe and foreman of weavers [of Amun, Nebsen]y. [He] says: [For your *ka* a bouquet of Amun].[369] May he praise you and love you! Take it to you! Put it to your nostrils, and it will renew the breath of your nose day by day.

In the Offering Table Icon, the *ankh*-bouquet was often presented by the son to his parents, or less often, by the tomb owner's daughter or colleague.[370] The focus on male offspring reflects the ancient Egyptian cultural ideal that the son should serve as the chief mortuary cult officiant for his parents. The gift of the life-bouquet as it was passed between the living and the dead also conveys the idea of familial devotion towards their transfigured ancestors. More often, however, the bouquet was proffered between anonymous private donors to the deceased and wife which accentuates the importance of the offering itself.[371]

Lanny Bell has discussed the underlying significance of the exchange of the *ankh*-bouquet, and he noted that the god's blessing and "life" contained in the bouquet was conveyed directly between two private individuals without evoking the king or a priest as intermediary.[372] He suggests that the exchange of the life-bouquet (as well as other life-bearing objects) may help in reconstructing the development of personal piety, in which common people could make direct, personal approaches to the god without mediation by priests. In support of Bell's thesis, the text accompanying the presentation of the bouquet in the Offering Table Icon begins with the *n k3 n* formula and is followed by the wish that the bouquet recipient be an object of a deity action.[373] However, this wish is not an independent request to a god but is instead a wish for the deities' blessing or power that is expressed between private individuals. Independent requests to a deity that are characteristic of personal piety do not begin in the offering formula until the nineteenth dynasty, although these requests may have originally grown out of the formula used in eighteenth dynasty Theban tomb chapels.[374]

In the Offering Table Icon, text and image indicate that the life-bouquet offering, which mediated the divine life force and came from the presence of the god, was passed directly between private people along with wishes for the

Walter Otto, *Eine neue Urkunde zu der Siegesfeier des Ptolemaios IV und die Frage der ägyptischen Priestersynoden*, SBAW 1926, 2 (Munich, 1926), 9; L. Bell, *Temples*, 137. On reverted floral offerings for the dead: Dittmar, *Blumen*, 40-46.

[366] Schott, *Das schöne Fest*, 49; M. Bell, *Cahiers de la céramique égyptienne* I, 57; L. Bell, *Temples*, 137.

[367] Bonnet, *Reallexikon*, 120-121, who says "In den Sträussen sind die Götter selbst gegenwärtig." See discussion in: Dittmar, *Blumen*, 74-75, 125-128. See also discussion, pp. 67-68.

[368] *s3.f sš hry mrw [n Imn Nb-sn]y dd.[f n k3.k 'nh n Imn] hsi.f tw mri.f tw šsp n.k sw di tw r fnd.k (s)nhh.f t3w r fnd.k hrt-hrw nt r' nb*. Nina Davies, *Some Theban Tombs*, 5, pl. III.

[369] Reconstructed by Nina Davies, *Some Theban Tombs*, 5. Destruction to the name Amun occurs in the tomb: Kampp, *Nekropole* I, 229.

[370] *Ankh*-bouquets presented by: TT 38, PM (4)I, the tomb owner's son Nebseny, an unnamed son, and a daughter Nebettawy; TT 38, PM (6)III, the tomb owner's sons Nebseny and Neferhebef, as well as the *iry 't n Imn;* TT 52, PM (3)II; TT 139, PM (5), the tomb owner's son Amenhotep; TT 161, PM (3)I, the tomb owner's sons Huynefer, Kha, Pareheny, and Weser, daughters Ahmosi and Nehemetawy; TT 181, PM (8)II, son Amenmehet and anonmyous offerers (Davies, *Two sculptors*, 36-37); TT 253, PM (4), a daughter (Strudwick, *The Tombs of Amenhotep, Khnummose, and Amenmose*, 42-43).

[371] Anonymous offerers of *ankh*-bouquets: TT 38, PM (4)III; TT 69, PM (7)I; TT 89, PM (8); TT 108, PM (5)II; TT 165, PM (5)I (Davies, *Four Theban Tombs*, 40).

[372] L. Bell, *Temples*, 137, 183-184, 301, n. 177, who cites his paper on the transfer of the divine life-giving force in certain objects from the sacred realm to the profane worlds: Lanny Bell, "The *'nh*–bouquet, the *mdw-špsy*, and the Transmission of the Divine Life Force: Communication between the Sanctuary and the 'Profane' World," paper presented at the symposium "Tempel am Nil - Struktur und Funktion," Humboldt-Universität (Bereich Sudanarchäologie-Meroitistik und Ägyptologie), Berlin, October 22-26, 1990.

[373] Dariusz Niedziółka, "Note on the Egyptian Construction ACTIVE *SDM.F/IRY.F+IN*+NOUN in One of the Inscriptions in the Theban Tomb of Userhat (TT 56)," *Rocznik orientalistyczny,* Warszawa 50 (1996), 15-17.

[374] Ibid., 15, n. 36. Wishes that a god would praise the deceased do not occur as independent requests until the nineteenth dynasty. For example, see: Winfried Barta, *Aufbau und Bedeutung der altägyptischen Opferformel*, ÄF 24 (Glückstadt, 1968), no. 272, 157, 244, and no. 278, 158, 245.

god's action, without evoking the king as an intermediary through the *htp-di-nsw* formula. The divinely charged bouquet is passed between family members and private individuals, two of whom (the deceased and wife) are depicted in their potential, transcended state existing among the gods in the hereafter. Thus, the life-bouquet offering passes from the earthly sphere into the divine, and from the family to their blessed ancestors to ensure their eternal life.

Other offerings of life-bearing objects are made to the deceased and wife in the Offering Table Icon. *Wah*-collars, *menit*-necklaces, and sistrums are given to the tomb owner and wife.[375] As mentioned above, the *wah*-collar was an instrument of rejuvenation and related to the vindicated dead, while the *menit* and sistrum were protective life-giving objects.[376] The significance of the *menit* and the sistrum can be explained by an image in the tomb of Amenemhet (TT 82), which portrays three women who are musicians of Amun celebrating the Hathor festival. The caption to the scene says:[377]

> I offer to you (Amenemhet) the *menit*, the arched-sistrum (*shm*) and the naos-sistrum (*sššt*) belonging to Amun [lord of Karnak? together with] his [Ennead] and (belonging to) Hathor in all her names, in order that they may grant you a fair and long-lasting life.

Charged with life-giving force, the *wah*-collars, sistrums, and *menits* are proffered by family and anonymous individuals to the tomb owner and wife in the Offering Table Icon for their eternal well-being.

In the Offering Table Icon, cups or vessels are offered by a daughter to her parents, and, more often, by anonymous cup bearers.[378] The cups were presumably filled with alcohol from the flask carried in the daughter's other hand. One scene is captioned as follows:[379]

> The gardener of the divine offerings of Amun, Nakht, justified; his beloved wife, the mistress of the house, Tahemt, justified. 'To your *ka*! Spend a happy day (*hrw nfr*), you praised by Amun. May he cause you to come and go to his temple to behold the beauty of his face, and to receive *snw*-cakes from what his *ka* gives on the occasion of every feast in heaven and on earth.' (Said) by his beloved daughter, Ahmosi.

As indicated by the text and the image that accompanies it, the beverage within the cup and *snw*-cakes were provided by the god, in this case Amun. The phrase "spend a happy day" often occurs in conjunction with depictions of the Valley Festival banquet (see Banquet Icon 3.2.7 below).[380] During the Valley Festival, ancient Egyptian families strengthened the bonds between their living and dead relatives by returning to the tombs of their ancestors. They held an all-night vigil with music, food, and copious amounts of alcohol, the goal being to blur the limits between this world and the next so the living could communicate with the dead.[381] The deceased would drain the cup offered by his daughter in the Offering Table Icon to "spend a happy day" in the drunkenness supplied by the deity. The divine beverage allowed the tomb owner to contact the divine, and it brought together the living and the dead for a short time through the blurring of boundaries. The offering of the cup is heralded by the use of the word *nfr*, which is equated with qualities of dynamism, potency, and efficiency, all of which were needed for the dead to live again.[382]

Also officiating before the deceased and wife is the figure of a *sem*-priest wearing a panther skin. In one case, the *sem*-priest is identified in the caption as the son of the tomb owner (B&W Plate 5).[383] The *sem*-priest acted as the

[375] *Wah*-collar: TT 38, PM (6) by daughter Nebtawy. *Menit*-necklaces and/or sistrums offered by anonymous girls: TT 69, PM (7); TT 181, PM (8)II (name destroyed?); TT 249, PM (4)I.

[376] See discussion above, pp. 64-65, 83.

[377] Davies and Gardiner, *Amenemhet*, 95, pl. 19; Manniche, *Music and Musicians in Ancient Egypt* (London, 1991), 64, fig. 37.

[378] TT 38, PM (6)I, daughter Mery-re; and TT 161, PM (3)II, daughter, Ahmosi. On the significance of the cup offering: Schott, *Das schöne Fest*, 76-78. Anonymous cup offerers: TT 139, PM (6)I; TT 175, PM (4)I; TT 249, PM (4)I who is accompanied by other offerers who bear floral bouquets and various foodstuffs.

[379] TT 161, PM (3)II: Manniche, *JEA* 72 (1986), 61, no. 22; Schott, *Das schöne Fest*, 123, inscr. 119. Variant text in the Offering Table Icon: TT 38, PM (6), *Urk.* IV, 1638-1639; Nina Davies, *Some Theban Tombs*, pl. V-VI.

[380] On the significance of the cup offering, see: Schott, *Das schöne Fest*, 76-78, 123, no. 119; for similar texts, see: Ibid., 82-84, 125-127.

[381] See complete discussion of the Valley Festival in 1.1.2, pp. 11-12.

[382] Wiebach, *SAK* 13 (1986), 277-281; Manniche, *La peinture égyptienne ancienne,* 32-33.

[383] Unidentified *sem*-priest: TT 69, PM (7)II; TT 108, PM (5)I, figure of *sem*-priest destroyed (Guilio Farina, *La Pittura egiziana* (Milano, 1929), tav. LXXVI; Kampp, *Nekropole* I, 388). In TT 139, PM (6)II, the *sem*-priest is identified as a son in the caption, performing a *htp-di-nsw*.

intermediary between the dead and the next world.[384] In private Theban tomb ceremonies, these *sem*-priests were often the 'main' son closest to the father who, by performing acts of filial piety, emulated the actions of Horus to Osiris, thus strengthening the symbolic connection between the deceased and the god of the underworld and his resurrection.[385] In the Offering Table Icon, the *sem*-priest censes and libates the deceased and wife with a spouted-jar or raises his hand in a gesture of consecration (Figure 18). These activities relate to the concluding ceremonies in the "Opening of the Mouth," a rite that reanimated the dead and allowed them to enjoy cultic provisions (see Funerary Rites Icon 3.2.11 below).[386]

In a number of instances, the *sem*-priest is depicted in a gesture of consecration before an offering list, ritually activating items and guidelines that would provide regular mortuary offerings for the deceased and wife in the next world.[387] Offering lists in the Offering Table Icon are composed of 20 to 22 columns, each inscribed with keywords for food and drink, with portions and icons written below, indicating whether they were to be purified or censed.[388] In the Offering Table Icon, the *sem*-priest is depicted eternally activating the creative power of the offering list, producing a liminal condition by which the deceased and wife could be contacted and magically provisioned in the next world.[389] Through the actions of the *sem*-priest, the deceased and wife would be able to pass through to enjoy the provisions set before them and enumerated in the list. The offering list and its abbreviations were also meant to be read aloud by performers of the deceased's cult, thus enabling the items magically to come to life for the dead.

In sum, the Offering Table Icon operated on an integrated religious, magical, and commemorative level. The deceased and wife (or mother) are shown in their potential state as the blessed dead, joined with the gods and seated before a table heaped with food 'partaking' of the post-vindication funerary meal that signified their incorporation into the divine realm. Specific furniture, dress, and accessories provided the necessary preliminaries for the deceased and wife's sexual union in the next world which would result in birth (signified by children) and ultimately their rebirth in the afterlife. Before the seated couple, family members, colleagues, and anonymous individuals bestow life-bearing offerings, from life-bouquets imbued with the divine essence to *wah*-collars, *menit*-necklaces, and sistrums that held the power of the gods to protect and rejuvenate. Cups offered to the deceased, filled with beverages blessed by deities, allowed the tomb owner to live again. These gifts mediated divine power or came from the presence of the god, and were bestowed directly between private individuals along with wishes for a god's action without evoking the king as intermediary. At the same time, these gifts were passed between the living and their transfigured ancestors, transferred from the earthly to the divine sphere to ensure eternal life. Many of these images symbolically represent offerings that were given at necropolis festivals, at which time the dead were reincorporated into the world of the living as well as at the funerary meal during which the deceased (hopefully) entered into the divine realm as a blessed ancestor (see Banquet Icon 3.2.7 below). To the viewer, the dead's status and abilities were relayed by his or her insignia and titles. These titles, in all but two cases, relate to the realm of the god's temples,[390] where the tomb owner would continue to serve in the hereafter. At the burial and during necropolis festivals, family members and visitors performed cult on behalf of the blessed dead and their ancestors– in essence, speaking prayers and undertaking the same actions depicted on the walls, providing for the efficacy of the dead. However, the creative power of text and image guaranteed the deceased's eternal provisioning and rebirth, and it commemorated identities and status that would be projected into the next world.

[384] Aylward M. Blackman, *Gods, Priests and Men: Studies in the Religion of Pharaonic Egypt*, edited by A.B. Lloyd (London and New York, 1998), 119, 141-142.

[385] On the duties and symbolism of the *sem*-priest: Bettina Schmitz, "Sem(priester)," *LÄ* V (1984), 833-836; Sauneron, *Priests*, 108-109; Doxey, *OEAE* III (2001), 69, 71; Taylor, *Death and the Afterlife*, 191; Hodel-Hoenes, *Life and Death in Ancient Egypt*, 40-41, 76, 169. See also excellent analysis of the literature concerning "the son whom he loves" *sem*-priest in: Lorton, *Born in Heaven, Made on Earth*, 154, n. 47.

[386] Martin, *LÄ* V (1984), 1129-1130, 1132, n. 25; Otto, *Mundöffnungsritual* II, scenes 65A-72B, 146-164; Cruz-Uribe, *Gold of Praise*, 70; Roth, *OEAE* II (2001), 605. In TT 69, PM (7) (Figure 18), the *sem*-priest is followed by four *sem*-priests carrying *hst*-vases for libations, two offering-bearers with rhomboid-shaped lamps on poles (see: Norman de Garis Davies, "A peculiar form of a New Kingdom lamp," *JEA* 10 (1924), 11, fig. 4), and several men bearing a table heaped with food intended for the mortuary ceremonies conducted before the deceased and wife. For an English synopsis and diagram of the Opening of the Mouth ritual from the tomb of Rekhmire (TT 100), see: Hodel-Hoenes, *Life and Death in Ancient Egypt*, 169-172, fig. 122.

[387] Gesture described in: Dominicus, *Gesten*, 77-88. This gesture originated in the Old Kingdom, where it was associated with the reciter of the offering list (Joachim Spiegel, "Die Entwicklung der Opferszenen in den Thebanischen Gräbern," *MDAIK* 14 (1956), 190-191).

[388] TT 69, PM (7)II; TT 108, PM (5)I (*sem*-priest expunged, see n. 383); TT 139, PM (6)II; TT 253, PM (7). These lists conform to type C in: Winfried Barta, *Die altägyptische Opferliste von der Frühzeit bis zur griechisch-römischen Epoche*, MÄS 3 (Berlin, 1963), 111-114, 118-120, Abb. 6; idem, "Opferliste," *LÄ* II, 588.

[389] Fitzenreiter, *Social Aspects of Funerary Culture*, 81.

[390] See n. 291.

3.2.7 Banquet Icon

The multivalent imagery in the Banqueting Icon mixes themes of sexuality and rebirth with the aspects of the Valley Festival, the funerary banquet, and other commemorative meals held in the tomb. The symbolism of banqueting imagery has been examined extensively by Lise Manniche,[391] and specific details have been analyzed by Phillipe Derchain,[392] Wolfhart Westendorf,[393] and Gay Robins,[394] who have all focused in large part on themes of sexuality and rebirth inherent in the compositions. While eroticism is certainly present, there are additional religious and symbolic meanings inherent in banqueting representations that will be discussed below.

The Banqueting Icon occurs on eleven focal walls as an expanded scene that covers the entire length of the wall or as an abbreviated vignette that is integrated with other motifs (Figures 8-9, 17-18, 33, 39, 47-49; B&W Plates 2,1; 5, 7).[395] In every case, the Banqueting Icon is linked to the Offering Table Icon through the action of family members, colleagues, and anonymous participants bestowing life-bearing gifts or acting as *sem*-priests before the deceased or wife. Texts frequently contain songs or descriptions of particular offering actions, and they identify the participants, who, without exception, served within the estate of the god's temples (Table 1).[396]

Captions in the Banqueting Icon or in the adjacent Offering Table Icon are often unclear as to the nature of the banquet. The banquet may be a combination of the meal that took place at burial, during commemorative celebrations, or in connection with special necropolis festivals such as the Valley Festival. Often, the banquet is situated in the chapel adjacent or opposite images relating to the Valley Festival, such as that of the burning of offerings, the bringing of the bouquet of Amun, the choir of singers, and the cup offering bearing the wish that the deceased "spend a happy day" praised by Amun.[397] For example in the tomb of Nakht (TT 161) (B&W Plate 7), the banquet on PM (3) is separated by a vertical text band from PM (2) that depicts the deceased's wife, Tahemt, offering a prayer to Amun-Re and Mut, accompanied by five sons and four daughters who offer goods intended for the Valley Festival offering on PM (1).[398] Even though the Valley Festival offering on PM (2) is understood as part of the non-focal wall PM (1), its proximity to the banquet on PM (3) sets the context of the celebration. Other banqueting images occur in connection with depictions of the *sem*-priest performing an offering ritual or rites that are associated with the "Opening of the Mouth" ceremony that suggests the funerary meal.[399] Banqueting images rarely contain temporal captions that would situate the meal in a particular time and place, and this betrays the Egyptian tendency to conflate specific details to create a timeless image.[400] In banqueting scenes, participants are a combination of both living and dead relatives, friends, and colleagues, whom the

[391] Manniche, *La peinture égyptienne ancienne*, 29-35; idem, *City of the Dead*, 41-45; idem, *Sexual Life*, 40-44.

[392] Phillipe Derchain, "Le lotus, la mandragore et le perséa," *CdÉ* 50, nos. 99-100 (1975), 65-86; idem, *SAK* 2 (1975), 55-74.

[393] Westendorf, *ZÄS* 94 (1967), 139-150.

[394] Gay Robins, *DIE* 17 (1990), 52-53; idem, *Sexuality in Ancient Art*, 27-33.

[395] Expanded scene: TT 38, PM (6); TT 52, PM (3); TT 69, PM (4); TT 108, PM (5); TT 139, PM (6); TT 249, PM (4); TT 253, PM (4) & (7). Abbreviated: TT 69, PM (7), middle register; TT 161, PM (3), middle register and part of lower register; TT 175, PM (4), upper register.

[396] Tomb owners with focal walls that preserve the Banqueting Icon who are priests in the god's temples: Nakht (TT 52), Nebseny (TT 108), Pairy (TT 139); stewards of priests: Djeserkarasoneb (TT 38); or supervise temple holdings: Menna (TT 69), Haty (TT 151); or were grain scribes: Khnummose (TT 253); or were in charge of temple provisioning: Nakht (TT 161), owner of TT 175 (unguent maker); Neferrenpet (TT 249). See also n. 291.

[397] Text and image relating to the Valley Festival banquet: TT 38, PM (6) (*Urk.* IV, 1638-1639); TT 161, PM (3)II (Manniche, *JEA* 72 (1986), 61, no. 22); TT 253, PM (4) (Strudwick, *The Tombs of Amenhotep, Khnummose, and Amenmose*, 43-44). Iconography suggestive of the Valley Festival banquet: TT 52, PM (3); TT 69, PM (4) & (7)I; TT 108, PM (5)I; TT 139, PM (6); TT 175, PM (4); TT 249, PM (4); TT 253, PM (7). For more on the iconography of the Valley Festival, see: Schott, *Das schöne Fest*.

[398] In TT 161, the scene on PM (2) is oriented to the Valley Festival offering scene on PM (1) which serves as the end point of the scene. Therefore, PM (2) is to be understood as part of the content of PM (1) wall, rather than the focal wall, PM (3). On the images and texts for PM (2), see: Manniche, *JEA* 72 (1986), 58-59, texts 3-12. Vertical text band between PM (3) and (2): Ibid., 59, text. 13.

[399] For example, TT 108, PM (5); TT 139, PM (6)II; TT 253, PM (7); probably all of these banqueting images were conflated with aspects of the Valley Festival banquet.

[400] Specific captions such as "this splendid god Amun coming from Karnak" are quite rare. See discussion in: Hodel-Hoenes, *Life and Death in Ancient Egypt*, 15.

dead knew, and who would continue to exist with them in the afterlife.[401] In fact, the tomb owner himself also may have celebrated the rites of the Valley Festival during his life in the 'reception hall' of his tomb chapel.[402] Therefore, in light of this discussion, a certain flexibility in terms of time and place must be assumed when examining the iconography of the Banqueting Icon, which could function simultaneously on multiple levels.

In the Banqueting Icon, the participants are dispersed over a number of registers, seated on chairs or stools with lattice bracing. Sometimes participants kneel or sit cross-legged on reed mats that are laid out on the floor. Male and female guests are often separated by register, whereas 'married' couples sit side-by-side on a couches or beds.[403] Servant girls or boys attend to the guests by adjusting locks of hair, applying ointment, handing them cups or vessels filled with drink, and bestowing lotus flowers and *wah*-collars.[404] The guests are dressed in their finery, as people of stature depicted in a state of eternal youth; no common or coarse lower-order individuals are illustrated.[405]

A number of details in the Banqueting Icon expand on the general concept of perpetual youth and the deceased's rebirth. Many banqueters hold lotuses, some to their noses to inhale the scent. As mentioned above, whoever breathed the scent of the lotus received life-giving strength, based on the lotus' connection to regeneration and eternal life. The wearing of blue and white lotus *wah*-collars by a number of banqueters reinforced the theme of rebirth inherent in the burial or necropolis celebrations where these collars were distributed.[406] The depiction of scented unguent cones related to the state of resurrection and vindication, but its pleasing odor had erotic overtones that would aid the deceased's rebirth.[407]

The sniffing of the lotus also may have promoted a type of sedation that resulted in the breaking down of the inhaler's inhibitions. The *Nymphaea* species of lotus is known to have had narcotic properties that may have been used by the ancient Egyptians to liberate the mind.[408] The smell of the lotus was pleasantly strong and contained alkaloids, which, when mixed with alcohol, acted as a narcotic in a number of ancient societies, including Egypt.[409] Yet, the smell alone may have been enough to produce giddiness, euphoria, and the loosening of inhibitions, especially since people in ancient societies likely had a more sensitive sense of smell than we have today. The lotus' erotic qualities are referenced in ancient Egyptian love songs,[410] and in the Turin Erotic papyrus 55001.[411] The latter illustrates a woman engaged in a series of acrobatic sexual acts with a lotus above her, in essence signifying that she is 'under' its influence.[412]

Other organic substances in the Banqueting Icon had erotic and liberating effects. A few women playfully pass a yellow mandrake fruit to a female companion.[413] The mandrake fruit was considered an aphrodisiac in the ancient

[401] Schott, *Das schöne Fest*, 7; Lopez, *LÄ* II (1977), 383-386; Graefe, *LÄ* VI (1986), 187; Wiebach, *SAK* 13 (1986), 263-291. See the side-by-side depictions of the two wives of Nebamun (TT 90) (one of whom predeceased the other) within the context of a scene in the Valley Festival cycle that appears on the eastern transverse wall of the tomb, PM (1) (Whale, *Family*, 250). Note also the two successive wives of Haremhab who offer to him and his mother at the Valley Festival banquet, PM (2) (Whale, *Family*, 291, n. 151), which Brack, *Haremhab*, 25, mistakenly understood as an example of polygamy. Living participants are mixed with those who are described as *m3'-ḥrw* ("true of voice"), indicating that they would or had joined the society of the dead.

[402] Hermann, *Stelen*, 100; Assmann, *5000 Jahre Ägypten: Genese und Permanenz*, 28; Hodel-Hoenes, *Life and Death in Ancient Egypt*, 15.

[403] Married status conveyed by sitting together and their gesture; see: Whale, *Family*, 283, n. 57. Couch/bed discussed under the Offering Table Icon, 3.2.6, pp. 89-90.

[404] Servants with cups or vessels: TT 38, PM (6)I-III; TT 161, PM (3)III; TT 175, PM (4)I; TT 249, PM (4)II; TT 253, PM (4); presenting *wah*-collars and lotus: TT 38, PM (6)I; anointing: TT 38, PM (6)II; TT 175, PM (4)I-II; fixing locks of hair: TT 38, PM (6)I. The lower status of these servants is indicated by standing below the mat on which the banqueters are seated (excl. TT 38, PM (6)I).

[405] See discussion in Assmann, *Schöne Frauen, schöne Männer*, 13-32.

[406] See p. 91.

[407] See p. 92.

[408] Manniche, *La peinture égyptienne ancienne*, 31; idem, *Sacred Luxuries*, 99-100.

[409] W.A. Emboden, "Transcultural use of narcotic water lilies in ancient Egyptian and Maya drug ritual," *Journal of Ethnopharmacology* 3 (1981), 58; W. Benson Harer Jr, M.D. "Nymphae: Sacred Narcotic Lotus of Ancient Egypt?," *JSSEA* 14 (1984), 100-102; idem, "Pharmacological and Biological Properties of the Egyptian Lotus," *JARCE* 22 (1985), 49-54.

[410] Derchain, *CdÉ* 50 (1975), 72.

[411] J.A. Omlin, *Der Papyrus 55001 und seine satirisch-erotischen Zeichnungen und Inschriften* (Turin, 1973).

[412] Harer, *JSSEA* 14 (1984), 102; Harer, *JARCE* 22 (1985), 54.

[413] TT 38, PM (6)I; TT 52, PM (3)II; TT 175, PM (4)II. In art, the mandrake and the persea fruit were often indistinguishable from one another.

world, where it was used in love potions and as a lotion for the body.[414] Hallucinogenic and soporific, inhalation of the mandrake led to the loosening of inhibitions. A passage from Egyptian love poetry reveals the mandrake's effects:[415]

> I wish I were her Nubian slave
> Surely, she would make me bring
> a bowl of mandrake fruits,
> And when she holds it in her hand,
> she would breathe from it,
> Thus offering me the color
> of her entire body.

Thus, the inhalation of the mandrake led the woman to offer "the color of her entire body," a coded phrase indicating her availability for love. Another poem equates the skin/color of a lover as the *"reremt* (mandrake) which causes love."[416]

References to scent played an important role in the Banqueting Icon. The ancient Egyptians believed scent originated with the divine and that it was composed of the same vegetal, mineral, and resinous substance that made up the gods.[417] In the Pyramid Texts, incense acted as an intermediary that brought about the king's merging with the gods.[418] Scent was equated with the healing properties of the Eye of Horus to rejuvenate the body.[419] When contained in the form of an unguent, scent was rendered even more potent. In the temple, for example, unguent, being derived from the same elements as the gods, was used to anoint statues to make them vehicles of the divine force.[420] Likewise, the Seven Sacred Oils were used in funerary rituals for anointing the body during the Opening of the Mouth ritual to render the deceased effective.[421]

In the Banqueting Icon, solid unguent is represented in large vessels and in carrying bowls. Servant girls apply scented unguent or oil to guests' heads, collars, and arms. Perfumed oil was also applied to their garments. Captions to banqueting songs in eighteenth dynasty tomb chapels indicate that scented unguent, resin, and incense were associated with particular gods and their divine offerings. Not only do these songs suggest that scent was provided to celebrants through the industries in the god's temples, but it was also imbued with the divine essence:[422]

> Place *antiu* resin on your head
> Dress in fine linen.
> Anoint yourself with the true wonders
> Of the divine offering.

These various motifs in the Banqueting Icon emphasize the presence of scent, signaling its physical and symbolic importance for the dead. In the temple and the tomb, the burning and offering of incense was a means of in-

[414] Theophrastus, *Enquiry into Plants and Minor Works on Odours and Weather Signs*, translated by Sir Arthur Hort, Loeb Classical Library (London, 1980), IX.8.8; IX.9.1, mentions the use of mandrake in love potions and to cure sleeplessness. See also: Ludwig Keimer, "La baie qui fait aimer, Mandragora officinarum L. dans l'Égypte ancienne," *BIE* 32 (1951), 351; Wolfhart Westendorf, "Aphrodisiakon, A.," *LÄ* I (1975), 337; Derchain, *CdÉ* 50, nos. 99-100 (1975), 72. Quoted poetry passage in Manniche, *Sacred Luxuries*, 102.

[415] Manniche, *Sacred Luxuries*, 101. See recent discussion by Bernard Mathieu, "L'univers végétal dans les chants d'amour égyptiens," *Encyclopédie religieuse de l'Univers végétal, Croyances phytoreligieuses de l'Égypte ancienne,* vol. I, edited by S. Aufrère, Orientalia Monspeliensia 10 (Montpellier, 1999), 102.

[416] Manniche, *Sacred Luxuries*, 102.

[417] Aufrère, *L'univers minéral*, 329-330. See also: Maarten J. Raven, "Magic and Symbolic Aspects of Certain Materials in Ancient Egypt," *VA* 4 (1988), 237-242.

[418] *PT* 376b-377, Faulkner, *Pyramid Texts*, 77.

[419] Manniche, *Sacred Luxuries*, 35-36. For a translation of text equating the Eye of Horus with scented unguent, see: Aufrère, *L'univers minéral* I, 213-215.

[420] See, for example, the application of the Min unguent to statues in the Temple of Horus at Edfu: Aufrère, *L'univers minéral* I, 329-330.

[421] Nigel Strudwick, "Oil tablet," in *Mummies and Magic: The Funerary Arts of Ancient Egypt*, edited by S. D'Auria, P. Lacovara, and C. H. Roehrig (Boston, 1988), 81-82; Taylor, *Death and the Afterlife*, fig. 134. Serpico, *Ancient Egyptian Materials and Technology*, 461-462, and fig. 18.22, illustrates a depiction of pressing unguents that is accompanied by seven unguent jars, each labeled as one of the Seven Sacred Oils (modern term).

[422] Manniche, *Sacred Luxuries*, 94. See also song on Ibid., 95: "Your garments are white, fine oil is on your shoulders, garlands around your neck...to give you life and health, *antiu* resin and *senetjer* incense of Amun, in your house of eternity." See examples of scented ointment manufacture in TT 175 probably done in factories within the temple using the process of maceration (Figure 39); discussion in Serpico, *Ancient Egyptian Materials and Industries*, 461.

teraction between the earthly and the divine. Through the power of scent, banqueters experienced the god's essence, which acted as the intermediary between the blessed dead and the living.

However, scent could also carry erotic connotations. The ancient Egyptian word for scent, *seti*, is written with the same letters as the word for "engender." Since rebirth was the reenactment of birth, references to scent and the sexual act abound. In one poem, a lovesick man says, "I feel like a man in incense land who is immersed in scent."[423] Another describes the release of scent during climax:[424]

> When you go to the room of the sister,
> she being alone and without another,
> you can do what you wish with the latch.
> The door hangings flutter when the sky comes down in the wind,
> but it does not carry it away, that is, her fragrance
> when she brings you an abundance of scent,
> intoxicating those present...

In the Banqueting Icon, references to heavy drinking abound. Wine and beer jars are depicted on stands, and cups filled with intoxicating drink are presented to guests. Loti-form chalices decorated with the flowers of eternal life also may refer to the narcotic brew of alcohol and lotus held within the vessel that brought about the loosening of inhibitions. Drink also could overwhelm the imbiber, as rendered in one Banqueting Icon image in which a man is shown vomiting in a jar beside his chair.[425] Drinking had religious connotations to Hathor, who was known as the "mistress of intoxication" as well as the goddess of love, music, fertility, and rebirth.[426] Drinking was also an integral part of the banquet held during funeral rites and the Valley Festival, where it helped the celebrants loosen their critical faculties so they could communicate (temporarily) with the gods and the dead.[427] In essence, the allusion to drinking in the Banqueting Icon may have commemorated and magically recreated the eternal communion that was sought between the dead and the living.

The presence of inebriating drinks in the Banqueting Icon also related to sexual union. Westendorf has interpreted the action of pouring, identified by the word *stí*, with the word for procreation which was written with the very same letters.[428] By means of this pun, poured beverages are equated with the spurting of the liquid that is part of the creative sexual act. In the Banqueting Icon, the pouring of beverages is implied, and in one case, it is clearly represented.[429] In Egyptian love poetry, drunkenness went hand-in-hand with the amorous encounter, as relayed by a pomegranate tree who says, "I gather my girl and her lover together; it's my arms they lie under on a limp day, happy and high on wine and my cider, their bodies streaming with sweet-oil."[430] References to scent and intoxication in the Banqueting Icon evoked an atmosphere conducive to love that, within the context of the tomb, would aid the deceased's rebirth.

Music and musicians acted as mediators for communication with the divine during popular festivals in ancient Egypt. As described by Lise Manniche:[431]

> ...to Plutarch it (music) was one of the ways of opening and relaxing the mind. Apart from the (sic) that, music was the vehicle for the words which give a clue to the nature of the senses. The musicians were the mediators in the ongoing efforts of communicating with the divine. Through the phrases that they chanted in between their musical accompaniment, or coinciding with it, they expressed in

[423] See n. 341.

[424] Manniche, *Sexual Life*, 81; and discussed in: idem, *Sacred Luxuries*, 92. See also translation in: Alan H. Gardiner, *The Library of A. Chester Beatty: The Chester Beatty Papyrus,* (London, 1931), 36-37, recto XVI, 9-XVII.

[425] TT 38, PM (6)III. Other tombs that portray vomiting are TT 49 (Norman de Garis Davies, *The tomb of Nefer-hotep at Thebes*, vol. I, PMMA 9 (New York, 1933), pl. XVIII); TT 53 (Wreszinski, *Atlas* I, 179); and see discussion in Nina Davies, *Some Theban Tombs*, 7.

[426] Salima Ikram, "Banquets," *OEAE* I (2001), 164; Terry G. Wilfong, "Intoxication," *OEAE* II (2001), 181. See also: Hellmut Brunner, "Trunkenheit," *LÄ* VI (1986), 773-777.

[427] Schott, *Das schöne Fest*, 76-77; Graefe, *LÄ* VI (1986), 187.

[428] Westendorf, *ZÄS* 94 (1967), 142; *Wb.* IV, 326 ~ *Wb.* IV, 347.

[429] TT 161, PM (3)III. Although this wall is presented in facsimile in this volume, images in the tomb chapel clearly represent the pouring of liquid into several banqueters' cups.

[430] John L. Foster, *Love Songs of the New Kingdom* (New York, 1974), 83.

[431] Manniche, *La peinture égyptienne ancienne*, 34-35.

crystallized form the thoughts of the participants. Through the power of the spoken word, emphasized by the music, they made the situation come true. The god was there with them, in their midst, sharing the moment with the deceased relatives in whose monument they were sheltering.

In the Banqueting Icon, groups of musicians appear playing instruments,[432] clapping to the music, and dancing. In the tomb of Djeserkarasoneb (TT 38), the song caption above the three female clappers praises Amun "unto the height of heaven" and commemorates the beauty of the god (Figure 8).[433] The lyrics refer to their devotion and desire to see the god, which situates the depiction within the festivities of the Valley Festival, at which time the barks of Amun-Re, his consort Mut and their child, Khonsu, were taken in procession past the private necropolis to the mortuary temples of the kings in the valley below.[434]

In the Banqueting Icon, a male harper is sometimes depicted seated cross-legged and plucking at the strings of a harp.[435] While the image of the male harper is not captioned in the Banqueting Icon, his painted image in the later eighteenth dynasty became associated with a genre of songs known as the "The Harper's Songs" that were inscribed along with his figure on the wall. These songs, which may derive from oral traditions in ancient Egypt, are essentially mortuary in content and purpose and tell of the inevitability of death while asserting the benefits of life in the hereafter. These songs also urge listeners/readers to live for the moment.[436] Placed in connection with images of the funerary or festival banquet, the depiction of the male harper may have acted as a memorial for the actual performance in the tomb.[437] Drawing on the ancient Egyptian feeling towards death and the celebration of life that permeated the Harper's Songs, the image of the harper appears as a type of subtle *memento mori* and assurance of eternal happiness for the dead within the creative environment of the tomb.[438] In fact, the harper represented in the guise of a wise man may act as a visual symbol for the wisdom embodied in the song. Literate and non-literate tomb visitors may have retrieved this meaning from the image of the harper, which, when reinforced by their actual experience with these songs, instructed them "in the true meaning and value of the mortuary maintenance cult."[439]

[432] A combination of instruments appear in the Banqueting Icon, from boat-shaped harps to a ladle-shaped harp (known as the *bnt*-harp) adorned with a female head, flutes, double oboes, and, in one case, a lyre. For more on specific instruments, see: Manniche, *Music and Musicians in Ancient Egypt*, 40-51, fig. 21.

[433] TT 38, PM (3)II. Scheil, *Mém. Miss.* V,2 (1894), 575, pl. 2; Kuentz, *BIFAO* 21 (1923), 129, no. (22); *Urk.* IV, 1639; Nina Davies, *Some Theban Tombs*, 6, pl. VI. For other examples, see: Schott, *Das schöne Fest*, 79-80, 128-133, nos. 135-148.

[434] See discussion in: Assmann, *Torat ha-Adam*, 13-29.

[435] TT 108, PM (5)I; TT 161, PM (3)II. On the depiction of the harper: Schott, *Das schöne Fest*, 79.

[436] The Harper's Songs are found inscribed on tomb walls and mortuary stelae. In the eighteenth dynasty, these songs often were connected to the image of the harper alone, as for example in TT 11 (Torgny Säve-Söderbergh, "Eine Gastmahlsszene im Grabe des Schatzhausvorstehers Djehuti," *MDAIK* 16 (1958), 282-285, Abb. 2-4). The Harper's Songs have been examined in a number of different articles which discuss both their textual content, meaning, and pictorial context. The fundamental study on the meaning of the Harper's Songs is that of Miriam Lichtheim, "The songs of the harpers," *JNES* 4 (1945), 178-212; and idem, *Ancient Egyptian Literature* I, 193-197, who views the song as essentially mortuary in content which acts as a "statement of skepticism regarding the afterlife." This interpretation of skepticism towards the afterlife in the Harper's Songs has been revised recently by other scholars, including David Lorton, "The Expression *Šms-ib*," *JARCE* 7 (1968), 45-48, who agrees that the song belongs to the mortuary repertoire, but that it is "a strong affirmation of faith in the afterlife." Hans Goedicke, "The Date of the 'Antef-Song,'" *Fragen an die altägyptische Literatur: Studien zum Gedenken an Eberhard Otto*, edited by J. Assmann, E. Feucht, and R. Grieshammer (Wiesbaden, 1977), 185-196, notes that the Antef song focuses on the transience of life. Jan Assmann, "Fest des Augenblicks--Verheissung der Dauer: Die Kontroverse der ägyptischen Harfnerlieder," in *Fragen an die altägyptische Literatur: Studien zum Gedenken an Eberhard Otto*, edited by J. Assmann, E. Feucht, and R. Grieshammer (Wiesbaden, 1977), 55-84; and idem, "Harfnerlieder," *LÄ* II (1977), 972-982, focuses on the contradictory nature of the songs that both praise life on earth and yet exult the afterlife. Focusing particularly on their literary association with banquet poetry, Edward F. Wente, "Egyptian 'Make Merry' Songs Reconsidered," *JNES* 21 (1962), 118-128, disagrees with the song's mortuary content and context, finding instead that these songs are secular and depict banquets in which the deceased 'makes merry.' A few other examinations of the Harper's Songs are: Hellmut Brunner, "Wiederum die ägyptischen 'Make Merry' Lieder," *JNES* 25 (1966), 130-131; Michael V. Fox, "A Study of Antef," *Orientalia* 46 (1977), 393-423; Pierre Gilbert, "Les chants du harpiste," *CdÉ* 29 (1940), 38-44; David Lorton, "The Expression '*iri hrw nfr*'," *JARCE* 12 (1975), 23-31; idem, "A Note on the Expression *Šms-ib*," *JARCE* 8 (1969-1970), 55-57. In the end, the Harper's Song can be viewed as a text in which life and life after death are celebrated, and that may indeed reflect an oral, secular tradition of songs.

[437] Bo Lowergren, "Music," *OEAE* II (2001), 453.

[438] Dietrich Wildung, *Ägyptische Malerei, Das Grab des Nacht* (Zürich, 1978), 57-58, discussed the depiction of the harper in TT 52 as an image whose songs commemorated the joining of the *Diesseits* and *Jenseits*, the pleasure of life and the yearning for death.

[439] Michael V. Fox, "The Entertainment Song Genre in Egyptian Literature," in *Egyptological Studies*, edited by S. Israelit-Groll, Scripta Hierosolymitana 28 (Jerusalem, 1982), 301, argues that "the dual purpose of the songs as they were sung and heard, and written and read, was to ensure eternal blessedness for the deceased through the creative force of word and representation and to instruct listeners and readers in the true meaning and value of the mortuary maintenance cult." Patricia A. Bochi, "Gender and Genre in Ancient Egyptian Poetry: The Rhetoric of Performance in the Harpers' Songs," *JARCE* 35 (1998), 93-95, discusses the role of the image of the harper and its accompanying texts on the viewer.

In terms of its cultural and religious significance, the Banqueting Icon associates both the living and the dead participants with the gods Amun, Hathor, and Osiris as well as the royal and private ancestor cults. As discussed in Chapter 1, the Valley Festival was originally a Hathoric festival that in the eighteenth dynasty became linked with the god Amun-Re.[440] Hathor was referenced in the festivities not only in her role as the "Mistress of the West" but also as goddess of love, music, fertility, birth, and drunkenness. Deceased ancestors were reincorporated with the living through the use of mind-altering substances, alcoholic beverages, intoxicating scent, and music that broke down the barriers between this world and the next. The funerary banquet related to the realm of Osiris and was celebrated after the rites of burial had been completed.[441]

In terms of the magical and commemorative significance of the Banqueting Icon, images and visual puns relate to sensuality, procreation, and rebirth to aid the dead in their quest for eternal life in the creative environment of the tomb. Banqueting images served as magical provisions for the eternal sustenance of the tomb owner in the next world. To the living, these images may have chronicled actual celebrations held in the chapel, identified family member participants, and served as visual reminders to the living of the ancient Egyptian mortuary maintenance cult. Furthermore, accomplished renderings, such as the three musicians in the tomb of Nakht (Figure 9), may have been deliberately placed on the wall to appeal to the viewer's aesthetic sense and impress upon him or her the status of the deceased as a worthy cult recipient who had access to such skilled artists.[442]

Thus, iconography of the Banqueting Icon mixed aspects of the Valley Festival, the funerary banquet, and other meals held in the tomb. On an integrated commemorative, creative, and symbolic level, the rites of incorporation that joined the living and the dead, celebrated family ties, and associated all participants with the earthly and divine spheres, were preserved in this world and transferred to the world hereafter. The Banqueting Icon is thematically and symbolically linked with the Offering Table Icon through the representation of the meal that symbolized the deceased's potential incorporation into the divine realm as a blessed ancestor and through the bestowal of gifts that mediated divine power. These gifts were given during necropolis festivals at which time the dead were reincorporated into the world of the living, and they were also bestowed during the funerary meal, after the rites of transfiguration had been completed.[443] Magically, the banquet with its foodstuffs would provision the dead in the next world. The Banqueting Icon encoded references to sensuality and rebirth, associated with the gods Hathor, Amun-Re, and Osiris, that along with offerings imbued with the divine essence, identified the deceased with these gods in the hereafter. The deceased was also distinguished by his insignia and titles, which, in all cases, related to the administration of the god's temples and its holdings – an identity that would be preserved in this world and transferred into the next.

3.2.8 Fishing & Fowling Icon

The fishing and fowling scene has been extensively examined by a number of scholars who have noted, as a point of departure, the elaborateness of the participant's clothes and their positioning on the papyrus skiff, all of which seem oddly out of place for a hunting outing in the marshes. While a few scholars deduce that the fishing and fowling scene reflects privileged recreation and the securing of provisioning for the deceased,[444] some argue that the scene references a more symbolic realm and functioned apotropaically for the afterlife of the deceased.[445] Many scholars note

[440] See discussion 1.1.2, pp. 11-12.

[441] Taylor, *Death and the Afterlife*, 27, 193.

[442] The motif is given emphasis at the center of the lower register and framed by two registers of banqueters to the left and the son offering the bouquet to Nakht and his wife on the right. For a compositional analysis of the motif and style of the painters, see Shedid and Seidel, *Nakht*, 17, 21, 28-29.

[443] Lloyd, *Religion and Philosophy in Ancient Egypt*, 126-131; Bell, *Temples*, 286-287 with n. 42.

[444] Erika Feucht, "Fishing and Fowling with the Spear and the Throw-Stick Reconsidered," in *The Intellectual Heritage of Egypt: Studies presented to László Kákosy by Friends and Colleagues on the Occasion of his 60th Birthday*, edited by U. Luft, Studia Aegyptiaca 14 (Budapest, 1992), 168; Jan Assmann, "Spruch 62 der Sargtexte und die ägyptischen Totenliturgien," in *The World of the Coffin Texts: Proceedings of the Symposium Held on the Occasion of the 100th Birthday of Adriaan de Buck, Leiden, December 17-19, 1992*, edited by H. Willems, EU 9 (Leiden, 1996), 25-26.

[445] Dietrich Wildung, "Feindsymbolik," *LÄ* II (1977), 146-148; idem, *Nacht*, 59-60; Assmann, *Schöne Frauen, schöne Männer*, 13-32; Laboury, *La peinture égyptienne ancienne*, 69-71.

that rebirth and fertility are present in the erotically charged details of the scene,[446] and one scholar has argued that the fishing and fowling scene was a manipulative image in which the deceased's single-handed securing of food for his family presented him as one worthy of cult to relatives who would view the image.[447] However, all interpretations are not necessarily mutually exclusive and can be combined,[448] along with other commemorative elements in the scene, to illustrate how fishing and fowling functioned on behalf of the deceased within the context of the tomb. Because of the large volume of literature on the fishing and fowling scene, the following discussion will highlight only those details that are relevant to the tombs in this study.

The Fishing & Fowling Icon is composed of two antithetically placed images of the deceased fowling with a throw stick and fishing with a spear against a marsh backdrop, accompanied by his wife and children and, sometimes, attendants. This icon occurs on two focal walls where it is connected with the Offering Table Icon (Figures 10 and 38).[449] Captions accompanying the icon identify the deceased and wife and denote that the tomb owner is involved in a ritual act, as "the companion the mistress of the prey" who engages in "the work of the goddess Sekhet."[450]

Known as the *nbt ḥ3b* or "Mistress of the Prey," Sekhet was the deity of the marshlands and the fields, and all activities in this realm were called *k3t Sḫt* or the "work of Sekhet."[451] Fowling with a throw stick also may have represented the celebration of a cultic ceremony associated with goddess Hathor in her form as Sekhet.[452] It is well known that Hathor was closely associated with the marsh in the form of a cow emerging from the papyrus thicket. Themes relating to sexuality and rebirth abound in the Fishing & Fowling Icon and reinforce the symbolic associations to Hathor. Furthermore, the religious character of the Fishing & Fowling Icon is underscored by the deceased's being engaged in "the work of the goddess Sekhet," thus traversing the marshes becomes an act of worship to the combined goddess Sekhet/Hathor.[453]

In myth, the papyrus thicket symbolized rebirth. It was associated with the young Horus and the environment in which he was born and raised ultimately to avenge his father's death. The papyrus thicket also evoked the primordial swamp from which life grew, equating the origin of creation with the deceased's hope for rebirth.[454] In the fowling scenes, tomb owners use grey herons as decoys. The heron symbolized the rebirth of the rising sun and man's regeneration after death.[455] However, in general, birds were associated with the enemies of the Creator God and thus needed to be symbolically destroyed to preserve the order of the cosmos.[456] By killing birds with his throw stick, the deceased is involved in a sacred activity that would maintain cosmic order by quelling the forces of chaos that could penetrate the tomb and disturb his family's eternal peace.[457]

[446] Westendorf, *ZÄS* 94 (1967), 142-143; Derchain, *SAK* 2 (1975), 62-64; Phillipe Derchain, "Symbols and Metaphors in Literature and Representations of Private Life," *RAIN* 15 (1976), 8-10; Manniche, *Sacred Luxuries*, 103-106.

[447] Barocas, *La mort, les morts dans les sociétés anciennes*, 429-440.

[448] Most notably by Robins, *Women in Ancient Egypt*, 187-189; Laboury, *La peinture égyptienne ancienne*, 70-73; Hodel-Hoenes, *Life and Death in Ancient Egypt*, 23; Miller and Parkinson, *Colour and Painting*, 50.

[449] TT 52, PM (6); TT 165, PM (4).

[450] TT 52, PM (6): *Urk.* IV, 1605; TT 165, PM (4): "the praised one of the mistress of the prey," *Urk.* IV, 1607. On the ritual nature of the text: Laboury, *La peinture égyptienne ancienne*, 70.

[451] "Mistress of the Prey": *Wb.* III, 62, 4. Waltraud Guglielmi, "Die Feldgöttin *Sḫt*," *WdO* 7 (1973-1974), 206-227; idem, "Sechet," *LÄ* V (1984), 778.

[452] Karl Martin, "Vogelfang, -jagd, -netz, -steller," *LÄ* VI (1986), 1052; Kamrin, *Khnumhotep II*, 108. See also: Guglielmi, *WdO* 7 (1974), 206-227.

[453] Textual examples relating to the "work" of Sekhet from other Theban tombs dating to Thutmose IV and Amenhotep III: Brack, *Haremhab*, 60-61 (TT 78); *Urk.* IV, 1600 (TT 77); Manniche, *Lost Tombs*, 151-152 (Tomb of Nebamun, BM 37977). On sacred interpretation of fishing and fowling scenes in the New Kingdom, see: Susanne Binder, "The Tomb Owner Fishing and Fowling," in *Egyptian Art: Principles and Themes in Wall Scenes*, edited by L. Donovan and K. McCorquadale, Prism Archaeological Series 6 (Egypt, 2000), 115.

[454] Robins, *Women in Ancient Egypt*, 188.

[455] TT 52, PM (6), one grey heron; TT 165, PM (4), a group of birds resembling grey herons or possibly egrets. For more on the heron and egret, see: Houlihan, *Birds of Ancient Egypt*, 15-18.

[456] Wildung, *LÄ* II (1977), 147; Kamrin, *Khnumhotep II*, 97-98, 107-108.

[457] Laboury, *La peinture égyptienne ancienne*, 70-71.

In the Fishing & Fowling Icon, the deceased's spear punctures two fish, either a *Lates nilotica* and a *Tilapia nilotica*, or two *Tilapia nilotica*, which are framed in an arc of water (*Wasserberg*).[458] The *Lates* or Nile Perch was associated with rebirth as well as the goddess Neith, who turned herself into a *Lates* to navigate the primeval waters of Nun.[459] The *Lates* is found predominantly in the Upper Egyptian portions of the Nile. The *Tilapia* was connected to Hathor and represented fertility and rebirth, in part because of its mouth-brooding habits.[460] After her eggs are fertilized, the *Tilapia* takes them into her mouth, and when the eggs hatched, the fry leave only to return when they are in danger. The ancient Egyptians associated the *Tilapia* with the Creator God Atum, who took his seed in his mouth and spat out the world. During breeding, the brilliant colors of the Tilapia led to its name "red fish" and its connection with the sun as the guardian and protector of the solar boat on its daily cycle.[461] The *Book of Going Forth by Day* addressed the deceased's hope to "see the *Tilapia* (*int*) in the stream of turquoise" while sailing with the sun god in his sacred bark.[462] In ancient Egypt, the *Tilapia* was associated with the shallow marshlands of the Delta. Thus, by spearing the *Lates* and *Tilapia* fish in the Fishing & Fowling Icon, the deceased is depicted magically taking possession of the cycle of creation and rebirth implied by the symbolism of these fish for his regeneration.[463] Also, by spearing these fish, the deceased may have delimited his hunting grounds, with symbolism that evoked the landscape of both Upper and Lower Egypt.[464]

As symbols of the cycle of life, young sons and daughters stand on the prow of the skiff, and young girls kneel beneath the legs of their father in the Fishing & Fowling Icon.[465] In the tomb of Nakht (TT 52) (Figure 10), the young son holds a stick similar to that wielded by his father, and his daughter holds a lotus bud, both symbols of creation and rebirth. The wife holds a small chick, and in the space between the two antithetically placed images of fishing and fowling, several nests filled with eggs are guarded by their mothers. All signify the interaction of the male and female that not only resulted in birth that extended the family line, but within the creative environment of the tomb, the union of man and wife that would guarantee the deceased's rebirth in the next world.[466]

Other motifs associated with rebirth and sexuality appear in the Fishing & Fowling Icon. The ancient Egyptians believed rebirth to be the reenactment of birth, so images as well as visual word play evoked the necessities needed for the act of conception. The visual pun of hurling a throw stick has been equated with its hieroglyphic sign used in the word *ḳm3* "to create" and "to beget."[467] Likewise, the word for spearing a fish, *sti*, resembles the spelling of the word "to impregnate." In the tomb of Nakht (Figure 10), the deceased's wife is dressed in a diaphanous gown that is tied around her breast, and she wears a broad collar and floral wreath over her wig. Taken together, the wife's dress presents her as an alluring symbol of fertility and sexuality.[468] The geese on the boat's prow have erotic associations and held a sacred connection to the god Amun-Re.[469] The pintail ducks that are flushed from the papyrus thicket also carry sexual

[458] TT 52, PM (6): *Lates nilotica* and a *Tilapia nilotica* (compare with image in Douglas J. Brewer and Renée F. Freidman, *Fish and Fishing in Ancient Egypt* (Warminster, 1989), fig. 3.36); TT 165, PM (4): two *Tilapia nilotica*. On the arc of water: Heinrich Balcz, "Zu dem 'Wasserberg,'" *MDAIK* 8 (1939), 158-160.

[459] Douglas J. Brewer, "Fish," *OEAE* I (2001), 535; Gamer-Wallert, *Fische und Fischkulte*, 128-130; idem, "Fische, religiös," *LÄ* II (1977), 230.

[460] Gamer-Wallert, *Fische und Fischkulte*, 110-111; Martin Dambach and Ingrid Wallert, "Das Tilapia-Motiv in der altägyptischen Kunst," *CdÉ* 41, no. 82 (1966), 283-294; Dietrich Sahrhage, *Fischfang und Fischkult im alten Ägypten*, Kulturgeschichte der Antiken Welt 70 (Mainz, 1998), 137-138; Robins, *DIE* 17 (1990), 50; Brewer, *OEAE* I, 533.

[461] Brewer and Friedman, *Fish and Fishing*, 77; Gamer-Wallert, *LÄ* II (1977), 232-233.

[462] Faulkner, *The Egyptian Book of the Dead*, pl. 21; Robins, *Women in Ancient Egypt*, 188.

[463] Laboury, *La peinture égyptienne ancienne*, 72; Manniche, *Sacred Luxuries*, 104.

[464] Kamrin, *Khnumhotep II*, 113; Binder, *Egyptian Art: Principals and Thebes in Wall Scenes*, 116.

[465] Whale, *Family*, 189, 197-198.

[466] Robins, *DIE* 17 (1990), 50; Shedid and Seidel, *Nakht*, 17; Hodel-Hones, *Life and Death in Ancient Egypt*, 39. See also the significance of the egg in particular Egyptian cosmogonies, Françoise Dunand and Christiane Zivie-Coche, *Dieux et hommes en Égypte:3000 av. J.-C. - 395 apr. J.-C*, Anthropologie religieuse, Histoire ancienne (Paris 1991), 59.

[467] Westendorf, *ZÄS* 94 (1967), 142, who also discusses the significance and symbolism of the word *sti*.

[468] Derchain, *SAK* 2 (1975), 55-74; Robins, *Sexuality in Ancient Art*, 36-39; idem, "Hair and the Construction of Identity in Ancient Egypt c. 1480-1350 B.C.," *JARCE* 36 (1999), 63.

[469] TT 165, PM (4); and TT 52, PM (6), the goose has been hacked out by Atenists. On the goose as the sacred bird of Amun: Charles Kuentz, *L'oie du Nile (Chenalopex Aegyptiaca) dans l'antique Égypte*, Archives du Muséum d'Histoire naturelle de Lyon 14 (1926), 48-50. Erotic associations: Derchain, *SAK* 2 (1975), 63. See also: Houlihan, *Birds of Ancient Egypt*, 62-65.

connotations.[470] Moreover, the marsh is often cited as an erotic location in love poetry:[471]

> How good it would be, just you there with me,
> while I set my carefullest trap!
> And what luck for a lover-outbound for the marsh
> with that special one waiting to love!

Fishing and fowling are also referenced in ancient Egyptian love songs as a metaphor for a husband's extramarital sexual activity.[472] In the Fishing & Fowling Icon, the combination of these details suggest an erotic outing that would result in the sexual union of the man and wife leading to the deceased's rebirth in the hereafter.

As a means of provisioning, the wild game taken by the tomb owner in the Fishing & Fowling Icon would magically provide for his sustenance in the next world.[473] Likewise, the heroic depiction of the deceased's competency in the hunt also may have influenced viewers to perform cultic actions on his behalf. Commemoratively, the deceased and wife are presented as individuals of wealth and stature who are identified not only by the importance of their titles but also by their fine dress.

In the Fishing & Fowling Icon, the tomb owners are commemorated as men of status who worked in the estate of Amun, an identity that would be preserved for the living and projected into the afterlife (Table 1).[474] The tomb owner, depicted ritually engaged in an act of divine worship quelling the forces of chaos, not only harnesses the powers of rebirth for his afterlife, but commemorates his earthly association within the god's realm. Set within the context of the papyrus thicket, all the necessary elements for conception, guaranteeing the deceased's eternal rebirth, were included. By spearing the *Lates* and *Tilpia*, the deceased takes possession of the cycle of creation and regeneration and maintains *Maat* by conquering birds, which symbolize the dangerous forces that could threaten his immediate environment. By means of these pursuits, the deceased is also magically provided with eternal entertainment and food delicacies in the next life. Connected to the Offering Table Icon, the Fishing & Fowling Icon enhances themes of the deceased's eternal provisioning, rebirth, and integration with the gods.

3.2.9 Natural Resource Icon

The Natural Resource Icon encompasses images of wine making, gardening, agriculture, unguent manufacturing, clap-netting, the preparation of fish and fowl, the tending of cattle, and, in one case, the tomb owner's estate and its connection to the pharaoh. While this seems like a wide assortment of motifs, each image is connected by its association to the utilization and maintenance of the natural resources of Egypt.

The Natural Resource Icon decorates six focal walls, covering the entire wall or as a series of vignettes (Figures 10, 30, 36, 38, 39; B&W Plate 7). In all but one tomb, the Natural Resource Icon is adjacent to the Offering Table Icon and occurs in connection with the Fishing & Fowling or Banqueting icons.[475] When texts appear, they identify the individuals and explain the actions depicted in the scene. With the exception of the tomb of Nebamun (TT 90), the

[470] Erotic associations: Derchain, *RAIN* 15 (1976), 8. On the appearance of the pintail duck in fishing and fowling scenes: Patrick F. Houlihan, "Birds," *OEAE* I (2001), 190.

[471] Foster, *Love Songs*, 101.

[472] William C. Hayes, "A Much-Copied Letter of the Early Middle Kingdom," *JNES* 7 (1948), 8, reading: "Go, Au, and see this, thy grief-stricken wife, who weeps on account of thee because of thy fishing by night and thy fowling by day."

[473] The attendants carrying captured geese says "the waterfowl which he has taken in season" (*Urk*. IV, 1606) to the seated figures of the deceased and wife (Figure 10). On the literal reading of fishing and fowling scenes as provisioning, see: Feucht, *Studies Kákosy*, 168. See also the tantalizing phrase from the tomb of Haremhab (TT 78) that accompanies the deceased's fishing and fowling "which is carried out therein in the necropolis" (Brack, *Haremhab*, 60).

[474] Nakht (TT 52) was an "Hour Observer of Amun," and Nehemaway (TT 165) was a "Sculptor of Amun." For more on these titles, see: Eichler, *Die Verwaltung des "Hauses des Amun,"* 148, 170. Concerning the title of Nehemaway, Eichler (Ibid., 298, no. 381) hesitates to add the extension "of Amun" and takes the *n* as a phonetic complement for *s'nḫ*. However, there is clearly enough room between the *n* and Nehemaway's outstretched hand to take the written characters for *Imn*, based on similar sign groupings measured at the wall in TT 165 by the author. Therefore, Eichler's reservations are noted, but not accepted here.

[475] Composed of an abbreviated series of vignettes, TT 52, PM (6); TT 161, PM (3); TT 165, PM (4); and TT 175, PM (4). Entire wall: TT 151, PM (2). The exception is TT 90, PM (8), which is connected to the Royal Kiosk Icon on PM (9).

Natural Resource Icon is found in chapels of officials who were employed in the Amun temple or its estate (Table 1).[476] Given the variety of motifs that appear in the Natural Resource Icon, each vignette type will be discussed below along with its texts, and their results will be summarized at the end to arrive at the larger symbolic meaning of the icon.

Images concerned with wine making are represented in the Natural Resource Icon (Figures 10, 30, 38). The most complete cycle of scenes involving wine making comes from the tomb of Nebamun (TT 90) and includes images of men picking the grapes off vines trained on a papyrus-columned pergola, placing them into baskets, and bringing them to a treading vat raised on a platform (Figure 30).[477] In the treading basin, a group of men stomp the grapes while hanging onto ropes tied to beams, and they sing a prayer to the harvest goddess Renenutet: "For your *ka*, Renenutet! Give food and sustenance!"[478] Below, a man scoops into a jar the grape juice that flows from a spigot decorated with the image of the goddess Renenutet in the form of a snake. Behind the man stretches several sub-registers of wine jars either resting on stands or on the ground, two of which have juice bubbling over the rim, indicating the turbulent fermentation of the juice as it heats under the sun.[479] Nebamun is depicted at the far right seated on a field stool[480] overseeing the entire operation, and he is captioned: "Having the grape-harvest pressed by the Troop Commander of the West of Thebes, the Standard Bearer, [Nebamun]."[481]

The inclusion of the vintage cycle in the tomb assured the deceased a plentiful supply of wine in the hereafter. Although not all aspects of the wine production are shown, the complete cycle is implied, and its success is magically ensured by the prayer to the harvest goddess Renenutet. The song also may have related to an actual practice in the New Kingdom of singing a rhythmic melody to help the treaders pass the time.[482] According to later Greco-Roman texts, the harvesting and processing of the grapes occurred in late August during the months of *Shemu*.[483]

The drinking of wine was enjoyed on many occasions in ancient Egypt and was considered a prestigious drink.[484] As discussed above, the drinking of wine abolished the barrier between the living and the dead, as well as between this world and the world of the gods. Wine was linked to Hathor, the goddess of love and fertility, who was also called the "Mistress of Drunkenness," and "Mistress of the West" in her venerated form at Thebes. Grapes and wine were also linked to the god of the underworld, Osiris, who was called the "Lord of Wine."[485] As symbols of regeneration, grapes were proffered to the deceased as part of the "Opening of the Mouth" ceremony.[486] Wine also signified blood, and was associated with the god of the wine press, Seshmu, who protected the justified dead by massacring their enemies as well

[476] As Amun temple priests: Nakht (TT 52); Amun estate for the God's Wife of Amun: Haty (TT 151); and Amun temple provisioners: Nakht (TT 161), and TT 175; and Amun temple artists: Nehemaway (TT 165). Nebamun (TT 90) was affiliated with the military as a standard bearer. See also n. 291.

[477] TT 90, PM (8). The cycle of vintage scenes in TT 52, PM (6) includes grape picking and stomping, as well as juice collection and its fermentation in wine jars. In TT 165, PM (4) the series includes preliminary sketches of men picking grapes (not girls as indicated by Davies, *Five Theban Tombs*, 41) and stomping them in a raised treading vat. On the common depiction of men harvesting grapes, see: Mary Anne Murray, "Viticulture and wine production," in *Ancient Egyptian Materials and Technology*, edited by P.T. Nicholson and I. Shaw (Cambridge, 2000), 585.

[478] Davies, *Two officials*, pl. XXX; *Urk.* IV, 1625. For more on Renenutet, see: Christine Beinlich-Seeber, "Renenutet," *LÄ* V (1984), 232-236. See similar songs in: Davies, *Rekh-mi-re*, pl. XLV; and Säve-Söderbergh, *Four Eighteenth Dynasty Tombs*, 17, pl. XIV.

[479] For more on the ancient Egyptian fermentation process, see: Murray, *Ancient Egyptian Materials and Technology*, 577-608.

[480] Nebamun sits on a field stool with legs that end with duck heads. This was a favorite chair among officials in the military. Unfortunately, Atentists destroyed the duck heads believing they were geese, the bird sacred to Amun. See parallel examples in the tombs of other military officials such as Tjanuny (TT 74) (Brack, *Tjanuni*, taf. 21a); discussed in Schott, *Das schöne Fest*, 70.

[481] Davies, *Two officials*, pl. XXX-XXXIII; *Urk.* IV, 1624.

[482] See Old Kingdom songs captioning images of grape stomping: Dimitri Meeks, "La production de l'huile et du vin dans l'Égypte Pharaonique," in *La production du vin et de l'huile en Mediterranée*, edited by M.C. Amouretti and J.P. Brun (Athens, 1993), 21. For the New Kingdom: Pierre Montet, *Everyday Life in Egypt in the days of Ramesses the Great*, translated from the French by A.R. Maxwell-Hyslop and M.S. Drower (Philadelphia, 1981), 106.

[483] P.T.H. Unwin, *Wine and the Vine: An Historical Geography of Viticulture and the Wine Trade* (London, 1996), 187; Leonard Lesko, "Egyptian Wine Production During the New Kingdom," in *The Origins and Ancient History of Wine*, edited by P. McGovern, S. Fleming, and S. Katz (Luxembourg, 1995), 230. See also: Dominic Rathbone, *Economic Rationalism and Rural Society in Third Century A.D. Egypt: The Heroninos Archive and the Appianus Estate* (Cambridge, 1991), 250.

[484] See discussion and bibliography in: Poo, *Wine and Wine Offering*, 27-28; Murray, *Ancient Egyptian Materials and Technology*, 577-578.

[485] Christine Meyer, "Wein," *LÄ* VI (1986), 1175-1176, who cites PT 1524.

[486] Christine Meyer, "Weintrauben," *LÄ* VI (1986), 1191; Otto, *Mundöffnungsritual* II, szene 38, 98-99; Poo, *LÄ* VI (1986), 1186.

as the enemies of the gods.[487] Wine was conceived as the blood which Seshmu pressed from the enemy's heads as they were crushed in the god's vat, thus symbolizing the annihilation of the forces of chaos. In short, the representation of vintage on the tomb chapel's walls provided the deceased with an abundant supply of wine, which was guaranteed through a prayer to the harvest goddess, Renenutet. Through its connection to the gods Seshmu, Osiris, Renenutet, and Hathor, wine also protected the dead from chaotic forces and offered them the promise of rebirth and regeneration.[488] With the possible exception of Nebamun (TT 90) (see discussion below), the depiction of viticulture and wine production in the Natural Resource Icon may have been a creative fiction for the beyond rather than a realistic image of activities conducted during the life of the tomb owner or on his estate, given the middle class origins of the tomb owners who made use of this icon.[489] Nevertheless, given the prestige the beverage and its production imparted, the icon may have been included in the chapel to enhance the status of the tomb owner. Its presence on the tomb walls certainly ensured a constant supply of wine for the deceased's afterlife.

The supervision of the temple gardens is chronicled in the Natural Resource Icon in the tomb of Nakht (TT 161) (B&W Plate 7). In each representation, Nakht is identified by his title "Gardener of Divine Offerings of Amun" (k3ríí n htp-ntr n Imn), overseeing the picking of sycamore-figs, supervising the watering and growing of grain, flax, lettuce fields, and grape vines, and "strolling" in gardens of the Temple of Amun-Re at Karnak.[490] The products Nakht oversaw all related to the Amun temple worship: Lettuce was offered to Amun-Min; flax was produced for the clothing of priests and statues as well as linseed oil; and other food was grown to supply the temple. On a symbolic level, the layout of the temple garden represented the perfect cosmos in microcosm.[491] Pools teeming with fish symbolized the primeval ocean, Nun, from which all life arose. Papyrus and lotus were the plants associated with creation. Grape vines evoked Osiris, date palms related to the sun god Re, and the sycamore tree was connected to the goddesses Hathor and Nut. When considered in the context of the tomb, the garden with its cycle of vegetal life acted as a metaphor for the cyclic nature of all life and regeneration.

Images concerned with the cereal harvest are represented as part of the Natural Resource Icon in TT 175 (Figure 39). Two groups of oxen plow the land with a sower between them dropping seeds from a basket. Before them, a man forks grain onto a semi-circular threshing floor which is trampled by several oxen.[492] To the right of the threshing floor, several laborers are bent over and are cutting ears with a sickle against a mustard-yellow backdrop which, although unfinished, was meant to indicate the grain fields.[493] To the far right of the register, the products of the land are displayed. The entire cycle, from plowing to harvesting, went from the beginning of *Peret* to early *Shemu*.[494]

A series of vignettes relating to the making of unguent compose another portion of the Natural Resource Icon in TT 175. These vignettes illustrate the maceration process (hot steeping) that produced scented unguent.[495] The stages

[487] Poo, *Wine and Wine Offering*, 151-152. For more on Seshemu, see: Wolfgang Helck, "Schesemu," *LÄ* V (1984), 590-591; Bonnet, *Reallexikon*, 679-680; Mark Ciccarello, "Shesmu the Letopolite," in *Studies in Honor of George R. Hughes*, SAOC 39 (Chicago, 1976), 43-54; Hodel-Hoenes, *Life and Death in Ancient Egypt*, 40.

[488] See interpretation in Laboury, *La peinture égyptienne ancienne*, 73-74.

[489] On the status of the tomb owners, see: Eichler, *Die Verwaltung des "Hauses des Amun,"* 147-148, 170. On the creative fiction of this scene, see: James, *The Origins and Ancient History of Wine*, 205.

[490] On the duties of the k3ríí n htp-ntr n Imn, see: Eichler, *Die Verwaltung des "Hauses des Amun,"* 71-72. For the discussion of the components of this scene, see: Marcelle Werbrouck and Baudouin van de Walle, *La tombe de Nakht: notice sommaire* (Brussels, 1929), 12-13; Alix Wilkinson, *The Garden in Ancient Egypt* (London, 1998), 136. Text to the gardening scene in the tomb of Nakht (TT 161): Manniche, *JEA* 72 (1986), 61, text 34-37.

[491] See discussion in: Renate Germer, "Gardens," translated from the German by J. Harvey and M. Goldstein, *OEAE* II (2001), 4-5; Jean-Claude Hugonot, *Le jardin dans l'Égypte ancienne* (Frankfurt am Main, 1989), 169; Dietrich Wildung, "Garten," *LÄ* II (1977), 376.

[492] Manniche, *Three Theban Tombs*, 38, suggests the animals are threshing in a net which is not supported in the visual record of eighteenth dynasty threshing scenes. For more on threshing, see: Mary Anne Murray, "Cereal production and processing," in *Ancient Egyptian Materials and Technology*, edited by P.T. Nicholson and I. Shaw (Cambridge, 2000), 524-525.

[493] Compare similar depictions in J.J. Tylor and F. Ll. Griffith, *The tomb of Paheri at El Kab*, EEF 11 (London, 1894), pl. III; and the tomb of Menna (TT 69): Hodel-Hoenes, *Life and Death in Ancient Egypt*, fig. 54.

[494] Kamrin, *Khnumhotep II*, 72. See also: Murray, *Ancient Materials and Technology*, 518-520.

[495] For discussion on the maceration process, see: Serpico, *Ancient Egyptian Materials and Technology*, 461; and Manniche, *Three Theban Tombs*, 38; idem, *An Ancient Egyptian Herbal* (Austin, 1989), 50-54. See also: Mohamed el-Shimy, "The Preparation and Use of Perfumes and Perfumed Substances in Ancient Egypt," in *Egyptology at the Dawn of the Twenty-First Century: Proceedings of the Eighth International Congress of Egyptologists, Cairo 2000*, vol. 2, edited by Z. Hawass and L.P. Brock (Cairo, 2003), 510.

depicted include the straining of raw materials, the melting of lipids, and the grinding of aromatics, which are then boiled in large vats, stirred, and later decanted. The jars that rest upright on stands indicate the final product. As mentioned above, unguent was a sacred substance that was used in private funerary cults and temple rites.[496] From the beginning of the eighteenth dynasty on, the god Seshmu was associated with the oil-press from which the aromatic substances for perfume were pressed out.[497] As the god associated with perfume and unguent, Seshmu was also equated with embalming and brought provisions to the dead.[498] The manufacturing of unguent also commemorated the deceased's official position in life and his connection to an industry associated with the estate of Amun.[499]

The depiction of clap-netting occurs on several focal walls in connection with the Natural Resource Icon (Figures 10 and 38).[500] The best-preserved example appears in the tomb of Nakht (TT 52) (Figure 10). In it, a man who is partially obscured behind a papyrus thicket gives the signal to his companions to pull close the clap-net. Against the backdrop of the thicket, the trapped birds flap their wings against the confining ropes. A blue band of water rims the net and lies underneath the papyrus swamp indicating the watery environment in which the birds were caught. The birds are identified as coots, winter visitors whose migration to Egypt occurred during the month of *Peret*.[501]

The image of clap-netting reinforces several themes seen above in the viticulture vignettes. The waterfowl trapped in the nets will serve as food for the deceased in the hereafter, but the image also expresses the idea of the maintenance of order over the chaotic forces that were embodied by birds.[502] In addition, the depiction of the gesturing man partially obscured by the papyrus thicket is an illusionary attention-gathering device that draws the viewer to the composition.[503]

The preparation of fish and fowl is depicted in the Natural Resource Icon. In the tomb of Nakht (TT 52) (Figure 10), ducks are being plucked, cleaned, and hung to tenderize the meat. Once processed, the fowl would be placed in the amphorae in the registers above which were probably filled with salt according to the ancient practice in Egypt.[504] In the tomb of Nehemaway (TT 165) (Figure 38), a sketch of men cleaning fish, with outlines of the splayed fish above, remains.[505] Both of these procedures reference the eternal provisioning of the tomb owner, but also represent payment and revenue in ancient Egypt, and may have related to wealth.[506] In the Egyptian world view, fish were connected to the "cyclical life-giving forces of the Nile."[507] Although fish held sacred associations, the depiction of fillet preparation recalls actions, cited in texts, of putting knives to the throats of fish as embodiments of the god of chaos, Seth.[508] Thus, fish represented chaotic forces that needed to be contained to protect the deceased within the creative environment of the tomb. Images of the preparation of fish and fowl together relate to the winter season (*Akhet* to *Peret*) at the end of the innundation when the watery marshes reemerged.[509]

[496] See discussion p. 100. For example, *hekenu* unguent was used both in the private mortuary rituals of the Opening of the Mouth as well as in temple rituals at Edfu, where its recipe was written down on the east wall of the "laboratory" of the Temple of Horus (Manniche, *Sacred Luxuries*, 37-38).

[497] Helck, *LÄ* V, 590-591, esp. n. 1; Ciccarello, *Studies Hughes*, 43, 46-47.

[498] *CT* VI, 172m = Raymond O. Faulkner, *The Ancient Egyptian Coffin Texts* II (Warminster, 1977), 173; *BOD*, Spell 170,6 .

[499] During the New Kingdom, unguent magazines and laboratories are attested in the reigns of Hatshepsut and Thutmose III in the Karnak precinct as well as in Theban royal mortuary temples; see: Pierre Lacau, "Deux magasins à encens du temple de Karnak," *ASAE* 52 (1952), 185-190; Mohamed Abdel-Hamid Shimy, *Parfums et parfumerie dans l'ancienne Egypte* (Villeneuve d'Ascq, 2000), 342-343.

[500] TT 52, PM (6). TT 165, PM (4) preserves only a sketch of a man pulling the outline of a net, see: Davies, *Five Theban Tombs*, 41.

[501] Houlihan, *Birds of Ancient Egypt*, 90.

[502] For more on the meaning of clap-netting imagery within the tomb, see: Kamrin, *Khnumhotep II*, 97-98, with bibliography.

[503] See discussion of attention-gathering figures (*Apellfiguren*) in 1.2.1, n. 97. For more on partially obscured figures in Egyptian art, see: Schäfer, *Principles of Egyptian Art*, 134-137.

[504] Salima Ikram, "Meat processing," in *Ancient Egyptian Materials and Technology*, edited by P.T. Nicholson and I. Shaw (Cambridge, 2000), 658-664.

[505] Davies, *Five Theban Tombs*, 41. Compare similar scenes in Brewer and Friedman, *Fish and Fishing*, fig. 1.6; Ikram, *Ancient Egyptian Materials and Technology*, 659.

[506] Houlihan, *Birds of Ancient Egypt*, 72; Brewer and Friedman, *Fish and Fishing*, 16. On payment of the workmen in terms of fish and fowl at Deir el-Medina, see: Valbelle, *The Egyptians*, 44-45.

[507] Brewer and Friedman, *Fish and Fishing*, 19.

[508] Gamer-Wallert, *LÄ* II (1977), 228-234; Hermann Kees, *Ancient Egypt: A Cultural Topography*, translated from the German by I.F.D. Morrow, edited by T.G.H. James (London, 1961), 92.

[509] Kamrin, *Khnumhotep II*, 121.

The administration of cattle occurs in the Natural Resource Icon in several tombs. In the tomb of Nebamun (TT 90), representations of cattle branding and recording depict holdings of the tomb owner's personal estate, possibly intended for the Temple of Amun-Re (Figure 30).[510] In the tomb of Haty (TT 151), images of cattle feeding and recording relate specifically to his office as "Scribe of Counting Cattle for the God's Wife of Amun" (Figure 36). The office of the God's Wife of Amun, in particular, created a special relationship between the royal family and the temple. Although the office was managed separately from Karnak temple holdings by a male steward, it was considered part of the temple's worship.[511] In Figure 36, Haty is depicted standing with a scribal palette in his hand before the temple stalls. Above, cattle are led to a platform or a stall that is rendered in profile. Below, are the actual stalls with feed chambers in which the cattle rest or graze, and where they are are force-fed to fatten them for offering or their meat.

Beef was a luxury item that denoted status and wealth in ancient Egypt.[512] Meat was eaten, and used for funerary and temple offerings, where it had to be deemed ritually pure before sacrifice.[513] The careful feeding of the cattle under the tomb owner's supervision manifested in healthy animals not only for eternal food and cultic offerings, but by extension could signify the well-being of all those under the official's charge.[514] Cows and bulls were associated with particular ancient Egyptian deities and their epithets. The cow was equated chiefly with Hathor in her various forms such as the goddess of the West and the divine protector of the king whom she suckled with her milk.[515] The bull was connected with fertility and imbued with the power of life. As Kamutef, "bull of his mother," the bull was equated with the gods Amun and Min in the eighteenth dynasty and was closely connected with divine kingship.[516] As "bull of his mother," Amun created himself, thus achieving a legitimacy without ancestry that was adopted in the Egyptian theocracy to express the continuity and regeneration of kingship. The God's Wife of Amun, who was also known as the "god's hand," was charged with stimulating the creator god sexually so that he would reenact creation. Through the office of the God's Wife, the royal house was joined with the worship of Amun, which manifested in the god's regeneration as well as the continuity of royal dynastic succession.[517] Taken thus, the depiction of temple bulls not only expressed the mundane aspects of Haty's job but also may allude to larger concepts of self-generation inherent in the Kamutef ideology and duties of the God's Wife of Amun (who Haty served) to reenact creation.

In the tomb of Nebamun (TT 90), several additional vignettes appear as components of the Natural Resource Icon that are not duplicated in the other tomb chapels in this study (Figure 30). On the top register to either side of the grape harvest are images associated with offering. Several offering-bearers bring items intended for burning such as cones of incense and fowl tied to ropes. Next, several men slaughter and cut the foreleg of an ox. After the grape trellises, a T-shaped pool is depicted surrounded by trees, before which several offerers bring fowl and the ḫpš-foreleg from the previous scene of slaughter to a small shrine framed by two trees (symbolizing an avenue of trees). The shrine is composed of a simple whitewashed facade crowned by a cavetto cornice with flagpoles and is inscribed on the door jambs for the king, Amenhotep III.[518] Before the shrine, Nebamun makes a fire offering and wine libation by raising a

[510] The caption to the scene says: "What the Standard Bearer [Nebamun], justified, said to the Scribe Djehuty-nefer: Do not neglect the cattle of [Amun] (our) lord!" (*Urk.* IV, 1624). These animals do not appear to be intended as a "cattle tax" for the temple of Amun (as suggested by Eichler, *Die Verwaltung des "Hauses des Amun,"* 73-74), based on the text of the adjacent wall that gives tax-exempt status to Nebamun's holdings (*Urk.* IV, 1618-1619); see complete text in 2.3, p. 42.

[511] Bryan, *Thutmose IV*, 272; Robins, *Women in Ancient Egypt*, 152; David O'Connor, "Beloved of Maat, the Horizon of Re: The Royal Palace in New Kingdom Egypt," in *Ancient Egyptian Kingship*, edited by D. O'Connor and D. Silverman, PÄ 9 (Leiden, 1995), 267; Eichler, *Die Verwaltung des "Hauses des Amun,"* 77, 92-93.

[512] Houlihan, *Animal World of the Pharaohs*, 15-16.

[513] Douglas J. Brewer, "Cattle," *OEAE* I (2001), 244; Salima Ikram, "Diet," *OEAE* I (2001), 390; Sauneron, *Priests*, 159-160.

[514] Kamrin, *Khnumhotep II*, 100; H.S. Smith, "Animal domestication and animal cult in dynastic Egypt," *The domestication and exploitation of plants and animals*, edited by P.J. Ucko, et al. (Chicago, 1969), 307-314.

[515] Houlihan, *Animal World of the Pharaohs*, 19; Lothar Störk, "Rind," *LÄ* V (1984), 260-263.

[516] Helmuth Jacobsohn, "Kamutef," *LÄ* III (1980), 308-309; Claude Traunecker, "Kamutef," translated from the French by S. Romanosky, *OEAE* II (2001), 221-222; Quirke, *Ancient Egyptian Religion*, 46.

[517] Robins, *Women in Ancient Egypt*, 152-153. See also: Michel Gitton and Jean Leclant, "Gottesgemahlin, A.," *LÄ* II (1977), 792-812.

[518] There has been confusion about whether this is the facade of a temple or private chapel. Davies originally asserted that the structure in the tomb of Nebamun (TT 90) was one of the great state temples (Davies, *Two officials*, 31) but later stated that the structure was a private estate temple based on a similar depiction in TT 324 (Norman de Garis Davies, "The town house in ancient Egypt," *MMS* 1 (1929), 248, fig. 9). Another parallel to this private shrine in TT 90 is found in TT 134 (Nina Davies, *JEA* 41 (1955), fig. 4, 80-82). See also the representation in the tomb of Sennefer (TT 96) of a private chapel in a garden beside a house. The private chapel is divided into three statue rooms, one containing a statue of Amun (now-destroyed), the second containing a statue group of Amenhotep II kneeling before another statue of Amun (the god's statue is destroyed), and the third room

lighted brazier topped by a fowl and pouring wine into a lotus blossom vessel.[519] The text mentions the action of Nebamun:[520]

> Offering all good and pure things, a thousand of long- and short-horned cattle, fowl, lotus flowers, reeds, lotus buds, all (kinds of) scented plants (of) sweet smell [to Amun-re], "May you preserve the ruler (*ḥḳ3* in a cartouche), l.p.h.," by the Standard Bearer [Nebamun] repeating life!

Nebamun's offering action for the king's renewal is underscored by the symbolism of the T-shaped pool, which was associated with the waters of Nun and the continual process of life-force creation.[521]

Below, naval troops[522] march in celebration along with the now-destroyed figure of Nebamun in his capacity as the standard-bearer. Nebamun is portrayed proportionally larger than the rest of the troops and holds a standard of the king's ship.[523] Nebamun is preceded by a group of five striding men who hold bunches of foliage, indicating a celebration is underway.[524] They are greeted at the doorway of Nebamun's house by his wife, Tiy, and another woman who was possibly a daughter, but the caption is too destroyed to lend more information.[525] The song of the troops mentions that Nebamun nurtures (*sḫpr*) young troops (*ḏ3mw*) for Amun's ruler.[526] Furthermore, the song is placed at eye-level for the spectator and is addressed to no one in particular in the scene.[527]

In the tomb of Nebamun, the Natural Resource Icon contains several unique depictions that stress his connection with the king. In TT 90, the Natural Resource Icon occurs in connection with the Royal Kiosk Icon. In the latter, Nebamun is depicted bringing plunder and enemy prisoners to Thutmose IV, as a faithful administrator who aids the king's role as the defeater of chaos and upholder of *Maat*. In the Natural Resource Icon, Nebamun's official duties emphasize the training young troops for the royal naval service as well as his piety and devotion to the king. By joining the offering action with the tomb owner's self-representation as a loyal servant of the pharaoh, Nebamun is shown supporting the ruler's two primary roles: Politically, he serves the king as the maintainer of *Maat*, and in religious terms,

containing a standing statue of the king (Wolfgang Helck, "Tempeldarstellungen," *LÄ* VI (1986), 377, n. 8). Davies, *MMS* I, fig. 8, 246-248, mistakenly assigned this chapel/house arrangement to the garden of Amun rather than to the estate of Sennefer. See illustration in: Regine Schulz and Matthias Seidel (eds.), *Egypt World of the Pharaohs* (Cologne, 1998), 386, fig. 96. For archaeological remains of chapels dedicated to the cults of living kings at Deir el-Medina and Amarna, see: Ann H. Bomann, *The Private Chapel in Ancient Egypt* (London and New York, 1991), 68, 73-74.

[519] Davies, *Two officials*, 31. On burning offerings: Schott, *Das schöne Fest*, 12-23. On the use of lotus blossom cups (*ssn*) in connection with wine offerings, see: The Epigraphic Survey, *Medinet Habu*, vol. 4, taf. 229.

[520] *Urk.* IV, 1625.

[521] Bomann, *The Private Chapel in Ancient Egypt*, 113-114; A. Wilkinson, *The Garden in Ancient Egypt*, 97, 101 (called an "offering pool"). T-shaped basins were often found in connection with private chapels, particularly in the workmen's village at Amarna, as a symbol of the waters of Nun – the continuous process of the life force – and immortality.

[522] Based on the presence of the back patch on the naval kilt worn by the last soldier which was meant to be part of a lattice-work leather loincloth that was never completed (see finished depiction in Brack, *Tjanuni*, taf. 40). For more on this type of kilt, see: William Stevenson Smith, *Ancient Egypt as Represented in the Museum of Fine Arts, Boston* (Boston, 1960), 125, fig. 76-77; Torgny Säve-Söderbergh, *The navy of the eighteenth Egyptian dynasty*, Uppsala Universitets årrskrift, 6 (Uppsala, 1946), 75-78, fig. 14; Vogelsang-Eastwood, *Pharaonic Egyptian Clothing*, 31. In TT 90, the larger figure of Nebamun (see n. 523) had the distinctive lattice-work leather loincloth painted over his cloth loincloth, as seen by the vertical stripe. However, Davies did not reconstruct the remainder of the lattice pattern, preferring instead to show the excess material that was pulled out in front of the two garments.

[523] Davies, *Two officials*, 32, identified the figure as a standard-bearer, but this is a figure of Nebamun. Compare a similar scene in TT 63 (Dziobek and Raziq, *Sobekhotep*, 46, taf. 34) which portrays the tomb owner as proportionally larger, preceded by two files of men holding stalks of lettuce.

[524] Lettuce stalks correspond to the hieroglyphic sign that acted as the determinative in the word *ḥts*, meaning "to celebrate (a feast)," (*Wb.* III, 202, 17; Gardiner, *EG*(3), 583). A similar motif appears in the Middle Kingdom tomb of Djehuty-hotep at Bersheh, which is accompanied by a text that states: "...its (=The Hare Nome's) troops who refresh its children are rejoicing, their hearts in feast, when they see their master..." (Percy E. Newberry, *El Bersheh* I, ASE Memoire 3 (London, 1894), 21-22). See also discussion above, p. 83.

[525] Reading: *iw [/////] p3 [////] snt.f [/////].f sy n p3 [//] nbt pr Ty iw mr sw* "....the...his wife....it for the......lady of the house, Tiy, whom he loves (?)."

[526] *Urk.* IV, 1621; see parallel text in Nina Davies and Gardiner, *Huy*, 12, pl. V. *sḫpr.f m ḏ3mw*: *Wb.* IV, 241, 25; and *Belegstellen* IV, 59.

[527] The song is placed ca. 4' ½" from the floor; however, it is clear that the floor has risen since antiquity.

he offers to the god in order to preserve the ruler,[528] who would provide for the tomb owner's livelihood and well-being in the eternal time of the afterlife.[529]

In sum, the Natural Resource Icon contains images concerned with the flora and fauna of Egypt, its use, and its administration. As diverse as these vignettes may seem, they are linked by a common goal: to commemorate the deceased's career, secure his rebirth, and provision him eternally. Visual hooks such as half-obscured figures behind the clapnet, rough-hewn laborers, and sequential vignettes in the vintage and agricultural cycles engage the viewers' attention and ask them to complete the narrative process. A number of these products (cattle, fish, fowl, vintage) also illustrate the wealth of the tomb owner, which would be projected into the next world and impress those in this world. These products also illustrate the fruits of the land, which would magically provision the deceased and his family in the hereafter.

On a ritual level, the vignettes reference the gods Seshmu, Osiris, Renenutet, Hathor, and Amun; the gods and goddesses who protected the dead from chaotic forces through the enforcement of *Maat* and offered them the promise of rebirth and regeneration. The images of the Natural Resource Icon also relate to the cycle of the seasons from *Akhet* (innundation) to *Peret* (growth) to *Shemu* (harvest). With the exception of the tomb of Nebamun (TT 90) discussed above, the officials who decorated their focal walls with the Natural Resource Icon had occupations that dealt with the natural world, such as tracking the movement of celestial bodies (Nakht, TT 52)[530] and the administration, preparation, or fashioning of organic and natural products (Haty, TT 151; Nakht, TT 161; Nehemaway, TT 165; and the owner of TT 175) (Table 1). These tomb owners celebrated their offices by illustrating their duties directly or indirectly through depictions that referenced aspects of the natural world. Ritually, the use of imagery relating to the cycle of the seasons may have acted as a metaphor for the tomb owner's rebirth. Symbolically, the seasonal cycle was generated by the solar cycle and was equated in ancient Egyptian thought with *nhh*–time, or cyclic eternity.[531] The deceased may have sought, through the use of imagery that related to the seasons, to express his desire to join with the eternal cycle of the sun in the hereafter, the source of eternal life and youth.[532] Thus, the components of the Natural Resource Icon may have been used to commemorate the deceased's status and identity to the living, secure his official position and eternal well-being in the next world, and guarantee, through references to the cycle of the seasons, his rebirth.

3.2.10 Worshiping Osiris Icon

The image of the deceased worshiping Osiris directly enters the visual repertoire in Theban tombs during the eighteenth dynasty, and its development has important ramifications for the rise of personal religion. In this study, the Worshiping Osiris Icon appears on two focal walls, and components associated with the worship of Osiris occur on two additional focal walls in this study. The complete icon is placed on the walls directly adjacent to the entrance to the chapel shrine or inner hall, and it is composed of the image of the deceased before a table of offerings, adoring Osiris and Isis or Hathor, who are housed within a kiosk. In the tomb of Nebamun and Ipuky (TT 181), Nebamun is accompanied by his brother-in-law and colleague, Ipuky,[533] both of whom adore Osiris and Isis (Figure 40). In the tomb of Neferrenpet (TT 249), the deceased alone worships the image of Osiris and Hathor who are seated in a kiosk (Figure 46). Thematically, individual components of the Worshiping Osiris Icon such as the Four Sons of Horus and an offering prayer to Osiris (and Amun-Re) appear in the tomb of Pairy (TT 139) around the doorway to the sloping passage leading

[528] The use of the word *hk3* written in a cartouche in the offering text may have been a deliberate choice to reference both Amenhotep III, whose name is inscribed on the shrine's jambs, as well as Thutmose IV, whose depiction adorns both focal walls in the tomb of Nebamun (TT 90). Nebamun's tomb dates to the transitional period of Thutmose IV/Amenhotep III (see Appendix I).

[529] Thutmose IV clearly provided for the tomb owner's well-being during his life as evidenced by the text on the left focal wall (Figure 29) (see Award of Distinction Icon 3.2.5, and translation of text (see 2.3, p. 42), which enumerated the holdings of Nebamun that were to be exempt from state taxation, such as "his household, his cattle, his arable lands, his servants, and all his property on water and on land" (*Urk.* IV, 1618-1619). These goods are depicted in the Natural Resource Icon in Nebamun's tomb (TT 90), effectively joining the text on the left focal wall, PM (4), with the representations on the right focal wall, PM (8).

[530] See discussion in: Hartwig, *Valley of the Kings,* 391, 394.

[531] See 1.1.1, p. 7, n. 18. See also Patrica A. Bochi, "Images of Time in Ancient Egyptian Art," *JARCE* 31 (1994), 61-62.

[532] The same desire to join with the solar cycle was expressed by the dead in the Coffin Texts and the *Book of Going Forth by Day,* see: Meeks, *Daily Life of the Egyptian Gods,* 149-150; Taylor, *Death and the Afterlife,* 196-198.

[533] See discussion on Ipuky's filiation in: Polz, *MDAIK* 46 (1990), 318-325.

to the burial chamber (B&W Plate 6).[534] The voyage to Abydos is another component which is depicted directly below the image of Osiris and Hathor seated in a kiosk in TT 249. In the tomb of Menkheper (TT 258), the offerers who are represented on the focal wall PM (2) (Figure 50) wrap around to the adjacent statue niche wall on PM (4) on which the deceased and mother worship a hymn to Osiris and offer to the god of the underworld.[535] Texts in the Worshiping Osiris Icon identify the gods, sometimes contain prayers to Osiris, and give the name and titles of the deceased as well as those who accompany him.[536] In all but one case, the Worshiping Osiris Icon appears in chapels whose tomb owners provision or serve the god's temples (Table 1).[537]

In the tomb of Nebamun and Ipuky (TT 181), Osiris is shown seated on a palace facade throne or a variant of the *srḫ*-block throne, which is associated with the god Horus and, by extension, his father Osiris.[538] In the tomb of Neferrenpet (TT 249), Osiris and Hathor are seated on the *ḥwt*-block throne with feather pattern, the former decorated with a *sm3-t3wy* motif, the symbol of the unified two lands. According to Kuhlmann, the *srḫ* and *ḥwt*-block thrones were interchangeable and were frequently used for sacred personages.[539] Seated on the throne, Osiris is dressed in his characteristic mummiform garment wearing the *Atef*-crown, divine beard, and holding the crook and flail.[540] Osiris' dress is painted white in TT 249, and red with small blue circles in TT 181. While the color white was often used to emulate linen wrappings of the mummified Osiris,[541] red may have been used for the god's garments to evoke his connection to rebirth and resurrection.[542] Behind the god stands Isis (TT 181) or Hathor (TT 249), both of whom are identified in the kiosk legend. Both goddesses have a close connection to Osiris: Isis as his sister/wife, and Hathor whose name, *Ḥwt-ḥr* meaning "house" or "womb" of Horus, marked her significance as the mother of Horus, the son of Osiris.[543] Furthermore, in Thebes, Hathor was worshiped as a funerary goddess called the "Mistress of the West."

Above Osiris is a kiosk composed of columns that hold up an architrave decorated with a block border, cavetto cornice, and a *uraeus* frieze.[544] Above the architrave in TT 181 is the sign for heaven (*pt*) signifying the cosmos.[545] In both TT 181 and TT 249, a grape frieze hung below the level of the column capitals, likely in direct relation to Osiris' epithet as the "Lord of Wine." The god's throne rests on a podium which, in TT 249, is decorated with the hieroglyphic signs for "all life, all stability, and all dominion" (*'nḫ-dd-w3s-nb*), the divine qualities of the gods.[546] Together, the ramp and the podium form the outline of the platform-sign, which was the phonogram for *Maat* or "truth, justice."[547] Seated thus, Osiris appears as the deity who rests on truth and justice, in reference to his role as the judge of the dead.

In the Worshiping Osiris Icon in the tomb of Nebamun and Ipuky (TT 181), a group of lotus stalks rise up before the god and once held the small mummiform figures of the Four Sons of Horus.[548] The Four Sons of Horus is a rare motif

[534] Scheil, *Mém. Miss.* V, 2 (1894), 581, simply mentions the presence of a subterranean path that comes through wall O (conforming to entire wall, PM (5) & PM (6)). This is rendered as a sloping passage by Kampp, *Nekropole* I, 426-427, fig. 317.

[535] The offerers, however, are separated from the offerers on the adjacent wall by a color band that frames PM (2) and PM (4).

[536] Texts: TT 181, PM (5): Davies, *Two sculptors*, 41; TT 249, PM (2): Manniche, *Three Theban Tombs*, 47-50; TT 139, PM (5): Scheil, *Mém. Miss*, V,2 (1894), 587-588. There are no texts on TT 258, PM (2); however, the offerers join the actions on PM (4) with the deceased and his mother worshiping before a hymn to Osiris; see: *Urk.* IV, 1643.

[537] Exception: Menkheper (TT 258) who was the scribe of the house of the king's children.

[538] Metzger, *Königsthron und Gottesthron*, 64. However, see Kuhlmann's objections to Metzger's assignment of this throne type, which Kuhlmann identifies as a variant of the *srḫ*-block throne: Kuhlmann, *BiOr* 44 (1987), 358.

[539] Kuhlmann, *Thron*, 85. On the *ḥwt*-block throne, see discussion above p. 55.

[540] In TT 181, Osiris is holding two crooks and two flails; in TT 249, the god holds a crook and two flails. On the dress and significance of the garments and insignia of Osiris, see: J. Gwyn Griffiths, "Osiris," *OEAE* II (2001), 615.

[541] See discussion of the symbolism of white in: John H. Taylor, "Patterns of colouring on ancient Egyptian coffins from the New Kingdom to the Twenty-sixth Dynasty: an overview," in *Colour and Painting in Ancient Egypt*, edited by W.V. Davies (London, 2001), 165.

[542] Strudwick, *The Tombs of Amenhotep, Khnummose, and Amenmose*, 75-76; see also: Pinch, *Colour and Painting*, 182-185.

[543] J. Gwyn Griffiths, "Isis," *OEAE* II (2001), 189; Vischak, *OEAE* II, 84.

[544] The *uraeus* frieze does not appear in Figure 46 as originally published in Manniche, *Three Theban Tombs*, 47, fig. 48, but appears in the tomb.

[545] Gardiner, *EG*(3), Sign-list N 1. Hornung, *LÄ* II (1980), 1215-1218; R. Wilkinson, *Symbol & Magic*, 139, figs. 86-87.

[546] Kuhlmann, *Thron*, 47; idem, *BiOr* 1986, 342, n. 67-68.

[547] Brunner, *Vetus Testamentum* 8 (1958), 426-428; Kuhlmann, *Thron*, 93-95; and see discussion above, pp. 58-59.

[548] Davies, *Two sculptors*, 41.

in eighteenth dynasty private tomb decoration, and it occurred in connection with the depictions of Osiris.[549] The Four Sons of Horus protected the viscera, eliminated hunger and thirst, and protected the god of the underworld.[550] Perched on a lotus, the flower associated with creation, the Four Sons of Horus offer the promise that through them the dead, just like Osiris, would be protected and reborn.[551]

As a component of the Worshiping Osiris Icon, three of the Four Sons of Horus are represented on the lintel doorway in the tomb of Pairy (TT 139) (B&W Plate 6). Duamutef, Imsety, and Hapy are shown in human form, and the figure of Anubis-*Imiut* (*imi-wt*) is painted with a jackal head.[552] Each god is rendered in polychrome seated in a shrine that is fronted by a vertical text band, all against a white background. The texts that accompany the figures in TT 139 appear to have been derived from bands of inscriptions carrying portions of Chapter 151 of the *Book of Going Forth by Day* that ran along white-ground eighteenth dynasty coffins.[553] As protectors of the dead, the Sons of Horus along with the figure of Anubis-*Imiut* frequently decorated the spaces between text bands on the sides of early eighteenth dynasty white-type anthropoid coffins.[554] Their appearance over the doorway to the sloping passage or "underworld" in the tomb of Pairy suggests that the Sons of Horus may have been placed here to act as guardians and caretakers of the burial much in the same way as they guarded the body of the deceased housed within the coffin.[555]

Another component of the Worshiping Osiris Icon is the voyage to Abydos, which is depicted in the lower register in the tomb of Neferrenpet (TT 249) (Figure 46). The deceased and wife are seated in a cultic bark under a baldachin that is tugged by a rowboat to Abydos. The goal of the procession is a white temple facade composed of a cavetto cornice with a winged sun disc on the lintel beneath. The door is captioned: "Osiris in the district of the precinct of Osiris at Abydos (*W-Pkr*)."[556] The deceased[557] stands before the sanctuary of Osiris and raises his arms in adoration. The voyage to Abydos with the deceased worshiping at the great shrine of Osiris is thematically linked with the Worshiping Osiris Icon. Through this depiction, the deceased eternally associates himself with the god's rites at Abydos and the realm of Osiris.[558]

The offerers on the far right of the focal wall in the tomb of Menkheper (TT 258) are part of the procession headed by the tomb owner and his mother on the shrine wall, PM (4), who adore a hymn to Osiris and bring gifts to the god of the underworld.[559] Although the shrine wall in TT 258 is outside of the scope of this study, it contains a prayer

[549] See for example: TT 93 (Davies, *Ken-Amun*, pl. XLIII); TT 254 (Strudwick, *The Tombs of Amenhotep, Khnummose, and Amenmose*, 76, pl. XXIX); TT 49 (Davies, *Nefer-hotep* I, pl. XXX); and the judgement scene in TT 78 (Brack, *Haremhab*, 53-54, taf. 56). See also discussion in: Nigel Strudwick, "Change and Continuity at Thebes: The Private Tomb after Akhenaton," in *The Unbroken Reed: Studies in the Culture and Heritage of Ancient Egypt in Honour of A.F. Shore*, edited by C. Eyre, A. Leahy, and L. Leahy, Occasional Publications 11 (London, 1994), 326.

[550] Bonnet, *Reallexikon*, 315-316; Matthieu Heerma van Voss, "Horuskinder," *LÄ* III (1980), 52-53; Aidan Dodson, "Four Sons of Horus," *OEAE* I (2001), 561-563.

[551] On the significance of this motif, see: Schlögl, *Sonnengott auf der Blüte*, 26-28.

[552] On the rendering of the Sons of Horus with human heads, see: Dodson, *OEAE* I (2001), 562. On Anubis-*imi-wt*, see: Brigitte Altenmüller, "Anubis," *LÄ* I (1975), 328.

[553] For example, compare TT 139 texts (Scheil, *Mém. Miss*, V,2 (1894), 588) with Faulkner, *Book of the Dead*, pl. 33. For white-ground eighteenth dynasty coffins with similar legends and depictions, see: Mirosław Barwik, "Typology and Dating of the "White"-type Anthropoid Coffins of the Early XVIIIth Dynasty," *Études et Travaux* 18 (1999), group D, 16-19, 29 with fig. 6. On Chapter 151, see: Barbara Lüscher, *Untersuchungen zu Totenbuch Spruch 151*, Studien zum altägyptischen Totenbuch 2 (Wiesbaden, 1998).

[554] See examples in: Barwik, *Études et Travaux* 18 (1999), 12, 17, 29; Hayes, *Scepter* II, 70-71; Robins, *Art of Ancient Egypt*, 146; Dodson, *OEAE* I (2001), 562. As for their significance to the dead, the Four Sons of Horus became part of the "seven blessed ones" who guarded the coffin of Osiris in the northern sky (Shaw and Nicholson, *Dictionary of Ancient Egypt*, 275). Anubis-*Imiut* was ruler of the necropolis and was associated with caring for the dead as well as embalming (Altenmüller, *LÄ* I (1975), 328).

[555] Discussion of the meaning of the sloping passage in: Assmann, *MDAIK* 40 (1984), 277-290; Karl J. Seyfried, "Zweiter Vorbericht über die Arbeiten des Ägyptologischen Instituts der Universität Heidelberg in thebanischen Gräbern der Ramessidenzeit," *MDAIK* 40 (1984), 269-273; idem, *ASAE* 71 (1987), 229-249. Other examples of sloping passages in private painted Theban tombs dating to the reigns of Thutmose IV and Amenhotep III are: TT 63, TT 69, TT 78, TT 90, TT 201, TT 239, TT 226 (incomplete), TT 253 (Kampp, *Nekropole* I, 93-94). On the role and symbolic purposes of the coffin, see: Taylor, *Colour and Painting*, 164-165.

[556] *W-Pkr*: Faulkner, *CDME*, 95.

[557] Although this figure is not labeled, it can be identified as the tomb owner (Manniche, *Three Theban Tombs*, 50).

[558] Hartwig Altenmüller, "Abydosfahrt," *LÄ* I (1975), 42-47; Barbara S. Lesko, "Cults: Private Cults," *OEAE* I (2001), 336; Ann Macy Roth, "Funerary Ritual," *OEAE* I (2001), 578-579; and Hodel-Hoenes, *Life and Death in Ancient Egypt*, 125, who notes that it was the wish of every Egyptian to be buried in Abydos and participate in the rituals at the main cult center of Osiris.

[559] *PM* I,1(2), 342.

or hymn to Osiris to the left of the statue niche that explains the intent of the deceased's offering action:[560]

> I want to give you praise and elevate you
> I want to sing you a song of propitiation in all your names
> Osiris, Khentamenty
> and you gods of the underworld
> Listen to me, for I am calling to you
> turn your heart to my pleading
> There is no god who forgets his creation
> For may your breath of life
> enter my body,
> may your north wind be sweet in my nostrils
> I have come upon the beautiful path of righteousness
> to preserve all my limbs
> May my *ba* live, my *akh* be divine
> may my name be excellent in the mouth of people.

According to Assmann, this appeal to the 'heart' of the god recalls prayers of personal piety in which the tomb owner makes a personal statement to a deity.[561] Thus, the offering on PM (2) can be seen as part of an action where the tomb owner makes a direct, personal statement and offering to the god Osiris on the adjacent shrine wall.[562]

Included here is a special offering action that shows the deceased and wife[563] offering before a food pile and a shrine in the tomb of Menna (TT 69) (Figure 18). The action of the deceased is not preserved, but his wife carries a *menit* and a sistrum, followed by attendants with lotus bouquets, incense, and cloth. The shrine is unnamed, and has a whitewashed facade with a cavetto cornice. In outline, the structure in TT 69 is identical to the hieroglyphic ideogram or determinative for *sḥ-nṯr* or "shrine,"[564] and is identified as a private shrine or chapel. The action of the deceased and wife illustrates the ritual practice of incensing and food offering that occurred in private ancestral and religious chapels that linked the celebrant to Osiris and the realm of the gods.[565]

Thus, in the tombs of Nebamun and Ipuky (TT 181) and Neferrenpet (TT 249), the tomb owners stand before Osiris and Isis/Hathor "giving adoration to Osiris" and offering prayers to the god.[566] The rendering of the deceased worshiping the god directly without a royal intermediary is an example of direct divine access, which is one of the hallmarks of personal piety.[567] The king does not appear, nor is he evoked textually through the use of the *ḥtp-dí-nsw*

[560] TT 258, PM (4): Jan Assmann, *Egyptian Solar Religion in the New Kingdom: Re, Amun and the Crisis of Polytheism*, translated from the German by A. Alcock (London and New York, 1995), 112-113; Assmann, MSS., 111, consulted in the Theban tomb archive at the Ägyptologisches Institut Universität Heidelberg. Special thanks to Friederike Kampp-Seyfried for making this archive available to me during my visit in the summer of 1999. See also *Urk*. IV, 1643. For images of the shrine wall in TT 258, see Schott photos 3474, 7351.

[561] Assmann, *Egyptian Solar Religion*, 112, n. 65.

[562] The presence of the god is indicated by the hymn to Osiris. The image of Osiris cam be reconstructed on the lower right register before the offering pile on PM (4), TT 258.

[563] The identity of these figures as the tomb owner Menna and his wife Henettawy is made based on the similarity of their dress with the main figures on the same wall. None of the figures on the wall are captioned.

[564] Gardiner, *EG*(3), Sign-List O 21; Faulkner, *CDME*, 237. See also: Spencer, *Egyptian Temple*, 114-119.

[565] Bomann, *The Private Chapel in Ancient Egypt*, 57-79, notes well-excavated examples of private chapels at Deir el Medina and Amarna that had plant remains and preserved evidence of burning on portable offering tables in the halls and sanctuaries. Ashraf Iskander Sadek, *Popular Religion in Egypt during the New Kingdom*, HÄB 27 (Hildesheim,1987), 79-82, mentions chapels at Deir el-Medina outside of which people slept in order to effect cures or gain communication with the gods. See also: B. Lesko, *OEAE* I (2001), 338-339.

[566] TT 181: Davies, *Two sculptors*, 41. No text accompanying the adoration gesture in TT 249, PM (2). See also the offering prayer to Osiris and Amun on right door jamb of TT 139, PM (5), B&W Figure 6.

[567] Jørgen Podemann Sørensen, "Divine Access: The So-called Democratization of Egyptian Funerary Literature as a Socio-cultural Process," in *The Religion of the Ancient Egyptians: Cognitive Structures and Popular Expressions*, edited by G. Englund (Uppsala, 1989 (sic); 1991), 120-121; B. Lesko, *OEAE* I (2001), 337.

formula. Instead, the tomb owner is shown adoring the chief funerary god face-to-face, accompanied by offerings and hymns in a depiction that is regularly associated with Ramesside tomb chapels and monuments.[568]

During the eighteenth dynasty, the image of Osiris gradually occupies visually and symbolically significant walls in the tomb chapel. According to Joachim Spiegel in the early eighteenth dynasty, the deceased is shown worshiping Osiris on the architrave over the entry to the inner hall of the chapel.[569] The motif then moves to the side walls of the front transverse hall in T-shaped tombs and takes the place of the stela or false door. The motif later moves to the area over the statue niche, or the west end of the south wall in the inner hall, and finally appears on both side walls of the inner hall or in the chapel to either side of the statue niche, as for example in TT 258, PM (4). The image of worshiping Osiris then finds its way to the back walls of the front transverse hall, where, in earlier tombs, images of the tomb owner offering to the king or the deceased seated at an offering table had resided.[570]

While the quantity of Osirian representations in eighteenth dynasty Theban tombs is relatively limited when compared to Ramesside examples,[571] when the god's image does appear in pre-Amarna Theban chapels, it is found on structurally and symbolically significant places such as the false door, the shrine walls, and the back walls of the transverse hall. These walls were the focus of the tomb owner's cult, and served as contact points between the living and the dead as well as between this world and the next.[572] Perhaps the representation of Osiris on these walls symbolized the realm in which the deceased eternally resided and would pass through to partake of offerings and contact the living in the tomb chapel. The image of Osiris on these focal walls is also concerned with the tomb owner's self-presentation and links the deceased with Osiris and his eternal life in the hereafter.

In the Worshiping Osiris Icon, the deceased is depicted adoring the god who would be integral for his passage into and life in the next world. In TT 181, Nebamun offers a prayer to Osiris, followed by Ipuky, who adds: "The beauty of your daily dawning brings contentment." These texts and the image of Osiris (who is seated against a yellow solar background in his kiosk) creates a causal link between the themes of solar and Osirian regeneration; processes that the tomb owners hoped to join in the hereafter.[573] In terms of the deceased's self-presentation, the Worshiping Osiris Icon in TT 181 and the text on the right jamb of TT 139 preserved the tomb owner's names and titles to commemorate them to the living. However, both chapels that contained the complete icon belonged to tomb owners whose positions associated them with mortuary installations in the estate of Amun: Neferrenpet (TT 249) delivered sweets to the mortuary temple of *Nebmaatre* (Amenhotep III) and the temple of Amun-Re;[574] and Nebamun and Ipuky (TT 181) were both "Chief of Sculptors in the *Dsrt-Ist*" or the temple of Hatshepsut and Thutmose III at Medinet Habu.[575] The latter, known as the Small Temple, was associated with the worship of a special form of Amun and the Ogdoad who were buried there within the "mound of Djeme."[576] Rites held within the temple underscored its central mythological role in the necropolis'

[568] Ramesside examples of the tomb owner worshiping Osiris in a kiosk, see: Morris L. Bierbrier, "The Tomb of Sennedjem," in *Valley of the Kings: The Tombs and Funerary Temples of Thebes West*, edited by K.R. Weeks (Vercelli, Italy, 2001), 344-345; Erika Feucht, *Das Grab des Nefersecheru (TT 296)*, Theben II (Mainz, 1985), taf. XXII-XXIII, XXIV-XXV, XXVIII. For post-Amarna Theban tombs, see: Strudwick *The Tombs of Amenhotep, Khnummose, and Amenmose*, pl. XXIX (TT 254).

[569] See discussion on the placement and evolution of Osiris worshiping scenes in: Spiegel, *MDAIK* 14 (1956), 201-203.

[570] Depictions of Osiris on the back wall of the transverse hall: TT 49, PM (11); TT 181, PM (5); TT 249, PM (2); TT 254, PM (3). At the same time, the image of worshiping Osiris also penetrates the inner walls of the statue niche where it replaces images concerned with the provisioning of the dead.

[571] For example, see Strudwick, *The Unbroken Reed: Studies A.F. Shore*, 326.

[572] See discussion in 1.2.1, pp. 16-17.

[573] For a similar series of causally linked texts and vignettes on New Kingdom non-royal stelae and the *Book of Going Forth by Day*, see the discussion by Jørgen Podemann Sørensen, "Ancient Egyptian Religious Thought and the XVIth Hermetic Tractate," in *The Religion of the Ancient Egyptians: Cognitive Structures and Popular Expressions*, edited by G. Englund, Boreas 20 (Uppsala, 1989 (sic); 1991), 48-53; and idem, *The Religion of the Ancient Egyptians*, 119-121.

[574] On the titles of Neferrenpet, see: Manniche, *Three Theban Tombs*, 46; Friederike Kampp, review of *The Wall Decoration of Three Theban Tombs (TT 77, 175, and 249)* by Lise Manniche, CNI Publications 4 (Copenhagen, 1988), *OLZ* 86 (1991), 29; Eichler, *Die Verwaltung des "Hauses des Amun,"* 294, no. 355, who takes a more limited view of Neferrenpet's position by suggesting that he belonged to the service personnel and not directly in the circle of people employed in the administration of the *pr-Imn*. However, Neferrenpet served both the funerary temples and the temple of Amun-Re (*iri bnrwt n hwt n Imn-R'*) and is treated here within the estate of Amun.

[575] Titles in Davies, *Two sculptors*, 5-6. On the *Dsrt-Ist*, see: Helck, *Materialien*, 74-76; Stadelmann, *LÄ* VI, 472; Polz, *MDAIK* 46 (1990), 320, n. 82.

[576] William J. Murnane, *United with Eternity: A Concise Guide to the Monuments of Medinet Habu* (Chicago and Cairo, 1980), 76-77; idem, "Medinet Habu," *OEAE* II (2001), 358.

cycle of death and rebirth.[577] In the Worshiping Osiris Icon, the prominent depiction of the god of the underworld on the focal walls of the tomb may have been a subtle reference, within the limits of decorum, to the tomb owners' professional connection to the funerary installations on the west bank as well as their piety and desire to join with the god and the cosmic cycle in the hereafter.

3.2.11 Funerary Rites Icon

The Funerary Rites Icon illustrates the ceremonies performed at the funeral of the deceased and includes processional journeys with the mummy, farewell ceremonies at the tomb, and a selection of key actions associated with the "Opening of the Mouth," which was the ritual performed on the mummy at the burial to animate it so that the deceased could eat, breath, see, hear, and partake in cultic provisions.[578] The Funerary Rites Icon occurs on four focal walls in connection with the Offering Table Icon (Figures 18 and 27), the Worshiping Osiris Icon (Figure 40), or the Fishing & Fowling Icon (Figure 38). In the tombs of Amenmose (TT 89) and Nebamun and Ipuky (TT 181) the names and titles of the tomb owners appear above the representations of their mummies. The tomb owners who utilized the Funerary Rites Icon belonged to the religious administration: Two were sculptors, one was a field scribe, and one was part of the regional establishment of Thebes who was involved in the administration of the estate of Amun, the chief cult in Thebes (Table 1).[579]

The most complete series of images belonging to the Funerary Rites Icon occur in the tombs of Amenmose (TT 89) (Figure 27) and Nebamun and Ipuky (TT 181) (Figure 40). In the tomb of Amenmose, two registers of actions from the Opening of the Mouth ritual are portrayed. Across the top register, four representations of Amenmose as a mummy are depicted in which the mummy stands upright before a table of offerings.[580] Before him, a priest is shown libating the mummy and holding the *netjerty* (*n t̠rty*) adze to the deceased's mouth. Descended from root *n t̠r* "god," the name of the *netjerty* adze relates to its purpose to make the ritually buried deceased a *n t̠r* and the object of cult.[581] These scenes from the Opening of the Mouth ritual, such as libating the mummy (Scenes 2-7) and the use of the *netjerty* to open the mouth (Scene 26/27), were the most frequently depicted scenes in New Kingdom tombs and could be used to signify the entire ritual.[582]

In the second register, three actions are preserved with inscriptions. First, the priest embraces the mummy accompanied by the inscription: "words spoken by the *ḥry-ḥbt* (lector priest): [*Sem*] ushering in the son whom he loves into....".[583] This action conforms to Scene 31 in which the "son whom he loves" is introduced, and has its origin in the offering ritual.[584] The next action relates to Scene 33 in which the priest presses his finger (now destroyed) to the statue's mouth, saying: "(I) open for you your mouth and your eyes with my own finger."[585] The third action is destroyed, but the

[577] As stated by Murnane, *United with Eternity*, 77: "Given this building's status as the mythological tomb of the Ogdoad and its plain connection with the cycle of death and resurrection, one is tempted to view this installation as a dynamo for the ancient cemetery, integrating Amon into the mortuary religion of his nome and thus creating one more prototype for the transformations undergone by the blessed dead."

[578] On the Opening of the Mouth ritual, see: Otto, *Mundöffnungsritual* I-II; Reinhard Grieshammer, "Mundöffnung(sritual)," *LÄ* IV (1982), 223-224; Roth, *OEAE* II, 605-609.

[579] Nehemaway (TT 165) as "sculptor of Amun"; Nebamun and Ipuky (TT 181) were both chief sculptors in the *Dsrt-Ist* or the temple of Hatshepsut and TIII at Medinet Habu; and Menna (TT 69) who was the Overseer of the Fields of Amun but also carried civil field titles (Eichler, *Die Verwaltung des "Hauses des Amun,"* 56, 60-61, 72, 228). On the titles of Amenmose (TT 89), see n. 291 above.

[580] Although they are not captioned, these mummies clearly represent Amenmose based on their identification in the captions below.

[581] Lorton, *Born in Heaven, Made on Earth*, 149; Dimitri Meeks, "Notion de 'dieu' et structure du panthéon dans l'Égypte ancienne," *Revue de l'Histoire des Religions* 204 (1988), 425-446. See also discussions on the nature of the instrument in: Otto, *Mundöffnungsritual* II, 83.

[582] Otto, *Mundöffnungsritual* II, 28.

[583] Ibid. I, 78, Scene 31, IIa, varr. 47; WB-Zettel "Thebanische Gräber 1724," consulted at the Theban tomb archive, Ägyptologisches Institut, Universität Heidelberg.

[584] Otto, *Mundöffnungsritual* II, 90-91.

[585] Ibid. I, 86, Scene 33a, text 47; II, 93-95; WB-Zettel "Thebanische Gräber 1721."

last vignette on the register is from Scene 37 and is conducted with a *psš-kf* knife[586] by the priest who says: "(I) open for you your mouth with the *psš-kf*, the mouth of every god and every goddess having been opened with it."[587] The mummies to whom these actions are directed are identified as "the Osiris, Steward in the Southern City, Amenmose, *m3'-ḫrw*."[588]

In the tomb of Nebamun and Ipuky (TT 181), Scenes 1a and 2b of the Opening of the Mouth ritual are represented on the middle register,[589] below the Worshiping Osiris Icon (Figure 40). These scenes depict in text and image the mummy's placement outside of the tomb, facing south, and its purification by evoking the Four Gods of the cardinal directions.[590] Two anthropoid coffins are shown, one for Nebamun and the other for Ipuky.[591] Following the libator is the ritual officiant who is labeled "his son, Amenhotep" holding the *netjerty* adze and the lector priest who reads from a scroll that contains the caption "The scribe and the *w3b*-priest, Pa[si]nisw (?),[592] Opening the Mouth...". As with TT 89, the depictions of libation and Scene 26 are utilized to evoke the entire ritual procedure.

In the tomb of Menna (TT 69) on the lowermost register, Scenes 69A and 69C from the Opening of the Mouth Ritual are illustrated with no textual accompaniment.[593] The ritual cycle begins with a kneeling man holding his hands out over an offering chest while another man standing over him pours water from a spouted jar (Scene 69C).[594] From the transfiguration spell (Scene 69A), four kneeling, overlapping lector-priests are followed by another lector priest who stands in a gesture of address. These actions are aided by offering-bearers who bring unguent jars, bags of linen, and other items for the completion of the rituals that will result in the well-being of the deceased and wife in the hereafter.[595]

A single vignette in the tomb of Nehemaway (TT 165) reveals the image of the deceased being purified; it also shows two cloth strips being brought to the deceased (Figure 38). Both scenes belong to the Opening of the Mouth Ritual. The bringing of cloth strips, in particular, relates to the clothing of the statue, which has its origin in the Pyramid Texts and later passed into temple statue rituals.[596]

In the Funerary Rites Icon, images concerned with the burial of the deceased also appear in TT 181 (Figure 40). The two top registers depict the bringing of offerings before two false-door tomb facades that each rest on a pile of pink sand relating to the necropolis. On the top register, the procession moves towards the goddess of the West, who receives offerings borne by priests on behalf of Nebamun and welcomes him into the hereafter. At the far left end of the register is a young girl holding a bivalve censer, and below her are mourners who use the same shell to scoop up the dust to throw on their bodies.[597]

On the third register (along with several ceremonies belonging to the Opening of the Mouth), mourners are shown, as well as four light reed shelters intended for the funerary celebration. The lowest register shows boats carrying

[586] On the meaning and origin of the *psš-kf* knife, see: Otto, *Mundöffnungsritual* II, 16-17, 97, who believes it derived from the embalming ritual; Rene van Walsem, "The *psš-kf*: An Investigation of an Ancient Egyptian Funerary Instrument," *OMROL* 59 (1978-1979), 205-206, 220-223, who believed it was used to support the lower jaw of the corpse during mummification; Ann Macy Roth, "The *psš-kf* and the 'Opening of the Mouth' Ceremony: A Ritual of Birth and Rebirth," *JEA* 78 (1992), 113-147, who asserts it was used to cut the infant's umbilical cord; and Lorton, *Born in Heaven, Made on Earth*, 170-171, who sees the *psš-kf* as an implement that allows the mouth to open and close based on the utterance associated with Scene 37 and word punning.

[587] Otto, *Mundöffnungsritual* I, Scene 37a, 90, varr. 47; II, 97-99; WB-Zettel "Thebanische Gräber 1724."

[588] From complete caption above the last mummy on the second register.

[589] Otto, *Mundöffnungsritual* I, 1-2, varr. 51; II, 29, 34-37, 42-44; 179, no. 51. The tomb of Nebamun and Ipuky contains a shortened version of the Opening of the Mouth Ritual, Type 2.

[590] Texts in: Davies, *Two sculptors*, 46-47.

[591] Davies, *Two sculptors*, 27, 38, 45-46, who assigns the first coffin (closest to the tomb) to Nebamun and the second to Ipuky. Rather than Henutnofret being the wife of both Nebamun and Ipuky, she is only the sister of the latter and the wife of the former. On the geneology in TT 181, see: Polz, *MDAIK* 46 (1990), 318-325.

[592] Perhaps the same *P3-s3-nsw* who is called *P3-rn-nfr* who appears on PM (6) in TT 181: *Urk.* IV, 1855; Davies, *Two sculptors*, pls. XI-XII, XIV.

[593] Otto, *Mundöffnungsritual* II, 153-154, Abb. 1. Otto describes this scene as the 'Ausrufen der Opfer,' an action that begins in the funerary cult of the Old Kingdom and appears in temple cult during the New Kingdom.

[594] See parallel in Eberhard Dziobek, *Das Grab des Ineni Theben Nr. 81*, AV 68 (Mainz, 1992), 73-74, taf. 22b, 23b.

[595] Martin, *LÄ* V (1984), 1129-1130, 1132, n. 25; Otto, *Mundöffnungsritual* II, Scenes 65A-72B, 146-164.

[596] Scene 50: Otto, *Mundöffnungsritual* II, 112-114.

[597] Davies, *Two sculptors*, 42.

the funerary delegation and gifts to the West Bank of Thebes. At the arrival of the boats stand the "Magistrates of [the West]," "the Overseers of the Western Districts of Thebes," and the mourners who raise their arms in grief before two structures set up in front of the tomb.[598]

The processions are to be understood as a continuation of the movement, begun on the adjacent wall, PM (4), that lead to the four tomb facades depicted on each register of PM (5).[599] On PM (5), the two tomb facades on the upper register are schematically rendered as false doors, the two tombs on the lower registers are more conventional tomb representations, each composed of a white facade, a wooden door with stela, and a stelophorous statue or stela inset at the top of the structure along with four rows of funerary cones.[600] The difference between the two types of tomb renderings is addressed by their conceptual meanings within the composition. The false door tombs relate to the hereafter (signified by the presence of the Goddess of the West) and symbolize the door through which the deceased would pass between this world and the next to receive the offerings left for his cult. The conventionally rendered tomb facades related to the world of the living as well as the activities conducted at the tomb on the day of burial. Furthermore, the realm of the gods is represented on the upper two registers (along with the Worshiping Osiris Icon) and the earthly realm concerned with provisioning the deceased is shown on the two registers below. The division between sacred and profane coupled with the horizontal wrapping around of scenes from one wall to the next prefigures the distribution and content of scenes found in Theban tombs during the Ramesside Period.[601] In addition, the depiction of two different types of tombs, each depicted twice, references the two owners of the tomb, Nebamun and Ipuky and their cultic needs in this world and the hereafter.

The Funerary Rites Icon, composed of the burial procession and key vignettes from the Opening of the Mouth ritual, affirms the deceased's rebirth and provisioning in the hereafter. Through the use of libation, the adze, and the *pss̆-kf* knife on the mummy, the entire Opening of the Mouth Ritual is evoked, commemorated, and reinforced magically for the eternal benefit of the deceased. The depiction of the ceremonies conducted at the funeral of the tomb owner secured his eternal provisioning but also underscored his status by the size of the procession, the burial equipment and offerings, the funerary performance, and the notable individuals who participated in the burial ceremony.[602] The Funerary Rites Icon was thematically linked with the Offering Table Icon, the Worshiping Osiris Icon, or the Fishing & Fowling Icon. Through the creative power of text and image, the rites performed guaranteed the deceased's eternal provisioning, rebirth, and incorporation into the divine realm as a blessed ancestor. Furthermore, the rites of mourning and the Opening of the Mouth ceremony led to the mummy's acceptance into the realm of Osiris, identification with the god, and rebirth.[603]

In summary, the Banquet, Fishing & Fowling, and Natural Resource icons are connected thematically and symbolically to either the Offering Table Icon or the Worshiping Osiris Icon. To either side of the entrance to the chapel's inner hall or the shrine, the deceased and wife (or mother) are shown in their potential, transcended state as the blessed dead, joined with the gods, receiving life-bearing gifts imbued with the divine essence or worshiping a deity directly – offering actions that would provision, protect, rejuvenate, and allow the dead to live eternally. Gifts that mediated divine power such as *ankh*-bouquets, *wah*-collars, *menit*-necklaces, sistrums, and cups filled with divinely blessed beverages as well as the tomb owner's direct worship of Osiris symbolized and secured magically the deceased's rejuvenation among the gods in the hereafter. Connecting icons augmented the mechanisms of the deceased's provisioning, protection, and rebirth through metaphors and symbols that referred to the gods. The tomb owner and wife are shown joined with the living and the dead, celebrating family ties at the meal that brought together the earthly and divine spheres, and incorporated the deities Amun, Hathor, and Osiris. The dead are shown ritually engaged with the activities of Hathor and the goddess of the hunt, and identified with Osiris through the rites of mourning and the funerary ceremonies. Chaotic forces are conquered through visual metaphors to Seshmu, Renenutet, Hathor, and Osiris. The necessary elements for sexual union and conception that would guarantee the deceased's eternal rebirth were included.

[598] Ibid., 49-50; *Urk.* IV, 1855 (lower).

[599] Davies, *Two sculptors*, 42-44, 48-49, 50-51, pls. XXII, XXIV = PM (4).

[600] For a compilation of two-dimensional representations of Theban tombs, see: Kampp, *Nekropole* I, 98, figs. 72-76.

[601] For more on the arrangement and composition of Ramesside tomb decoration, see: Assmann, *Problems and Priorities in Egyptian Archaeology*, 34-36; Jan Assmann, *Das Grab des Amenemope TT 41*, Text, Theben III (Mainz, 1991), 184-186; Kampp-Seyfried, *Egypt: The World of the Pharaohs*, 254.

[602] *Urk.* IV, 1855 (lower); and Davies, *Two sculptors*, 49-50, pl. 19.

[603] Griffiths, *OEAE* II, 618.

Potent visual devices such as sequential vignettes, attention-getting figures, and accomplished renderings may have been inserted to impact and impress viewers. Likewise, depictions of luxurious clothing, status industries, and ceremonial display presented the deceased to viewers as an important individual. Furthermore, the tomb owner's identity was commemorated through his name and titles as well as depictions of his professional duties in connection with the god's temples or referenced indirectly through activities or events relating to the divine realm and the cosmic cycle. The deceased's identity would be projected into the permanent time of the afterlife, where the tomb owner would continue to serve the gods in the hereafter. Thus, the iconography of the Offering Table and Worshiping Osiris icons and their adjacent images commemorated the tomb owner's service and contact with the gods, who would also secure his eternal well-being in the hereafter.

CHAPTER 4

CONCLUSION

4.1 Painting and Identity

The previous chapters have explored the private eighteenth dynasty Theban tomb and its chapel imagery as the vehicle for the preservation and dissemination of identity. Within the tomb, the deceased existed on an individual level, a family level, a societal or professional level, and a cosmological level. In ancient Egypt, the individual was composed of physical and non-physical elements called *kheperu* (*ḫprw*) or "manifestations" that needed to be maintained after death. These modes of human existence included the body (living: *ḥt* or *ḥ'w*; corpse: *ḥ3wt*; physical appearance), the heart (*ib* or *ḥ3ty*, the intellectual, emotional and moral aspects of the person), the *ka* (vital force or "double"), the *ba* (movement and effectiveness after death), the shadow (*šwt*, associated with the body and individuality of the owner after death), and the name (*rn*, identity). The *akh* (*3ḫ*) was the complete person as a transfigured being in the netherworld. The deceased was also part of a family or kinship group that determined his or her ancestry, mortuary obligations, and (often) career.[1] The tomb owner also functioned as a member of a particular professional community. For example, in the New Kingdom titulary, a man was identified not only by his name and title but also by his institutional affiliation, which was prominently displayed in his tomb.[2] The cosmological level was achieved by an individual only at death when, as a transfigured being, the deceased lived in a sphere of light in a divine community centered around the sun god and Osiris and joined with their immortal rejuvenations.[3]

The decoration in the tomb was engineered to serve these various levels of identity by commemorating the dead and aiding their transformation and eternal prosperity in the afterlife. The decoration also bore the imprint of the time in which it was created, translating the cultural trends into religious terms within the eternal time of the tomb. These levels of meaning were manifested in the *Blickpunktsbilder* or focal point representations that occurred on the western back walls to either side of the entrance into the inner hall (or shrine) of the T-shaped tomb. In rectangular tomb chapels, one of the long walls (either southern or northern) held imagery of similar content and meaning (Figure 4). These walls and their imagery and texts were aesthetically, symbolically, and creatively significant for the tomb owner and his eternal life. Composed of standardized scenes called icons, images and texts were arranged thematically into a program that reflected and preserved the deceased's identity and contained key components for his rebirth, which, in turn, mirrored societal influences.

In the previous chapters, the icons and texts in 30 painted Theban tombs were investigated, all of which dated to the reigns of Thutmose IV and Amenhotep III and met the stated research criteria outlined in Appendix I (Table 1). Focal walls in these 30 tombs contain three iconic configurations composed of the central icons positioned directly adjacent to the door to the chapel's inner hall or shrine, followed by the icons that are thematically associated with them. These are the Royal Kiosk Icon and its adjacent icons ('Tribute' Icon, Registration Icon, Gift Icon, Award of Distinction Icon); the Offering Table Icon and the icons usually connected to it (Banquet Icon, Fishing & Fowling Icon, Natural

[1] Erika Feucht, "Family," *OEAE* I (2001), 501-504; Detlef Franke, "Kinship," *OEAE* II (2001), 247. See also: Lanny Bell, "Family Priorities and Social Status: Preliminary Remarks on the Ancient Egyptian Kinship System," *Sesto Congresso Internazionale di Egittologia: Abstracts of Papers* (Turin, 1991), 96-97; idem, "The Meaning of the Term Ka in The Instructions of Ptahhotep" (paper presented at the annual meeting of the American Research Center in Egypt, St. Louis, MO, April 12-14, 1996), 30-31; idem, *Temples*, 131-132, 284 with n. 22, 286 with n. 39, who interprets the *ka* as a creative or generative ancestral power that was not individual-specific but generic to a family group and continually replicated as an inherited life force.

[2] Eyre, *Labor*, 211.

[3] Jan Assmann, "Death and Initiation in the Funerary Religion of Ancient Egypt," *Religion and Philosophy in Ancient Egypt* (New Haven, 1989), 148.

Resources Icon); and the Worshiping Osiris Icon and the icons characteristically associated with it (Funerary Rites Icon) (Table 2).[4] Since each icon was examined separately in Chapter 3, the overall meanings of the iconic configurations will be summarized here to understand their commemorative aspects, creative mechanisms, and cultural significance on behalf of the deceased and the society of which he was a part.

Commemoratively, text and image addressed pertinent levels of the deceased's identity and served as a link between the living and the dead. This exchange depended on the visitor's reception of text and image, based on their degree of literacy, level of cultural understanding, and apprehension of visual symbolism, which was a significant mode of ancient Egyptian thought. Individually, the deceased was identified by his name. Images of family members and genealogical designations situated the deceased within a kinship system. The tomb owner's title, institutional affiliation, and biography marked him as a member of a professional community. Depictions of the tomb owner's accomplishments, accouterments of 'official status' such as dress and insignia as well as indirect references to occupational activities, anchored the deceased in a professional context for the viewer.

The tomb chapel and its painting style in these 30 tombs also associated the owner with a particular institutional group. The tomb, acquired through state license, presented the deceased's professional and societal identity through the style of decoration, through the chapel's placement within the necropolis among tombs of similarly titled officials, and through its participation in the "monumental discourse"[5] of Egypt. During the reigns of Thutmose IV and Amenhotep III, stylistic evidence suggests, the artists who painted non-royal Theban tomb chapels came from institutional workshops most closely associated with the tomb owners' administrative branch.[6] Officials of the "state class" (military, palace, civil, and regional administrations) secured or were assigned painters attached to palace workshops such as the Palace of Amenhotep III at Malqata and other state ateliers. Officials attached to the religious administration (priests, temple provisioners, grain or field scribes of Amun and temple artisans) preferred or received painters from Karnak temple workshops. In this way, the similarity and cohesiveness of the tomb painting style linked officials in the religious administration on one hand, while on the other, the state class were joined by the consistency and resemblance of their tomb painting style. In this study, these painting styles were named the Temple Style and the Court Style to reflect the correspondence between the suggested origin of the painters and the tomb owner's professional affiliation. While intentionality on the part of the patron is difficult to prove given the absence of specific contracts and work orders, the painting style within the tomb chapel did link members of a professional group and commemorate their institutional bond.

The professional identity of the owners of these 30 tombs is commemorated by the iconography of the *Blickpunktsbilder* or focal representations, which differed among the two groups of officials. Members of the state class and those promoted by the king defined their identity through their service to the pharaoh. In the Royal Kiosk Icon, the deceased is shown as a high-status individual who had a personal relationship to the ruler. Adjacent icons ('Tribute,' Registration, Gift, Award of Distinction) stress the tomb owner's contribution to the territorial, economic, and ideological roles of the king.

Officials of the religious administration and temple artisans commemorated their service to the realm of the gods. The Offering Table Icon represents the tomb owner and wife in their potential transcended state who are joined with the immortal rejuvenations of the sun god and Osiris, partaking of the post-vindication meal that signified their integration into the realm of the blessed dead. In the Worshiping Osiris Icon and its adjacent Funerary Rites Icon, the tomb owner(s) are shown adoring the god who signifies the nature of the mortuary installations the tomb owner(s) served. Icons adjacent to the Offering Table Icon, such as the Natural Resource Icon, depict temple employees discharging duties for the god's temples, or they reference their office indirectly through depictions of activities concerned with the divine cosmic cycle.[7] Likewise, the Banqueting and Fishing & Fowling icons celebrate the sacred realm through the depiction of festivals and actions that joined the earthly and divine spheres. While the tomb owners who utilized the Royal Kiosk

[4] Exceptions to these groupings exist and are examined in depth in Chapter 3. Results will be summarized in the footnotes and paragraphs to follow.

[5] See Chapter 2, pp. 42-43.

[6] According to this hypothesis, painters attached to the Karnak temple, Malqata complex, or other state ateliers may have been detached from their permanent ateliers to decorate their colleague's tombs, returning to their institution's workshops once the work was complete. See discussion in Chapter 1, pp. 31-35.

[7] For example, Nakht (TT 52), who was the "Hour Observer of Amun," was charged with the monitoring of celestial bodies.

and adjacent icons could easily illustrate their service to the king on the focal walls of their chapels, tomb owners who displayed the Offering Table, Worshiping Osiris, and adjacent icons were perhaps restricted by issues of decorum,[8] and used encoded imagery to commemorate their service to the gods via their potential, transcended state, association with the deities in the hereafter and depictions of the celestial cycle.

Several exceptions exist. In the tomb of the Second Prophet of Amun, Amenhotep-si-se (TT 75) referenced the ritual domain of the Amun Temple precinct at Karnak by depicting context-specific objects and ceremonies on his focal walls (Figures 19-20). Texts accompanying Amenhotep-si-se's initiation into the priesthood on the right focal wall relay the tomb owner's acquisition of critical faculties needed to maintain the gods and by extension, the cosmos. On each of his focal walls, Amenhotep-si-se depicted the Royal Kiosk Icon; however, text and image are subtly altered to convey the tomb owner's relationship to the god Amun, Amenhotep-si-se's connection to Thutmose IV, and the piety of that king towards the god. Another Second Prophet of Amun, Anen (TT 120) depicted himself – now destroyed – before Amenhotep III and his great royal wife, Tiy, an image that relayed Anen's connection with the royal house as the brother-in-law to the king. In both tombs, the presence of the Royal Kiosk Icon on the focal walls celebrated the king's role in these individuals' promotion to Second Prophet of Amun.[9]

The Steward in the Southern City, Amenmose (TT 89), depicted the Offering Table Icon (now destroyed) with the adjacent Funerary Rites Icon on his chapel's left focal wall (Figure 27); and Menkheper (TT 258) is shown in the Offering Table Icon (Figure 50). Amenmose, as mayor of the "Southern City," was involved in the administration of the estate of Amun, the chief cult in Thebes,[10] which may explain his use of the Offering Table and Funerary Rites icons with its themes of solar and Osirian regeneration that evoked not only the conceptual landscape of Thebes, but the complete cosmic cycle of the hereafter. On the other hand, Menkheper, as the "scribe of the house of the king's children," adopted the icons associated with the religious administration which may be due to his tomb type which, before the Amarna Period, never depicted the king seated in a kiosk on its walls.[11]

In other tombs of religious administrators, the deceased is not identified by his relationship to the king; instead, on the focal walls of the chapel, the tomb owner uses imagery that relates to his legitimization and maintenance by the gods. When the king fails to appear on the focal walls of eighteenth dynasty Theban tombs, it has been ascribed to the lower status of the tomb owner.[12] Status, however, does not play a significant role in the king's absence on the focal walls of religious officials and artisans: Tomb owners who utilized the Offering Table Icon, Worshiping Osiris Icon, and associated icons belonged to prominent members of temple orders such as the High Priest of Onuris (TT 108), the High Priest of Ptah at Thebes (TT 139), and the Steward of the God's Wife of Amun (TT 151).[13]

A critical component concerning the commemoration of the tomb owner laid in the manipulation of the imagery to impress upon visitors the importance of the deceased. The immortality of the transfigured dead, or *akhu*, was dependent on the living for offerings and ritual actions in liminal areas such as the tomb chapel. Thus, unique motifs, context-specific objects, and accomplished renderings were placed on the wall, often at eye-level, presumably to engage viewers and impress upon them the status of the deceased. Visual narrative and sequential images, which are particularly potent communicative devices, were also utilized.[14]

[8] On decorum, see: Baines, *Fecundity Figures*, 277-305; idem, *The Dictionary of Art*, vol. 9, 796-798.

[9] On the king's role in the promotion of Amenhotep-si-se (TT 75) and Anen (TT 120) to Second Prophet of Amun, see: *Urk.* IV, 1208-1209; Sauneron, *Priests of Ancient Egypt*, 45-47. On the promotion of Anen as a result of family connections, see: Kees, *Priestertum*, 16; Helck, *LÄ* I (1975), 270; Murnane, *Amenhotep III: Perspectives*, 210.

[10] See Chapter 3, n. 291.

[11] Kampp, *Nekropole* I, 13, fig. 1, Typ Ib; II, 536; see Figure 3. Radwan, *Königs*, 110-112.

[12] As, for example, Engelmann-von Carnap, *Thebanische Beamtennekropolen*, 123-127; and Fitzenreiter, *SAK* 22 (1995), 119-121. For discussion of the specific problems associated with the measuring of status in Theban tombs, see: Hartwig, "Institutional Patronage and Social Commemoration," 93-95.

[13] On the titles of Nebseny (TT 108): Bryan, *Thutmose IV*, 275-276; Pairy (TT 139): Eichler, *Die Verwaltung des "Hauses des Amun,"* 63; Haty (TT 151): Bryan, *Thutmose IV*, 275-276, who tends to discount the status of the tomb owner based on her assessment of the quality of the chapel decoration. However, the chapel painting is stylistically similar to paintings in the chapel of Pairy (TT 139) (compare Plate 6,1 (TT 139) with Plate 6,3 (TT 151), and see discussion above, Chapter 1, p. 31).

[14] By definition, visual narrative and sequential images require the viewer to complete the cycle and retrieve the message of the scene.

Creatively, the decoration of the focal walls projected the deceased's personality into the next world and acted as a vehicle for his or her rebirth. In essence, the creative power of the image created a permeable link between this world and the next. Within the tomb, painted scenes were mechanisms for bridging time, thrusting images from normal time to eternal time, and assuring their efficacy forever.[15] The key component in this exchange laid in the symbolism inherent in the image that created a bridge between what was represented and what was signified, between the mundane and the sacred, between the here and the hereafter. Through the intersection of magic and symbolism, painted images of people, places, and things acted as creative mediums to protect, provision, and regenerate the deceased in the next life.

In chapel decoration, the deceased's identity was projected into the next world through his name, titles, and biography. Likewise, his family relationships were secured through kinship terms and depictions of relatives. Depictions of male members of the tomb owner's family also related to the deceased's rank and professional community in the afterworld, especially given the tendency for sons to follow their father into the same occupation. The continuity of the family profession is expressed in wishes attached to the Appeal to the Living: "May your office descend to your children, the son remains in the place of the father in the praise of the local gods."[16]

Through the creative power of text and image, the central icons (i.e. those directly adjacent to the door to the inner hall or shrine of the chapel) displayed the mechanism that secured the deceased's rebirth, and this was anchored in the iconography of gift giving. Once again, the two administrative groups displayed different agents of provisioning and regeneration. The state class and those promoted by the king were provisioned eternally through the pharaoh. In the Royal Kiosk Icon, the tomb owner offers gifts of life to the pharaoh, such as *ankh*-bouquets imbued with divine essence, pectorals relating to life and protection, and 'official gifts' given as tokens by foreign peoples to secure the ruler's "breath of life." The deceased's offering was based on a reciprocal action in which the life inherent in the gift was given in a *do-ut-des* ("I give in order that you give")[17] arrangement to the pharaoh to provide for the deceased in the eternal time of the afterlife. The gift functioned conceptually according to the symbolic role of the king as the source of all goods in ancient Egypt, and by the nature of the reversion of offerings, in which offerings given by the king to the gods in the temple reverted back out into the necropolis to provide for the eternal well-being and life of the dead. In essence, gift giving in the Royal Kiosk Icon is a visual rendering of the *ḥtp-dỉ-nsw* offering formula, reflecting the reciprocal arrangements that underlie it as well as the theoretical role of the king as the chief officiant to the gods and provider of goods for the dead. The Royal Kiosk Icon also functioned in the eternal time of the hereafter, and represented the king in his potential or deceased, deified state, assimilated with the gods. In this way, the deceased's gifts of life are offered to the king as a god with the same eventual goal: to enjoy the sustenance the king provides and his favor in the next world.

Icons adjacent to the Royal Kiosk Icon augment the deceased's service to the king and the nature of royal ideology. Through depictions that showed his successful discharging of duties, the deceased is shown maintaining *Maat* and aiding the central roles of the king who, as the theoretical source of all goods in Egyptian thought and practice, would assure the deceased's eternal maintenance in the ruler's reassembled kingdom in the hereafter.

On the other hand, members of the religious administration (priests, temple provisioners, field/grain scribes of Amun and temple artisans) were provisioned by the gods directly. In the Offering Table Icon, the tomb owner and wife receive life-bouquets imbued with the deity's essence; life-bearing objects such as *wah*-collars, sistrums, and *menits*; and cups filled with divinely blessed beverages, allowed the dead to be integrated into the realm of the gods and live eternally. As objects that mediated divine power, these gifts are conveyed directly between the living and the dead along with wishes for the god's action, without evoking or depicting the king or a priest intermediary. These life-bearing objects are passed from the earthly sphere into the divine, as well as from the living family to their blessed ancestors for their benefit in the next life. This offering action on the tomb's focal walls symbolized the dead's direct maintenance by the

[15] See discussion of Egyptian art as a mechanism for bridging normal time and eternal time in: W. Raymond Johnson, "The Setting: History, Religion, and Art," in *Pharaohs of the Sun: Akhenaten, Nefertiti, Tutankhamen*, edited by R.E. Freed, Y.J. Markowitz, and S.H. D'Auria (Boston-New York-London, 1999), 39-40; Bolshakov, *OEAE* II (2001), 218.

[16] *Urk.* IV, 1197, 17; *Urk.* IV, 151, 17; 121, 8; 509, 10; 965, 17; 1032, 9; 1223, 16.

[17] For the fundamental study on the *do-ut-des* offering, see: Marcel Mauss, *The gift: forms and functions of exchange in archaic societies*, translated from the French by I. Cunnison (New York, 1967).

gods in the eternal time of the afterlife. Later in the reign of Amenhotep III, this encoded imagery was externalized in the Worshiping Osiris Icon, and tomb owners adore directly the god with whom they hoped to be identified.[18] The depiction of the deceased honoring the personal funerary gods and being provisioned for the next world would reach its fullest expression in private Theban tombs during the Ramesside period.[19]

Sometimes, in the Offering Table Icon, a mortuary priest is depicted activating an offering list composed of abbreviated rituals and provisions that would provide regular mortuary offerings for the deceased and wife in the next world. In ancient Egypt, the role of *sem*-priest was often performed by the son closest to the father, who, by emulating the mythic actions of Horus to Osiris, strengthened the symbolic connection between his father and Osiris' resurrection. In the Offering Table Icon, family members such as the son, sometimes daughters and colleagues, present life-bearing objects to the transfigured deceased and wife. Through the presentation of divine gifts of life, the family's eternal devotion towards their transfigured ancestors is relayed.[20] Yet, the presence of a number of anonymous offerers proffering life-bearing objects to the deceased indicates that, by and large, the magical thrust of the offering lied in the nature of the gift, which was infused with the god's blessing for the eternal life of the dead.[21]

Connecting icons reinforce the mechanism of the tomb owners' provisioning, protection, and rebirth in the realm of the gods and their integration with the cosmic processes through metaphor and symbolism. Images of banqueting celebrate the dead and incorporate them in actions evoking the deities Amun, Hathor, and Osiris. Chaotic forces are quelled through visual metaphors to the gods Seshmu, Renenutet, Hathor, and Osiris. The deceased is shown ritually engaged with the activities of Hathor and Sekhet, the mistress of the hunt. As a mummy, the dead identified with Osiris through rites of mourning and the Opening of the Mouth ceremony. Images and word play in these connecting icons also evoked themes relating to sexuality and conception, which would lead to the deceased's rebirth in the creative environment of the tomb and in the eternal time of the hereafter.

While officials of the state class and religious administration during the reigns of Thutmose IV and Amenhotep III illustrate different mechanisms to secure their well-being in the hereafter, the ultimate source of sustenance for both groups was potentially the same and laid in the realm of the gods among whom they hoped to exist as the blessed dead. The state class are provisioned by the king, who was both a cultic intermediary for mankind and, in his potential, deceased form, a god. Whereas, members of the religious administration are provisioned directly by the gods through gifts of life that mediated the divine essence.

4.2 Painting and Society

Yet, these distinct iconographical processes of provisioning in the 30 tombs that comprise this study reflect important underlying societal trends that were present during the reigns of Thutmose IV and Amenhotep III. One noted scholar of contemporary visual theory asserts that "painting is bathed in the same circulation of signs which permeates the rest of the social structure."[22] In order for one to interpret its meaning, a painting must be retraced back to its original context of production, which includes the complex interaction of a number of aspects that make up culture, all of which

[18] For example, the tomb Nebamun and Ipuky (TT 181) (Figure 40) and the tomb of Neferrenpet (TT 249) (Figure 46), both have the Worshiping Osiris Icon on their focal walls and date to the reign of Amenhotep III. For discussion of the dating of these tombs, see Appendix I.

[19] Jan Assmann, "Eine Traumoffenbarung der Göttin Hathor: Zeugnisse 'Persönlicher Frömmigkeit' in thebanischen Privatgräbern der Ramessidenzeit," *RdÉ* 30 (1978), 22-23; Nigel and Helen Strudwick, *Thebes in Egypt* (London, 1999), 164-166.

[20] On the status of the dead in Egyptian society, see: Taylor, *Death and the Afterlife*, 41-44; Lloyd, *Religion and Philosophy in Ancient Egypt*, 127-131.

[21] In the Offering Table Icon, some family members are identified; however, many offerers are anonymous; see Chapter 3, n. 360, 371, 375, 378. The presence of anonymous participants in eighteenth dynasty Theban tombs was also noted by Fitzenreiter, *SAK* 22 (1995), 121, whose ideas about the family as the sole source of provisioning for the deceased are not followed here. Instead, the creative emphasis within the Offering Table Icon is placed on the deceased's potential justified state and provisioning by the gods using offerings that conveyed a particular god's blessing.

[22] Bryson, *Visual Theory: Painting and Interpretation*, 66.

are integrated into the painting.[23] While this approach can be quite broad in its application, when it is applied to ancient Egyptian art, one must take into account the context in which the painting occurs. Within the tomb, painting occurs in a space governed by the permanent time of the afterlife, a ritual sphere that served very specific commemorative and magico-religious purposes for the tomb owner. Still, the tomb was also a part of society, and its painting reflected cultural trends, *albeit* in encoded ways, given the dictates of decorum and the demands of ritual space.

Icons that illustrated the tomb owner's direct maintenance by the gods appear to mirror the growing trend of personal piety in the mid-eighteenth dynasty.[24] At this time, processional festivals allowed people to see the veiled images of their local gods and enter into direct, personal communication with them.[25] During particular religious festivals, the processions of the god's image from one temple to the next were public holidays as well as important social and religious events for the people of Thebes. People would come out to witness the sacred bark of Amun, write prayer ostraca, and leave them in the path of the god as he went out in procession through the necropolis. Prayers on these ostraca attest to the petitioners' love and devotion to the god in phrases such as "Amun-Re, you are the beloved one, you are the only one!"[26] and also ask the god to help them in their travails.[27]

A rereading by Jan Assmann of the famous hieratic inscription in the tomb of Pairy (TT 139) gives contemporary evidence concerning the importance of these divine processional festivals to the common people (B&W Plate 6).[28] The writer of the graffito, Pawah, complains that he is living in "darkness" and longs to see the face of the god "when your neck receives garlands" during the Valley Festival. He pleads for the god to "turn your face towards us," noting "you were here before 'they' arose, you will be here when 'they' are gone." In this phase, the word 'they' refers to Ankhkheperure Neferneferuaten, in whose year 3 the graffito was written.[29] The tenor of the passage relates to the longing of Pawah to see the god in procession and the darkness that resulted from the banishment of the god's Theban procession festivals during the Amarna period and its aftermath.[30]

Other pre-Amarna developments along the road to personal piety include eulogies to Amun-Re;[31] the shrine of the "Hearing Ear" at Karnak dating to the reigns of Hatshepsut and Thutmose III where common people went to have their prayers heard by the god;[32] statue cults of private individuals who acted as intermediaries between the petitioner

[23] See Chapter 2, pp. 48-49.

[24] Personal piety is defined as direct personal contact made between a man and a deity, without aid of a king or priest intermediary. For a few discussions that include pre-Amarna personal piety in Thebes, see: Assmann, *Hymnen und Gebete*, 349-417; idem, *Religion and Philosophy*, 68-73; idem, *Search for God*, 197-198; Georges Posener, "La piété personnelle avant l'âge amarnien," *RdÉ* 27 (1975), 195-210; Hellmut Brunner, "Persönliche Frömmigkeit," *LÄ* IV (1982), 951-952; Sadek, *Popular Religion in Egypt*, 5-11, 45-46, 48-51; John Baines, "Society, Morality, and Religious Practice," in *Religion in Ancient Egypt: Gods, Myths, and Personal Practice*, edited by B. Shafer (London, 1991), 172-186; Boyo Ockinga, "Piety," *OEAE* III (2001), 44-47.

[25] Assmann, *The Mind of Egypt*, 231-232; Ockinga, *OEAE* III (2001), 44.

[26] O. Cairo 12202, in: Posener, *RdÉ* 27 (1975), 195-202, pl. 19.

[27] One such ostraca is O. Cairo 12217, which says: "I gave you into my heart because of your strength...You are my protector. Behold, my fear has vanished"; see: Posener, *RdÉ* 27 (1975), 206-209, pl. 21; quote from Assmann, *Torat ha-Adam*, 23.

[28] Assmann, *Torat ha-Adam*, 13-29. See also: José M. Galán, "Seeing Darkness," *CdÉ* 147 (1999), 18-30. The inscription was originally published by Alan H. Gardiner, "The graffito from the tomb of Pere," *JEA* 14 (1928), 10-11.

[29] See recent redating of the graffito in: Allen, *GM* 141 (1994), 9, n. 22.

[30] It is particularly interesting that the owner of TT 139, Pairy, held the title *"wab*-priest in front of Amun," which indicated he acted as the lead porter of the god's bark when it was carried out of the temple during Theban festivals (Hermann Kees, "Wêbpriester der 18. Dynastie im Trägerdienst bei Prozessionen," *ZÄS* 85 (1960), 45). As the lead porter of the procession, Pairy would have been responsible for the god's oracular decrees, which were indicated by moving the bark forward (yes) or backwards (no). Perhaps Pawah's graffito was intentionally left in Pairy's tomb to reference the tomb owner's connection with the god. On oracles, see: Jean-Marie Kruchten, "Oracles," *OEAE* II (2001), 609-612.

[31] Assmann, *Egyptian Solar Religion*, 102-132.

[32] Charles F. Nims, "The Eastern Temple at Karnak," *Aufsätze zum 70. Geburtstag von Herbert Ricke*, BABA 12 (Wiesbaden, 1971), 107-111; idem, "Places About Thebes," *JNES* 14 (1955), 110-123; idem, "Popular Religion in ancient Egyptian Temples," *Proceedings of the Twenty-Third International Congress of Orientalists, Cambridge 21st-28th August, 1954*, edited by D. Sinor (London, 1956), 79-80; Emily Teeter, "Popular Worship in Ancient Egypt," *KMT* 4 (1993), 31. Many thanks to Emily Teeter for the Nims references. The Shrine of the Hearing Ear was found at the exterior rear wall of the Temple of Amun at Karnak and was dedicated by Hatshepsut and Thutmose III. The shrine is currently being examined by the Epigraphic Mission of the University of Liège, under the direction of Jean Winand and Dimitri Laboury.

and Amun;[33] and New Kingdom stele on which the owner is shown adoring the god directly.[34] All of these examples indicate the growing trend of personal religion in the eighteenth dynasty that, along with divine festival processions, led to the breakdown of barriers that separated the individual from the gods and encouraged direct access.

On the other hand, icons that showed the tomb owner's eternal provisioning by the king reflect the growing influence of the ruler's divine solar role and his importance as an intermediary for the population. In terms of the king's solarization, the ruler appears in a few Royal Kiosk icons wearing the gold-disk *shebyu*-collar, which indicates his status in a potential, deceased, deified state in the eternal time of the tomb.[35] However on non-funerary monuments, Thutmose IV and Amenhotep III are depicted wearing the *shebyu*-collar which, according to W. Raymond Johnson, denotes the rulers' uplifted status as a god.[36] In fact, one of the first kings to wear the *shebyu*-collar in such a context is Thutmose IV, who is shown on the Giza Stela worshiping the Great Sphinx. On this stela, the king stresses his divinity by identifying himself with Horemakhet, calling himself the son of Atum, the heir of Khepri, and the image made by Re.[37] Thutmose IV is also adorned with the *shebyu*-collar on an ivory wristlet[38] and on a royal wooden chariot.[39] Additional objects, such as a statue of the king as a falcon,[40] and the earliest standard-bearing statue of the New Kingdom type (a form which emphasizes the king's intermediary function between the people and the gods) stresses the king's divinity and solarization.[41] In the tomb of Tjenuna (TT 76), who calls himself the "true foster child of the king," Thutmose IV is shown censing a golden statue of himself, a motif which references the ruler's potential deification. Furthermore, in the last years of his reign, the king is shown wearing the *shebyu*-collar along with changed facial features such as oblique almond eyes, elongated face, and full lips that suggests an ideological transformation.[42] By identifying himself with the sun god and creating statues that emphasized the king's divinity and intermediary role, Thutmose IV set the course that was ultimately finished by his son, Amenhotep III.[43]

Amenhotep III appropriates the gold-disk *shebyu*-collar and wears it continually in depictions that date after his first Sed Festival celebration.[44] These depictions are accompanied by solarized dress and a change in style that

[33] Sadek, *Popular Religion in Egypt*, 45-46; Dietrich Wildung, *Egyptian Saints: Deification in Pharaonic Egypt* (New York, 1977), 87-88; Emily Teeter, "Amunhotep Son of Hapu at Medinet Habu," *JEA* 81 (1995), 232-236; J.M. Galán, "Amenhotep Son of Hapu as Intermediary between the People and God," in *Egyptology at the Dawn of the Twenty-First Century: Proceedings of the Eighth International Congress of Egyptologists, Cairo 2000*, vol. 2, edited by Z. Hawass and L.P. Brock (Cairo, 2002), 221-229.

[34] Sørensen, *Religion of the Ancient Egyptians*, 121. Examples include: BM 289 (Hall, *Hieroglyphic Texts* VII, 8, pl. 20), BM 307 (Ibid., 9, pl. 23), BM 148 (Ibid., 13, pl. 43-44), BM 348 (Ibid., pl. 45).

[35] Preserved examples in this study where the king wears the *shebyu* collar: TT 64, PM (5); TT 91, PM (5) (Thutmose IV); TT 116, PM (2) (Thutmose IV); TT 226, PM (4) (Amenhotep III). Amenhotep II is the first king to wear the *shebyu*-collar enthroned in a kiosk; for examples, see: Peter Brand, "The Iconography of the *Shebyu*-Collar in the New Kingdom," *JARCE* 40 (2003), in press. I am indebted to Peter Brand for showing me a portion of his manuscript before its publication.

[36] W. Raymond Johnson, "Images of Amenhotep III in Thebes: Styles and Intentions," *The Art of Amenhotep III: Art Historical Analysis*, edited by L. Berman (Cleveland, 1990), 36-38; idem, *Atti del VI Congresso Internazionale di Egittologia*, 231-232; idem, *Amenhotep III: Perspectives*, 86; idem, *Gold of Praise*, 232.

[37] Bryan, *Thutmose IV*, 144-150, fig. 10.

[38] Ludwig Borchardt, "Ausgrabungen in Tell el-Amarna," *MDOG* 55 (1914), 30-34, pl. 5; Bryan *Thutmose IV*, 162-163.

[39] Howard Carter and Percy Newberry, with Gaston Maspero, and G.E. Smith, *The Tomb of Thoutmôsis IV*, Bibân el Molûk Series (Westminster, 1904), 24-33, pls.10-11; Bryan, *Thutmose IV*, 193-194.

[40] CG 42081: Legrain, *Statues et Statuettes de rois et de particuliers* I, 47-48; CG 747: Ludwig Borchardt, *Statuen und Statuetten von Königen und Privatleuten*, vol. 3, Catalogue général des antiquités égyptiennes du musée du Caire nos. 1-1294 (Berlin, 1930), 72; Bryan, *Thutmose IV*, 179-180, figs. 27-28; and see Plate 16,3 above for relief image of a royal statue of Thutmose IV as a falcon on the upper register of the Peristyle Court, Karnak. On divine falcon images, see: Donald Redford, "The Sun Disc in Akhenaten's Program: Its Worship and Antecedants,1," *JARCE* 13 (1976), 51, 53.

[41] JE 43611: Bryan, *JARCE* 24 (1987), 13-20; idem, *Thutmose IV*, 175-176, figs. 25-26. The statue of Thutmose IV holding a standard of Amun is identified as "[Amun] who hears prayers" after a depiction in the tomb of Amenhotep-si-se (TT 75). Both the statue's name and form indicate its intermediary function.

[42] Byran, *Thutmose IV*, 175, 351-352.

[43] Bryan, *The Oxford History of Ancient Egypt*, 258-259; John Baines, "The Dawn of the Amarna Age," in *Amenhotep III: Perspectives on His Reign*, edited by D. O'Connor and E. Cline (Ann Arbor, 1998), 294; Johnson, *Pharaohs of the Sun*, 42; idem, *Gold of Praise*, 232.

[44] Johnson, *Art of Amenhotep III*, 37; idem, *Amenhotep III:Perspectives*, 87. Based on comparison of 1st and 3rd Sed Festival depictions in the tomb of Kheruef (TT 192).

accentuates the ruler's youth.[45] In Nubia, Amenhotep III is shown worshiping figures of himself as a god in his cult temple at Soleb.[46] The king is equated with the sun disk in epithets from Malqata jar seals that form a new rebus spelling of the king's prenomen: "Nebmaatre-is-the-Dazzling-Aten."[47] This name was also given to Amenhotep III's palace at Malqata, to the royal barge, and to a battalion in the army.[48] Amenhotep III is identified and worshiped as the Creator god Ptah at the temple called "Nebmaatre-is-United-with-Ptah" at Memphis.[49] The king also assembles a number of statues in divine and animal form which he set up in his mortuary temple at Kom el-Hetan[50] and throughout the country.[51] Furthermore, statuettes of the living king were dedicated in his mortuary temple to commemorate his exalted state.[52] The goal of this building and statuary program was to celebrate Amenhotep III's deification while alive in Egypt and Nubia, and the ruler's assimilation with all the gods of Egypt with an emphasis on the sun god, Re.[53]

This action of raising kingship to the level of the gods served several purposes: It not only affirmed the king's divinity and solar role,[54] but it also incorporated the elite in the process. As discussed by Donald Redford, Amenhotep III's *sed*-festival celebrations were observed in both royal and private inscriptions and brought the gods (including the king) and the elite together on the same spiritual playing field "to reaffirm the kingship of Horus, the inheritance of Geb; [and] on a more mundane level to enjoy the king's largess at a continuous feast over several days."[55] Hundreds of jar-labels and other types of inscribed material from Amenhotep III's Malqata palace attest to mass participation in the

[45] On dress, see above Chapter 3, p. 60-62. On stylistic evolution: Johnson, *Amenhotep III: Perspectives*, 80-85.

[46] Bryan, *Egypt's Dazzling Sun*, 106-110; W. Raymond Johnson, "Amenhotep III and Amarna: Some New Considerations," *JEA* 82 (1996), 67; idem, *Amenhotep III: Perspectives*, 79-80. The temple is currently being prepared for publication by Dr. N. Beaux for the Institut Français d'Archéologie Orientale.

[47] Hayes, *JNES* 10 (1951), 157-181; Johnson, *Art of Amenhotep III*, 38-41; idem, *Pharaohs of the Sun*, 43. Furthermore, Amenhotep III's jubilee palace at Malkata is referred to as the "Palace of Nebmaatre-is-the-Dazzling-Sun-Disk" (Aten).

[48] Redford, *JARCE* 13 (1976), 51.

[49] There exists a strong probability that this temple was also connected to Amenhotep III's celebration of the Heb Sed in Memphis, see: Robert Morkot, "*Nb-M3 't-R ˀ* – United-with-Ptah," *JNES* 49 (1990), 323-337; Bryan, *Egypt's Dazzling Sun*, 135; Johnson, *Amenhotep III: Perspectives*, 65; Murnane, *Amenhotep III: Perspectives*, 213.

[50] See discussion in: Betsy M. Bryan, "The statue program for the mortuary temple of Amenhotep III," in *The Temple in Ancient Egypt: New discoveries and recent research*, edited by S. Quirke (London, 1997), 57-81; idem, *Egypt's Dazzling Sun*, 135-136. It is likely that BMA 76.39, published in Richard Fazzini, et. al. *Masterpieces in The Brooklyn Museum, New York* (New York, 1988), no. 40, also came from Kom el-Hetan.

[51] For enumeration of statues, see: Bryan, *Egypt's Dazzling Sun*, 125-230; Johnson, *Amenhotep III: Perspectives*, 64-85. See also Susanne Bickel, "Aspects et fonctions de la déification d'Amenhotep III," *BIFAO* 102 (2002), 67-73, 78.

[52] Johnson, *Pharaohs of the Sun*, 45; Bryan, *Egypt's Dazzling Sun*, 200-202; idem, "Striding Glazed Steatite Figures of Amenhotep III: An Example of the Purposes of the Minor Arts," in *Chief of Seers: Egyptian Studies in Memory of Cyril Aldred*, edited by E. Goring, N. Reeves, and J. Ruffle (London and New York, 1997), 63-65. Both authors assert that Kom el-Hetan was fully functioning before death, in part due to the presence of statuettes dedicated to the "living image" of Amenhotep III.

[53] Johnson, *JEA* 82 (1996), 68; idem, *Amenhotep III: Perspectives*, 88-89; Erik Hornung, *Akhenaten and the Religion of Light*, translated from the German by D. Lorton (Ithaca, 1999), 26. Amenhotep III was identified with Amun, Aten, Atum, Geb, Hapi, Hathor, Horakhty, Horus, Montu, Osiris, Re, Seth, Thoth, and a number of secondary deities, see: Bickel, *BIFAO* 102 (2002), 67-72, 79-83. On Amenhotep III's identification with Osiris, see: Ali Radwan, "Amenophis III, dargestellt und angerufen als Osiris (*wnn-nfrw*)," *MDAIK* 29 (1973), 71-76; and with other deities: idem, "Zur bildlichen Gleichsetzung des ägyptischen Königs mit der Gottheit," *MDAIK* 31 (1975), 99-108; idem, *Ägypten, Dauer und Wandel*, 53-69. See also Baines, *Amenhotep III: Perspectives*, 284-286, who discusses three stele from Amenhotep III's mortuary temple that narrate the ruler's constructions in Thebes and show a heightened dialogue between the king and the gods. Note, however, that Baines (Ibid., 300) does not believe that Amenhotep III was deified while alive, but he states that the meaning of the Luxor Temple, the iconography of the *sed* festival reliefs in the tomb of Kheruef, the religious geography of the city, and the royal statuary program "bring the king as close as possible to being a god."

[54] Although all kings were divine (*netjeru neferu*: "perfect god" or "junior god," see: Jaromir Malek, "The Old Kingdom (ca. 2686-2125 BC)," in *The Oxford History of Ancient Egypt*, edited by I. Shaw (Oxford, 2000), 99) in the New Kingdom, this identification was framed in solar terms. As stated by Hornung, the king was the "son of Re" and "was himself the sun, lighting the world and playing the role of the sun god on earth through his deeds" (Hornung, *Akhenaten and the Religion of Light*, 26).

[55] Donald B. Redford, "The Concept of Kingship during the Eighteenth Dynasty," in *Ancient Egyptian Kingship*, edited by D. O'Connor and D. Silverman, PÄ 9 (Leiden, 1995), 175. See also Amenhotep III's corvée exemption for Amun temple personnel, the *rmt* and Thebes during his first jubilee: José M. Galán, "The Ancient Egyptian Sed-Festival and the Exemption from Corvée," *JNES* 59, no. 4 (2000), 255-256, 261, 263. For a listing of royal and private inscriptions relating to Amenhotep III's sed festivals, see: Johnson, *Amenhotep III: Perspectives*, 64-80.

king's *sed*-festival program.[56] The official Kheruef recorded an actual event in his tomb (TT 192) in which Amenhotep III is shown participating in rites that celebrated the king's union with the sun god during his first jubilee. One such scene shows members of the court towing Amenhotep III and Queen Tiy in the evening and morning barks of Re.[57] Amenhotep III promoted his transformed state through cult statues[58] and colossal statuary constructed for his jubilee, with eyes tipped outwards and down to the petitioner below.[59] As the "Dazzling Aten," the living Amenhotep III also may have aspired to be the divine father of Egypt if one accepts Gerhard Feucht's association between the word Aten (pronounced *yāti* or with an indistinct final vowel) and the Egyptian *íti* "father" (probably pronounced *yāta*).[60]

Thus, while the king's status was raised to the level of the gods, it also incorporated the elite, and perhaps, the non-elite as well. Was Amenhotep III's elevation to the level of Egypt's major gods a calculated move on behalf of the crown to incorporate the increasing presence of personal religion? In other words, was the eighteenth dynasty trend of elevating royal associations with Egypt's major gods[61] a brilliant political strategy aimed at incorporating personal piety by reasserting divine kingship? Thutmose IV stresses his identification with the sun god. Amenhotep III deifies himself while alive, and equates himself with Re, Ptah, Aten, and all the other deities of Egypt, in effect, situating himself as the ultimate divine focus of all personal appeals to the gods.[62] By the reign of his son, Akhenaten, personal piety for non-royal individuals was identical with total loyalty to the king.[63] Akhenaton's "revolution from above" aimed at regaining royal monopoly by taking religious experience out of the hands of the people and putting it under the exclusive control of the crown.[64] If we look at Akhenaton's efforts as the culmination of a trend, from germination during the reign of Thutmose IV and externalization in the reign of Amenhotep III to its apogee in the reign of Akhenaten, then, by the Amarna period, the king's power over the elite was absolute, and their religious experience depended completely on the monarch.[65]

During the reigns of Thutmose IV and Amenhotep III, the *Blickpunktsbilder* in the chapels of state class officials and individuals promoted by the king reveal a devotional relationship between the tomb owner and his ruler. In fact,

[56] Hayes, *JNES* 10 (1951), 35-40; 82-104, esp. 82-83, 100-103; 156-183; M.A. Leahy, *Excavations at Malkata and the Birket Habu, 1971-1974*, vol. 4, *The Inscriptions* (Warminster, 1978); Larry M. Berman, "Amenhotep III and His Times," in *Egypt's Dazzling Sun*, edited by A. Kozloff and B. Bryan (Cleveland, 1992), 45.

[57] The Epigraphic Survey, *Kheruef*, 43, pl. 24, and 53: "Amenhotep, ruler of Thebes....will occupy the dais of the one who begat him in the jubilee which he celebrated on the west of the City". See also: Johnson, *Amenhotep III: Perspectives*, 86-88.

[58] Johnson, *JEA* 82 (1996), 69-71; Bickel, *BIFAO* 102 (2002), 76-78. See also the cult statue of Amenhotep III in the guise of Atum or Re-Atum from the Luxor cachette (M 838) in: Mohammed El-Saghir, *The Discovery of the Statuary of the Luxor Temple* (Mainz, 1992), 21-27; Bryan, *Egypt's Dazzling Sun*, 132-135, fig. V.14-16, color plate 5.

[59] Bryan, *Egypt's Dazzling Sun*, 156-157. These outwardly tipped eyes are also found in the face of Tiy flanking the Colossi of Memnon and may have been present in the colossi as well. I thank Ray Johnson for this observation. A colossal striding statue of Amenhotep III called "Nebmaatre, Montu of the Rulers," had similarly tipped eyes from the 10th pylon at Karnak (Johnson, *Amenhotep III: Perspectives*, 69-70). See also Baines, *Amenhotep III: Perspectives*, 294, on Amenhotep's use of colossi and standard-bearing statues to promote his divinity and intermediary role, which he notes "faced toward the outside world, and ostensibly addressed the temple visitor."

[60] Gerhard Fecht, "Amarna-Probleme (1-2)," *ZÄS* 85 (1960), 114; discussion in Baines, *Amenhotep III: Perspectives*, 291.

[61] See discussion in Bryan, *The Oxford History of Ancient Egypt*, 244, 258-259, 261-263.

[62] Johnson, *Pharaohs of the Sun*, 45. Bickel, *BIFAO* 102 (2002), 63-90, argues that Amenhotep III's divine association with the gods was not a means to control personal piety. She suggests that public veneration of the ruler as a divine image on earth not only stressed the king's role as a benefactor who was capable of providing support and protection in the next world, but was engineered by the elite to address the growing need for personal religiosity. However, several problems exist with this argument. First, Bickel's statement that Amenhotep III functioned as a divine benefactor on numerous monuments is not dissimilar from the traditional role of the king as the intermediary role between god and man, particularly with regard to the king's intercessory capacity in the *htp-di-nsw* offering formula. Second, Bickel's assertion that colossal statues of Amenhotep III were created by the State in response to the growing need in the eighteenth dynasty to express individual religiosity suggests a State-sanctioned action whose only goal could be to redirect personal piety towards the person of the king.

[63] Assmann, *Search for God*, 216-217; Hornung, *Akhenaten and the Religion of Light*, 55-56; Boyo Okinga, "Zum Fortleben 'Amarna-Loyalismus' in der Ramessidenzeit," *WdO* 14 (1983), 207-215.

[64] Jan Assmann, *Theologie und Frömmigkeit einer frühen Hochkultur* (Stuttgart-Berlin-Köln-Mainz, 1984), 221-257; idem, *Egyptian Solar Religion*, 133; idem, *Search for God*, 221. Quote in: Marianne Eaton-Krauss, "Akhenaten," *OEAE* I (2001), 50.

[65] Hornung, *Akhenaten and the Religion of Light*, 55; Jacobus van Dijk, "The Amarna Period and the Later New Kingdom (c.1352-1069 BC)," in *The Oxford History of Ancient Egypt*, edited by I. Shaw (Oxford, 2000), 311. See also the discussion in: Rolf Gundlach, "Weltherrscher und Weltordnung: Legitimization und Funktion des Ägyptischen Königs am Beispiel Thutmosis III. und Amenophis III.," in *Legitimation und Funktion des Herrschers vom Ägyptischen Pharao zum neuzeitlichen Diktator*, edited by R. Gundlach and H. Weber (Stuttgart, 1992), 23-50.

when the focal walls of all eighteenth dynasty Theban tombs are examined, the image of the king seated in a kiosk appears with greater frequency during the reigns of Thutmose IV and Amenhotep III than in the reigns of the previous or later kings,[66] which argues for the importance of the pharaoh to the tomb owner as a means of social identity and eternal provisioning. Furthermore, in these tombs the king is often presented as the primary source of the deceased's sustenance and well-being in the hereafter. On other walls in the tomb chapel, images of banqueting and offering are populated largely by professional peers or anonymous participants, and only rarely by family members.[67]

With these societal and religious trends in mind, the icons and their mechanisms of provisioning ultimately converge in meaning as an expression of culture during the reigns of Thutmose IV and Amenhotep III. The iconography of the king enthroned in his kiosk reflects not only his deified state in the afterlife, but reveals the monarch's increased identification with (Thutmose IV) and personification of (Amenhotep III) the sun god in life. By stressing this iconography in his monuments, the king may have actively sought to incorporate personal piety by making himself the divine focus of religion and the source of all creation through his association with the sun god Re (Thutmose IV),[68] and his deification and identification with all the gods (Amenhotep III), particularly in light of later developments during the reign of Akhenaten, who completely usurps personal piety in his reformulation of "supernal and earthly kingship."[69] By stressing the king's intermediary and direct role in the tomb and their eternal provisioning, officials of the state class incorporated the pharaoh in their afterlife as the primary guarantor of their well-being.

In the end, on the focal walls of their Theban tomb chapels, the state class and those promoted by Thutmose IV or Amenhotep III stress their service to the ruler while the religious administration and temple artisans emphasize their association with the gods. Through the bestowal of gifts of life, tomb owners were eternally provisioned through the king, in his intermediary role and potentially divine state. Other tomb owners, particularly temple artisans and those connected with Egypt's religious institutions, were provisioned by the gods directly through offerings of life that mediated the divine essence. Both mechanisms of provisioning ultimately reflected the cultural and religious forces that heralded the advent of personal piety on one hand, and the identification of the living king with the gods, on the other. In the style of decoration and the iconographic configurations that adorned the focal walls of these tomb chapels, the deceased's personal and professional identity as well as the underlying religious and cultural trends of Egypt were manifested, presented, preserved, and projected into this world and the eternal time of the afterlife.

[66] In Radwan, *Königs*, 110-112, 46 tombs had image(s) of the king seated in a kiosk on their back wall(s). Of these, twenty back walls date to the early eighteenth dynasty, and to the reigns of: Hatshepsut (TT 73), transitional Hatshepsut/Thutmose III (TT 110), Thutmose III (TT 84, TT 86, TT 99), transitional Thutmose III/Amenhotep II (TT 42, TT 85, TT 100, TT 143, TT 200, TT 256), and Amenhotep II (TT 43, TT 56, TT 72, TT 88, TT 92, TT 93, TT 96, TT 101, TT 367). Thirty-three back walls (21 tombs) date to the reigns of Thutmose IV and Amenhotep III: thirteen from the reign of Thutmose IV (TT 63, TT 64, TT 66, TT 74, TT 75, TT 76, TT 77, TT 116); ten from the transitional period of Thutmose IV/Amenhotep III (TT 78, TT 90, TT 91, TT 201, TT 239, C 6) and ten from the reign of Amenhotep III (TT 47, TT 48, TT 57, TT 58, TT 89, TT 120, TT 226). From the reigns of Amenhotep IV to Tutankhamun, only five tombs (nine back walls), had the image(s) of the king in a kiosk (TT 40, TT 49, TT 55, TT 188, TT 192). All dates based on those in Kampp, *Nekropole* I, 140-143, and Appendix I.

[67] In this study, the state class tombs and those promoted by the king primarily show colleagues or anonymous participants in scenes of banqueting and offering: TT 63 (Bryan, in Dziobek and Raziq, *Sobekhotep*, 83-84, on genealogy), Paser, the son of Meryt, is shown once in the tomb offering to Sobekhotep and wife; however, the majority of offerers are in the service of the treasurer, see: Dziobek and Raziq, *Sobekhotep*, 67-69); TT 64, only the father is shown and he shares the same professional office as Hekerneheh (Whale, *Family*, 201-202); TT 74, anonymous participants and offerers (Brack, *Tjanuni*, 88-89; Whale, *Family*, 192-193); TT 76, anonymous participants and offerers (Whale, *Family*, 194-195); TT 77, anonymous offerers and colleagues (Manniche, *Three Theban Tombs*, 7-9, 11); TT 78, princess Amenemopet, Haremhab's mother and colleagues, anonymous participants and offerers (Brack, *Haremhab*, 24-30, 82; Whale, *Family*, 212-213); TT 89, anonymous participants and offerers (*Urk.* IV, 1021-1025; Nina de Garis Davies and Norman de Garis Davies, "The Tomb of Amenmosě (No. 89) at Thebes," *JEA* 26 (1940), 131-136); TT 91 (*Urk.* IV, 1598-1599; *PM* I,1(2), 185-187); TT 116, a daughter is indicated but all other banqueting participants are anonymous (*Urk.* IV, 1602); TT 118, no offerers preserved (*PM* I,1(2), 234); TT 201, offerers anonymous (Redford, *Re'a (TT 201)*, 4-14); TT 226, anonymous offerers (Davies, *Menkheperrasonb*, 35-40); TT 258, anonymous offerers (Davies, MSS 11,6 and 11,39).

[68] Bryan, *The Oxford History of Ancient Egypt*, 258; idem, *Amenhotep III: Perspectives*, 61-62.

[69] Assmann, *Search for God*, 228; Sørensen, *Religion of the Ancient Egyptians*, 121; van Dijk, *The Oxford History of Ancient Egypt*, 284, 311-312. Quote: Redford, *Ancient Egyptian Kingship*, 180.

APPENDIX I

SELECTION, RESEARCH CRITERIA, AND DATING OF TOMBS

Thirty painted private tomb chapels were selected based on a number of criteria (Table 1). In order to be chosen for study, the painting in the tomb had to be completed during the reigns of Thutmose IV and Amenhotep III. The decoration in the tomb chapel had to be flat painting and not painted relief. Several reasons support this choice. One of the aims of this study was to examine style (i.e. decorative design, figural proportions, color choices) in the private Theban necropolis and how it revealed the traits of a group of painters with the goal of understanding workshop organization in the mid-eighteenth dynasty. Flat painting was often achieved by a small group of draughtsmen who drew, painted, and outlined the forms according to fixed rules within a cooperative workshop system that ensured a stylistic consistency across the wall. Painted relief was excluded from this study because it showed a number of overlapping procedures done by both sculptors and draughtsmen, with the sculptor's work taking precedence in the final product. Flat painting also occurs in two general tomb plans during the period (see below), which allowed for a more consistent comparison of focal walls. Painted relief, on the other hand, is found in a number of different tomb plans, including the "funerary temple" type that manifested in a new decorative scheme.[1]

To study painting in its original conception, there could also be no indication of usurpation or repainting by successive occupants of the tomb. Enough decoration had to remain *in situ* to reconstruct the subject matter and many of its aesthetic details. If the decoration was no longer *in situ*, it had to be archaeologically excavated and removed.[2] In a few cases, the modern reconstruction of the tomb wall was so poorly done that the iconography and decorative scheme could not be analyzed in depth.[3] If the tomb was currently inaccessible and the only record of the chapel painting was by facsimile copy, the tomb was removed from this study. Tomb chapels were selected with texts or the images that provided enough information about the owner, his career, or his institutional affiliation. Lastly, the painted tombs at Deir el-Medina form a separate architectural and decorative tradition, and thus were not included in this study.[4]

Flat painted decoration occurs in two general types of Theban tomb chapels: rectangular chapels[5] and chapels that conformed to an inverted T-shape arrangement[6] (Figure 4). The western back walls of the transverse hall in T-shaped chapels[7] and the northern or southern long walls in rectangular chapels were selected as a stable means of comparison based on ancient documentary evidence, the architectonic importance of the wall, and the aesthetic and symbolic significance of its decoration. These focal walls held the *Blickpunktsbild* or focal point representation which was important for the self-preservation and self-presentation of the tomb owner.

Focal wall scenes in unpublished tombs were drawn using a combination of photographs and carefully measured drawings done at the wall by the author, and then inked by Tamara Bower, a professional draftsperson/artist. These drawings were included to provide a clear picture of the iconography and texts on the focal walls of unpublished tombs. Although small distortions may regrettably occur in the drawings, a relative proportionality was rigorously maintained

[1] On the "funerary temple" tomb type, see: Kampp-Seyfried, *Encyclopedia of the Archaeology of Ancient Egypt*, 810; idem, *Nekropole* I, 120. On the decorative scheme, see: Kozloff, *Egypt's Dazzling Sun*, 274-279

[2] As for example the focal wall of TT 226 which was published and removed by Norman de Garis Davies; see below, n. 54.

[3] In particular, the entire left back wall, PM (4), of the transverse hall in the tomb of Menna (TT 69), in particular, the portion closest to the doorway to the chapel's inner hall.

[4] See discussion in Chapter 1. One tomb from Deir el-Medina belonged to the temporal period treated in this book and was excluded. The tomb of Kha (TT 8) was constructed in the reign of Amenhotep III (based on Schiaparelli's find of a cup made out of electrum inscribed with the king's cartouche in the sarcophagus chamber (Turin, sup. 8355 = Ernest Schiaparelli, *Relazione sui lavori della Missione Archeologica Italiana in Egitto (anni 1903-1920)*, vol. II: *La tomba intatta dell'architetto 'Cha' nella necropoli di Tebe* (Turin, 1927), 172, fig. 157). On its architecture, see: Kampp, *Nekropole* I, 188-190.

[5] Kampp, *Nekropole* I, 13, fig. 1: Types I, IIb.

[6] Ibid.: Types IIa, Va, Vb, Vd, VIa, VIb, VIIa, VIIb.

[7] Defined as the paintings which occur on the back walls of the transverse hall on either side of the shrine or entry to the inner passage of the tomb, opposite the outer doorway of the chapel.

by the author and draftsperson. Texts and images were checked, whenever possible, against earlier drawings, photographs, and early collated hand copies of the pertinent texts.[8]

Roughly three time periods of Theban tomb painting are reflected in the tombs chosen for this study: 1, Thutmose IV; 2, the transitional period of Thutmose IV/Amenhotep III; 3, Amenhotep III. These temporal periods are based on the recent and excellent compilation on Theban tombs by Friederike Kampp.[9] A number of tomb walls bear the cartouche of both Thutmose IV and Amenhotep III which indicates that they were begun during the brief reign of the former and finished under the latter.[10] Even when a king's cartouche was not present, these paintings often betray a mixture of styles that exhibit characteristics consistent with art of both pharaohs.[11]

From the reign of Thutmose IV, TT 63,[12] TT 64,[13] TT 66,[14] TT 74,[15] TT 75,[16] TT 76,[17] TT 77,[18] and TT 116,[19] were chosen based on the appearance of king's cartouche and/or image(s) on the focal walls in the chapel. The following have been excluded because the painting was completed during the reign of Amenhotep II (TT 22,[20] TT 43,[21] TT 56,[22]

[8] The archives consulted were the photographic archives of The Epigraphic Survey of the Oriental Institute, The University of Chicago, Luxor, Egypt; the Burton photo archive at The Metropolitan Museum of Art, New York; the Schott photo archive at the Universität Trier, Germany; Wörterbuch Zetteln at the Theban Tomb archive at the Ägyptologisches Institut, Universität Heidelberg, Germany; and Norman de Garis Davies and Alan H. Gardiner notebooks from the Griffith Institute, Oxford, U.K.

[9] Kampp, *Nekropole* I, 139-149.

[10] For example, TT 90 has the cartouches of Thutmose IV on PM (4) & PM (9), and the cartouche Amenhotep III on PM (8) (see n. 34 above); TT 91 contains the images and cartouches of Thutmose IV on PM (5) and Amenhotep III on PM (3) (see n. 35 above); and TT 78 (see n. 33 above) has cartouches of Thutmose III (*Ka*), Amenhotep II, Thutmose IV, Amenhotep III on PM (11).

[11] Kozloff, *The Art of Amenhotep III*, 61-62. The transitional date of Thutmose IV/Amenhotep III in Theban tomb painting was first used by Wegner, *MDAIK* 4 (1933), 125-131, 144. Steindorff and Wolf, *Die thebanische Gräberwelt*, 65-69, esp. 67, n. 1, followed Wegner's three stylistic divisions in their survey of the private tomb decoration in the Theban necropolis; and, most recently, Kampp, *Nekropole* I, 139-149.

[12] Dziobek and Raziq, *Sobekhotep*, 19, taf. 11. On PM (13), the wife of Sobekhotep holds a *menit* with the cartouche of Thutmose IV. See discussion of Sobekhotep's career and additional documentation on the tomb owner: Bryan, in Dziobek and Raziq, *Sobekhotep*, 81-88.

[13] *PM* I,1(2), 128-129; nomen and prenomen recorded by Lepsius, *Denkmäler, text* III, 260, 69a.

[14] Hepu is dated to the reign of Thutmose IV based on the Munich papyrus 809, where he appears as a judge bearing the title *ṯзt*; Wilhelm Spiegelberg, "Ein Gerichtsprotokoll aus der Zeit Tuthmosis' IV," *ZÄS* 63 (1928), 105-115. See also: Nina Davies, *Some Theban Tombs*, 9, n. 1.

[15] Brack, *Tjanuni*, 90, from the stela inscription, which mentions he began his career under Thutmose III and ended it under Thutmose IV. The tomb painting was completed in the reign of Thutmose IV (Ibid., 83). Partial cartouche of Thutmose IV recorded by Vincent Scheil, "Le tombeau de Djanni," *Mém. Miss.* V, 2 (1894), 597.

[16] Dating based on representation of a statue that is identified by cartouche *Mn-ḫprw-Rʿ* "Menkheperure," the prenomen of Thutmose IV (Davies, *Two officials*, 4, pl. XII). This cartouche was incorrectly read by Sethe, *Urk.* IV, 1212 b, as *Mn-ḫpr-Rʿ*.

[17] Säve-Söderbergh, *Four Eighteenth Dynasty Tombs*, 51, notes the depiction of a necklace drawn by Hay with the prenomen of Thutmose IV. Tjenuna is also recorded on a scribal palette dated by cartouche to the reign of Thutmose IV (*Urk.* IV, 1615, 15 = BM 5512).

[18] Manniche, *Three Theban Tombs*, 22, who notes the remains of the king's cartouche with his prenomen on PM (4) and a text on PM (7) that mentions "the house of *Mn-ḫprw-Rʿ m pr Imn* which his Majesty built anew for his father [Amun-Re]."

[19] On the right focal wall, PM (2), the name of Amenhotep II (*Imn-ḥtp ḥk3 w3st*) is over-painted with name of Thutmose IV (*Ḏḥwtí-msí(w) ḫʿí-ḫʿw*); see note: *Urk.* IV, 1602, 15 (Cumming, *Egyptian Historical Records* III, 295).

[20] *PM* I,1(2), 37-38. The decoration of TT 22 was apparently completed under the original owner of the tomb, Wah; the later reuse of the chapel by Meryamun during Amenhotep II/III affected the texts in several places in the chapel (Polz, *MDAIK* 46 (1990), 304; Kampp, *Nekropole* I, 205).

[21] *PM* I,1(2), 83-84; Lydia Collins, "The Private Tombs of Thebes: Excavations by Sir Robert Mond 1905-1906," *JEA* 62 (1976), 39. The tomb of Neferrenpet (TT 43) dates to the reign of Amenhotep II based on a scene of two kings in which the ruler seated to the rear is identified as Amenhotep II by cartouche; the other ruler has a blank cartouche (Helck, *MDAIK* 17 (1961), 99-110; complete bibliography in Der Manuelian, *Amenophis II*, 23). The king in front with the blank cartouche is generally identified as Thutmose III. For discussion, see: Helck, *MDAIK* 17 (1961), 106; Donald B. Redford, "The Coregency of Tuthmosis III and Amenophis II," *JEA* 51 (1965), 116; William J. Murnane, *Ancient Egyptian Coregencies*, SAOC 40 (Chicago, 1977), 53d; and see examples in: Der Manuelian, *Amenophis II*, 23-24. Stylistically, the tomb has been assigned to the reign of Thutmose IV (Shedid, *Stil der Grabmalereien*, 93-95); and to the early reign of Amenhotep III (Bryan, *Thutmose IV*, 303, 330 with n. 394) based on the similarity of the name and titles in the tomb with a statue of Neferrenpet (Louvre, no. E 14241, time of Amenhotep III; in Kozloff and Bryan, eds., *Egypt's Dazzling Sun*, no. 38, 242-243). Although these divergent datings are noted, the evidence strongly favors a date of Amenhotep II for the painting of the tomb.

[22] Beinlich-Seeber, *Userhat*, 112-113, dates the tomb to the first half of Amenhotep II based on prosopography, and Shedid (Ibid., 144-145), dates TT 56 to the latter part of the same king's reign on stylistic grounds. Kampp, *Nekropole* I, 265, 267 with fig. 155, pushes the date of TT 56 into the reign of Thutmose IV based on a brick found by Mond (Robert Mond, "Report of work in the necropolis of Thebes during the winter of 1903-1904," *ASAE* 6 (1905), 67-69) stamped with the cartouche Thutmose IV. Mond mentioned that it came from a northern wall which Kampp suggests was

TT 101,[23] TT 176).[24] Other tombs from this period had no decoration on their focal walls or texts with which to identify the tomb owner (TT 62,[25] TT 350,[26] TT 376,[27] TT 400);[28] or displayed extensive repainting (TT 295).[29]

Fourteen tombs date to the temporal period of Thutmose IV/Amenhotep III: TT 38,[30] TT 52,[31] TT 69,[32] TT 78,[33]

the wall below the modern steps of TT 56 or the facade wall. However, the plausible family connection between Userhet and Imunedjeh (TT 84, tp. of Thutmose III), Imunedjeh's representation in TT 56 (Beinlich-Seeber and Shedid, *Userhat*, 110, fig. 45) and the style of the chapel, places the painting of the tomb convincingly in the reign of Amenhotep II. The brick *may* have been part of a wall connected with the founding of the adjacent tomb structure of Khaemhet (TT 57).

[23] *PM* I,1(2), 214-215. The presence of the cartouche of Amenhotep II gives a secure date for the tomb (Norman de Garis Davies, "The Egyptian Expedition 1934-1935," *BMMA*, part II (November, 1935), 53-54, fig. 8). Although Shedid argues for a date of Thutmose IV based on stylistic evidence (Shedid, *Stil der Grabmalereien*, 95), the style is closer to that of Amenhotep II based on the author's personal photos.

[24] *PM* I,1(2), 281-282, gives a date range of Amenhotep II to Thutmose IV based on stylistic criteria, but it more likely dates to Amenhotep II. See: Bryan, *Thutmose IV*, 303.

[25] Unpublished; *PM* I,1(2), 125; Kampp, *Nekropole* I, 279: "Die Dekoration is fast vollkommen zerstört."

[26] *PM* I,1(2), 417; Ahmed Fakhry, "A Report on the Inspectorate of Upper Egypt," *ASAE* 46 (1947), 40; Kampp, *Nekropole* II, 587-588, mentions that the tomb is probably inhabited since it lies between two houses and therefore is inaccessible.

[27] *PM* I,1(2), 434; Kampp, *Nekropole* II, 597-598, cautiously assigns this tomb to Meryre based on a frieze cone found in the forecourt, which corresponds to Davies and Macadam, *Corpus*, nr. 262, and read as *imy-r pr wr n nswt Mr-R'* "Chief Steward of the King, Meryre" (*Urk.* IV, 1614). The author was able to visit the tomb in December 2000 and found the decoration to date earlier than Thutmose IV based on the bright yellow tone of the women's skin. The poor quality of the decoration, meager size, and placement of TT 376 also strongly argues against the assignment of the tomb to Meryre, who held an exalted position in the court. The tomb of another chief steward, TT 76 belonging to Tjenuna, is lavishly appointed and one of the largest tombs constructed during the reign of Thutmose IV. Instead, the cone of *Mr-R'* in the forecourt of TT 376 may have strayed, or it may have originated from a nearby (undiscovered?) burial.

[28] *PM* I,1(2), 444; Kampp, *Nekropole* I, 609, dates the tomb to "(A.II.)/T.IV." She mentions cones found in and around the tomb conformed to Davies and Macadam, *Corpus*, nr. 341, reading *ẖrd n k3p Pn-imn* "Child of the Nursery, Penamun." Unfortunately, no texts remain in the chapel to substantiate this assignment to the tomb owner, nor is Penamun attested to in the written record as a *ẖrd n k3p* during the reign of Amenhotep II or Thutmose IV; see list of children of the nursery in: Der Manuelian, *Amenhophis II*, 304; Bryan, *Thutmose IV*, 294-295.

[29] The faces of the figures in Sayed Aly el-Hegazy and Mario Tosi, *A Theban Private Tomb, Tomb No. 295*, AV 45 (Mainz, 1983), 27, were clearly painted over, which makes a stylistic assessment of this tomb impossible. See also discussion in: Bryan, *Thutmose IV*, 303, 331 with n. 406.

[30] Part of Djeserkarasoneb's career can be placed with certainty in the reign of Thutmose IV. He is portrayed twice with his steward and scribal titles in the tomb of his employer, Amenhotep-si-se (TT 75), who was the Second Prophet of Amun in the reign of Thutmose IV. However, several criteria suggest that decoration of TT 38 dated to the transitional period of Thutmose IV/Amenhotep III. Nina de Garis Davies noted that TT 38 lies near the tomb of Nakht (TT 52) and uses some of its scenes as models (Davies, *Some Theban Tombs*, 1, 5). Futhermore, the chapel painting is stylistically similar to Nakht (TT 52) as well as paintings in Nebseny (TT 108) and TT 175, all dated to the transitional period of Thutmose IV/Amenhotep III.

[31] Also dating TT 52 to Thutmose IV/Amenhotep III are Wildung, *Nacht*, 16; Cherpion, *BSFÉ* 110 (1987), 41; Kampp, *Nekropole* I, 257; Eichler, *Die Verwaltung des "Hauses des Amun,"* 299, no. 385; and Hartwig, *Valley of the Kings*, 391-393.The date of Nakht's tomb is not secured by cartouche or proposographical data on the tomb owner. The stylistic similarity between the paintings in Nakht and those in the transitional Thutmose IV/Amenhotep III-style tombs of Menna (TT 69), Nebseny (TT 108), Djeserkarasoneb (TT 38), as well as the Thutmose IV-style tomb of Amenhotep-si-se (TT 75), date Nakht's chapel to this transitional period. The Thutmose IV/Amenhotep III dating is supported by figural details such as the plump, rounded proportions of the female figures, elongated eyes with pupils that take up half of the upper eyelid, and tendrils escaping the wig, found in the reign of Amenhotep III; and the yellow skin tone used to distinguish the women on PM (1) which is characteristic in the reign of Thutmose IV.

[32] A number of indicators support a date of Thutmose IV/Amenhotep III for the tomb of Menna (TT 69). The sunken forecourt of TT 69, which is surrounded on three sides by walls with a ramp leading down into the court, recalls similar structures from the reigns of Thutmose IV/Amenhotep III (TT 38) and Amenhotep III (TT 139) (Kampp, *Nekropole* I, 294). The Judgement of the Dead scene portrayed on PM (10) in TT 69 is dated to the reign of Amenhotep III based on a similar scene in the inner hall of TT 78 dated by cartouche to the reign of that king; (see n. 33 below). The form of the Osiris hymn in TT 69 is also found in TT 139, which is dated to the reign of Amenhotep III (Kampp, *Nekropole* I, 294, n. 5 and see n. 51 below). Menna may have married a daughter of Amenhotep-si-se (Whale, *Family*, 208), the owner of TT 75 (tp. Thutmose IV), which would place Menna's career in the reigns of Thutmose IV and Amenhotep III. In TT 69, the painting style and figural proportions of the two girls carrying sistrums on PM (5) has been dated stylistically to the reign of Amenhotep III (Cherpion, *BSFÉ* 110 (1987), 39); however, the painting on PM (7) retains many of the stylistic indicators of Thutmose IV (Melinda K. Hartwig, "The Tomb of Menna," in *Valley of the Kings: The Tombs and Funerary Temples of Thebes West*, edited by K.R. Weeks (Vercelli, Italy, 2001), 400). Likewise, the painting style in TT 69 is also very similar to the chapels of Pairy (TT 139) and Neferrenpet (TT 249), both of which are dated to the reign of Amenhotep III by cartouche.

[33] Brack, *Haremhab*, 83-84, dates the tomb to the reigns of Thutmose IV and Amenhotep III based on their cartouches and the depiction of the former king on PM (4) & (8). According to the Bracks, the transverse hall was completed under Thutmose IV, and the inner hall was done early in the reign of Amenhotep III, an observation that is accepted here.

TT 90,[34] TT 91,[35] TT 108,[36] TT 151,[37] TT 165,[38] TT 175,[39] TT 201,[40] TT 239,[41] TT 253,[42] TT 258.[43] Of the tombs assigned by Kampp to Thutmose IV/Amenhotep III, TT 147 was blackened by soot, and its iconography was unreadable

[34] Based on text dated to year 6 of Thutmose IV on PM (4) (Davies, *Two officials*, 35) and the presence of the Amenhotep's cartouche on the shrine on PM (8) (Ibid., 30).

[35] Champollion, *Not. desc.* I, 498-499, recorded the cartouche of *Nb-m3't-R'* (Amenhotep III) on PM (3); on PM (5), the cartouche of *Mn-ḫprw-R'* (Thutmose IV) remains. Gun Björkman argued that the owner of TT 91 was the mayor of Sile, Neby (Gun Björkman, "Neby, the Mayor of Tjaru in the Reign of Tuthmosis IV," *JARCE* 11 (1974), 43-51), which Bryan counters with the lack of titles relating to Tjaru in the tomb. Bryan suggests the brother of Nebamun (TT 90), Turo, may be a good candidate as the owner of TT 91, based on the appearance of the title *hry Md3yw hr W3st*, but states that identification is not sure (Bryan, *Thutmose IV*, 289). For these reasons, the identity of the owner of TT 91 remains anonymous pending more definitive documentation.

[36] Date assigned stylistically by Wegner, *MDAIK* 4 (1933), 121. The style of painting in the banqueting scene and its similarity to scenes in the tombs of Amenhotep-si-se (TT 75, tp. Thutmose IV), Nakht (TT 52, tp. Thutmose IV/Amenhotep III) and Djeserkarasoneb (TT 38, tp. Thutmose IV/Amenhotep III) also reinforces Wegner's assignment. Nebseny may have served as "High Priest of Onuris" at the same time as Amenhotep in the reign of Thutmose IV and, perhaps, succeeded him early in the reign of Amenhotep III (Bryan, *Thutmose IV*, 276).

[37] Bryan, *Thutmose IV*, 272, dates the tomb to the reign of Thutmose IV based on the hanging lotus friezes and the type of garments worn by the figures. However, the style of painting in the transverse hall bears a strong resemblance to the painting in the tomb of Menkheper, TT 258, which is stylistically dated in this study to the transitional period of Thutmose IV/Amenhotep III. Furthermore, the style of painting in the inner passage appears to have been painted later during the reign of Amenhotep III (Plate 6,3), due to its close parallel with TT 249 (tp. Amenhotep III) (Plate 6,2), and TT 139 (tp. Amenhotep III) (Plate 6,1), both dated by cartouche.

[38] Wegner, MDAIK 4 (1933), 144, first dated this tomb to the transitional period of Thutmose IV/Amenhotep III. The painting in TT 165 bears a striking resemblance to the tomb of Nakht, TT 52, a fact that was also noted by Davies when he published the tomb in 1913 (Davies, *Five Theban Tombs*, 40). The painting in TT 52 belongs to the transitional period of Thutmose IV/Amenhotep III, which places TT 165 in the same time period. The style of painting in TT 165 is also found in the tombs of Amenhotep-si-se (TT 75, tp. Thutmose IV), Nebseny (TT 108, tp. Thutmose IV/Amenhotep III); and TT 175 (tp. Thutmose IV/Amenhotep III). The translation of the tomb owner's name Nehemaway remains problematic (Ranke, *PN* I, 208, 5; Kampp, *Nekropole* I, 454).

[39] Wegner, *MDAIK* 4 (1933), 131, 144. Stylistic similarities can be found between the unfinished banqueting scene on PM (5) and similar scenes found in the chapels of Djeserkarasoneb (TT 38, tp. Thutmose IV/Amenhotep III), Nakht (TT 52, tp. Thutmose IV/Amenhotep III) and Nebseny (TT 108, tp. Thutmose IV/Amenhotep III). The finished paintings on PM (2) also bear a strong resemblance to the painting style in the chapels of Pairy (TT 139, tp. Amenhotep III), Neferrenpet (TT 249, tp. Amenhotep III) and Nakht (TT 161, tp. Amenhotep III). Manniche, *Three Theban Tombs*, 32, dates this tomb to Thutmose IV based on the presence of the square offering table which is not a credible dating criterion; see Introduction, n. 18 above.

[40] The decoration of TT 201 extended into the early years of Amenhotep III based on the appearance of a king's cartouche on a standard on PM (9) (Bryan, *Thutmose IV*, 248-249). Redford, *Re'a (TT 201)*, 28, is less convinced that Re lasted into the reign of Amenhotep III because his official titles are attested only in the reign of Thutmose IV. Stylistically, however, the tomb can be placed squarely in the transitional period of Thutmose IV/Amenhotep III. The motif of cattle in TT 201, PM (2) & (3) (Plate 12,2) is extremely similar to the cattle in TT 76, PM (2) (tp. Thutmose IV) (Plate 12,1), and TT 90, PM (8) (tp. Thutmose IV/Amenhotep III); and the proportions and rendering of the offering-bearers in TT 201, PM (2) & (3) are similar to those in TT 90, PM (8) and TT 78, PM (1) & (2) (tp. Thutmose IV/Amenhotep III; see photo in Brack, *Haremhab*, taf. 29b, 30b).

[41] Wegner, *MDAIK* 4, 131, 144, dates the tomb to the end of the transitional period of Thutmose IV/Amenhotep III; Gardiner notebook no. 72, p. 125 verso: "Thutmosis IV or Amenophis III style." *PM* I,1(2), 330, dates the tomb to "Thutmose IV to Amenhotep II (?)"; Bryan, *Thutmose*, 303, "Amenhotep III probably"; Kampp, *Nekropole* II, 516, dates it to Thutmose IV/Amenhotep III. The chronology of the office of "Overseer of Northern Countries" suggests that Penhet followed Amenmose, whose career dated to the reigns of Thutmose III and Amenhotep II (Der Manuelian, *Amenophis II*, 121). It is likely that Penhet surrendered his office sometime in the reign of Amenhotep III to Khaemwaset (*Urk.* IV, 1930-1932). See discussion of this office in: Murnane, *Amenhotep III: Perspectives*, 180 with n. 22.

[42] For dating of tomb to the reigns of Thutmose IV/Amenhotep III, see: Strudwick, *The Tombs of Amenhotep, Khnummose, and Amenmose*, 24-25. The closest stylistic parallels to TT 253 are the tombs of Nakht (TT 52, tp. Thutmose IV/Amenhotep III), Menna (TT 69, tp. Thutmose IV/Amenhotep III), and Amenhotep-si-se (TT 75, tp. Thutmose IV).

[43] PM I,1(2), 342 gives a date of "Thutmose IV (?)"; and Bryan, *Thutmose* IV, 303, 311, n. 403, dates the tomb of Menkheper to Thutmose IV-Amenhotep III based on the presence of the lotus frieze, varnish on the dresses, and hem lengths that extend to the top of the foot on female figures. The painting in the transverse hall of Haty (TT 151) (tp. Thutmose IV/Amenhotep III) offers the best comparison to depictions in TT 258, particularly in the rendering of the male figures with shortened near arms (compare Plate 13,2 with Wreszinski, *Atlas* I, 351). Also the proportions of the female figures in the tomb of Menna (TT 69) (Lhote and Hassia, *La peinture égyptienne*, pl. XVII, fig. 54) are similar to the female figures on the shrine wall, PM (4). However, the wrapping of decoration from PM (2) to PM (4) (separated only by a color band) is similar to other tombs dating solely to the reign of Amenhotep III such as TT 181 (compare PM (4) and PM (5), Davies, *Two sculptors*, pls. XIX, XXII, XXIV). For these reasons, a date in the transition period of Thutmose IV/Amenhotep III is accepted.

without extensive cleaning;[44] TT 87 was usurped;[45] TT 247 dates to the reign of Amenhotep II stylistically;[46] and TT 393 had no information on the tomb owner or his career either by inscription or by scene content.[47] TT 297 was recently published by Nigel Strudwick using earlier facsimile drawings due to the destruction of the tomb.[48]

Eight tombs were selected from the reign of Amenhotep III (TT 89,[49] TT 118,[50] TT 120,[51] TT 139,[52] TT 161,[53] TT 181,[54] TT 226,[55] TT 249).[56] Thirteen chapels dated by Kampp to the reign of Amenhotep III were excluded because

[44] Images and texts in the tomb are covered with a thick layer of soot. However, several images were clear enough to reveal a strong stylistic similarity with paintings in the tomb of Menna (TT 69, tp. Thutmose IV/Amenhotep III). See Kampp, *Nekropole* I, 432. Brief treatments of details in this tomb appear in Nina Davies, *JEA* 41 (1955), 8, fig. 1; and Bryan, *BES* 6 (1984), 23, pls. 30-31.

[45] Guksch, *Nacht-Min und Men-cheper-Ra-seneb*, 411-413.

[46] Wegner, *MDAIK* 4 (1933), 144, dates this tomb stylistically to the transitional period of Thutmose IV/Amenhotep III which is accepted by Kampp, *Nekropole* II, 522; and Eichler, *Die Verwaltung des "Hauses des Amun,"* 313, no. 482. Unfortunately, neither the career of Simut nor that of his sons Amenmose (Ibid., no. 011) and Pawah (Ibid., no. 204) can be securely dated to the reigns of either of these kings. When the tomb was visited and photographed by the author, the decoration clearly dated to the reign of Amenhotep II and bore close resemblance to the style of painting in the tomb of Userhat (TT 56, tp. Amenhotep II (see n. 22 above); compare Beinlich-Seeber and Abdel Ghaffar Shedid, *Userhat*, taf. 14, 24c and 24d with Wegner, *MDAIK* 4 (1933), pl. XVII (c).

[47] *PM* I,1(2), 442. Date given as "Early Dyn. XVIII." Kampp, *Nekropole* II, 604, dates the tomb to "T.IV./(A.III.)" on stylistic grounds.

[48] Nigel Strudwick, *The Tomb of Amenemopet called Tjanefer at Thebes (TT 297)*, ADAIK 19 (Berlin, 2003). The author states on p. 2 that the tomb "is indeed completely inaccessible and that all the paintings have presumably been destroyed." The decoration is only attested by facsimile copies.

[49] *PM* I,1(2), 182 (15) with representation and cartouche of Amenhotep III. See also Brock and Shaw, *JARCE* 34 (1997), 167-177, who are also preparing a publication of this tomb. Amenmose may have lived into year 37 of Amenhotep III based on a sealing of the "royal scribe Amenmose" (Hayes, *JNES* 10 (1951), no. 220).

[50] *PM*, I,1(2), 233-234. Kampp, *Nekropole* I, 405, dates the tomb to Amenhotep III based on architectural similarities with the ground plan with TT 78 (see: Eberhard Dziobek, "The Architectural Development of Theban Tombs in the Early Eighteenth Dynasty," *Problems and Priorities in Egyptian Archaeology*, edited by J. Assmann, G. Burkard, and V. Davies (London and New York, 1987), 75, fig. 2). However, Kampp's assignment of the frieze cone Davies and Macadam, nr. 325 with the title of *t3y sryt Imn-ms* cannot be substantiated. Amenmose (TT 118) was a [*t3w hw hr*] *wnmy nsw* or "Fan-Bearer on the Right of the King" from a text on the door lintel (personal photo), and the ceiling gives the name of the deceased. Pomorska, *Les flabellifères*, 106, assigns TT 118 to Amenmose but mistakenly assigns the tomb owner to the reign of Amenhotep II even after citing a palette that dates to the reign of Thutmose IV. A statue from Deir el-Medina may also belong to this individual, see: Bernard Bruyère, *Rapport sur les fouilles de Deir el Médineh (1935-1940)*, FIFAO 20,2 (Cairo, 1952), 106-107, figs. 183-184, pl. XIX.

[51] Date based on the cartouche of Amenhotep III on the throne and bracelet of the king in the royal kiosk scene on PM (3) as well as Anen's family relationship as brother-in-law to the king. For a few existing publications with drawings and facsimile copies of the focal wall of TT 120, see: Davies, *BMMA*, part II (November, 1928-1929), 35-49; Cyril Aldred, *Akhenaton, King of Egypt* (London and New York, 1988), 166; Robins, *Art of Ancient Egypt*, 137, fig. 155. There is a recent publication by Brock, *JARCE* 36 (1999), 71-85. Photos are published in idem, "Polishing a Jewel in the Gebel: The Tomb of Anen (TT 120) Conservation Project," *BARCE* 183 (Fall-Winter 2002-2003), 1, 5-7.

[52] *PM* I,1(2), 252-254. The dating of TT 139 is based on the tomb lintel that gives Pairy's titles and depicts the deceased at each end adoring the cartouches of Amenhotep III with addresses to Amun and Mut (BM 1182: Hall, *Hieroglyphic Texts from Egyptian Stelae, etc., in the British Museum*, part VII (London, 1925), 6, pl. 7).

[53] *PM* I, 1(2), 274-275; Kampp, *Nekropole* I, 451. The painting in TT 161 bears distinct resemblance to paintings in TT 139 and TT 249, both of which are dated by king's cartouche to the reign of Amenhotep III.

[54] Kampp, *Nekropole* I, 467-469. On the middle register of PM (6) (Davies, *Two sculptors*, pl. XI), two artisans are portrayed working on a box that contains a pectoral with two cartouches of Amenhotep III which read *Imn-htp hk3-w3s* and *Nb-m3't-R'*. Although Davies dated the tomb into the early years of Amenhotep IV presumably on the basis of style, the closest stylistic parallels to TT 181 are found in the tomb of Kha (TT 8), which is dated to the reign of Amenhotep III; see n. 4 above.

[55] *PM* I,1(2), 327; Davies, *Menkheperrasonb*, 35-40, with line drawings of scenes. The kiosk scene of Amenhotep III dates the tomb which was once a part of the focal wall of TT 226. No longer *in situ*, the tomb was published by Davies, and the painting was removed in its entirety. Based on its archaeological context, publication, and complete state of preservation, it is included in this study. The painting is now on exhibit in the Luxor Museum of Art: Bothmer, et al., *The Luxor Museum of Ancient Egyptian Art*, no. 101, 79, fig. 59, pl. VII. The tomb is almost completely destroyed. Habachi (Labib Habachi, "Tomb No. 226 of the Theban Necropolis and its Unknown Owner," *Festschrift für Sigfried Schott zu seinem 70. Geburtstag am 20. August 1967*, edited by W. Helck (Wiesbaden, 1968), 61-70; supported by Paul J. Frandsen, "Heqareshu and the Family of Thutmosis IV," *Acta Orientalia* 37 (1976), 5-10) argued that Hekaresu was buried in TT 226, based largely on the title of *hrd n k3p*, a title Hekaresu never held and doesn't appear in TT 226. Likewise, the titles that are recorded for Hekaresu such as "Overseer of Nursing" (*imy-r mn'*), "Doorkeeper of Am[un]" (*iry-'3 n Im[n]*), and "Overseer of Works" (*imy-r k3t*) are not found in TT 226. For discussion, see: Bryan, *Thutmose IV*, 56, 247, 259-260; Roehrig, "The Eighteenth Dynasty titles royal nurse (*mn't nswt*), royal tutor (*mn' nswt*), and foster brother/sister of the Lord of the Two Lands (*sn/snt mn' n nb t3wy*)," 250-256.

[56] The cartouche of Amenhotep III on the tomb jamb of TT 249, now in the Egyptian Museum, Cairo, places the decoration of the tomb in the reign of Amenhotep III (Kampp, *OLZ* 86 (1991), 30; idem, *Nekropole* II, 524; Bryan, *Thutmose IV*, 303, n. 402; Kozloff, *Egypt's Dazzling Sun*, 280, n. 34). Manniche, *Three Theban Tombs*, 46 with n. 14, discounts the importance of the jamb, stating it may have been the last item made for

they were decorated primarily in relief (TT 47,[57] TT 48,[58] TT 57,[59] TT 107,[60] TT 257);[61] were reused and decorated during different periods under various owners (TT 54,[62] TT 58,[63] TT 68);[64] or were summarily published, or inaccessible, or largely undecorated and destroyed (TT 30,[65] TT 102,[66] TT 162,[67] TT 334,[68] TT 383).[69] Of the group of "tombs without official numbers,"[70] only three, A 24,[71] C 4,[72] and possibly A 21,[73] are localized in the necropolis. However these tombs

the tomb. Manniche prefers to date the tomb to the reign of Thutmose IV based largely on the presence of the square offering table; see Introduction, n. 18.

[57] *PM* I,1(2), 87, presently inaccessible; decoration described in Howard Carter, "Report of work done in Upper Egypt (1902-1903)," *ASAE* 4 (1903), 177-178; Kampp, *Nekropole* I, 246: "Das Grab is heute nicht mehr auffindbar...". See also Kozloff, *Egypt's Dazzling Sun*, 275, 289-290, no. 56.

[58] Säve-Söderbergh, *Four Eighteenth Dynasty Tombs*, 33-49, pl. XXX-LXIII.

[59] Victor Loret, "La tombe de Khâ-m-hâ," *Mém. Miss.* I (1884), 113-132; *PM* I,1(2), 113-119; Betsy M. Bryan, "Private Relief Sculpture Outside Thebes and Its Relationship to Theban Relief Sculpture," in *The Art of Amenhotep III: Art Historical Analysis*, edited by L. Berman (Cleveland, 1990), 65-80.

[60] Wegner, *MDAIK* 4 (1933), pl. XX; MMA photos T. 2987-2998, 3122; *PM* I,1(2), 224-225.

[61] Maha F. Mostafa, *Das Grab des Neferhotep und des Meh (TT 257)*, Theben VIII (Mainz, 1995); the tomb was also usurped in the twentieth dynasty by Mahu.

[62] Daniel Polz, *Das Grab des Hui und des Kel: Theben Nr. 54*, AV 74 (Mainz, 1997), 125-127.

[63] *PM* I,1(2), 119-120; Kampp, *Nekropole* I, 269-272. The original occupant's name and title is also unknown: The name Amenemhat assigned by Polz (Polz, *MDAIK* 46 (1990), 307, n. 19) was the repetition of a mistake originally made by Gardiner, who confused the adjoining tomb TT 122 belonging to Amenemhat with TT 58 (Gardiner notebook No. 70, p. 46; Kampp, *passim.*, 269). The Ramesside reuser also emulated the original decoration, which dated to the reign of Amenhotep III, and added images of himself to existing scenes.

[64] Karl-Joachim Seyfried, *Das Grab des Paenkhemenu (TT 68) und die Anlage TT 227*, Theben VI (Mainz, 1991), 10, 126-128. The tomb was apparently not decorated by the first occupant, Meryptah, who lived during the reign of Amenhotep III; the successive occupants from the twentieth dynasty were responsible for the decoration.

[65] *PM* I,1(2), 46-47; Kampp, *Nekropole* I, 215-219, who states that the original decoration dating to the reign of Amenhotep III, if the tomb was ever decorated then, is no longer preserved.

[66] *PM* I,1(2), 215-216. Even at the turn of the last century, Mond, *ASAE* 6 (1905), 67, mentioned that the inscriptions in the tomb were "nearly completely destroyed." Kampp, *Nekropole* I, 375, notes that the architecture of the tomb places it in the time of Hatshepsut/Thutmose III and was reused by a man named Amenhotep, during the reign of Amenhotep III, who decorated the tomb facade.

[67] Nina Davies, *Some Theban Tombs*, 14-18; *PM* I,1(2), 275-276. While Daressy took photographs of the chapel in 1895 (Georges Daressy, "Une flotille phénicienne d'après une peinture égyptienne," *Revue archéologique*, 3 sér., vol. 27 (1895), 286-292, pls. XIV, XV), they are not detailed nor clear enough to be used for stylistic analysis. Facsimile drawings of the scant remains of the focal wall decoration on PM (2) & (4) were done by Nina de Garis Davies (Ibid., pl. XVIc) and are in the archive of the Griffith Institute, Oxford. The tomb is currently inaccessible (*PM* I,1(2), 275; Kampp, *Nekropole* I, 452).

[68] *PM* I,1(2), 401; Kampp, *Nekropole* II, 579: "Die Anlage TT 334 konnte während der Nekropolenbegehung nicht aufgefunden werden."

[69] *PM* I,1(2), 436; Kampp, *Nekropole* II, 602; no decoration cited, except for the sarcophagus chamber.

[70] *PM* I, 1(2), 447. "Tombs without official numbers" indicates their current position is unknown. See modifications to this below.

[71] This tomb was discussed by Manniche, *Lost Tombs*, 93-99, who admirably reconstructed the tomb program. One drawing done by John Gardner Wilkinson that was published in *The manners and customs of the ancient Egyptians* (London, 1837-1841) was fit by Manniche into the left western wall of the hall. Waseda University later rediscovered the tomb and found traces of a fishing and fowling scene on "the west wall of its hall" (Jiro Kondo, "The Re-discovery of Theban Tombs of A21 and A24," in *Atti del VI Congresso Internazionale di Egittologia*, vol. 1 (Turin, 1993), 371-374; Waseda University, Egypt Cultural Center, *Research in Egypt: 1966-1991* (Tokyo, 1991), 21ff. Unfortunately, the author could not verify the remains and their assignment in 2003, since the tomb appears to be used as a dwelling for the family of Husein Ahmed Masaud. For these reasons A 24 has been omitted from this study. See also: *PM* I,1(2), 454; Kampp, *Nekropole* II, 618.

[72] *PM* I,1(2), 457; Manniche, *Lost Tombs*, 100-124. Manniche dates the tomb stylistically to the reign of Amenhotep III. See in particular the similarity between the style of C 4 (Ibid., pl. 42) and figures in the tomb of Menna (TT 69 = Lhote and Hassia, *La peinture égyptienne*, pl. 54, 57) and Pairy (TT 139 = Ibid., pl. 14). However, the layout of C-4 could not be located, and seems to have disappeared under the house of the Badhdady family. According to Lise Manniche who entered the tomb in 1985, the original decorative program no longer remains on the walls having been removed or obscured by a layer of modern mud plaster. While Manniche valiantly reconstructed much of the decoration using tracings done by Hay and inserting small fragments now found in various European museums, the scene of the fields of *Iaru* is rather unusual for the western back wall in pre-Amarna T-shaped tombs. Burton's clue that the scene decorated "the south end" of the chapel indicates that it was probably originally found on the left side wall of the transverse hall, a point Manniche also suggests. Given the lack of decoration of the back walls of the transverse hall that remains *in situ* as well as the current inaccessibility of the chapel, C-4 is not added to the corpus of tombs in this study.

[73] *PM* I,1(2), 453. However, Kampp, *Nekropole* II, 617, states "Identifikation mit W 5 fraglich....." On W 5, see: Kondo, *Sesto Congresso Internazionale di Egittologia: Atti*, vol. 1, 371-374; Waseda University, *Research in Egypt*, 21ff. Manniche, *Lost Tombs*, 53-54, dates the tomb to Amenhotep III based on the king's cartouche but she does not reconstruct it.

have decoration that is completely destroyed or has been reconstructed based on sketches that cannot be checked against the remaining decoration which does not allow for in-depth study of the iconography. The other tombs, including A 19,[74] A 22,[75] C 1,[76] C 6,[77] E 2,[78] and E 4,[79] are lost or are preserved only in fragments in European museums.

Tombs dated by Kampp to the transitional period of Amenhotep III/Amenhotep IV lie outside the scope of this inquiry, largely due to the appearance of stylistic tendencies that are characteristic of Amarna art.

[74] *PM* I, 1(2), 453; Kampp, *Nekropole* II, 617; Manniche, *Lost Tombs*, 52-53, belonging to Amenhotep based on a funerary cone in: Davies and Macadam, *Corpus*, nr. 482, dating to the reign of Thutmose IV.

[75] Belonging to Neferhebef. *PM* I,1(2), 453-454; Kampp, *Nekropole* II, 617, dating to the reign of Thutmose IV after Manniche, *Lost Tombs*, 54-55, fig. 8a (?), 9. Fragment preserved in the Louvre D 60.

[76] Victor Loret, "Le tombeau de l'am-xent Amen-hotep," *Mém. Miss.* I, 1 (1889), 23-32, who dated the tomb to the reign of Amenhotep II. *PM* I,1(2), 456; Manniche, *Lost Tombs*, 57.

[77] *PM* I,1(2), 458-459; Manniche, *Lost Tombs*, 125-135, dated to Thutmose IV/Amenhotep III based on his titles. Only very brief descriptions of the scenes were given by Lepsius, Rosellini, and Champollion with contradictory statements on their placement in the tomb. Furthermore, there was no plan of the tomb ever drawn nor of the scenes.

[78] Kampp, *Nekropole* II, 621. The tomb of the "scribe and counter of grain," Nebamun, is now in fragments in the British Museum. See reconstruction in: Manniche, *Lost Tombs*, 136-157, plates 44-48. Stylistically dated to the reign of Amenhotep III, see: Kozloff, *NARCE* 95 (Fall 1975-Winter 1976), 8. No plan of the tomb was made when the fragments were removed, thus "it must be emphasized that due to lack of precise information about the appearance of the tomb, the reconstruction is conjectural" (Manniche, *Lost Tombs*, 155).

[79] Ibid. "The Turin Tomb," is now in fragments in the Museo Egizio in Turin. See reconstruction of one wall in Manniche, *Lost Tombs*, 181-184, pl. 58, who dates it to the end of the eighteenth dynasty.

LIST OF TABLES, FIGURES, AND PLATES

Tables:

Table 1: Tomb Owner's Name, Characteristic Title, and Institutional Affiliation, Painting Style and Date

Table 2: Icons on Tomb Chapel Focal Walls

Figures:

All drawings by Tamara Bower unless otherwise noted.

Figure 1: Lateral view of the tomb of Nakht (TT 52) (William J. Murnane, "Paintings from the Tomb of Nakht at Thebes," *Field Museum of Natural History Bulletin* 52, no. 10 (November, 1981), 13).

Figure 2: Reconstruction of the facade and courtyard of an eighteenth dynasty tomb chapel, ca. 1550-1290 (Kampp-Seyfried, *Egypt: The World of the Pharaohs,* fig. 197). Courtesy of Friederike Kampp-Seyfried.

Figure 3: Ground plans types of New Kingdom Theban tombs (Kampp, *Nekropole* I, fig. 1). Courtesy of Friederike Kampp-Seyfried.

Figure 4: Focal walls of T-shaped and rectangular Theban tomb chapels.

Figure 5: Architectural and symbolic levels of private tombs (Kampp-Seyfried, *Egypt: The World of the Pharaohs*, 250). Courtesy of Friederike Kampp-Seyfried.

Figure 6: Feet of dancing Nubians from the antechamber (D) at the Palace of Malqata (After Tytus, *Palace of Amenhetep III*, figs. 6-7).

Figure 7: Drawing of left focal wall, tomb of Djeserkarasoneb (TT 38), PM (4) (Nina Davies, *Some Theban Tombs*, pl. III). Courtesy of the Griffith Institute, Oxford.

Figure 8: Drawing of right focal wall, tomb of Djeserkarasoneb (TT 38), PM (6) (Ibid., pl. V, VI, VII). Courtesy of the Griffith Institute, Oxford.

Figure 9: Drawing of left focal wall, tomb of Nakht (TT 52), PM (3) (Davies, *Nakht*, pl. 15).

Figure 10: Drawing of right focal wall, tomb of Nakht (TT 52), PM (6) (Ibid., pl. 22).

Figure 11: Drawing of left focal wall, tomb of Sobekhotep (TT 63), PM (4) & PM (5) (Dziobek and Raziq, *Sobekhotep*, taf. 34). Courtesy of the Deutsches Archäologisches Institut, Abteilung Kairo.

Figure 12: Drawing of right focal wall tomb of Sobekhotep (TT 63), PM (10) & PM (9) (Ibid., taf. 33). Courtesy of the Deutsches Archäologisches Institut, Abteilung Kairo.

Figure 13: Drawing of left focal wall, tomb of Hekerneheh (TT 64), PM (5).

Figure 14: Drawing of right focal wall, tomb of Hekerneheh (TT 64), PM (8).

Figure 15: Drawing of left focal wall, tomb of Hepu (TT 66), PM (4).

Figure 16: Drawing of right focal wall, tomb of Hepu (TT 66), PM (6) (Davies, *Some Theban Tombs*, pls. X-XI). Courtesy of the Griffith Institute, Oxford.

Figure 17: Drawing of part of the left focal wall, tomb of Menna (TT 69), PM (4).

Color Plates:

All photographs by Melinda Hartwig unless otherwise noted.

Plate 17,2: Seated male banqueter, tomb of Nebseny (TT 108), PM (5).

Plate 17,3: Procession in the Temple of Amun-Re at Karnak, tomb of Amenhotep-si-se (TT 75), PM (6).

Plate 18,1: Bringing of field products and offerings, tomb of Menna (TT 69), PM (2).

Plate 18,2: Figure of Amunet, Peristyle Court of Thutmose IV in the Temple of Amun-Re at Karnak.

Plate 18,3: West wall of the Peristyle Court of Thutmose IV in the Temple of Amun-Re at Karnak.

Black and White Plates:

B&W Plate 1: Leaping calf, side panel of a bench in the southwest suite of the palace of Amenhotep at Malqata (MMA 11.215.453). All rights reserved, The Metropolitan Museum of Art.

B&W Plate 2,1: Left focal wall, tomb of Menna (TT 69), PM (4) (Zahi Hawass and Mahmoud Maher-Taha, *Le tombeau de Menna* [TT. No. 69] (Cairo, 2002), pl. XXXVII A-B). Courtesy of the Centre d'étude et de documentation sur l'ancienne Egypte.

B&W Plate 2,2: Right focal wall, tomb of Re (TT 201), PM (7). Photograph by Melinda Hartwig.

B&W Plate 3: Left focal wall, tomb of Tjanuny (TT 74), PM (5) & PM (6) (Brack, *Tjanuni*, taf. 28a and 29a). Courtesy of the Deutsches Archäologisches Institut, Abteilung Kairo.

B&W Plate 4: Right focal wall, tomb of Tjanuny (TT 74), PM (11) & PM (10) (Ibid., taf. 28b and 29b). Courtesy of the Deutsches Archäologisches Institut, Abteilung Kairo.

B&W Plate 5: Right focal wall, tomb of Pairy (TT 139), PM (6). The Metropolitan Museum of Art, Photography by Egyptian Expedition, 1925-1926.

B&W Plate 6: Right focal wall, tomb of Pairy (TT 139), PM (5). The Metropolitan Museum of Art, Photography by Egyptian Expedition, 1925-1926.

B&W Plate 7: Left focal wall, tomb of Nakht (TT 161), PM (3) & (2). Painting by Marcelle Baud. Musées Royaux d'Art et d'Histoire, *La Tombe de Nakht,* Guides du département Égyptien, no. 1 (Brussels, 1972). Copyright IRPA-KIK, Brussels.

BIBLIOGRAPHY

Aldred, Cyril. *New Kingdom Art in Ancient Egypt During the Eighteenth Dynasty 1570-1320 B.C.* 2d rev. ed. (London, 1961).

Aldred, Cyril. "The 'New Year' Gifts to the Pharaoh." *JEA* 55 (1969): 73-81.

Aldred, Cyril. "The Foreign Gifts Offered to Pharaoh." *JEA* 56 (1970): 105-116.

Aldred, Cyril. "Bild ("Lebendigkeit"eines Bildes)." *LÄ* I (1975): 793-795.

Aldred, Cyril. "Grabdekoration." *LÄ* II (1977): 853-857.

Aldred, Cyril. *Akhenaton, King of Egypt* (London and New York, 1988).

Aling, Charles F. "A Prosopographical Study of the Reigns of Thutmosis IV and Amenhotep III." Ph.D. Dissertation, University of Minnesota, 1976.

Aling, Charles F. "The title 'Overseer of Horses' in the Egyptian Eighteenth Dynasty." *Near East Archaeological Society Bulletin* 38 (1993): 53-60.

Allam, Schafik. *Hieratische Ostraka und Papyri aus der Ramessidenzeit.* URAÄ 1 (Tübingen, 1973).

Allam, Schafik. "Inheritance." *OEAE* II (2001): 158-161.

Allen, James P. "Nefertiti and Smenkh-ka-re." *GM* 141 (1994): 7-17.

Allen, James P. *Middle Egyptian. An Introduction to the Language and Culture of Hieroglyphs* (Cambridge, 2000).

Allen, James P. "Ba." *OEAE* I (2001): 161-162.

Allen, James P. "Shadow." *OEAE* III (2001): 277-278.

Altenmüller, Brigitte. "Anubis." *LÄ* III (1975): 327-333.

Altenmüller, Hartwig. "Abydosfahrt." *LÄ* I (1975): 42-47.

Altenmüller, Hartwig. "Denkmal memphitischer Theologie." *LÄ* I (1975): 1066-1069.

Altenmüller, Hartwig. "Feste." *LÄ* II (1977): 171-191.

Altenmüller, Hartwig. "Opfer." *LÄ* IV (1982): 579-584.

Althusser, Louis. *Lenin and philosophy and other essays.* Translated from the French by B. Brewster (New York, 1971).

Amer, Amin A.M.A. "A Unique Theban Tomb Inscription under Ramesses VIII." *GM* 49 (1981): 9-12.

Andreu, Guillemette. "Polizei." *LÄ* IV (1982): 1068-1071.

Andreu, Guillemette, Marie-Hélène Rutschowscaya, and Christiane Ziegler. *Ancient Egypt at the Louvre* (Paris, 1997).

Andrews, Carol. *Ancient Egyptian Jewellery* (London, 1996).

Arnold, Dieter. *Wandrelief und Raumfunktion in ägyptischen Tempeln des Neuen Reiches.* MÄS 2 (Berlin, 1962).

Arnold, Dieter. "Grabbau. A." *LÄ* II (1977): 846-851.

Arnold, Dieter. *The encyclopedia of ancient Egyptian architecture*. Translated from the German by S.H. Gardiner and H. Strudwick. Edited by N. and H. Strudwick (Princeton, 2003).

Assmann, Jan. "Flachbildkunst des Neuen Reiches." *Die Alte Ägypten*. Edited by C. Vandersleyen. Propyläen Kunstgeschichte 15 (Berlin, 1975): 304-325.

Assmann, Jan. *Zeit und Ewigkeit im alten Ägypten* (Heidelberg, 1975).

Assmann, Jan. "Fest des Augenblicks--Verheissung der Dauer. Die Kontroverse der ägyptischen Harfnerlieder." In *Fragen an die altägyptische Literatur: Studien zum Gedenken an Eberhard Otto*. Edited by J. Assmann, E. Feucht, R. Grieshammer (Wiesbaden, 1977): 55-84.

Assmann, Jan. "Harfnerlieder." *LÄ* II (1977): 972-982.

Assmann, Jan. "Eine Traumoffenbarung der Göttin Hathor: Zeugnisse 'Persönlicher Frömmigkeit' in thebanischen Privatgräbern der Ramessidenzeit." *RdÉ* 30 (1978): 22-50.

Assmann, Jan. "Die Gestalt der Zeit in der ägyptischen Kunst." In *5000 Jahre Ägypten: Genese und Permanenz Pharaonischer Kunst*. Edited by J. Assmann and G. Burkard (Nussloch, 1983): 11-32.

Assmann, Jan. "Schrift, Tod und Identität. Das Grab als Vorschule der Literatur im alten Ägypten." *Schrift und Gedächtnis: Beiträge zur Archäologie der literarischen Kommunikation* I. Edited by A. and J. Assmann, C. Hardmeier (Munich, 1983): 64-93.

Assmann, Jan. *Theologie und Frömmigkeit einer frühen Hochkultur* (Stuttgart-Berlin-Köln-Mainz, 1984).

Assmann, Jan. "Das Grab mit gewundenem Abstieg. Zum Typenwandel des Privat-Felsgrabes im Neuen Reich." *MDAIK* 40 (1984): 277-290.

Assmann, Jan. "Vergeltung und Erinnerung." In *Studien zu Sprache und Religion Ägyptens. Zu Ehren von Wolfhart Westendorf*. Edited by F. Junge (Göttingen, 1984): 687-701.

Assmann, Jan. "Totenkult, Totenglauben." *LÄ* VI (1986): 659-676.

Assmann, Jan. "Hierotaxis: Textkonstitution und Bildkomposition in der ägyptischen Kunst und Literatur." In *Form und Mass: Beiträge zur Literatur, Sprache und Kunst des alten Ägypten. Festschrift für Gerhard Fecht*. Edited by J. Osing and G. Dreyer. ÄAT 12 (Wiesbaden, 1987): 18-42.

Assmann, Jan. "Priorität und Interesse: Das Problem der Ramessidischen Beamtengräber." In *Problems and Priorities in Egyptian Archaeology*. Edited by J. Assmann, G. Burkard and V. Davies (London and New York, 1987): 31-42.

Assmann, Jan. "Sepulkrale Selbstthematerisierung im alten Ägypten." *Selbstthematisierung und Selbstzeugnis: Bekenntnis und Geständnis*. Edited by A. Hahn and V. Kapp (Frankfort, 1987): 208-232.

Assmann, Jan. "Ikonographie der Schönheit im alten Ägypten." In *Schöne Frauen - schöne Männer. Literarische Schönheitsbeschreibungen*. Edited by Th. Stemmler (Mannheim, 1988): 13-32.

Assmann, Jan. "Der schöne Tag, Sinnlichkeit und Vergänglichkeit im altägyptischen Fest." In *Das Fest*. Edited by W. Haug and R. Warning. Poetik und Hermeneutik 14 (Munich, 1989): 3-28.

Assmann, Jan. "State and Religion in the New Kingdom." In *Religion and Philosophy in Ancient Egypt*. YES 3 (New Haven, 1989): 55-88.

Assmann, Jan. "Ikonologie der Identität. Vier Stilkategorien der ägyptischen Bildniskunst." In *Das Bildnis in der Kunst des Orients*. Edited by M. Kraatz, J. Meyer zur Capellen, D. Seckel (Stuttgart, 1990): 17-43.

Assmann, Jan. *Ma'at: Gerechtigkeit und Unsterblichkeit im alten Ägypten* (Munich, 1990).

Assmann, Jan. "Die Macht der Bilder. Rahmenbedingungen ikonischen Handelns im alten Ägypten." In *Genres in Visual Representations. Visible Religion 7* (Leiden, 1990): 1-20.

Assmann, Jan. *Ägypten. Theologie und Frömmigkeit einer frühen Hochkultur* (Stuttgart-Berlin-Cologne, 1991).

Assmann, Jan. "Das ägyptische Prozessionsfest." In *Das Fest und das Heilige: Religiöse Kontrapunkte zur Alltagswelt*. Edited by J. Assmann and Th. Sundermeier. Studien zum Verstehen fremder Religionen 1 (Gütersloh, 1991): 105-122.

Assmann, Jan. *Das Grab des Amenemope TT 41*, 2 vols. Theben III (Mainz, 1991).

Assmann, Jan. *Stein und Zeit. Mensch und Gesellschaft im Alten Ägypten* (Munich, 1991).

Assmann, Jan. *Das kulturelle Gedächtnis. Schrift, Erinnerung und politische Indentität in frühen Hochkulturen* (Munich, 1992).

Assmann, Jan. "Semiosis and Interpretation in Ancient Egyptian Ritual." In *Interpretation in Religion*. Edited by S. Bidermann and B.-A. Scharfstein. Philosophy and Religion: A Comparative Yearbook 2 (Leiden-New York-Köln, 1992): 87-109.

Assmann, Jan. "Zur Geschichte des Herzens im alten Ägypten." In *Die Erfindung des Inneren Menschen: Studien zur religiösen Anthropologie*. Edited by Th. Sundermeier and J. Assmann (Gütersloh, 1993): 81-112.

Assmann, Jan. "Ancient Egypt and the Materiality of the Sign (=Nr. 68)." In *Materialities of Communication*. Edited by H.U. Gumbrecht and K.L. Pfeiffer. Translated from the German by W. Whobrey (Stanford, 1994): 15-31.

Assmann, Jan. "Ocular Desire in a Time of Darkness. Urban Festivals and Divine Visibility in Ancient Egypt." In *Torat ha-Adam*. Edited by A.R.E. Agus and J. Assmann. Yearbook of Religious Anthropology 1 (Berlin, 1994): 13-29.

Assmann, Jan. *Egyptian Solar Religion in the New Kingdom. Re, Amun and the Crisis of Polytheism*. Translated from the German by A. Alcock (London and New York, 1995).

Assmann, Jan. "Geheimnis, Gedächtnis und Göttesnähe: zum Strukturwandel der Grabsemantik und der Diesseits-Jenseitsbeziehungen im Neuen Reich." In *Thebanische Beamtennekropolen. Neue Perspektiven archäologischer Forschung, Internationales Symposion Heidelberg 9.- 13.6.1993*. Edited by J. Assmann, E. Dziobek, H. Guksch, F. Kampp. SAGA 12 (Heidelberg, 1995): 281-293.

Assmann, Jan. "Der literarische Aspekt des ägyptischen Grabes und seine Funktion im Rahmen des 'monumentalen Diskurses.'" In *Ancient Egyptian Literature: History and Forms*. Edited by A. Loprieno (Leiden-New York-Köln, 1996): 97-104.

Assmann, Jan. "Preservation and Presentation of Self in Ancient Egyptian Portraiture." *Studies in Honor of William Kelley Simpson*, vol. 1. Edited by P. Der Manuelian (Boston, 1996): 55-81.

Assmann, Jan. *Ägyptische Hymnen und Gebete*. 2d rev. ed. (Göttingen, 1999).

Assmann, Jan. *The Search for God in Ancient Egypt*. Translated from the German by D. Lorton (Ithaca and London, 2001).

Assmann, Jan. *The Mind of Egypt: History and Meaning in the Time of the Pharaohs*. Translated from the German by A. Jenkins (New York, 2002).

Aufrère, Sydney. "Les couleurs sacrées dans l'Egypte ancienne: vibration d'une lumière minérale." *Techne* 9-10 (1999): 26-29.

Aufrère, Sydney. *L'univers minéral dans la penseé égyptienne*, 2 vols. BdÉ 105/1-2 (Cairo, 1991).

Badawy, Alexander. "The Stela of Irtysen." *CdÉ* 36, no. 72 (1961): 269-276.

Badawy, Alexander. *A History of Egyptian Architecture: The Empire (the New Kingdom)* (Berkeley and Los Angeles, 1968).

Baines, John. "Literacy and Ancient Egyptian Society." *Man* 18 (1983): 572-599.

Baines, John. "Color Terminology and Color Classification: Ancient Egyptian Color Terminology and Polychromy." *American Anthropologist* 87 (1985): 282-297.

Baines, John. *Fecundity Figures: Egyptian Personification and the Iconology of a Genre* (Warminster, 1985).

Baines, John. "Practical Religion and Piety." *JEA* 73 (1987): 79-98.

Baines, John. "Communication and display: the integration of early Egyptian art and writing." *Antiquity* 63 (1989): 471-482.

Baines, John. "Techniques of Decoration in the Hall of Barques in the Temple of Sethos I at Abydos." *JEA* 75 (1989): 13-30.

Baines, John. "Restricted Knowledge, Hierarchy, and Decorum: Modern Perceptions and Ancient Institutions." *JARCE* 27 (1990): 1-23.

Baines, John. "Society, Morality, and Religious Practice." In *Religion in Ancient Egypt. Gods, Myths, and Personal Practice*. Edited by B. Shafer (London, 1991): 123-200.

Baines, John. "On the Status and Purposes of Ancient Egyptian Art." *CAJ* 4 (1994): 67-94.

Baines, John. "Egypt, ancient, IV, I (iiii): Ideology and conventions of representation: Decorum." *The Dictionary of Art*, vol. 9. Edited by J. Turner (New York, 1996): 796-798.

Baines, John. "The Dawn of the Amarna Age." In *Amenhotep III: Perspectives on His Reign*. Edited by D. O'Connor and E. Cline (Ann Arbor, 1998): 271-312.

Baines, John. "Colour use and the distribution of relief and painting in the Temple of Sety I at Abydos." In *Colour and Painting in Ancient Egypt*. Edited by W.V. Davies (London, 2001).

Baines, John, and C.J. Eyre. "Four Notes on Literacy." *GM* 61 (1983): 65-96.

Baines, John, and Norman Joffee, "Order, Legitimacy, and Wealth in Ancient Egypt and Mesopotamia." In *Archaic States*. Edited by G. Feinman and J. Marcus (Sante Fe, 1998): 199-260.

Baines, John, and Peter Lacovara. "Burial and the Dead in ancient Egyptian society." *Journal of Social Archaeology* 2.1 (2002): 5-36.

Balcz, Heinrich. "Zu dem 'Wasserberg.'" *MDAIK* 8 (1939): 158-160.

Barguet, Paul. *Le Temple d'Amon-Rê à Karnak*. Recherches d'archéologie, de philologie et d'histoire 21 (Cairo, 1962).

Barocas, Claudio. "La décoration des chapelles funéraires égyptiennes." In *La mort, les morts dans les sociétés anciennes*. Edited by G. Gnoli and J.-P. Vernant (Cambridge, 1982): 429-440.

Bárta, Miroslav. "Archaeology and Iconography: *bd3* and *'prt* bread moulds and 'Speisetischszene' development in the Old Kingdom." *SAK* 22 (1995): 21-35.

Barta, Winfried. *Die altägyptische Opferliste von der Frühzeit bis zur griechisch-römischen Epoche.* MÄS 3 (Berlin, 1963).

Barta, Winfried. *Aufbau und Bedeutung der altägyptischen Opferformel.* ÄF 24 (Glückstadt, 1968).

Barta, Winfried. *Das Selbstzeugnis eines altägyptischen Künstlers (Stele Louvre C 14).* MÄS 22 (Berlin, 1970).

Barta, Winfried. "Materialmagie und -symbolik." *LÄ* III (1980): 1233-1237.

Barta, Winfried. "Opferliste." *LÄ* IV (1982): 586-589.

Barwik, Mirosław. "Typology and Dating of the "White"-type Anthropoid Coffins of the Early XVIIIth Dynasty." *Études et Travaux* 18 (1999): 7-33.

Baud, Marcelle. *Les dessins ébauchés de la nécropole thébaine (au temps du Nouvel Empire).* MIFAO 63 (Cairo, 1935).

Beaud, Richard. "L'offrande du collier-*ousekh*." In *Studies in Egyptology Presented to Miriam Lichtheim*, vol I. Edited by S. Israelit-Groll (Jerusalem, 1990): 46-62.

Beinlich-Seeber, Christine, and Abdel Ghaffar Shedid. *Das Grab des Userhat (TT 56).* AV 50 (Mainz, 1987).

Beinlich-Seeber, Christine. "Renenutet." *LÄ* V (1984): 232-236.

Beinlich-Seeber, Christine. *Bibliographie Altägypten 1822-1946*, 3 vols. ÄA 61 (Wiesbaden, 1998).

Bell, Lanny. "Aspects of the Cult of Deified Tutankhamun." In *Mélanges Gamal Eddin Mokhtar*, vol. I. Edited by P. Posener-Kriéger. BdÉ 97 (Cairo, 1985): 31-59.

Bell, Lanny. "Luxor Temple and the Cult of the Royal *Ka.*" *JNES* 44 (1985): 251-294.

Bell, Lanny. "Family Priorities and Social Status: Preliminary Remarks on the Ancient Egyptian Kinship System." *Sesto Congresso Internazionale di Egittologia: Abstracts of Papers* (Turin, 1991): 96-97.

Bell, Lanny. "The Meaning of the Term Ka in The Instructions of Ptahhotep." Paper presented at the annual meeting of the American Research Center in Egypt, St. Louis, MO, April 12-14, 1996.

Bell, Lanny. "The New Kingdom 'Divine' Temple: The Example of Luxor." In *Temples of Ancient Egypt.* Edited by B. Shafer (London-New York, 1997): 127-184.

Bell, Lanny D. "Appendix: Ancient Egyptian Personhood (Anthropology/Psychology): the nature of humankind, individuality, and self-identity." *Akten der Ägyptologischen Tempeltagungen* 3. Edited by H. Beinlich, et al., ÄAT 33 (Wiesbaden, 2002): 38-42.

Bell, Martha. "Regional Variation in Polychrome Pottery of the 19th Dynasty." In *Cahiers de la ceramique égyptienne*, vol. I. Edited by P. Ballet (Cairo, 1987): 49-76.

Bell, Martha. "Floral Collars, *W3ḥ ny m3ʿ-ḫrw* in the Eighteenth Dynasty." In *Abstracts of Papers, Fifth International Congress of Egyptology.* Edited by A. Cherif (Cairo, 1988): 20.

Bell, Martha. "Lotiform collar terminal." In *Mummies and Magic: The Funerary Arts of Ancient Egypt.* Edited by S. D'Auria, et al. (Boston, 1988): 134.

Berman, Larry M. "Amenhotep III and His Times." In *Egypt's Dazzling Sun.* Edited by A. Kozloff and B. Bryan (Cleveland, 1992): 33-66.

Bianchi, Robert S. "Ancient Egyptian Reliefs, Statuary, and Monumental Paintings." *CANE* IV (1995): 2533-2554.

Bickel, Susanne. "Aspects et fonctions de la déification d'Amenhotep III." *BIFAO* 102 (2002): 63-60.

Bierbrier, Morris L. "Terms of Relationship at Deir el-Medina." *JEA* 66 (1980): 100-107.

Bierbrier, Morris L. *The Tomb-Builders of the Pharaohs* (London, 1982).

Bierbrier, Morris L. "The Tomb of Sennedjem." In *Valley of the Kings: The Tombs and Funerary Temples of Thebes West*. Edited by K.R. Weeks (Vercelli, Italy, 2001): 340-349.

Binder, Susanne. "The Tomb Owner Fishing and Fowling." In *Egyptian Art: Principles and Themes in Wall Scenes*. Edited by L. Donovan and K. McCorquadale. Prism Archaeological Series 6 (Egypt, 2000): 111-128.

Björkman, Gun. "Neby, the Mayor of Tjaru in the Reign of Tuthmosis IV." *JARCE* 11 (1974): 43-51.

Blackman, Aylward M. *The rock tombs of Meir*, vol. II. ASE 23 (London, 1915).

Blackman, Aylward M. "Oracles in Ancient Egypt." *JEA* 12 (1926): 176-185.

Blackman, Aylward M. *Gods, Priests and Men. Studies in the Religion of Pharaonic Egypt*. Edited by A.B. Lloyd (London and New York, 1998).

Bleiberg, Edward. "The Redistributive Economy in New Kingdom Egypt: an Examination of *b3kw(t)*." *JARCE* 25 (1988): 157-168.

Bleiberg, Edward. *The Official Gift in Ancient Egypt* (Norman, Oklahoma and London, 1996).

Bochi, Patricia A. "Images of Time in Ancient Egyptian Art." *JARCE* 31 (1994): 55-62.

Bochi, Patricia A. "Gender and Genre in Ancient Egyptian Poetry: The Rhetoric of Performance in the Harpers' Songs." *JARCE* 35 (1998): 89-95.

Bochi, Patricia A. "Death by Drama: The Ritual of *Damnatio Memoriae* in Ancient Egypt." *GM* 171 (1999): 73-86.

Bogoslovsky, Evgeni S. "Hundred Egyptian Draughtsmen." *ZÄS* 107 (1980): 89-116.

Bolshakov, Andrey. "The Moment of the Establishment of the Tomb-Cult in Ancient Egypt." *Altorientalische Forschungen* 19 (1991): 204-218.

Bolshakov, Andrey O. *Man and his Double in Egyptian Ideology of the Old Kingdom*. ÄAT 37 (Wiesbaden, 1997).

Bolshakov, Andrey O. "Ka." *OEAE* II (2001): 215-217.

Bolshakov, Andrey O. "Ka-Chapel." *OEAE* II (2001): 217-219.

Bolshakov, Andrey O. "Offerings: Offering Tables." *OEAE* II (2001): 572-576.

Bomann, Ann H. *The Private Chapel in Ancient Egypt* (London and New York, 1991).

Bommas, Martin. "Zur Datierung einiger Briefe an die Toten." *GM* 173 (1999): 53-60.

Bonhême, Marie-Ange. "Royal Roles." Translated from the French by E. Schwaiger. *OEAE* III (2001): 159-163.

Bonnel, Roland G. "The ethics of el-Amarna." In *Studies in Egyptology Presented to Miriam Lichtheim*. Edited by S. Israelit-Groll (Jerusalem, 1990): 71-97.

Bonnet, Charles, and Dominique Valbelle. "Le village de Deir el-Médineh. Reprise de l'étude archéologique." *BIFAO* 75 (1975): 429-446.

Bonnet, Hans. *Die ägyptische Tracht bis zum Ende des Neuen Reiches* (Leipzig, 1917).

Bonnet, Hans. *Reallexikon der ägyptischen Religionsgeschichte*, 3d ed. (Berlin, 2000).

Borchardt, Ludwig. "Ausgrabungen in Tell el-Amarna 1913/14: vorläufiger Bericht." *MDOG* 55 (1914): 3-39.

Borchardt, Ludwig. *Statuen und Statuetten von Königen und Privatleuten*, vol. 3. Catalogue général des antiquités égyptiennes du musée du Caire nos. 1-1294 (Berlin, 1930).

Borghouts, J.F. *Nieuwjaar in het Oude Egypte* (Leiden, 1986).

Bothmer, Bernard V., et al. *The Luxor Museum of Ancient Egyptian Art. Catalogue* (Cairo, 1979).

Boulanger, Robert, and Hatice Nesrin. *Egyptian Painting and the Ancient Near East*. Translated from the French by A. Rhodes (London, 1965).

Bouriant, Urbain. "Le tombeau d'Harmhabi." *Mém. Miss.* V,2 (1894): 413-434.

Brack, Artur, and Annelies Brack. *Das Grab des Tjanuni. Theben Nr. 74*. AV 19 (Mainz, 1977).

Brack, Artur, and Annelies Brack. "Hieratische Ostraka vom Grab des Tjanuni, Theben Nr. 74, Funde von der Schweizerischen Grabung 1975." In *Acts, First International Conference of Egyptology*. Edited by W. F. Reineke. Schriften zur Geschichte und Kultur des Alten Orients 14 (Berlin, 1979): 121-124.

Brack, Artur, and Annelies Brack. *Das Grab des Haremhab. Theben Nr. 78*. AV 35 (Mainz, 1980).

Brand, Peter. "The Iconography of the *Shebyu*-Collar in the New Kingdom." *JARCE* 40 (2003). In Press.

Bresciani, Edda. "Foreigners." In *The Egyptians*. Edited by S. Donadoni and translated from the Italian by B. Bianchi (Chicago, 1997): 221-254.

Brewer, Douglas J. "Cattle." *OEAE* I (2001): 242-244.

Brewer, Douglas J. "Fish." *OEAE* I (2001): 532-535.

Brewer, Douglas J. and Renée F. Freidman. *Fish and Fishing in Ancient Egypt* (Warminster, 1989).

Brewer, Douglas J., Terence Clark and Adrian Phillips. *Dogs in Antiquity* (Warminster, England, 2001).

Brock, Lyla Pinch. "Jewels in the Gebel: A Preliminary Report on the Tomb of Anen." *JARCE* 36 (1999): 71-85.

Brock, Lyla Pinch. "Polishing a Jewel in the Gebel: The Tomb of Anen (TT 120) Conservation Project." *BARCE* 183 (Fall-Winter 2002-2003): 1, 3-7.

Brock, Lyla Pinch. "ARCE's Egyptian Antiquities Project: The Anen Protection Project-Guarding A Jewel in the Gebel." Paper presented at the American Research Center in Egypt, Cairo, Egypt, September 17, 2003.

Brock, Lyla Pinch, and Roberta Lawrie Shaw. "The Royal Ontario Museum Epigraphic Project-Theban Tomb 89 Preliminary Report." *JARCE* 34 (1997): 167-177.

Brovarski, Edward. "Old Kingdom Beaded Collars." In *Ancient Egypt, the Aegean, and the Near East: Studies in Honour of Martha Rhoads Bell*, vol. I. Edited by J. Phillips, et al. (San Antonio, 1997): 137-162.

Brovarski, Edward, Susan K. Doll, and Rita E. Freed (eds.) *Egypt's Golden Age. The Art of Living in the New Kingdom, 1558-1085 B.C.* (Boston, 1982).

Brunner, Hellmut. "Eine Dankstele an Upuaut." *MDAIK* 16 (1958): 5-19.

Brunner, Hellmut. "Gerechtigkeit als Fundament des Thrones." *Vetus Testamentum* 8 (1958): 426-428.

Brunner, Hellmut. "Wiederum die ägyptischen 'Make Merry' Lieder." *JNES* 25 (1966): 130-131.

Brunner, Hellmut. "Herz." *LÄ* II (1977): 1158-1168.

Brunner, Hellmut. "Persönliche Frömmigkeit." *LÄ* IV (1982): 951-963.

Brunner, Hellmut. "Trunkenheit." *LÄ* VI (1986): 773-777.

Brunner, Hellmut. "Tür und Tor." *LÄ* VI (1986): 778-787.

Brunner-Traut, Emma. "Blume." *LÄ* I (1975): 834-837.

Brunner-Traut, Emma. "Blumenstrauss." *LÄ* I (1975): 837-840.

Brunner-Traut, Emma. "Farben." *LÄ* II (1977): 117-128.

Brunner-Traut, Emma. "Geier." *LÄ* II (1977): 513-515.

Brunner-Traut, Emma. "Gesten." *LÄ* II (1977): 573-585.

Brunner-Traut, Emma. "Krokodil," *LÄ* III (1980): 791-801.

Brunner-Traut, Emma. "Lotos." *LÄ* III (1980): 1091-1096.

Bruyère, Bernard. *Rapport sur les fouilles de Deir el Médineh (1924-1925).* FIFAO 3 (Cairo, 1926).

Bruyère, Bernard. *Rapport sur les fouilles de Deir el Médineh (1935-1940).* FIFAO 20, II (Cairo, 1952).

Bruyère, Bernard. *Tombes thébaines de Deir el-Médineh à décoration monochrome* (Cairo, 1952).

Bryan, Betsy M. "Evidence for Female Literacy from Theban Tombs of the New Kingdom." *BES* 6 (1984): 17-32.

Bryan, Betsy M. "Portrait Sculpture of Thutmose IV." *JARCE* 24 (1987): 3-20.

Bryan, Betsy M. "Private Relief Sculpture Outside Thebes and Its Relationship to Theban Relief Sculpture." In *The Art of Amenhotep III: Art Historical Analysis*. Edited by L. Berman (Cleveland, 1990): 65-80.

Bryan, Betsy M. "The Tomb Owner and his Family." In Eberhard Dziobek and Mahmud Abdel Raziq, *Das Grab des Sobekhotep Theben Nr. 63*. AV 71 (Mainz, 1990): 81-88.

Bryan, Betsy M. *The Reign of Thutmose IV* (Baltimore and London, 1991).

Bryan, Betsy M. "Royal and Divine Statuary." In *Egypt's Dazzling Sun: Amenhotep III and His World*. Edited by A. Kozloff and B. Bryan (Cleveland, 1992): 125-153.

Bryan, Betsy M. "Private Statuary." In *Egypt's Dazzling Sun: Amenhotep III and His World*. Edited by A. Kozloff and B. Bryan (Cleveland, 1992): 237-240.

Bryan, Betsy M. "Statue of Anen, Second Prophet of Amen." In *Egypt's Dazzling Sun: Amenhotep III and His World*. Edited by A. Kozloff and B. Bryan (Cleveland, 1992): 249-250.

Bryan, Betsy M. "A work in progress: the unfinished tomb of Suemniwet." *Egyptian Archaeology* 6 (1995): 14-16.

Bryan, Betsy M. "The Disjunction of Text and Image in Egyptian Art." *Studies in Honor of William Kelly Simpson*. Edited by P. Der Manuelian (Boston, 1996): 161-168.

Bryan, Betsy M. "The statue program from the mortuary temple of Amenhotep III." In *The Temple in Ancient Egypt. New discoveries and recent research*. Edited by S. Quirke (London, 1997): 57-81.

Bryan, Betsy M. "Striding Glazed Steatite Figures of Amenhotep III: An Example of the Purposes of the Minor Arts." In *Chief of Seers: Egyptian Studies in Memory of Cyril Aldred*. Edited by E. Goring, N. Reeves, and J. Ruffle (London and New York, 1997): 60-82.

Bryan, Betsy M. "Antecedants to Amenhotep III." In *Amenhotep III: Perspectives on His Reign*. Edited by D. O'Connor and E. Cline (Ann Arbor, 1998): 27-62.

Bryan, Betsy M. "The 18th Dynasty before the Amarna Period (*c.* 1550-1352 BC)." In *The Oxford History of Ancient Egypt*. Edited by I. Shaw (Oxford, 2000): 218-271.

Bryan, Betsy M. "Amenhotpe III." *OEAE* I (2001): 72-74.

Bryan, Betsy M. "Painting techniques and artisan organization in the Tomb of Suemniwet, Theban Tomb 92." *Colour and Painting in Ancient Egypt*. Edited by W.V. Davies (London, 2001): 63-72.

Bryson, Norman. "Semiology and Visual Interpretation." In *Visual Theory: Painting and Interpretation*. Edited by N. Bryson, et al. (New York, 1991): 61-73.

Burkhard, Günter. "Die Besucherinschriften." In Eberhard Dziobek and Mahmud Abdel Raziq, *Das Grab des Sobekhotep Theben Nr. 63*. AV 71 (Mainz, 1990): 88-91.

Burnstein, Stanley M. "Images of Egypt in Greek Historiography." In *Ancient Egyptian Literature: History and Forms*. Edited by A. Loprieno. PÄ 10 (Leiden-New York-Köln, 1996): 591-604.

Butzer, Karl W. "Wüste." *LÄ* VI (1986): 1292-1295.

Camille, Michael. "Seeing and Reading: Some Visual Implications of Medieval Literacy and Illiteracy." *Art History* 8 (March, 1985): 26-49.

Caminos, Ricardo A. *Late Egyptian Miscellanies*. Brown Egyptological Studies 1 (London, 1954).

Carter, Howard. "Report of work done in Upper Egypt (1902-1903)." *ASAE* 4 (1903): 171-180.

Carter, Howard, and Percy Newberry, with Gaston Maspero, and G.E. Smith. *The Tomb of Thoutmôsis IV*. Bibân el Molûk Series (Westminster, 1904).

Cauville, Sylvie. *Dendara IV: Traduction*. OLA 101 (Leuven, 2001).

Černý, Jaroslav. "Papyrus Salt 124 (Brit. Mus. 10055)." *JEA* 15 (1929): 243-258.

Černý, Jaroslav. *A Community of Workmen at Thebes in the Ramesside Period*. BdÉ 50 (Cairo, 1973).

Černý, Jaroslav. *Catalogue des ostraca hiératiques non littéraires de Deir el Médineh*, vol. III. DIFAO 5 (Cairo, 1973).

Černý, Jaroslav. *The Valley of the Kings*. BdÉ 61 (Cairo, 1973).

Černý, Jaroslav, and Alan H. Gardiner. *Hieratic Ostraca*, vol. I (Oxford, 1957).

Chadefaud, Catherine. *Les statues porte-enseignes de l'Egypte ancienne (1580-1085 av. J.C.): Signification et insertion dans le culte du Ka royal* (Paris, 1982).

Champollion, Jean-François. *Notices descriptives*. Collection des classiques égyptologiques (Genève, 1973-1974).

Chassinat, Émile. *Le temple d'Edfou* I. Mem. Miss. 10 (Paris, 1897).

Chassinat, Émile. *Le temple d'Edfou* II-III. *Mem. Miss.* 11-20 (Paris, 1918 1928).

Chassinat, Émile. *Le temple d'Edfou* II, 2. 2d rev. ed by S. Cauville and D. Devauchelle. *Mem. Miss.* 11/22 (Cairo, 1990).

Cherpion, Nadine. "Quelques jalons pour une histoire de le peinture thébaine." *BSFÉ* 110 (Octobre, 1987): 27-47.

Cherpion, Nadine. *Mastabas et hypogées d'Ancien Empire: Le problème de la datation* (Brussels, 1989).

Cherpion, Nadine. "Le <<cône d'onguent>>, gage de survie." *BIFAO* 94 (1994): 79-106.

Cherpion, Nadine. "Sentiment conjugal et figuration à l'Ancien Empire." In *Kunst des Alten Reiches*. SDAIK 28 (Mainz, 1995): 33-47.

Chevereau, Pierre-Marie. *Prosopographie des cadres militaires égyptiens du Nouvel Empire* (Paris, 1994).

Ciccarello, Mark. "Shesmu the Letopolite." In *Studies in Honor of George R. Hughes*. SAOC 39 (Chicago, 1976): 43-54.

Clère, Jacques J. "Fragments d'une nouvelle représentation égyptienne du monde." *MDAIK* 16 (1958): 30-46.

Cline, Eric H. "Amenhotep III, the Aegean, and Anatolia." In *Amenhotep III: Perspectives on His Reign*. Edited by D. O'Connor and E. Cline (Ann Arbor, 1998): 236-249.

Colinart, Sylvie, and Michel Menu, eds. *La couleur dans la peinture et l'émaillage de l'Égypte ancienne*. Actes de la Table Rhonde Ravello, 20-22 mars 1997. Scienze e materiali del patrimonio culturale 4 (Bari, 1998).

Collier, Sandra A. "The Crowns of Pharaoh: Their Development and Significance in Ancient Egyptian Kingship." Ph.D. Dissertation, University of California-Los Angeles, 1996.

Collins, Lydia. "The Private Tombs of Thebes: Excavations by Sir Robert Mond 1905 and 1906." *JEA* 62 (1976): 18-40.

Cooney, Kathlyn. "The Economics of Art: An Analysis of Price and Wages from the Ramesside Period." Ph.D. Dissertation, The Johns Hopkins University, 2002.

Cruz-Uribe, Eugene. "Opening the Mouth as Temple Ritual," In *Gold of Praise: Studies on Ancient Egypt in Honor of Edward F. Wente*. Edited by E. Teeter and J.A. Larson. SAOC 58 (Chicago, 1999): 69-73.

Cruz-Uribe, Eugene. "Scripts: An Overview." *OEAE* III (2001): 192-198.

Cumming, Barbara. *Egyptian Historical Records of the Later Eighteenth Dynasty*, fasc. I-III (Warminster, 1982-1984).

Dambach, Martin, and Ingrid Wallert. "Das Tilapia-Motiv in der altägyptischen Kunst." *CdÉ* 41, no. 82 (1966): 273-294.

Dann, Rachael. "Clothing and the Construction of Identity: Examples from the Old and New Kingdoms." *Current Research in Egyptology* 2000. Edited by A. McDonald and C. Riggs. BAR International Series 909 (Oxford, 2000): 41-44.

Daressy, Georges. "Remarques et notes (suite)." *Rec. Trav.* 11 (1889): 79-95.

Daressy, Georges. "Une flotille phénicienne d'après une peinture égyptienne." *Revue archéologique*, 3 sér., 27 (1895): 286-292.

Daumas, François. "Hathor." *LÄ* II (1977): 1024-1033.

Daumas, François. "Neujahr." *LÄ* IV (1982): 466-472.

D'Auria, Sue, Peter Lacovara, and Catharine H. Roehrig. *Mummies and Magic: The Funerary Arts of Ancient Egypt* (Boston, 1988).

Davies, Benedict G. *Egyptian Historical Records of the Later Eighteenth Dynasty*, fasc. IV-VI (Warminster, 1992-1995).

Davies, Nina de Garis. *Ancient Egyptian Paintings*, 3 vols. (Chicago, 1936).

Davies, Nina de Garis. "Some representations of tombs from the Theban necropolis." *JEA* 24 (1938): 25-40.

Davies, Nina de Garis. *Egyptian Paintings* (London, 1954).

Davies, Nina de Garis. "Two Pictures of Temples." *JEA* 41 (1955): 80-82.

Davies, Nina de Garis. *Scenes from some Theban Tombs (Nos. 38, 66, 162, with excerpts from 81)*. PTT IV (Oxford, 1963).

Davies, Nina de Garis, and Norman de Garis Davies. "The Tomb of Amenmosě (No. 89) at Thebes." *JEA* 26 (1940): 131-136.

Davies, Nina de Garis, and Alan H. Gardiner. *The Tomb of Huy, viceroy of Nubia in the reign of Tut'ankhamun (no. 40)*. TTS 4 (London, 1926).

Davies, Nina de Garis, and Alan H. Gardiner. *La peinture égyptienne ancienne* (Paris, 1954).

Davies, Norman de Garis. *Five Theban Tombs*. ASE 21 (London, 1913).

Davies, Norman de Garis. *The Tomb of Nakht at Thebes*. PMMA, Robb de Peyster Tytus Memorial Series I (New York, 1917).

Davies, Norman de Garis. *The tomb of Antefoker, vizier of Sesostris I and of his wife, Senet (No. 60)*. TTS 2 (London, 1920).

Davies, Norman de Garis. *The tombs of two officials of Thutmosis IV (nos. 75 and 90)*. TTS 3 (London, 1923).

Davies, Norman de Garis. "A peculiar form of a New Kingdom lamp." *JEA* 10 (1924): 9-14.

Davies, Norman de Garis. "The place of audience in the palace." *ZÄS* 60 (1925): 50-56.

Davies, Norman de Garis. *The tomb of two sculptors at Thebes*. PMMA, Robb de Peyster Tytus Memorial Series 4 (New York, 1925).

Davies, Norman de Garis. "The Graphic Work of the Expedition." *BMMA*, part II (November, 1928-1929): 35-49.

Davies, Norman de Garis. "The town house in ancient Egypt." *Metropolitan Museum Studies* I (1929): 233-255.

Davies, Norman de Garis. *The tomb of Ken-Amun at Thebes*, 2 vols. PMMA 5 (New York, 1930).

Davies, Norman de Garis. *The tombs of Menkheperrasonb, Amenmose, and another (nos. 86, 112, 42, 226)*. TTS 5 (London, 1933).

Davies, Norman de Garis. *The tomb of Nefer-hotep at Thebes*, 2 vols. PMMA 9 (New York, 1933).

Davies, Norman de Garis. "The Egyptian Expedition 1934-1935." *BMMA*, part II (November, 1935): 3-57.

Davies, Norman de Garis. *The tomb of the vizier Ramose*. Mond Excavations at Thebes I (London, 1941).

Davies, Norman de Garis. *The tomb of Rekh-mi-re at Thebes*, 2 vols. PMMA 11 (New York, 1943; reprint 1973).

Davies, Norman de Garis, and Alan H. Gardiner. *The Tomb of Amenemhet (no. 82)*. TTS I (London, 1915).

Davies, Norman de Garis and M.F.L. Macadam, ed. *A Corpus of Inscribed Egyptian Funerary Cones* I (Oxford, 1957).

Davis, Whitney. "Plato on Egyptian Art." *JEA* 65 (1979): 121-127.

Davis, Whitney. *The Canonical Tradition in Ancient Egyptian Art* (Cambridge, 1989).

Davis, Whitney. "Communication Theory." *The Dictionary of Art*, vol. 7. Edited by J. Turner (New York, 1996): 659-662.

de Buck, Adriaan. *The Egyptian Coffin Texts*, 7 vols. (Chicago, 1935-1961).

de Cenival, J. L., and Gerhard Haeny. "Rapport préliminaire sur la troisième campagne de fouilles à Ouadi es-Sebouâ Novembre-Décembre 1961." *BIFAO* 62 (1964): 219-229.

de Keyser, E. *La signification de l'art dans les Enneades de Plotin* (Louvain, 1955).

Defossez, Michel. "Les laitues de Min." *SAK* 12 (1985): 1-4.

Delvaux, Luc and Eugène Warmenbol. *Les divins chats d'Égypte: un air subtil, un dangereux parfum* (Leuven, 1991).

Demarée, Robert. J. *The 3ḫ iḳr n rꜥ-stelae: On Ancestor Worship in Ancient Egypt*. EU 3 (Leiden, 1983).

Depuydt, Leo. "On the nature of the hieroglyphic script." *ZÄS* 121 (1994): 1-36.

Derchain, Philippe. "La visite de Vespasien au Sérapéum d'Alexandrie." *CdÉ* 28, no. 56 (1953): 261-279.

Derchain, Phillipe. "Le lotus, la mandragore et le perséa." *CdÉ* 50, nos. 99-100 (1975): 65-86.

Derchain, Phillipe. "La perruque et le cristal." *SAK* 2 (1975): 55-74.

Derchain, Phillipe. "Symbols and Metaphors in Literature and Representations of Private Life." *RAIN* 15 (1976): 7-10.

Derriks, Claire. "Mirrors." *OEAE* II (2001): 419-422.

Desroches-Noblecourt, Christiane. "Concubines du mort et mères de famille au Moyen Empire. A propos d'une supplique pour une naissance." *BIFAO* 53 (1953): 7-47.

Desroches-Noblecourt, Christiane. "Poissons, tabous et transformations du mort." *Kêmi* 13 (1954): 33-42.

Dessenne, André. *Le sphinx: Étude iconographique* (Paris, 1957).

Dittmar, Johanna. *Blumen und Blumensträusse als Opfergabe im alten Ägypten*. MÄS 43 (Munich-Berlin, 1986).

Dodson, Aidan. "Four Sons of Horus." *OEAE* I (2001): 561-563.

Dominicus, Brigitte. *Gesten und Gebärden in Darstellungen des Alten und Mittleren Reichs*. SAGA 10 (Heidelberg, 1994).

Dorman, Peter F. *The Monuments of Senenmut. Problems in Historical Methodology* (London, 1988).

Dorman, Peter F. "Two Tombs and One Owner." *Thebanische Beamtennekropolen. Neue Perspektiven archäologischer Forschung, Internationales Symposion Heidelberg 9.- 13.6.1993*. Edited by J. Assmann, E. Dziobek, H. Guksch, F. Kampp. SAGA 12 (Heidelberg, 1995): 141-154.

Doxey, Denise M. *Egyptian Non-royal Epithets in the Middle Kingdom: A Social and Historical Analysis* (Leiden, 1998).

Doxey, Denise M. "Names." *OEAE* II (2001): 490-492.

Doxey, Denise M. "Priesthood." *OEAE* III (2001): 68-73.

Drenkhahn, Rosemarie. "Darstellungen von Negern in Ägypten." Dissertation zur Erlangung der Doktorwürde der Philosophischen Fakultät der Universität Hamburg, 1967.

Drenkhahn, Rosemarie. "Auszeichnung." *LÄ* I (1975): 581-582.

Drenkhahn, Rosemarie. *Die Handwerker und ihre Tätigkeiten im alten Ägypten*. ÄA 31 (Wiesbaden, 1976).

Drenkhahn, Rosemarie. "Handwerker." *LÄ* II (1977): 949-951.

Drenkhahn, Rosemarie. "Leibwache." *LÄ* III (1980): 993-994.

Drenkhahn, Rosemarie. "Pinsel." *LÄ* IV (1982): 1053-1054.

Drenkhahn, Rosemarie. "Statussymbol." *LÄ* V (1984): 1270-1271.

Drenkhahn, Rosemarie. "Werkstatt." *LÄ* VI (1986): 1224-1225.

Drenkhahn, Rosemarie. "Artisans and Artists in Pharaonic Egypt." Translated from the German by J. Baines. *CANE* I (1995): 331-343.

Dunand, Françoise and Christiane Zivie-Coche. *Dieux et hommes en Égypte. 3000 av. J.-C. - 395 apr. J.-C.* Anthropologie religieuse. Histoire ancienne (Paris, 1991).

Dziobek, Eberhard. "The Architectural Development of Theban Tombs in the Early Eighteenth Dynasty." *Problems and Priorities in Egyptian Archaeology*. Edited by J. Assmann, G. Burkard, and V. Davies (London and New York, 1987): 69-80.

Dziobek, Eberhard. *Das Grab des Ineni Theben Nr. 81*. AV 68 (Mainz, 1992).

Dziobek, Eberhard, Thomas Schneyer, and Norbert Semmelbauer. *Eine ikonographische Datierungsmethode für thebanische Wandmalereien der 18. Dynastie*. SAGA 3 (Heidelberg, 1992).

Dziobek, Eberhard. *Die Gräber des Vezirs User-Amun Theben Nr. 61 und 131*. AV 84 (Mainz, 1994).

Dziobek, Eberhard. *Denkmäler des Vezirs User-Amun*. SAGA 18 (Heidelberg, 1998).

Dziobek, Eberhard, and Mahmud Abdel Raziq. *Das Grab des Sobekhotep Theben Nr. 63*. AV 71 (Mainz, 1990).

Eaton-Krauss, Marianne. "Concerning Standard-Bearing Statues." *SAK* 4 (1976): 69-73.

Eaton-Krauss, Marianne. "Broad-collar necklace." In *Egypt's Golden Age: The Art of Living in the New Kingdom 1558-1085 B.C.* Edited by E. Brovarski, S. K. Doll, R. E. Freed (Boston, 1982): 234, no. 307.

Eaton-Krauss, Marianne. "Disk Beads." In *Egypt's Golden Age: The Art of Living in the New Kingdom 1558-1085 B.C.*. Edited by E. Brovarski, S. K. Doll, R. E. Freed (Boston, 1982): 238-239, no. 316.

Eaton-Krauss, Marianne. *The Representations of Statuary in Private Tombs of the Old Kingdom.* ÄA 39 (Wiesbaden, 1984).

Eaton-Krauss, Marianne. "Akhenaten." *OEAE* I (2001): 48-51.

Eaton-Krauss, Marianne. "Artists and Artisans." *OEAE* I (2001): 136-140.

Eaton-Krauss, Marianne. "Tiye." *OEAE* III (2001): 411.

Edel, Elmar. "Untersuchungen zur Phraseologie der ägyptischen Inschriften des Alten Reiches." *MDAIK* 13 (1944): 1-90.

Edwards, I.E.S. *Treasures of Tutankhamun* (New York, 1976).

Eggebrecht, Arne. "Brandopfer." *LÄ* I (1975): 848-850.

Eichler, Selke S. *Die Verwaltung des"Hauses des Amun" in der 18. Dynastie.* SAK Beihefte 7 (Hamburg, 2000).

el Hadadi, M. Nabil. "Notes on Egyptian Weeds of Antiquity: 1. Min's Lettuce and the Nagada Plant." In *The Followers of Horus: Studies dedicated to Michael Allen Hoffman 1944-1990.* Edited by R. Friedman and B. Adams. Egyptian Studies Association Publication No. 2, Oxbow Monograph 20 (Oxford, 1992): 323-326.

el-Hotabi, Heike Sternberg. "Die 'Götterliste' des Sanktuars im Hibis-Temple von El-Chargeh: Überlegungen zur Tradierung und Kodifizierung religiösen und kulttopographischen Gedankengutes." In *Aspekte spätägyptischer Kultur. Festschrift für Erich Winter zum 65. Geburtstag.* Edited by M. Minas und J. Zeidler. Aegyptiaca Treverensia 7 (1994): 239-254.

el-Leithy, Hisham. "Letters to the Dead in Ancient and Modern Egypt." In *Egyptology at the Dawn of the Twenty-First Century: Proceedings of the Eighth International Congress of Egyptologists, Cairo 2000,* vol. 1. Edited by Z. Hawass and L.P. Brock (Cairo, 2003): 304-313.

El Mallakh, Kamal, and Arnold C. Brackman. *The Gold of Tutankhamen* (New York, 1978).

El-Menshawy, Sherine. "Pictorial Evidence Depicting the Interaction between the King and his People in Ancient Egypt." In *Current Research in Egyptology 2000.* Edited by A. McDonald and C. Riggs. BAR International Series 909 (Oxford, 2000): 83-89.

El-Menshawy, Sherine. "The Protocol of the Ancient Egyptian Royal Palace." In *Egyptology at the Dawn of the Twenty-First Century: Proceedings of the Eighth International Congress of Egyptologists, Cairo 2000,* vol. 2. Edited by Z. Hawass and L.P. Brock (Cairo, 2003): 400-406.

el-Shimy, Mohamed. "The Preparation and Use of Perfumes and Perfumed Substances in Ancient Egypt." In *Egyptology at the Dawn of the Twenty-First Century: Proceedings of the Eighth International Congress of Egyptologists, Cairo 2000,* vol. 2. Edited by Z. Hawass and L.P. Brock (Cairo, 2003): 509-513.

Engelmann-von Carnap, Barbara. "Soziale Stellung und Grabanlage: zur Struktur des Friedhofs der ersten Hälfte der 18. Dynastie in Scheich Abd el-Qurna und Chocha." In *Thebanische Beamtennekropolen. Neue Perspektiven archäologischer Forschung, Internationales Symposion Heidelberg 9.- 13.6.1993.* Edited by J. Assmann, E. Dziobek, H. Guksch, F. Kampp. SAGA 12 (Heidelberg, 1995): 107-128.

Engelmann-von Carnap, Barbara. "Zur zeitlichen Einordnung der Dekoration thebanischer Privatgräber der 18. Dynastie anhand des Fisch- und Vogelfang-Bildes." In *Stationen: Beiträge zur Kulturgeschichte Ägyptens: Rainer Stadelmann gewidmet.* Edited by H. Guksch and D. Polz (Mainz, 1998): 247-262.

Engelmann-von Carnap, Barbara. *Die Struktur des Thebanischen Beamtenfriedhofs in der ersten hälfte der 18. Dynastie: Analyse von Position, Grundrissgestaltung und Bildprogramm der Gräber.* ADAIK 15 (Berlin, 1999).

Englund, Gertie. *Akh - Une notion religieuse dans l'Égypte pharaonique.* Boreas 11 (Uppsala, 1978).

Englund, Gertie. "Gifts to the Gods - a necessity for the preservation of cosmos and life. Theory and praxis." *Gifts to the Gods: Proceedings of the Uppsala Symposium 1985.* Edited by T. Linders and G. Nordquist. Boreas 15 (Uppsala, 1987): 57-66.

Englund, Gertie. "Offerings: An Overview." *OEAE* II (2001): 564-569.

Epigraphic Survey. *Medinet Habu,* 8 vols. OIP 8, 9, 23, 51, 83, 84, 93, 94 (Chicago, 1930-1970).

Epigraphic Survey. *The Tomb of Kheruef. Theban Tomb 192.* OIP 102 (Chicago, 1980).

Erman, Adolf. "Gebete eines ungerecht Verfolgten und andere Ostraka aus den Königsgräbern." *ZÄS* 38 (1900): 19-41.

Erman, Adolf, and Hermann Grapow. *Wörterbuch der Aegyptischen Sprache,* I-VII, 4th ed. (Berlin, 1982); *Belegstellen* I-VI (Berlin, 1982).

Eschweiler, Peter. *Bildzauber im alten Ägypten.* OBO 137 (Freiburg and Göttingen, 1991).

Eyre, Christopher J. "A Draughtsman's Letter from Thebes." *SAK* 11 (1984): 195-207.

Eyre, Christopher J. "Work and the Organization of Work in the New Kingdom." In *Labor in the Ancient Near East.* Edited by M.A. Powell. AOS 68 (New Haven, 1987): 167-221.

Fakhry, Ahmed. "A Report on the Inspectorate of Upper Egypt." *ASAE* 46 (1947): 25-54.

Fantecchi, Silvana E., and Andrea P. Zingarelli. "Singers and Musicians in New Kingdom Egypt." *GM* 186 (2002): 27-35.

Farina, Guilio. *La pittura egiziana* (Milano, 1929).

Faulkner, Raymond O. "Egyptian Military Standards." *JEA* 27 (1941): 12-18.

Faulkner, Raymond O. "The Installation of the Vizier." *JEA* 41 (1955): 18-29.

Faulkner, Raymond O. *The Ancient Egyptian Pyramid Texts,* 2 vols. (Oxford, 1969).

Faulkner, Raymond O. *The Ancient Egyptian Coffin Texts,* 2 vols. (Warminster, 1977).

Faulkner, Raymond O. *The Ancient Egyptian Book of the Dead.* Rev. ed. (London, 1985).

Faulkner, Raymond O. *The Egyptian Book of the Dead.* With introduction and commentaries by C. Andrews and O. Goelet Jr. Edited by E. Von Dassow. (San Francisco, 1994).

Faulkner, Raymond O., and Norman de Garis Davies. "A Syrian Trading Venture to Egypt." *JEA* 33 (1947): 40-46.

Fazzini, Richard. *Images for Eternity. Egyptian Art from Berkeley and Brooklyn* (Brooklyn, 1975).

Fazzini, Richard, et. al. *Masterpieces in The Brooklyn Museum, New York* (New York, 1988).

Fecht, Gerhard. "Amarna-Probleme (1-2)." *ZÄS* 85 (1960): 83-118.

Feucht, Erika. "Gold, Verleihung des." *LÄ* II (1977): 731-733.

Feucht, Erika. "Pektorale." *LÄ* IV (1982): 922-923.

Feucht, Erika. "Verjüngung und Wiedergeburt." *SAK* 11 (1984): 401-417.

Feucht, Erika. *Das Grab des Nefersecheru (TT 296)*. Theben II (Mainz, 1985).

Feucht, Erika. "The *ḥrdw n k3p* Reconsidered." In *Pharaonic Egypt. The Bible and Christianity*. Edited by S. Israelit-Groll (Jerusalem, 1985): 38-47.

Feucht, Erika. "Fishing and Fowling with the Spear and the Throw-Stick Reconsidered." In *The Intellectual Heritage of Egypt. Studies presented to László Kákosy by Friends and Colleagues on the Occasion of his 60th Birthday*. Edited by U. Luft. Studia Aegyptiaca 14 (Budapest, 1992): 157-169.

Feucht, Erika. "Childhood." *OEAE* I (2001): 261-264.

Feucht, Erika. "Family." *OEAE* I (2001): 501-504.

Firth, Cecil M., and J.E. Quibell. *Excavations at Saqqara: The Step Pyramid*, 2 vols. (Cairo, 1935).

Fischer, Henry G. "An Elusive Shape within the Fisted Hands of Egyptian Statues." *MMJ* 10 (1975): 9-21.

Fischer, Henry G. "Geissel." *LÄ* II (1977): 516-517.

Fischer, Henry G. "Notes on Sticks and Staves in Ancient Egypt." *MMJ* 13 (1978): 5-32.

Fischer, Henry G. "Hunde, A." *LÄ* III (1980): 77-81.

Fischer, Henry G. *L'écriture et l'art de l'Égypte ancienne. Quatre leçons sur la paléographie et l'épigraphie pharaoniques* (Paris, 1986).

Fischer, Henry G. "Stöcke und Stäbe." *LÄ* VI (1986): 49-57.

Fischer-Elfert, Hans-Werner. "Uto." *LÄ* VI (1986): 906-911.

Fitzenreiter, Martin. "Zum Ahnenkult in Ägypten." *GM* 143 (1994): 51-72.

Fitzenreiter, Martin. "Totenverehrung und soziale Repräsentation im thebanischen Beamtengrab der 18. Dynastie." *SAK* 22 (1995): 95-130.

Fitzenreiter, Martin. "Grabdekoration und die Interpretation funerärer Rituale im Alten Reich." In *Social Aspects of Funerary Culture in the Egyptian Old and Middle Kingdoms*. Edited by H. Willems. OLA 103 (Leuven, 2001): 67-140.

Foster, John L. *Love Songs of the New Kingdom* (New York, 1974).

Foucart, George. *Tombes thébaines: nécropole de Dirâ' Abû'n Nâga*. In colaboration with Marelle Baud and Étienne Drioton. MIFAO 57 (Cairo, 1928).

Fox, Michael V. "A Study of Antef." *Orientalia* 46 (1977): 393-423.

Fox, Michael V. "The Entertainment Song Genre in Egyptian Literature." In *Egyptological Studies*. Edited by S. Israelit-Groll. Scripta Hierosolymitana 28 (Jerusalem, 1982): 268-316.

Frandsen, Paul J. "Heqareshu and the Family of Thutmosis IV." *Acta Orientalia* 37 (1976): 5-10.

Frandsen, Paul J. "Trade and Cult." In *The Religion of the Ancient Egyptians: Cognitive Structures and Popular Expressions*. Edited by G. Englund. Boreas 20 (Uppsala, 1989 (sic); 1991): 95-108.

Frandsen, Paul J. "The Letter to Ikhtay's Coffin: O. Louvre Inv. no. 698." In *Village Voices: Proceedings of the Symposium 'Texts from Deir el-Medina and their Interpretation,' Leiden, May 31 - June 1, 1991*. Edited by R.J. Demarée and A. Egberts. CNS 13 (Leiden, 1992): 31- 49.

Frandsen, Paul J. "On Categorization and Metaphorical Structuring: Some Remarks on Egyptian Art and Language." *CAJ* 7 (1997): 71-104.

Franke, Detlef. *Das Heiligtum des Heqa-ib auf Elephantine, Geschichte eines Provinzheiligtums im Mittleren Reich*. SAGA 9 (1994).

Franke, Detlef. "Kinship." *OEAE* II (2001): 245-248.

Frankfort, Henri. *Kingship and the Gods. A Study of Ancient Near Eastern Religion as the Integration of Society and Nature* (Chicago and London, 1948; reprint 1978).

Freed, Rita E., Yvonne J. Markowitz, and Sue H. D'Auria. *Pharaohs of the Sun: Akhenaten, Nefertiti, Tutankhamen* (Boston-New York-London, 1999).

Fuchs, Robert. "Stuck." *LÄ* VI (1986): 87-92.

Fuchs, Robert. "Wachs." *LÄ* VI (1986): 1088-1094.

Gaballa, G.A. *Narrative in Egyptian Art* (Mainz, 1976).

Gabolde, Luc. "La 'Cour de Fêtes' de Thoutmosis II à Karnak." *Karnak* IX (Paris, 1993): 1-100.

Galán, José M. "Seeing Darkness." *CdÉ* 147 (1999): 18-30.

Galán, José M. "Amenhotep Son of Hapu as Intermediary between the People and God." In *Egyptology at the Dawn of the Twenty-First Century: Proceedings of the Eighth International Congress of Egyptologists, Cairo 2000*, vol. 2. Edited by Z. Hawass and L.P. Brock (Cairo, 2003): 221-229.

Galán, José M. "The Ancient Egyptian Sed-Festival and the Exemption from Corvée." *JNES* 59, no. 4 (2000): 255-264.

Gamer-Wallert, Ingrid. *Fische und Fischkulte im alten Ägypten*. ÄA 21 (Wiesbaden, 1970).

Gamer-Wallert, Ingrid. "Fische, religiös." *LÄ* II (1977): 228-234.

Gardiner, Alan H. "Some Personifications." *Proceedings of the Society of Biblical Archaeology* 38 (1916): 43-54, 83-94.

Gardiner, Alan H. "The Graffito from the Tomb of Pere." *JEA* 14 (1928): 10-11.

Gardiner, Alan H. *The Library of A. Chester Beatty: The Chester Beatty Papyrus* (London, 1931).

Gardiner, Alan H. *The attitude of the ancient Egyptians to death and the dead* (Cambridge, 1935).

Gardiner, Alan H. *Ancient Egyptian Onomastica*, 3 vols. (Oxford, 1947).

Gardiner, Alan H. *Egyptian Grammar*. 3d rev. ed. (Oxford, 1957).

Gardiner, Alan H., and Kurt Sethe. *Egyptian letters to the dead, mainly from the Old and Middle Kingdoms* (London, 1928).

Garnot, Jean Sainte Fare. *L'appel aux vivants* (Cairo, 1938).

Gauthier-Laurent, Madeleine. "Les scènes de coiffure féminine dans l'ancienne Égypte." *Mélanges Maspero*, vol. 1, fasc. 2. MIFAO 66 (Cairo, 1935-1938): 673-696.

George, Beate. *Zu den altägyptischen Vorstellungen vom Schatten als Seele* (Bonn, 1970).

Germer, Renate. "Die Bedeutung des Lattichs als Pflanze des Min." *SAK* 8 (1980): 85-87.

Germer, Renate. "Lattich." *LÄ* III (1980): 938-939.

Germer, Renate. "Flora." Translated from the German by J. Harvey. *OEAE* I (2001): 535-541.

Germer, Renate. "Flowers." Translated from the German by J. Harvey. *OEAE* I (2001): 541-544.

Germer, Renate. "Gardens." Translated from the German by J. Harvey and M. Goldstein. *OEAE* II (2001): 3-5.

Germer, Renate. "Vegetables." Translated from the German by J. Harvey and M. Goldstein. *OEAE* III (2001): 477-478.

Gilbert, Pierre. "Les chants du harpiste." *CdÉ* 29 (1940): 38-44.

Gilroy, Thomas. "Outlandish Outlanders: Foreigners and Caricature in Egyptian Art." *GM* 191 (2002): 35-52.

Gitton, Michel, and Jean Leclant. "Gottesgemahlin. A." *LÄ* II (1977): 792-811.

Gnirs, Andrea M. "Das Pfeilerdekorationsprogramm im Grab des Meri, Theben Nr. 95: Ein Beitrag zu den Totenkultpraktiken der 18. Dynastie." *Thebanische Beamtennekropolen. Neue Perspektiven archäologischer Forschung, Internationales Symposion Heidelberg 9.- 13.6.1993*. Edited by J. Assmann, E. Dziobek, H. Guksch, F. Kampp. SAGA 12 (Heidelberg, 1995): 233-253.

Gnirs, Andrea M. *Militär und Gesellschaft. Ein Beitrag zur Sozialgeschichte des Neuen Reiches*. SAGA 17 (Heidelberg, 1996).

Gnirs, Andrea M. "Ancient Egypt." In *War and Society in the Ancient and Medieval Worlds: Asia, the Mediterranean, Europe, and Mesoamerica*. Edited by K. Raaflaub and N. Rosenstein. Center for Hellenic Studies Colloquia 3 (Cambridge, Mass., 1999): 73-107.

Gnirs, Andrea M. "Military: An Overview." *OEAE* II (2001): 400-406.

Goebs, Katja. "Untersuchungen zu Funktion und Symbolgehalt des *nms*." *ZÄS* 122 (1995): 154-181.

Goebs, Katja. "Crowns." *OEAE* I (2001): 321-326.

Goedicke, Hans. "The Date of the 'Antef-Song.'" In *Fragen an die altägyptische Literatur: Studien zum Gedenken an Eberhard Otto*. Edited by J. Assmann, E. Feucht, R. Grieshammer (Wiesbaden, 1977): 185-196.

Goedicke, Hans. "The High Price of Burial." *JARCE* 25 (1988): 195-199.

Goldwasser, Orly. "The Narmer Palette and the 'Triumph of Metaphor.'" *Lingua Aegyptia* 2 (1992): 67-85.

Goldwasser, Orly. *From Icon to Metaphor: Studies in the Semiotics of the Hieroglyphs*. OBO 142 (Fribourg and Göttingen, 1995).

Goldwasser, Orly. "The Determinative System as a Mirror of World Organization." *GM* 170 (1999): 49-68.

Goldwasser, Orly. "Scripts: Hieroglyphs." *OEAE* III (2001): 198-204.

Goldwasser, Orly. *Prophets, Lovers and Giraffes: wor(l)d classification in ancient Egypt.* Göttinger Orientforschungen. IV, Reihe: Ägypten 38,3 (Wiesbaden, 2002).

Golvin, Jean-Claude, and Jean-Claude Goyon. *Les bâtisseurs de Karnak* (Paris, 1987).

Gordon, Andrew. "Foreigners." *OEAE* I (2001): 544-548.

Goyon, Jean-Claude. *Confirmation du pouvoir royal au nouvel an: Brooklyn Museum Papyrus 47.218.50.* BdÉ 52 (Cairo, 1972).

Goyon, Jean-Claude. *Rituels funéraires de l'ancienne Égypte* (Paris, 1972).

Graefe, Erhart. "Talfest." *LÄ* VI (1986): 187-189.

Graham, Geoffrey. "Insignias." *OEAE* II (2001): 163-167.

Graindorge, Catherine. "L'oignon, la magie et les dieux." In *Encyclopédie religieuse de l'Univers végétal. Coyances phytoreligieuses de l'Égypte ancienne,* vol. I. Edited by S. Aufrère. Orientalia Monspeliensia 10 (Montpellier, 1999): 317-334.

Green, Lorna. "Colour transformations of ancient Egyptian pigments." In *Colour and Painting in Ancient Egypt.* Edited by W.V. Davies (London, 2001): 43-48.

Green, Lyn. "Clothing and Personal Adornment." *OEAE* I (2001): 274-279.

Green, Lyn. "Toiletries and Cosmetics." *OEAE* III (2001): 412-417.

Greven, Liselotte. *Der Ka in Theologie und Königskult der Ägypter des Alten Reiches.* ÄF 17 (Glückstadt-Hamburg-New York, 1954).

Grice, H.P. "Utterer's Meaning and Intentions." *Philosophical Review* LXXVIII (1969): 147-177.

Grieshammer, Reinhard. "Briefe an Tote. A." *LÄ* I (1975): 864-870.

Grieshammer, Reinhard. "Mundöffnung(sritual)." *LÄ* IV (1982): 223-224.

Griffiths, J. Gwyn. "Isis." *OEAE* II (2001): 188-191.

Griffiths, J. Gwyn. "Osiris." *OEAE* II (2001): 615-619.

Groenewegen-Frankfort, H.A. *Arrest and Movement. An Essay on Space and Time in the representational Art of the ancient Near East* (London, 1951).

Gülden, Svenja A., Irmtraut Munro, Christina Regner, and Oliver Sütsch. *Bibliographie zum altägyptischen Totenbuch.* Studien zum altägyptischen Totenbuch 1 (Wiesbaden, 1998).

Guglielmi, Waltraud. "Die Feldgöttin *Sḫt.*" *WdO* 7 (1973-1974): 206-227.

Guglielmi, Waltraud. "Holzkohle." *LÄ* II (1977): 1271-1272.

Guglielmi, Waltraud. "Sechet." *LÄ* V (1984): 778.

Guksch, Heike. "Ergänzungen zu Davies-Macadam, Cone Nr. 475." *GM* 44 (1981): 21-22.

Guksch, Heike. "Ergänzungen zu den 'Ergänzungen zu Davies-Macadam, Cone Nr. 475.'" *GM* 47 (1981): 23-27.

Guksch, Heike. *Königsdienst. Zur Selbstdarstellung der Beamten in der 18. Dynastie.* SAGA 11 (Heidelberg, 1994).

Guksch, Heike. *Die Gräber des Nacht-Min und des Men-cheper-Ra-seneb. Theben Nr. 87 und 79.* AV 34 (Mainz, 1995).

Guksch, Heike. "Die Grabkegelaufschrift DAVIES-MACADAM Nr. 475 - und ein Ende!" *GM* 158 (1997): 9-13.

Gundlach, Rolf, et al. *Sennefer. Die Grabkammer des Bürgermeisters von Theben.* 2d ed. (Mainz, 1991).

Gundlach, Rolf. "Weltherrscher und Weltordnung: Legitimization und Funktion des Ägyptischen Königs am Beispiel Thutmosis III. und Amenophis III." In *Legitimation und Funktion des Herrschers vom Ägyptischen Pharao zum neuzeitlichen Diktator.* Edited by R. Gundlach and H. Weber (Stuttgart, 1992): 23-50.

Gunn, Battiscombe. Review of *Egyptian Letters to the Dead, mainly from the Old and Middle Kingdoms* by Alan H. Gardiner and Kurt Sethe. *JEA* 16 (1930): 147-155.

Habachi, Labib. "Grands Personnages en mission ou de passage à Assouan. I. Mey, attaché au Temple de Rê." *CdÉ* 29, no. 58 (1954): 210-220.

Habachi, Labib. "Tomb No. 226 of the Theban Necropolis and its Unknown Owner." In *Festschrift für Siegfried Schott zu seinem 70. Geburtstag am 20. August 1967.* Edited by W. Helck (Wiesbaden, 1968): 61-70.

Habachi, Labib. *Features of the Deification of Ramesses II.* ADAIK 5 (1969).

Hall, Henry R. *Hieroglyphic Texts from Egyptian Stelae, &c., in the British Museum*, vol. 7 (London, 1925).

Hannig, Rainer, and Robert Fuchs. "Ocker." *LÄ* IV (1982): 550-551.

Hannig, Rainer, and Petra Vomberg. *Wortschatz der Pharaonen in Sachgruppen. Kulturhandbuch Ägyptens. Hannig-Lexica 2.* Kulturgeschichte der Antiken Welt 72 (Mainz, 1999).

Harer Jr., M.D., W. Benson. "Nymphae: Sacred Narcotic Lotus of Ancient Egypt?" *JSSEA* 14 (1984): 100-102.

Harer Jr., M.D., W. Benson. "Pharmacological and Biological Properties of the Egyptian Lotus." *JARCE* 22 (1985): 49-54.

Harer Jr., M.D., W. Benson. "Lotus." *OEAE* II (2001): 304-305.

Hartwig, Melinda K. "Institutional Patronage and Social Commemoration in Private Theban Tomb Painting during the reigns of Thutmose IV (1419-1410 BC) and Amenhotep III (1410-1382 BC)." Ph.D. Dissertation, Institute of Fine Arts - New York University, 2000.

Hartwig, Melinda K. "Fist holding a cylindrical object." In *The Collector's Eye: Masterpieces of Egyptian Art from The Thalassic Collection, Ltd..* Edited by P. Lacovara, B. Trope, and S. D'Auria (Atlanta, 2001): 68.

Hartwig, Melinda K. "Painting." *OEAE* III (2001): 1-13.

Hartwig, Melinda K. "The Tomb of Menna." In *Valley of the Kings: The Tombs and Funerary Temples of Thebes West.* Edited by K.R. Weeks (Vercelli, Italy, 2001): 398-407.

Hartwig, Melinda K. "The Tomb of Nakht." In *Valley of the Kings: The Tombs and Funerary Temples of Thebes West.* Edited by K.R. Weeks (Vercelli, Italy, 2001): 390-397.

Hartwig, Melinda K. "Style and Visual Rhetoric in Theban Tomb Painting." In *Egyptology at the Dawn of the Twenty-First Century: Proceedings of the Eighth International Congress of Egyptologists, Cairo 2000*, vol. 2. Edited by Z. Hawass and L.P. Brock (Cairo, 2003): 298-307.

Hassan, Ali. *Stöcke und Stäbe im Pharaonischen Ägypten bis zum Ende des Neuen Reiches*. MÄS 33 (Munich and Berlin, 1976).

Hassan, Selim. *Hymnes religieux du Moyen Empire* (Cairo, 1928).

Hawass, Zahi, and Mahmoud Maher-Taha. *Le tombeau de Menna [TT. No. 69]* (Cairo, 2002).

Hayes, William C. *Ostraka and name stones from the tomb of Sen-Mut (no. 71) at Thebes*. PMMA 15 (New York, 1942).

Hayes, William C. "A Much-Copied Letter of the Early Middle Kingdom." *JNES* 7 (1948): 1-10.

Hayes, William C. "Inscriptions from the Palace of Amenhotep III." *JNES* 10 (1951): 35-111, 156-183, 231-242.

Hayes, William C. "A Selection of Tuthmoside Ostraca from Dēr el-Bahri." *JEA* 46 (1960): 29-52.

Hayes, William C. *The Scepter of Egypt. Part II: The Hyksos Period and the New Kingdom (1675-1080 B.C.)*. Rev. ed. (New York, 1990).

Heerma van Voss, Matthieu. "Horuskinder." *LÄ* III (1980): 52-53.

Heerma van Voss, Matthieu. "Nechbet." *LÄ* IV (1982): 366-367.

Hegazy, El Sayed Aly, and Mario Tosi. *A Theban Private Tomb. Tomb No. 295*. AV 45 (Mainz, 1983).

Helck, Wolfgang. *Der Einfluss der Militärführer in der 18. ägyptischen Dynastie*. UGAÄ 14 (Leipzig, 1939).

Helck, Wolfgang. "Die Bedeutung der ägyptischen Besucherinschriften." *ZDMG* 102, n.s. (1952): 39-46.

Helck, Wolfgang. *Urkunden der 18. Dynastie. Heften 17-22* (Berlin, 1955-1958).

Helck, Wolfgang. *Zur Verwaltung des Mittleren und Neuen Reiches*. PÄ 3 (Leiden and Köln, 1958).

Helck, Wolfgang. "Die soziale Schichtung des ägyptischen Volkes im 3. und 2. jahrtausend v. Chr." *JESHO* 2 (1959): 1-36.

Helck, Wolfgang. *Materialien zur Wirtschaftsgeschichte des Neuen Reiches*, vols. I-V (Wiesbaden, 1961-1970).

Helck, Wolfgang. "Das thebanische Grab 43." *MDAIK* 17 (1961): 99-110.

Helck, Wolfgang. *Urkunden der 18. Dynastie. Übersetzung zu den Heften 17-22* (Berlin, 1961).

Helck, Wolfgang. "Soziale Stellung und Grablage: Bemerkungen zur thebanischen Nekropole." *JESHO* 5 (1962): 225-243.

Helck, Wolfgang. *Zur Verwaltung des Mittleren und Neuen Reichs: Register* (Leiden, 1975).

Helck, Wolfgang. "Anen." *LÄ* I (1975): 270.

Helck, Wolfgang. "Fremde in Ägypten." *LÄ* II (1977): 306-310.

Helck, Wolfgang. "Harze." *LÄ* II (1977): 1022-1023.

Helck, Wolfgang. "Kiosk A." *LÄ* III (1980): 441-442.

Helck, Wolfgang. "Maat." *LÄ* III (1980): 1110-1119.

Helck, Wolfgang. "A. Papyri, hieratische: Papyrus Koller." *LÄ* IV (1982): 717.

Helck, Wolfgang. "Schesemu." *LÄ* V (1984): 590-591.

Helck, Wolfgang. "Sohn." *LÄ* V (1984): 1054.

Helck, Wolfgang. "Taschentuch." *LÄ* VI (1986): 237-238.

Helck, Wolfgang. "Tempeldarstellungen." *LÄ* VI (1986): 377-379.

Helck, Wolfgang. "Wer konnte sich ein Begräbnis in Theben-West leisten?" *GM* 135 (1993): 39-40.

Helck, Wolfgang. "Ein verlorenes Grab in Theben-West. TT 145 des Offiziers Neb-Amun unter Thutmosis III." *Antike Welt* 27 (1996): 73-85.

Hermann, Alfred. *Die Stelen der thebanischen Felsgräber der 18. Dynastie*. ÄF 11 (Glückstadt-Hamburg-New York, 1940).

Heywood, Ann. "The use of huntite as a white pigment in ancient Egypt." In *Colour and Painting in Ancient Egypt*. Edited by W.V. Davies (London, 2001): 5-9.

Hickmann, Hans. *45 siècles de musique dans l'Égypte ancienne* (Paris, 1956).

Hodel-Hoenes, Sigrid. *Life and Death in Ancient Egypt. Scenes from Private Tombs in New Kingdom Thebes*. Translated from the German by D. Warburton (Ithaca and London, 2000).

Hölscher, Uvo. *The Excavation of Medinet Habu* , 3 vols. OIP 21, 41, 54 (Chicago, 1934-1941).

Hölzl, Regina. *Ägyptische Opfertafeln und Kultbecken. Eine Form- und Funktionsanalyse für das Alte, Mittlere und Neue Reich*. HÄB 45 (Hildesheim, 2002).

Hoffmeier, James K. "Military: Materiel." *OEAE* II (2001): 406-412.

Hofmann, Inge. *Indices zu W. Helck, Materialien zur Wirtschaftsgeschichte des Neuen Reiches* (Mainz, 1970).

Holliday, Peter J. *Narrative and event in ancient art* (Cambridge and New York, 1993).

Holub, Robert C. *Reception theory: a critical introduction* (London and New York, 1984).

Hornung, Erik. *Das Grab des Haremhab im Tal der Könige* (Bern, 1971).

Hornung, Erik. *Das Totenbuch der Ägypter* (Zürich and Munich, 1979).

Hornung, Erik. "Himmelsvorstellungen." *LÄ* II (1980): 1215-1218.

Hornung, Erik. *Conceptions of God in Ancient Egypt: The One and the Many*. Translated by J. Baines (Ithaca, 1982).

Hornung, Erik. *Idea into image: Essays on Ancient Egyptian Thought*. Translated by E. Bredeck (New York, 1992).

Hornung, Erik. *L'esprit du temps des Pharaons* (Paris, 1996).

Hornung, Erik. *The Ancient Egyptian Books of the Afterlife*. Translated from the German by D. Lorton (Ithaca and London, 1999).

Hornung, Erik. *Akhenaten and the Religion of Light*. Translated from the German by D. Lorton (Ithaca, 1999).

Houlihan, Patrick F. *The Birds of Ancient Egypt*. Natural History of Egypt 1 (London, 1986).

Houlihan, Patrick F. *The Animal World of the Pharaohs* (London,1996).

Houlihan, Patrick F. "Birds." *OEAE* I (2001): 189-191.

Houlihan, Patrick F. "Canines." *OEAE* I (2001): 229-231.

Hugonot, Jean-Claude. *Le jardin dans l'Égypte ancienne* (Frankfurt am Main, 1989).

Iamblichus, *Theurgia or The Egyptian Mysteries.* Translated from the Greek by A. Wilder (London, 1911).

Iamblichus. *The Mysteries of the Egyptians, Chaldeans, and Assyrians*, 3d ed. Translated from the Greek by T. Taylor (London, 1968).

Ikram, Salima. "Meat processing." In *Ancient Egyptian Materials and Technology*. Edited by P.T. Nicholson and I. Shaw (Cambridge, 2000): 656-671.

Ikram, Selima. "Banquets." *OEAE* I (2001): 162-164.

Ikram, Selima. "Diet." *OEAE* I (2001): 390-395.

Iser, Wolfgang. *The Act of Reading: A Theory of Aesthetic Response* (Baltimore and London, 1978).

Iversen, Erik. *The Myth of Egypt and its Hieroglyphs in European Tradition* (Copenhagen, 1961).

Iversen, Erik. "The Hieroglyphic Tradition." In *The Legacy of Egypt*, 2d ed. Edited by J.R. Harris (Oxford, 1971): 170-196.

Jacobsohn, Helmuth. "Kamutef." *LÄ* III (1980): 308-309.

Jacquet, Jean. *Karnak-Nord V: Le trésor de Thoutmosis Ier.* FIFAO 30/1-2 (Cairo, 1983).

James, T.G.H. *Egyptian Painting and Drawing in the British Museum* (Cambridge, Mass., 1985).

James, T.G.H. "Painting Techniques on Stone and Wood." In *Conservation of Ancient Egyptian Materials*. Edited by S.C. Watkins and C.E. Brown (London, 1988): 55-59.

James, T.G.H. "The Earliest History of Wine and Its Importance in Ancient Egypt." In *The Origins and Ancient History of Wine*. Edited by P. McGovern, S. Fleming, S. Katz (Amsterdam, 1996): 197-213.

James, T.G.H. "Egypt, ancient, X: Painting and Drawing." In *The Dictionary of Art*, vol. 9. Edited by J. Turner (New York, 1996): 897-906.

Jankuhn, Dieter. "Kranz der Rechtfertigung." *LÄ* III (1980): 764.

Janssen, Jac J. "Prolegomena to the Study of Egypt's Economic History during the New Kingdom." *SAK* 3 (1975): 127-185.

Janssen, Jac. J. *Commodity Prices from the Ramessid Period* (Leiden, 1975).

Janssen, Jac. J. "Khaʿemtōre, a Well-to-do workman." *OMROL* 58 (1977): 221-232.

Janssen, Jac. J., and P.W. Pestman. "Burial and Inheritance in the Community of the Necropolis Workmen at Thebes (Pap. Bulaq X and O. Petrie 16)." *JESHO* 11 (1968): 137-170.

Jasnow, Richard. "Insinger Papyrus." *OEAE* II (2001): 167-169.

Jauss, H.R. *Toward an Aesthetic of Reception.* Translated by Timothy Bahti (Minneapolis, 1982).

Johnson, Janet H. "What's in a Name?" *Lingua Aegyptia 9* (2001): 143-152.

Johnson, W. Raymond. "Images of Amenhotep III in Thebes: Styles and Intentions." In *The Art of Amenhotep III: Art Historical Analysis*. Edited by L. Berman (Cleveland, 1990): 26-46.

Johnson, W. Raymond. "The Deified Amenhotep III as the Living Re-Horakhty: Stylistic and Iconographic Considerations." In *Atti del VI Congresso Internazionale di Egittologia*, vol. 2 (Turin, 1993): 231-236.

Johnson, W. Raymond. "Amenhotep III and Amarna: Some New Considerations." *JEA* 82 (1996): 65-82.

Johnson, W. Raymond. "The Revolutionary Role of the Sun in the Reliefs and Statuary of Amenhotep III." *The Oriental Institute News and Notes*, no. 15 (Fall 1996): 1-7.

Johnson, W. Raymond. "Monuments and Monumental Art under Amenhotep III: Evolution and Meaning." In *Amenhotep III: Perspectives on His Reign*. Edited by D. O'Connor and E. Cline (Ann Arbor, 1998): 63-94.

Johnson, W. Raymond. "The *nfrw*-Collar Reconsidered." In *Gold of Praise. Studies on Ancient Egypt in Honor of Edward F. Wente*. Edited by E. Teeter and J.A. Larson. SAOC 58 (Chicago, 1999): 223-234.

Johnson, W. Raymond. "The Setting: History, Religion, and Art." In *Pharaohs of the Sun: Akhenaten, Nefertiti, Tutankhamen*. Edited by R.E. Freed, Y.J. Markowitz, S.H. D'Auria (Boston, New York, and London, 1999): 38-49.

Kadish, Gerald E. "Wisdom Tradition." *OEAE* III (2001): 507-510.

Kampp, Friederike. Review of *The Wall Decoration of Three Theban Tombs (TT 77, 175, and 249)* by Lise Manniche. CNI Publications 4 (Copenhagen, 1988). *OLZ* 86 (1991): 27-30.

Kampp, Friederike. *Die thebanische Nekropole. Zum Wandel des Grabgedankens von der XVIII. bis zur XX. Dynastie*, 2 vols. Theben XIII (Mainz, 1996).

Kampp-Seyfried, Friederike. "Overcoming Death - The Private Tombs of Thebes." In *Egypt: The World of the Pharaohs*. Edited by R. Schulz and M. Seidel (Cologne, 1998): 249-263.

Kampp-Seyfried, Friederike. "Thebes, New Kingdom private tombs." In *Encyclopedia of the Archaeology of Ancient Egypt*. Edited by K. Bard, et al. (London and New York, 1999): 809-811.

Kampp-Seyfried, Friederike. "The Theban necropolis: an overview of topography and tomb development from the Middle Kingdom to the Ramesside period." In *The Theban Necropolis: Past, Present and Future*. Edited by N. Strudwick and J.H. Taylor (London, 2003): 2-10.

Kamrin, Janice. *The Cosmos of Khnumhotep II at Beni Hasan* (London and New York, 1999).

Kanawati, Naguib. *The Tomb and Beyond: Burial Customs of Egyptian Officials* (Warminster, Wiltshire, 2001).

Kaplony, Peter. *Die Inschriften der ägyptischen Frühzeit*, vols. I-III. ÄA 8-9 (Wiesbaden, 1963-1964).

Kaplony, Peter. "Königstitulatur." *LÄ* III (1980): 642-659.

Kaplony, Peter. "Toter am Opfertisch." *LÄ* VI (1986): 711-726.

Kaplony, Peter. "Zepter." *LÄ* VI (1986): 1373-1389.

Karkowski, Janusz. "Notes on the Beautiful Feast of the Valley as represented in Hatshepsut's temple at Deir el-Bahri." In *50 Years of Polish Excavations in Egypt and the Near East: Acts of the Symposium at the Warsaw University 1986* (Warsaw, 1992): 155-166.

Kaufmann, Thomas Dacosta. "Reception Theory." *The Dictionary of Art*, vol. 26. Edited by J. Turner (New York, 1996): 61-64.

Kees, Hermann. *Das Priestertum im ägyptischen Staat vom Neuen Reich bis zur Spätzeit. Indices und Nachträge.* PÄ I (Leiden 1953-1958).

Kees, Hermann. "Wêbpriester der 18. Dynastie im Trägerdienst bei Prozessionen." *ZÄS* 85 (1960): 45-56.

Kees, Hermann. *Ancient Egypt: A Cultural Topography*. Translated from the German by I.F.D. Morrow. Edited by T.G.H. James (London, 1961).

Keimer, Ludwig. "Die Pflanze des Gottes Min." *ZÄS* 59 (1924): 140-143.

Keimer, Ludwig. "Egyptian formal bouquets (bouquets montés)." *AJSL* 41 (1924-1925): 145-161.

Keimer, Ludwig. "La baie qui fait aimer. Mandragora officinarum L. dans l'Égypte ancienne." *BIE* 32 (1951): 351.

Keller, Cathleen A. "The Draughtsmen of Deir el-Medina: A Preliminary Report." *NARCE* 115 (1981): 7-21.

Keller, Cathleen A. "Royal painters: Deir el-Medina in Dynasty XIX." In *Fragments of a Shattered Visage: The Proceedings of the International Symposium on Ramesses the Great*. Edited by E. Bleiberg and R. Freed. Monographs of the Institute of Egyptian Art and Archaeology 1 (Memphis, 1991): 50-86.

Keller, Cathleen A. "A family affair: the decoration of Theban Tomb 359." In *Colour and Painting in Ancient Egypt*. Edited by W.V. Davies (London, 2001): 73-93.

Kemp, Barry J. *Ancient Egypt. Anatomy of a Civilization* (London and New York, 1989).

Kemp, Wolfgang. *Der Betrachter ist im Bild: Kunstwissenschaft und Rezeptionsästhetik* (Cologne, 1985).

Kessler, Dieter. "Neferusi." *LÄ* IV (1982): 383-385.

Killen, Geoffrey. *Ancient Egyptian Furniture, Vol. I: 4000-1300 BC* (Warminster, 1980).

Killen, Geoffrey. *Egyptian Woodworking and Furniture*. Shire Egyptology 21 (Princes Risborough, 1994).

Kitchen, Kenneth A. *Pharaoh Triumphant. The Life and Times of Ramesses II, King of Egypt* (Cairo, 1997).

Kitchen, Kenneth A. "The World Abroad: Amenhotep III and Mesopotamia." In *Amenhotep III: Perspectives on His Reign*. Edited by D. O'Connor and E. Cline (Ann Arbor, 1998): 250-260.

Klebs, Luise. *Die Reliefs und Malereien des neuen Reiches (XVIII. - XX. Dynastie, ca. 1580-1100 v. Chr.).* Teil I: *Szenen aus dem Leben des Volkes* (Heidelberg, 1934).

Kleinsgütl, Dagmar. *Feliden in Altägypten*. Beiträge zur Ägyptologie 14 (Wien, 1997).

Kondo, Jiro. "The Re-discovery of Theban Tombs of A21 and A24." In *Atti del VI Congreso Internazionale di Egittologia*, vol. 1 (Turin, 1993): 371-374.

Kozloff, Arielle. "Paintings from the So-called Tomb of Nebamun in the British Museum." *NARCE* 95 (Fall 1975-Winter 1976): 8.

Kozloff, Arielle. "A Study of the painters of the Tomb of Menna, No. 69." In *Acts, First International Congress of Egyptology*. Edited by Walter F. Reineke. Schriften zur Geschichte und Kultur des Alten Orients 14 (Berlin, 1979): 395-402.

Kozloff, Arielle. "Study of Two Styles of Theban Paintings from the Amarna Period." *L'Egyptologie en 1979. Axes prioritaires de recherches*, vol. 2. Colloques Internationaux du Centre National de la Recherche Scientifique 595 (Paris, 1982): 263.

Kozloff, Arielle. "Mirror, Mirror." *Bulletin of the Cleveland Museum of Art* 71 (1984): 271-276.

Kozloff, Arielle. "Theban Tomb Paintings from the Reign of Amenhotep III: Problems in Iconography and Chronology." In *The Art of Amenhotep III: Art Historical Analysis*. Edited by L.M. Berman (Cleveland, 1990): 55-64.

Kozloff, Arielle. "Jewelry." In *Egypt's Dazzling Sun: Amenhotep III and His World*. Edited by A. Kozloff, B. Bryan, L. Berman (Cleveland, 1992): 434-441.

Kozloff, Arielle. "Molded and Carved Vessels and Figurines." In *Egypt's Dazzling Sun: Amenhotep III and His World*. Edited by A. Kozloff, B. Bryan, L. Berman (Cleveland, 1992): 393-399.

Kozloff, Arielle. "Tomb Decoration: Paintings and Relief Sculpture." In *Egypt's Dazzling Sun: Amenhotep III and His World*. Edited by A. Kozloff and B. Bryan (Cleveland, 1992): 261-283.

Kozloff, Arielle, and el Sayed Ali Higazy. "The Painted Scenes in the Tomb of Paser, Theban Tomb no. 367." *Abstracts of Papers. Fourth International Congress of Egyptology* (Munich, 1985): 115-116.

Krauss, Rolf. "Wie jung ist die memphitische Philosophie auf dem Shabaqo-Stein?" In *Gold of Praise: Studies on Ancient Egypt in Honor of Edward F. Wente*. Edited by E. Teeter and J. Larson. SAOC 58 (1999): 239-246.

Kristensen, W. Brede. *Life Out of Death: Studies in the Religions of Egypt and Ancient Greece*. Translated from the Dutch by H.J. Franken and G.R.H. Wright (Louvain, 1992).

Kruchten, Jean-Marie. *Les annales des prêtres de Karnak (XXI-XXIIImes dynasties) et autres textes contemporains relatifs à l'initiation des prêtres d'Amon*. OLA 32 (Leuven, 1989).

Kruchten, Jean-Marie. "Oracles." *OEAE* II (2001): 609-612.

Kuentz, Charles. "Les textes du tombeau no. 38 à Thèbes (Cheikh Abd-el-Gourna)." *BIFAO* 21 (1923): 119-130.

Kuentz, Charles. *L'oie du Nile (Chenalopex Aegyptiaca) dans l'antique Égypte*. Archives du Muséum d'Histoire naturelle de Lyon 14 (1926): 1-64.

Kuhlmann, Klaus P. "Eine Beschreibung der Grabdekoration mit der Aufforderung zu kopieren und zum Hinterlassen von Besucherinschriften aus saitischer Zeit." *MDAIK* 29 (1973): 205-213.

Kuhlmann, Klaus P. *Der Thron im alten Ägypten. Untersuchungen zu Semantik, Ikonographie und Symbolik eines Herrschaftszeichens*. ADAIK 10 (Glückstadt, 1977).

Kuhlmann, Klaus P. "Bemerkungen zum Lattichfeld und den Wedelsinsignien des Min." *WO* 14 (1983): 196-206.

Kuhlmann, Klaus P. and Wolfgang Schenkel. *Das Grab des Ibi, Obergutsverwalters der Gottesgemahlin des Amun (Thebanisches Grab Nr. 36)*, 2 vols. AV 15 (Mainz, 1983).

Kuhlmann, Klaus P. "Thron." *LÄ* VI (1986): 523-529.

Kuhlmann, Klaus. "Königsthron und Gottesthron." Review of *Königsthron und Gottesthron* by Martin Metzger. AOAT 15 (Kevelaer and Neukirchen-Vluyn, 1985). In *BiOr* 44 (1987): 326-376.

Kurtz, D.C. "Beazley and the Connoisseurship of Greek Vases." *Greek Vases in The J. Paul Getty Museum* 2. Occasional Papers on Antiquities 3 (Malibu, 1985): 237-250.

Laboury, Dimitri. "Une relecture de la tombe de Nakht (TT 52, Cheikh 'Abd el-Gourna)." In *La peinture égyptienne ancienne. Un monde de signes à préserver. Actes de Colloque international de Bruxelles, avril 1994*. Edited by R. Tefnin. Monumenta Aegyptiaca 7 (Brussels, 1997): 49-81.

Laboury, Dimitri. "Fonction et signification de l'image égyptienne." *Bulletin de la Classe des Beaux-Arts* 7 (1998): 131-148.

Lacau, Pierre. *Stèles du Nouvel Empire* (Cairo, 1909-1957).

Lacau, Pierre. "Suppressions et modifications de signes dans les textes funéraire." *ZÄS* 51 (1914): 1-64.

Lacau, Pierre. "Deux magasins à encens du temple de Karnak." *ASAE* 52 (1952): 185-198.

Lakoff, George. *Women, Fire, and Dangerous Things: What Categories Reveal about the Mind* (Chicago & London, 1987).

Lansing, Ambrose. "Excavations at the palace of Amenhotep III at Thebes." *BMMA* (supp.) 13 (March 1918): 8-14.

Lash, Willem F. "Iconography and iconology." *The Dictionary of Art*, vol. 15. Edited J. Turner (New York, 1996): 89-98.

Lauffray, Jean. *Karnak d'Égypte. Domaine du divin* (Paris, 1979).

Lee, Lorna, and Stephan Quirke. "Painting materials." In *Ancient Materials and Technology*. Edited by P.T. Nicholson and I. Shaw (Cambridge, 2000): 104-120.

Lefebvre, Gustave. *Histoire des grand prêtres d'Amon de Karnak jusqu'à la XXIe dynastie* (Paris, 1929).

Lefebvre, Gustave. *Romans et contes égyptiens de l'époque pharaonique* (Paris, 1949).

Legrain, Georges. *Statues et statuettes de rois et de particuliers*, 4 vols. Catalogue général des antiquités égyptiennes du musée du Caire nos. 42001-42250 (Cairo, 1906-1925).

Leitz, Christian, ed. *Lexikon der ägyptischen Götter und Götterbezeichnungen*, 7 vols. OLA 110-116 (Leuven, 2002).

Leprohon, Ronald J. "Offerings: Offering Formulas and Lists." *OEAE* II (2001): 569-572.

Leprohon, Ronald J. "Titulary." *OEAE* III (2001): 409-411.

Lepsius, Richard. *Das Todtenbuch der Ägypter nach dem hieroglyphischen Papyrus in Turin* (Leipzig, 1842).

Lepsius, Richard. *Denkmäler aus Aegypten und Aethiopien*, 12 vols. (Berlin 1849-1865/R Geneva, 1971-1975).

Lesko, Barbara S. "Cults: Private Cults." *OEAE* I (2001): 336-339.

Lesko, Leonard H. "Some Comments on Ancient Egyptian Literacy and Literati." *Studies in Egyptology Presented to Miriam Lichtheim*, vol II. Edited by S.I. Groll (Jerusalem, 1990): 656-667.

Lesko, Leonard H. "Egyptian Wine Production During the New Kingdom." In *The Origins and Ancient History of Wine*. Edited by P. McGovern, S. Fleming, and S. Katz (Luxembourg, 1995): 215-230.

Lesko, Leonard H. "Literacy." *OEAE* II (2001): 297-299.

Letellier, Bernadette. "La cour à péristyle de Thoutmosis IV à Karnak." *BSFÉ* 84 (1979): 33-49.

Letellier, Bernadette. "La cour à péristyle de Thoutmosis IV à Karnak (et la "cour des Fêtes" de Thoutmosis II)." In *Hommages à la mémoire de Serge Sauneron*, vol. I. BdÉ 81 (Cairo, 1979): 51-71.

Lhote, André, and Hassia. *Les chefs-d'oeuvre de la peinture égyptienne* (Paris, 1954).

Lichtheim, Miriam. "The songs of the harpers." *JNES* 4 (1945): 178-212.

Lichtheim, Miriam. *Ancient Egyptian Literature, Volume I: The Old and Middle Kingdoms* (Berkeley-Los Angeles-London, 1973).

Lichtheim, Miriam. *Ancient Egyptian Literature, Volume II: The New Kingdom* (Berkeley-Los Angeles-London, 1976).

Lichtheim, Miriam. *Ancient Egyptian Literature, Volume III: The Late Period* (Berkeley-Los Angeles-London, 1980).

Lichtheim, Miriam. *Maat in Egyptian Autobiographies and Related Studies*. OBO 120 (Freiburg and Göttingen, 1992).

Lilyquist, Christine. *Ancient Egyptian Mirrors from the Earliest Times through the Middle Kingdom*. MAS 27 (Munich-Berlin, 1979).

Lilyquist, Christine. "Mirrors." In *Egypt's Golden Age: The Art of Living in the New Kingdom 1558-1085 B.C.* Edited by E. Brovarski, S. K. Doll, and R. E. Freed (Boston, 1982): 184.

Liverani, Mario. *International relations in the ancient Near East, 1600-1100 BC* (New York, 2001).

Lloyd, Alan B. *Herodotus, Book II. Commentary 1-98* (Leiden, 1976).

Lloyd, Alan B. "Psychology and Society in the Ancient Egyptian Cult of the Dead." *Religion and Philosophy in Ancient Egypt*. YES 3 (New Haven, 1989): 117-133.

Lloyd, Alan B. "Ancient Historians." *OEAE* I (2001): 85-88.

Loeben, Christian E. "Thebanische Tempelmalerei--Spuren religiöser Ikonographie." In *La peinture égyptienne ancienne. Un monde de signes à préserver. Actes de Colloque international de Bruxelles, avril 1994*. Monumenta Aegyptiaca 7. Edited by R. Tefnin (Brussels, 1997): 111-120.

Loeben, Christian E. "Beobachtungen zu Kontext und Funktion königlicher Statuen im Amun-Tempel von Karnak." Ph.D. dissertation, Humboldt-Universität zu Berlin, 1999.

Lopez, Jesus. "Gastmahl." *LÄ* II (1977): 383-386.

Loprieno, Antonio. *Topos und Mimesis. Zum Ausländer in der ägyptischen Litteratur*. ÄA 48 (Wiesbaden, 1988).

Loprieno, Antonio. "Der demotische 'Mythos vom Sonnenauge.'" In *Weisheitstexte, Mythen und Epen. Mythen und Epen* III. Texte aus der Umwelt des Alten Testaments III/5 (Gütersloh, 1995): 1038-1078.

Loprieno, Antonio. "Slaves." *The Egyptians*. Edited by S. Donadoni and translated from the Italian by B. Bianchi (Chicago, 1997): 185-219.

Loret, Victor. "Le tombeau de l'am-xent Amen-hotep." *Mém. Miss.* I, 1 (1889): 23-32.

Loret, Victor. "La tombe de Khâ-m-hâ." *Mém. Miss.* I, 1 (1889): 113-132.

Lorton, David. "The Expression Šms-íb." *JARCE* 7 (1968): 41-54.

Lorton, David. "A Note on the Expression Šms-íb." *JARCE* 8 (1969-1970): 55-57.

Lorton, David. *The Juridical Terminology of International Relations in Egyptian Texts Through Dyn. XVIII* (Baltimore and London , 1974).

Lorton, David. "Terminology Related to the Laws of Warfare in Dyn. XVIII." *JARCE* 11 (1974): 53-68.

Lorton, David. "The Expression *'irí hrw nfr.*'" *JARCE* 12 (1975): 23-31.

Lorton, David. "The Theology of Cult Statues in Ancient Egypt." In *Born in Heaven, Made on Earth: The Making of the Cult Image in the Ancient Near East.* Edited by M.B. Dick (Winona Lake, Indiana, 1999): 123-209.

Lucas, Alfred. *Ancient Egyptian Materials and Industries.* 4th rev.ed. by J.R. Harris (London, 1962).

Lüscher, Barbara. *Untersuchungen zu Totenbuch Spruch 151.* Studien zum altägyptischen Totenbuch 2 (Wiesbaden, 1998).

Luft, Ulrich H. "Religion." *OEAE* III (2001): 139-145.

Lurker, Manfred. *An Illustrated Dictionary of The Gods and Symbols of Ancient Egypt.* Translated from the German by B. Cumming (London, 1995).

Mackay, Ernest. "Proportional squares on tomb walls in the Theban necropolis." *JEA* 4 (1917): 74-85.

Mackay, Ernest. "On the use of beeswax and resin as varnishes in Theban tombs." *Ancient Egypt* 5 (1920): 35-38.

Mackay, Ernest. "The cutting and preparation of tomb-chapels in the Theban necropolis." *JEA* 7 (1920): 154-168.

Malek, Jaromir. *The Cat in Ancient Egypt* (London, 1993).

Malek, Jaromir. "The Old Kingdom (ca. 2686-2125 BC)." In *The Oxford History of Ancient Egypt.* Edited by I. Shaw (Oxford, 2000): 89-117.

Manniche, Lise. "The Body Colours of Gods and Men in Inlaid Jewellery and Related Objects from the Tomb of Tutankhamun." *Acta Orientalia* 43 (1982): 5-13.

Manniche, Lise. "The Tomb of Nakht, the Gardener, at Thebes (No. 161), as Copied by Robert Hay." *JEA* 72 (1986): 55-72.

Manniche, Lise. *City of the Dead. Thebes in Egypt* (Chicago, 1987).

Manniche, Lise. *Sexual Life in Ancient Egypt* (London and New York, 1987).

Manniche, Lise. *Lost Tombs. A Study of Certain Eighteenth Dynasty Monuments in the Theban Necropolis* (London and New York, 1988).

Manniche, Lise. *The Wall Decoration of Three Theban Tombs (TT 77, 175, 249).* CNI Publications 4 (Copenhagen, 1988).

Manniche, Lise. *An Ancient Egyptian Herbal* (Austin, 1989).

Manniche, Lise. *Music and Musicians in Ancient Egypt* (London, 1991).

Manniche, Lise. "Reflections on the Banquet Scene." In *La peinture égyptienne ancienne: Un monde de signes à préserver. Actes de Colloque international de Bruxelles, avril 1994.* Edited by R. Tefnin. Monumenta Aegyptiaca 7 (Brussels, 1997): 29-35.

Manniche, Lise. *Sacred Luxuries: Fragrance, Aromatherapy, and Cosmetics in Ancient Egypt* (Ithaca and London, 1999).

Manniche, Lise. "Funerary Cones." *OEAE* I (2001): 565-567.

Manniche, Lise. "Sexuality." *OEAE* III (2001): 274-277.

Manniche, Lise. "Sistrum." *OEAE* III (2001): 292-293.

Manniche, Lise. "The so-called scenes of daily life in the private tombs of the Eighteenth Dynasty: an overview." In *The Theban Necropolis: Past, Present and Future*. Edited by N. Strudwick and J. H. Taylor (London, 2003): 42-45.

Manuelian, Peter Der. "Classic Chair." In *Egypt's Golden Age: The Art of Living in the New Kingdom 1558-1085 B.C.* Edited by E. Brovarski, S.K. Doll, and R.E. Freed (Boston, 1982): 66-67.

Manuelian, Peter Der. *Studies in the Reign of Amenophis II*. HÄB 26 (Hildesheim, 1987).

Manuelian, Peter Der. "Semi-Literacy in Egypt: Some Erasures from the Amarna Period." In *Gold of Praise: Studies on Ancient Egypt in Honor of Edward F. Wente*. Edited by E. Teeter and J.A. Larson. SAOC 58 (Chicago, 1999): 285-298.

Maraite, Élisabeth. "Le cône de parfum dans l'ancienne Égypte." In *Amosiadès. Mélanges offerts au Professeur Claude Vandersleyen par ses anciens étudiants*. Edited by C. Obsomer and A. L. Oosthoek (Louvain-la-Neuve, 1992): 213-219.

Marciniak, Marek. "Une texte inédit de Deir el-Bahri." *Bulletin du centenaire. Supplément au BIFAO* 81 (1981): 283-291.

Mariette, Auguste. *Catalogue général des monuments d'Abydos découverts pendant les fouilles de cette ville* (Paris, 1880).

Martin, Karl. "Speisetischszene." *LÄ* V (1984): 1128-1133.

Martin, Karl. "Uräus." *LÄ* VI (1986): 864-868.

Martin, Karl. "Vogelfang, -jagd, -netz, -steller." *LÄ* VI (1986): 1051-1054.

Maspero, Gaston. *Études égyptiennes*, vols. 1-2, 4 (Paris, 1886-1890).

Maspero, Gaston. *Egyptian archaeology*. Translated from the French by A.B. Edwards (New York, 1887).

Mathieu, Bernard. "L'univers végétal dans les chants d'amour égyptiens." *Encyclopédie religieuse de l'Univers végétal. Croyances phytoreligieuses de l'Égypte ancienne,*vol. I. Edited by S. Aufrère. Orientalia Monspeliensia 10 (Montpellier, 1999): 99-106.

Mauss, Marcel. *The gift: forms and functions of exchange in archaic societies*. Translated from the French by I. Cunnison (New York, 1967).

McCarthy, Blythe. "Technical analysis of reds and yellows in the Tomb of Suemniwet, Theban Tomb 92." In *Colour and Painting in Ancient Egypt*. Edited by W.V. Davies (London, 2001): 17-21.

McDowell, Andrea. "Teachers and Students at Deir el-Medina." In *Deir el-Medina in the Third Millennium AD. A Tribute to Jac. J. Janssen*. Edited by R.J. Demarée and A. Egberts. EU 14 (London, 2000): 217-233.

Meeks, Dimitri. "Génies, Anges, Démons en Égypte." In *Génies, Anges and Démons*. Sources Orientales 8 (Paris, 1971): 17-84.

Meeks, Dimitri. "Notion de 'dieu' et structure du panthéon dans l'Égypte ancienne." *Revue de l'Histoire des Religions* 204 (1988): 425-446.

Meeks, Dimitri. "La production de l'huile et du vin dans l'Égypte Pharaonique." In *La production du vin et de l'huile en Mediterranée*. Edited by M.C. Amouretti and J.P. Brun (Athens, 1993): 3-38.

Meeks, Dimitri, and Christine Favard-Meeks. *Daily Life of the Egyptian Gods*. Translated from the French by G.M. Goshgarian (Ithaca and London, 1997).

Megally, Mounir. "A propos de l'organisation administrative des ouvriers à la XVIIIe dynastie." *Studia Aegyptiaca. Recueil d'études dédiées à Vilmos Wessetzky à l'occasion de son 65e anniversaire,* vol. I (Budapest, 1974): 297-311.

Megally, Mounir. "Un intéressant ostracon de la XIIIe dynastie de Thèbes." *Bulletin du centenaire, Supplément au BIFAO* 81 (1981): 293-312.

Megally, Mounir. "Two Visitors' Graffiti from Abûsîr." *CdÉ* 56, no. 112 (1981): 218-240.

Mekhitarian, Arpag. *Egyptian Painting* (Geneva, 1954).

Mekhitarian, Arpag. "Personnalité de peintres thébains." *CdÉ* 31, no. 62 (1956): 238-248.

Mekhitarian, Arpag. "Un peintre thébain de la XVIIIe dynastie." *MDAIK* 15 (1957): 186-192.

Meltzer, Edmund S. "Horus." *OEAE* II (2001): 119-122.

Metzger, Martin. *Königsthron und Gottesthron*, 2 vols. AOAT 15/1-2 (Kevelaer and Neukirchen-Vluyn, 1985).

Meyer, Christine. "Wein." *LÄ* VI (1986): 1169-1182.

Meyer, Christine. "Weintrauben." *LÄ* VI (1986): 1190-1192.

Meyer, Klaus-Heinrich. "Kunst." *LÄ* III (1980): 872-881.

Miles, Margaret R. *Plotinus on body and beauty: Society, philosophy, and religion in third-century Rome* (Oxford and Malden, Mass., 1999).

Miller, Eric and R.B. Parkinson. "Reflections on a gilded eye in 'Fowling in the Marshes' (British Museum, EA 37977)." In *Colour and Painting in Ancient Egypt*. Edited by W.V. Davies (London, 2001): 49-52.

Mond, Robert. "Report of work in the necropolis of Thebes during the winter of 1903-1904." *ASAE* 6 (1905): 65-96.

Montet, Pierre. *Everyday Life in Egypt in the days of Ramesses the Great*. Translated from the French by A.R. Maxwell-Hyslop and M.S. Drower (Philadelphia, 1981).

Morenz, Siegfried. *Egyptian Religion*. Translated from the German by A.E. Keep (London, 1973).

Morkot, Robert. "*Nb-M3't-R'* – United-with-Ptah." *JNES* 49 (1990): 323-337.

Mostafa, Doha M. "L'usage culturel du bouquet et sa signification symbolique." In *Hommages à Jean Leclant*, vol. 4. Edited by C. Berger, G. Clerc and N. Grimal. BdÉ 106/4 (1994): 243-245.

Mostafa, Maha F. *Das Grab des Neferhotep und des Meh (TT 257)*. Theben VIII (Mainz, 1995).

Moxey, Keith. "Semiotics and the Social History of Arts: Toward a History of Visual Representation." In *Acts of the 27th International Congress of the History of Art*, vol. V (Strasbourg, 1992): 209-218.

Moxey, Keith. *The Practice of Theory: Poststructuralism, Cultural Politics and Art History* (Ithaca and London, 1994).

Müller, Christa. "Anruf an Lebende." *LÄ* I (1975): 293-299.

Müller, Christa. "Salbkegel." *LÄ* V (1984): 366-367.

Müller, Christa. "Speigel." *LÄ* V (1984): 1147-1150.

Müller, Hans Wolfgang. *Alt-Ägyptische Malerei* (Berlin, 1959).

Müller, Maya. "Malerei." *LÄ* III (1980): 1168-1173.

Müller, Maya. "Musterbuch." *LÄ* IV (1982): 244-246.

Müller, Maya. "Zum Werkverfahren an thebanischen Grabwänden des Neuen Reiches." *SAK* 13 (1986): 149-164.

Müller, Maya. *Die Kunst Amenophis' III und Echnatons* (Basel, 1988).

Müller, Maya. "Die ägyptische Kunst aus kunsthistorischer Sicht." In *Studien zur ägyptischen Kunstgeschichte.* Edited by M. Eaton-Krauss and E. Graefe. HÄB 29 (Hildesheim, 1990): 39-56.

Müller, Maya. "Afterlife." Translated from the German by R.E. Shillenn and J. McGary. *OEAE* I (2001): 32-37.

Müller-Wollermann, Renate. "Bemerkungen zu den sogenannten Tributen." *GM* 66 (1984): 81-93.

Murnane, William J. *Ancient Egyptian Coregencies.* SAOC 40 (Chicago, 1977).

Murnane, William J. *United with Eternity: A Concise Guide to the Monuments of Medinet Habu* (Chicago and Cairo, 1980).

Murnane, William J. "Paintings from the Tomb of Nakht at Thebes." *Field Museum of Natural History Bulletin* 52, no. 10 (November, 1981): 13-25.

Murnane, William J. "The Organization of Government under Amenhotep III." In *Amenhotep III: Perspectives on His Reign.* Edited by E. Cline and D. O'Connor (Ann Arbor, 1998): 173-222.

Murnane, William J. "Medinet Habu." *OEAE* II (2001): 356-358.

Murray, Mary Anne. "Cereal production and processing." In *Ancient Egyptian Materials and Technology.* Edited by P.T. Nicholson and I. Shaw (Cambridge, 2000): 505-536.

Murray, Mary Anne. "Fruits, vegetables, pulses and condiments." In *Ancient Egyptian Materials and Technology.* Edited by P.T. Nicholson and I. Shaw (Cambridge, 2000): 609-655.

Murray, Mary Anne. "Viticulture and wine production." In *Ancient Egyptian Materials and Technology.* Edited by P.T. Nicholson and I. Shaw (Cambridge, 2000): 577-608.

Musées Royaux d'Art et d'Histoire. *La Tombe de Nakht.* Guides du département Égyptien, no. 1 (Brussels, 1972).

Naguib, Saphinaz-Amal. "The Beautiful Feast of the Valley." In *Understanding and History in Arts and Sciences.* Edited by R. Skarsten, et al. Acta Humaniora Universitatis Bergensis I (Oslo, 1991): 21-32.

Naville, Édouard. *Das ägyptische Todtenbuch der XVIII. bis XX. Dynastie*, 3 vols. (Berlin, 1886/R Austria, 1971).

Naville, Édouard. *The temple of Deir el Bahri*, 7 vols. EEF 12-14, 16, 19, 27, 29 (1894-1908).

Newberry, Percy E. *El Bersheh*, 2 vols. ASE Memoire 3-4 (London, 1894-1895).

Newberry, Percy E. "The shepherd's crook and the so-called 'flail' or 'scourge' of Osiris." *JEA* 15 (1929): 84-94.

Newman, Richard, and Margaret Serpico. "Adhesives and binders." *Ancient Egyptian Materials and Technology*. Edited by P.T. Nicholson and I. Shaw (Cambridge, 2000): 475-494.

Newman, Richard, and Susana M. Halpine. "The binding media of ancient Egyptian painting." In *Colour and Painting in Ancient Egypt*. Edited by W.V. Davies (London, 2001): 22-32.

Nibbi, Alessandra. *Lapwings and Libyans in Ancient Egypt* (Oxford, 1986).

Nibbi, Alessandra. "The So-called Plant of Upper Egypt." *DIE* 19 (1991): 53-68.

Nibbi, Alessandra. "Some Notes on the Two Lands of Ancient Egypt and the 'Heraldic' Plants." *DIE* 37 (1997): 23-49.

Nibbi, Alessandra. "*Rḫy.t* Again." *DIE* 46 (2000): 39-48.

Niedziółka, Dariusz. "Note on the Egyptian Construction ACTIVE *SḎM.F/IRY.F+IN*+NOUN in One of the Inscriptions in the Theban Tomb of Userhat (TT 56)." *Rocznik orientalistyczny,* Warszawa 50 (1996): 9-25.

Nims, Charles F. "Places About Thebes." *JNES* 14 (1955): 110-123.

Nims, Charles F. "Popular Religion in ancient Egyptian Temples." *Proceedings of the Twenty-Third International Congress of Orientalists, Cambridge 21st-28th August, 1954.* Edited by D. Sinor (London, 1956): 79-80.

Nims, Charles F. "The Eastern Temple at Karnak." *Aufsätze zum 70. Geburtstag von Herbert Ricke.* BABA 12 (Wiesbaden, 1971): 107-111.

Novitz, David. *Pictures and their use in communication* (The Hague, 1977).

Nussbaum, Martha C. "Aesthetics, II,1: Classical." *The Dictionary of Art*, vol. 1. Edited by J. Turner (New York, 1996): 174-176.

Okinga, Boyo. "Zum Fortleben "Amarna-Loyalismus" in der Ramessidenzeit." *WdO* 14 (1983): 207-215.

Ockinga, Boyo. "Piety." *OEAE* III (2001): 44-47.

O'Connor, David. "Malqata." *LÄ* III (1980):1173-1177.

O'Connor, David. "New Kingdom and Third Intermediate Period, 1552-664 B.C." *Ancient Egypt: A Social History* (Cambridge, 1983): 183-278.

O'Connor, David. "Beloved of Maat, the Horizon of Re: The Royal Palace in New Kingdom Egypt." In *Ancient Egyptian Kingship*. Edited by D. O'Connor and D. Silverman. PÄ 9 (Leiden, 1995): 263-300.

O'Connor, David. "Sexuality, Statuary and the Afterlife; Scenes in the tomb-chapel of Pepyankh (Heny the Black). An Interpretive Essay." In *Studies in Honor of William Kelly Simpson*, vol. 2. Edited by P. Der Manuelian (Boston, 1996): 621-633.

O'Connor, David. "The City and the World: Worldview and Built Forms in the Reign of Amenhotep III." *Amenhotep III: Perspectives on His Reign*. Edited by D. O'Connor and E. Cline (Ann Arbor, 1998): 125-172.

O'Connor, David. "The World Abroad: Amenhotep III and Nubia." In *Amenhotep III: Perspectives on His Reign*. Edited by D. O'Connor and E. Cline (Ann Arbor, 1998): 261-270.

O'Connor, David. "Egypt's View of 'Others'," In *'Never Had the Like Occurred': Egypt's View of its Past*. Edited by J. Tait. Encounters with Ancient Egypt (London, 2003): 155-186.

O'Donoghue, Michael. "The 'Letters to the Dead' and Ancient Egyptian Religion." *BACE* 10 (1999): 87-104.

Oldfather, C.H. *Diodorus of Sicily* I, Loeb Classical Library nr. 279 (Cambridge, Mass., 1968).

Omlin, J.A. *Der Papyrus 55001 und seine satirisch-erotischen Zeichnungen und Inschriften* (Turin, 1973).

Otto, Eberhard. *Die biographische Inschriften der ägyptischen Spätzeit*. PÄ 2 (Leiden, 1954).

Otto, Eberhard. *Das ägyptische Mundöffnungsritual*, 2 vols. ÄA 3 (Wiesbaden, 1960).

Panofsky, Erwin. *Studies in Iconology* (New York, 1939/R 1972).

Panofsky, Erwin. "Iconography and Iconology: An Introduction to the Study of Renaissance Art." In *Meaning in the Visual Arts* (Garden City, N.Y., 1955/R London, 1970): 26-54.

Parkinson, Richard B. *Voices from Ancient Egypt. An Anthology of Middle Kingdom Writings* (London, 1991).

Pecoil, Jean-François, and Mahmoud Maher-Taha. "Quelques aspects du bandeau-*seched*." *BSÉG* 8 (1983): 67-79.

Peden, Alexander J. *The Graffiti of Pharaonic Egypt: Scope and Roles of Informal Writings (c. 3100-332 BC)*. PÄ 17 (Leiden-Boston-Köln, 2001).

Petrie, W.M.F. *Medum* (London, 1892).

Piacentini, Patrizia. "Scribes." *OEAE* III (2001): 187-192.

Piehl, Karl. *Inscriptions hiéroglyphiques recueillies en Europe et en Égypte*, 6 vols. (Leipzig, 1886-1903).

Pierret, Paul. *Recueil d'inscriptions inédites du Musée Égyptien du Louvre*, 2 vols. (Paris, 1874-1878).

Pinch, Geraldine. "Red things: the symbolism of colour in magic." In *Colour and Painting in Ancient Egypt*. Edited by W.V. Davies (London, 2001): 182-185.

Plato. *Laws*. Translated by Benjamin Jowett (Amherst, New York, 2000).

Polz, Daniel. "Excavation and Recording of a Theban Tomb: Some Remarks on Recording Methods." *Problems and Priorities in Egyptian Archaeology*. Edited by J. Assmann, G. Burkhard, V. Davies (London and New York, 1987): 119-140.

Polz, Daniel. "Bemerkungen zur Grabbenutzung in der thebanischen Nekropole." *MDAIK* 46 (1990): 301-336.

Polz, Daniel. *Das Grab des Hui und des Kel: Theben Nr. 54*. AV 74 (Mainz, 1997).

Pomorska, Irena. *Les flabellifères à la droite du roi en Égypte ancienne*. Académie polonaise des sciences. Comité des études orientales (Warsaw, 1987).

Poo, Mu-Chou. *Wine and Wine Offering in the Religion of Ancient Egypt* (London and New York, 1995).

Poo, Mu-Chou. "Weinopfer." *LÄ* VI (1986): 1186-1190.

Poo, Mu-Chou. "Encountering the Strangers: A Comparative Study of Cultural Consciousness in Ancient Egypt, Mesopotamia, and China." In *Proceedings of the Seventh International Congress of Egyptologists*. Edited by C.J. Eyre. OLA 82 (Leuven, 1998): 885-892.

Poo, Mu-Chou. "Wine." *OEAE* III (2001): 502-503.

Porter, Bertha, and Rosalind Moss. *Topographical Bibliography of Ancient Egyptian Hieroglyphic Texts, Reliefs and Paintings*, 8 vols. (Oxford, 1927-1999).

Posener, Georges. *De la divinité du Pharaon*. Cahiers de la Société Asiatique 15 (Paris, 1960).

Posener, Georges. *Catalogue des ostracas hiératiques littéraires de Deir el-Médineh*, vol. II. Documents de Fouilles 18 (Cairo, 1972).

Posener, Georges. "La piété personnelle avant l'âge amarnien." *RdÉ* 27 (1975): 195-210.

Posener, Georges. "Le vizir Antefoqer." In *Pyramid Studies and Other Essays Presented to I.E.S. Edwards*. Edited by J. Baines, T.G.H. James, A. Leahy, and A.F. Shore. Occasional Publications 7 (London, 1988): 73-77.

Posener-Kriéger, Paule. "Construire une tombe à l'ouest de *mn-nfr* (P. Caire 52002)." *RdÉ* 33 (1981): 47-58.

Pritchard, J.B. "Syrians as Pictured in the Paintings of the Theban Tombs." *BASOR* 122 (April, 1951): 36-41.

Quirke, Stephen. "The Hieratic texts in the Tomb of Nakht the Gardener, at Thebes (No. 161) as Copied by Robert Hay." *JEA* 72 (1986): 79-90.

Quirke, Stephen. *Who Were the Pharaohs? A history of their names with a list of cartouches* (New York, 1990).

Quirke, Stephen. *Ancient Egyptian Religion* (London, 1992).

Quirke, Stephen. *Owners of Funerary Papyri in the British Museum*. BM Occassional Paper 92 (London, 1993).

Quirke, Stephen. "Colour vocabularies in Ancient Egyptian." In *Colour and Painting in Ancient Egypt*. Edited by W.V. Davies (London, 2001): 186-192.

Quirke, Stephen, and Werner Forman. *Hieroglyphs and the Afterlife in Ancient Egypt* (London, 1996).

Radwan, Ali. *Die Darstellungen des regierenden Königs und seiner Familienangehörigen in den Privatgräbern der 18. Dynastie*. MÄS 21 (Berlin, 1969).

Radwan, Ali. "Amenophis III, dargestellt und angerufen als Osiris (*wnn-nfrw*)." *MDAIK* 29 (1973): 71-76.

Radwan, Ali. "Zur bildlichen Gleichsetzung des ägyptischen Königs mit der Gottheit." *MDAIK* 31 (1975): 99-108.

Radwan, Ali. "Einige Aspekte der Vergöttlichung des ägyptischen Königs." *Ägypten-Dauer und Wandel*. SDAIK 18 (Mainz, 1985): 53-69.

Radwan, Ali. "Ramesses II as mediator." In *Fragments of a Shattered Visage: The Proceedings of the International Symposium on Ramesses the Great*. Edited by E. Bleiberg and R. Freed. Monographs of the Institute of Egyptian Art and Archaeology 1 (Memphis, 1991): 221-225.

Radwan, Ali. "Thutmosis III. als Gott." In *Stationen: Beiträge yur Kulturgeschichte Ägyptens Rainer Stadelmann Gewidmet*. Edited by H. Guksch and D. Polz (Mainz, 1999): 329-340.

Rathbone, Dominic. *Economic Rationalism and Rural Society in Third Century A.D. Egypt: The Heroninos Archive and the Appianus Estate* (Cambridge, 1991).

Raven, Maarten J. "Magic and Symbolic Aspects of Certain Materials in Ancient Egypt." *VA* 4 (1988): 237-242.

Redford, Donald B. "The Coregency of Tuthmosis III and Amenophis II." *JEA* 51 (1965): 107-122.

Redford, Donald B. *History and Chronology of the Eighteenth Dynasty of Egypt. Seven Studies.* Near and Middle East Studies 3 (Toronto, 1976).

Redford, Donald B. "The Sun Disc in Akhenaten's Program: Its Worship and Antecedants, 1." *JARCE* 13 (1976): 47-61.

Redford, Donald B. *Pharaonic King-Lists, Annals and Day-Books. A Contribution to the Study of the Egyptian Sense of History.* SSEA 4 (Mississauga, Canada, 1986).

Redford, Donald B. "The Concept of Kingship during the Eighteenth Dynasty." In *Ancient Egyptian Kingship.* Edited by D. O'Connor and D. Silverman. PÄ 9 (Leiden, 1995): 157-184.

Redford, Susan and Donald. *Tomb of Re'a (TT 201).* The Akhenaton Temple Project 4 (Toronto, 1994).

Ritner, Robert K. *The Mechanics of Ancient Egyptian Magical Practice.* SAOC 54 (Chicago, 1993).

Ritner, Robert K. "Magic: An Overview." *OEAE* II (2001): 321-326.

Ritner, Robert K. "Magic in the Afterlife." *OEAE* II (2001): 333-336.

Robichon, Clément, and Alexandre Varille. *Le temple du scribe royal Amenhotep, fils de Hapou.* FIFAO 11 (Cairo, 1936).

Robins, Gay. "Natural and Canonical Proportions in Ancient Egyptians." *GM* 61 (1983): 17-25.

Robins, Gay. "The Stature and Physical Proportions of the Brothers Nakhtankh and Khnumnakht (Manchester Museum, nos. 21470-1)." *ZÄS* 112 (1985): 44-48.

Robins, Gay. *Egyptian Painting and Relief.* Shire Egyptology 3 (Aylesbury, 1986).

Robins, Gay. "Ancient Egyptian Sexuality." *DIE* 11 (1988): 61-72.

Robins, Gay. "Problems in interpreting Egyptian art." *DIE* 17 (1990): 45-58.

Robins, Gay. *Women in Ancient Egypt* (London, 1993).

Robins, Gay. *Proportion and Style in Ancient Egyptian Art.* (Austin, 1994).

Robins, Gay. "Dress, Undress, and the Representation of Fertility and Potency in New Kingdom Egyptian Art." In *Sexuality in Ancient Art: Near East, Egypt, Greece, and Italy.* Edited by N.B. Kampen (Cambridge, 1996): 27-40.

Robins, Gay. *The Art of Ancient Egypt* (Cambridge, Mass., 1997).

Robins, Gay. "Hair and the Construction of Identity in Ancient Egypt, c. 1480-1350 B.C." *JARCE* 36 (1999): 55-69.

Robins, Gay. "Color Symbolism." *OEAE* I (2001): 291-294.

Robins, Gay. "Grid Systems." *OEAE* II (2001): 68-71.

Robins, Gay. "The use of the squared grid as a technical aid for artists in Eighteenth Dynasty Painted Theban Tombs." In *Colour and Painting in Ancient Egypt.* Edited by W.V. Davies (London, 2001): 60-62.

Robins, Gay. "Women." *OEAE* III (2001): 510-516.

Roehrig, Catherine. "The Eighteenth Dynasty titles royal nurse (*mn't nswt*), royal tutor (*mn' nswt*), and foster brother/sister of the Lord of the Two Lands (*sn/snt mn' n nb t3wy*)." Ph.D. Dissertation, University of California-Berkeley, 1990.

Römer, Malte. *Gottes- und Priesterherrschaft in Ägypten am Ende des Neuen Reiches.* ÄAT 21 (Wiesbaden, 1994).

Rössler-Köhler, Ursula "Löwe, L.-Köpfe, L.-Statuen." *LÄ* III (1980): 1079-1090.

Romer, John. "Who Made the Private Tombs of Thebes?" In *Essays in Egyptology in honor of Hans Goedicke.* Edited by B. Bryan and D. Lorton (San Antonio, 1994): 211-232.

Roth, Ann Macy. "The Social Aspects of Death." In *Mummies & Magic. The Funerary Arts of Ancient Egypt.* Edited by S. D'Auria, P. Lacovara, and C. H. Roehrig (Boston, 1988): 52-59.

Roth, Ann Macy. "The *psš-kf* and the 'Opening of the Mouth' Ceremony: A Ritual of Birth and Rebirth." *JEA* 78 (1992): 113-147.

Roth, Ann Macy. "Social Change in the Fourth Dynasty: The Spacial Organization of Pyramids, Tombs, and Cemeteries." *JARCE* 30 (1993): 33-55.

Roth, Ann Macy. "The Practical Economics of Tomb-Building in the Old Kingdom: A Visit to the Necropolis in a Carrying Chair." In *For His Ka. Essays Offered in Memory of Klaus Baer.* Edited by D.P. Silverman. SAOC 55 (Chicago, 1994): 227-240.

Roth, Ann Macy. "The Absent Spouse: Patterns and Taboos in Egyptian Tomb Decoration." *JARCE* 36 (1999): 37-53.

Roth, Ann Macy. "Funerary Ritual." *OEAE* I (2001): 575-580.

Roth, Ann Macy. "Opening of the Mouth." *OEAE* II (2001): 605-609.

Sadek, Ashraf Iskander. *Popular Religion in Egypt during the New Kingdom.* HÄB 27 (Hildesheim, 1987).

Säve-Söderbergh, Torgny. *The navy of the eighteenth Egyptian dynasty.* Uppsala Universitets årrskrift 6 (Uppsala, 1946).

Säve-Söderbergh, Torgny. "Några egyptiska nyårsföreställningar." *Religion och Bibel.* Nathan Söderblom-Sällskapets Årsbok, Lund, C. W. K. Gleerup 9 (1950): 1-19.

Säve-Söderbergh, Torgny. *Four Eighteenth Dynasty Tombs.* PTT I (Oxford, 1957).

Säve-Söderbergh, Torgny. "Eine Gastmahlsszene im Grabe des Schatzhausvorstehers Djehuti." *MDAIK* 16 (1958): 280-291.

El-Saghir, Mohammed. *The Discovery of the Statuary of the Luxor Temple* (Mainz, 1992).

Sahrhage, Dietrich. *Fischfang und Fischkult im alten Ägypten.* Kulturgeschichte der Antiken Welt 70 (Mainz, 1998).

Sakurai, K., S. Yoshimura, and J. Kondo. *Comparative Studies of Noble Tombs in the Theban Necropolis (Tomb nos. 8, 38, 39, 48, 50, 54, 57, 63, 64, 66, 74, 78, 89, 90, 91, 107, 120, 139, 147, 151, 181, 201, 253, 295)* (Tokyo, 1988).

Saleh, Mohamed, and Hourig Sourouzian. *The Egyptian Museum Cairo. Official Catalogue* (Mainz, 1987).

Sauneron, Serge. "Le chef de travaux Mây." *BIFAO* 53 (1953): 57-63.

Sauneron, Serge. *Les prêtres de l'ancienne Égypte* (Paris, 1988).

Sauneron, Serge. *The Priests of Ancient Egypt*. Translated from the French by D. Lorton (Ithaca, 2000).

Schäfer, Heinrich. *Die altägyptischen Prunkgefässe mit aufgesetzten Randverzierungen: ein Beitrag zur Geschichte der Goldschmiedekunst*. UGAÄ 4 (Leipzig, 1903).

Schäfer, Heinrich. "Die Simonsche Holzfigur eines Königs der Amarnazeit." *ZÄS* 70 (1934): 1-25.

Schäfer, Heinrich. "Die 'Vereinigung der beiden Länder': Ursprung, Gehalt und Form eines ägyptischen Sinnbildes im Wandel der Geschichte." *MDAIK* 12 (1943): 73-95.

Schäfer, Heinrich. *Principles of Egyptian Art*. Translated from the German by J. Baines (Oxford, 1974).

Schapiro, Meyer. "On the Relation of Patron and Artist: Comments on a Proposed Model for the Scientist." In *Theory and Philosophy of Art: Style, Artist and Society* (New York, 1994): 227-238. First published in *The American Journal of Sociology* LXX, 3 (November, 1964): 363-369.

Scheil, Vincent. "Le tombeau de Djanni." *Mém. Miss.* V, 2 (1894): 591-603.

Scheil, Vincent. "Le tombeau de Pârj." *Mém. Miss.* V, 2 (1894): 581-590.

Scheil, Vincent. "Le tombeau de Rat'eserkasenb." *Mém. Miss.* V, 2 (1894): 571-579.

Schiaparelli, Ernest. *Relazione sui lavori della Missione Archeologica Italiana in Egitto (anni 1903-1920)*. Vol. II: *La tomba intatta dell'architetto 'Cha' nella necropoli di Tebe* (Turin, 1927).

Schlick-Nolte, Birgit. "Glass." *OEAE* II (2001): 30-34.

Schlögl, Hermann. *Der Sonnengott auf der Blüte. Eine ägyptische Kosmogonie des Neuen Reiches*. AH 5 (Genève, 1977).

Schlögl, Hermann. "Gott auf der Blume." *LÄ* II (1977): 786-787.

Schmitz, Bettina. "Sem(priester)." *LÄ* V (1984): 833-836.

Schmitz, Bettina. "Wedelträger." *LÄ* VI (1986): 1161-1163.

Schmoll, Patrick. "Organisation des représentations, symbolisme et écriture dans la peinture égyptienne." *La linguistique* 17 (1981): 77-89.

Schneider, Hans D. *Life and Death under the Pharaohs. Egyptian Art from the National Museum of Antiquities in Leiden, The Netherlands* (Leiden, 2002).

Schoske, Sylvia, Barbara Kreissl, and Renate Germer. *"Anch" Blumen für das Leben. Pflanzen im alten Ägypten*. SAS 6 (Munich, 1992).

Schott, Siegfried. "The Feasts of Thebes." In *Work in Western Thebes 1931-1933*. Edited by H. H. Nelson and U. Hölscher. OIC 18 (Chicago, 1934): 63-90.

Schott, Siegfried. *Das schöne Fest vom Wüstentale. Festbräuche einer Totenstadt* (Mainz, 1952).

Schott, Siegfried. "Symbol und Zauber als Grundform altägyptischen Denkens." *Studium Generale* 5 (1953): 278-288.

Schulman, Alan. *Military Rank, Title and Organization in the Egyptian New Kingdom*. MÄS 6 (Berlin, 1964).

Schulman, Alan. "Some Remarks on the Alleged 'Fall' of Senmut." *JARCE* 8 (1969-1970): 29-48.

Schulman, Alan. *Ceremonial Execution and Public Rewards. Some Historical Scenes on New Kingdom Private Stelae*. OBO 75 (Freiburg and Göttingen, 1988).

Schulz, Regine, and Matthias Seidel, eds. *Egypt World of the Pharaohs* (Cologne, 1998).

Schumann-Antelme, Ruth, and Stéphane Rossini. *Sacred Sexuality in Ancient Egypt*. Translated from the French by J. Graham (Vermont, 2001).

Schweitzer, Ursula. *Das Wesen des Ka im Diesseits und Jenseits der alten Ägypter*. ÄF 19 (Gückstadt-Hamburg-New York, 1956).

Seidlmayer, Stephan J. "Necropolis." *OEAE* II (2001): 506-512.

Serpico, Margaret. "Resins, amber and bitumen." In *Ancient Egyptian Materials and Technology*. Edited by P.T. Nicholson and I. Shaw (Cambridge, 2000): 430-474.

Serpico, Margaret, and Raymond White. "Oil, fat and wax." In *Ancient Egyptian Materials and Technology*. Edited by P.T. Nicholson and I. Shaw (Cambridge, 2000): 390-429.

Sethe, Kurt. *Die altägyptischen Pyramidentexte nach den Papierabdrücken und Photographien des Berliner Museums* (Leipzig, 1908-1922).

Sethe, Kurt. *Die Einsetzung des Veziers unter der 18. Dynastie: Inschrift im Grabe des Rech-mi-re' zu Schech Abd el Gurna*. UGAÄ 5, Heft. 2 (Leipzig, 1909).

Sethe, Kurt. *Urkunden des Alten Reiches. Übersetzung zu Heft 1-4* (Leipzig, 1914).

Sethe, Kurt. *Dramatische Texte in altägyptischen Mysterienspielen*. UGAÄ 10 (Leipzig, 1928).

Sethe, Kurt. *Das hieroglyphische Schriftsystem*. LÄS 3 (Glückstadt-Hamburg-New York, 1935).

Sethe, Kurt. *Übersetzung und Kommentar zu den altägyptischen Pyramidentexten*, vol. 5 (Hamburg, 1962).

Seyfried, Karl-Joachim. "Zweiter Vorbericht über die Arbeiten des Ägyptologischen Instituts der Universität Heidelberg in thebanischen Gräbern der Ramessidenzeit." *MDAIK* 40 (1984): 265-276.

Seyfried, Karl-Joachim. "Bemerkungen zur Erweiterung der unterirdischen Anlagen einiger Gräber des Neuen Reiches in Theben -Versuch einer Deutung." *ASAE* 71 (1987): 229-249.

Seyfried, Karl-Joachim. *Das Grab des Paenkhemenu (TT 68) und die Anlage TT 227*. Theben VI (Mainz, 1991).

Seyfried, Karl-Joachim. "Generationeneinbindung." In *Thebanische Beamtennekropolen. Neue Perspektiven archäologischer Forschung, Internationales Symposion Heidelberg 9.- 13.6.1993*. Edited by J. Assmann, E. Dziobek, H. Guksch, F. Kampp. SAGA 12 (Heidelberg, 1995): 219-231.

Shaw, Ian. *Egyptian Warfare and Weapons*. Shire Egyptology 16 (Princes Risborough, 1991).

Shaw, Ian, and Paul Nicholson. *British Museum Dictionary of Ancient Egypt* (London, 1995).

Shedid, Abdel Ghaffar. *Stil der Grabmalereien in der Zeit Amenophis' II. untersucht an den Thebanischen Gräbern Nr. 104 und Nr. 80*. AV 66 (Mainz, 1988).

Shedid, Abdel Ghaffar, and Matthias Seidel. *The Tomb of Nakht*. Translated by M. Eaton-Krauss (Mainz, 1996).

Shimy, Mohamed Abdel-Hamid. *Parfums et parfumerie dans l'ancienne Egypte* (Villeneuve d'Ascq, 2000).

Simpson, William Kelly. *The Offering Chapel of Sekhem-ankh-Ptah in the Museum of Fine Arts, Boston* (Boston, 1976).

Simpson, William Kelly. "Egyptian Sculpture and Two-dimensional Representation as Propaganda." *JEA* 68 (1982): 266-271.

Smith, H.S. "Animal domestication and animal cult in dynastic Egypt." In *The domestication and exploitation of plants and animals*. Edited by P.J. Ucko, et al. (Chicago, 1969): 307-314.

Smith, Stuart Tyson. "Ancient Egyptian Imperialism: Ideological Vision or Economic Exploitation?: Reply to Critics of *Askut in Nubia*." *CAJ* 7 (1997): 301-307.

Smith, Stuart Tyson. "State and Empire in the Middle and New Kingdoms." In *Anthropology and Egyptology. A Developing Dialogue*. Edited by J. Lustig (Sheffield, 1997): 66-89.

Smith, Stuart Tyson. "Imperialism." *OEAE* II (2001): 153-158.

Smith, Stuart Tyson. "Race." *OEAE* III (2001): 111-116.

Smith, William Stevenson. *Ancient Egypt as Represented in the Museum of Fine Arts, Boston* (Boston, 1960).

Sørensen, Jørgen Podemann. "Ancient Egyptian Religious Thought and the XVIth Hermetic Tractate." In *The Religion of the Ancient Egyptians. Cognitive Structures and Popular Expressions*. Edited by G. Englund. Boreas 20 (Uppsala, 1989 (sic); 1991): 41-57.

Sørensen, Jørgen Podemann. "Divine Access: The So-called Democratization of Egyptian Funerary Literature as a Socio-cultural Process." In *The Religion of the Ancient Egyptians. Cognitive Structures and Popular Expressions*. Edited by G. Englund. Boreas 20 (Uppsala, 1989 (sic); 1991): 109-125.

Spalinger, Anthony. "From Local to Global: The Extension of an Egyptian Bureaucratic Term to the Empire." *SAK* 23 (1996): 353-376.

Spalinger, Anthony J. *The Private Feast Lists of Ancient Egypt*. ÄA 57 (Wiesbaden, 1996).

Spalinger, Anthony J. "Festivals." *OEAE* I (2001): 521-525.

Spencer, Patricia. *The Egyptian Temple. A Lexicographical Study* (London, 1984).

Spiegel, Joachim. "Die Entwicklung der Opferszenen in den Thebanischen Gräbern." *MDAIK* 14 (1956): 190-207.

Spiegelberg, Wilhelm. "Eine Künstlerinscrift des Neuen Reiches." *Rec. Trav.* 24 (1902): 185-187.

Spiegelberg, Wilhelm. "Der 'Steinkern' in der hand von Statuen." *Rec. Trav.* 28 (1906): 174-176.

Spiegelberg, Wilhelm. "Ein Gerichtsprotokoll aus der Zeit Tuthmosis' IV." *ZÄS* 63 (1928): 105-115.

Spiegelberg, Wilhelm, and Walter Otto. *Eine neue Urkunde zu der Siegesfeier des Ptolemaios IV und die Frage der ägyptischen Priestersynoden*. SBAW 1926, 2 (Munich, 1926).

Stadelmann, Rainer. "Theben." *LÄ* VI (1986): 466-473.

Stadelmann, Rainer. "Sphinx." *OEAE* III (2001): 307-310.

Steindorff, Georg, and Walther Wolf. *Die thebanische Gräberwelt*. LÄS IV (Glückstadt-Hamburg-New York, 1936).

Steinmann, Frank. "Untersuchungen zu den in der handwerklich-künstlerischen Produktion beschäftigten Personen und Berufsgruppen des Neuen Reichs. I." *ZÄS* 107 (1980): 137-157.

Steinmann, Frank. "Untersuchungen zu den in der handwerklich-künstlerischen Produktion beschäftigten Personen und Berufsgruppen des Neuen Reichs. II: Klassifizierung der Berufsbezeichnungen und Titel." *ZÄS* 109 (1982): 66-72.

Steinmann, Frank. "Untersuchungen zu den in der handwerklich-künstlerischen Produktion beschäftigten Personen und Berufsgruppen des Neuen Reichs. III: Bemerkungen zu den an Titel und Berufsbezeichnungen angeknüpften Angaben über Dienstverhältnisse, etc." *ZÄS* 109 (1982): 149-156.

Steinmann, Frank. "Untersuchungen zu den in der handwerklich-künstlerischen Produktion beschäftigten Personen und Berufsgruppen des Neuen Reichs. IV. Bemerkungen zur Arbeitsorganisation." *ZÄS* 111 (1984): 30-40.

Steinmann, Frank. "Untersuchungen zu den in der handwerklich-künstlerischen Produktion beschäftigten Personen und Berufsgruppen des Neuen Reichs. V. Bemerkungen zur sozialen Stellung und materiellen Lage. *ZÄS* 118 (1991): 149-161.

Stewart, H.M. *Egyptian Stelae, Reliefs and Paintings from the Petrie Collection. Part One: The New Kingdom* (Warminster, 1976).

Störk, Lothar. "Rind." *LÄ* V (1984): 257-263.

Strawson, P.F. "Intention and Convention in Speech Acts." *Philosophical Review* LXXIII (1964): 439-460.

Strudwick, Nigel. "Oil tablet." In *Mummies and Magic: The Funerary Arts of Ancient Egypt.* Edited by S. D'Auria, P. Lacovara, and C. H. Roehrig (Boston, 1988): 81-82.

Strudwick, Nigel. "Change and Continuity at Thebes: The Private Tomb after Akhenaton." In *The Unbroken Reed. Studies in the Culture and Heritage of Ancient Egypt in Honour of A.F. Shore.* Edited by C. Eyre, A. Leahy, and L. Leahy. Occasional Publications 11 (London, 1994): 321-336.

Strudwick, Nigel. "The population of Thebes in the New Kingdom: Some preliminary thoughts." *Thebanische Beamtennekropolen. Neue Perspektiven archäologischer Forschung, Internationales Symposion Heidelberg 9.- 13.6.1993.* Edited by J. Assmann, E. Dziobek, H. Guksch, and F. Kampp. SAGA 12 (Heidelberg, 1995): 97-105.

Strudwick, Nigel, with Helen Strudwick. *The Tombs of Amenhotep, Khnummose, and Amenmose at Thebes (Nos. 294, 253, and 254)* (Oxford, 1996).

Strudwick, Nigel, and Helen Strudwick. *Thebes in Egypt* (London, 1999).

Strudwick, Nigel. Review of *Life and Death in Ancient Egypt. Scenes from Private Tombs in New Kingdom Thebes* by Sigrid Hodel-Hoenes (Ithaca and London, 2000). *JARCE* 38 (2001): 142-144.

Taylor, Jeanette Anne. *An Index of Male Non-Royal Egyptian Titles, Epithets & Phrases of the 18th Dynasty* (London, 2001).

Taylor, John H. *Death and the Afterlife in Ancient Egypt* (London, 2001).

Taylor, John H. "Patterns of colouring on ancient Egyptian coffins from the New Kingdom to the Twenty-sixth Dynasty: an overview." In *Colour and Painting in Ancient Egypt.* Edited by W.V. Davies (London, 2001): 164-181.

Teeter, Emily. "Female Musicians in Ancient Egypt." In *Rediscovering the Muses: Women's Musical Traditions.* Edited by K. Marshall (Boston, 1993): 68-91.

Teeter, Emily. "Amunhotep Son of Hapu at Medinet Habu." *JEA* 81 (1995): 232-236.

Teeter, Emily. *The Presentation of Maat. Ritual and Legitimacy in Ancient Egypt.* SAOC 57 (Chicago, 1997).

Teeter, Emily. "Maat." *OEAE* II (2001): 319-321.

Teeter, Emily. "Popular Worship in Ancient Egypt." *KMT* 4 (1993): 28-37.

Tefnin, Roland. "Discours et iconicité dans l'art égyptien." *Annales d'Histoire de l'Art et d'Archéologie* 5 (1983): 5-17.

Tefnin, Roland. "Discours et iconicité dans l'art égyptien." *GM* 79 (1984): 55-72.

Tefnin, Roland. "Réflexions liminaires sur la peinture égyptienne, sa nature, son histoire, son déchiffrement et son avenir." In *La peinture égyptienne ancienne: Un monde de signes à préserver. Actes de Colloque international de Bruxelles, avril 1994*. Edited by R. Tefnin. Monumenta Aegyptiaca 7 (Brussels, 1997): 3-9.

Tefnin, Roland. "Éléments pour une sémiologie de l'image égyptienne." *CdÉ* 66 (1991): 60-88.

Tefnin, Roland. "Reflexiones sobre la imagen Egipcia antigua: La medida y el juego." *Arte y sociedad del Egipto antiguo*. Edited by M.Á. Molinero Polo, and D. Sola Antequera (Madrid, 2000): 15-36.

te Velde, Herman. "The God Heka in Egyptian Theology." *JEOL* 21 (1970): 175-186.

te Velde, Herman. "The Cat as Sacred Animal of the Goddess Mut." *Studies in Egyptian Religion. Dedicated to Professor Jan Zandee*. Edited by M. Heerma van voss, D.J. Hoens, G. Mussies, D. van der Plas, and H. te Velde. Studies in the History of Religions 43 (Leiden, 1982): 127-137.

te Velde, Herman. "Commemoration in Ancient Egypt." *Visible Religion* 1: *Commemorative Figures: Papers Presented to Dr. Th. P. van Baaren on the Occasion of His Seventieth Birthday, May 13, 1982* (Leiden, 1982): 135-153.

te Velde, Herman. "Mittler." *LÄ* IV (1982): 161-163.

te Velde, Herman. "Egyptian Hieroglyphs as Signs, Symbols and Gods." *Visible Religion* 4-5 (1985-1986): 63-72.

te Velde, Herman. "Some Remarks on the Concept of 'Person' in the Ancient Egyptian Culture." *Concepts of Person in Religion and Thought*. Edited by H.G. Kippenberg, et al. (Berlin and New York, 1990): 83-101.

Thissen, Heinz Josef, ed. *Des Niloten Horapollon Hieroglyphenbuch I: Text und Übersetzung*. Archiv für Papyrusforschung und verwandte Gebiete, Beiheft 6/1 (Munich and Leipzig, 2001).

Thissen, Heinz Josef, ed. *Des Niloten Horapollon Hieroglyphenbuch II: Kommentar*. Archiv für Papyrusforschung und verwandte Gebiete, Beiheft 6/2 (Munich and Leipzig, 2003).

Thompson, Stephen E. "Cults: An Overview." *OEAE* I (2001): 326-332.

Tiradritti, Francesco, ed. *Egyptian Treasures from the Egyptian Museum in Cairo* (New York, 1999).

Tobin, Vincent Arieh. "Myths: Creation Myths." *OEAE* II (2001): 469-472.

Traunecker, Claude. "Farbe." *LÄ* II (1977): 115-117.

Traunecker, Claude, F. Le Saout, and O. Masson. *La chapelle d'Achôris à Karnak. II. Texte (et) Documents*. Recherche sur les grandes civilisations: Synthèse 5 (Paris, 1981).

Traunecker, Claude. "Kamutef." Translated from the French by S. Romanosky. *OEAE* II (2001): 221-222.

Troy, Lana. *Patterns of Queenship in Ancient Egyptian Myth and History*. Boreas 14 (Uppsala, 1986).

Tylor, J.J., and F. Ll. Griffith, *The tomb of Paheri at El Kab.* EEF 11 (London, 1894).

Tytus, Robb de Peyster. *A Preliminary Report on the Re-excavation of the Palace of Amenhetep III* (1903/R San Antonio, 1994).

Unwin, P.T.H. *Wine and the Vine: An Historical Geography of Viticulture and the Wine Trade* (London, 1996).

Valbelle, Dominique. "Craftsmen." In *The Egyptians.* Edited by Sergio Donadoni and translated from the Italian by B. Bianchi (Chicago, 1997): 31-59.

van Dijk, Jacobus. "The Amarna Period and the Later New Kingdom (*c.*1352-1069 BC)." In *The Oxford History of Ancient Egypt.* Edited by I. Shaw (Oxford, 2000): 272-313.

van Walsem, Rene. "The *pss-kf*: An Investigation of an Ancient Egyptian Funerary Instrument." *OMROL* 59 (1978-1979): 193-249.

van Walsem, René. *De iconografie van Egyptische elitegraven van het Oude Rijk. De studie van iconografieprogramma's van Egyptische elitegraven van het Oude Rijk. Theoretische en methodologische aspecten.* Opuscula Niliaca Noviomagensia 3 (Nijmegen, 1994).

Vandier, Jacques. *Manuel d'archéologie égyptienne*, tome 1,2. *Les époques de formation* (Paris, 1952).

Vandier, Jacques. *Manuel d'archéologie égyptienne*, tome IV-V. *Bas-reliefs et peintures. Scènes de la vie quotidienne* (Paris, 1964-1969).

Vandier d'Abbadie, Jeanne. *Deux tombes de Deir el-Médineh : I. La chapelle de Khâ.* MIFAO 73 (Cairo, 1939): 1-18.

Varille, Alexandre, and Clément Robichon. "Nouvelles fouilles de temples funéraires thébains (1934-1935)." *RdÉ* 2 (1936): 177-181.

Ventura, Raphael. *Living in a City of the Dead. A Selection of Topographical and Administrative Terms in the Documents of the Theban Necropolis.* OBO 69 (Freiburg and Göttingen, 1986).

Vercoutter, Jean. "The Iconography of the Black in Ancient Egypt: From the Beginnings to the Twenty-fifth Dynasty." In *The Image of the Black in Western Art*, I: *From the Pharaohs to the Fall of the Roman Empire.* Edited by L. Bugner (New York, 1976): 33-88.

Vercoutter, Jean. "L'image du noir en Égypte ancienne." *BSFÉ* 135 (Mars, 1996): 30-38.

Verhoeven, Ursula. "Totenmahl." *LÄ* VI (1986): 677-679.

Verhoeven, Ursula. "The Mortuary Cult." In *Egypt: The World of the Pharaohs.* Edited by R. Schulz and M. Seidel (Cologne, 1998): 480-489.

Vernus, Pascal. "Quelques exemples du type du 'parvenu' dans l'Égypte ancienne." *BSFÉ* 59 (1970): 31-47.

Vernus, Pascal. "Name." *LÄ* IV (1980): 320-326.

Vernus, Pascal. "L'écriture hiéroglyphique: une écriture duplice?" *Cahiers Confrontation* 16 (Automne, 1986): 59-66.

Vernus, Pascal. "Des relations entre textes et représentations dans l'Egypte pharaonique." In *Écritures* II. Edited by A.-M. Christin (Paris, 1988): 45-66.

Vernus, Pascal. *The Gods of Ancient Egypt.* Translated from the French by J. M. Todd (New York, 1998).

Virey, Philippe. "Le tombeau d'Amenemheb." *Mem. Miss.* V,2 (1891): 224-285.

Vischak, Deborah. "Hathor." *OEAE* II (2001): 82-85.

Vittmann, Günter. "Orientierung." *LÄ* IV (1982): 607-609.

Vittmann, Günter "Verfluchung." *LÄ* VI (1986): 977-981.

Vogelsang-Eastwood, Gillian. *Pharaonic Egyptian Clothing*. Studies in Textile and Costume History 2 (Leiden-New York-Cologne, 1993).

Vogelsang-Eastwood, Gillian M. *Tutankhamun's Wardrobe: Garments from the Tomb of Tutankhamun* (Rotterdam, 1999).

Vogelsang-Eastwood, Gillian. "Textiles." In *Ancient Egyptian Materials and Technology*. Edited by P.T. Nicholson and I. Shaw (Cambridge, 2000): 268-298.

von Beckerath, Jürgen. *Handbuch der ägyptischen Königsnamen*. MÄS 20 (Munich, 1984).

von Beckerath, Jürgen. "Zur Geschichte von Chonsuemhab und dem Geist." *ZÄS* 119 (1992): 90-107.

von Deines, Hildegard. "Das Gold der Tapferkeit, eine militärische Auszeichnung oder eine Belohnung?" *ZÄS* 79 (1954): 83-86.

Vycichl, Werner. *Dictionnaire étymologique de la langue copte* (Leuven, 1983).

Wachsmann, Shelley. *Aegeans in the Theban Tombs*. OLA 20 (Leuven, 1987).

Wallace, Anthony. *Religion: An Anthropological View* (New York, 1966).

Walton, Kendall L. "Aesthetics, I. Introduction." *The Dictionary of Art*, vol. 1. Edited by J. Turner (New York, 1996): 171-174.

Warburton, David. Review of *Death and the Afterlife in Ancient Egypt* by John H. Taylor (London, 2001). In *DIE* 52 (2002): 115-128.

Ware, Edith W. "Egyptian artists' signatures." *AJSL* 43 (1926-1927): 185-207.

Warmenbol, Eugène, and Florence Doyen. "Le chat et la maîtresse: les visages multiples d'Hathor." *Les divins chats d'Égypte: un air subtil, un dangereux parfum*. Edited by L. Delvaux and E. Warmenbol (Leuven, 1991): 55-67.

Waseda University, Egypt Cultural Center. *Research in Egypt: 1966-1991* (Tokyo, 1991).

Waseda University. *Studies on the Palace of Malqata, 1985-1988. Investigations at the Palace of Malqata 1985-1988*. Waseda University, Architectural Research Mission for the Study of Ancient Egyptian Architecture (Tokyo, 1993).

Wasmuth, Melanie. *Innovationen und Extravaganzen: ein Beitrag zur Architektur der thebanischen Beamtengräber der 18. Dynastie*. BAR International Series 1165 (Oxford, 2003).

Weeks, Kent R. "Art, Word, and the Egyptian World View." In *Egyptology and the Social Sciences: Five Studies*. Edited by K.R. Weeks (Cairo, 1979): 59-81.

Wegner, Max. "Die Stilentwickelung der thebanischen Beamtengräber." *MDAIK* 4 (1933): 38-164.

Weidner, Stephan. *Lotos im Alten Ägypten* (Freiburg, 1985).

Wente, Edward F. "Egyptian 'Make Merry' Songs Reconsidered." *JNES* 21 (1962): 118-128.

Wente, Edward F. *Late Ramesside Letters*. SAOC 33 (Chicago, 1967).

Wente, Edward F. *Letters from Ancient Egypt*. Edited by E.S. Meltzer. Society of Biblical Literature Writings from the Ancient World 1 (Atlanta, 1990).

Wente, Edward F. "The Scribes of Ancient Egypt." *CANE* IV (1995): 2211-2221.

Wente, Edward F. "Correspondence." *OEAE* I (2001): 311-315.

Werbrouck, Marcelle, and Baudouin van de Walle. *La tombe de Nakht: Notice Sommaire* (Brussels, 1929).

Westendorf, Wolfhart. "Bemerkungen zur 'Kammer der Wiedergeburt' im Tutanchamungrab." *ZÄS* 94 (1967): 139-150.

Westendorf, Wolfhart. "Aphrodisiakon, A." *LÄ* I (1975): 336-337.

Westendorf, Wolfhart. "Symbol, Symbolik." *LÄ* VI (1986): 122-128.

Whale, Sheila. *The Family in the Eighteenth Dynasty of Egypt*. The Australian Centre for Egyptology Studies 1 (Sydney, 1989).

White, H.G. Evelyn. "The Egyptian Expedition, 1914-15: excavations at Thebes." *BMMA* 10 (December, 1915): 253-256.

Wiebach, Silvia. "Die Begegnung von Lebenden und Verstorbenen im Rahmen des thebanischen Talfestes." *SAK* 13 (1986): 263-291.

Wiese, André, with Silvia Winterhalter, and Andreas Bodbeck. *Antikenmuseum Basel und Sammlung Ludwig: Die Ägyptische Abteilung* (Mainz, 2001).

Wildung, Dietrich. *Die Rolle ägyptischer Könige im Bewusstsein ihrer Nachwelt. Teil I: Posthume Quellen über die Könige der ersten vier Dynastien*. MÄS 17 (Munich, 1969).

Wildung, Dietrich. "Besucherinschriften." *LÄ* I (1975): 766-767.

Wildung, Dietrich. *Egyptian Saints. Deification in Pharaonic Egypt* (New York, 1977).

Wildung. Dietrich. "Feindsymbolik." *LÄ* II (1977): 146-148.

Wildung, Dietrich. "Flügelsonne." *LÄ* II (1977): 277-279.

Wildung, Dietrich. "Garten." *LÄ* II (1977): 376-378.

Wildung, Dietrich. *Ägyptische Malerei. Das Grab des Nacht* (Zürich, 1978).

Wildung, Dietrich. "Écrire sans écriture. Réflexions sur l'image dans l'art égyptien." In *La peinture égyptienne ancienne. Un monde de signes à préserver. Actes de Colloque international de Bruxelles, avril 1994*. Edited by R. Tefnin. Monumenta Aegyptiaca 7 (Brussels, 1997): 11-16.

Wilfong, Terry G. "Intoxication." *OEAE* II (2001): 179-182.

Wilkinson, Alix. *The Garden in Ancient Egypt* (London, 1998).

Wilkinson, John Gardner. *The manners and customs of the ancient Egyptians* (London, 1837-1841).

Wilkinson, Charles K., and Marsha Hill. *Egyptian Wall Paintings. The Metropolitan Museum of Art's Collection of Facsimiles* (New York, 1983).

Wilkinson, Richard H. "The Turned Bow in Egyptian Iconography." *VA* 4 (1988): 181-187.

Wilkinson, Richard H. "The Representation of the Bow in the Art of Ancient Egypt and the Near East." *JANES* 20 (1991): 83-99.

Wilkinson, Richard H. *Reading Egyptian Art: A Hieroglyphic Guide to Ancient Egyptian Painting and Sculpture* (London and New York, 1992).

Wilkinson, Richard H. *Symbol & Magic in Egyptian Art* (London and New York, 1994).

Wilkinson, Richard H. "Symbols." *OEAE* III (2001): 329-335.

Wilkinson, Toby A.H. "Social Stratification." *OEAE* III (2001): 301-305.

Wimmer, Stefan. "Hieroglyphs - Writing and Literature." In *Egypt: The World of the Pharaohs.* Edited by R. Schulz and M. Seidel (Cologne, 1998): 342-355.

Winlock, Herbert E. "The Work of the Egyptian Expedition." *BMMA* 7 (October, 1912): 184-190.

Winlock, Herbert E. "Excavations at Thebes 1919-20." *BMMA* 15, pt. II, *The Egyptian expedition 1918-1920.* (December, 1920): 12-32.

Winlock, Herbert E. "The Museum's Excavations at Thebes." *BMMA* 18, pt. II, *The Egyptian Expedition 1922-23* (October, 1923): 11-39.

Winlock, Herbert E. *Materials used at the embalming of King Tut-'Ankh-Amun*. The Metropolitan Museum of Art Papers 10 (New York, 1941).

Wirth, Jean. "Symbols." *The Dictionary of Art*, vol. 30. Edited J. Turner (New York, 1996): 163-168.

de Wit, Constant. *Le rôle et le sense du lion dans l'Égypte ancienne* (Leiden, 1951).

de Wit, Constant. "Un curieux symbole de résurrection dans l'ancienne Égypte: le double lion." *Revue Belge de Philologie et d'Histoire*, Bruxelles 29 (1951): 318-319.

Wolf, Walther. *Die Kunst Ägyptens: Gestalt und Geschicte* (Stuttgart, 1957).

Worsham, Charles E. "A Reinterpretation of the So-called Bread Loaves in Egyptian Offering Scenes." *JARCE* 16 (1979): 7-10.

Wreszinski, Walter. *Atlas zur altägyptischen Kulturgeschichte*, 3 vols. (Slatkine Reprints, Genève-Paris, 1988).

Yoshimura, Sakuji, ed. *Painting Plaster from Kom el-Samak at Malqata South* [I]. The Egyptian Culture Center of Waseda University Occasional Papers 1 (Tokyo, 1995).

Yoshimura, Sakuji, and Yumiko N. Nagasaki. *Painted Plaster from Kom el-Samak at Malqata-South* [II]. The Egyptian Cultural Center of Waseda University Occasional Papers Number 2 (Tokyo, 1999).

Yoyotte, Jean. *Les pèlerinages dans l'Égypte ancienne*. Sources orientales 3 (Paris, 1960).

Ziegler, Christiane. "Music." In *Egypt's Golden Age: The Art of Living in the New Kingdom 1558-1085 B.C.* Edited by E. Brovarski, S.K. Doll, and R.E. Freed (Boston, 1982): 255-256.

Ziegler, Christiane. "Sistrum." *LÄ* V (1984): 959-963.

INDEX

Theban Tombs (TT)

Table 1
Tomb Owner's Name, Characteristic Title, Institutional Affiliation, Painting Style & Date

Tomb #	Name	Characteristic Title	Institutional Affiliation	Style	Date
38	Djeserkarasoneb	Steward for the Second Prophet of Amun	Religious administration	Temple	TIV/AIII
52	Nakht	Hour Observer of Amun	Religious administration	Temple	TIV/AIII
63	Sebekhotep	Overseer of the Treasury	Civil administration	Court	TIV
64	Hekameheh	Tutor of the King's son Amenhotep	Palace administration	Court	TIV
66	Hepu	Vizier (South)	Civil administration	Court	TIV
69	Menna	Overseer of the Fields of Amun	Religious administration	Temple	TIV/AIII
74	Tjanuny	Scribe of Recruits	Military administration	Court	TIV
75	Amenhotep-si-se	Second Prophet of Amun	Religious administration	Temple	TIV
76	Tjenuna	Chief Steward of the King	Palace administration	Court	TIV
77	Ptahemhet	Child of the Nursery, Fan-Bearer	Palace administration	Court	TIV
78	Haremhab	Scribe of Recruits	Military administration	Court	TIV/AIII
89	Amenmose	Steward in the Southern City	Regional administration	Court	AIII
90	Nebamun	Standard Bearer of the King's Ship 'Beloved of Amun'	Military administration	Court	TIV/AIII
91	Unknown	Troop Commander of the Lord of Two Lands	Military administration	Court	TIV/AIII
108	Nebseny	High Priest of Onuris	Religious administration	Temple	TIV/AIII
116	Anonymous	Provincial Governor ($h3ty$-')	Regional administration	Court	TIV
118	Amenmose	Fan Bearer on the Right of the King	Palace administration	Court?	AIII
120	Anen	Second Prophet of Amun	Religious administration	Temple	AIII
139	Pairy	*Wab*-priest in front of Amun, High Priest of Ptah at Karnak	Religious administration	Temple	AIII
151	Haty	Scribe of Counting Cattle and Chief Steward for the God's Wife of Amun	Religious administration	Temple	TIV/AIII
161	Nakht	Gardener of Divine Offerings of Amun	Temple provisioner	Temple	AIII
165	Nehemaway	Sculptor of Amun	Temple artisan	Temple	TIV/AIII
175	Unknown	[Unguent Maker]	Temple provisioner	Temple	TIV/AIII
181	Nebamun & Ipuky	Chief of Sculptors in the *Dsrt-Ist*	Temple artisans	Temple	AIII
201	Re	First Royal Herald	Palace administration	Court	TIV/AIII
226	Anonymous	Overseer of Royal Nurses	Palace administration	Court	AIII
239	Penhet	Overseer of all Northern Countries	Regional administration	Court	TIV/AIII
249	Neferrenpet	Deliverer of Sweets for the Temple of Amun-Re	Temple provisioner	Temple	AIII
253	Khnummose	Scribe of Counting Grain of Amun	Religious administration	Temple	TIV/AIII
258	Menkheper	Scribe of the House of the King's Children	Palace administration	Court	TIV/AIII

Table 2
Icons on Tomb Chapel Focal Walls

Tomb Nr.	Far Left Icon	Left Icon	Door/ Shrine	Right Icon	Far Right Icon
TT 38		Offering Table PM (4)		Offering Table PM (6)	Banquet PM (6)
TT 52	Banquet PM (3)	Offering Table PM (3)		Offering Table PM (6)	Fishing & Fowling Natural Resource PM (6)
TT 63	Award of Distinction PM (4)	Royal Kiosk PM (5)		Royal Kiosk PM (10)	'Tribute' PM (9)
TT 64		Royal Kiosk PM (5)		Royal Kiosk PM (8)	
TT 66	Award of Distinction (Homecoming or Statue) PM (4)	[Royal Kiosk?] PM (4)		Royal Kiosk PM (6)	Award of Distinction (Installation of the Vizier) PM (6)
TT 69	Offering Table Banquet PM (4)	Offering Table PM (4)		Offering Table PM (7)	Worshiping Osiris Banquet Funerary Rites Offering Table PM (7)
TT 74	Registration PM (5)	Royal Kiosk PM (6)		Royal Kiosk (with 'Tribute') PM (11)	Registration PM (10)
TT 75	Gift Award of Distinction PM (3)	Royal Kiosk PM (3)		[Royal Kiosk] PM (6)	Award of Distinction PM (6)
TT 76				Royal Kiosk PM (5)	Gift PM (5)
TT 77	Award of Distinction PM (4)	Royal Kiosk PM (4)		Royal Kiosk PM (7)	Registration PM (7)
TT 78	Registration PM (4)	Royal Kiosk PM (4)		Royal Kiosk PM (8)	'Tribute' PM (8)
TT 89	Funerary Rites PM (7)	Offering Table PM (8)		Royal Kiosk PM (15)	'Tribute' PM (15)
TT 90	Award of Distinction PM (4)	[Royal Kiosk] PM (4)		Royal Kiosk (with 'Tribute' & Prisoners) PM (9)	Natural Resource (with offering and service to the king) PM (8)
TT 91	'Tribute' PM (3)	Royal Kiosk PM (3)		Royal Kiosk PM (5)	'Tribute' PM (5)
TT 108	Banquet PM (5)	Offering Table PM (5)			
TT 116				Royal Kiosk PM (2)	
TT 118				[Royal Kiosk?] PM (1)	'Tribute' PM (1)
TT 120		Royal Kiosk Northwest back wall		Royal Kiosk PM (3)	

Table 2
Icons on Tomb Chapel Focal Walls

Tomb Nr.	Far Left Icon	Left Icon	Door/Shrine	Right Icon	Far Right Icon
TT 139				Offering Table PM (6)	Banquet = PM (6) Offering Table = PM (5) Worshiping Osiris = PM (5) (Four Sons of Horus)
TT 151		Natural Resource PM (2)		Offering Table PM (4)	
TT 161	Banquet Natural Resource PM (3)	Offering Table PM (3)			
TT 165				Offering Table PM (5)	Fishing & Fowling = PM (4) Natural Resource = PM (4) Funerary Rites - PM (3)
TT 175				Offering Table PM (4)	Banquet Natural Resource PM (4)
TT 181	Funerary Rites PM (5)	Worshiping Osiris PM (5)		Offering Table PM (8)	
TT 201	'Tribute'? PM (7)	[Royal Kiosk?] PM (7)		[Royal Kiosk?] PM (9)	Registration PM (9)
TT 226				Royal Kiosk PM (4)	
TT 239	'Tribute' PM (3)	[Royal Kiosk?] PM (3)		[Royal Kiosk?] PM (6)	'Tribute' PM (6)
TT 249		Worshiping Osiris PM (2)		Offering Table PM (4)	Banquet PM (4)
TT 253	Banquet PM (4)	Offering Table PM (4)		Offering Table PM (7)	Offering Table Banquet PM (7)
TT 258	Offering Table PM (1)	Offering Bearers = PM (2) (part of Worshiping Osiris on PM (4))			

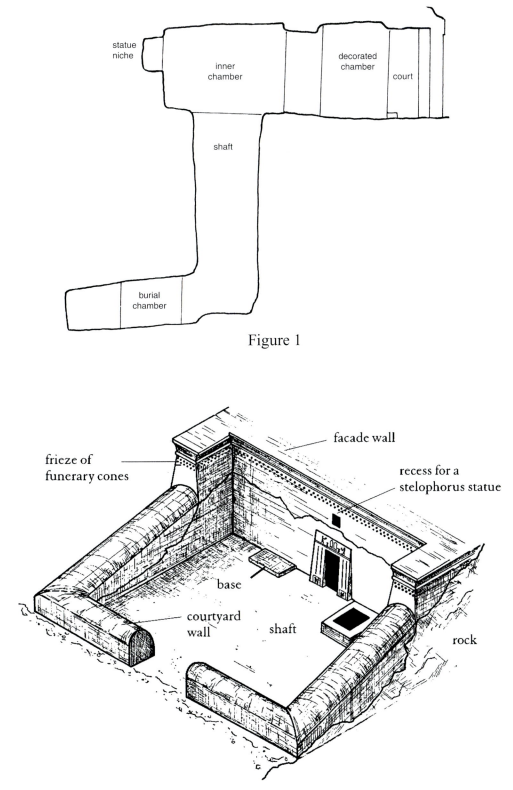

Figure 1

Figure 2

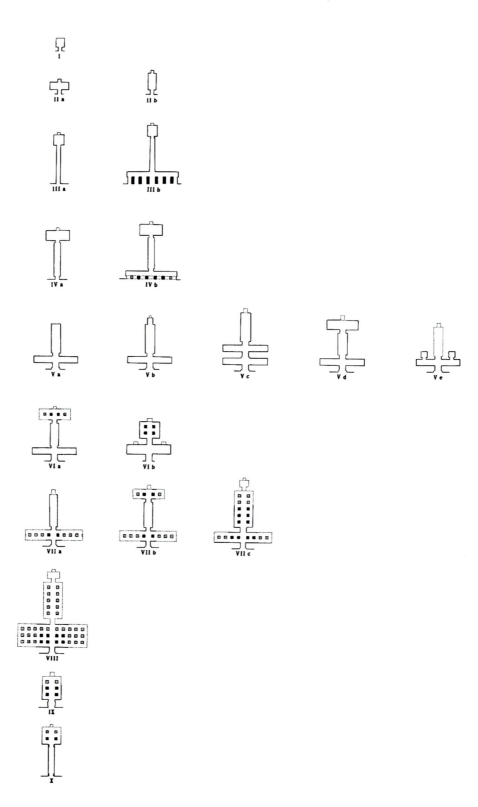

Figure 3

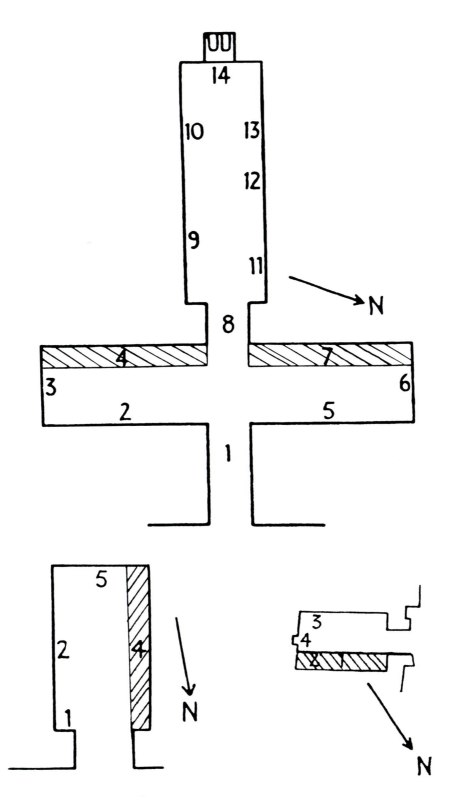

Figure 4

Site	Function	Architectural Form
1. Upper Level	Aspect of solar cult, sun worship	Superstructure in the shape of a chapel or pyramid or a facade recess with a stelophorus statue
2. Middle Level	Site for worship and ceremonial cults, social monument to the tomb occupant	Courtyard and horizontal inner tomb chambers such as transverse and longitudinal hall and chapel
3. Lower Level	Aspect of Osirian cult, realization of landscapes of the next world, and resting place of the body	Subterranean burial complex with shafts and corridors, ante-chambers and side rooms, and a burial chamber containing the sarcophagus

Figure 5

Figure 6

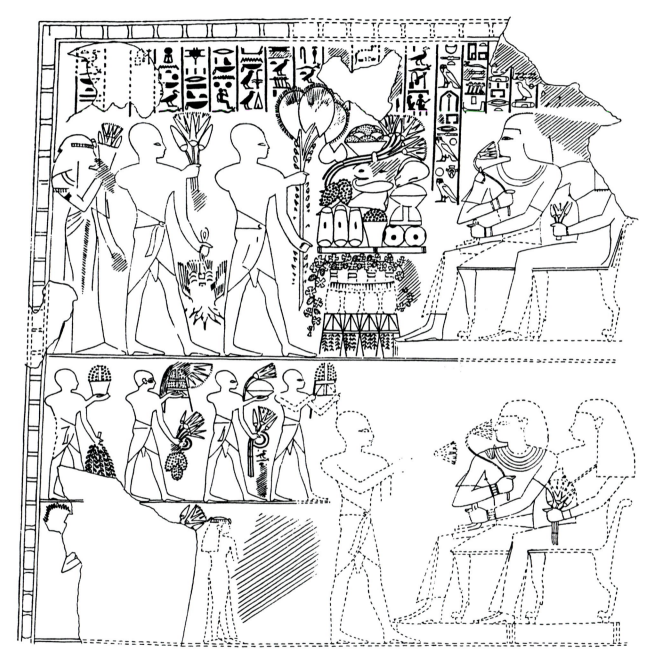

Figure 7

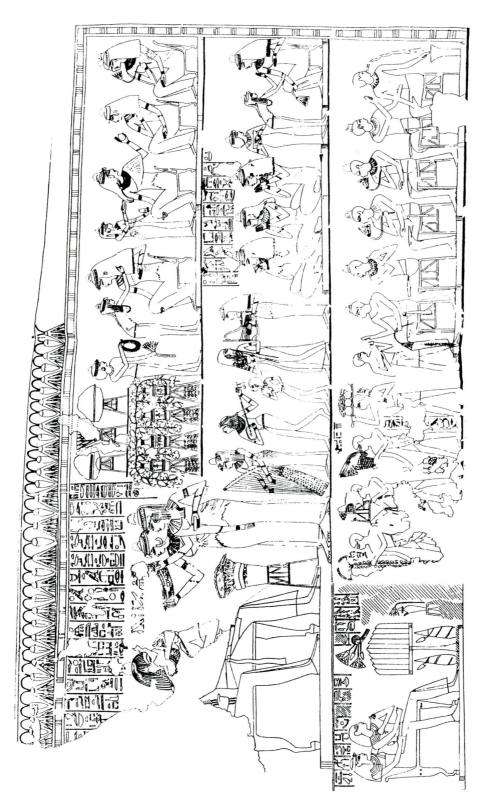

Figure 8

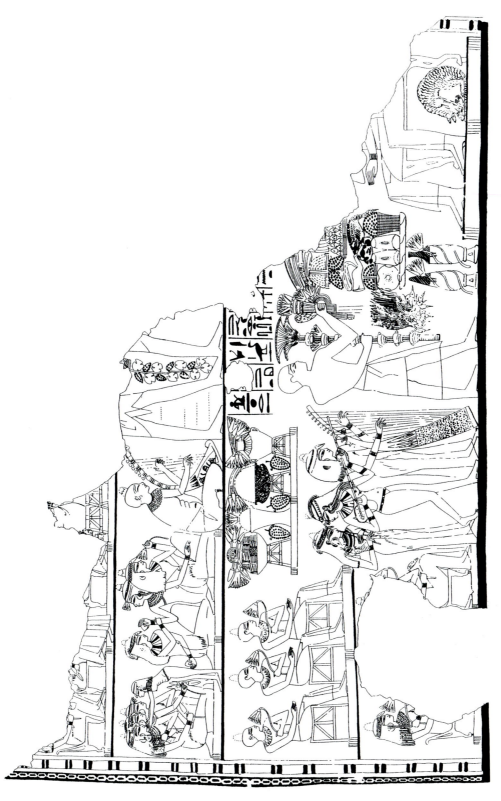

Figure 9

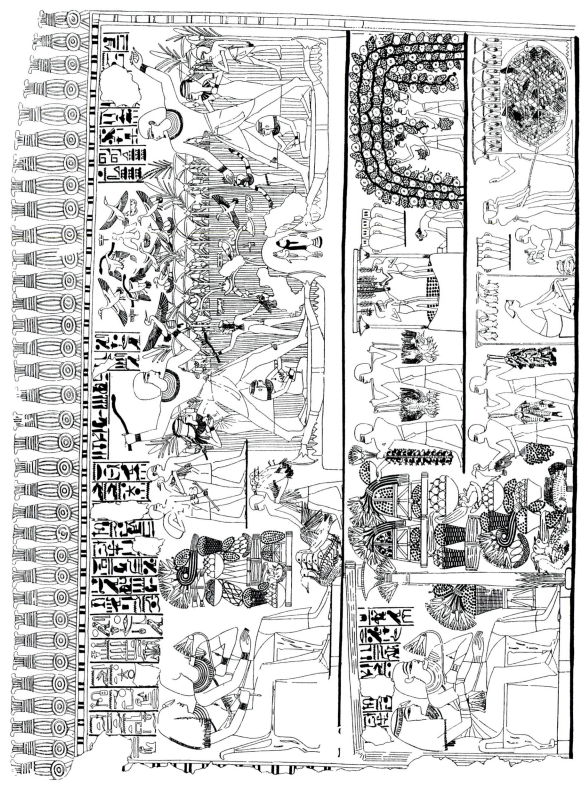

Figure 10

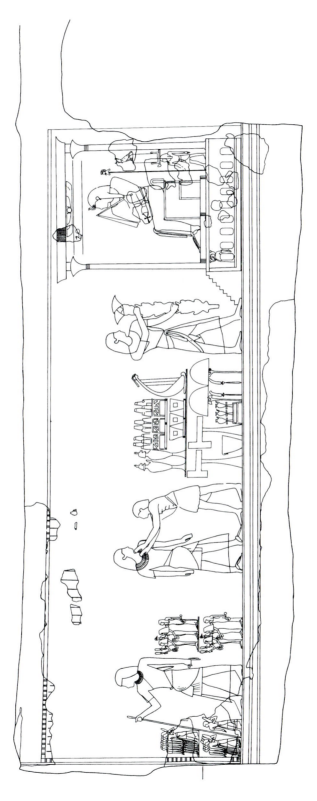

Figure 11

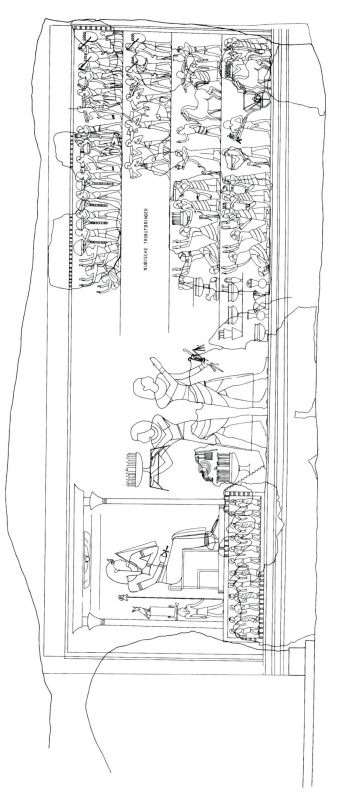

Figure 12

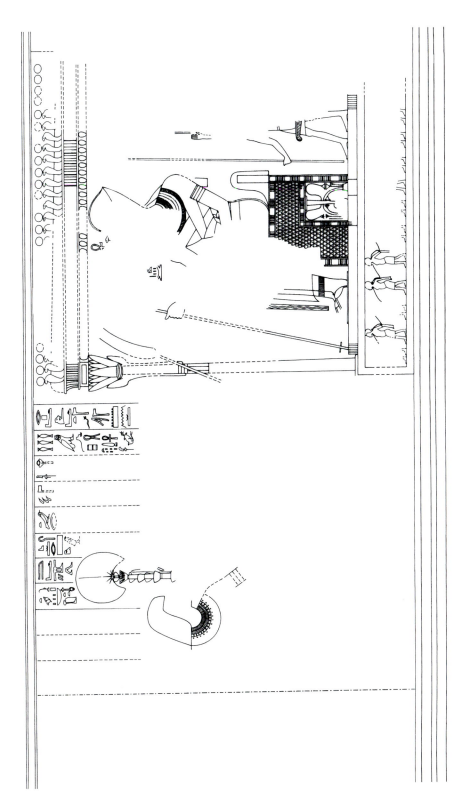

Figure 13

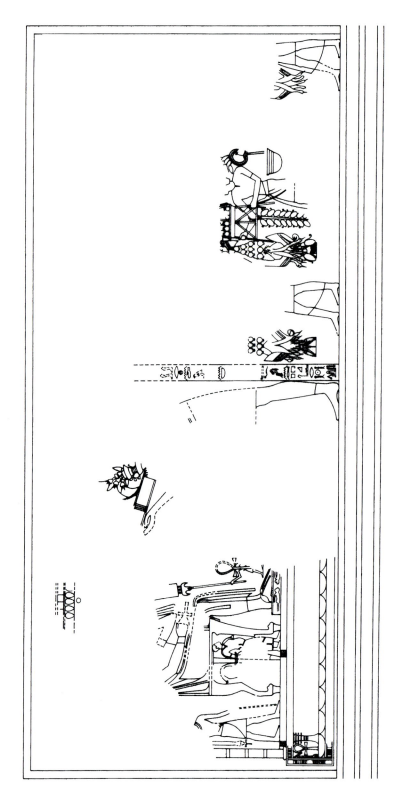

Figure 14

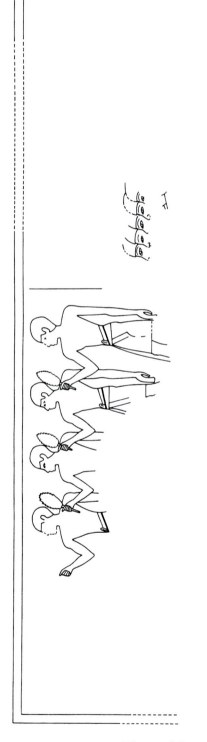

Figure 15

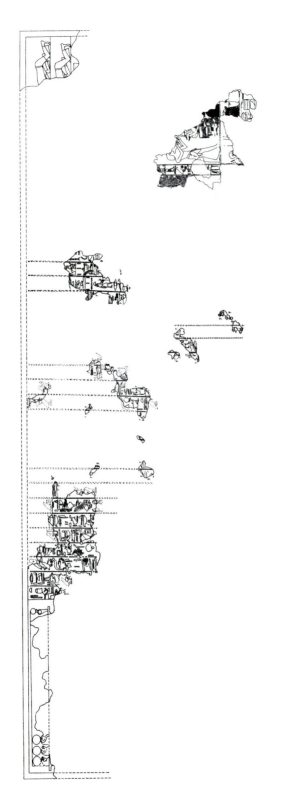

Figure 16

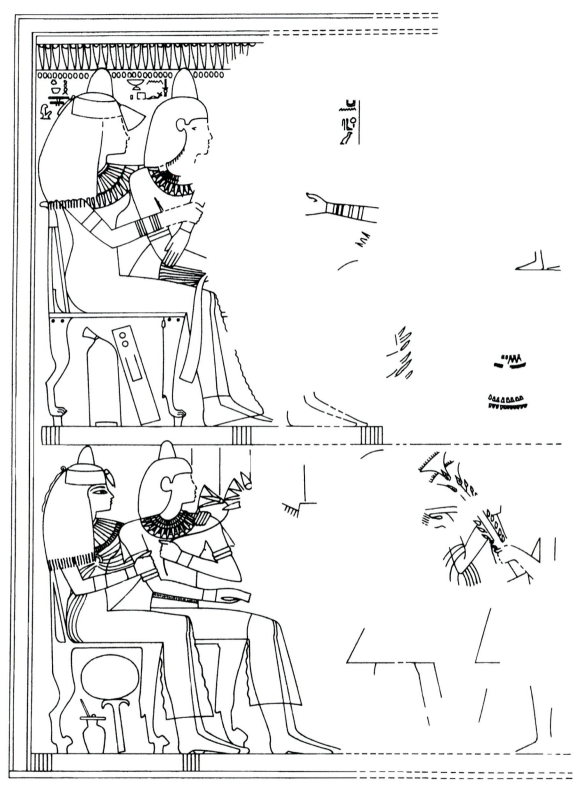

Figure 17

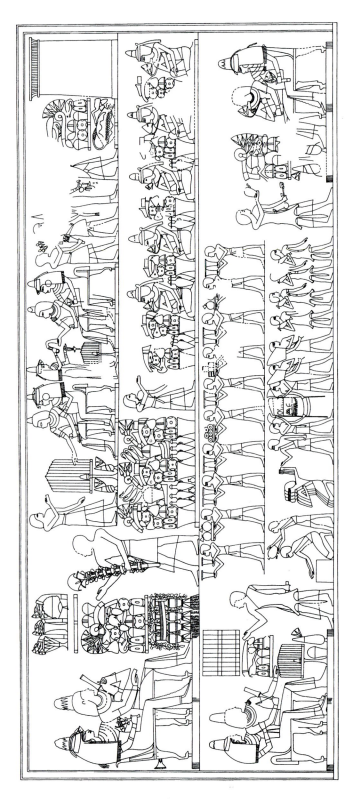

Figure 18

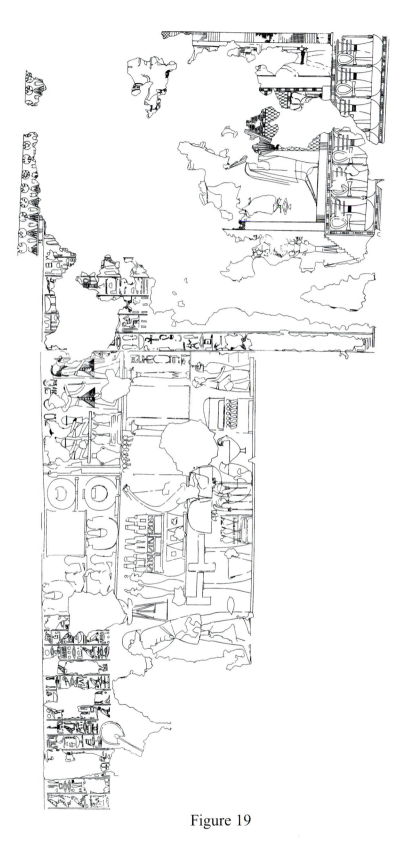

Figure 19

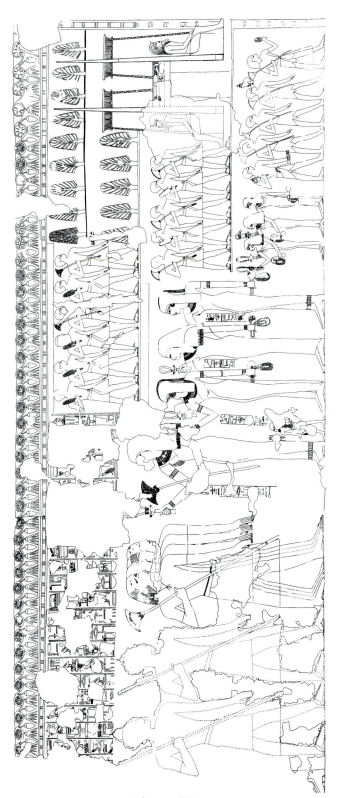

Figure 20

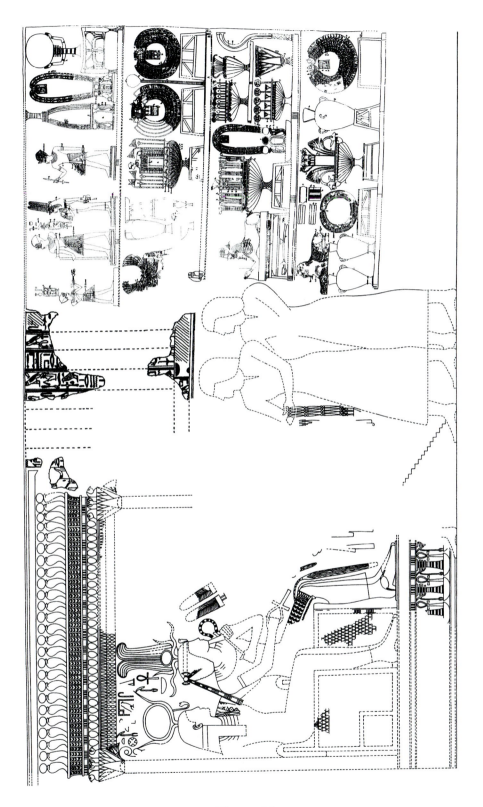

Figure 21

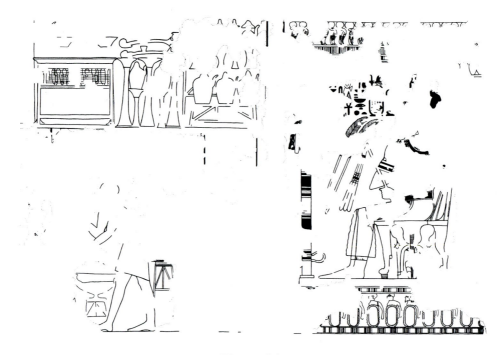

Figure 22

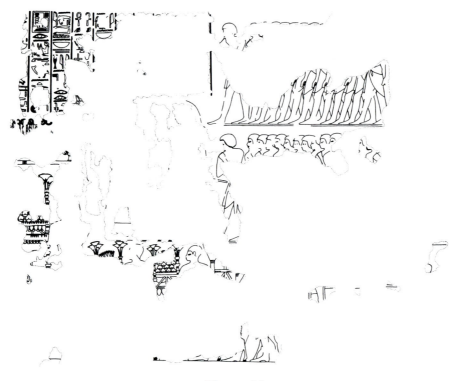

Figure 23

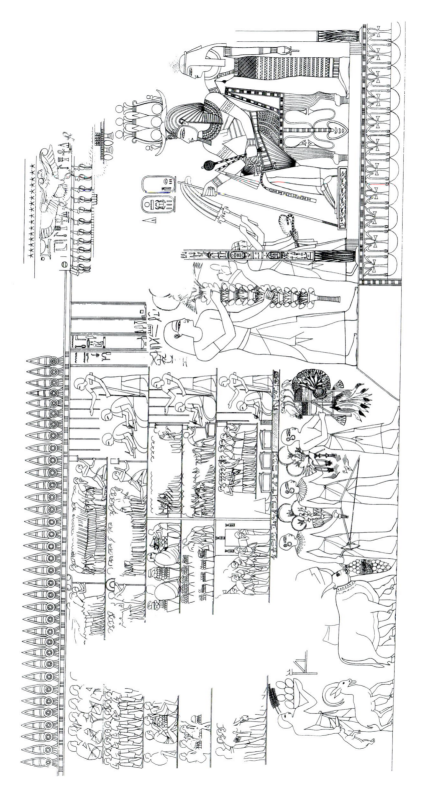

Figure 24

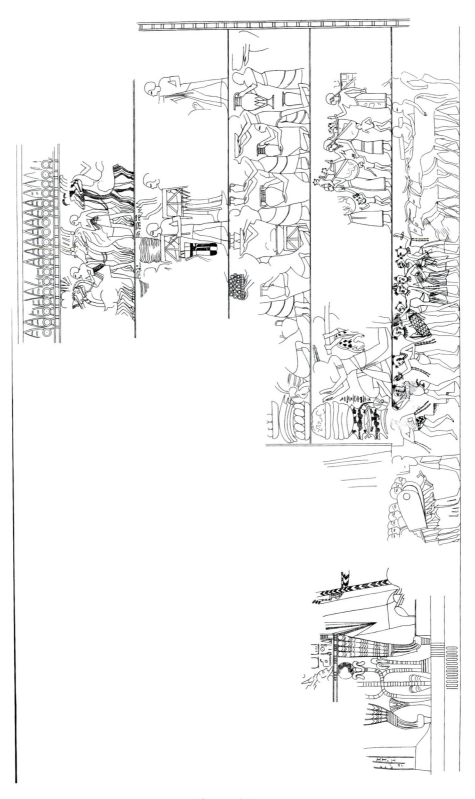

Figure 25

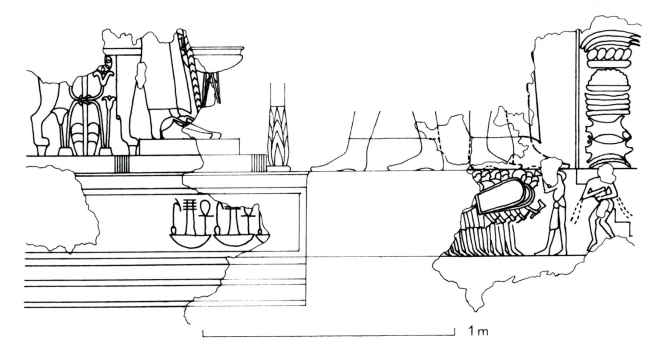

Figure 26

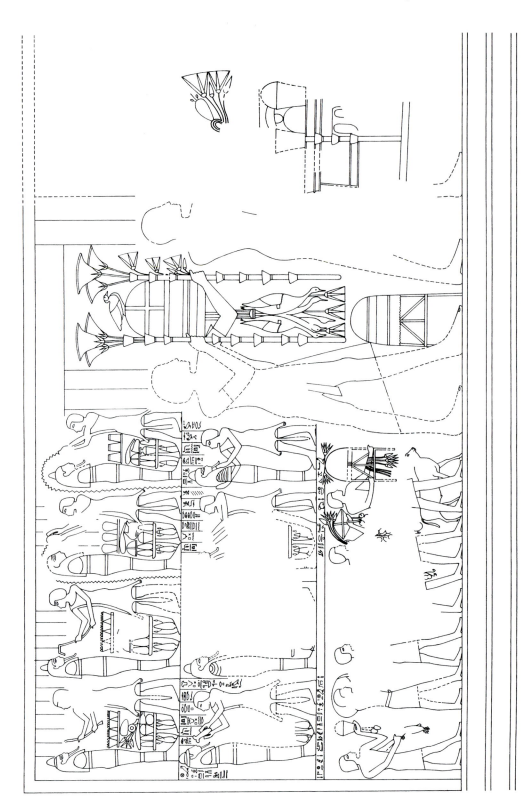

Figure 27

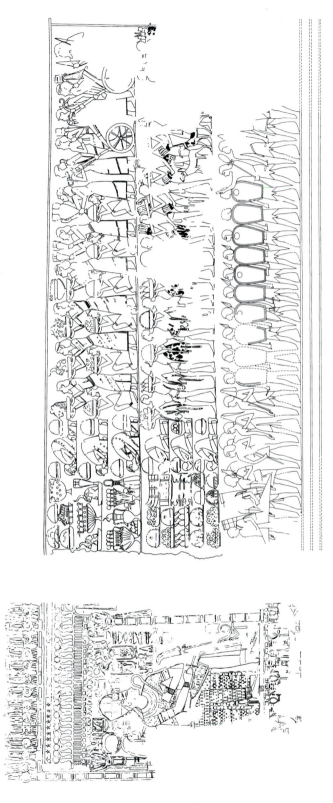

Figure 28

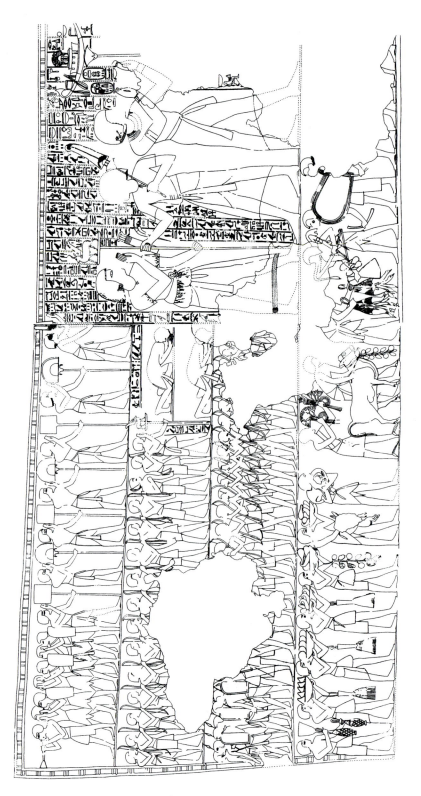

Figure 29

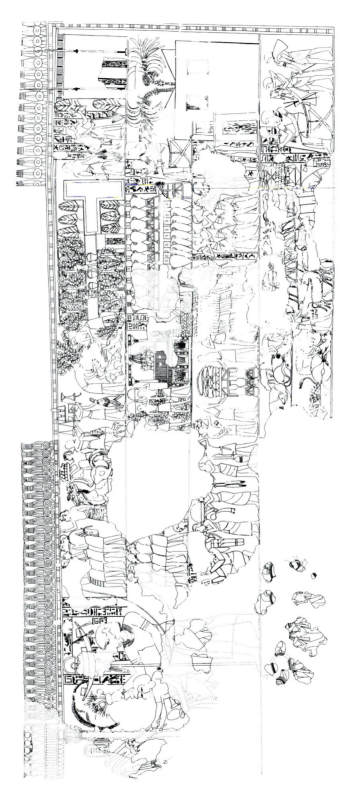

Figure 30

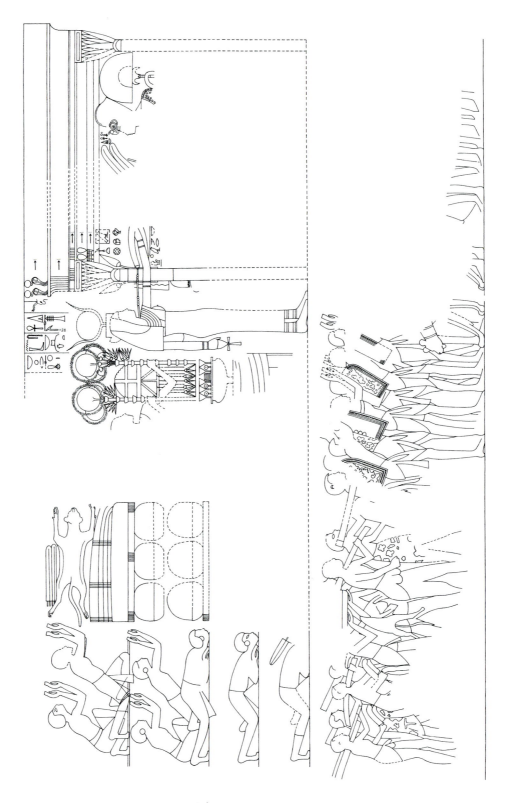

Figure 31

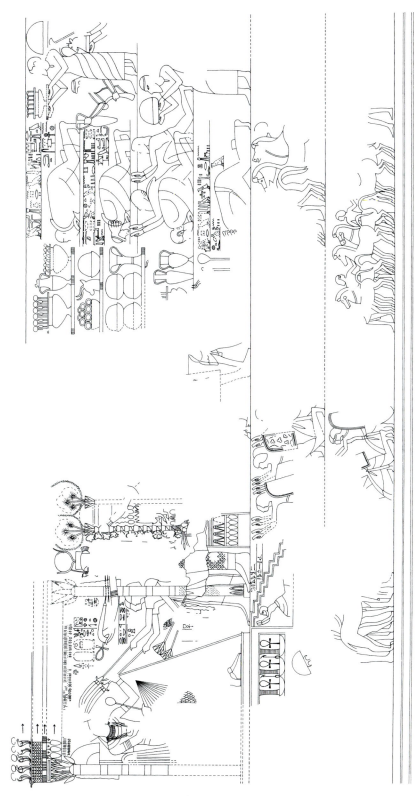

Figure 32

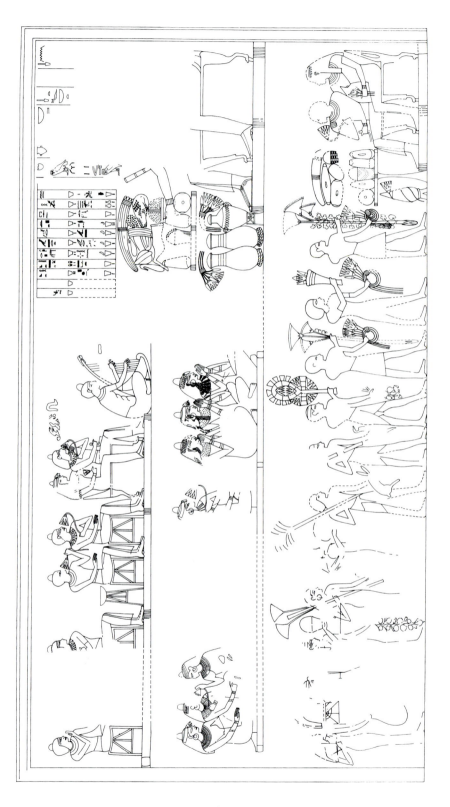

Figure 33

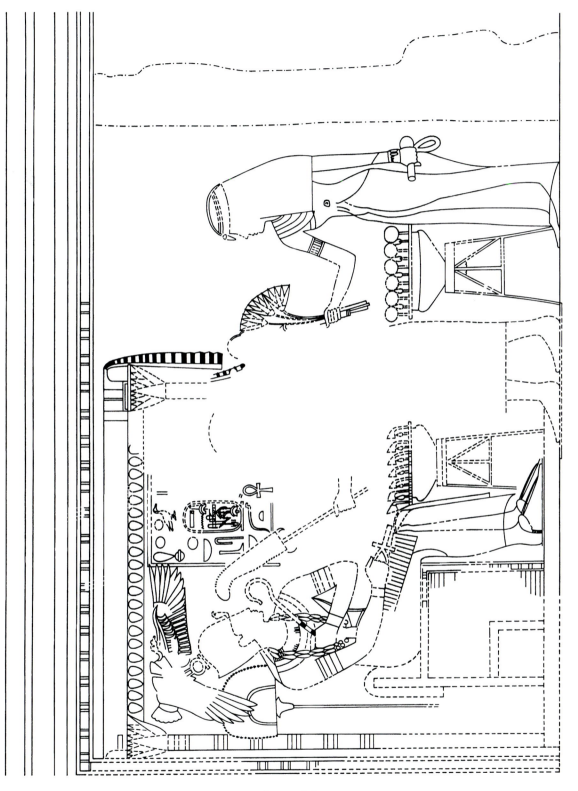

Figure 34

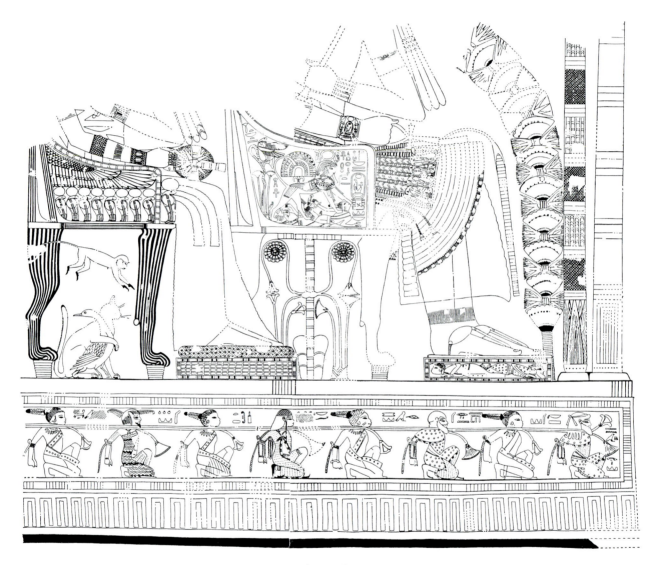

Figure 35

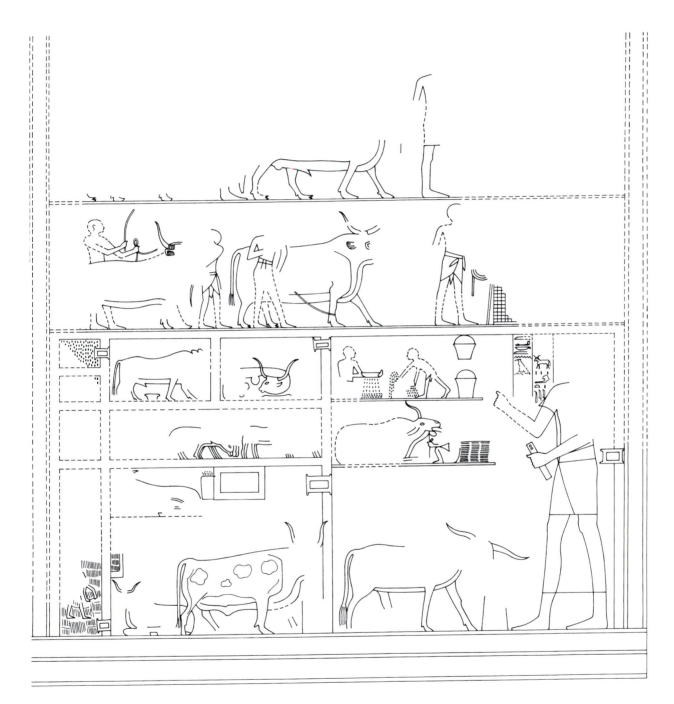

Figure 36

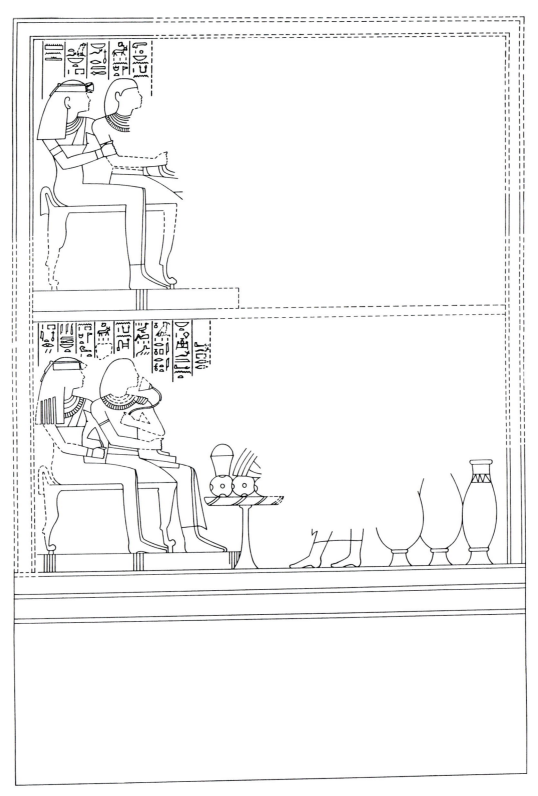

Figure 37

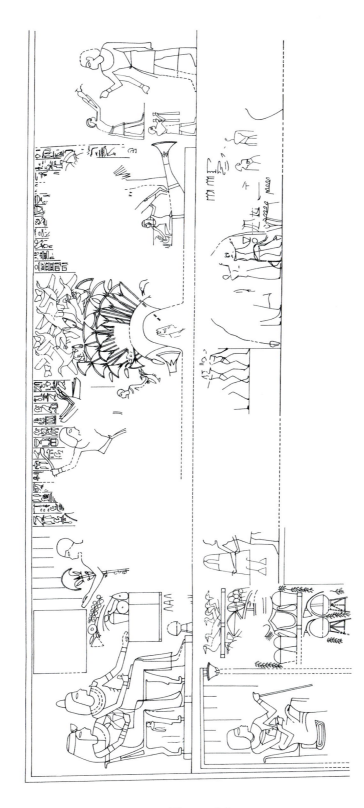

Figure 38

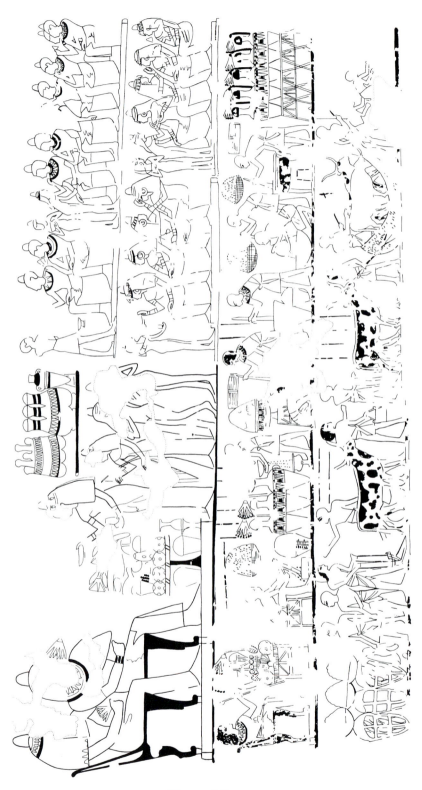

Figure 39

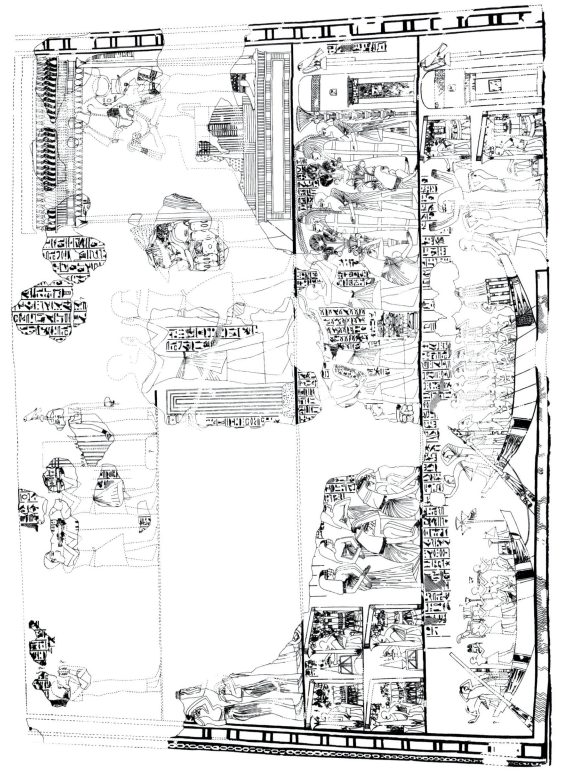

Figure 40

Figure 41

Figure 42

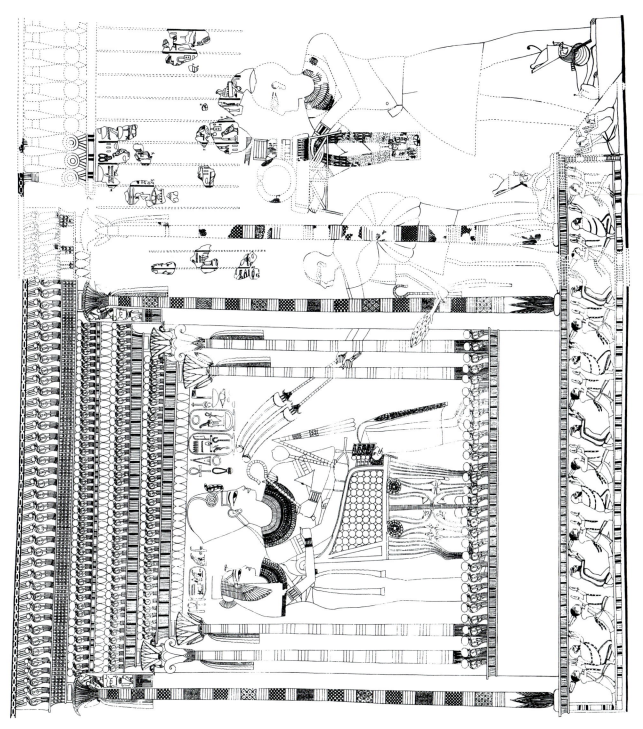

Figure 43

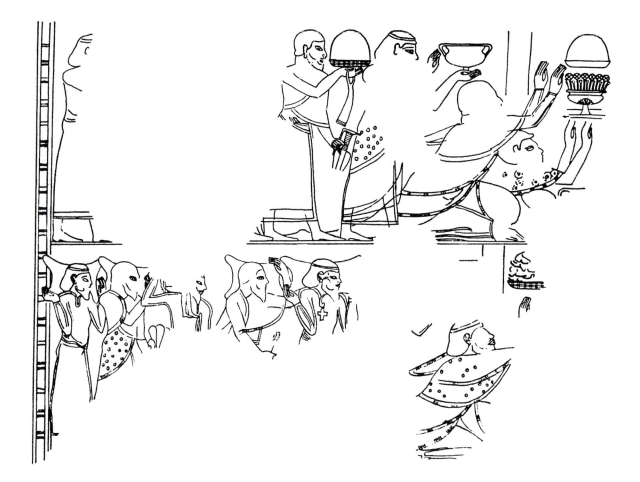

Figure 44

Figure 45

Figure 46

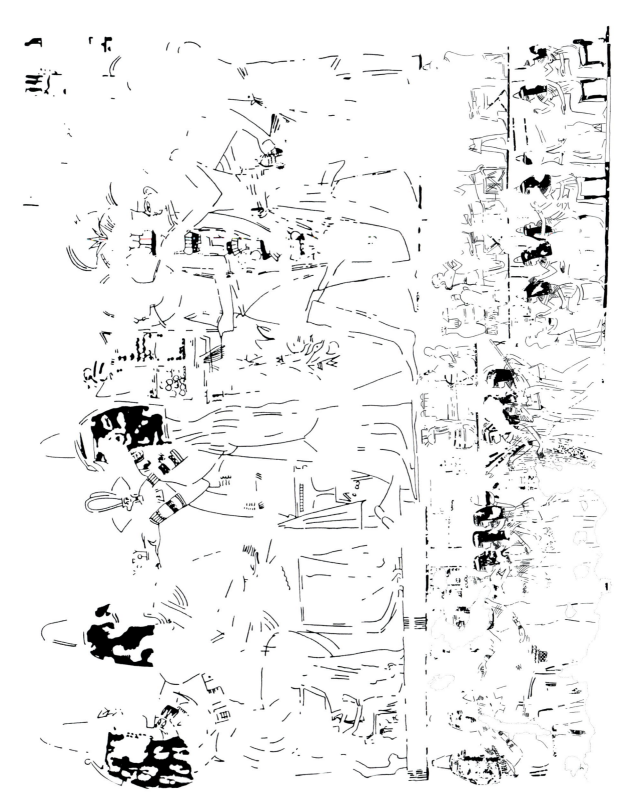

Figure 47

Figure 48

Figure 49

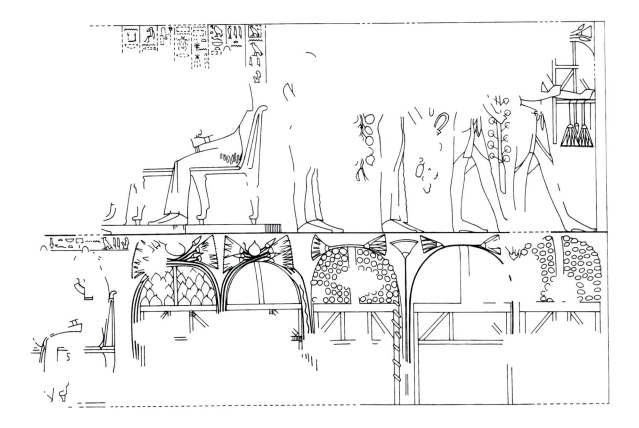

Figure 50

Plate 1

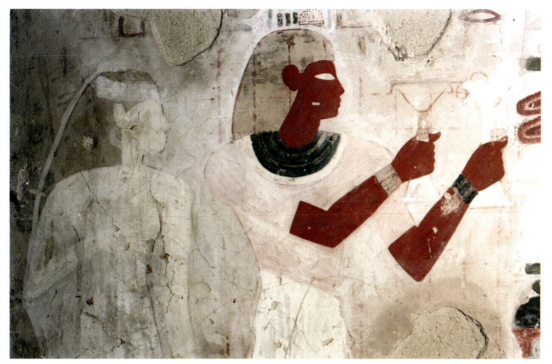

1, 1

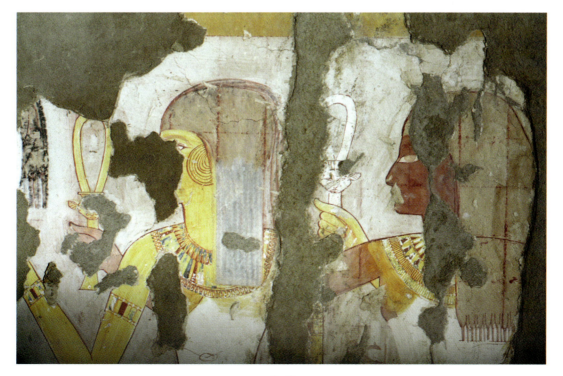

1, 2

Plate 2

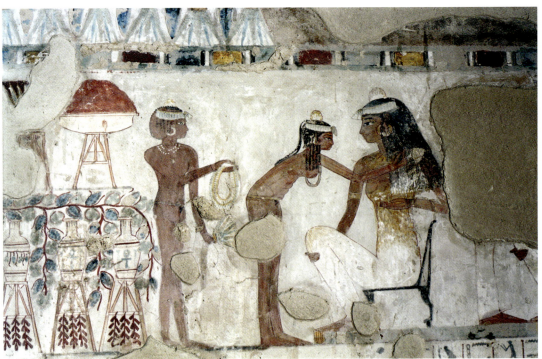

2, 1

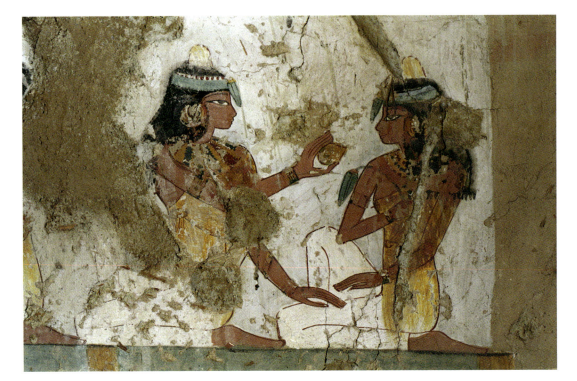

2, 2

Plate 3

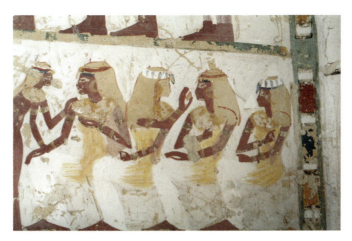

3, 1

3, 2

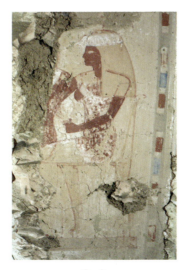

3, 3

Plate 4

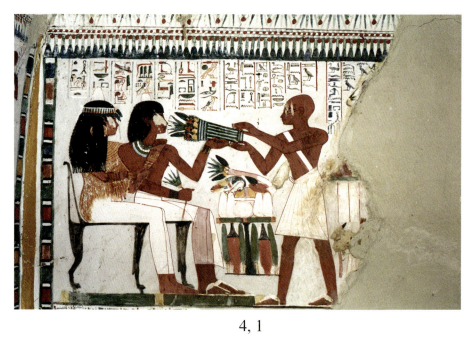

4, 1

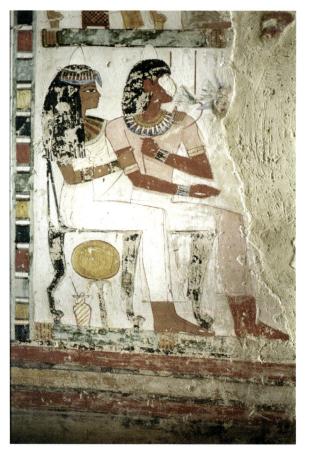

4, 2

Plate 5

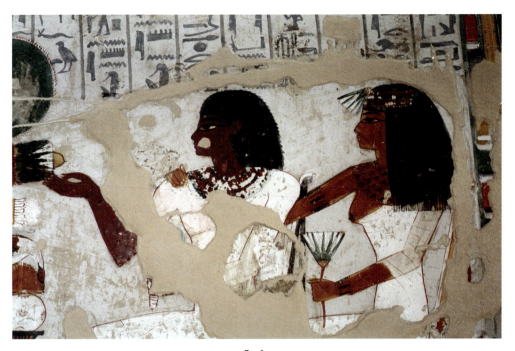

5, 1

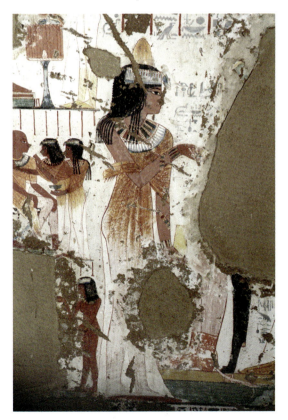

5, 2

Plate 6

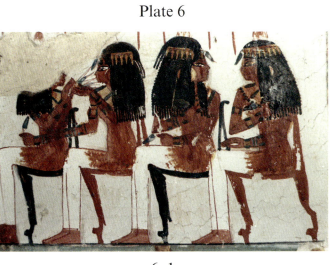

6, 1

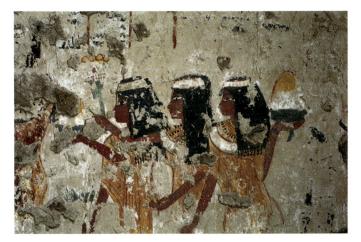

6, 2

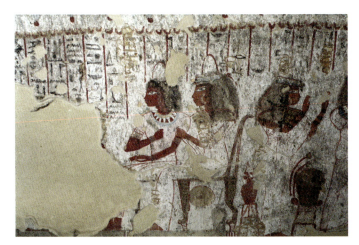

6, 3

Plate 7

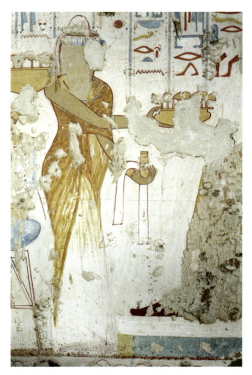

7, 1

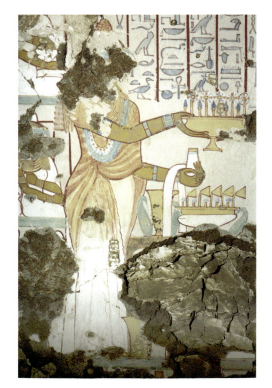

7, 2

Plate 8

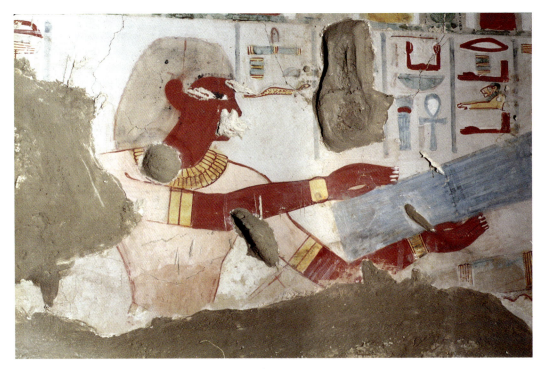

8, 1

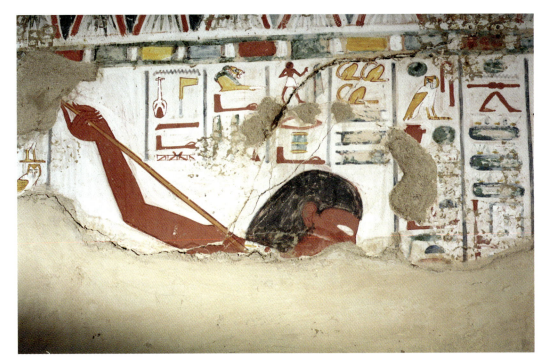

8, 2

Plate 9

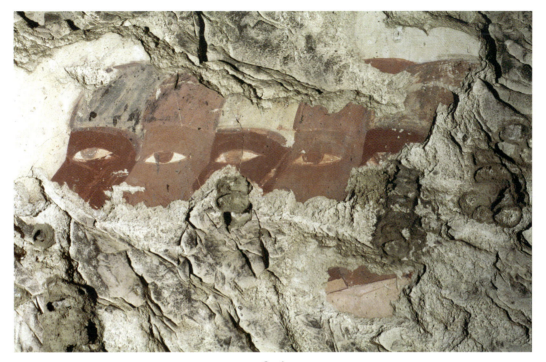

9, 1

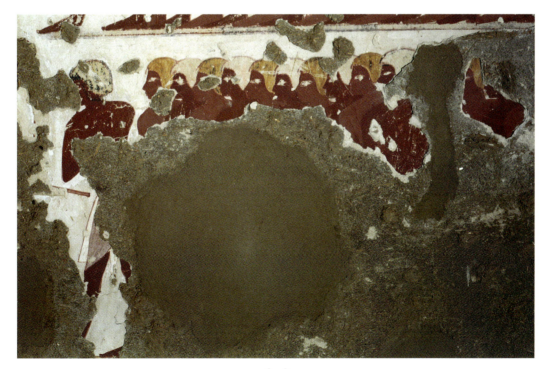

9, 2

Plate 10

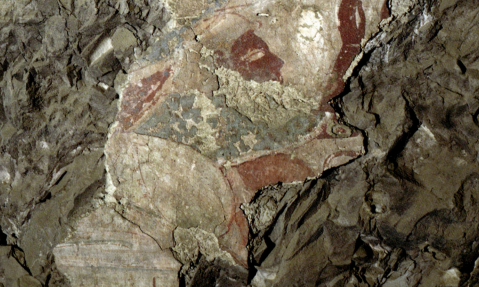

10, 1

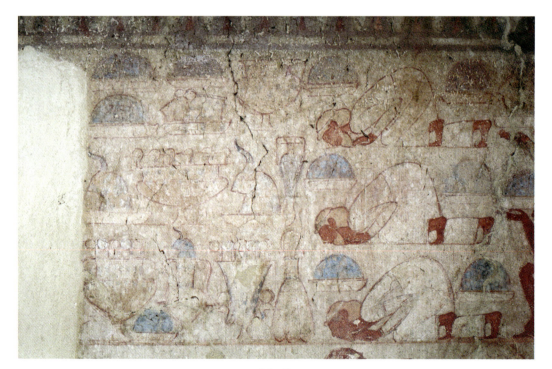

10, 2

Plate 11

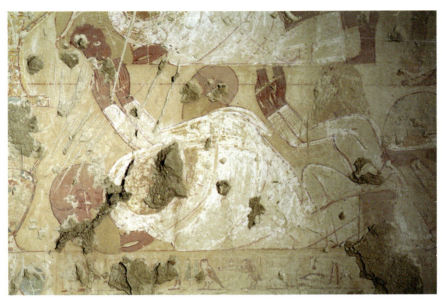

11, 1

11, 2

Plate 12

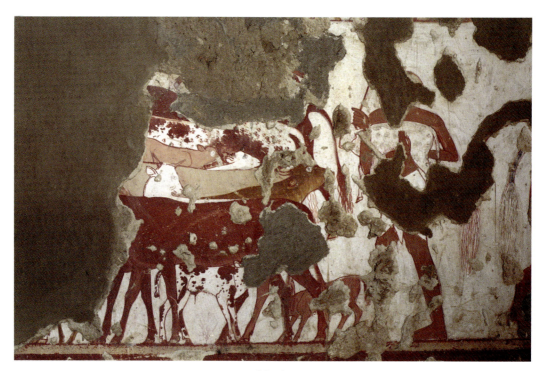

12, 1

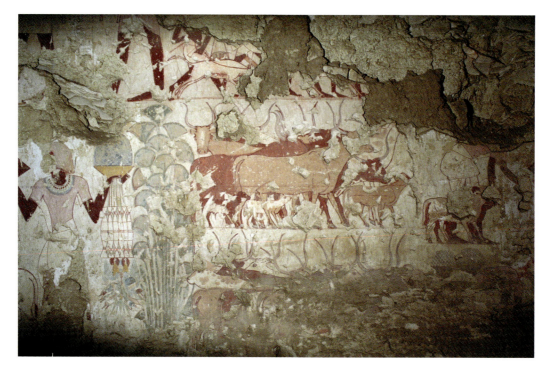

12, 2

Plate 13

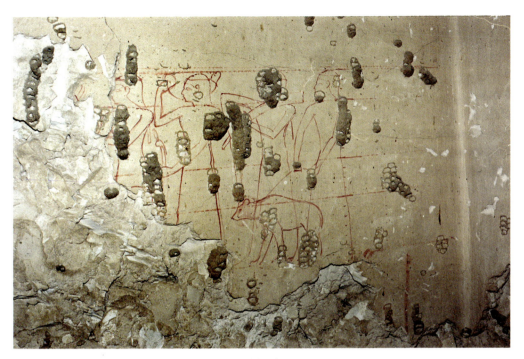

13, 1

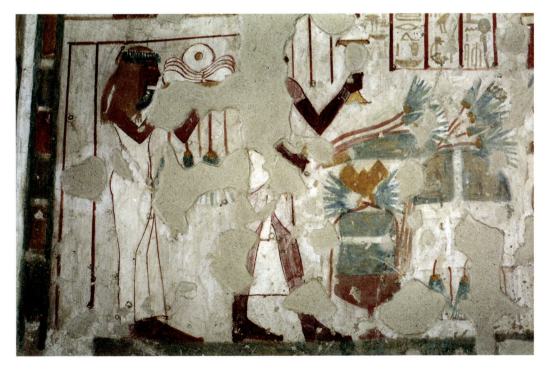

13, 2

Plate 14

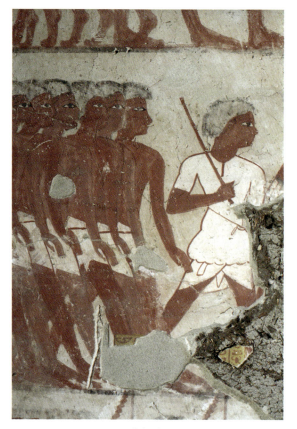

14, 1

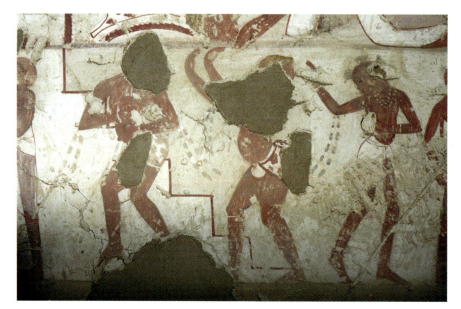

14, 2

Plate 15

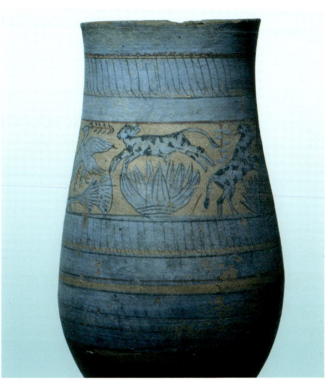

15, 1

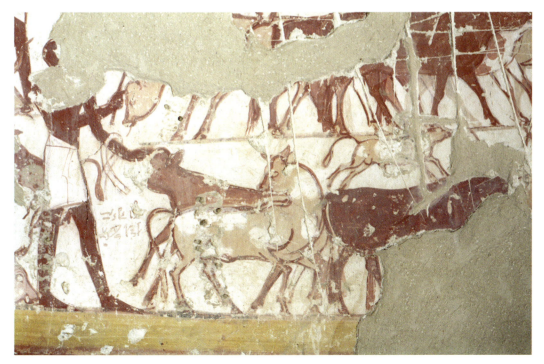

15, 2

Plate 16

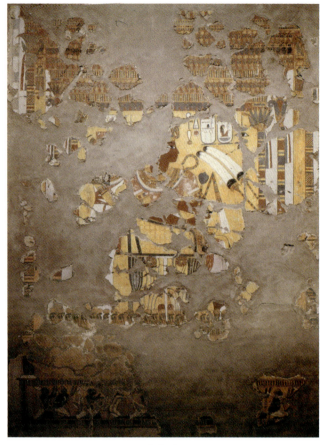

16, 1

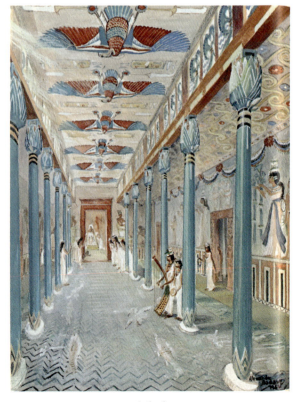

16, 2

Plate 17

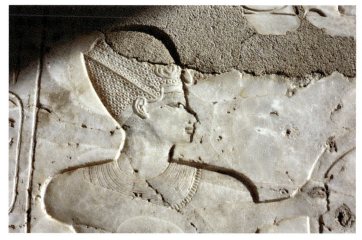

17, 1

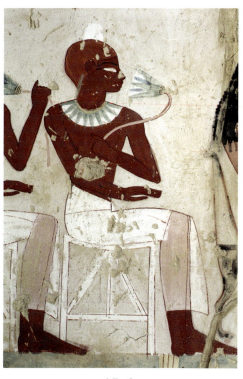

17, 2

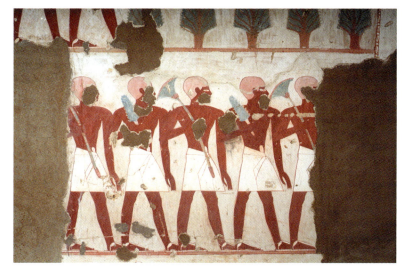

17, 3

Plate 18

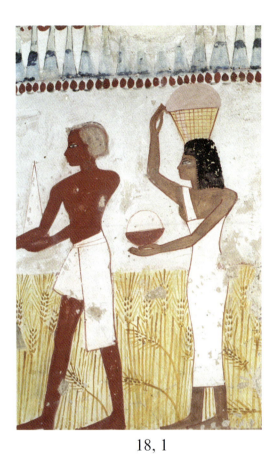

18, 1

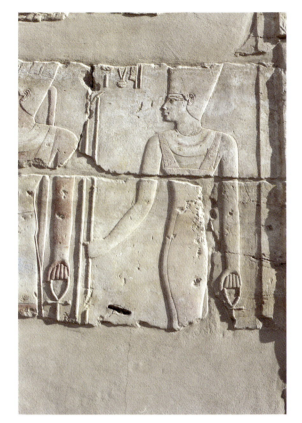

18, 2

18, 3

B & W Plate 1

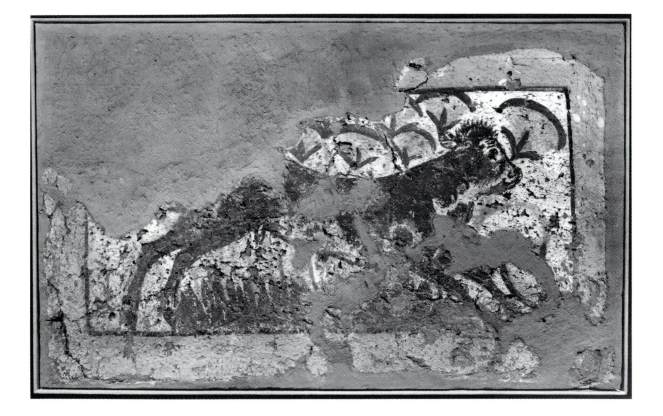

B & W Plate 2

2, 1

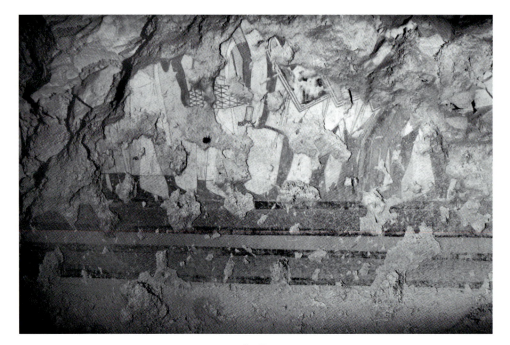

2, 2

B & W Plate 3

3, 1

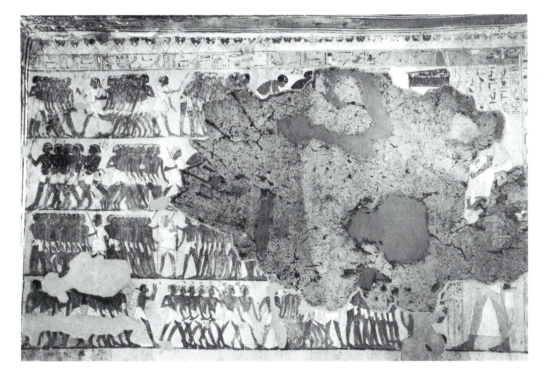

3, 2

B & W Plate 4

4, 1

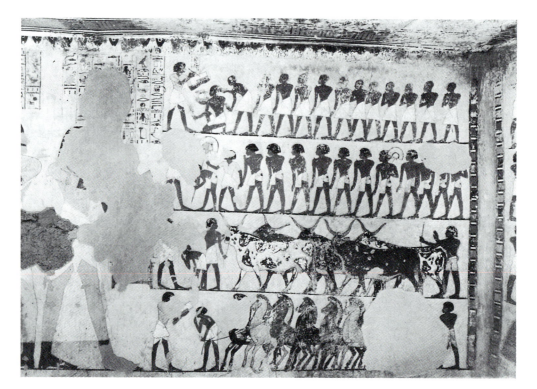

4, 2

B & W Plate 5

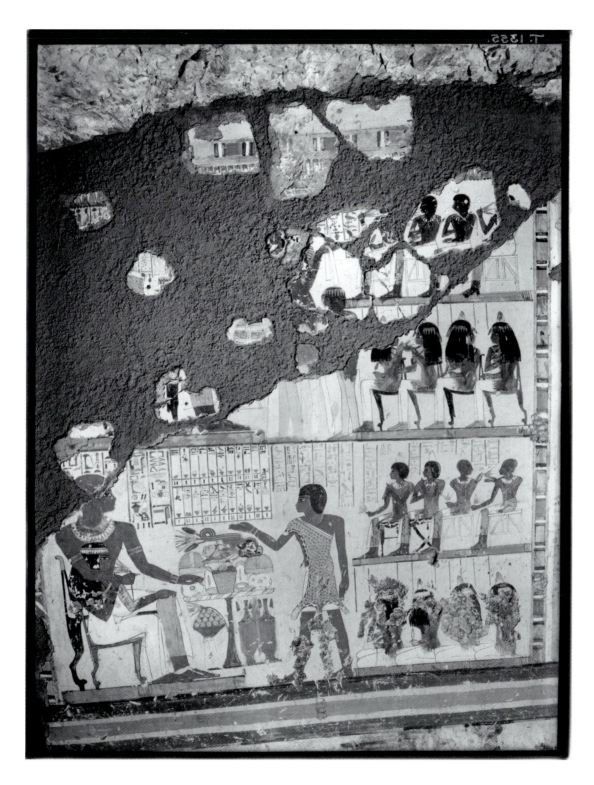

B & W Plate 6

B & W Plate 7

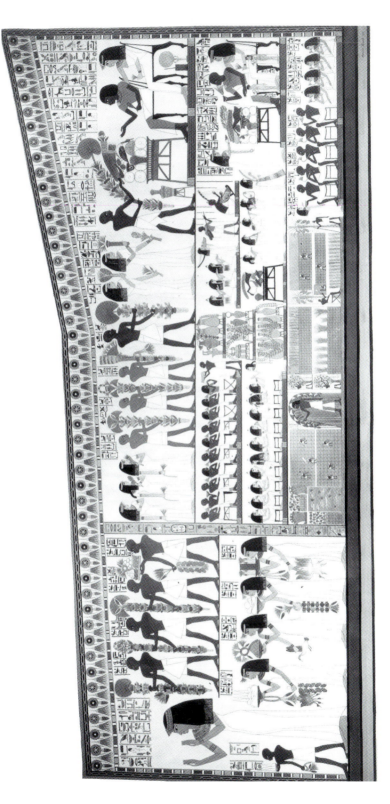